JOHN POPE-HENNESSY

ITALIAN HIGH RENAISSANCE AND
BAROQUE SCULPTURE

PHAIDON

AN INTRODUCTION
TO ITALIAN SCULPTURE

BY

JOHN POPE-HENNESSY

PART I

ITALIAN GOTHIC SCULPTURE

PART II

ITALIAN RENAISSANCE SCULPTURE

PART III

*ITALIAN HIGH RENAISSANCE AND
BAROQUE SCULPTURE*

JOHN POPE-HENNESSY

Italian High Renaissance and Baroque Sculpture

PHAIDON · LONDON AND NEW YORK

PHAIDON PRESS LIMITED, 5 CROMWELL PLACE, LONDON SW7

PUBLISHED IN THE UNITED STATES BY PHAIDON PUBLISHERS, INC
AND DISTRIBUTED BY PRAEGER PUBLISHERS, INC
III FOURTH AVENUE, NEW YORK, N.Y. 10003

FIRST PUBLISHED 1963
SECOND EDITION 1970

ISBN 0 7148 1460 1
LIBRARY OF CONGRESS CATALOG CARD NUMBER: 70-125304

PRINTED IN GREAT BRITAIN BY HUNT BARNARD PRINTING LIMITED
AYLESBURY, BUCKINGHAMSHIRE

CONTENTS

Plates

FOREWORD TO THE SECOND EDITION

Since 1963 a number of significant additions have been made to the literature of sixteenth- and seventeenth-century Italian sculpture. Account of these has been taken in the text and notes of the present book.

In the new edition the bibliography of Michelangelo has been extended, and minor changes have been made in the entries on individual works. The sections on Tribolo, Bandinelli, Cellini and Francavilla have been somewhat amplified, and those on Girolamo Campagna and Tiziano Aspetti have been thoroughly revised. The bronze bust of Pope Sixtus V in Berlin (Plate 134) now appears under the name of Taddeo Landini, not under that of Bastiano Torrigiani. The biography and bibliography of Bernini have been reconsidered and extended in the light of recent discoveries, and a number of substantial changes have been introduced into the notes on individual works by Bernini, Maderno, Duquesnoy and Algardi.

JOHN POPE-HENNESSY

1970

ITALIAN HIGH RENAISSANCE AND
BAROQUE SCULPTURE

THE little that we know about the attitude of sculptors in the fifteenth century to the art of their own time comes from the *Commentaries* of Ghiberti. For the sixteenth century the sources are richer and more informative, but one of them transcends all others in importance, Vasari's *Lives*. Not only was Vasari on terms of friendship with most of the great sculptors of his day, but he supplies, in the prefaces to the three sections of the *Lives*, a precise account of the view which artists in the middle of the century took of the present and the past. For Vasari the history of Italian art falls into three sections, the first a pre-history running down to the end of the Trecento, the second the Early Renaissance – the period, that is, between the competition for the bronze doors of the Baptistry in Florence in 1400 and the emergence of Michelangelo – and the third 'the modern age'. It is the modern age, or High Renaissance, that is the subject of this book.

In sculpture the heroes of Vasari's three sections are Nicola Pisano, Donatello and Michelangelo, and his criterion of judgement is their relationship to the antique. Whereas Nicola was no more than an agent by whom the art of sculpture was improved, the works of Donatello 'are up to the level of the good antiques', while those of Michelangelo 'are in every respect much finer than the ancient ones'. This theory of continuous upward progress was fortified by the belief that a similar development had taken place in Greece, where the three phases were represented by Canachus, whose statues were lacking in vivacity and truth, Myron, who 'endowed his works with such excellent proportion and grace that they might be termed beautiful', and Polycletus, by whom 'absolute perfection' was attained.

In one respect Vasari recognised that this analogy might be misleading, in that the motive power behind Greek sculpture was self-generated, whereas Renaissance sculpture was a renewal, and its course was therefore influenced by the availability of antique sculptures. During the first phase 'the admirable sculptures . . . buried in the ruins of Italy remained hidden or unknown'; the second was one of discovery, though so exiguous were the remains that sculptors were necessarily guided by the light of nature rather than by that of the antique; in the third phase more and better sculptures became known. 'Some of the finest works mentioned by Pliny,' writes Vasari, 'were dug out of the earth, the Laocoon, the Hercules, the great torso of Belvedere, the Venus, the Cleopatra, the Apollo and countless others, which are copied in their softness and their hardness from the best living examples, with actions which do not distort them, but give them motion and display the utmost grace.' This made it possible for sculptors in Vasari's day to attain 'the zenith of design'. This view was not peculiar to Vasari; it was held universally, and is accountable for the main difference between Early and High Renaissance sculpture, that the background of the first is a sense

of struggle towards a distant goal, while that of the second is a feeling of achievement, the sense of life lived on a plateau from which the only advance possible is a descent. What Vasari, writing in 1550, could not foresee was that the revolution which was associated with the name of Michelangelo would be followed by two further stylistic revolutions led by Giovanni Bologna and Bernini, and that these later revolutions would also spring from the action of classical sculpture on the creative imaginations of great artists.

Growing familiarity with the antique, especially with Hellenistic sculpture, had the practical result that it led to changes in technique which are apparent initially in the work of Michelangelo. The best account of Michelangelo's technical procedure is given by Cellini in his *Treatise on Sculpture*. Michelangelo, Cellini tells us, was in the habit of drawing the principal view of his statue on the block, and of beginning the sculpture on this face as though it were in half-relief. Gradually the image, covered with its penultimate skin, was disclosed, and then, with a file and small-toothed chisel, this last skin was removed, leaving a figure modelled with the same veracity and freedom as an antique sculpture. The classic example of this technique is Michelangelo's unfinished statue of St. Matthew (Figs. 9, 10). Vasari stresses that technical advances in the sixteenth century enabled painters to turn out more and larger works; advances in technique also permitted sculptors to carve more rapidly and on a steadily expanding scale. The creative vistas that were opened up by this new technical facility can be gauged from the contract with Michelangelo for twelve more than life-size marble statues of Apostles to be delivered at the rate of one a year, and from the impractical first project for the tomb of Pope Julius II. According to Vasari, Michelangelo at first worked from a small model, but became a convert to the full-scale model while engaged on the Medici tombs. Full-scale models were invariably used by Giovanni Bologna. One advantage of employing them was that the execution of the marble could be entrusted to other hands. This contingency is first openly discussed in the case of Michelangelo, who was forced by circumstances to delegate the carving of certain statues for the Medici Chapel and the Julius tomb. In most of Giovanni Bologna's marble sculptures assistants played a material part. The use of full-scale models was pressed to its logical conclusion by Bernini in a number of large works – the monument of the Countess Matilda, the Fountain of the Four Rivers, the Chair of St. Peter, the tomb of Pope Alexander VII – in the execution of which he himself had practically no share. No exception was taken to this practice at the time – it was the prerequisite of superhuman productivity – but in judging the sculptures that resulted as works of art, a firm distinction must be drawn between the sculptor as designer and the sculptor as executant.

High Renaissance sculptors are distinguished from their predecessors by a concern with style, that is with the form in which their works are cast. In sixteenth-century art theory painting and sculpture are commonly presented as branches of *disegno* or design, and the prevailing faith in a style-concept applicable to both arts gave rise, at very beginning of the century, to the suggestion that the marble block from which Michelangelo subsequently

carved the David should be made available to Leonardo, who had no experience of marble sculpture. This concern with form led to an unprecedented readiness to acknowledge the supremacy of the stylistic innovator, that is of the great artist. No sculptor in the fifteenth century enjoyed the god-like authority of Michelangelo. One of the epigrams written for his funeral describes his return to the celestial regions whence he had briefly descended upon Florence. Adaptations of Michelangelo's St. Peter's Pietà were carved during the sculptor's lifetime for Genoa and Florence; no sooner had the figures in the Medici Chapel been abandoned than reduced copies of them were made by Tribolo; casts of works by Michelangelo were known to Vincenzo Danti at Perugia and to Vittoria in Venice; and small bronzes were made after the Bacchus, the Moses and the Minerva Christ. As a result these works came to be looked upon as archetypes. But the style of a great artist arises from the demands of his own temperament, and when it is adapted as an academic discipline, it is transformed. This occurred in Florence with the style of Michelangelo, and contributed to the phenomenon which is known as Mannerism.

When this book was first announced, it was called *Italian Mannerist and Baroque Sculpture*. The epithet Mannerist has since been eliminated from its title, and the noun Mannerism has, so far as possible, been avoided in the text. Originally descriptive of a homogeneous style, the *maniera*, practised locally in Florence over a short period of time, the concept of Mannerism has been slowly extended to a point where it is little but a synonym for style during the sixteenth century. High Renaissance sculpture is of its nature meditated and sometimes artificial, but only by exception is it Mannerist, and the effect of applying this or any other descriptive label to it is to impose a spurious uniformity on a number of widely differing artists and works of art. In its legitimate historical sense, Mannerism is no more than a substyle of Renaissance sculpture, a brief parenthesis in a development that leads from the trial relief of Brunelleschi to the final dissolution of Renaissance ideals and Renaissance style in the mature sculptures of Bernini.

MICHELANGELO : THE EARLY WORKS

MICHELANGELO was the first artist in history to be recognised by his contemporaries as a genius in our modern sense. Canonised before his death, he has remained magnificent, formidable and remote. Some of the impediments to establishing close contact with his mind are inherent in his own uncompromising character; he was the greatest sculptor who ever lived, and the greatest sculptor is not necessarily the most approachable. But others are man-made, and when we turn for help to the books dealing with his work, only occasionally do the sculptures stand out from the pervasive Nietzschean mist.

Born in 1475, Michelangelo was brought up in the neighbourhood of Florence, and in 1488, when he was thirteen, was apprenticed to the painter Ghirlandaio. In later life he tended to play down the significance of this apprenticeship, mainly because of the terms in which he

came to view himself and his own work. He had never, he claimed, been a professional painter or sculptor, by which he meant that he maintained no workshop, and he looked on his career as a break with the immemorial tradition of the artist as artificer and the work of art as artefact. Had events pursued their normal course he would have stayed with Ghirlandaio for three years, but he was rescued from that fate by Lorenzo de' Medici, who had established what was later known as the Medici Academy. This was not an academy in the sense of 1550 or of to-day; it was a loose arrangement whereby youths of exceptional talent were freed from routine duties, and set down under supervision to study the antiques in the Medici collection. It affected Michelangelo in two fundamental ways. It meant in the first place that he set off on his journey without the handicap of a conventional style or of an inculcated, an imposed technique; in both respects his attitude to sculpture was, from the first, empirical. It meant secondly that at fifteen he was imbued, through contact with the Medicean circle, with a conception of the visual arts as an exclusively intellectual activity. Years later, when he described the painter as working not with the brush but with the brain, and praised the sculptor's hand obedient to his intellect, he was pursuing trains of thought that must go back to this extremely early time.

Only one work dating from these years survives, the relief known as the Battle of the Centaurs in the Casa Buonarroti (Plate 2). From the life of Michelangelo written by his pupil Condivi in 1553 we learn that it was carved before the death of Lorenzo de' Medici, that is before April 1492, and was inspired by the humanist Politian. 'Michelangelo,' writes Condivi, 'gave himself up to his studies, showing every day some fruit of his labours to Lorenzo il Magnifico. In the same house lived Politian, who, perceiving Michelangelo to be a lofty spirit, conceived much affection for him, and used continually to spur him on in his studies, and was for ever interpreting and showing him some theme for his work. Among other things he proposed to him one day the rape of Dejanira, and the battle of the Centaurs, explaining the whole fable, passage by passage.' From a narrative standpoint the Battle of the Centaurs is ambiguous – a great many thousand words have been devoted to discussing exactly what it represents – and of all Michelangelo's multiple concerns when carving it, we should, on the evidence of our eyes alone, judge academic programme to have been least prominent. The importance of the relief is that it marks a revolutionary change of attitude to the morphology of the antique.

The Medici Academy was directed by the bronze sculptor Bertoldo, and we have one clue as to the methods of instruction he employed, for Vasari tells us that Michelangelo's co-pupil Torrigiani 'worked in the round in clay certain figures which had been given him by Bertoldo'. Michelangelo must have been trained in the same way. In London there is a Bertoldo statuette of Hercules on a little platform which is sunk into a later base. The platform indicates the point from which Bertoldo intended the figure to be seen, and the pose of the figure from this view (Fig. 1), with shoulders receding diagonally into space, neck tensed, head turned, and one knee thrust forward into a front plane, occurs again in a standing youth on the left of

Michelangelo's relief. Immediately to the right is a male figure seen from behind, and when we look at the back of Bertoldo's statuette (Fig. 2), it offers a precedent for this pose too. When, therefore, scholars tell us, as nowadays they sometimes do, that Michelangelo owed nothing to Bertoldo, and that the Medici Academy is a myth, we can answer that both propositions are wrong.

Bertoldo's interests extended from the single figure to the group. The main evidence for this is a bronze battle relief in the Bargello based on a classical sarcophagus (Vol. II, Figs. 138, 139). In the eyes of Renaissance sculptors Roman sarcophagus reliefs had one and only one defect, that they were inadequately organised. In Bertoldo's relief this is redressed by a number of devices of which one is specially significant, that of linking two figures so that they form a single unit within the scene. In the foreground, for example, a little to the right of centre, are two figures with backs turned, which have been linked together to establish a diagonal through the relief. This practice is taken over in the Battle of the Centaurs, where the male figure with back turned is joined to the female figure beneath him, and his left arm rests on a diagonal between the upper left and lower right corners of the figurated part of the relief. Michelangelo's employment of this compositional device is infinitely bolder than Bertoldo's (an example is the linked arms of the figures on the right, which establish a horizontal line parallel to the body of the woman beneath them and to the base of the relief), his command of movement is incomparably greater, and already, in the seated figure on the left, we sense the stirring of the divine compassion that inspired so many of his adult works. This exclusive, obsessive concentration on the human figure, not as representation but as language, this vocabulary of the nude is fundamental for all his later sculptures. In this sense the Battle of the Centaurs is a mirror which reflects the face not of the sixteen-year-old boy by whom it was carved, but of the ageing artist of the Medici tombs.

In another respect too the relief looks forward to the sculptor's later works: in that it is incomplete. In the fifteenth century unfinished marble sculptures are extremely rare; they exist, but they can be counted on the fingers of two hands. With Michelangelo, however, the number of works that were not finished far exceeds those that were. This fact is fundamental for an understanding of his work. A vast literature has grown up on Michelangelo and the unfinished, and the prevalence of unfinished sculptures has been explained in many different ways. There have been aesthetic explanations, and moral explanations, and metaphysical explanations, and distinctions have been drawn between what is called *innere* and *äussere Vollendung*, intrinsic and extrinsic finish, and between the unfinished and unfinishable, the *unvollendet* and the *unvollendbar*.

The first writer to discuss the problem was Vasari, who counted eleven completed statues. Since most of them were early works, he deduced that Michelangelo in youth had an ideal of completeness from which he retreated in later life. This diagnosis is not quite correct. The early works that are complete were one and all commissions, and the later sculptures that are finished were also works of whose utility there was no doubt; even the Moses remained unfinished in

the sculptor's studio for almost thirty years until it was absolutely certain it would be required. The specific reasons why works were left unfinished are almost as numerous as the works themselves. Sometimes the sculptor was dissatisfied with the marble block, sometimes he lost his temper and damaged the block wantonly, sometimes he revolted against the patron for whom he was working, sometimes he reacted against the subject with which he had to deal. Just because the ostensible causes are so various, they can only be regarded as a projection of his creative nature, an expression of the kind of sculptor that he was. More than any other artist, Michelangelo worked at the limits of the possible. Each of his sculptures from the very first dealt with an artistic problem, and it seems that his interest in them waned once they were formulated to a point at which the solution was no longer in doubt. Michelangelo's concern lay with the problem, not with the completed work of art.

This had consequences that must be mentioned briefly here. The difficulties that beset his great commissions were inherent in his own psychology; his temperament made it preternaturally difficult for him to maintain a steady course. For this reason his influence on contemporary sculpture, great though it was, was infinitely less than it would otherwise have been. In the fifteen-eighties Francesco Bocchi, in his little eulogy of the St. George of Donatello, took it upon himself to express the academic critic's disapproval of the *bruttezza*, the ugliness, of Michelangelo's unfinished sculptures, and it was almost exclusively through finished or virtually finished works that the sculptor's influence was felt. But Michelangelo's unfinished works none the less introduced a new factor into art. They revealed the possibilities of the indefinite, and postulated a relationship between the work of art and the spectator, whereby the spectator was called on to invest with meaning forms whose exact meaning was not defined. The full significance of this transpired in the nineteenth century, when Michelangelo's lack of finish was acclaimed as an affirmation of individual liberty and as an intimation of the infinite, a realm superior to art. From there it was no more than a short step to the conviction that the unfinished works of Michelangelo were in fact complete. As an English writer on Michelangelo put it, 'they are complete to us'. But by objective standards these sculptures are not complete; they were not regarded by the sculptor as complete; in practically every case they were begun in the conviction that they would be finished; and they should be interpreted in terms of the completed sculptures they imply.

Between 1492, when Michelangelo left the Palazzo Medici, and 1494, when he visited Venice and Bologna, only one statue is recorded, an over-life-size Hercules. It remained in Florence till 1529, when it was sent to France, and there it disappeared leaving no trace. At this time Michelangelo embarked on the study of anatomy. We hear of his analysing corpses for the first time in Florence in 1492, and for the last time in Rome in the fifteen-forties, when he dissected the body of a Moor that had been given him by a physician friend. The scope of his studies was artistic and not medical – he despised the anatomical writings of Dürer because in them gesture and action were left unexplained – and they account for the preternatural confidence with which his earliest large sculptures are carved.

On his return to Florence in 1495 he carved two statues which have also vanished. One of them was a commission from Botticelli's patron, Lorenzo di Pierfrancesco de' Medici, for a Giovannino, and the other was a sleeping Cupid. The Cupid, which was based on a classical sleeping Cupid type and passed as an antique, was bought by Cardinal Riario, and in June 1496 Riario encouraged Michelangelo to move to Rome. Michelangelo went to Rome for purposes of study, and while there he depended upon the perceptiveness of private patrons, of whom the most important was Jacopo Galli, a rich collector of antiques. All his major sculptures at this time were either carved for Galli, or were contracted for with Galli as an intermediary, and if we knew more about Galli, we should understand more than we do about the early work of Michelangelo. For Galli he carved a second Cupid, which like the earlier Cupid has disappeared, and one work which has survived, the Bacchus in the Bargello (Plates 10, 11). Work on the Bacchus was probably begun at the end of 1496 or in the following year. About 1532 a drawing was made of the statue standing in Galli's garden, among his collection of antiques. The Bacchus was carved in Galli's house, and the classical carvings represented in the drawing may have been before the sculptor's eyes when it was made.

Like the Battle of the Centaurs, the Bacchus is based on the antique, but is constructed in a way peculiar to the fifteenth century. In Roman sculpture (Fig. 13) the subject of Bacchus and a Satyr is treated with a dominant view, usually with the two figures set flat across one plane. But in Florence the aesthetic of the free-standing statue had been developed in a contrary direction, first by Donatello, who devised a type of figure with four interdependent faces (Vol. II, Figs. 9–11), and then by Verrocchio, who in the Putto with a Fish (Vol. II, Plate 78) evolved a serpentine figure in which no view was predominant. In the Bacchus the corkscrew motion of the Satyr would be unthinkable without Verrocchio's experiments, and so would the slow spiral movement by which the Satyr is linked to the main figure, and the eye is carried upwards to the cup held in the right hand. One of the recurring preoccupations of Florentine Early Renaissance sculptors was with mobility, play of the features as well as movement of the frame. Donatello introduced this factor of mobility into the niche figure, so that the Prophets on the Campanile step forward as though about to speak, and both Desiderio da Settignano and Benedetto da Majano depict the Baptist advancing with parted lips. Hence Michelangelo's concern with the unstable stance of the drunken figure and with the loose movement of his lips. But there is nothing conventional in his perception of the human form, and nothing conventional in his technique. The form is apprehended not as surface only, but as a rational organism, and the means by which it is recorded derive from the antique. In the Bacchus Michelangelo proclaims his freedom from the fetters of technique; whatever problems faced him in the future, they could not arise from the rendering of the human figure in the round.

For religious sculpture the relevance of the antique was less direct, but its influence is manifest in Michelangelo's first sacred work. His arrival in Bologna in 1494 was timely, for the principal Bolognese sculptor, Niccolò dell'Arca, had died a few months earlier, while engaged

upon the marble lid of the Arca of St. Dominic (Vol. I, Fig. 48). Two statuettes of Saints and one of a pair of candle-bearing angels were missing from the shrine, and responsibility for these was transferred to Michelangelo. Niccolò dell'Arca's roots were in Ferrara – his most intense experience was drawn from paintings by Cossa and Ercole de' Roberti – and his candle-bearing angel on the altar is elegant and fragile, and so lacking in tactility that from the front it looks as though its back were flat. Michelangelo made no attempt to imitate its style. He set his figure (Plate 1) not straight across the base, but with a slight diagonal emphasis in the extended leg, and posed the body so that the shoulders receded from the front plane. The principle of posture is that which underlies the figures in the Battle of the Centaurs, and the head is carved in precisely the same fashion as the head of Theseus in the relief. The points of juncture at the ankles, wrists and neck, and the attachment of the wings and shoulder blades, are articulated with amazing confidence. One of the most impressive features of this little figure is the way in which the candlestick acquires its own specific weight, and rests firmly on the pedestal of the knee and foot. The two Saints are less forward-looking, and the St. Petronius (Fig. 3) conforms in type to the statue of this Saint by Quercia above the doorway of San Petronio.

In 1498, in Rome, Michelangelo received his first commission for a major religious sculpture. There resulted one of his most famous works, the St. Peter's Pietà (Plate 6). We are prone to take the Pietà for granted, as we do all the greatest works of art, but if we could contrive for a moment to see it with fresh eyes, we should find it an entirely inexplicable sculpture on the counts of style, subject and typology. No large marble Pietà was carved anywhere in Italy in the whole fifteenth century, but in Florence about 1490 the subject became popular in painted altarpieces. The altarpieces are, however, self-contained – they show the Virgin mourning over the dead Christ – whereas the sculptured group is not – it shows the Virgin displaying the dead Christ to the onlooker. That this is the subject of the group is left in no doubt by the Virgin's extended hand, part of which has been restored, but where everything save possibly the index finger is in the position Michelangelo designed. The Virgin is a youthful figure. Many years later Michelangelo defended this break with conventional iconography, but it was not universally acceptable, and when a copy of the group was made for Genoa by Michelangelo's one-time assistant Montorsoli, this aspect of its imagery was modified.

The group is constructed with great deliberation as a pyramid. Christ's head is turned back in such a way as not to break the bounding line, and beneath his body the folds of the Virgin's cloak flood down like a waterfall. In the sculpture of the fifteenth century there is no motif at all like this, and for that reason parallels have been sought in the North among German Vesper-bildern and French sculptured Pietàs. The group was commissioned by a Frenchman, Cardinal Jean Villier de la Grolaie, who came from Auch and had been Abbot of Saint Denis, so it is not impossible that it was planned with a French Pietà in mind. But to admit that (and it is far from certain) is to recognise the transformation that has taken place. The jagged drapery has been rounded and ordered and filled out, a Hellenistic hero has been substituted for the doll-like

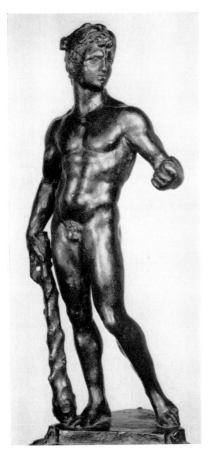
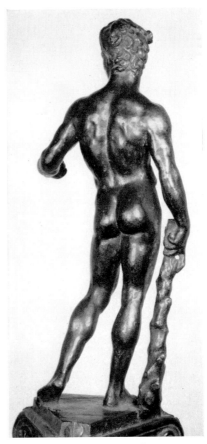

Figs. 1, 2. Bertoldo: HERCULES. Victoria & Albert Museum, London.

Fig. 3. Michelangelo: ST. PETRONIUS.
S. Domenico Maggiore, Bologna.

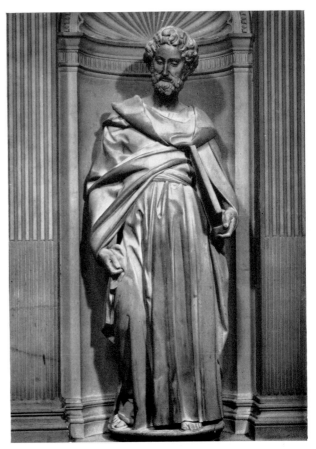

Fig. 4. Michelangelo: ST. PETER.
Duomo, Siena.

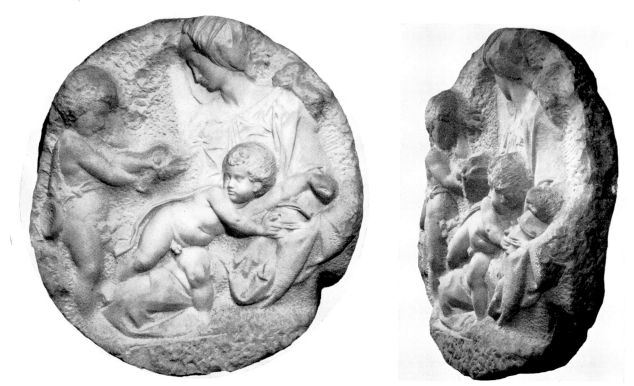

Figs. 5, 6. Michelangelo: THE TADDEI TONDO. Royal Academy of Arts, London.

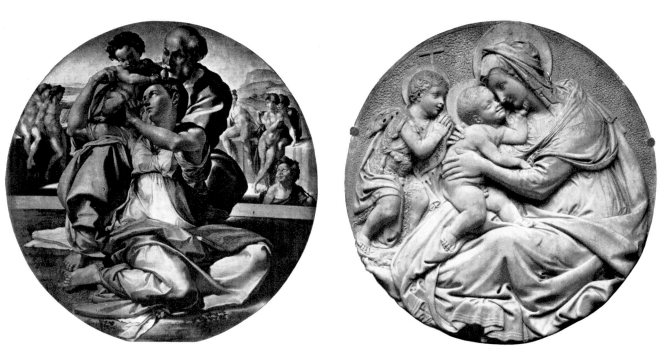

Fig. 7. Michelangelo: THE DONI TONDO. Uffizi, Florence.
Fig. 8. Rustici: VIRGIN AND CHILD WITH THE YOUNG BAPTIST. Museo Nazionale, Florence.

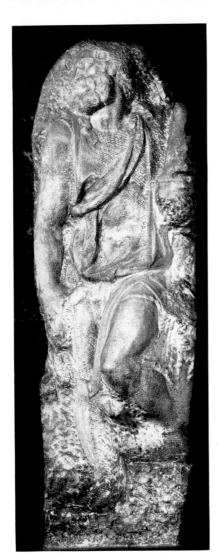
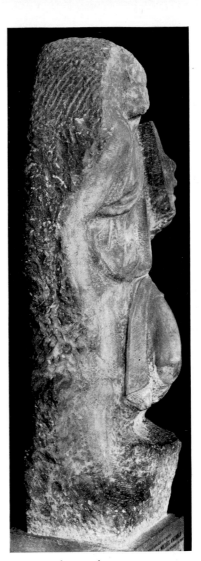

Figs. 9, 10. Michelangelo: ST. MATTHEW. Accademia, Florence.

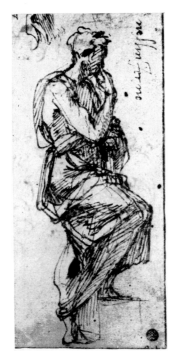
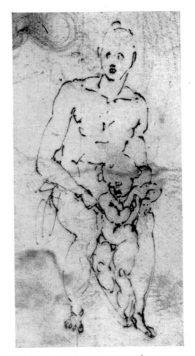

Fig. 11. Michelangelo: DRAWING FOR AN APOSTLE STATUE. British Museum, London.
Fig. 12. Michelangelo: DRAWING FOR THE BRUGES MADONNA. British Museum, London.

Fig. 13. Roman, first century A.D.: BACCHUS AND A SATYR. Museo delle Terme, Rome.
Fig. 14. Roman copy of a Greek original: PENELOPE. Museo Vaticano, Rome.

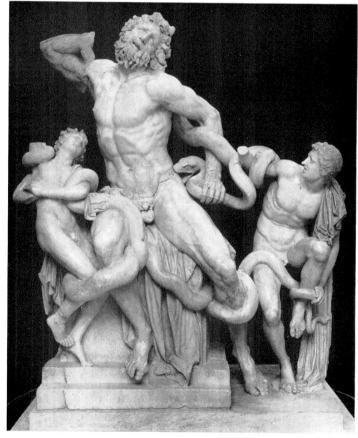

Fig. 15. Hellenistic, first century B.C.: THE BELVEDERE TORSO. Museo Vaticano, Rome.
Fig. 16. Rhodian, second century B.C.: LAOCOON. Museo Vaticano, Rome.

Christ, and the emotion on the Virgin's face is rendered with supremely classical restraint.

The Pietà can only have resulted from close intellectual application, but we have no way of reconstructing the ideas the sculptor sifted and dismissed. Some impression of the nature of his thought can none the less be gained from the only other work he produced of the same kind. This is the Madonna at Bruges (Plate 7), which was carved after he returned to Florence, probably in 1504 or 1505. Here, thanks to the survival of a number of preliminary drawings, we can watch Michelangelo's creative machinery at work. In what is presumably the earliest of the drawings, the Child is not shown standing, as in the completed group, but is supported on the Virgin's knee, with his head turned in right profile and his right leg outstretched. The Virgin in this version, like so many of her predecessors in the fifteenth century, is gazing down, and her feet, like the feet of so many fifteenth-century Madonnas, are set flat on the base. In another study the scheme is modified; the left foot of the Virgin is set higher than her right, and the Child stands between her legs. In a third sketch on the same sheet the relative positions of the two feet of the Virgin are preserved, but the Child is shown standing in front of her right knee, while in a fourth sketch (Fig. 12), in the British Museum, the Virgin gazes dispassionately outwards, as she does in the completed group. These preliminary drawings register a change of concept as well as form. The maternal motif on which fifteenth-century Madonnas almost without exception had been founded is progressively abandoned, and the resulting statue has the same relation to traditional Madonna groups that the Pietà has to the traditional Mourning over the dead Christ. In both the narrative element has been excised, and the Virgin is shown with her features frozen by suffering or by premonition, offering to the spectator the dead or living Christ. The effect is so meditated and withdrawn that at first sight we may be tempted to describe it as impersonal, but these are in fact the first examples of the highly personalised religious iconography which was to reach its climax in Michelangelo's late works.

In the spring of 1501 Michelangelo left Rome for Florence. Before he did so, negotiations were begun for the last of the commissions in which Jacopo Galli was involved, some statuettes for the Piccolomini altar in Siena Cathedral. The contract for them was signed in June 1501, and the four figures Michelangelo completed were finished by September 1504. The phrase the 'four figures Michelangelo completed' has an ominous ring. In Rome between 1496 and the first months of 1501 he finished three major works, but in Florence, between 1501 and March 1505 when he returned to Rome, the balance between his capacity and the demands made on it was for the first time disturbed. In 1501 it seemed that Michelangelo would complete a whole series of great sculptures; by 1505 some of the factors which would prevent his doing so were already making themselves felt. Michelangelo looked on the commission for Siena without enthusiasm; his figures were intended for a pre-existing setting, and on only one previous occasion, at Bologna, had he undertaken a commission of the kind. In the interval his stylistic will had grown increasingly intractable. The measure of the change can be judged if we contrast the St. Petronius at Bologna (Fig. 3), with its backward glances at Quercia and Niccolò dell'Arca, and the St. Peter at Siena (Plate 9, Fig. 4), where the pose is severely rational, and

each fold of drapery is calculated in relation to the total scheme. The St. Peter is almost twice the size of the St. Petronius, but for the sculptor of the Bacchus and the Pietà its scale was still too small to engage his whole mind or his whole heart.

Not so the Madonna relief. There are two of these, both carved after Michelangelo's return to Florence. In the fifteenth century a large number of tombs included reliefs of the Virgin and Child. For architectural reasons they were generally circular, so that the task of designing half-length reliefs of the Virgin and Child inside a circular frame had been very fully explored. Their emotional range is comparatively limited, since it was dictated by their function on the tomb, and all of them are variations on one theme, that of the Virgin holding up the Child as he blesses or absolves the figure on the bier below. The painted tondo, on the other hand, had no structural function to perform; its imagery was self-contained, and its figures were depicted in interior space. In Michelangelo's reliefs these two traditions fuse. Though they were carved in marble, they were not planned in relation to a larger whole, but were intended as autonomous, self-consistent works of art.

The earlier of the two reliefs, the Taddei Madonna in London (Plates 3, 5, Fig. 5), seems to have been carved in 1503 or 1504, and must be almost exactly contemporary with the Doni tondo in the Uffizi (Fig. 7), which Michelangelo painted between 1503 and 1505. In High Renaissance theory a distinction was drawn between painting, which had the advantage of internal light, and sculpture, which was lit externally. That thought occurs for the first time in Leonardo da Vinci's *Paragone*, and in front of the Doni Madonna its significance becomes self-evident, for the forms and their relationship to one another are defined by means of light; the head of the Virgin is outlined against a pool of light on St. Joseph's cloak, the protruding arm of the Child is outlined against the high light on the beard, and the Virgin's left arm and the Child's right knee are isolated in precisely the same way. Were it not for the system of illumination, all these forms would inevitably coalesce. In the London relief Michelangelo investigates the problem of a circular Madonna composition lit externally. The ideal of coherence is unchanged, but it is achieved by means of a frieze-like scheme in which each element is invested with the maximum lucidity. The Virgin faces to the left, with the upper part of her body turned towards the spectator and her head turned slightly away, so that both contribute to the spatial content of the scene. The Child is set diagonally on the relief surface, with head turned back and the right leg, body and left arm in a continuous line. This motif was suggested to Michelangelo by one of the children on a Medea sarcophagus, but it is here refined so that the left, that is the further, leg of the Child is in a forward plane, and the right, that is the forward leg, is at the back. On the left is the young Baptist holding a bird in his outstretched hand. His head and heels are on the perimeter of the relief, and his left arm is parallel with the base.

Whatever the reason, Michelangelo was dissatisfied with this relief, and a little, but only a little, later he started work on a smaller Madonna relief, the Pitti tondo in the Bargello (Plate 4). Here the expedient of the flat platform is done away with, and at the base the Virgin's cloak

conforms to the curved frame. The figure of the Virgin is set on a block protruding at an angle from the relief surface, and is tighter and more compressed than in the earlier relief, but the Child once more depends from the antique, this time – such is the continuity of Tuscan sculpture – from the Phaedra sarcophagus in the Campo Santo at Pisa (Vol. 1, Fig. 5), from which Nicola Pisano had drawn the figures for the Pisa pulpit two hundred and fifty years before. In the Pitti tondo only the head and throat of the Virgin have been worked up, and only the area behind the head of the Child is excavated to its intended depth. The Virgin was evidently to be shown on a concave ground in extremely deep relief, the Child in half relief, and the Baptist in lower relief still. In the London tondo the relief system is more uniform. A small area of background beside the Virgin's head has been smoothed off, and if that had been extended, the three figures would have been shown on a flat surface essentially in the same depth. If we look at the tondo from one side (Fig. 6), we can see that the full depth of the block is used throughout, and that the head and shoulders of the Virgin and St. John and the knees of St. John and the Child Christ all rest on a single plane.

What finished sculptures are implied in these reliefs? For the Pitti tondo we have an exact analogy, on almost the same scale, in the figure of St. Peter which was carved by Michelangelo under the terms of the Siena contract, and we can imagine the shoulder, sleeve and skirt of the seated Virgin finished off in rather the same way. The case of the Taddei tondo is more difficult, since parts of the relief are in a rudimentary and parts in a more highly finished state. The St. John, for example, is blocked out roughly, while the thighs, torso and head of Christ are more highly worked. It has been argued that the more highly finished parts were worked over by an assistant or by a later hand, but this is a misreading of the technique of the relief, and there can be no reasonable doubt that three separate technical stages, all of them auto-graph, are illustrated first by the head of Christ in the Pitti tondo, next by the head of Christ in the relief in London, and lastly by the head of Christ at Bruges. Certainly the Christ at Bruges would be inexplicable had it not been preceded by the technical phase recorded in the London relief. In the same way the drapery on the shoulder of the Taddei Virgin, where a claw tool is stroked across the surface till it produces a fine mesh of lines, is a prerequisite for the smooth folds of the Bruges Madonna.

The magnet that attracted Michelangelo to Florence in the spring of 1501 was the opportun-ity to carve a statue on a colossal scale. Forty-odd years earlier the sculptor Agostino di Duccio had made a gigantic Hercules for the outside of the Cathedral, and in the summer of 1464 it was decided to commission a second figure from the same sculptor. The intention was that this should be made from four pieces of marble, but at the end of 1466 a block of exceptional size was quarried at Carrara, and it became apparent that the new statue, unlike the old, could be manufactured in one piece. Confronted with this block, Agostino di Duccio began to excavate the area between the legs, probably in such a way that its stability seemed to be impaired. But he left Florence shortly afterwards, and ten years later the mutilated block was offered to Antonio Rossellino. When Rossellino died in 1477, it was abandoned as what Vasari calls 'a

dead thing'. The attitude of High Renaissance sculptors to size was very different from that of sculptors in the fifteenth century; and by 1501, only twenty-five years after it was pressed on the reluctant Rossellino, the block had ceased to be a liability, and was instead the focus of jealous eyes. Michelangelo had known it when he was in Florence, and seems at that time to have wished to carve a figure from it; Andrea Sansovino, in 1500 or 1501, petitioned for the block, guaranteeing that if pieces were added to it he could produce a statue; and Piero Soderini, as Gonfaloniere, contemplated giving it to Leonardo, who for the previous ten years had been occupied in Milan with the Sforza monument. However, it was to Michelangelo that the block was eventually awarded, and by January 1504 his statue was all but complete.

Paradoxically the David (Plates 12, 13) is a statue which nobody alive to-day has really seen. When it was finished, a committee of Florentine artists was convened to decide where it should be placed. Opinion was divided into two main camps: one that it should be shown in the Loggia dei Lanzi, because of the weathered condition of the stone, the other – a minority view which was in fact adopted – that it should replace Donatello's Judith outside the Palazzo Vecchio. Behind both views was implicit one assumption, that the statue should be shown before a flat wall surface in unrestricted space. But when in 1873 it was moved to the tribune of the Accademia, it was put in limited space, so that each of its component elements looks grotesquely large, and in a rotunda where the wall surface and mouldings destroy its silhouette.

The block was thin relatively to its width and height, and since the area between the legs was excavated, Michelangelo, when he started work, was committed to a pose that was both open and flat. In the nature of things the side views could never rival that from the front, and it was through contour that the figure must make its effect. In that respect the structure of the David is more classical than it might have been if Michelangelo had found himself, as a free agent, confronted by a deeper block. His source of inspiration was the colossal Horse Tamers on the Quirinal, which are within a few millimetres of the same height, but as Vasari claimed in 1550 it surpassed these and all the other colossal statues that were to be seen in Rome. What Vasari particularly praised about it is a quality that is no longer evident, its elegance, the contours of the legs, the smooth lines of the thighs, the grace of the conception and the sweetness of the pose. Vasari's words form a corrective to much that has been written on the statue in the last eighty years, for since 1873 writers on Michelangelo have seen it only as we see it now, and have been hypnotised, as we are, by the power of the conception and the magnitude of the detail. Vasari too must have looked up at the mat of hair that Michelangelo adapted from an Antinous, at its colossal pectoral muscles, and at its menacing eyes, but for him the merits of the figure were those of scale, not size.

As the David reached a stage of half completion early in 1503, one question assumed increasing urgency, to what could Michelangelo's energies be harnessed when the statue was complete? Soderini was alive to Michelangelo's potentialities; 'in his profession,' he wrote to his brother, the Cardinal of Volterra, in 1506, 'he is unique in Italy, perhaps even in the world.'

The plan he sponsored was unexpectedly ambitious, that Michelangelo should carve twelve more than life-size figures of Apostles for the nave of the Cathedral. What made this exceptional commission possible was the speed at which the sculptor worked. The St. Peter's Pietà was finished in one year or a little more, the David was begun in 1501 with the stipulation that it should be finished in three years, and in two and a half it was practically complete. So it seemed logical to the Consuls of the Arte della Lana, who were responsible for drawing up the contract, that Michelangelo should carve twelve statues of Apostles in twelve years. But they reckoned without Michelangelo's temperament and without the Pope.

At first all went well. The contract was signed in April 1503, and Michelangelo, still busy with the David, started to make drawings for the statues. There are three of them on a sheet in the British Museum. The most legible (Fig. 11) shows a figure with the left foot raised on a step or block, holding a book in his left hand, with his right hand pressed to his cheek. The drawing represents the side, not the front, view of the figure, and it leaves no doubt that the step and the projecting knee were alone to rest on the front plane of the block. On the basis of this and similar drawings five marble blocks were ordered from Carrara, and were quarried in the course of 1504, but in March 1505, before the blocks arrived in Florence, Michelangelo returned to Rome.

In practice he had no choice, since he was summoned by the Pope and was instructed by him to begin work on his tomb. But years later he seems to have looked back on the decision as a turning point, and considered that the path he chose was wrong. When the Pope sent for him, he wrote, he was busy with two great commissions, for the battle fresco in the Palazzo della Signoria and for the Apostle statues, and as a result of leaving Florence he completed neither work. His papal honeymoon was very short. He received his instructions from the Pope, spent eight months at Carrara procuring marble, returned to Rome in December and stayed there through the first months of 1506. But in the middle of April a crisis was reached. Starved of funds, suspicious of Bramante, frightened, angry and resentful, Michelangelo had recourse to flight. He fled to Florence, and remained there till November of that year. Instructions had been given that the Apostle contract should be cancelled, but the marble blocks lay there to hand, and Michelangelo returned to his old scheme. He was in a state of great emotional disturbance at the time – his grandiose projects for the tomb were thwarted, he had been treated by the Pope with what appeared to him to be contempt, and by precipitate action he had closed, it might be for good, the wide avenues of promise at the papal court – and all this is reflected in the statue of St. Matthew (Plate 14, Figs. 9, 10) on which he started work.

In the statue as it was carved the pose of the lower part was an inversion of that in the surviving drawing, and the protruding knee was brought across the figure, in such a way as to establish a continuous movement through the block. He had been cogitating the Apostle project spasmodically for three years, and many other sketches must have been made, but since the surviving drawing is our only point of reference, we must infer that the static composition of 1503 was invested in 1506 with a dynamism for which there was no parallel in any earlier work.

One reason for this was the discovery in January 1506 of the Laocoon. The Laocoon is not the basis of the St. Matthew in a formal sense – if the upper part has a precedent in the antique it is rather the statue known as the Pasquino, with which Michelangelo must have been familiar at least since 1501 – but without it the St. Matthew could not have been conceived. It was the Laocoon, with its sense of all-embracing effort, its disciplined emotional excess, that released in Michelangelo not only new formal rhythms and vastly enhanced tactility, but a state of self-immersion in his sculpture, whereby the statue was no longer something external to himself, but a projection of his total personality. Where his emotional condition came into play was in the speed and recklessness with which the work was carved. Precisely because its promise is so rich and its psychological horizons are so wide, it is in some respects more moving than the uncompleted later works. It is as though, after his rebuff in Rome, he had attacked the inert block in an effort to affirm to himself, not to the world, that he was indeed the supreme, the transcendent genius he supposed.

But suddenly his dream dissolved. The Pope's demands became increasingly insistent, in July he promised Michelangelo immunity if he returned, and Soderini, powerless to protect him, encouraged him to go, so in November he left Florence for Bologna, where the papal court then was.

MICHELANGELO : THE MEDICI CHAPEL

THE price of reconciliation with the Pope was that Michelangelo should make a more than life-size statue of the patron whom he feared in a medium he despised. Through the first half of 1507 the statue was modelled at Bologna, in the summer it was cast in bronze, and early in 1508 it was hoisted into its tabernacle high on the front of San Petronio, and Michelangelo was free to leave. As soon as the statue was finished, he returned to Florence to resume work on the Apostles, but he had been there only a few weeks when he received a new summons from the Pope. In April he left for Rome, where he signed the contract for the ceiling of the Sistine Chapel. The ceiling occupied him for over four years, to the exclusion of all other work, and on it the world of form opened up in the St. Matthew was first explored. Painting is a freer medium than sculpture, in that the figure is not fettered by a marble block, and in the Punishment of Haman on the ceiling Michelangelo develops the conception of the St. Matthew pictorially. But the nineteen genii on the body of the ceiling have the physical compression of marble statues, and the ideas investigated in them are fundamental for the artist's later style in sculpture.

Hardly was the ceiling finished than in 1513 Pope Julius II died, and fate conferred on Michelangelo the greatest benefit it could, the election of a Pope who did not really like his work. For the first three years of the new reign he was left in peace to work uninterruptedly on the tomb of the dead Pope, but in 1515 Pope Leo X visited Florence, and by the following year Michelangelo's peaceful concentration on the Julius tomb was at an end. The cause

was the decision of the Pope and of his cousin Cardinal Giulio de' Medici to complete the Medici church of San Lorenzo. The first project was for a façade. It is easy to understand what attracted Michelangelo in this commission; it gave him the chance to create a major architectural work, and to devise a sculptural complex richer by far than that of the Apostles in the Cathedral. Early in 1517 the façade was to have ten statues, and soon afterwards the number was increased to twenty-four. In 1518 the contract was signed, but from then on enthusiasm – not on Michelangelo's part, but on that of his patrons – started to wane, and in March 1520 the contract was annulled. There were many reasons why work on the façade was not continued – its estimated cost had almost doubled in under twelve months – but the most important of them was that by 1519 interest had shifted to the building of a commemorative chapel.

From the very first San Lorenzo was designed as a Medicean place of burial. Giovanni and Piccarda de' Medici, the parents of Cosimo il Vecchio, were buried in the Old Sacristy, Cosimo himself was commemorated by a tomb slab in front of the high altar, and in the left transept was the tomb of his sons, Giovanni and Piero de' Medici. No monument had been erected to Lorenzo il Magnifico, because the Medici regime in Florence had collapsed soon after his death, and none had been put up to his brother Giuliano, who was killed in the Pazzi conspiracy in 1478. Since Lorenzo was the father of Pope Leo X, and Giuliano was the father of the future Pope Clement VII, both the Pope and Cardinal were interested in erecting a memorial. After Giovanni de' Medici was elected Pope in 1513, his younger brother, Giuliano de' Medici, Duc de Nemours, was appointed Captain of the Church, but three years later he died, and was succeeded by Lorenzo de' Medici, Duke of Urbino, his nephew, a grandson of Lorenzo il Magnifico. When Lorenzo in turn died in 1519, the commemorative project came to a head. The motive of the Pope and Cardinal was a double one, to commemorate Lorenzo il Magnifico and Giuliano de' Medici, who are referred to as the Magnifici, and the Dukes of Nemours and Urbino, who are referred to as the Capitani.

The earliest stage in the history of the Medici Chapel is totally undocumented. All we know is that the area adjacent to the right transept of the church, balancing Brunelleschi's Old Sacristy off the left transept, was a void, and that the new Chapel and the Old Sacristy were designed to correspond. Vasari tells us that Michelangelo planned the Chapel as an imitation of the Old Sacristy, but with another order of ornaments, and the meaning of that becomes plain if we examine the two schemes, for both are square, both have a small protruding choir or apse, and both are conceived in terms of the contrast between structural elements in pietra serena and the white wall surfaces. Stated in factual terms the difference between the structures sounds minimal; Michelangelo interpenetrated the pietra serena elements with marble, placed heavy pietra serena strips along the inner edge of the pilasters, filled the lunettes with tapering windows, and introduced beneath them an intermediate zone which divides them from the main register. On an aesthetic plane, however, it is very great. The Old Sacristy is a static architectural unit, whereas in the Chapel (Figs. 17, 18) everything conspires

to carry the eye upwards, first from the lower to the intermediate zone, then from the inter-
mediate zone to the lunettes, and thence, through the dynamic placing of the windows, to
the cupola, which is based on the dome of the Pantheon. The Chapel, in other words,
gives a sense of physical ascent. That is an aesthetic phenomenon, but it lies at the root of a
good deal that has been written on the meaning of the tombs.

The little that we know about the tombs themselves during the planning stage depends
on one or two fragments of written evidence and on a number of drawings, and the
task is to reconcile what we read with what we see. One of the difficulties is that the projects
do not follow each other in an orderly fashion, as they would have done with other artists,
but were worked on simultaneously. One of them (which had no influence whatever on the
tombs as they were built) was for a free-standing central tomb. We first hear of it in a letter
written by Cardinal Giulio de' Medici to Michelangelo in 1520, and it collapsed when
the Cardinal suggested that the tomb should have the form of a four-faced triumphal
arch. A drawing made at this time (Fig. 19) shows a face of the free-standing tomb with two
mourning figures beside a sarcophagus. If these figures had been carried out, the genii on
the Sistine Ceiling would have been provided with a three-dimensional equivalent. Cal-
culations show that these figures were below life-size, and Michelangelo must have rejected
them without regret, since, in the space available in the Chapel, no centralised tomb could
offer proper scope for figure sculpture.

Simultaneously Michelangelo was turning over in his mind the possibility of placing
two monuments on each of the two lateral walls. This course involved two alternatives;
the first was to space out each pair of tombs so that they occupied the area now filled by
the doorways at each end, and the other was to link them together in the centre of the wall.
Michelangelo tried out both schemes, and in the drawings for the second (Fig. 20) we have
the first clear proof of his determination to augment the figure sculpture. Not only are
there mourners standing beside the podium, but on top of each sarcophagus is a reclining
figure on a much larger scale, and beneath the sarcophagus on the left is a River God. The
standing figures were omitted from the tombs as they were executed, but to the very end
the reclining figures on the lids and the River Gods remained part of the scheme. From the
proposal for linked monuments there grew the plan he actually adopted, to group two of
the tombs, those of the Magnifici, together on the third wall, leaving each of the side walls
free for a single tomb.

To discuss the drawings in this way is to suggest that they involved no more than the
placing of abstract forms in space. But the goal towards which Michelangelo was working
his way forward was the idea of the chapel, and not just the shape and size of the tombs. As
he finally planned it, the altar was reversed and faced towards the Chapel. The opposite
wall, therefore, was an altar wall separated from the altar by the whole depth of the room.
For that reason it was to contain not the tomb of the Magnifici only, but also a group of the
Virgin and Child with figures of the Medici patrons, SS. Cosmas and Damian, at her side.

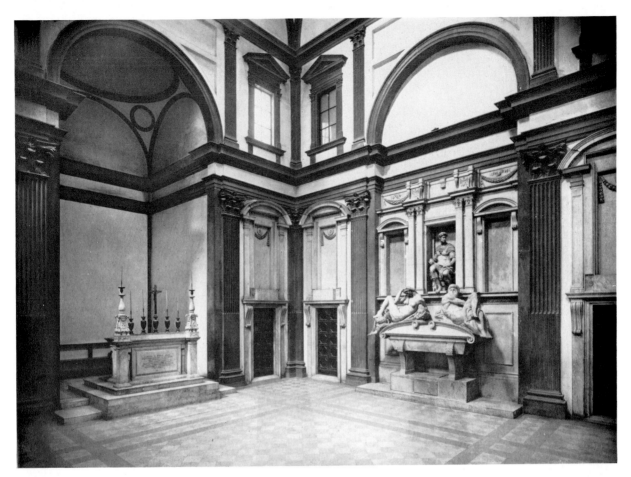

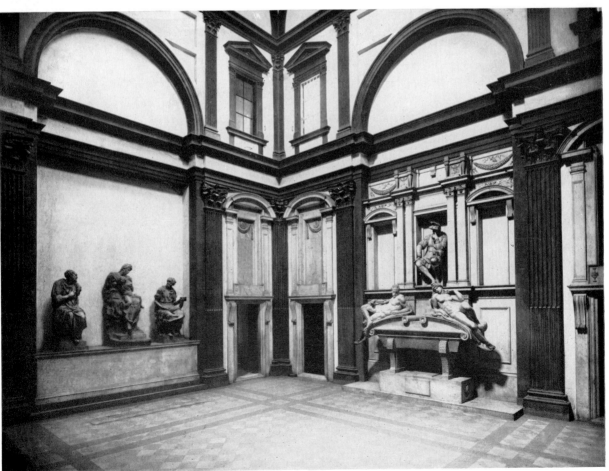

Figs. 17, 18. THE MEDICI CHAPEL. S. Lorenzo, Florence.

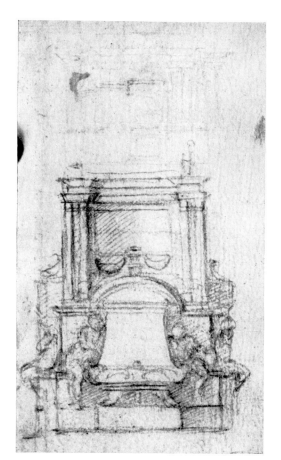
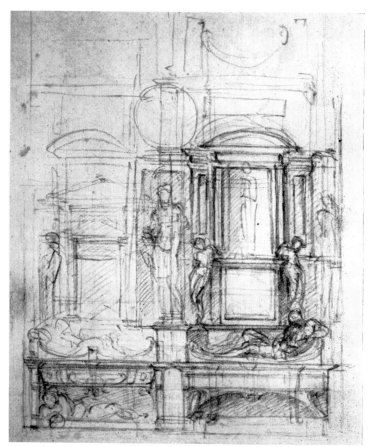

Fig. 19. Michelangelo: DRAWING FOR A CENTRALISED TOMB. British Museum, London.
Fig. 20. Michelangelo: DRAWING FOR TWO LINKED WALL MONUMENTS. British Museum, London.

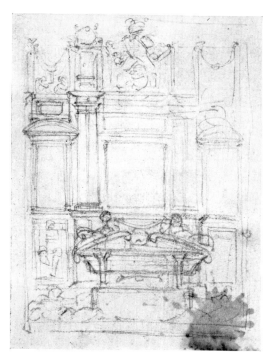
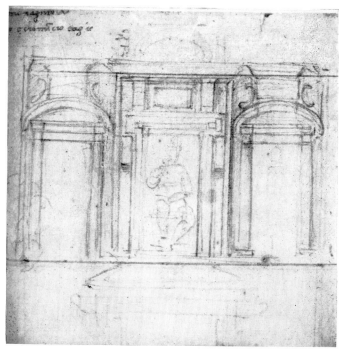

Fig. 21. Michelangelo: DRAWING FOR THE TOMB OF GIULIANO DE' MEDICI. British Museum, London.
Fig. 22. Michelangelo: DRAWING FOR THE TOMB OF GIULIANO DE' MEDICI. Ashmolean Museum, Oxford.

The focal point was naturally the altar, and it was from the altar that the complex of three tombs was intended to be seen. Seen from this position, the heads of the two Capitani gazed directly at the Virgin and Child.

Looking at the drawings, we might suppose that from the moment when work started on the tombs, Michelangelo had in his mind an inalterable scheme which he realised over the next fourteen years, but as soon as we approach the sculptures it transpires that that was not the case. The scheme, in quite important points as well as in detail, was constantly revised, and work on it was fraught with what, in any lesser sculptor, we should call uncertainty. Michelangelo in middle life treated the marble block almost as though it were a sketch-model, feeling his way forward, changing his direction, improvising, and in this same empirical spirit he approached the planning of the tombs.

We have a good deal of scattered information on the progress of work in the Chapel. The shell was under construction in March 1520, and by April of the following year it was completed up to the architrave. At this point Michelangelo visited Carrara and signed contracts with two stonecutters for marble blocks for figure sculptures. Some of these arrived in Florence in the summer of 1521, and by 1524 a quantity of marble had been quarried and shipped. An exception was the marble for the sarcophagus lids. The architecture of one of the two tombs was building by the summer of 1524, and the architecture of the other was begun in 1526. In practice work seems to have progressed less smoothly than these documentary references suggest, first because Leo X died in 1521, and his short-lived successor, Adrian VI, tried, probably successfully, to divert Michelangelo back on to the Julius tomb, and secondly because the quarrying presented unexpected difficulties. The marble for four figures was extracted in the summer and autumn of 1524, and Michelangelo, anxious to get down to work, added a block from his own studio in the Via Mozza, where the sculptures for the Julius tomb were carved. By October 1525 four figures had been begun, but they did not include the River Gods. In June 1526 Michelangelo proposed beginning what he refers to as 'the other Capitano', so one of the seated figures of the Capitani must have been blocked out before that time. The letter in which this statement occurs is very important for a study of the sculptures. What it says is this: 'The four figures on the tomb-chests, the four River Gods for the bottom of the tombs, the two Capitani and the Virgin and Child, those are the figures that I should like to carve with my own hand, and of them six are begun.' So already it was envisaged that some of the sculptures in the Chapel should be carved by other hands than Michelangelo's.

In 1527 work on the Chapel came to a halt. The Sack of Rome occurred in May, and at the end of the month a republican government was installed in Florence. A year later Michelangelo received an official commission for a colossal group of Samson and a Philistine which was to form a pendant to the David outside the Palazzo della Signoria, and soon after this he was forced to turn his mind to the task of fortifying Florence against attack. Through the summer of 1529 the situation became increasingly alarming, and in September he left

Florence, but returned in the second half of November, and was still in Florence in the summer of 1530 when the city surrendered to Pope Clement VII. The project for the Samson was put into abeyance, and Michelangelo resumed work in the Medici Chapel.

What had occurred in Florence was not simply that one government had been substituted for another, but that a regime which corresponded closely with Michelangelo's political ideals, and with which he was emotionally bound up, had been displaced by another, to which he was in principle opposed. As at other times during his life, this disillusionment was reflected in the rhythm of his work. At first he threw himself with unprecedented violence into the carving of the tombs. A letter of September 1531 tells us that he is overworking, eating little, sleeping badly, suffers from headaches, and is unlikely to live unless some steps are taken about his health; it recommends that he should be prevented from working in the Chapel through the winter. But suddenly his work slowed down. In April 1532 he went to Rome, returned briefly to Florence, and in August went back to Rome once more, staying there this time until the summer of 1533. He returned to Florence for four months, spent eight months in Rome, spent another three months in Florence, and in September 1534 left Florence never to return. The Pope, meanwhile, who was thoroughly familiar with the pattern of his conduct, became urgently concerned with the task of finishing the Chapel, and proposed that the physical labour of carving the outstanding statues should be entrusted to other hands. In 1533 the sculptor Tribolo, who was at Loreto working on the Holy House, was ordered to go at short notice to Florence to help carve the tombs, and use was also made of two other sculptors, Raffaello da Montelupo and Montorsoli. Before leaving Florence, Michelangelo installed the statues of the Capitani in the niches that had been designed for them, but the four Allegories were not put in position on the tombs. Soon after he reached Rome, Pope Clement VII died. For Michelangelo the Pope had been both a sympathetic patron and a bulwark against the newly installed Duke of Florence, the tyrannical Alessandro de' Medici, and without the Pope's protection he was, in common prudence, unable to return. Alessandro de' Medici at once diverted Tribolo and Raffaello da Montelupo to other tasks, and work in the Chapel was continued only after his murder in 1537, when his cousin and successor, Cosimo I, ordained that his body should be placed in the tomb of Lorenzo de' Medici, Duke of Urbino. Michelangelo was invited to return, but refused to do so, and in 1545 the four Allegories were placed by Tribolo on the sarcophagus lids. Fourteen years later the ugly pavement of the Chapel was laid down by Vasari, and the bodies of the Magnifici were interred beneath the site of their projected monument on the facing wall. Finally in 1562, when Michelangelo was on the threshold of the grave, Cosimo I made a last despairing effort to elicit his intentions for the Chapel, and his views on how it should be finished off. It is often difficult to follow the minds and motives of great artists, and at first sight nothing is stranger than that Michelangelo should have looked for the last time in 1534 at these great statues strewn about the Chapel floor, and then for thirty years refused not only to place

them in position, but even to explain how he intended that they should be placed. But his reasons become more intelligible when we examine the individual sculptures.

Almost all of them are in some respect unfinished – the only fully completed figure is the Giuliano de' Medici – and Michelangelo must have worked on them concurrently. On one point he procrastinated through the entire period of work; he deferred until too late the moment at which the expressions of the two male figures had to be defined. None the less, there is one large caesura in the sculptures, and that is between the two pairs of Allegories. A letter of 1531 relates to the two female figures, and places them in order. The Night is described first, as though it had been in existence for some time, and the Dawn, the corresponding figure opposite, is mentioned without name. So on that fragile evidence the Night and Day would seem to be the earlier and the Morning and Evening to be the later pair. The same letter mentions the statue of Lorenzo de' Medici; Michelangelo could carve it this winter, it says. We know from other sources that one Capitano was well advanced before this time, so only one interpretation is permissible, that the statue of Giuliano de' Medici precedes that of Lorenzo on the tomb opposite. Whereas the Allegories on the tomb of Lorenzo de' Medici are moulded to the shape of the sarcophagus lid, the bases of the Allegories on the tomb opposite are almost flat. Augustus Hare, in an irreverent passage in *Walks in Florence*, describes them as slipping off the tomb, and that is what they seem to do. The distinction stands out very clearly if we look more closely at two of the figures. The pose of the Evening (Plate 32) on the Lorenzo tomb is ideally adjusted to the lid; one foot rests on the edge, and the extended leg is supported to a point rather below the knee. But with the Day (Plate 31) the legs and thighs are not supported, and the pose is unintelligible in relation to this sarcophagus. Perhaps it is worth while to emphasise the point by examining the figures from the back. In the Day (Fig. 26) the bottom of the block to all intents and purposes is flat, while in the Evening (Fig. 27) it is excavated. This difference has been explained in many different ways. It has been suggested, for example, that the Day and the companion figure of Night were originally intended not for the Giuliano tomb but for the monument of the Magnifici, in one version of which rather different tomb chests are shown. But the Night and Day and the Morning and Evening are counterparts, and it is inconceivable that they were not intended to stand opposite to one another, just as they do now. So we are bound to assume that when the Night and Day were carved the sarcophagus of the Giuliano tomb was to have had a different lid. Admittedly some early drawings for the tomb (Fig. 21) show the lid in its present form, but a later drawing (Fig. 22) also shows a sarcophagus with two flat sloping ends. There was, as we know, difficulty in procuring the marble from which the lids were made, and with Michelangelo nothing was settled until it was finally carved.

The figures also differ in size and scale – in size in that one of them, the Day, is carved from a somewhat shorter block than the remaining three, and in scale in that the Night is heavier and more monumental than the Morning and Evening, though it is carved from a block of

almost the same size. If, therefore, we believe that the Dawn and Evening were carved before the Night and Day, we are committed to the view that Michelangelo developed from a less to a more monumental style, and if we invert the sequence we are committed to the opposite hypothesis. Luckily there are two securely datable works, one finished just before the Medici Chapel was begun, and the other begun just before it reached its final phase. The first is the Christ in Santa Maria sopra Minerva in Rome (Plate 23), which was delivered in 1521, and the second is a little figure of Apollo (Plate 22) carved for Baccio Valori in 1530 or 1531. The Christ is a version of an earlier statue which proved to have a flaw, and for Michelangelo is rather a weak work, but it has none the less the rigid, intractable quality of the Day, while the Apollo has the elegance and flexibility of the two figures opposite. The Day, then, was the first of the Allegories to be begun. The most striking confirmation of this is the fact that from the altar it reads extremely awkwardly. So clumsy is it that we might guess Michelangelo planned it in quotation marks, and that inference would be correct, for if we take the Belvedere torso (Fig. 15), which he unquestionably knew, and place it on its back, the source of the figure is not in the smallest doubt. It has been mentioned that in 1524 Michelangelo transferred to the Chapel a block from his studio in the Via Mozza. Since three of the Allegories on the tombs are carved from uniform blocks and one is exceptional, it is a reasonable inference that the exceptional figure, the Day, was carved from the exceptional block. It follows that in 1524, when work on this statue was started, the harmonious conception of the figures as we find it on the Lorenzo tomb did not exist even in embryo in the sculptor's mind. At that time the Allegories were conceived as four aggressive, classicising figures on angled sarcophagi, the two male figures like Roman River Gods.

For the corresponding female figure, the Night, Michelangelo also went back to the antique, to a Leda sarcophagus in Rome, now lost but recorded in a drawing made in the sixteenth century. Its scheme was changed in two significant respects, first that the further arm was brought across the body so that it conformed with the Day, and second that the near arm was eliminated. This second change was apparently due to a mischance, for we have near-contemporary evidence that the original left arm was spoiled, and that Michelangelo for that reason adopted the solution of concealing it. This is confirmed by the top of the mask beneath the shoulder, which would have been covered by the arm, and instead was left in the rough. In 1529 when Michelangelo turned to this same sarcophagus again for his lost painting of Leda for Alfonso d'Este, the complete left arm was shown. Perhaps the Night was impoverished by the change, but this casual occurrence had incalculable consequences, since the revised position of the arm meant that the front plane of the figure was no longer coterminous with the front plane of the block; a new tension was introduced into the pose, above all in the area of the waist, which rises slightly from the couch on which it rests. The emphatic diagonal movement of the Day and Night is rejected in the two Allegories opposite, and the off side of each figure is raised so that the whole surface of the body is exposed to the spectator, and the figure partakes of the nature both of a statue and of a relief.

Logically it can only have been at this point that the lids of the sarcophagi assumed their present form. How fundamental was this change of style becomes apparent as soon as we look at the Allegories from on top. From this view the earliest of the Allegories, the Day of 1524 (Fig. 28), is seen to be contained within its block as tightly as is the Minerva Christ, while in the latest of them, the Dawn of 1531 (Fig. 29), the open forms of Baroque art are clearly predicated.

In the seated statues of the Capitani the classicising imagery of the tombs reaches its peak. A large number of Roman commemorative statues were known in the sixteenth century; they comprised both seated and standing figures, and in a loose sense the Giuliano de' Medici (Plate 24) is an amalgam of the two types. Though the figure is shown wearing armour, the breasts and torso are depicted as though nude, and in this area the Belvedere torso once more served as a model, so that the figure of Giuliano de' Medici and the Day beneath depend from one and the same classical original. The corresponding area in the statue opposite is not worked up. In the Chapel the features of Lorenzo de' Medici (Plate 25) are in shadow. For that reason the figure was known in the eighteenth and nineteenth centuries as the Pensieroso, the meditative man, and a whole romantic literature grew up around the thoughts which were presumed to be passing through his head. Even Henry James 'lingered often in the sepulchral chapel of San Lorenzo, and watched Michelangelo's dim-visaged warrior sitting there like some awful Genius of Doubt and brooding behind his eternal mask upon the mysteries of life.' This figure was, however, also inspired by the antique, and the shadow on its face is nothing but an accident. The statue is slightly deeper than that on the Giuliano tomb, and in order to align the two front planes the wall was excavated so that it could be pushed back. If it were brought forward just a little, it would protrude (as do many other High Renaissance statues), but its ambiguity in relation to the second tomb and to the Madonna wall would be resolved.

The only other sculptures for the Capitani tombs the form of which we know are the River Gods, which were destined for the platforms beneath the sarcophagi. One of the four, for the left side of the Lorenzo tomb, is known through a model in the Accademia in Florence (Fig. 25), and a second, for the Giuliano tomb, is recorded in preliminary drawings. It has been inferred, probably correctly, that the model was made in 1524, that blocks were ordered on the basis of it, that the figures were then increased in size, and that new blocks were accordingly required. If this was so, the River Gods were subject to the same law of change as the other sculptures in the Chapel. It is extremely difficult to imagine what effect these sculptures would have made had they been set on the ground on a front plane, with the slightly smaller Allegories on the intermediate plane of the lid of the sarcophagus, and figures in the niches above. One of the few classical works known to Michelangelo which offers a parallel for this conception is the relief on the base of the column of Antoninus Pius, where a seated figure at the bottom, a diagonal nude figure above, and two portraits at the top are linked together in three superposed registers.

What, lastly, do the figures mean? If we trouble to collate what has been written about one of the four Allegories, the Dawn, we shall find that the results are most peculiar. Broadly the interpretations fall into two groups. First there are the optimists, who describe the figure as though she were Brünnhilde, in the third act of *Siegfried*, greeting the sun, and then there are the pessimists who believe she is reluctant to awake: 'Why, O my God, hast thou not made the night eternal,' are the words one of them puts into her parted lips. Obviously interpretations of this kind are subjective in the highest degree, and discussion of the meaning of the individual sculptures must be preceded by discussion of the programme of the chapel as a whole. The accounts that are given of the programme are, however, disconcertingly diverse. It has been explained theologically in terms of Ambrosian hymns, and politically as a Gladstonian anti-Medicean allegory. But in the last quarter of a century interpretations have settled into the rut of Neoplatonism. The subject of the tombs is a Neoplatonic apotheosis, and both represent ascent, from the zone of Hades symbolised by the River Gods, through a terrestrial sphere symbolised by the Allegories and the seated statues, to a celestial sphere symbolised by the thrones on the architraves of the two monuments and by the lunettes above. This explanation is susceptible of a number of refinements – that the seated statues show the two Dukes after death, or the antithesis between Nous and Psyche, the active and the contemplative life, that the niches beside them were intended to be filled with figures symbolising the contrasting souls of man, that the River Gods showed both the Rivers of Hades and the four elements or the fourfold aspect of matter as a source of potential evil, and that the Allegories depict the four humours as well as the times of day and transmit the conception of life on earth as a state of suffering through 'an impression of intense and incurable pain.'

Fundamental to all this is the notion of ascent. There is an objection to it, that we know the subjects of the projected figures for the niches of the Giuliano tomb. According to Vasari, they were to be carved by Tribolo from Michelangelo's models, and the models depicted Earth, crowned with cypress with hands outstretched and her head bowed, and Heaven, with a smiling countenance and both hands raised. It would be possible to claim that Vasari was mistaken, were it not for another piece of evidence which comes from Michelangelo. It occurs in a prose fragment with a dialogue between the figures of Night and Day on the Giuliano tomb, and in the form in which it is transcribed it reads simply, 'Heaven, Earth, Heaven, Earth.' As soon as we look at the sheet in the Archivio Buonarroti on which it occurs, however, its meaning becomes unambiguous, for the word Heaven (*Cielo*) occurs twice on the left, in the position of the left-hand niche on the monument, in the centre is a gap where the seated figure should be, on the right twice repeated is the word Earth (*Terra*), and below, running across the sheet in the position occupied by the Allegories, is a conversation between the Times of Day on the sarcophagus. If Heaven and Earth were represented horizontally in the same register on one of the two tombs, the whole idea of the tombs as an ascent falls to the ground. It appears as what it is, the philosophical rationalisation of a visual phenomenon.

There is no evidence at all that the River Gods represented Hades, but we have some reason to suppose that their significance was locative. It occurs in a poem by Gandolfo Porrini, which is quoted in the *Lezioni* of Varchi only fifteen years after Michelangelo left Florence. The tombs, complains Porrini, will await in vain the magnanimous rulers of Tiber and Arno. That could be disregarded, were it not for a tiny piece of confirmation that makes Porrini's testimony credible. In 1513, three years before his death, Giuliano de' Medici was invested in Rome as a patrician, and on the stage on which the ceremony was performed there were two River Gods, not the Rivers of Hades, but the Tiber on the right and the Arno on the left. So there is a presumption that this not very abstruse imagery was carried over to the tombs.

It is best to approach the seated figures from a tangent. One of the duties of the art historian is to explain what distinguishes the very greatest works from works of lower quality. This is an intricate and exacting task, and there is a temptation to evade it by explaining the difference in terms of the ideas implicit in the work rather than through the work itself. In 1544, for example, Cosimo I commissioned from Bandinelli a statue of his father Giovanni dalle Bande Nere (Fig. 120), which is still outside the church of San Lorenzo. It shows Giovanni dalle Bande Nere seated in classical military costume, and because it is an inferior statue no one has ever doubted that it is what it appears to be, an idealised commemorative portrait conceived in the style of the antique. Michelangelo was a much greater sculptor than Bandinelli, and whereas the Giovanni dalle Bande Nere is a sterile work, the Giuliano de' Medici has the enhanced communicative power of all transcendent works of art. But the reason for that is not that it represents a different idea from Bandinelli's statue; it represents the same idea on a different level of creativity.

With Michelangelo we are dealing with a sculptor who could not help carving expressively. The most conventional ornament takes on a personal inflection at his hands. Whether it be the swags above the Giuliano tomb with sacrificial ewers over them, or the funerary emblems on the ends of the sarcophagus under this same tomb (Plate 26), or the face on the corselet of the seated figure, or the extraordinary frieze of grimacing masks, or the bat head beneath the elbow of Lorenzo de' Medici (Plate 27), the effect is so personal that we instinctively ask ourselves, 'What does this mean?' The right answer to that question is that in terms of logic it means nothing at all, or rather that it means no more than ordinary ornament would mean in the hands of a pedestrian sculptor. If we insist on rationalising these intuitive projections of the sculptor's personality, we debar ourselves from entering fully into his fantastically rich imaginative world.

Historically there is one useful step that we can take, and that is to put into the witness box some of Michelangelo's contemporaries, and ask them what they think the Chapel signifies. The first witness is Condivi, Michelangelo's biographer and friend. The Night and Day, Condivi tells us, signify Time, which consumes all things. Michelangelo, he adds, had intended to portray Time as a mouse, and left a piece of the block for that purpose, but

was prevented (*impedito*) from using it. The next witness is the Vasari of the 1550 Life of Michelangelo. Michelangelo, he declares, considered that the earth alone was not enough to give the Captains the honoured burial they merited, and wished that all parts of the world should be present in the Chapel. The antithesis in this passage is between *terra* and *mondo*, the earth and the natural world. For that reason he put the figures of Night and Day, and Morning and Evening on the tombs. The Dawn is 'a naked woman who is such as to awaken melancholy in the soul. In her attitude may be seen her effort, as she rises, heavy with sleep, and raises herself from her downy bed; and it seems that in awakening, she has found the eyes of the great Duke closed in death, so that she writhes with bitterness, lamenting her continued beauty in token of her great sorrow.' As for the Night, 'in her may be seen not only the stillness of one sleeping, but the grief and melancholy of one who has lost a great and honoured possession.' So far as concerns the seated statues, it does not enter Vasari's head that anything save their ostensible subject is shown. These statues are described in a letter of 1544 by Niccolò Martelli, who explains that Michelangelo did not represent the Capitani as they were in nature, but gave them a grandeur, a proportion, a decorum which would earn them greater praise; a thousand years hence, Michelangelo observed, nobody would realise that they did not look quite as he had shown them on their monuments. The fourth witness is Benedetto Varchi, whose account is vaguer than Vasari's, but who maintains the same antithesis between earth and world, though with a slightly different emphasis. The fifth witness is Michelangelo, who testifies through two manuscripts in his own hand. The first of them, written about 1520, occurs on a sheet for the Magnifici tomb in the British Museum (Fig. 23), and reads as follows: 'Fame holds the epitaphs; it neither advances nor retreats, because they are dead, and their work is at an end.' The second was written about 1526, and is the dialogue between Night and Day already referred to: 'Day and Night are speaking, and they say: With our speedy course, we have led Duke Giuliano to his death; and it is right that he should take revenge for this as he has done. The revenge is this: that just as we have killed him so he in death has deprived us of our light, and with his closed eyes has closed our eyes, which no longer shine upon the earth. What then would he have done with us, while he was still alive?' Quite a number of scholars refer to the Allegories as incarnations of the times of day. That is an awkward term when one is speaking about marble statues, and Michelangelo's words suggest that he considered them the opposite – living figures turned to stone.

There are differences between these interpretations, but they have much in common, first of all in the things that are not mentioned – the Rivers of Hades, the four humours, the four elements, the three zones and the twin souls of man – and secondly in the things that are mentioned, or more strictly in the assumptions that lie behind them. That the iconography of the tombs was concerned with Fame, that is with immortalising the official personae of the two Dukes as patricians and Captains of the Church, and was therefore orthodox; that the portraits are portraits, albeit idealised; and that the Times of Day are shown in a state of deep

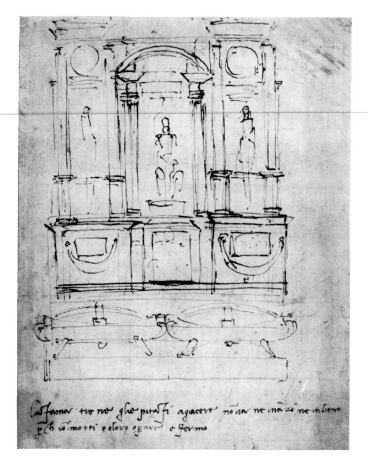
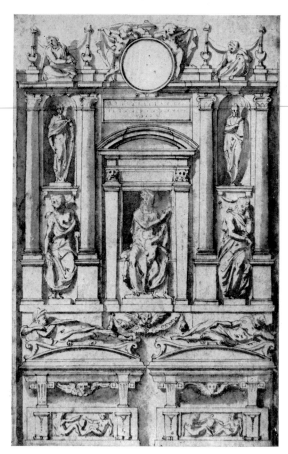

Fig. 23. Michelangelo: DRAWING FOR THE MAGNIFICI MONUMENT. British Museum, London.
Fig. 24. After Michelangelo: DRAWING FOR THE MAGNIFICI MONUMENT. Ashmolean Museum, Oxford.

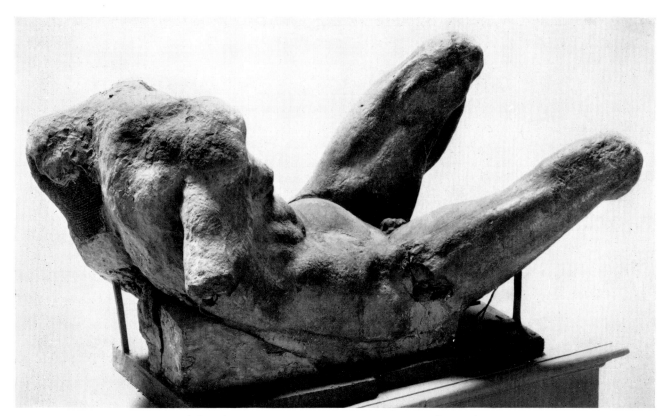

Fig. 25. Michelangelo: MODEL OF A RIVER GOD. Accademia, Florence.

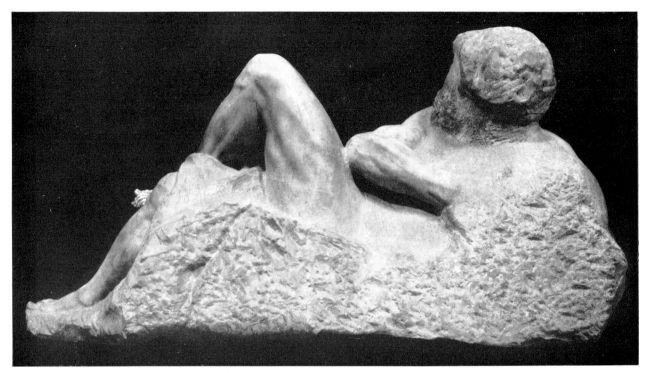

Fig. 26. Michelangelo: BACK OF THE DAY. Medici Chapel, Florence.

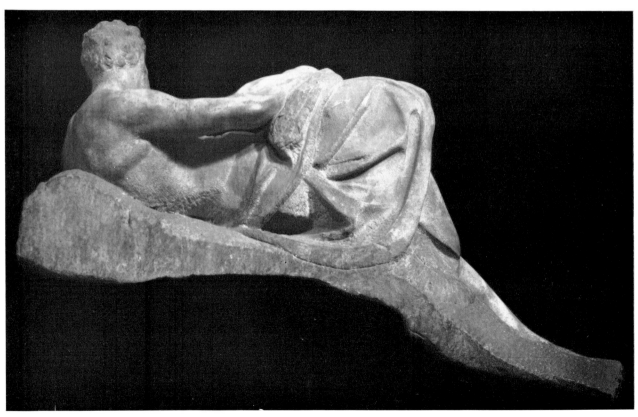

Fig. 27. Michelangelo: BACK OF THE EVENING. Medici Chapel, Florence.

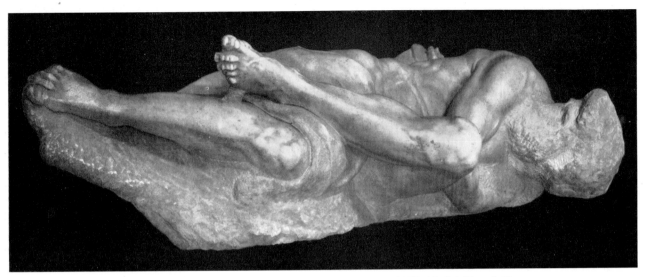

Fig. 28. Michelangelo: VIEW OF THE DAY FROM ABOVE. Medici Chapel, Florence.

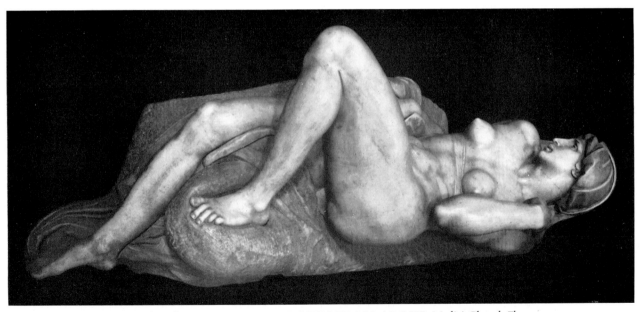

Fig. 29. Michelangelo: VIEW OF THE DAWN FROM ABOVE. Medici Chapel, Florence.

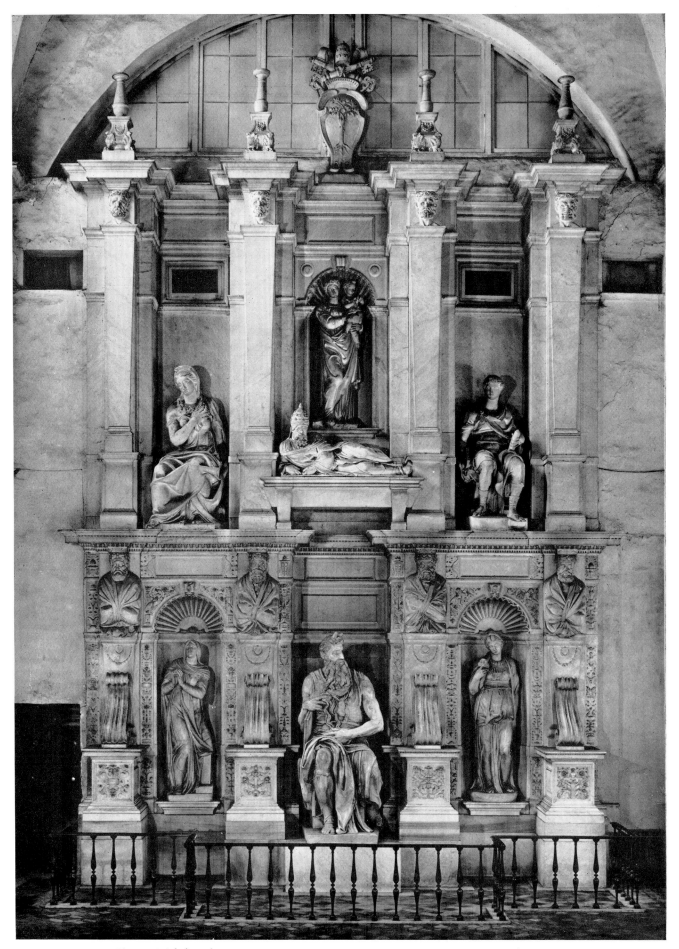

Fig. 30. Michelangelo: THE TOMB OF POPE JULIUS II. S. Pietro in Vincoli, Rome.

and incurable grief, not of deep and incurable pain. To this we can apply a simple test of probability, for not only do we know many letters from Michelangelo, but we have as well two transcripts of discussions in which he took part. Everything we learn from these sources about his mental processes suggests that the imagery of the Chapel is likely to have been comparatively simple, intensely apprehended, and based on the principle of direct plastic communication, not on some elaborate intellectual theorem. Indeed the vagueness of his intentions, the indefiniteness of his objective, the fact that by temperament he was an artist not an expositor, may have been among the reasons why he lacked the impulse to complete the tombs.

The least finished, earliest and most anomalous of the sculptures in the Chapel is the Virgin and Child (Plate 20). It is the only figure in which an element of movement is introduced, not gentle movement, but violent movement that seems a little irreverent in the still complex of the tombs. The pose of the Virgin, seated on a rectangular plinth, with her right hand at her side and her left leg crossed over her right knee, derives from a Roman copy of a fifth-century Greek statue of Penelope (Fig. 14). The employment of this model is surprising, because we know that the tomb of the Magnifici was to have in the centre a rectangular tabernacle corresponding with those of the Capitani tombs. The Capitani are centralised, with both knees on a single plane, but the Madonna is inherently unsuited to a tabernacle of the kind. Moreover, it can be established both from copies and autograph drawings that Michelangelo, when he planned the tomb of the Magnifici, conceived a group (Figs. 23, 24) of a rather different kind, with a symmetrical figure of the Virgin looking down at the Child between her knees. We have then a figure which was suited to the Chapel but was not carved, and a figure which was carved but was not suited to the Chapel. Through the whole period of work in the Chapel Michelangelo had a second contractual obligation for the tomb of Pope Julius II, and between 1521 and 1523 he was actively at work on sculptures for a revised version of this tomb. There is proof that the possibility of exchanging sculptures for the tomb and sculptures for the Chapel was entertained, and one of the figures now on the tomb seems indeed to have been carved for a niche on the monument of Lorenzo de' Medici in Florence. The most likely explanation of the Virgin and Child is that the opposite occurred, that it was carved for the 1519 version of the tomb and was later diverted to the Chapel. The focus of the Virgin's gaze, therefore, may not, as we might now suppose, be an arbitrary point in the middle of the Chapel floor, but the dead body of the Pope.

MICHELANGELO : THE TOMB OF POPE JULIUS II

OF all great works of art the tomb of Pope Julius II in San Pietro in Vincoli in Rome (Fig. 30) is the most dispiriting. The first thing we notice as we look at it is the incongruity of the architecture of the upper and the lower parts. So divergent are they that we might infer either (and this would be wrong) that they were by two different artists, or (and this would be

correct) that they were designed by the same artist at different points in time. The great statue of Moses in the centre is not integrated in the tomb, and is discrepant both in style and size from the figures in the niches at the sides, while the side figures, though they are consistent with the figures in the upper register, differ from them in quality. Strangest of all, it appears that no space was left for the figure of the Pope, which is placed on a sarcophagus spanning the centre of the tomb. From a sculptural point of view this figure, and the Virgin and Child in the niche behind it, are far the worst and puniest pieces of the monument. On a superficial level the story of the Julius II monument is the story of how this tomb came to be built; on a deeper level it is the story of Michelangelo's development over exactly forty years.

In March 1505 he was summoned to the papal court. According to Condivi, some months passed before the tomb was formally commissioned, but the time that elapsed cannot in practice have been very long, for that summer Michelangelo was at Carrara procuring the marble for the monument. Given this short interval, it is reasonable to suppose that the tomb had been discussed before Michelangelo arrived in Rome, and that in at least two respects its form was dictated by the Pope. The contract for it is lost, but it was to cost the enormous sum of ten thousand ducats. The reason for this becomes clear from two sub-contracts which Michelangelo signed at Carrara in the winter of 1505, providing for the quarrying of unprecedented quantities of marble and their despatch by sea to Rome. In January 1506 Michelangelo was back in Rome, impatiently waiting for the marble to arrive. When it did so, a financial crisis broke, and the Pope, instigated by Bramante, began to retreat from the whole scheme. Michelangelo endeavoured to see him, but was turned away by a chamberlain, and he thereupon despatched a letter of protest to the Pope. 'Most Holy Father,' ran this letter, 'I was this morning chased out of the palace on the instructions of your Holiness. I wish to intimate that if from henceforth you require me, you must seek me elsewhere than in Rome.' That is the first phase in the history of the monument.

We have only one means of telling what Michelangelo intended, and that is by analysing the account which he himself, almost half a century later, gave to his biographer Condivi. There are other written sources for the tomb (Vasari for example), but they are of secondary importance compared to this. According to Condivi, Michelangelo planned a free-standing tomb, not a wall monument, with two longer and two shorter sides. The long sides measured eighteen braccia and the short sides measured twelve, so that the ratio of the longer to the shorter sides was three to two, and the ground plan of the tomb was a square and a half. The tomb was designed to be set endwise, with the short sides forming the back and front. It consisted of a lower section at eye level, of a kind of platform on top with figures seated on it, and of an upper section which Condivi does not fully describe. The lower section contained niches with statues, and between them were terms, against which stood figures of bound captives symbolising the Liberal Arts. Above the niches ran a unifying cornice, and on top of this, on the platform, were 'four great statues' one of which represented

Moses. Inside the tomb was 'a chamber in the form of a little temple, in the midst of which was a sarcophagus in marble wherein the Pope was to be buried,' and at the extreme top were two angels holding up what Condivi describes as an *arca* (presumably a symbolic tomb chest), one of whom appeared to laugh 'as though rejoicing that the soul of the Pope should be received among the blessed spirits,' while the other appeared to weep 'as though mourning that the world should be deprived of such a man.'

Pope Julius II, as Cardinal Giulio della Rovere, had been responsible for the tomb of his uncle Pope Sixtus IV (Vol. II, Fig. 72). This tomb also was free-standing, and it is likely that the impulse towards a free-standing monument came from the Pope and not from Michelangelo. At all events when the Pope died, this aspect of the tomb was modified. The Sixtus IV tomb was installed in the middle of a specially constructed chapel, but the new tomb was far more cumbersome. The joint egotism of a great Pope and a great artist conspired to produce a monument which would have covered about eight hundred square feet of floor space, was extremely high, and included, in addition to bronze reliefs of scenes from the Pope's life, more than forty marble statues. At first it was suggested, it seems by Giuliano da Sangallo, that the choir of St. Peter's, which was still unfinished, should be roofed over to receive it, and from this proposal there grew the project for the complete rebuilding of St. Peter's by Bramante. On this point the dates speak for themselves; the form of the tomb was settled by the summer of 1505, and in November of that year we first hear of the centralised plan that Bramante had worked out for the church. Though one scheme touched off the other, it is not the case that the centralised church was devised as a setting for the tomb. The two projects were in competition and the commission to Bramante for the church was the death warrant of the monument.

Two drawings in Berlin enable us to put some flesh on the dry bones of Condivi's account of the bottom of the tomb. There is no absolute proof that the lower register in these two drawings (Fig. 33) relates to the scheme of 1505 rather than that of 1513, when work on the tomb was resumed, but it is likely that this is so. Certainly it corresponds with Condivi's account in so far as it shows niches, and terms, with figures in front of them in the form of prisoners, and a platform on top. It has been suggested that this scheme may have been inspired by classical sarcophagi with figures of prisoners, of a class of which an example is in the Vatican; we should have only to transfer the prisoners on this sarcophagus from the sides of the columns to the front, and reproduce them at the ends, to obtain a scheme that would be generally similar to that of the base of the tomb. There are, moreover, other reasons to suppose that Michelangelo thought along these or somewhat similar lines. Years later, on a drawing by Zanobi Lastricati in Milan, there occurs a mysterious sentence to the effect that Michelangelo, for the first project of the tomb, planned 'a free-standing rectangular catafalque shaped like that of Septimius Severus near the Antoniane'. A number of drawings by Giovanni Battista da Sangallo also show reconstituted classical sepulchral monuments. One of the prisoners on the Berlin drawings corresponds in rather a suggestive way with a classical statue of

Narcissus in the Louvre. These, it must be reiterated, are not the specific models used by Michelangelo, but give some indication of the kind of thinking that lay behind the first version of the tomb.

Condivi does not mention the subjects of the niche figures, and Vasari's account of the bottom of the monument is exceedingly confused. He says, for example, that the prisoners represented not the Liberal Arts, but the provinces subjugated by Pope Julius II; this cannot be correct, because in 1505 no provinces had yet been subjugated. But he also mentions Virtues, and not only would we expect to find Virtues on a papal tomb – they and the Liberal Arts occur on the tomb of Pope Sixtus IV – but the female figures in the niches of the drawings in Berlin can hardly be explained in any other way. These particular figures must have had some sort of actuality, perhaps in the form of models, since years later, about 1540, a protégé of Michelangelo, the Florentine sculptor Ammanati, made use of one of them for the Nari monument in the church of the Annunziata in Florence (Plate 73).

We know much less about the two sections above, and the interest of the attempts that have been made to reconstruct them on the basis of our present evidence is purely dialectical. Condivi tells us that on the platform there were 'four great statues, one of which, namely the Moses, is to be seen in San Piero ad Vincula,' and Vasari, in addition to the Moses, mentions three other statues, a St. Paul and figures of the Active and the Contemplative Life. The juxtaposition of Moses and St. Paul is Neoplatonic – Pico della Mirandola describes them as types of intellectual and intuitive cognition – as are the Active and the Contemplative Life, so there is a strong probability that the first version of the tomb, unlike the Medici Chapel, had a Neoplatonic programme, or at least a programme with a strong Neoplatonic accent, for which Michelangelo, however, was not necessarily responsible. According to Vasari, the smiling and lamenting figures in the topmost section represented Heaven and Earth, and that is quite possibly correct; figures of Heaven and Earth were to be included in the Giuliano de' Medici monument, and Michelangelo, with his limited interest in formal iconography, may have transferred this idea from the earlier to the later tomb. Otherwise the wording of Condivi's and Vasari's descriptions is extremely vague. Neither source mentions a statue of the Pope, though that must certainly have been included in the monument. Two theories have been advanced, that the Pope was represented in a death effigy or in a life statue. The balance of evidence is that a life image was employed. In the summer of 1508 a stonemason at Carrara was busy blocking out the papal statue, and this piece of marble seems to have remained in Michelangelo's studio for the remainder of his life. Eventually, in 1602, it was used by Niccolò Cordieri for a statue of St. Gregory the Great in San Gregorio al Celio (Fig. 153). It is very doubtful if any of the carving in this figure in its present form is due to Michelangelo, but the pose cannot have been radically changed, and we shall not go far astray if we imagine a statue of this general type at the apex of the tomb.

When he returned to Rome in 1508, Michelangelo's preoccupations were with the Sistine ceiling, which was unveiled in October 1512. A few months later the Pope died, but before

his death his mind reverted to the monument, and as soon as his successor was elected steps were taken to resume work on the tomb. In May 1513 the late Pope's executors signed a new contract with Michelangelo. Under its terms the work was to be finished in seven years, that is by 1520, and Michelangelo was to receive a further thirteen thousand ducats. At the same time the scheme of the monument was modified. It was no longer to be free-standing, but it was not thought out afresh as a conventional wall monument; instead it was conceived as a free-standing monument with one end attached, in a more or less arbitrary fashion, to the wall. The width of the exposed end was a little less than in the scheme of 1505, and the long sides were less long, but even so the depth of the sides contiguous to the wall was very nearly double the width of the front. There were two niches on the front and two on each of the two sides, six niches in all, filled with two-figure groups, one figure standing on the other as in the scheme of 1505. Each of the niches was flanked by pilasters with figures placed in front of them, so that round the bottom there were six two-figure groups and twelve single figures. The tomb was also to include three large reliefs. The fact that the monument was now to be set against the wall made it necessary to replan the upper part. On the platform was a tomb-chest supported by four figures which were roughly double life-size, and round its edges were six seated figures on the same scale. At the back, against the wall, was a structure described as a *cappelletta*, a little chapel, which seems from the contract to have been a kind of altar piece. It was to be extremely tall – its height above the platform was equal to the total depth of the tomb – and it was to contain five further figures, one in the centre, two on the sides and two on the returns against the wall, all of them larger than the double life-size figures since they were further from the eye.

The scheme of 1513 has been described as an enlargement and as a reduction of the scheme of 1505, and both statements are true. It was an enlargement in so far as it was much higher, and the size of the figure sculptures was greater than it had been before. It was a reduction in so far as the number of figures, on a quantitative count, was slightly reduced. We can get some impression of how the upper part of the tomb, the *cappelletta*, might have looked from a section added to the top of the drawing in Berlin (Fig. 31). Though the subjects of the figures are not mentioned in the contract – they are never mentioned in any of the later contracts for the matter of that – it is generally assumed that the central feature of the *cappelletta* was, as in this drawing, a Virgin and Child. By combining the contract and the drawing, we can reach a tentative reconstruction of the 1513 monument, and once we do so it becomes obvious that a great deal more was changed than the shape of the tomb. In 1505, apart from the Moses and the conjectural St. Paul, the tomb contained no religious imagery. Now it is presided over by the Virgin and Child, and probably by four standing Saints as well. In 1505 the statue of the Pope was a life portrait, now a death effigy is shown. In 1505 the four figures on the platform were seated at the corners of a central architectural structure, now they, and the sarcophagus, and the four figures supporting it, are grouped together as elements in an immense sculptural tableau, and are posed in an almost pictorial fashion

against the high niche behind. This can be deduced from the insistence in the contract that the further figures should be larger than the nearer figures with a view to keeping them in scale.

The touchstone of this scheme is the Moses (Plate 15), which was carved not for the niche that it now occupies, but for the right hand corner of the platform of the 1513 tomb. The figure was designed to be looked at from below, and what is now its front is its least favourable aspect, since the point of vision it presumes was from the centre of the 1513 tomb, that is about ten feet to the left of its present niche. Its secondary function was to link the front and sides, or turn the corner of the tomb, and this it achieves with complete success by means of the withdrawn left leg. Its present placing violates not only its structure, but its meaning too. Viewed at such close proximity the pose takes on an active character; one German critic claims that Moses is gazing in anger at the Golden Calf. But at its proper height the effect of this majestic figure, staring outwards into space, would have been less menacing and less theatrical, and its meaning has been interpreted correctly in the light of a passage from Pico della Mirandola: 'With this vision Moses and Paul and many others among the elect saw the face of God, and this vision is the vision that our theologians call intellectual or intuitive cognition.'

Speaking of the tomb of 1505, Condivi tells us that the figures in front of the pilasters round the base represented the Liberal Arts, and that by them Michelangelo 'sought to denote that all the Virtues had become with Pope Julius prisoners of Death, since they would never find anyone by whom they would be so favoured and nourished as they were by him.' In 1505, with the Pope alive and the prospect of a ten-year pontificate ahead, that was a permissible conceit. Retrospectively, however, it was meaningless, since it was abundantly apparent that the Liberal Arts had not died with the Pope, and that the Pope's reign opened a period of patronage that would continue through that of his successor. For this reason we must eliminate the idea of death when we look at the two figures of the Liberal Arts which Michelangelo carved between 1513 and 1516 for the 1513 tomb. These are the Dying Slave (Plate 16B) and the Rebellious Slave (Plate 16A) now in the Louvre. Many people would, of course, deny that these statues represent the Liberal Arts at all. In 1898 Ollendorf dismissed the explanation as *lächerlich*, and declared that instead they must portray the human soul on earth as though in prison. More recently they have been thought to represent 'the human soul enslaved by matter.' In Roman art prisoners were prisoners, and nothing more, and when the prisoner motif was taken over in Renaissance sculpture, it was often employed in the same restricted way. But Michelangelo's figures are symbolical. Whether they represent the soul enslaved by matter or the Liberal Arts in bondage, a convention from Roman sculpture is used as the means of conveying an idea which was not implicit in it from the start. So when it is argued that the personification of the Liberal Arts as slaves is opposed to the traditional use of the slave in art, or conversely that it is inconsistent with the traditional personification of the Liberal Arts, neither argument need be taken into serious ac-

count. We, moreover, like the Slaves, are bound – not by fetters but by evidence. There is no evidence at all that the Slaves represent the soul, but there is evidence that they represent the Liberal Arts, for on one there appears a roughly carved ape, and on the other there is a lump which might be a second embryonic ape. The likelihood, therefore, is that the two figures depict 'art the ape of nature,' and that the Dying and Rebellious Slaves are symbols respectively of the arts of Painting and Sculpture. Even if that is granted, what they are doing is not altogether clear. The Dying Slave is said in the great romantic Michelangelo biography of Grimm to portray 'the moment of death,' but it could equally portray the moment of awakening, and it is probable that the figures together represent what we might expect personifications of the Liberal Arts on a posthumous tomb of Julius II to represent, the resurgence of the Visual Arts.

In the seven years that intervene between the first and second versions of the tomb, Michelangelo's thoughts had naturally revolved from time to time round the problem of the Slaves. We know that from a sheet at Oxford (Fig. 32) which contains six studies for Prisoners, along with a large sketch for the Libyan Sibyl on the Sistine ceiling, and which must therefore have been made after the first project for the tomb had collapsed and before the second had been begun. The studies are for two angle figures, shown with knees raised in profile to left and right, and four frontal figures to be placed against the flat pilasters on the inside of each niche. These two categories of figure are also represented by the statues in the Louvre; one of them has the strong profile of an angle figure, and the other has the unemphatic profile of a figure intended to be seen only from the front. The Rebellious Slave is generally photographed as though it were facing to the left, but any study of its structure must lead one to the opposite conclusion, that it faced to the right, and stood immediately beneath the Moses on the right corner of the tomb. The Dying Slave is much more highly worked; part of the body is taken almost to the same state of completion as the Moses, and the transitions between the planes are less abrupt. The motif of the raised arm is one with which Michelangelo had experimented on the Sistine ceiling, but the planes in the statue recede less sharply, and the treatment of its contour is more mellifluous. This figure was intended to be seen against the flat pilaster to the left of the centre of the tomb, and the system on which it is composed depends from the David, where the thinness of the block had forced the sculptor to fall back upon a linear scheme. But the fact of the pilaster precluded the employment of an open scheme like that used for the David, so that the figure is closed in on itself. On one side the curved line of the leg is balanced by the unbroken contour of the torso, and on the other the straight line of the leg is balanced by the curved line of the waist, while above the two forearms are posed on corresponding diagonals.

One last point must be made about the 1513 scheme. Vasari tells us in parenthesis that Michelangelo made 'one side of the work in many pieces complete in every detail,' and a drawing of the base of the tomb, probably of about 1516, includes a statement in the sculptor's hand that all of the decorative carvings in it were complete, some of them in Florence and

some in Rome. The style of the decorative carvings on the bottom of the present tomb must logically belong to this and to no later phase, so we may guess that the bottom of the monument that was completed in 1545 was in large part identical with the bottom of the monument carved in 1513. If, therefore, we imagine the base of the monument as it now stands in San Pietro in Vincoli (Fig. 30) with the volutes removed from the pilasters, the Rebellious Slave on the right side and a corresponding figure on the left, the Dying Slave and a companion figure on the inside of each niche, and the Moses and a St. Paul at the ends of the platform at the top, we shall have a reasonably faithful picture of Michelangelo's visual intentions in the 1513 tomb.

In 1516 the whole scheme was once more thrown into the melting pot, and a new contract was drawn up. According to Michelangelo himself, the reason was that Pope Leo X diverted him against his will on to a new project, the façade of San Lorenzo. But a simplification of the tomb and a deferment of its terminal date must have been welcome on general grounds, since the 1513 tomb was due to be completed by 1520, and no more than three of its thirty-eight figures had been carved. Moreover, and one cannot help feeling this motive may have been predominant, by 1516 Michelangelo had outgrown the architectural conceptions embodied in the first two versions of the tomb. The new contract bound him to complete his task in nine years, that is by 1525, and it transformed the tomb into a true wall monument. The lower part of the structure was now to protrude from the wall by no more than one bay, that is by the depth of a niche flanked by two supporting Prisoners, and the platform on top was thereby eliminated. The front of the upper structure was therefore brought forward, and aligned with the front of the structure beneath, and the six figures on the platform were reduced to two, which were set between pilasters at either side. In the centre there was no longer room for the tomb chest in depth with its end to the spectator and four figures round it, and it was replaced by a seated figure of the Pope (possibly the statue which was blocked out in 1508) supported by two other figures, perhaps with a tomb-chest placed lengthwise with its long side towards the front of the tomb. This involved both a simplification and a revision of the earlier scheme. The forty-odd figures were reduced to twenty, and instead of the pictorial disposition of the sculptures before an architectural background which had been intended three years earlier, the sculpture was completely integrated in the architecture of the tomb.

New blocks were ordered for the new scheme, but work was irregular and slow. The façade project was partly responsible for that, but it transpires from the letters written to and by Michelangelo at this time that there were other obstacles, part artistic and part psychological. In the Medici Chapel the conceptions of the monuments and of the individual sculptures change shape and size seemingly of their own accord, and the same fate overtakes the Julius tomb. For a great part of the three years that followed the signature of the new contract Michelangelo was at Pietrasanta and Carrara, in daily communion with the medium through which he worked, and it would be contrary to everything we know of his

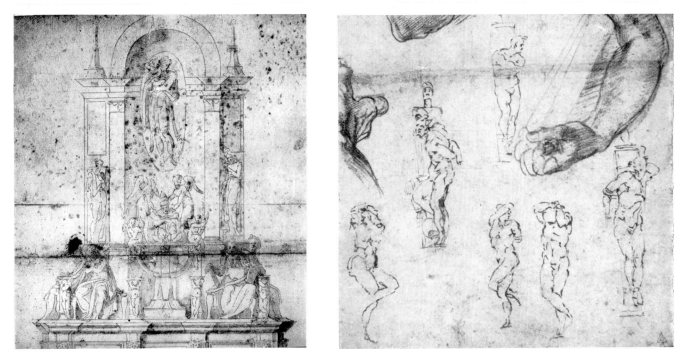

Fig. 31. After Michelangelo: UPPER PART OF A STUDY FOR THE TOMB OF POPE JULIUS II. Kupferstichkabinett, Berlin.
Fig. 32. Michelangelo: STUDIES FOR THE SLAVES ON THE TOMB OF POPE JULIUS II. Ashmolean Museum, Oxford.

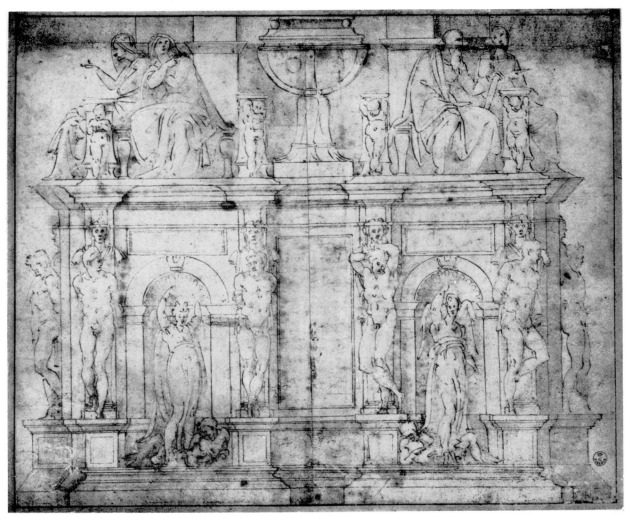

Fig. 33. After Michelangelo: LOWER PART OF A STUDY FOR THE TOMB OF POPE JULIUS II.
Kupferstichkabinett, Berlin.

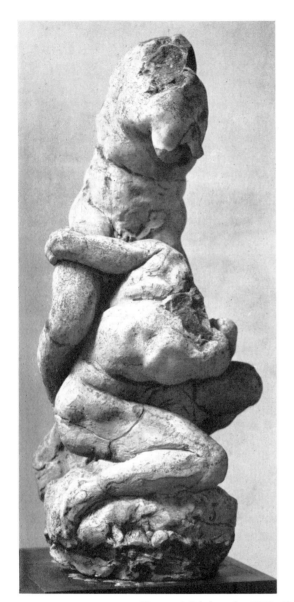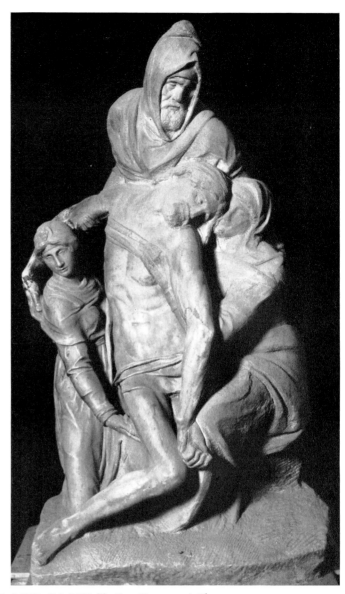

Fig. 34. Michelangelo: HERCULES AND CACUS(?). Casa Buonarroti, Florence.
Fig. 35. Michelangelo: THE DEPOSITION. Duomo, Florence.

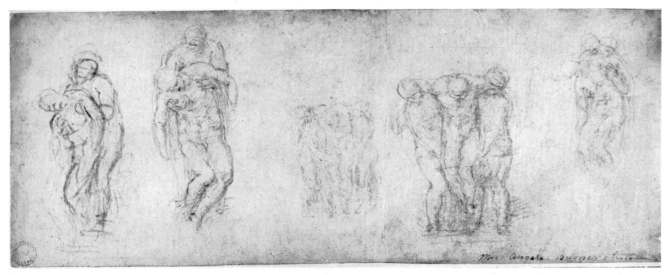

Fig. 36. Michelangelo: STUDIES FOR THE RONDANINI PIETA. Ashmolean Museum, Oxford.

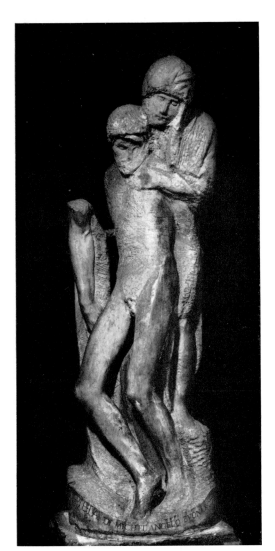

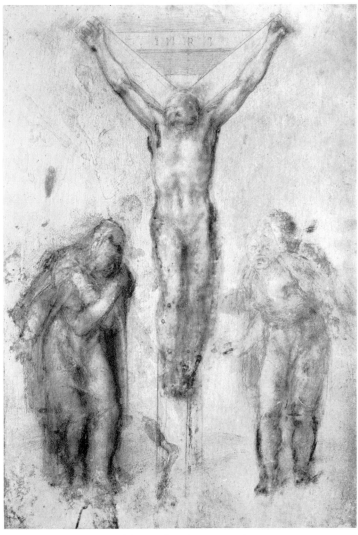

Fig. 37. Michelangelo: THE RONDANINI PIETA. Museo del Castello Sforzesco, Milan.
Fig. 38. Michelangelo: STUDY FOR A CRUCIFIXION. British Museum, London.

Fig. 39. Rustici: THE PREACHING OF THE BAPTIST. Baptistry, Florence.

Fig. 40. Danti: THE EXECUTION OF ST. JOHN BAPTIST. Baptistry, Florence.

creative processes if, while he was isolated with his scheme, the scheme itself remained un-
changed. The main evidence that it did not is afforded by the four unfinished Slaves (Plates
17A, 17B, 18, 19) in the Accademia in Florence.

In 1519, when the dead Pope's executors were exerting all possible pressure to compel
Michelangelo to complete the tomb, there is a reference to four figures on which he pro-
posed to work during the summer of that year, and it is very difficult to escape the conclusion
that those four figures are the Slaves. If they are, a second conclusion follows, that Michel-
angelo in 1519 proposed to revise the whole of the bottom of the tomb. Whereas the
Prisoners he had left behind in Rome – the Slaves in the Louvre – are roughly seven feet high,
the four Slaves in the Accademia are roughly eight, and are carved from deeper blocks. At
this time, in other words, he concluded that the old figures had to be abandoned since they
were too slender and too small to marry with the superstructure of the 1516 tomb, and that
new figures and a new base must be supplied. The four Slaves in Florence remained unfinished
because he had neither the time, nor the heart, nor the physical resilience to push this vast
revision through.

All unfinished sculptures present us with interpretative problems, and none more so than
these. For some students they are among the most valuable figures by Michelangelo that
we possess. Through them, as through no other works, we plumb the depths of his vast
reservoir of creative vitality; they are a physical embodiment of the romantic concept of
the spirit struggling to escape from the prison of the block. For others – a very small minority
– they are figures blocked out from the master's models in the quarry or the studio, in which
he himself had, manually speaking, scarcely any part. The realism of the second view is more
acceptable than the romanticism of the first, though it cannot be adopted in so crude a form.
Taking, for example, the figure known as the Awakening Slave (Plate 19), we find in the
area of the left shoulder and the raised left arm forms that are not only rudimentary, but are
so empty and distended and unfunctional that they could well be executed by a studio hand.
This is true also of the more highly worked right calf. But as soon as we approach the area
of the torso and the waist and the right thigh, Michelangelo's miraculous chisel can be seen
at work, shaping, refining, toughening the flaccid forms. This line of analysis can be pursued
through the companion figures. Whichever of the two views we adopt, the statues are no more
than potential works of art.

The contrast with the Louvre Slaves is so great that at first sight it might appear that
Fafner and Fasolt supplanted Mars and Apollo on the front of the tomb. But this is not
in the least what occurred, for two of the figures are direct substitutions for the two Slaves
in the Louvre. One of them is the figure known as the Young Slave (Plate 17A), where the
raised left elbow and the bent left knee are taken over from the Dying Slave, but are treated
with stronger plastic emphasis, so that the figure appears to support an upper structure and
not simply to rest against the flat plane of the wall. Plastically it is still conceived as a relief,
but a relief forcibly wrenching itself from its ground. The thick limbs would, of course,

have been thinned down. This figure, like the Dying Slave, was destined for the second pilaster from the left, and on the second pilaster from the right was its counterpart, the figure known as the Bearded Slave (Plate 18). On the extreme right, in the position occupied by the Rebellious Slave, there would have stood its substitute, the figure known as the Atlas Slave (Plate 17B), a much superior work in which the surface treatment is exactly consonant with that of the Day in the Medici Chapel. Once more the transitions are more violent and abrupt than in the earlier statue. Michelangelo's intention at this time was not just that the importance of the architecture vis-à-vis the sculpture should be increased, but that the supporting figures should establish a causative connection between the two. The Prisoners – whether or not they still represented the Liberal Arts we do not know, even Michelangelo may have been uncertain – were to have a functional relationship to the whole monument.

There were six niches in the scheme of 1513 and four in the scheme of 1516, and all of them were to contain two-figure groups. Only one group was carved, the Victory in the Palazzo Vecchio in Florence (Plate 21), where the hair is decorated with the oak leaves of the Della Rovere. Its height is almost exactly the same as that of the Accademia Slaves, and since it is unfinished, we should have reason on our side if we supposed that it was unfinished for the same reason, that it was made for the revised lower section of the tomb. The treatment of the torso contrasts at many points with the male nudes in the Medici Chapel, and there is a possibility that it was reworked later in the sixteenth century. When allowances are made for that, it is plain that its affinities are with the earlier Allegories in the Chapel, not with the more fluid forms of the Evening and the Dawn, and that it must date from the two mysterious years between the death of Leo X and the election of Clement VII, when the Della Rovere obtained the support of Pope Adrian VI, and Michelangelo was diverted back from the Chapel to the tomb. There are two main theories about the corresponding group for the niche opposite. The first, and less convincing, is that we have a model for it in the Casa Buonarroti (Fig. 34), and the second, and more persuasive, is that the model for it is recorded in a statue by another artist. Its subject is Honour triumphant over Falsehood (Plate 77), and it was carved in the early fifteen-sixties by an admirer of Michelangelo, Vincenzo Danti. One reason for supposing that this group was planned as a counterpart to the Victory is that the torso slopes away diagonally in the opposite sense, so that the relationship of the two figures is broadly analogous to that of the two unfinished slaves destined for the centre of the 1519 tomb.

One of Julius II's executors died in 1520, and the whole matter of the tomb was raised by the surviving executor at the end of 1523. With the terminal date of the 1516 contract little more than a year away, Michelangelo was asked to produce a statement of the sums that had been paid to him and the work that had been done. He replied that he needed eight thousand ducats more to finish off the tomb. This was presumably because the architecture of the lower part, into which the Prisoners were to be fitted, had to be carved afresh. The Cardinal on his side seems to have felt that the main impediment was not financial, and he made what,

on the face of it, was an extremely fair suggestion, that the tomb should be completed by Jacopo Sansovino and other artists, and should incorporate Michelangelo's sculptures, among them a Virgin and Child. In the autumn Michelangelo turned his proposal down, declaring that he would rather repay the money he had received than allow the tomb to be completed in that way. At this time and later he was resentful of the criticism to which he had exposed himself through his delays over the tomb. The impression left by the correspondence of his representatives in Rome is a little disingenuous, but that was not Michelangelo's own attitude. In the face of his commitment he felt a sort of sublime helplessness. No one was more alive to the nature of moral obligation than he, but he was no longer master of his destiny. From the letters of his representatives in Rome two aims stand out, still further to diminish the size of the tomb, and to entrust some of the sculptures to other hands. In October 1526 he prepared a reduced scheme, but the Pope's heirs rejected it. This was a counsel of despair. His mind was filled with the reality of the Medici Chapel, and for the first time we sense that the tomb is no longer a positive achievement borne forward on the creative wings of his own genius, but a negative duty to be carried out. It is contrary to probability to suppose that any of the major sculptures for the tomb were conceived after this time.

The negotiations were resumed in 1531, when Michelangelo, in a state of mounting frenzy, was working in the Medici Chapel. This time the spokesman for the heirs was Francesco Maria della Rovere, Duke of Urbino, but the decisive influence was that of the Pope, who regarded the completion of the tomb as a psychological necessity for Michelangelo. It was not essential, he suggested, for Michelangelo to admit to the Duke that the tomb would be finished by other sculptors; it would suffice if he prepared the models and tacitly allowed that to occur. There was, he insisted, already too much autograph sculpture in the monument. Suddenly, at the end of the year, the Duke of Urbino bowed to the inevitable, and accepted the proposal for a reduced tomb, so in April 1532 a new contract was signed. By its terms the number of sculptures was again cut down – they were now to consist of six by Michelangelo and five by other artists – and the tomb was transferred from St. Peter's to San Pietro in Vincoli, where, in 1533, work on the foundations began. The six sculptures by Michelangelo probably included the Dying and Rebellious Slaves, and excluded the unfinished sculptures carved for the 1516 tomb, the Prisoners in Florence and the Victory.

A letter to Michelangelo written by Sebastiano del Piombo from Rome at the end of 1531 reports an interview with the Pope, in which it was proposed that the sculptures carved for the tomb should be made available for use in the Medici Chapel. Then, said Sebastiano del Piombo, if any of them pleased His Holiness, His Holiness could say, 'I want this or that.' But His Holiness expressed some scruple about this, and declared that he would not touch a single stone destined for the tomb. There is no further written evidence, but the matter cannot have ended precisely at that point, since one of the figures used for the tomb, the Active Life (Plate 34), was very probably carved in the first instance for the Chapel. In practice the applicability of the tomb sculptures to the Chapel was extremely limited. The

Slaves could have no part in the scheme, and neither could the Moses nor the Victory. There was indeed only one major iconographical feature of the tomb that was common to the Chapel, and that was the Virgin and Child. Not only does the statue in the Chapel differ from the group that Michelangelo planned, but it is related, in form, condition and technique, to the Victory from the Julius tomb, and must have been carved at the same time. In the circumstances there is a strong case for supposing that it was made for the tomb not for the Chapel, as part of a revision of the upper section of the monument.

The beginning of work in San Pietro in Vincoli proved premature, for in 1534 Clement VII died, and was succeeded as Pope by Paul III, who was less indulgent than his predecessor towards the tomb. For him it was simply an impediment in the way of a new project, the fresco of the Last Judgement. The cartoon of the Last Judgement was prepared in September 1535, and work on it continued till the autumn of 1541. In 1538 Francesco Maria della Rovere died, and his successor as Duke of Urbino, Guidobaldo, had no alternative but to acquiesce in the completion of the fresco, but when it was finished the Pope at once diverted Michelangelo to a new task, the painting of the Cappella Paolina. A campaign was started to bludgeon the Duke of Urbino into accepting even less favourable terms than those that had previously been agreed upon. 'Michelangelo,' explains one letter, 'is obliged to paint the Pauline Chapel, and will be unable to work further on the tomb. He is old, and is resolved, when the chapel is finished in three or four years time, if he lives so long, to undertake no further work.' Some other arrangement for the completion of the tomb must therefore be made. The only difference, ran this insidious argument, was that the six statues supplied by Michelangelo, instead of being autograph sculptures, would be made from his designs. Possibly they might include something which he had carved or at least sketched out, but even that was uncertain, because the Pope thought the sculptures unsuited to the tomb but well adapted to his own chapel. To his credit the Duke of Urbino stood firm; there must be three completely autograph finished statues, he insisted, and one of them must be the Moses.

The Moses (Plate 15) in the twenty odd years of its existence had suffered rather a peculiar fate. The first indication we have of that occurs during a visit paid by Pope Paul III to Michelangelo's studio probably in 1535. He was accompanied by the Cardinal of Mantua, who caught sight of the statue, and exclaimed: 'This statue alone is amply sufficient to do honour to the tomb of Pope Julius.' By 1535 the Neoplatonic programme of the 1513 tomb was of small account, and the historical significance of Julius II's pontificate was open to no doubt. So the militant figure of Moses presented itself in a new light; it came to be regarded as an allegory of the pontificate and of the Pope. That idea lay at the base of the final revision of the tomb, was resuscitated in the nineteenth century – the figure is interpreted in that way, for example, by Gregorovius – and affects most of us when we look at it to-day. As the meaning of the Moses swelled, the effigy destined for the tomb shrivelled into its present insignificance.

The solution proposed by the Duke of Urbino was agreeable to Michelangelo, and in

1542 he agreed to supply three figures carved from his models by Raffaello da Montelupo, a Virgin and Child, a Prophet and a Sibyl, and three figures of his own which were almost complete, the Moses and the Dying and Rebellious Slaves. But he personally thought the Slaves unsuited for the niches on the reduced tomb – the reasons for that must have been part formal and part iconographical – and he preferred to substitute two other statues, one of which was already under way, of the Active and the Contemplative Life (Plates 34, 35). The Duke of Urbino delayed ratifying the new contract, but work went ahead. The bottom storey of the tomb of 1513 was completed and installed, the upper storey of 1516 was put on top of it, the Prisoners were replaced by volutes, the Moses was set in the centre of the tomb with smaller figures of the Active and the Contemplative Life on either side, and above were four workshop statues, a Prophet and Sibyl, an effigy and the Virgin and Child. By 1545 all this resulted in the monument we know to-day (Fig. 30). When it was finished, the surplus sculptures were dispersed. The Dying and Rebellious Slaves of 1513 were given to Ruberto Strozzi, and found their way to France. The Victory, discovered after the sculptor's death in the studio in Florence, was first provisionally allocated to his tomb, and was then installed by Vasari in the Salone dei Cinquecento of the Palazzo Vecchio. The four Prisoners were taken over by Cosimo I, and eventually were built by Buontalenti into a grotto in the Boboli Gardens, from which they were rescued as recently as 1908. Michelangelo's artistic conscience may have been weighed down by the enormity of what had happened, but his moral conscience was absolved.

The tragedy of the tomb – that famous expression is Condivi's – was not simply a tragedy of compromise, a great artistic concept trimmed by fate or by expediency; it was the tragedy of a work rooted in deep artistic convictions that was completed by a man to whom artistic considerations were in themselves no longer of great consequence. In 1542, the year of the final contract for the tomb, the Inquisition was introduced in Italy, the Council of Trent had already been convened, and the Counter-Reformation, which had cast its shadow over the preceding decade, was fully launched. In the life of Michelangelo reason was expelled, and dark contemplation took its place. This was the period of his spiritual intimacy with Vittoria Colonna, and of the mystical poems that have pride of place in his poetic works. Between the latest of the statues carved for the 1516 tomb, the Victory, and the new statues carved for the monument of 1542, there intervene the mysterious figures in the Pauline Chapel and the visionary images of the Last Judgement, in which painting is treated as a vehicle for the transmission of mystical experience. The bottom of the Julius monument is not just a union of figures of different dates, but the meeting point of two irreconcilable attitudes to sculpture. In the statue of the Contemplative Life the postulates that underpin the Moses are denied. The essential medievalism of this figure was apparent even to Condivi, who relates it and its companion figure to the Divine Comedy. It represents, he writes, 'a woman of rare beauty with head and hands turned towards heaven, which in all its parts breathes love.'

In 1541, in the course of the negotiations for the building of the tomb, it had been inti-

mated that Michelangelo would undertake no further work, and after the monument was finished he adhered to that so far as sculptural commissions were concerned. But in those nineteen years – he died in 1564 – he was tormented by the urge to create a sculptural equivalent for the style of the Pauline Chapel and of the Last Judgement. Before 1550 he started work on a group destined for his own tomb (Plates 36, 37, Fig. 35). It represented the active subject of the Deposition, not, like the early sculpture in St. Peter's, the passive subject of the Pietà. The mask of classicism has been torn away, and mother and son are participants in a real scene. Vasari describes the figures as shown in momentary action, the Virgin 'overcome by grief, failing in strength and not able to uphold Him,' and Nicodemus bending forward to assist her 'planted firmly on his feet in a forceful attitude,' while Christ 'sinking with the limbs hanging limp, lies in an attitude wholly different not only from that of any other work by Michelangelo, but from that of any other figure that was ever made.' Of conscious refinement of the sculpture as a work of art – as we meet it in the sculptures of the Medici Chapel and the Victory – there is no longer the least trace, and the communicative power of the whole group is inseparable from the brutal directness of its form. But the figures, though depicted in momentary action, are also symbols, and the head of Nicodemus expresses the compassion not of one onlooker, but of mankind.

Michelangelo, in the Hollanda Dialogues, declares that ideally the religious artist should be a saint, and in conformity with that belief the Deposition is conceived as a form of visual prayer. 'O flesh, O blood, O wood, O extreme suffering' exclaims Michelangelo in one of his later poems, 'through you may my sin be atoned,' and in a moving poem, also dating from the period of the marble group, he protests at the veil of ice by which his innermost being is encased, and begs Christ to break down the hard wall that prevents the light of grace from penetrating to his heart. The status of the group as a summation of these poems seems to have been accepted by Michelangelo's contemporaries, and in 1564 the head of Nicodemus was already looked upon as an idealised self-portrait.

In 1554 this group – the most subjective and most overtly emotional that has ever been produced – was defaced by the sculptor in a moment of exasperation, and was worked up by a studio hand into the state in which we see it now. This affected especially the kneeling figure on the left-hand side, which is smaller than the Virgin and is so incompetently carved that its function is not immediately evident. Condivi, however, tells us that the figure was conceived by Michelangelo as 'performing for Christ the office which his mother could not undertake,' that is the cleansing of the corpse. The block-like simplicity of the Virgin, for which Michelangelo was responsible, stands in sharp contrast to the artificial disposition of the figure opposite. At the side and back the figure of the Virgin is rounded in a way which is consistent only with the view that the group was intended for a niche, and in a containing space its effect would be even more pictorial than it is to-day. In the Hollanda Dialogues Michelangelo insists that 'amongst men there is but one single art or science, and that is drawing or painting, all others being members proceeding therefrom.' The primacy of painting is maintained visually in the

Deposition group. The linking of the three main figures in a single visual unit with a strong vertical emphasis is a device that was repeatedly employed by Michelangelo in the Last Judgement, and the Virgin and Nicodemus can indeed be looked upon as figures from the fresco invested with physical instead of notional tactility. Though the group was cast aside, the expressive problem it presented could not be so easily dismissed, and from this time there survive a number of drawings for a Crucifixion, conceived in the same style as the Pauline Chapel frescoes but projected as a marble group. Sometimes the three figures coalesce, as they do in the marble Deposition; sometimes they are spaced apart (Fig. 38) as three inter-dependent statues; and sometimes they are so lightly indicated that they seem to float below the level of the sculptor's consciousness. On the back of one of them there is an indication of the block from which, had the group become an actuality, the Christ would have been carved. It did not become an actuality, perhaps because the image was inherently unsculptural, perhaps because it was so charged with meaning that Michelangelo could not reconcile himself to reducing it to finite terms. There remained one last project for a sculpture of a subject he had treated in his youth, the Pietà. It appears first on a sheet at Oxford for a Virgin supporting the Dead Christ (Fig. 36). This eventually became the pathetic relic of the Rondanini Pietà (Fig. 37), where Michelangelo, in the last weeks of his life, hacked away the marble till nothing but a skeleton survived.

Seen in relation to his ambitions and to his own interior life, the career of Michelangelo the sculptor was one of failure, ending in a symbolic act of suicide. Seen in relation to the outer world, it was one of unparalleled success, for his contemporaries without exception recognised that he had raised the art of sculpture to an expressive level that had never been conceived before and could never be surpassed.

THE HIGH RENAISSANCE STATUE

AT the very beginning of the sixteenth century attention in Florence was once more directed to the Baptistry, the building on which it had been focused a hundred years before. The centre of interest was no longer the doors (which continued to excite the admiration that had been felt for them throughout the fifteenth century) but the register above them, which was filled by three decaying marble groups. Carved in the shop of Tino di Camaino, the three groups had one peculiarity, that they were narrative scenes composed of large-scale sculptures. Over the north door was St. John the Baptist preaching to a Levite and a Pharisee, over the south door was the Baptism of Christ, and over the east door, above the Porta de Paradiso, was the Baptist with figures of the Virtues and St. Michael. From the few fragments of them that survive we know that the individual figures were soft, immobile and bland. Vasari describes them as *goffe* (awkward or clumsy), and very primitive they must have looked in 1483 when Verrocchio's Christ and St. Thomas, which also depicted a large-scale

narrative scene, was installed on Or San Michele. No steps to replace the statues were taken, however, before 1502, when it was decided by the Arte de' Mercanti that marble figures of Christ and the Baptist should be commissioned to replace Tino di Camaino's Baptism, and be installed over the east, not the south, door. The figures were entrusted to Andrea Sansovino, who had established himself a short time earlier – with the Corbinelli altar in Santo Spirito and two still unfinished statues of the Virgin and Child (Plate 42) and St. John the Baptist for Genoa Cathedral – as the principal classicising sculptor of his time. Work on them was broken off in 1505, when Sansovino moved to Rome. In the winter of the following year a second large group was commissioned to replace the Preaching of the Baptist over the north door. The medium of the new group was bronze, and it was allotted to Giovanni Francesco Rustici, who completed it in 1511. A third group, the Decollation of the Baptist, was commissioned for the south door almost sixty years later from Vincenzo Danti.

It might be supposed that two groups designed for the same building in the same term of years would be stylistically uniform. But Andrea Sansovino's Baptism of Christ (Plate 43) and Rustici's Preaching of the Baptist (Fig. 39) have in common nothing save the architectural expedient by which they are united to the fabric of the church. The wall of the Baptistry above the entrances was covered with polychrome arcading, and the height of the statues was determined by the height of the arcade. The wall surface made it impossible to build external niches which would isolate the groups, and instead it was decided, in the case of the Baptism of Christ, to construct a simple tabernacle, comprising an entablature supported on two columns, planned as a background not as a containing niche. This scheme, in a somewhat different form, was used again by Rustici.

The contrast between the Baptism of Christ and the Preaching of the Baptist is not only one between a group in marble and a group in bronze. It is also the contrast between an artist whose predilections were strongly classical, and an artist whose concern was with expression and who for that reason disregarded the antique. The first group has a key place in the history of Renaissance sculpture, while the second stands alone, and for that reason it may be well to look at the later of the two groups first. The Preaching of the Baptist consists of three figures on circular bases disposed symmetrically against the tabernacle. In the centre, framed by columns, is the preaching Saint, and to the right and left there stand his auditors, a bald-headed Levite and a Pharisee. Though the statues are set on a single plane and widely spaced, they none the less form a dramatic unit; each is linked psychologically to the next. None of the three figures could be explained without reference to the other two; the auditors presuppose a preacher, and the preacher postulates an audience. There is no precedent in sculpture for a composition of this kind, but it had a parallel in painting, in the fresco of the Last Supper where Leonardo makes use of a very similar narrative device. This is significant, because the sources one and all link Leonardo's name with Rustici's at the time he was working on the group.

Though they are set in line, the three figures are posed in rather a peculiar way. The Baptist

is shown with the left shoulder retracted and the right advanced, and with his right knee thrust forward and his left leg drawn back. The spiral implications of the pose are underscored by a cloak which falls from the right shoulder and by the sharp turn of the head. The posture of the Levite (Plate 38) is still more complex: the left elbow is pushed forward and the right shoulder is held back, while below the rhythm is reversed and the right foot is crossed over the left. This opposition between the shoulders and the knees is found again in an inverted form in the figure of the Pharisee. Vasari, who refers to the group twice, tells us first, in his life of Rustici, that the sculptor was assisted by Leonardo, who never left him during the modelling of the figures, and second, in his life of Leonardo, that the figures were planned by Leonardo but made by Rustici. There is no documentary confirmation that this was so, but the three figures certainly establish a formal pattern that is typical of Leonardo and of no other artist, and this relationship can be confirmed from numberless details – the Levite's head, which so closely recalls the caricature heads by Leonardo, the crossed legs, which make use of a motif explored by Leonardo in his early studies for an Adoration of the Shepherds, and the Medusa-like hair shirt of St. John. An extraordinary feature is the extent to which the group preserves the spontaneity of modelled sculpture; one of the devices employed in it, the use of drilling in the cavities between the wild locks on the Baptist's head (Plate 39) and in the unruly tufts of his hair shirt, may also be ascribable to Leonardo's pictorial consciousness.

By contrast Sansovino's Baptism of Christ (Plate 43) is a work of great restraint. The hands of Christ are folded on his chest, and his shoulders are parallel with the wall. The Baptist is also posed frontally, with his head turned in profile towards Christ and his right arm raised above Christ's head. The effect is here made not by abrupt changes of plane, but by smooth transitions within a continuous silhouette. This and the pyramidal design also suggest analogies with painting – not with Leonardo, who was engaged upon his battle fresco in the Palazzo della Signoria while Sansovino was working on the group, but with Raphael, who arrived in Florence when the figures were already far advanced, in 1504. Unluckily this splendid group, which might have exercised a beneficial influence in Florence, was not finished, and only in 1569 was it set up on the Baptistry.

The reason why the group was left unfinished was that the eddies of Sansovino's reputation reached the papal court, and in 1505, seduced by the same prospects that had tempted Michelangelo before him, he moved to Rome. There, as the Baptism of Christ might lead us to expect, he rapidly aligned himself not with Michelangelo, but with the orthodox classicism of Bramante, and after 1508 with Raphael. Initially he was employed on two wall monuments for Bramante's choir of Santa Maria del Popolo, and when in 1510 or 1511 he was allotted the commission for a free-standing statue this was associated with a work by Raphael. Completed in 1512, it owed its origin to a native of Luxembourg, Johann Goritz, who formed the centre of a humanist circle in Rome. On the feast of St. Anne, Goritz habitually entertained his friends – Sadoleto, Bembo, Castiglione and Giovio among them –

at his villa, and he determined to give his devotion to this Saint permanent expression in Sant'
Agostino. In the monument he planned, painting and sculpture were combined. Above was
a fresco by Raphael of the Prophet Isaiah, bearing a Greek dedication to St. Anne, and below
it was a group of the Virgin and Child with St. Anne by Sansovino (Plate 48).

Goritz was not only a distinguished humanist, but a man of strong artistic views. With his
approval Raphael's fresco was revised in the light of the Prophets on the Sistine ceiling, and it
may have been at his request that Sansovino took as his starting point a work by Leonardo.
From Sansovino's years in Florence one event must have stood out with special clarity –
the exhibition, in 1501, of the cartoon of the Virgin and Child with St. Anne prepared by
Leonardo for the high altarpiece of the Annunziata. 'When it was finished,' Vasari tells us,
'men and women, young and old, continued for two days to crowd into the room where it
was shown, as if attending a solemn festival.' Leonardo's cartoon has disappeared, but ele-
ments of the composition are recorded in a second cartoon in London and in a painting in
the Louvre. In the London cartoon the Virgin is shown seated on St. Anne's right thigh.
This motif of one figure supported on the other was unsuited to sculpture, and was unclassical,
and Sansovino for this reason represents the figures seated side by side. The right foot of
each of Leonardo's figures is set lower than the left. This too Sansovino modified, placing
his figures on two different levels and showing St. Anne gazing at the Child. At the same
time he changed the axis of the group. He did this because his subject differed both from that
of the cartoon (where the Child is shown blessing the young St. John) and from that of the
painting in the Louvre (where the Child plays with a lamb). If there were no lamb and no
St. John, the Child need no longer be stretched across the composition from left to right, but
could instead be set across the Virgin's body from right to left. In this way Sansovino evolved
a closed, flattened composition, in which Leonardo's scheme was classicised.

The intellectual mastery of this group stands out most clearly if we compare it with a
group of the same subject (Plate 56) which Francesco da Sangallo completed for the altar
of St. Anne in Or San Michele in Florence fourteen years later, in 1526. Sangallo must also
have been familiar with Leonardo's scheme, and from it he took over the motif that
Sansovino had avoided with such care, the Virgin seated on St. Anne's right thigh. To achieve
this he set the right leg of St. Anne on the rear plane of the block, and treated the front
plane as a triangle, with the Virgin's left knee as its apex and her right leg and the left leg of
St. Anne as the two sides. Not only is this composition laboured and inelegant, but it is
lacking in the human content, the equipoise of form and subject, that is the crowning glory
of Sansovino's group.

The opposition to Michelangelo that is implicit in this statue becomes explicit in the work
of Andrea's namesake and disciple, Jacopo Sansovino. Jacopo left Florence for Rome in
1505, and may have been present in 1506 when Michelangelo and Giuliano and Francesco
da Sangallo identified the newly found Laocoon. Soon afterwards he made a wax copy of
it, which brought him to the notice of Raphael and Bramante. Returning to Florence about

1511, he began work on his first important marble statue, the Bacchus (Plate 50), commissioned by Giovanni Bartolini, later owned by Cosimo de' Medici and now in a sadly damaged state in the Bargello. Bartolini's palace at Gualfonda was designed by Baccio d'Agnolo, and there, in a courtyard or loggia, on a red and white marble base by Benedetto da Rovezzano, Sansovino's statue stood. When he designed it, he must have been thoroughly familiar with Michelangelo's Bacchus in Rome. Trained as he was in the orbit of Andrea Sansovino and of Raphael, he perceived what we too see today, that Michelangelo imposed upon his Bacchus a continuous spiral movement that was essentially unclassical. In Sansovino's Bacchus an attempt is made to revive the antique on its own terms. The realism of Michelangelo is replaced by a strain of idyllic poetry, and the figure, though it rests on a circular base, is planned with one main and three subsidiary views like a statue in the fifteenth century.

The contest between Sansovino and Michelangelo was fought out on a larger field in the Cathedral. All hope that Michelangelo would execute twelve more than life-size statues of Apostles for the Duomo was finally abandoned in 1508, when he began work on the Sistine ceiling. For three years the scheme was in abeyance, and then, in the first half of 1511, it was decided to allot the statues separately to such sculptors as were available. In June the first commission, for the St. James (Plate 51), was awarded to Sansovino. In the second half of 1512, after a vain attempt to induce Andrea Sansovino to undertake two statues, a figure of St. John was commissioned from Benedetto da Rovezzano, who completed it, with great expedition, in twelve months, and at about the same time a St. Andrew was commissioned from Andrea Ferrucci. In 1514 Ferrucci was unsuccessfully invited to carve a second statue, a St. Peter, and when he refused, this was entrusted, early in 1515, to a young and unproved protégé of Giuliano de' Medici, Baccio Bandinelli.

The four statues are of unequal merit. The least successful is the St. John of Benedetto da Rovezzano (Fig. 43), who was accustomed to working in relief, and whose figure reveals in every fold the limitations of a small-scale artist. Ferrucci's St. Andrew (Fig. 42) is more accomplished, though the elaborate drapery and the Michelangelesque motif of the left hand held heroically against the body are insufficient to redeem the inertia of its pose. Bandinelli's St. Peter (Fig. 41) is the victim not of slack sculptural thinking but of perfunctory technique, and its boldly contrived design is smothered in inanimate detail. The St. James is a sculpture of a very different class. In 1511, when Sansovino started work on it, the only basis of comparison was Michelangelo's St. Matthew. The challenge of this figure was the more real in that Sansovino was making use of a block quarried for Michelangelo. Moreover, he must have been familiar not only with Michelangelo's unfinished statue, but with the creative stages through which it had passed. He would, for example, have been aware of the importance that Michelangelo from the beginning attached to violent contrasts within the pose and of the emphasis that rested on the knee, protruding arrogantly from the block. In Sansovino's statue of St. James each of the propositions implied in the St. Matthew is contradicted by its opposite.

Plastic contrasts are replaced by a system of smooth articulation. A careful equilibrium is established between the planes of the shoulders and the knees, and a great fold of drapery softens the transition from the forward leg to that behind. One hand is raised, the other lowered, and the smooth drapery along the legs is balanced against broken drapery above, the two separated from each other by heavily scored folds of cloak held round the hips. The head is treated not with the visionary intensity of the St. Matthew but with classical restraint. Sansovino's point of departure in this work was the statue of the Baptist carved by Andrea Sansovino for Genoa, but its simple contours are overlaid by the influence of two other artists, one of them Ghiberti, whose statues of Apostles on Or San Michele were stylistically of far greater importance for the sixteenth century than for the fifteenth, and whose work still fascinated Sansovino at a much later time, and the other Raphael.

In 1518, when the St. James was finished, Jacopo Sansovino returned to Rome, and three years later began work on a group of the Virgin and Child for Sant'Agostino (Plate 49), where the Virgin and Child with St. Anne of Andrea Sansovino already stood. The relation of the later to the earlier group is that of the St. James in Florence to Andrea Sansovino's Baptist at Genoa. The core of classicism is unchanged, but the surface contrasts have been heightened and there is a new animation in the drapery. Where the robes in Andrea's group are spread tightly across the knees in repeated curves like a wave pattern in a Chinese painting, the robe of the Madonna del Parto is draped in heavy folds. The Virgin's lap is treated not as an indeterminate receding area, but as a solid platform for the Child, and the two free arms are not disposed on planes parallel with the body, but establish a circular movement which invests the group with greater amplitude. The figures have emerged from their cerebral cocoon, and in the posture of the Child there is an illusion of movement that is deeply Raphaelesque.

Sansovino's Virgin and Child is indeed more authentically Raphaelesque than the only statue Raphael himself designed, the Jonah (Fig. 44) in the Chigi Chapel in Santa Maria del Popolo, where his cartoon – and very beautiful it must have been – was blurred and weakened by the sculptor Lorenzetto. This is one of the few sculptures in the world whose true merits transpire more clearly from plaster casts than from the original.

In 1527, after the Sack of Rome, Jacopo Sansovino moved to Venice, and two years later Andrea Sansovino died at Loreto, where he had been at work since 1512. From this point on, Rome as a sculptural centre yields to Florence, where the accession of Alessandro de' Medici in 1530 opened a long period of stable patronage. For four years Michelangelo dominated the artistic scene, but in 1534 he left Florence never to return, and the leadership of Florentine sculpture passed, by default, to his rival Baccio Bandinelli. The hostility of the two sculptors centred upon a single work, or rather on the block of marble from which that work was to be carved. The David had been set in place outside the Palazzo della Signoria in 1504, and not long after it was proposed that Michelangelo should carve a two-figure companion group. A colossal block of marble was ordered by the Gonfaloniere, Piero Soderini, for his use, but

by 1525 the sculpture had not been begun, and Pope Clement VII, in defiance of the wishes of the Signoria, withdrew the block and allotted it afresh to Bandinelli. Boasting of his intention to surpass the David, Bandinelli made two models for a group of the same subject as Michelangelo's projected group, Hercules and Cacus, and the Pope personally opted for one of them. In 1527 carving began. But a year later the Medici were once more expelled, and the block was withdrawn by the popular government from Bandinelli and reallotted to Michelangelo, who started work on a project for a group of Samson and two Philistines. With the return of the Medici this project collapsed. Michelangelo was instructed to continue his work in the Medici Chapel, and Bandinelli resumed the carving of his Hercules and Cacus, which was completed in 1534. The group was much criticised when it was unveiled, and the authors of some of the lampoons directed at it were imprisoned by Alessandro de' Medici. This criticism was both artistic and political; the group from the beginning had been sponsored by the Medici, and was the first emphatic statement of Medicean High Renaissance taste.

In approaching the Hercules and Cacus (Plate 64), we must resist the temptation to compare it with the David, as Bandinelli intended, or with the model for the Samson and two Philistines, as his contemporaries would have done. The group is a product of the same academic-classicist mind as the St. Peter in the Cathedral. At first Bandinelli planned an active group showing Hercules 'holding the head of Cacus with one knee between two rocks and squeezing him with his left arm, pressing him between his legs in a painful attitude,' and Cacus 'suffering from the violence of Hercules with every muscle strained.' This scheme is recorded in a model in Berlin. Luckily for Bandinelli, it proved unsuited to the block, and he fell back instead on a static composition from which the element of movement was excised. From the first it was destined for a corner position on the steps of the Palazzo della Signoria near the Loggia dei Lanzi, and this affected its design; the rectangular base was aligned with the wall of the palace and the front of the platform and the figures were set diagonally across it. The dominant view is from the corner, not from the front of the base, and is established by the shoulders of Hercules and by a diagonal running from the right knee of this figure through the left shoulder of Cacus. On its own academic level, the group is a remarkable work, but its interest is structural, and nowhere does it rise above the level of an arid intellectual theorem. On a large scale Bandinelli was at once a coarse and timid sculptor, and we cannot but feel a pang of sympathy at his predicament, as he attempted, after the statue had been set in place, to strengthen its weak modelling by excavating it in greater depth.

In his own lifetime sympathy was an emotion Bandinelli did not commonly arouse, least of all in the mind of Benvenuto Cellini, who from the time of his return from France in 1545 emerged as Bandinelli's principal competitor. Cellini, in a poem, complains of Bandinelli's 'arrogant voice', and when Cellini's Perseus was unveiled, Bandinelli in turn wrote a lampoon on it which begins *Corpo di vecchio, gambe di fanciulla*. Cellini thought that Bandinelli was spiteful and ungenerous, and Bandinelli complained of the malignancy of *questo pessimo*

mostro di natura. But art and vice, he wrote, smugly recalling a dictum of Michelangelo, do not go hand in hand. A good deal of the hostility between Bandinelli and Cellini was professional, but it involved principle as well. Where Cellini by training and temperament was a sculptor craftsman, Bandinelli was an artist from whose composition the element of craftsmanship had been left out. For Cellini, who had gate-crashed into sculpture at the age of forty-two, Bandinelli, a fast worker, felt the scorn of the professional for the amateur, while Cellini seems to have sensed that the reach-me-down system of geometrical forms on which Bandinelli's groups were artificially built up was deeply at variance with the traditions of Florentine sculpture.

The first fissure appeared in August 1545, when Cosimo I awarded Cellini the commission for the Perseus (Plate 70). For Cellini this commission to add one more to the little group of statues in front of the Palazzo Vecchio was of immense significance. At the north corner of the building, on the platform that was later destroyed to make way for Ammanati's fountain, stood the Marzocco of Donatello. To the left of the entrance was Michelangelo's David, to the right of the entrance on the south-east corner stood Bandinelli's Hercules and Cacus, and in the westernmost of the three arches of the Loggia dei Lanzi, in the position now occupied by the Rape of the Sabines, was Donatello's Judith. The Perseus from the first was destined for the corresponding arch on the east side of the entrance, so for Cellini it offered a challenge on every count. He was to supply a bronze pendant to one of Donatello's greatest statues, in full view of the David of Michelangelo and adjacent to the Hercules and Cacus by the sculptor he intended to expose.

In looking at the Perseus there is one misconception that must be cleared away. Cellini is sometimes credited with what is called a kinetic view of sculpture, a conception of the statue as an infinite number of continuous, ceaselessly merging views. There is, admittedly, a poem in which, in a moment of not untypical hyperbole, he seems to state that statues have a thousand views. But in a letter which he contributed in 1549, while the Perseus was still in progress, to the *Lezioni* of Benedetto Varchi, he does not express himself in that fashion at all. 'I affirm,' he says, 'that the art of sculpture is seven times greater than any of the other arts depending on design, because a sculptured statue must have eight views, and all must be of equal excellence.' Another tell-tale passage occurs in the *Vita*, where he describes how Cosimo I, confronted with his model for the Neptune fountain, 'walked all round it, stopping at each of the four points of view exactly as the ripest experts would have done.' So Cellini's theory of statuary, if the written sources are to be trusted, belonged to the late fifteenth century, and was only a little more elaborate than the theory behind the Judith itself.

That conclusion receives ample confirmation from the statue. When it was designed, indeed, Cellini must have had the Judith (Vol. II, Plate 31) constantly in mind, for not only is the figure, like the Judith, planned in relation to a rectangular base, but the rectangle is once more established by a cushion, over which there hangs the Medusa's right arm. Curiously

enough this return to Donatello was not part of the original conception, for in the earlier of the two surviving sketches, a wax model in the Bargello (Fig. 45), the figure stands on a circular base with the Medusa draped around it – a goldsmith's image which was difficult to realise on a colossal scale. Only in a later sketch, a bronze model also in the Bargello (Plate 46), is a cushion, smaller and thicker than Donatello's, introduced. It is as though the artist were appealing for guidance to the past. From this it was no more than a short step to the wider, thinner cushion on which the body of Medusa in the final version rests.

The development of the figure of Perseus follows that of the base. In the wax model Perseus is a lithe, elegant, lightly balanced figure represented picking his way over the corpse with his face turned to one side and the Medusa head held outwards to his left. The posture is consolidated in the bronze model, where the Medusa head is represented frontally, the left knee is more sharply bent, and the torso is treated with greater emphasis. In making these changes, Cellini seems to have been influenced by one of the few great Florentine bronze nudes he can have known, the David of Donatello. The implications of movement are less in the bronze model than in the wax, and least of all in the large statue, where *maniera* reigns supreme. It is not just that the modelling is more carefully worked out, but that the whole scheme has been frozen and rationalised. The sword is no longer, as in the model, turned at an angle from the figure pointing down, but is poised horizontally parallel with the ground, and the body of Medusa is not a crumpled heap, but is placed diagonally across the base, with the lower legs set along the edges of the cushion. As we should expect from a goldsmith of Cellini's stature, the detail is notably expressive; the helmet in particular is treated with great imagination and vivacity, and the Medusa head (Plate 71) shows an astonishing command of nuances of form. But it is by the huge nude Perseus that the group must stand or fall, and this, if not a strikingly original invention, is none the less a work of great vitality. The Judith, fortunately for Cellini, no longer stands in the Loggia dei Lanzi, but the relationship between the Perseus and the Hercules and Cacus is still that which he intended. There is no doubt which statue is the greater work of art.

The whole of Florentine sculpture in the second quarter of the century is not comprised in the names of Cellini and Bandinelli; beside them there worked two less aspiring sculptors whose minds operated on a smaller scale, Tribolo and his pupil Pierino da Vinci. Tribolo had worked in Rome in his twenties on the tomb of Pope Adrian VI in Santa Maria dell'Anima (Fig. 61) in the legendary period before the Sack, was employed at Loreto after the death of Andrea Sansovino, and in 1546 was responsible for installing Michelangelo's sculptures in the Medici Chapel. These three commissions brought him into contact with all that was most fertile in the sculpture of his time. His stylistic convictions – and they must have been extremely strong – never found expression in a major statue (to judge from the account of his character given by Cellini, the inhibitions were psychological), but they inspired a number of distinguished garden sculptures, notably the fountains at Castello, and some small bronzes, and found consummate expression in the work of his pupil Pierino. The place of Pierino

da Vinci in the Florentine cinquecento is not unlike that of Desiderio da Settignano a century before: he was precocious (he first appears as a youth of fifteen executing independent carvings in Tribolo's shop), he was shortlived (the whole of his activity is comprised in the eight years between 1546 and 1554), and he was a hypersensitive marble sculptor. Pierino's sensuous apprehension of the possibilities of his material are apparent in the beautiful figure of a River God in the Louvre (Plate 63), which was carved for Luca Martini about 1548. The affinities of this enchantingly elegant work are not with Cellini or Bandinelli, but with Michelangelo, and though the tone is more intimate and the idiom more feminine, it is clear that the Apollo (Plate 22) was the source of inspiration of the group.

By the middle of the sixteenth century Bandinelli's Hercules and Cacus must have been widely recognised for what it was, a negation of all those principles which underlay Michelangelo's two-figure groups. In Rome in 1548 Pierino extended his knowledge of Michelangelo's sculptures, and when he returned to Tuscany he began work on a statue which had as its subject a theme associated with Michelangelo, was loosely based on Michelangelo's designs, and was an essay in Michelangelo's sculptural technique. These three points are stressed in Vasari's description of the group: 'Luca (Martini) next sent to Carrara for a marble block five braccia by three for Vinci to make two statues of five braccia on the subject of Samson slaying the Philistine with the jawbone of an ass, for which he had seen a design by Michelangelo. Before the marble arrived, Vinci busied himself by making models all different from each other. At length he settled on one, and when the block came, he set to work at once, imitating Michelangelo in gradually developing his idea from the block, without impairing it or making mistakes. He made the perforations with great facility.' This group (Plate 62) is now in the courtyard of the Palazzo Vecchio.

Unlike Bandinelli, Pierino da Vinci recognised the limits of his own capacity. He had no experience of carving a multi-facial action group fully in the round. The Samson is therefore planned as an exceptionally deep relief; it presents a single view to the spectator, and from this alone can it be read. The ultimate source of the design is Michelangelo's model for the Hercules and Cacus (Fig. 34), but divested of those features which lend it an effect of circularity. The pose of the Philistine follows the Cacus, but the left arm is hidden and the right leg and thigh are aligned on the front plane of the base, while the Samson is posed frontally, with his left knee on his opponent's neck and his head in profile to the right. Despite these changes the two figures retain much of their pristine force. The forms are tactile and three-dimensional, the idiom is broadly naturalistic, and there is a splendid intimation of movement in the tense torso of the standing nude. More important still, the head of Samson is treated with a gravity and earnestness which is at the opposite pole of creative endeavour to the grimacing automata of Bandinelli. Pierino da Vinci's Samson and a Philistine inaugurates a long series of two-figure action groups. When the Perugian sculptor Vincenzo Danti determined, about 1561, to prove himself in marble sculpture, his subject was Honour triumphant over Falsehood (Plate 77); Ammanati included a Victory (Plate 73) in one of

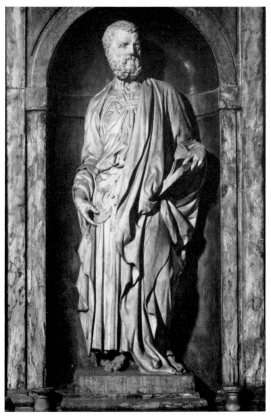

Fig. 41. Bandinelli: ST. PETER. Duomo, Florence.

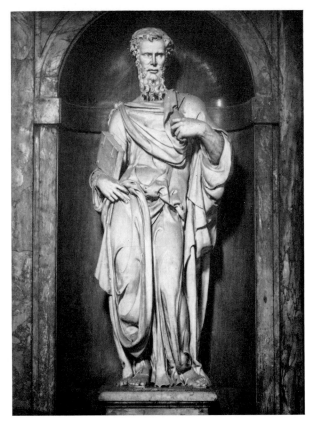

Fig. 42. Ferrucci: ST. ANDREW. Duomo, Florence.

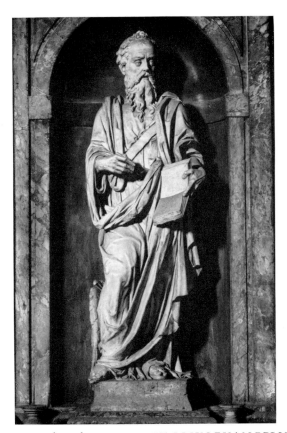

Fig. 43. Benedetto da Rovezzano: ST. JOHN EVANGELIST.
Duomo, Florence.

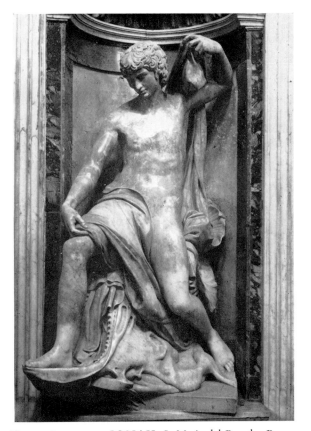

Fig. 44. Lorenzetto: JONAH. S. Maria del Popolo, Rome.

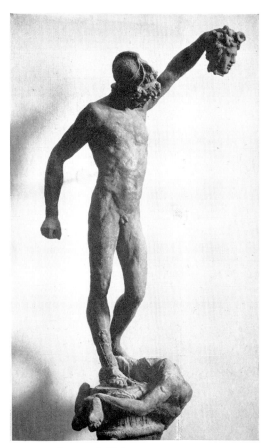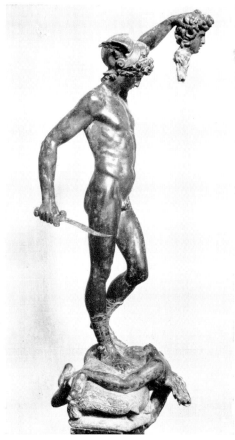

Fig. 45. Cellini: WAX MODEL FOR THE PERSEUS. Museo Nazionale, Florence.
Fig. 46. Cellini: BRONZE MODEL FOR THE PERSEUS. Museo Nazionale, Florence.

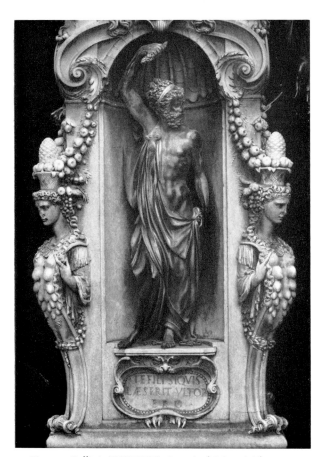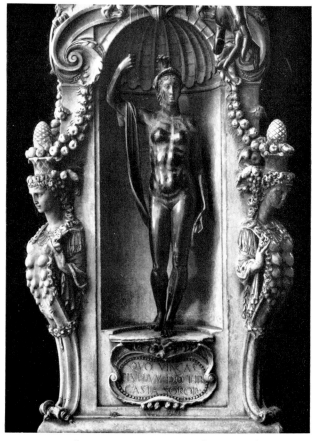

Fig. 47. Cellini: JUPITER. Loggia dei Lanzi, Florence. Fig. 48. Cellini: ATHENA. Loggia dei Lanzi, Florence.

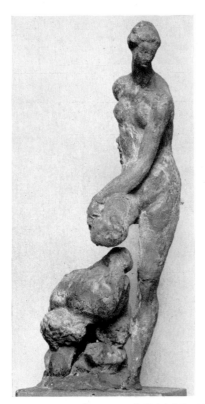

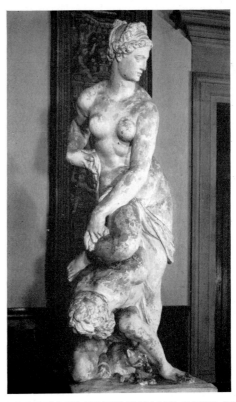

Fig. 49. Giovanni Bologna: WAX MODEL FOR FLORENCE TRIUMPHANT OVER PISA.
Victoria & Albert Museum, London.

Fig. 50 Giovanni Bologna: GESSO MODEL FOR FLORENCE TRIUMPHANT OVER PISA. Accademia, Florence.

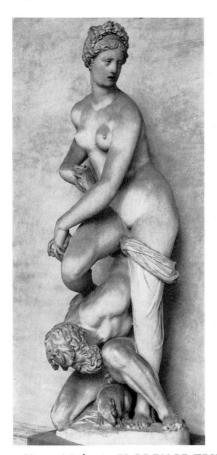

Fig. 51. Giovanni Bologna: FLORENCE TRIUMPHANT OVER PISA. Museo Nazionale, Florence.
Fig. 52. Giovanni Bologna: BACCHUS. Borgo San Jacopo, Florence.

Fig. 54. Giovanni Bologna:
WAX MODEL FOR THE RAPE OF THE SABINES.
Victoria & Albert Museum, London.

Fig. 53. Giovanni Bologna:
WAX MODEL FOR THE RAPE OF THE SABINES.
Victoria & Albert Museum, London.

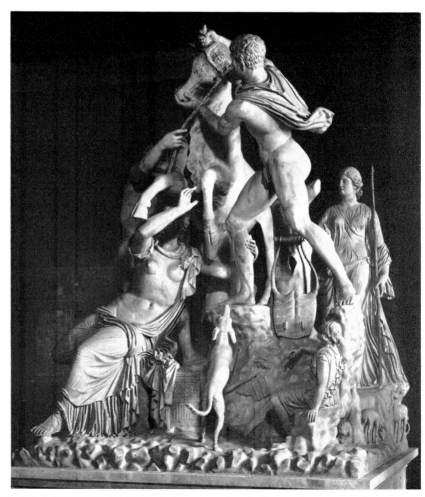

Fig. 55. Giovanni Bologna: THE RAPE OF A SABINE WOMAN. Museo Nazionale di Capodimonte, Naples.
Fig. 56. Hellenistic, second century B.C.: THE FARNESE BULL. Museo Nazionale, Naples.

his first works in Florence, the Nari monument in the Annunziata; and facility in handling the two-figure action group set the seal on the Florentine reputation of Giovanni Bologna. A climax was reached in 1564, when, at the obsequies of Michelangelo, the catafalque was surrounded by four two-figure groups.

In 1554, when the Perseus was set in place, it appeared to Cellini that he was destined to cast or carve a long series of major works. The death of Pierino in this year must have fortified him in that view. But never again did he receive an official commission for a major work of sculpture. One reason no doubt was his egotism and conceit, and another was that in the middle of the fifteen-fifties the climate of Florentine sculpture became more competitive. In 1555, after the death of Pope Julius III, Ammanati moved from Rome to Florence. His reputation had been made in Padua, and in Rome he had collaborated with Vasari on the splendid Del Monte monuments in San Pietro in Montorio. Two years later there arrived Vincenzo Danti, who had established himself by the forceful statue of Pope Julius III outside the Cathedral at Perugia, and in about 1560 he was followed by Vincenzo de' Rossi, who had completed the Cesi Chapel in Santa Maria della Pace. The style of Vincenzo de' Rossi was a projection of Bandinelli's; he was a coarse, ungainly sculptor who, in a series of large-scale statues of the Labours of Hercules executed after 1568 for the Palazzo Vecchio (Fig. 59), attempted vainly to reconcile a zest for violent action with a perverted brand of formal ingenuity. The importance of Ammanati, a more considerable artist, lies in his contribution to the tomb and fountain rather than to the statue. Vincenzo Danti, on the other hand, applied himself to the problems of the statue with the same seriousness as Pierino, and from a standpoint that was not entirely dissimilar, since his main article of faith was belief in Michelangelo.

The postulate that Michelangelo, as sculptor, painter and architect, surpassed all modern and perhaps all ancient artists forms the opening premise of the *Trattato delle perfette proporzioni*, which Danti published in 1567. But his devotion to Michelangelo was diluted by tendencies that were essentially unMichelangelesque. The proof of this is the group of Honour triumphant over Falsehood in the Museo Nazionale (Plate 77). Its status is not altogether clear. Either it is a synthesis of two separate works by Michelangelo, the Victory and the model for the Hercules and Cacus, or (and this explanation is more probable) it depends from a lost drawing or model by the master for a counterpart to the Victory intended for the Julius tomb. In favour of this second view is the fact that structurally the group is an inversion of the Victory. Where Pierino da Vinci, in the Samson and a Philistine, proves himself familiar with Michelangelo's technique, Danti's handling of his material is crisp and dry; his forms are linear and lacking in plasticity. The sense of organic growth which Michelangelo imposed upon the Victory was far beyond his reach, and though his intentions, in the back and exposed arm of Falsehood, were broadly realistic, he did not possess the means of translating them from theory into fact. He apprehended form as outline, and the point of reference for his group is not Michelangelo's own works, but the linear schemata based on

Michelangelo which were incorporated by Bronzino in his frescoes in the Palazzo Vecchio.

In Florence, the future lay not with Vincenzo Danti, nor Ammanati, nor Vincenzo de' Rossi, but with a young Fleming, Giovanni Bologna. He had been born in Mons in 1529, was trained locally in the studio of an Italianising sculptor, Jacques Dubroeucq, and in the fifteen-fifties, like so many Flemish artists, went to Rome. He went there to study, not to practise as a sculptor, and worked assiduously for two years, 'copying all the celebrated figures in clay and wax'. About 1556 he packed his bags, and taking his small models with him left for home. Heading northwards, he arrived in Florence, and there, by some stroke of inspired good fortune, his work came to the notice of Bernardo Vecchietti. Vecchietti, a collector and connoisseur, was so much impressed with the young artist's models that he volunteered to support him while he continued his studies in Florence. In making this offer Vecchietti changed the course of art, for instead of returning to Flanders, Giovanni Bologna remained in Florence for just over half a century, became the greatest sculptor of his time, and coined a language that flowed outwards in space from Tuscany to Vienna and Paris and Madrid, and onwards in time from the sixteenth century to the end of the eighteenth.

There was nothing meteoric about his career. In Florence he established himself slowly, participating unsuccessfully in 1560 in the competition for the Fountain of Neptune in the Piazza della Signoria. Leone Leoni, who was in Florence at the time, implies in a letter that if Giovanni Bologna had had heavier backing he, not Ammanati, might have been victorious. His failure, however, was short-lived, and three years later opportunity knocked once more, bringing him the commission for the Fountain of Neptune at Bologna, in which his plans for the Florentine fountain could be put to use. The successful progress of work on the Bologna fountain was one factor that contributed to his career in Florence. The other was the deaths in 1560 of Bandinelli and in 1564 of Michelangelo. Bandinelli's death removed the main obstructive force in Florentine sculpture. But when this was followed by the death of Michel-angelo, joy was succeeded by remorse, for Florence was filled with works by Bandinelli, while in his native city so much by Michelangelo was might-have-been, and so little was fact. This reacted in a positive way on Giovanni Bologna. Years later, in 1581, an agent wrote to the Duke of Urbino, who had wished for some works by Giovanni Bologna, explaining what kind of artist he was. 'He is the best person one can imagine,' runs the letter, 'entirely unmercenary, as his poverty proves, and dedicated only to glory. His dearest ambition is to equal Michelangelo, and in the view of many connoisseurs, he has already done so, and may surpass him if he lives. This is the Grand-Duke's view.' The Grand-Duke in 1581 was Francesco de' Medici, and it was Francesco de' Medici who was responsible, in 1565, for awarding Giovanni Bologna the two commissions which set him on this path. They were for two-figure groups, one of them a pendant to the Victory and the other a recreation of the Samson and a Philistine.

After Michelangelo died, the Victory (Plate 21), which had been presented to Cosimo I, was installed by Vasari in the Palazzo Vecchio, and for the marriage festivities of Francesco

de' Medici in 1565 Giovanni Bologna was commissioned to make a companion group of Florence triumphant over Pisa. As a counterpart, it was to represent a female figure, and was to reverse the axis of the Victory. That is the point from which Giovanni Bologna took off, in the only wax sketch-model for the group that has survived (Fig. 49). The model is constructed with a strong vertical accent on the right side (corresponding with the vertical accent on the left side of the Victory), and opposite the crouching figure is broadened out so that the visual unit becomes a half-pyramid. The Victory, like all Michelangelo's sculptures, proclaims the integrity of the marble block, but in Giovanni Bologna's model that is denied. The two figures touch only at one point, and the whole scheme is punctuated by voids, between the left leg of the female figure and the captive, between her left arm and her body, and between the captive's head and thigh. This compositional technique is drawn from Hellenistic sculpture, and probably from one specific work, the Farnese Bull, which had been excavated in the Baths of Caracalla in 1546, not long before Giovanni Bologna arrived in Rome.

The next stage in the Florence triumphant over Pisa is represented by the full-scale gesso model (Fig. 50) which was shown in 1565 in the Palazzo Vecchio. Some of the changes introduced in this are practical – for reasons of stability the two figures coalesce more closely than before – but others are stylistic. The left leg of the captive is now wound round the left leg of the female figure, so that the pose of the captive from the front reads as a triangle, and the hard line down the right side of the woman, which had been imitated from the Victory, is replaced by sinuous curves. There was a delay in translating this model into a permanent medium, and only in 1570 was the marble carved. But in this final version (Fig. 51) further changes were made, and all the apertures from the first model were reintroduced.

When the gesso model was finished Giovanni Bologna began work on the Samson and a Philistine (Plate 82), which was virtually completed in 1567. It was based on the same model that had been available to Pierino da Vinci and to Vincenzo Danti, that for the Hercules and Cacus (Fig. 34), amplified by bronze reductions of the lost models for the Samson and two Philistines (Fig. 128). The stages by which Giovanni Bologna first combined and then adapted Michelangelo's designs must have run parallel to those in the Florence triumphant over Pisa, but in this case no model and no full-scale gesso is preserved. When the group was contrasted, as it must have been, with Danti's Honour triumphant over Falsehood, it would have seemed pre-eminent in three respects. The first was its design; it was planned fully in the round, and was indeed, outside the work of Michelangelo and Donatello, the first multi-facial two-figure action group. The second was its musculature, which had had no equal since the Medici Chapel, and which was combined with a continuity of movement that recalled that of the Victory itself. The third was its expressiveness. The solemn head of Samson is based on the Evening in the Medici Chapel, and the dramatic range of the conception extends to the cowering Philistine. As we look at Samson gazing reflectively downwards at his victim, and the Philistine, his frightened face turned upwards to his executioner, our

minds go back to the Judith and the Abraham and Isaac on the Campanile, where Dona-
tello had imposed on bronze and marble the same overpowering humanity.

Not for ten years did Giovanni Bologna again apply the whole of his technical and in-
tellectual resources to a marble group. In the interval he had matured, his self-confidence
had grown, his propensity towards experiment had sharpened, and the spectre of Michel-
angelo had receded imperceptibly into the past. The result was the Rape of the Sabines
(Plate 86), which occupied him from 1579 till 1583. In Raffaello Borghini's *Riposo*, published
in 1584, there is a famous account of how the group came to be made. Giovanni Bologna, we
learn, wished to prove that he could carve not only ordinary marble figures, but groups
comprising a number of figures in the most difficult poses that could be devised. So, solely
to show his skill, he carved a proud youth seizing a girl of great beauty from a weak old
man. When the group was almost finished, the Grand-Duke decided to install it in the Loggia
dei Lanzi, opposite Cellini's Perseus, in the place then occupied by Donatello's Judith. In
1583 no statue could be exhibited without a title, and Giovanni Bologna therefore sought
for an invention that could be attached to it. At first it was suggested that the subject should
be assimilated to the Perseus statue, but this reasoning was rejected, and the title the Rape of
the Sabines was chosen instead.

One writer describes this attitude as a *l'art pour l'art Standpunkt*, but the definition is
not a very happy one. The fact is not that the group has no subject, but that it represents the
highest common factor in a number of alternative scenes. Its meaning was from the first
self-evident; only its context was in doubt. Nowadays, in our modern art-historical writing,
we use the terms 'subject' and 'programme' as though they were interchangeable, but we
must distinguish between them here. Giovanni Bologna's was a reaction against the concept
of programme, and the reason for it was that he took the concept of subject so seriously. Like
the Samson and a Philistine, the new group posed an expressive problem; it involved three
figures participating in different and contrasting fashions in one event. The dual relationship
between the Samson and the Philistine was superseded by a triple relationship between the
zestful youth, the distraught girl, and the cowed old man from whom she has been borne
away. In 1579 there was nothing exceptional about large figure sculptures whose meaning
was clear but whose subjects were uncertain, but they were all of them antique. Giovanni
Bologna's intention was to add one more to the great narrative groups of Hellenistic art. In
the marble this is freely admitted; the head of the female figure seems to have been inspired
by a figure of the class of the Niobe in the Uffizi – the Niobe group was not discovered until
1583 and became available in casts in Florence only in 1588 – and the motif of the outstretched
arms is also classical, while the torsion of the body of the girl and the stance of the youth originate
in the Farnese Bull (Fig. 56), and the head of the old man looks back to the Laocoon (Fig. 16).

The sculptor's intention was not to equal but to surpass. In the repertory of classical art
as it was known to him there was no lifting group. There were figures of Hercules and
Antaeus, of the child Dionysus raised on a satyr's shoulder, and of Ganymede caught up by

the eagle, and there were groups which showed a standing figure supporting the inert weight of a second figure slumped in front of him. But even Pliny gave no account of any lifting group. The Rape of the Sabines, therefore, was an extension of the principles of Hellenistic sculpture. Technically, too, it was superior to the multi-figure groups Giovanni Bologna can have known. Pliny repeatedly refers to the technical prowess by which the great classical groups were carved from single blocks. *Ex eodem lapide*, he says of the Farnese Bull; *ex uno lapide*, he says of the Laocoon. But Giovanni Bologna was fully aware that neither group was carved from a single block. On a technical plane, therefore, the Rape of the Sabines represents an antique aspiration that was not realised in antiquity.

Our first reference to the group is in a letter from the sculptor to Ottavio Farnese in 1579, in which he alludes to a two-figure bronze group that can be interpreted as the Rape of Helen, or the Rape of Proserpine, or the Rape of a Sabine Woman, 'a subject chosen to give scope to artistic ability and skill.' This bronze (Fig. 55) is now in Naples, and a very curious work it is. The male figure stands with the right knee flexed and the left turned slightly outwards holding the female figure with both arms. What the bronze illustrates is the extreme difficulty of the subject which the sculptor set himself; it represents a Pas-de-Deux and not a Rape. If a group of the kind were to be carved in marble, the poses had clearly to be consolidated. The first stage in this process is shown in a small wax model (Fig. 54) for the torsos of the two main figures. In this the female figure is transferred from the right side of the male figure to the left. Her weight rests on his left shoulder and left arm, and she is held in place by his right arm, which crosses her body horizontally with the hand on her left hip. This scheme was rejected probably because it was too flat; from the front both figures were seen frontally, and they appeared in profile from the sides. Moreover, it had a second disadvantage, that the heads were in two separate planes, so that the male figure was represented looking backwards across his shoulder at the head of the woman above. In the second and later of the surviving models (Fig. 53) the youth and girl are represented with their bodies at right angles to one another, with the third figure threaded through beneath, and through a number of in themselves trivial devices a spiral movement is introduced into the group, while the interconnection of the heads is made simpler and less strained. As with the Florence triumphant over Pisa, so here the next phase is a full-scale gesso model from which the marble was carved.

Like the Samson and a Philistine, the Rape of the Sabines has a rectangular base. But where the Samson presents a number of merging views, and has a clearly defined back and front, the Rape of the Sabines is serpentine. It has no preponderant view, and is indeed the first multi-figure group in European sculpture that was so planned. In that respect its neo-Hellenism differs from the neo-Hellenism of the young Bernini, who adhered, as Giovanni Bologna in one later work appears to do, to the classical principle of a dominant view. But to one aspect of Hellenistic sculpture Bernini was alive and Giovanni Bologna seems to have been blind, and that was the wealth of its illusionistic technique. The right hand of the youth

in the Rape of the Sabines presses into the soft flesh of the thigh with the same physical in-
sistence as does the right hand of Bernini's Pluto into that of Proserpine, but the texture of
the two bodies is not differentiated. The cause of this is not that Giovanni Bologna rejected
the factor of illusionism in Hellenistic art, but that he entered this Hellenistic phase with a
technique that was already formed.

Giovanni Bologna produced one other major marble sculpture, the Hercules and the
Centaur in the Loggia dei Lanzi (Plate 91). The subject filled his mind for nearly a quarter of
a century. It is first mentioned in 1576 when he made a silver cast. In 1587 he struck a medal
which had the subject of Hercules and the Centaur on its reverse, and seven years later, in
1594, he set to work on the marble group, which occupied him for five years. The genesis
of the Hercules and the Centaur, therefore, spans the whole of the period in which the vital
change in Giovanni Bologna's style recorded in the Rape of the Sabines took place. His point
of departure was the Hercules and the Centaur by Vincenzo de' Rossi (Fig. 59), which was
finished in 1568. In this the Centaur is shown with one flank on the ground. The only wax
model of the subject by Giovanni Bologna that survives also shows the Centaur in this way.
Predictably, however, the design is a much tighter one; the action of Hercules is reversed
and the body of the Centaur is twisted back. By 1587 this scheme had been revised, and on
the medal the Centaur is shown standing with its weight transferred from the hind quarters
to the front legs.

From time to time Giovanni Bologna was involved in the restoration of antiques, and in
one undated letter he refers to the projected reconstruction of a 'Centauro detto Cilla in
Roma'. Ferdinando de' Medici, too, owned a fragmentary Hercules and the Centaur, which
was completed by Giovanni Caccini in 1595. One or other of these figures may have inspired
the marble group. The Hercules and the Centaur is a less spectacular work than the Rape of
the Sabines, but it is the artist's masterpiece. The physical stresses are treated with great
freedom, and a splendid intimation of movement is conveyed by the Centaur's wildly curling
tail and powerful rear legs. To compare its bursting forms with the tight pyramid of the
Samson of thirty years before is to recognise that Giovanni Bologna, the alien in Florence,
had single-handed brought about a revolution which would decide the future of Italian art.

THE HIGH RENAISSANCE TOMB

WHILE Michelangelo was planning the tomb of Pope Julius II, there died in Rome an old
rival of the Pope, Cardinal Ascanio Sforza. A brother of Lodovico il Moro, Sforza had been
taken prisoner by the French and the Venetians in 1500, and was permitted to return to
Rome only after Giuliano della Rovere's election to the papacy. In the last months of his life
he and the new Pope were reconciled, and when he died in the early summer of 1505 the
building of his tomb was undertaken by the Pope. According to the epitaph at the bottom
of the monument, the Pope's motive was magnanimity born of respect for Sforza's conduct

in adversity. But he had an aesthetic motive as well, for the choir of Santa Maria del Popolo, for which the tomb was destined, was in course of reconstruction by Bramante. Standing behind the high altar against the left wall, Ascanio Sforza's tomb (Fig. 57) was one of the main features of a decorative scheme that included frescoes by Pinturricchio and windows by Guillaume de Marcillat. For the wall opposite the Pope commissioned a companion monument (Fig. 58) to Cardinal Girolamo Basso della Rovere, a son of the sister of Pope Sixtus IV and a cousin of Julius II, who died two years after Sforza, in 1507. Since the tombs are fully integrated in the choir, we might guess that they were due to the same architect, and there is some reason for supposing that they were indeed planned by Bramante. But the name that appears on them is that of the sculptor by whom they were carved, Andrea Sansovino.

The architecture of the monuments is much more complex than that employed in any quattrocento tomb. In the centre is a high triumphal arch, at each side on a forward plane is a niche flanked by decorated columns, and beneath is a deep base with a recessed epitaph. The effigy is represented sleeping, with the head supported on the arm (a motif that is reproduced in countless later cinquecento tombs), in the niches are statuettes of Virtues, and above are figures of Faith and Hope seated between candelabra, while at the top on an elaborate volute is God the Father in benediction flanked by two acolytes. The acolytes are the only features explicitly related to Sansovino's earlier work in Florence; they appear in the Corbinelli altar in Santo Spirito (Fig. 82), on which he must have been engaged before he carved the Baptism of Christ. Elsewhere the tombs offer irrefutable proof of the speed and the success with which Sansovino assumed the modes of thinking current in his new environment. In Rome a tradition of classicising carving had been established by the Lombard Andrea Bregno, and it is Bregno's idiom, not that of the Corbinelli altar, that Sansovino employs in the decorative portions of the tombs. In Rome, too, the niche figures on sepulchral monuments habitually assumed a strongly classicising form; Isaia da Pisa's Temperance on the Chiaves monument in St. John Lateran (Vol. II Fig. 108), is, for example, shown with bared breasts and with her lower limbs swathed in diaphanous drapery. In Andrea Sansovino's Temperance on the Basso monument (Plate 44) the same style is employed, and though the treatment of the pose is subtler and the handling of the drapery is more sophisticated, it is possible that a common model lies behind both statuettes. But the language of Sansovino's Virtues is more consistent and more meaningful than that of earlier Roman sculptures. For the seated Hope of the Sforza monument (Plate 45) there is a parallel in a beautiful preparatory study by Raphael for the Poetry on the ceiling of the Stanza della Segnatura, and the values implicit in the Stanze are implicit also in Sansovino's tombs.

Precisely because they are so unemphatic and so undemonstrative, the Sforza and the Basso tombs are easy works to underrate. But their sovereign merits emerge clearly enough if we compare them with the monuments produced in Rome in the third decade of the century. One of these, the tomb planned by the architect Peruzzi for Pope Adrian VI in

Santa Maria dell'Anima (Fig. 61), also includes statuettes of Virtues and a reclining figure of the Pope on a sarcophagus, but the statuettes are heavy and pedantic, and the effigy is clumsy and inelegant. Another, Jacopo Sansovino's Sant'Angelo monument in San Marcello (Fig. 62), is a more distinguished work, but here the delicate balance between the architecture and the figure sculpture is disrupted, and the Virtues are replaced by St. Peter and St. Paul gazing ferociously across the tomb. Raphael, on the other hand, planning the tomb of Agostino Chigi for Santa Maria del Popolo, designed it as an architectural unit, and made provision only for reliefs.

In Naples there was no Bramante to set the High Renaissance tomb upon its course, and the first important sixteenth-century sepulchral monument owes its appeal solely to its imagery. This is the tomb of the poet Sannazaro in Santa Maria del Parto (Fig. 63), which was carved at Pisa and Carrara in or soon after 1536 by a Florentine, Montorsoli, assisted by a younger artist, Ammanati. The church derived its title from Sannazaro's poem, *De Partu Virginis*, and on the tomb is the inscription:

DA SACRO CINERI FLORES. HIC ILLE MARONI
SINCERUS MUSA PROXIMUS UT TUMULO.

As the reference to Virgil's tomb might lead us to expect, the subject matter is classical. At the sides, under the sarcophagus, are seated figures of Apollo and Minerva, in the centre is a mythological relief with Pan, Marsyas, Euterpe, Neptune and Amphitrite, and at the top is the laureated bust of Sannazaro between two putti balanced on the lid of the sarcophagus. This programme is one to which the Jacopo Sansovino of the Bartolini Bacchus could alone have brought a concomitant of visual poetry; Montorsoli, for all his vigour, was an earth-bound artist, and Ammanati, destined to become one of the most distinguished sculptors of his time, was still hesitant and immature. Both artists worked under the spell of Michel-angelo, whose statue of Giuliano de' Medici was adopted by Ammanati as the basis of the Apollo on the tomb. Montorsoli's two genii on the sarcophagus, each with its outer arm thrown expansively across the body, also stem from Michelangelo. The bust was worked up by Montorsoli from a cast of the poet's face and skull.

In 1524, in a celebrated letter written to Marcantonio Michiel in Venice, the humanist Summonte names the artists working in Naples, and among them a young sculptor Giovanni da Nola, from whom Sannazaro had commissioned a wooden Nativity group for Santa Maria del Parto. The influence of this humanist circle on Giovanni da Nola was reflected in the classicising effigy of Antonia Gaudino of 1530 in Santa Chiara and in a lost group of Medea slaying her Children. Talented and sensitive, his object was to charm not to exalt, but from first to last his work, like that of his contemporary and disciple Girolamo Santacroce (Plate 53), is saved from facility by a vein of classicism still evident in the latest of his tombs, the cenotaph of Don Pedro da Toledo in San Giacomo degli Spagnuoli (Fig. 64, Plate 52). By Roman standards the cenotaph is strikingly unorthodox. It consists of a square platform, with the figures of the Viceroy and his wife at the front corners kneeling in prayer. On the

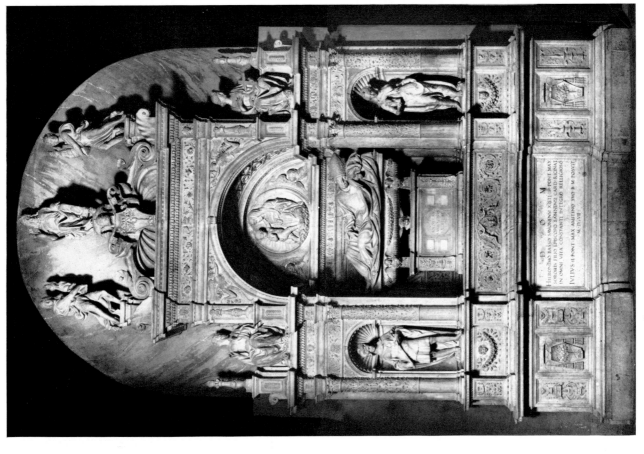

Fig. 58. Andrea Sansovino: THE BASSO MONUMENT.
S. Maria del Popolo, Rome.

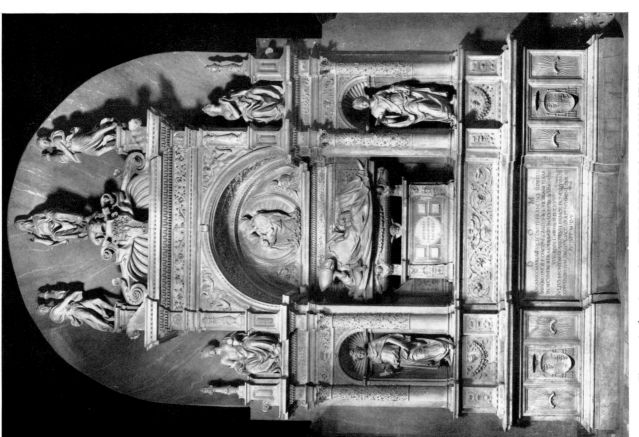

Fig. 57. Andrea Sansovino: THE SFORZA MONUMENT.
S. Maria del Popolo, Rome.

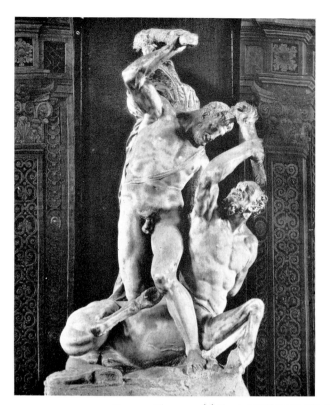

Fig. 59. Vincenzo de' Rossi: HERCULES AND THE CENTAUR. Palazzo Vecchio,. Florence.

Fig. 60. Giovanni Bandini and Pietro Tacca: MONUMENT OF FERDINAND I. Piazza della Darsena, Leghorn.

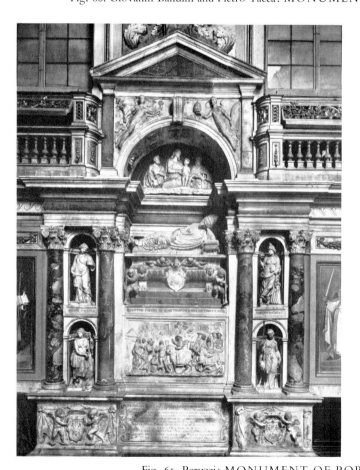

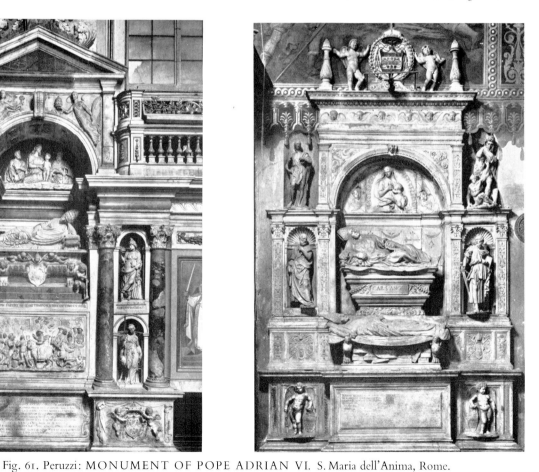

Fig. 61. Peruzzi: MONUMENT OF POPE ADRIAN VI. S. Maria dell'Anima, Rome.

Fig. 62. Jacopo Sansovino: MONUMENT OF THE CARDINAL OF SANT' ANGELO. S. Marcello, Rome.

faces of the platform are the epitaph and three scenes from the Viceroy's life, and beneath is a second platform at the corners of which are projecting consoles with four statues of Virtues. Vasari tells us that the tomb was to be despatched to Spain (like an earlier monument by Giovanni da Nola, which is at Bellpuig), and though there is some doubt whether this is correct – it was erected in Naples only in 1570 by Don Garzia da Toledo – there can be no doubt that Spain is its source of inspiration. Through the first quarter of the sixteenth century Spanish sculptors were at work in Naples, and the most important work they left behind them, the altar by Ordoñez in the Caracciolo di Vico chapel in San Giovanni a Carbonara, is a Spanish variation on a conventional Italian form. The tomb of Don Pedro da Toledo is the opposite, a Spanish form filtered through the mind of a cultivated local artist.

In the early stages of work on the Medici Chapel in Florence, Cardinal Giulio de' Medici expressed the wish to be buried there, and after he was elected Pope, a plan was considered for erecting his tomb and that of Pope Leo X either in the Chapel itself or in a room adjacent to the Old Sacristy of San Lorenzo. As late as September 1526 Michelangelo was urged to speed up his work in the Chapel, so as to leave himself free to execute the papal tombs. But in the last years of his life the Pope's principal concern was to ensure the completion of the Chapel, and he was compelled to look elsewhere for an artist for the papal monuments. To judge from a surviving drawing, Andrea Sansovino was a candidate for the commission, and before the Pope's death in 1534 Bandinelli also made models for the monuments. Michelangelo's drawings for the tombs were, however, in existence, and when the Pope died, it was decided by Cardinal Ippolito de' Medici that they should be realised in Santa Maria sopra Minerva in Rome by an Emilian sculptor, Alfonso Lombardi. Basing himself on the drawings, Lombardi prepared a wax model and would have carried out the monument, had the Cardinal not died and the commission been transferred, through the good offices of Donna Lucrezia Salviati, the sister of Pope Leo X, to Bandinelli. According to Vasari, Bandinelli obtained the commission through intrigue. Bandinelli's own account, in his *Memoriale*, is rather different. Pope Clement VII, he tells us, used to say that if the sculptor outlived him, he must prepare his tomb, and knowing this the Pope's executors gave him a free hand in the planning of the monument. At a late stage he received from Michelangelo a note containing his own proposals for the tombs, and these, he adds with the egotism that earned him the dislike of most of his contemporaries, 'were not far removed from mine'. The latitude that the Pope's executors allowed to Bandinelli amounted to considerably less than a free hand, for they mistrusted, as well they might, his capacity as a designer, and solicited from Antonio da Sangallo a plan for the architecture of the tombs. Cast in the conventional form of a triumphal arch, each shows in the centre a seated statue of the Pope and in the lateral niches two standing Saints (Fig. 65). In the attic are three large reliefs, one in the centre with a scene from the Pope's life, and two at the sides with scenes from the lives of the Saints standing in the niches underneath. Vasari complained that this iconography was profane and sycophantic, because the statues of the Popes were displayed more prominently than the

statues of the Saints, and because the scenes from the Popes' lives were double the width of
the religious scenes at either side. But in justice to Bandinelli it must be recognised, first that
a historical scene had been included in the tomb of Adrian VI in Santa Maria dell'Anima,
and second that Sangallo's scheme, with its wide central niche and its small niches at the
sides, was, from a sculptural standpoint, rather specially intractable. Probably the task of
devising a statue which would fill the central niche, and of carving reliefs which would be
legible in the top register of the two monuments, would have defeated a better sculptor than
Bandinelli, and in the event the only parts of the monuments that merit serious attention are
the four lateral Saints, in two of which he again makes use of the diagonal posture with which
he had experimented in the Hercules and Cacus a few years before. For contemporaries these
desiccated statues evidently had some interest, and one of them was reproduced by Vincenzo
de' Rossi on the façade of the Cesi Chapel in Santa Maria della Pace (Fig. 68).

On one other occasion Bandinelli was again involved with a sepulchral monument. The
tomb this time was his own, and it was set up in 1559 in a chapel in the Annunziata in
Florence, which was ceded to him by the Pazzi at the request of Eleanora of Toledo. Bandin-
elli's motives were seldom pure, and the initial impulse behind this work was jealousy, for in
1554 news reached him that Michelangelo in Rome had begun to carve a marble Pietà
intended for his monument. Bandinelli's son Clemente, before his death in 1555, started work
on a group of the Dead Christ supported by Nicodemus, apparently from a model by his
father, in which the head of Nicodemus was an ideal likeness of Bandinelli; and Bandinelli
determined to complete it as part of his own tomb. Despite its chequered origins, the group
(Plate 65), in the form in which it was erected on the altar of the Bandinelli Chapel, is a
moving work. As always with Bandinelli, the scheme is cerebral and self-conscious – the two
figures are cast in the form of a right-angled triangle, with the body of Christ supported by
the knee of Nicodemus and by a block placed providentially beneath the thigh – but the
conception is noble and serious, and the handling is exceptionally consistent and precise.

Bandinelli's group in turn impinged on the commemorative plans of Benvenuto Cellini.
In 1539 Cellini had been imprisoned in Rome in the Castel Sant'Angelo, and there, despair-
ing of human succour, he invoked the aid of God, praying that he might see the sun. The
prayer to which he had recourse is given in the *Vita*: 'Ah, very son of God, I pray thee by
thy birth, by thy death upon the Cross, and by thy glorious Resurrection, that thou wilt
deign to let me see the sun, if not otherwise, at least in dreams.' Early one morning Cellini's
prayer was granted. Bareheaded and dressed in a white shirt, he found himself walking be-
side an angel along a street illuminated by the sun, from which he climbed a stairway to a
point where the whole sphere of the sun, 'a bath of purest molten gold,' was visible. As he
watched, there emerged from the gold surface a crucified Christ, a Virgin and two angels,
and a priest, St. Peter, pleading Cellini's cause with Christ. Subsequently in the prison Cellini
was supplied with wax, modelling tools and paper, and with these he made a little wax
model of the Crucified Christ as the vision had revealed him. This model was still in his

possession years later, in 1555, when he was planning his own tomb in Santa Maria Novella, and in one of his many wills he asked that it should be preserved in a glass tabernacle in the church. The monument was to include two other features, one a marble Crucifix, and the other a marble relief showing the Virgin and Child enthroned, with on the left a little simulacrum of the Crucifix, below it a smiling angel, and on the right St. Peter interceding with Christ. The marble relief was to be surrounded with gold rays. So all of the elements of the tomb derived from Cellini's vision of sixteen years before.

The only part of the tomb to be completed was the Crucifix (Fig. 66, Plate 72). Originally Cellini intended that it should be carved from his model by a professional marble sculptor, and in a will of 1555 he made provision for this, but with the prudent reservation that the sons, pupils and kinsmen of Bandinelli should be ineligible for the task. Ultimately he decided to carve the Crucifix himself, and by 1562 he had completed both the white marble Christ and the black marble cross from which it hangs. At first the tomb was to be in Santa Maria Novella, and the Crucifix was to be placed in the right transept, as a counterpart to Brunelleschi's wooden Crucifix in the transept opposite. Later the plan for the monument was switched to the Annunziata (where, however, it was anticipated by Bandinelli's monument), and then in some mysterious fashion the tomb and Crucifix became detached from one another, and in 1559 the Crucifix was offered as a gift to Eleanora of Toledo. Had it been accepted, it might have been installed in the place for which it was stylistically most suitable, Bronzino's chapel in the Palazzo Vecchio. But unfortunately this proposal came to nothing, and it found a home at last in the Escorial. Though it is a personal testament, the Crucifix has the same meditated quality as the Perseus, and its relationship to the wax model of 1539 must in all essentials have been that of the Perseus to the first of the two models that are preserved. In the head Cellini for the first time successfully transfers to marble the full modelling, the rhythmical eyes and the loose, sensual mouth of the Medusa head in the Loggia dei Lanzi, and if the figure were shown, as he intended, without a loin-cloth, the long containing line would reveal it as what it is, the supreme achievement of Florentine mannerist sculpture.

In 1550 Giovan Maria del Monte was elected Pope as Julius III. Previously he had been legate in Bologna, where he was visited by the painter Vasari, and as he passed through Florence on his journey to the conclave, he and the artist met again. 'I am going to Rome,' said the Cardinal to Vasari, 'and I shall be elected Pope. As soon as you receive the news, come to Rome without awaiting any further summons.' Vasari did as he was bid, and on the day of his arrival hastened to kiss the new Pope's feet. He was not by any means unknown in Rome – under Pope Paul III he had carried out the sprawling frescoes in the Sala Paolina of the Palazzo della Cancelleria – but in the commission he received from Pope Julius III soon after his coronation he was employed in a new role, as architect and not as painter. The commission was for a commemorative chapel in San Pietro in Montorio to house the tombs of the Pope's uncle Cardinal Antonio del Monte and his great-uncle Fabiano del Monte. In the planning of the chapel Vasari's hands were tied, for the Pope's artistic mentor

was Michelangelo. At first Vasari proposed employing Simone Mosca, who had been responsible for the elaborate reliefs with classicistic ornament on the façade and in the interior of the Cesi Chapel in Santa Maria della Pace (Fig. 68). His plan was submitted by the Pope to Michelangelo, who observed that decorative carvings, though they might enrich the surface, would confuse the figures. 'Figures,' announced Michelangelo, 'do not like reliefs round them.' The plan for employing Simone Mosca in the chapel, and the ornate classicistic decoration which would have resulted, were therefore dropped. It was also intended by Vasari that the figure sculpture of the tombs should be entrusted to Raffaello da Montelupo, but this too was vetoed by Michelangelo, who preferred the work of a much younger artist, Bartolommeo Ammanati. This decision meant that the conception of the figure sculptures was also fundamentally revised. Finally, Michelangelo must have intervened in the architecture of the chapel, imposing on it the harmonious proportions that it retains to-day (Fig. 69).

Michelangelo also kept a watchful eye upon the figure sculptures. Visiting Ammanati in his studio not long after the sculptures were begun, he reported that 'he works with faith and love, and is a splendid boy, and so good-natured that he may be called Bartolommeo the angel.' The reputation of *l'angelo Bartolommeo* at this time rested mainly on a single work, the Benavides monument at Padua (1546), the only Tuscan tomb in the second quarter of the century outside the Medici chapel in which a serious attempt was made to weld sculpture and architecture into an aesthetic unity. The figure sculpture of the Benavides monument reflects, albeit obliquely, that of Sansovino. With the effigy of Antonio del Monte (Plate 75), however, Ammanati moves once more towards Michelangelo. In everything save the flattened legs and the forward movement of the head it depends from the Evening in the Medici Chapel, and we can well believe that when the model for it was prepared, Michelangelo was himself standing at Ammanati's side. In the same way the four pairs of putti on the balustrade are a recreation in three dimensions of the pairs of painted putti on the ceiling of the Sistine Chapel. The presence of Vasari is most clearly felt in the statues of Justice and Religion above the tombs. In the Sala Paolina the large frescoes are punctuated by allegorical figures in rectangular niches, and these formed the basis of the figures over the Del Monte monuments, though both the Justice, represented with her dress blown out by an imaginary gust of wind, and the Religion, wearing a cloak which hangs free of her body and is deeply undercut, are presented as lapidary statements cleansed of the looseness and the rhetoric that mar their painted counterparts.

A few years later Michelangelo's shadow again fell over the tomb. This was in 1560, when Pope Pius IV determined to erect a monument in Milan Cathedral to his brother, Gian Giacomo de' Medici, Marquess of Marignano (Fig. 70). With Michelangelo's approval, the contract was awarded to his friend and admirer, Leone Leoni, and according to Vasari Michelangelo himself prepared a drawing for the tomb. Architecturally it is a most distinguished work. A triple division of the lower register is effected by four variegated marble columns

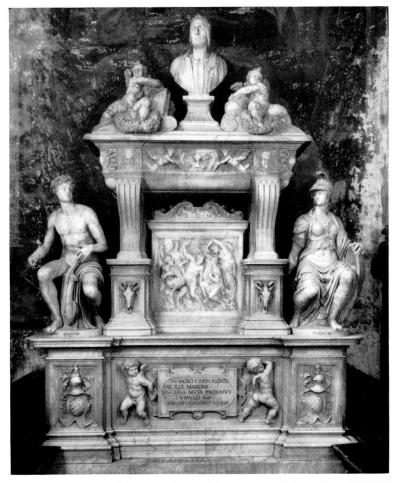

Fig. 63. Montorsoli and Ammanati: THE SANNAZARO MONUMENT.
S. Maria del Parto, Naples.

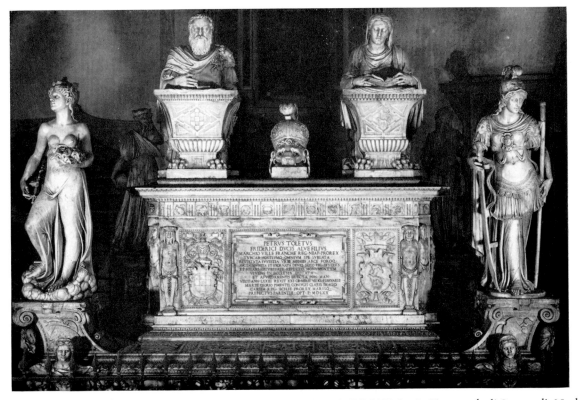

Fig. 64. Giovanni da Nola: MONUMENT OF DON PEDRO DA TOLEDO. S. Giacomo degli Spagnuoli, Naples.

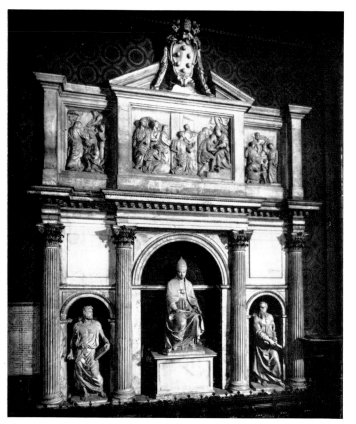

Fig. 65. Bandinelli: MONUMENT OF POPE LEO X.
S. Maria sopra Minerva, Rome.

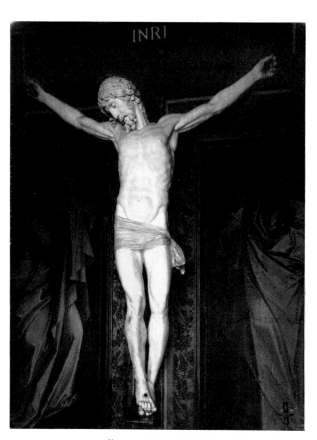

Fig. 66. Cellini: CRUCIFIX. Escorial.

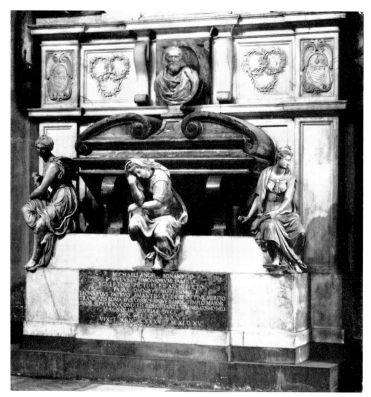

Fig. 67. Vasari: THE MICHELANGELO MONUMENT.
S. Croce, Florence.

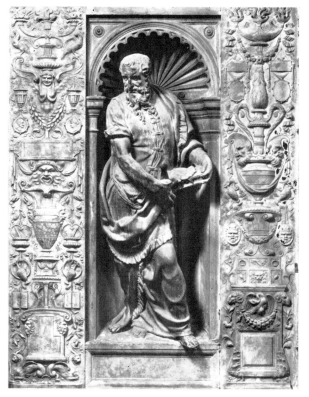

Fig. 68. Vincenzo de' Rossi: ST. PAUL.
S. Maria della Pace, Rome.

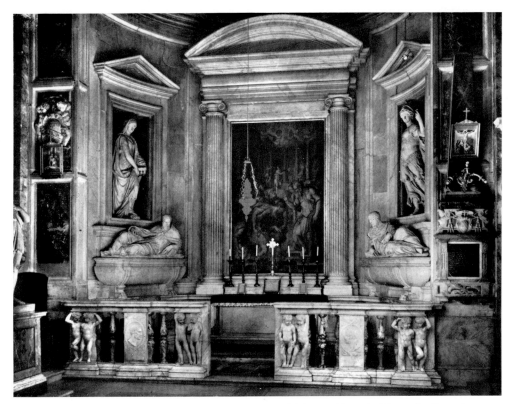

Fig. 69. Ammanati: THE DEL MONTE CHAPEL. S. Pietro in Montorio, Rome.

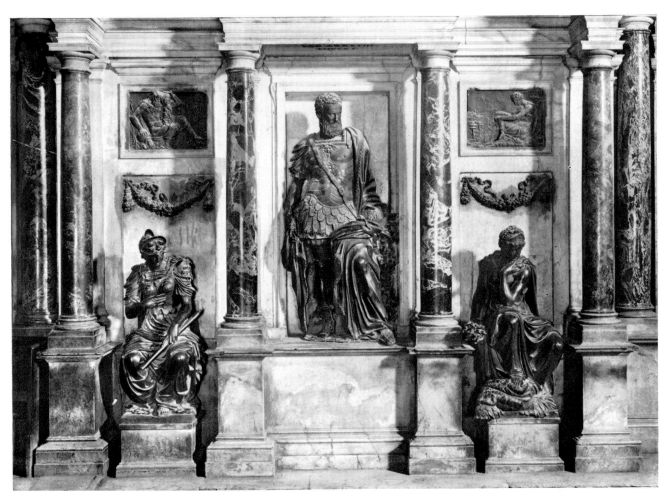

Fig. 70. Leone Leoni: THE MEDICI MONUMENT. Duomo, Milan.

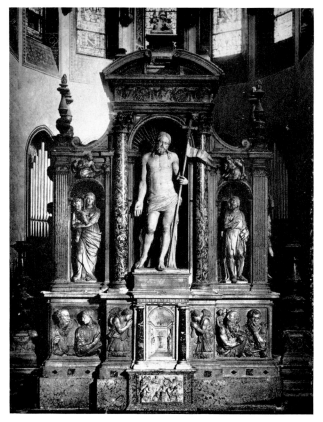

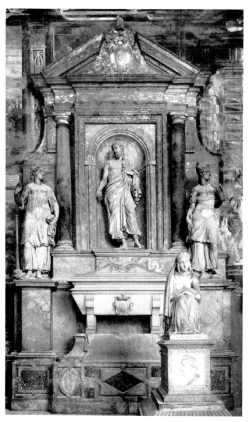

Fig. 71. Montorsoli: HIGH ALTAR. S. Maria dei Servi, Bologna.

Fig. 72. Ammanati: THE BUONCOMPAGNI
MONUMENT. Camposanto, Pisa.

Fig. 73. Giovanni Bologna: THE ALTAR OF LIBERTY.
Duomo, Lucca.

Fig. 74. Ammanati: THE BENAVIDES MONUMENT.
Eremitani, Padua.

which were sent from Rome for Leoni's use, and the intervening spaces are filled with a standing statue of Gian Giacomo de' Medici (Plate 103) and seated figures of Peace and Military Virtue gazing mournfully at the ground. The pyramidal disposition of the statues, the rectangular niche of the main figure, and the poetical concept of Virtues mourning a military leader, take us back to the world of the Medici Chapel. But Leoni was a modeller and a specialist in bronze casting, and the contrast in his monument between bronze statues, the white marble ground on which they are set, and the coloured marble columns, would have been condemned by Michelangelo as indefensibly pictorial.

None the less a truer understanding of Michelangelo's creative intentions is evinced by Leoni's monument in Milan than by the tomb which Vasari installed in Santa Croce in Florence after the sculptor's death in 1564 (Fig. 67). In 1563 the Grand-Duke Cosimo I had accepted a proposal, of which Vasari was the sponsor, for the creation of a Florentine Academy, and after Michelangelo died the Academy, as one of its first tasks, assumed responsibility for a commemorative service in San Lorenzo. The Academy was a restrictive body – its dogma sprang from prejudice, and its unifying bond was a determination to evade the challenge of a living art – and its official veneration of Michelangelo concealed a latent antagonism to the aesthetic values he exemplified. As we read the list of artists who prepared the decorations of the catafalque for this funeral festivity, it seems that no secondary sculptor was left unemployed. Once the ceremony was disposed of, there arose the problem of a permanent memorial. In Michelangelo's studio in Florence there were a number of rejected statues for the Julius tomb, among them the Victory and the four unfinished Slaves. The first suggestion, originating with Michelangelo's nephew Lionardo and his pupil Daniele da Volterra, was that these sculptures should be built into a monument. From the first Vasari was hostile to this plan – he was personally concerned with a project for installing the Victory in the Palazzo Vecchio – and Cosimo I, while ostensibly accepting it, made a counter-suggestion, that the damaged Deposition should instead be used for the purpose for which it was originally carved. The objection to this was that the Deposition was owned by Pierantonio Bandini, and that Bandini refused to part with it. None the less, Lionardo Buonarroti, in response to what was tantamount to a command, forewent the Victory and the Slaves, which were offered as a gift to Cosimo I, and there is no further mention of the use on the tomb of works by Michelangelo. At this point a new voice is heard, that of Vincenzo Borghini, the Prior of the Innocenti, one of the arbiters of taste in Florence, whose mistaken ingenuity doomed so many projects to sterility. Let Vasari design the tomb, was the gist of Borghini's advice, but in order to distribute the work fairly, let the sculptures be entrusted to young artists. Three names were mentioned, Battista Lorenzi, a pupil of Bandinelli, Giovanni Bandini, another Bandinelli pupil, and Battista, a pupil of Ammanati. This plan was adhered to, save that Ammanati refused to release his pupil and the third statue was accordingly commissioned from Valerio Cioli. Vasari's sarcophagus is an undistinguished travesty of the tomb-chests in the Medici Chapel, and in looking at the statues of Painting, Sculpture and

Architecture (Plate 67) seated below it, we must remember that abler and more experienced sculptors were, by the terms of the commission, automatically ruled out. None the less there is something ironical in the fact that Michelangelo, in his native town, should be commemorated in this mean and unimaginative manner by the spiritual heirs of Bandinelli.

The monument was finished in a healthier climate than that in which it was begun, for in 1578, in the very year in which Naldini painted the fresco of the Pietà that marked the completion of the tomb, Giovanni Bologna was at work on the first of his great religious commissions, the Altar of Liberty in Lucca Cathedral (Fig. 73), and three years later he started work on the shrine of Sant'Antonino in San Marco. In the lower register of the Altar of Liberty is a statue of the Risen Christ with figures of Saints Peter and Paulinus at the sides. This iconography is a product of the Counter-Reformation. In 1565 a Tuscan sculptor active in Venice, Danese Cattaneo, had completed for Sant'Anastasia at Verona an altar of the kind (Fig. 106), and two such works were known to Giovanni Bologna; one of them was in the Camposanto at Pisa, where in 1572 Ammanati was engaged upon the Buoncompagni monument (Fig. 72), which has a central niche housing a Risen Christ, and the other was the high altar of the Servi at Bologna (Fig. 71), which had been commissioned from Montorsoli in 1558. Montorsoli's Christ is a wretchedly stolid, inexpressive work, but it formed the point from which Giovanni Bologna took off. He was cogitating the Rape of the Sabines at the time, and his Christ (Plate 84) is shown in movement with head upturned and right arm raised. The pose has the same upward thrust as that of the youth in the large group, and the expression of momentary rapture in the features is handled in precisely the same way, while in the stance there is a marvellous illusion of lightness and incorporeality. This same lively imagination was brought to play on the Chapel of Sant'Antonino (Fig. 75). Round the walls are six niches with marble figures, all of them carved by Francavilla, two on the facing wall from models by Giovanni Bologna, above them are six bronze reliefs with scenes from the Saint's life, and over the altar are two bronze putti and an angel pointing with one arm towards heaven and extending the other towards the tomb (Plate 89). In 1580 Giovanni Bologna had cast the Medici Mercury which is now in the Bargello, and in the angel the principles that lie behind it are transferred to a religious theme. The Chapel as an active unit hinged on a sarcophagus beneath the altar, and this sarcophagus (which is now in the sacristy of the church) is the most inspired and most carefully planned feature of the shrine. It is in black marble and has a precedent in Flanders in a work Giovanni Bologna must have known, the De Croy monument of Jacques Dubroeucq at Saint-Omer. On top of it is a bronze effigy (Plate 92). Tranquil and compact, this flattened figure has no precedent in Florence in the sixteenth century, and when he designed it Giovanni Bologna may have had in mind an earlier Dominican bronze effigy, the Dati tomb-slab of Ghiberti.

The Chapel of Sant'Antonino is not a satisfactory whole, first because Giovanni Bologna was an indifferent architect, and second because provision was made for frescoes, and Florentine painting was at its lowest ebb. For this reason it is less effective than the Niccolini

Chapel in Santa Croce (Fig. 76), which was designed by Giovanni Antonio Dosio, and where there are no frescoes on the walls. The appeal of the Niccolini Chapel is exercised in part through its polychromy. In the centre of the lateral walls are tomb-chests with tabernacles over them, each containing a seated figure, on one side Aaron and on the other Moses (Plate 94). Two of the three Virtues beside them are signed by Francavilla, Giovanni Bologna's assistant on the Rape of the Sabines and the Altar of Liberty, and there is a presumption that Francavilla also carved the seated figures. The relation of the Moses to the Moses of Michelangelo is essentially the same as that of Giovanni Bologna's Samson and a Philistine to Michelangelo's projects for this group. The position of the knees has been reversed, and the head, turned over the right shoulder, is balanced by a book resting on the left thigh. While Francavilla's Moses lacks the solidity of Michelangelo's, it has a gravity and weight of meaning of which Michelangelo could not but have approved.

Before his death the Grand-Duke Cosimo I, obsessed with the consolidation of his dynasty, conceived a plan for building in San Lorenzo a third sacristy to house his own monument, and those of his wife, parents and descendants. A model for this was prepared by Vasari. Cosimo's successor, Francesco I, began to collect semi-precious stones – chalcedony, sardonyx, agate and jasper – for the adornment of the Chapel, but when he died in 1587 the sacristy had still not been begun. With the accession of Ferdinand I, however, a start was made, and plans were drawn up by Buontalenti, Giorgio Vasari il Giovane and the Grand-Duke's brother, Don Giovanni de' Medici. Buontalenti's scheme must have been much superior to the other two, but Don Giovanni de' Medici's was preferred. This was not due solely to sentiment – though the idea of a Medici mausoleum planned by a Medici was an inherently appealing one – but to the fact that Buontalenti's scheme divided the area of the sacristy into separate chapels, whereas in Don Giovanni de' Medici's all the tombs could be seen simultaneously (Fig. 77). The ground-plan was based on that of the Baptistry in Florence, but the preconceptions in the light of which it was revised were those which had been sketched out by Vignola in the church of the Gesù in Rome twenty years before.

As grand-ducal sculptor, Giovanni Bologna was naturally involved in the project for the tombs. Initially the effigies were thought of as marble statues ten feet high, with, in the case of the tomb of Ferdinand I, two huge allegorical supporting figures. But the commissioning of tombs would have been premature if the building to house them had not been started, and only in 1604 was the erection of the chapel, 'superior in price to the golden house of Nero and to the palace of King Cyrus', actually begun. In 1613 the semi-precious stones, which had been carefully amassed over more than thirty years, were set into the walls, and in 1626 Giovanni Bologna's successor as grand-ducal sculptor, Pietro Tacca, was commissioned to prepare two gesso models of the Grand-Dukes Ferdinand I and Cosimo II. In the quarter of a century that had elapsed since Giovanni Bologna was involved in the scheme, the figures had grown – they were now roughly fifteen feet high – but it was still intended that they should be carved not cast. According to Baldinucci, the change of medium from marble to bronze was

effected at Tacca's insistence, but it may also have been influenced by the news which filtered through to Florence of the most splendid commemorative project of the kind, the great bronze statues of the Emperor Charles V and Philip II of Spain with their families by Pompeo Leoni in the Escorial (Plate 107). A pupil of Giovanni Bologna, Tacca reacted against his master's style, preferring bronze to marble because of the greater liberty that it allowed him. His stylistic sympathies can be judged from one of his earliest independent works, the monument of the Grand-Duke Ferdinand I at Leghorn (Fig. 60), of which the statue was carved in 1599 by Giovanni Bandini and the bronze Slaves (Plate 96) round the base were added by Tacca in the sixteen-twenties. Bandini's statue is a typical product of its time, tight and self-contained, but the Slaves (which to this day remain Tacca's most popular works) are set freely round the plinth, so that they pull away from the corners of the monument. Tacca was an emotional artist, and the bulging bodies of the Slaves are modelled with strong dramatic sense. The strain of journalism in his temperament caused him difficulty in the Cappella dei Principi, where he was criticised not, as we might assume, for the caricature head of the Grand-Duke Cosimo II – one of the most unflattering portraits that has ever been inserted in a com- memorative sculpture – but for the statue of Ferdinand I. Buontalenti's intention was to place the statues on brackets, so that to one observer they looked as though they were walking in a garden, and Tacca, moving in the same direction, originally proposed to show the Grand- Duke Ferdinand I in contemporary costume with one thigh exposed, like a St. Roch. But this defect was quickly remedied, and instead the Grand-Duke was presented in a likeness (Plate 97) that appeared, by seventeenth-century standards of decorum, to be more dignified. Nowadays the Cappella dei Principi is regarded merely as a means of access to the Medici Chapel, but if we make the imaginative effort of isolating Tacca's tombs from their lugu- brious setting, and of seeing them as they were when they were new, with light refracted from their gilded surfaces and with the crowns in the centre of the gilded cushions on the tomb- chests studded with precious stones, we shall find no difficulty in accepting them as the first great Florentine baroque monuments.

THE HIGH RENAISSANCE RELIEF

THE story of the High Renaissance relief is governed by the fact that no mature relief was carved by Michelangelo. Both the Julius monument and the façade of San Lorenzo were to include narrative scenes, but none of them was sketched out, and the only thoughts that he committed to relief were contained in the Battle of the Centaurs and the Madonna of the Steps, preserved in his studio and therefore inaccessible, and the Pitti and Taddei tondi, which, as their names denote, remained in private hands. Had either of these last two works been finished, it would have inspired many secondary reliefs, but because they were unfinished, they were almost without influence. The word 'almost' is made necessary by a single work, a circular marble relief carved by Rustici, now in the Bargello (Fig. 8). It is not

Fig. 75. Giovanni Bologna: THE SALVIATI CHAPEL. S. Marco, Florence.

Fig. 76. Dosio: THE NICCOLINI CHAPEL. S. Croce, Florence.

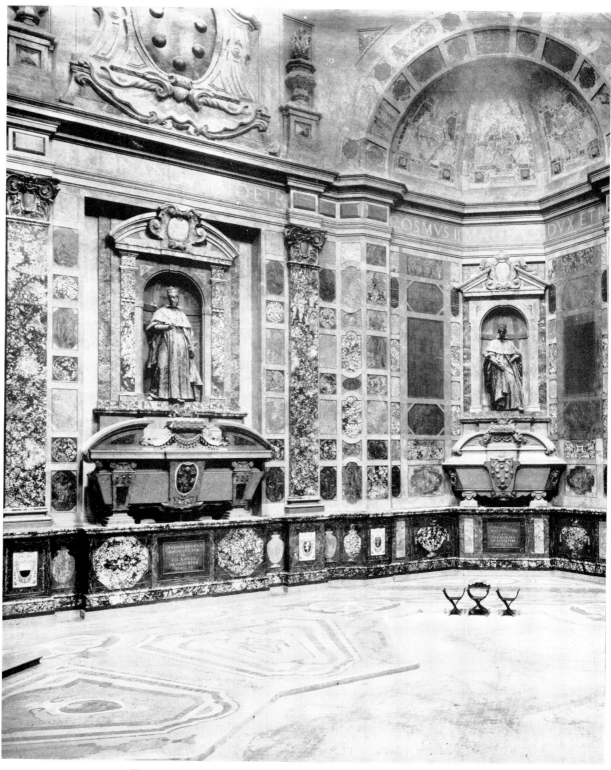

Fig. 77. THE CAPPELLA DEI PRINCIPI. S. Lorenzo, Florence.

a relief of great distinction – Rustici was a modeller rather than a carver, and his grasp of form in marble sculpture was insecure – but it shows that he was fascinated (as we might expect other sculptors to have been) by the organisation of the Taddei tondo and by Michelangelo's approach to the circular relief. Rustici's Virgin, like Michelangelo's, is seated with her forward leg outstretched across a segment at the base of the relief. The beautiful movement of the Taddei Child he does not attempt to emulate, but at the left a genuflecting figure of the Baptist on a rear plane proves that the spatial lesson of Michelangelo's design has been partly understood.

Where we might suppose that the two tondi would be reflected is in the circular Madonnas built into wall monuments. On Andrea Sansovino, however, they had not the smallest influence, and since he left Florence in 1505 it is even doubtful whether he had studied them. The lunette of his Sforza monument in Santa Maria del Popolo includes a Virgin in three-quarter length in profile to the left holding the Child in benediction in her arms (Fig. 57). The figure is carved in exceptionally deep relief, and is conceived illusionistically, with the head protruding from the frame and the moulding at the base hidden by cloud, but its style is fundamentally traditional. In his Basso monument in the same church (Fig. 58) the composition is more ambitious; the Virgin is relatively flatly carved, while the Child, in great depth, strides forward through the sky. Possibly this is the earliest surviving work by Jacopo Sansovino. Certainly the Madonna of the Basso monument marks an intervening stage between Andrea's tondo on the Sforza tomb and the lunette carved by Jacopo fifteen years later for the Sant' Angelo monument in San Marcello (Fig. 62), where the containing circle is dispensed with, and the Virgin is depicted frontally in a mandorla of cloud. In the years between Raphael had painted all of his mature Madonnas, and this is reflected in San Marcello in a scheme based on the same principles as the Madonna di Foligno.

From the beginning relief played a greater part in the work of Andrea Sansovino than in that of any other sculptor of his time. One of his earliest works in Florence, the Corbinelli altar in Santo Spirito (Fig. 82), was planned primarily in relief; it included a lunette relief of the Coronation of the Virgin, two tondi of the Annunciation, a relief predella and an antependium relief with the Lamentation over the dead Christ. It was not exceptional in this, for reliefs also occur in the altarpieces which Andrea Ferrucci was carving in Florence at a rather earlier date. What distinguishes it is the thought that was devoted to each of its constituent scenes. Where, for example, the Annunciatory Angel and Virgin Annunciate in Ferrucci's altar at Fiesole are depicted as simple relief figures silhouetted against a dark ground, in the Corbinelli altar the reliefs are planned spatially. The two figures are depicted in front of a perspective of receding columns, and the angle of vision is so adventurous, and the space illusion so complete, that the reliefs make the effect of two holes punched in the altarpiece.

In Rome Sansovino became involved in the greatest relief commission of the High Renaissance, the casing of the Holy House in the basilica at Loreto (Fig. 78). Designed by Bramante, probably in 1510, the casing is an oblong structure with two long sides and two narrow ends.

Each end is flanked by superposed niches between heavy columns, and is filled with wide narrative reliefs, while each of the long sides is punctuated by three superposed niches, with doorways in the intervening wall surfaces, above each of which is a relief. The sculpture of the Holy House comprises in all twenty figures in niches and nine exceptionally large reliefs. The form of the niches resembles those on the Sforza and Basso tombs, and Bramante must have intended that they should be filled with classicising statuettes like the Virtues on Andrea Sansovino's monuments. None of them was executed, and the seated and standing figures in the niches were carved in the fifteen-forties in an altogether different style. Projecting from their niches, they disturb the harmony of the whole scheme. The reliefs, on the other hand, seem to have been begun before Bramante's death (1514), and are conceived in a single style. Bramante's original intention was that the sculptures should be entrusted to Gian Cristoforo Romano, who had experience of a comparable commission in the Visconti monument in the Certosa at Pavia. This was agreed to in 1511, after Julius II had paid a visit to Loreto to inspect the progress of work on the shrine and the new church. But a year later Gian Cristoforo Romano died, and in 1513 he was succeeded by Andrea Sansovino. Among artists the Loreto project was specially unpopular – 'quanto tiene il tempio, bestialissimo quanto si può dire,' declared Gian Cristoforo Romano. Bandinelli, who was responsible for one of the reliefs, rapidly abandoned Loreto for the comfort of Ancona, and Sansovino, in an effort to escape from his purgatory in the Marches, opened negotiations with Michelangelo, offering to work in a subordinate capacity in Florence. His overtures were unsuccessful, and Loreto remained the main scene of his activity until the Sack of Rome brought work there to a temporary halt.

Two of the large reliefs were carved by Sansovino between 1518 and 1524. The less enterprising of them represents the Adoration of the Shepherds (Fig. 81, Plate 46). The scene takes place in front of a Bramante-like structure set at an angle to the relief plane. Beneath a thatched roof thrown out from the central archway is the kneeling Virgin who displays the Child to St. Joseph and the shepherds. All five figures are confined to the front of the relief, and the interest of the scene centres upon two illusionistic expedients. The first, on the right, is a block of masonry covered by a vine, which conceals the moulded border of the scene and thus introduces an element of spatial ambiguity. The second is a row of flying angels which cuts the border along the top of the relief. These figures seem to have been inspired by Raphael's angels in Santa Maria della Pace. The subject of the more enterprising scene is the Annunciation (Fig. 80, Plate 47). Divided into two unequal parts, it recedes backwards from right to left across the whole width of the relief. In the foreground on the right is the Virgin's house, demarcated by two receding walls, between which is the Virgin seated beside her bed. The left side of the scene takes place before a long arcade. In the foreground the annunciatory angel advances towards the Virgin, behind him are two further angels, one in the act of alighting from the sky, and above is God the Father despatching the dove towards the Virgin down a long line of cloud. The head of the Virgin is the only classical feature in this extraordinary work. Owing to the exceptional size of the Loreto reliefs, each of them was

made of two slabs of marble. We know from documents that Andrea Sansovino's two reliefs were both carved simultaneously, one slab or quadro from each scene between 1518 and 1520 and the second slab or quadro between 1520 and 1524. The right sides of the reliefs are more advanced in style than the corresponding sections on the left, and the spatial expedients employed in them have a close contemporary parallel in the paintings of Giulio Romano.

By the summer of 1527 Sansovino had partially completed the left-hand section of a third relief, the Marriage of the Virgin, where he carved the beautiful figures of the High Priest, the Virgin and St. Joseph and three attendants to the left. Work on this carving was interrupted by the Sack of Rome, and in 1533 the left side was finished and the whole of the right side carved by Tribolo. In the figures which he added to the left side Tribolo imitated Sansovino's style with great fidelity, but on the right five of the six figures are shown in poses inspired by Michelangelo. Sansovino may also have been responsible for the design of the Birth of the Virgin, begun by Baccio Bandinelli in 1524-5 and completed in 1533 by Raffaello da Montelupo. The scenes that were designed and executed after Sansovino's death are less coherent, and neither Raffaello da Montelupo's puerile Adoration of the Magi, nor the Translation of the Holy House, carved partly by Tribolo and partly by Francesco da Sangallo, approaches the quality of the earlier reliefs.

The problem of the classical relief was also threshed out in Rome, where Raphael designed two bronze roundels for the Chigi Chapel in Santa Maria della Pace, and is traditionally supposed to have made drawings for the relief of Christ and the Woman taken in Adultery now on the altar of the Chigi Chapel in Santa Maria del Popolo (Fig. 79, Plate 41). Unluckily his chosen instrument was not Jacopo Sansovino (who could so well have translated his conceptions into plastic terms), but Lorenzetto. Though the Santa Maria del Popolo relief is strongly Raphaelesque – its scheme recalls that of the tapestry cartoon of Christ's Charge to the Apostles – the whole scene is weak and without emphasis.

In Naples the High Renaissance relief was developed by the Spaniard Ordoñez along very different lines. By training and inclination Ordoñez was a relief artist, and the altar of the Caracciolo di Vico chapel in San Giovanni a Carbonara is, save for two statuettes of Saints, carried out wholly in relief; in front is an antependium relief of the Dead Christ, above it is a predella with St. George and the Dragon flanked by two Prophets, and above this again is a large relief of the Adoration of the Magi, which forms the body of the altarpiece. Not only do reliefs preponderate, but the reliefs are of a rather special kind, in which the surface is fluid and the forms are imperfectly defined. Giovanni da Nola was nothing if not an Italian artist, but in the latest and largest of his reliefs, the great Deposition altar in Santa Maria delle Grazie a Caponapoli (Plate 54), though the composition is Raphaelesque, the relief style into which it is translated is that of the Spanish sculptors among whom he had been reared.

The concern with action which is so incongruous a feature of Tribolo's Marriage of the Virgin at Loreto found a more appropriate outlet in the large relief of the Assumption of the

Virgin which he completed for the Madonna di Galliera at Bologna in 1537 (Fig. 83, Plate 60). The Assumption belongs to a class of composition that was initiated by Raphael in the Transfiguration, and not even the putti in the upper part, which were added in stucco in the eighteenth century, can impair the effect of the small figure of the Virgin isolated in the sky, and the ring of apostles far beneath her gesticulating as they peer into the tomb.

The implications of the Sistine ceiling were no less great for sculpture than for painting, and it was natural that sculptors in the middle of the sixteenth century should assume the task from which Michelangelo abstained, of transcribing this painted style into relief. This was the aim of Pierino da Vinci when, on his return from Rome in 1549, he carved a marble relief of Cosimo I as patron of Pisa, now in the Vatican (Plate 61). Pierino, alone of his contemporaries, worked in limited relief. Like Desiderio before him, he attached supreme importance to continuity of surface, but though his technique must have been based upon the study of quattrocento carvings, the use to which it was applied was an entirely different one. He was concerned neither with space nor atmosphere. His sole interest was the human form, and the human form under one aspect, as silhouette. In his relief there is no space illusion other than that created by a distant ship and by two little demons in the upper corners, and the relative position of the figures is indicated solely by their scale. Vasari tells us that in Rome Pierino made a wax reduction of the Moses of Michelangelo, and in this relief it was the ceiling of the Sistine Chapel that supplied him not with motifs, but with a vision of the beauty and coherence of the human figure that he re-translated into sculpture.

The characteristics of this relief are urbanity and elegance, two qualities that are conspicuously lacking in the reliefs of Bandinelli. Like Pierino, Bandinelli was cognisant of fifteenth-century reliefs, and especially of Donatello, but in the narrative reliefs on his two papal tombs and on the plinth of the statue of Giovanni dalle Bande Nere which he carved immediately afterwards, he relapsed into a type of coarse classicising carving which has few elements of interest. As a relief sculptor Bandinelli is none the less a far from negligible artist. In 1547 when planning the new high altar of the Cathedral in Florence, he surrounded it on eight sides with a balustrade composed of panels with figures in relief (Fig. 87). The conception is academic – each of the panels is surrounded by a moulded frame and shows a single figure posturing on a flat ground – but the figures (Plate 66) speak the language of conviction, and the attitude to Michelangelo reflected in the male nudes in particular is not wholly unlike that revealed by the nudes in Pierino's relief. The two artists are divided not by their approach to style but by their attitude to sculpture, for the tight forms and carefully worked surface of Pierino were alien to Bandinelli, even in these, his most completely realised works.

It was suggested that Cellini should execute a cycle of bronze reliefs for Bandinelli's choir screen, and one relief, an Adam and Eve, was modelled in wax; but the commission came to nothing, partly because Cellini was unwilling to work under Bandinelli, and partly because Bandinelli, as he confesses in a letter, thought that the strength of Cellini's reliefs lay in their chasing, not in their design. Most of what we know of Cellini as a sculptor in relief derives

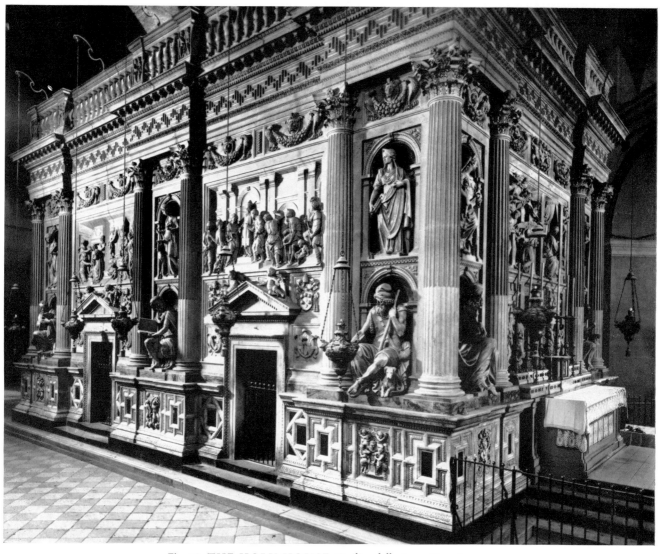

Fig. 78. THE HOLY HOUSE. Basilica della Santa Casa, Loreto.

Fig. 79. Lorenzetto: CHRIST AND THE WOMAN TAKEN IN ADULTERY. S. Maria del Popolo, Rome.

Fig. 80. Andrea Sansovino: THE ANNUNCIATION. Basilica della Santa Casa, Loreto.

Fig. 81. Andrea Sansovino: THE ADORATION OF THE SHEPHERDS. Basilica della Santa Casa, Loreto.

from a single work, the bronze relief on the base of the Perseus. Cellini's experience of relief when he began work on it was in the main limited to seals. The most elaborate of these, the seal of Ippolito d'Este, was made in 1540 in Rome. Because the Cardinal had a double title, its face is divided down the middle by a pier, with St. Ambrose chastising the Arians on one side and the Preaching of the Baptist on the other. Faced with the rectangular field of the Perseus and Andromeda (Fig. 84), Cellini treated it in the same way; at the top is the arrival of Perseus at the palace of Cepheus, in the centre is Perseus chiding Andromeda's parents, and at the left is Perseus slaying the Sea Monster. This system of multiple narration is a surprising phenomenon in the middle of the sixteenth century, and the reason for it may have been Cellini's professed admiration for the Porta del Paradiso. Like Ghiberti, he was a goldsmith, and his profession leaves its stamp on the beautiful figures of the flying Perseus in the upper left corner and of Andromeda in the centre of the relief.

The three surviving bronze reliefs by Vincenzo Danti, a Deposition in the National Gallery of Art in Washington, a safe door made for Cosimo I, now in the Bargello, and a large relief of Moses and the Brazen Serpent in the same museum (Fig. 85), are bolder and more sculptural. Danti set little store by finish; his three reliefs are chased, but not so extensively as to impair the freshness of the wax models from which they were cast. The modelling throughout is confident and diversified; the foreground figures are almost in the round while the rear figures are little more than scratches in the surface of the bronze. Like Pierino's, Danti's conception of the human figure was derived from Michelangelo, though in the Brazen Serpent his exemplar is not the early frescoes on the Sistine ceiling but the late pendentive of the same scene. In an environment in which results were habitually obtained through reason, there is something deeply disquieting in Danti's use of relief style as a revelation of his own interior vision, buttressed by the emotions but unsupported by rational thought processes.

With Giovanni Bologna reason is reintroduced. Once the subject of the Rape in the Loggia dei Lanzi had been decided on, it became necessary to define it, and with this in mind the sculptor made for its base a bronze relief (corresponding with the relief beneath Cellini's Perseus), which could only depict the Rape of the Sabines and would thus remove all ambiguity. In style the relief (Plate 86) conforms to the great group above. Giovanni Bologna was a clear-headed artist, and to him Danti's solution of an active composition peopled with figures through its whole width and depth must have appeared unworkable. He avoided it by two original expedients, increasing the depth of the relief and breaking up the figures into lucid, self-consistent units, each with a drama of its own. The foreground figures are consequently modelled almost in the round – it is as though rejected models for the statue were soldered on to the relief – and each of the four main groups into which the figures are divided is planned with astonishing resilience and resource.

Giovanni Bologna was not a prolific relief artist, but in two of his religious commissions relief plays an important part. The first of these, the Grimaldi Chapel in San Francesco di

Castelletto at Genoa, included six reliefs of Passion scenes. The Grimaldi Chapel has been destroyed, but we know that its programme, six bronze statues of Virtues and six Passion scenes, was basically Flemish – precedents for it occur in the alabaster carvings of Flemish rood-screens – and nowhere is the Flemish origin of the whole scheme more clearly apparent than in the iconography of the reliefs. Giovanni Bologna's attitude to religious imagery had been formed in the studio of Dubroeucq at Mons long before he was familiar with Italian sculptures, and it has parallels in the work of his contemporaries in Flanders. If, for example, we juxtapose the Ecce Homo at Genoa (Plate 87) with the same scene on Cornelis Floris' rood-screen at Tournai, the similarity of narrative method is self-evident. This is a case of two artists trained in the same tradition and working from the same postulates, and it has implications both for the imagery of the scene and for its style. The Christ stands a little to the right of centre, supported by a soldier and a priest. To his left and right are two caesuras, and at the edges of the scene are two groups of gesticulating figures massed together with their raised hands outlined against the flat wall surfaces.

We might guess that Giovanni Bologna was personally involved with the emotional content of these scenes. The evidence that that was so is supplied by three sketch-models in wax, which were made when the compositions of the scenes had been determined and were in large part immutable. None the less there are changes between the models and the finished works, and these are matters of interpretation rather than of form. In the wax model of the Christ before Pilate, Christ, his body bent and his head bowed, is hustled like a malefactor from the presence chamber, while Pilate gazes after him with an expression of remorse or compassion on his face. In the bronze both figures are modified; Christ's head and body are erect, and Pilate now leans forward intent upon the act of hand-washing. These are small changes, but they are tantamount to a psychological re-thinking of the scene, and the imaginative processes that lie behind them are responsible for the communicative power of the reliefs.

The sculptures for the Grimaldi Chapel were finished by 1585, and before they were complete Giovanni Bologna was caught up in a second undertaking of the same kind. This was for the decoration of the Salviati Chapel in San Marco which included six bronze reliefs of scenes from the life of S. Antonino. The Salviati reliefs (Fig. 88) are three times as large as the reliefs at Genoa, and are higher than they are wide. The relief system used at Genoa had therefore to be abandoned, since the action could no longer be restricted to a frontal plane. Instead of being spread across an oblong field the figures penetrate a narrow one, and Giovanni Bologna accordingly returns to the old Florentine tradition of figures in projected space. The physical recession of the figures is correspondingly reduced. This tendency towards a flattened relief style reaches its climax in a convex relief of Cosimo I summoned by the Signoria to the Government of Florence (Fig. 89) on the base of Giovanni Bologna's equestrian monument of Cosimo I in the Piazza della Signoria, where the figures and the setting are reconciled with marvellous subtlety.

Fig. 83. Tribolo: THE ASSUMPTION OF THE VIRGIN. S. Petronio, Bologna.

Fig. 82. Andrea Sansovino: THE CORBINELLI ALTAR. S. Spirito, Florence.

Fig. 84. Cellini: PERSEUS FREEING ANDROMEDA. Museo Nazionale, Florence.

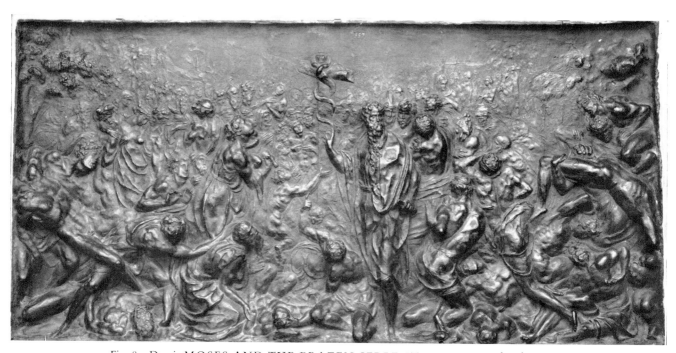

Fig. 85. Danti: MOSES AND THE BRAZEN SERPENT. Museo Nazionale, Florence.

Fig. 86. Bandinelli: UDIENZA. Palazzo Vecchio, Florence.

Fig. 87. Bandinelli: CHOIR. Duomo, Florence.

Fig. 88. Giovanni Bologna: MIRACLE OF ST. ANTONINUS.
S. Marco, Florence.

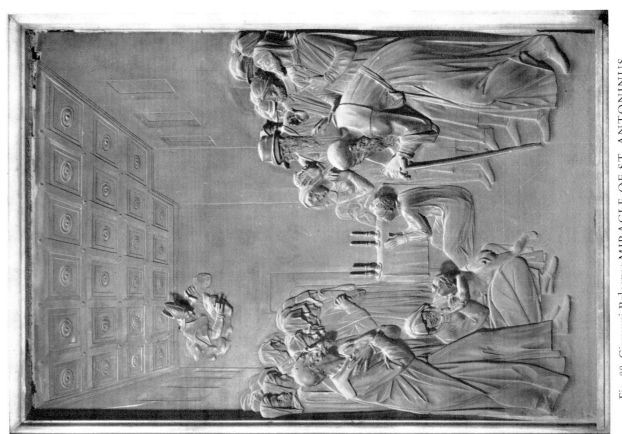

Fig. 89. Giovanni Bologna: COSIMO I RECEIVING HOMAGE.
Piazza della Signoria, Florence.

In 1595 the bronze doors at the west end of the Cathedral at Pisa were destroyed by fire. Three new pairs of doors were at once designed by the grand-ducal architect, Raffaello Pagni, and these provided for a total of twenty narrative reliefs. Through 1595 and the early months of 1596 attempts were made to induce Giovanni Bologna first to supervise the making of the doors, and then to undertake six of the reliefs. He was engaged, however, with the Hercules and the Centaur virtually to the exclusion of all other work, and was unwilling, he declared, to turn his hand to other artists' projects. The reliefs were therefore commissioned from individual members of his studio, Francavilla and Tacca among them, from Giovanni Caccini and from other artists. All three doors (Figs. 90, 91) were finished by 1604. In the fifteenth century work on the Porta del Paradiso had consumed twenty-seven years, and to complete three large doors in the space of nine years was a remarkable feat. But it was purchased at the cost of distinction in the overall design and of uniformity in the narrative reliefs. The Porta del Paradiso is fundamental for the Pisa doors, though the central door is not constructed like Ghiberti's with seven square panels in each wing, but with four scenes in each wing divided into pairs by wide strips of decoration with Saints and Prophets which are repeated at the top and bottom of the door. The reliefs are framed in foliated strips inspired by the jambs of the bronze doors of the Baptistry. This foliated decoration recurs in the two lateral doors, each wing of which contains one oblong and two upright scenes. The sense of organic structure throughout the doors is comparatively weak, and the border is so constructed that it repeatedly breaks in on the containing rectangles of the reliefs.

The obsession of the Deputati of the Cathedral with speed is reflected in a low degree of finish in the individual scenes. None the less the doors have some importance as an anthology of Tuscan relief style in the last years of the sixteenth century. In the Visitation on the central door Francavilla makes use of an open receding composition filled with loosely articulated figures for which there is no precedent in Giovanni Bologna's work, while in the Baptism of Christ on the left door and the Arrest of Christ and Christ carrying the Cross on the right, he falls back on loose, picturesque designs which reveal a fundamental lack of sympathy with Giovanni Bologna's constructive processes. By far the most distinguished of the reliefs are the five on the central door by Giovanni Caccini (Plate 93), whose relief style depends not from Giovanni Bologna, but from the marble reliefs carved by Giovanni Bandini about 1575 for the Gaddi Chapel in Santa Maria Novella, and thus, at one remove, from Bandinelli. The anarchical reliefs at Pisa signify the breakdown of an old order, not the creation of a new, and their main interest is as proof that in the field of the relief the style of Giovanni Bologna was not assimilated by local artists.

THE FLORENTINE FOUNTAIN

FOUNTAINS figure from time to time in the history of Gothic and Early Renaissance sculpture – the Fontana Maggiore of Nicola Pisano at Perugia and the Fonte Gaia of Jacopo della

Quercia at Siena are two of the most notable – but only in the sixteenth century did the
fountain come to be accepted as an art form in its own right. In the early Renaissance all the
great Florentine fountains were commissioned by the Medici. On the most famous of them,
in the courtyard or garden of the Palazzo Medici, stood Donatello's Judith pouring water from
the corners of a cushion into the basin beneath; in the second courtyard of the palace there
was a fountain by Antonio Rossellino, showing putti and dolphins, in which the water
spurted from the dolphins' mouths; and in the garden of Lorenzo de' Medici's villa at
Careggi was another celebrated fountain for which Verrocchio cast his Putto with a Fish.
The expulsion of the Medici in 1494 brought fountain building to a temporary halt, but
after their return in 1512 work began again. The Medici Palace had, in the interval, been
deprived of Donatello's Judith. The next fountain figure we hear of represented 'a naked
Mercury about a braccio high, in the act of flight, standing on a ball,' and in its hands was a
rotating instrument 'resembling a butterfly' with four blades set in motion by a jet of water
from the mouth. The figure was commissioned by Cardinal Giulio de' Medici, the future
Pope Clement VII, and was executed by a pupil of Verrocchio, Giovanni Francesco Rustici.
Rustici must have completed the great bronze group of the Preaching of the Baptist when he
started work on it, and the figure of Mercury (Plate 40), poised on one leg with head turned
upwards and distended cheeks, is modelled with the same liveliness and individuality.

At the beginning of 1537 Alessandro de' Medici was murdered, and his cousin Cosimo I
succeeded him. At this point the story of the High Renaissance fountain begins. From his father
Cosimo had inherited a villa at Castello, and he continued to live there after he was Duke.
But his change of status was reflected in his way of life, and owing to a blessed strain of
hedonism in his rather aloof character, the aspect of the villa on which he concentrated was
the garden. We have an accurate record of its lay-out sixty years later, in a painting of 1599. In
the foreground is the villa, with two pools of water in front of it, and behind, on a higher level
and sloping slightly upwards, is a formal garden closed at the back by a wall. Above the wall is
a second garden with a rectangular pool. The main features of the garden lie on the axis
of the villa. Nearest to the house is a fountain with two basins: a little farther off is a second
smaller fountain; and in the pool in the upper garden is a statue of a mountain god. Both
garden and fountains sprang from the brain of a single artist, Tribolo. Years later, in 1556
a painting was made by Vasari of Cosimo I surrounded by the artists he employed, and there
we see at the Duke's left hand Tribolo, holding a model of the fountains for the lower garden
at Castello.

Of all kinds of sculpture, fountains might appear to be some of the most stable. Not only
are they unwieldy, but they are technically tethered to the place on which they stand. In
Florence, however, as taste changed in the seventeenth and eighteenth centuries, a fashion
grew up for moving them about, and as a result of this the smaller and earlier of the Castello
fountains, the Fountain of the Labyrinth, was moved to the terrace of the Medici villa of
Petraia only a short walk away (Fig. 93). Its effect is made by contrasts. The first is a contrast

of form between the outer basin and the pedestal, which are both octagonal, and the inner basin and upper elements, which are both circular. The second is a contrast in plastic emphasis, for all the figure sculpture is in marble and in relief except the topmost figure, which is free-standing and in bronze. Tribolo was a disciple of Jacopo Sansovino, and he brought to the Castello garden sculpture many of the classicising predilections that Sansovino in his turn had brought to the Bacchus in the Gualfonda garden a quarter of a century before. Moreover at Loreto he had been involved in the decoration of Bramante's Holy House, and that experience too is distilled in the Fountain of the Labyrinth. The form of the upper part is classical – Lomazzo, the Milanese theorist, explains that fountains of this type were based on antique candelabra – and so is its imagery, from the marine nymphs at the bottom to the figure at the top. Such fountains were also made in the Quattrocento, but the proportions of Tribolo's fountain are those of its time. This can be seen in the much heightened stem above the basin, which ensured that the water descended from the upper to the lower basin in the long, thin, mannerist jets that were found specially appealing in the sixteenth century. The model that Tribolo holds in the painting in the Palazzo Vecchio shows a figure of Florence on top of the fountain, and the design for this must have been Tribolo's, though it was only realised after his death by Giovanni Bologna, who gave it a genre character more Flemish than Italian. But at one point he left Tribolo's design alone. The figure is represented wringing water from her hair, and when the fountain is turned on, it is from the damp tress of hair that the water springs.

The second and larger of Tribolo's fountains, the Fountain of Hercules (Fig. 92), still stands in the garden at Castello, and here too the upper part was left unfinished in 1550 when Tribolo died. But in this case also he prepared a model for the group, which was carried out in 1559 by Ammanati. Once more its principal distinction is a conceit, for when this fountain is turned on the water is precipitated from the mouth of the Antaeus in a single jet straight into the air. The main advance in the Fountain of Hercules is not in the conception of the fountain as an organism, but in the part that sculpture plays in it. In the Fountain of the Labyrinth all the marble sculpture is in relief; in the Fountain of Hercules much of it is carved fully in the round, or in such deep relief that it registers as free-standing sculpture. This is an extremely significant change, for Tribolo here develops an animate relationship between the jets of water and the sculpture, which opens the path to the fountains of Bernini. At the top are four little putti pouring water into the small basin below; round the stem between the basins are two more pairs of putti, again pouring water; at the base of the four main descending jets, on the lip of the basin, are four bronze bathing putti, and round the lower support are seven marble putti sheltering from the curtain of water that tumbles into the big pool beneath. These devices contained the seed of a whole new development.

Sculpturally the four putti with geese round the stem (Plate 59) are by far the finest feature of the fountain. They are fused in a continuous circular design, and though they depend from classical naturalistic sculptures, their limbs are opposed and combined and interlaced in such a way that they create an intricate harmony of form. In these figures Tribolo is working out

in sculpture ideas that were explored in painting by Pontormo twenty years before. It is as though Pontormo's putti were invested with a third dimension, and diluted in the brain of an artist whose temperament was more objective and more classical. The four bronze putti on the edge of the basin are said by Vasari to have been cast from models by Pierino da Vinci, and they are handled in a rather different way. It is not just that the modelling is tighter than Tribolo's, but that the figures themselves are conceived more naturalistically. Tribolo's putti are a compromise between children as we know they are and a theory of form that has been applied to them. With Pierino's putti the formal element is less pronounced, and if we imagine real children scrambling about on the rim of the basin, we can conceive that they might possibly get into poses somewhat like these. What the bronze figures lack in sculptural impact is made up in human spontaneity.

From private fountains the Duke's mind moved, slowly and logically as it habitually did, to a project for a public fountain in the Piazza della Signoria. Not one major public fountain was built in Florence in the whole fifteenth century. But in the sixteenth century public fountains were constructed in other towns, above all at Messina, and the Messina fountains served as a stimulus for the fountain in Florence. There was every reason why they should do so, because their sculptor was a Florentine, Montorsoli. The earlier of his fountains (Fig. 97) was building in 1550, and was substantially complete in 1551, and it must have seemed a specially exciting work on a number of counts. One of them was its size. When it was erected, it was by far the tallest fountain in Italy, and by far the largest in extent. Another reason was its unprecedentedly elaborate ground-plan; it was dodecagonal, and four of its faces were scooped away to make room for subsidiary basins into which water was poured by reclining River Gods. The central element has the same two basins that we find in Tribolo's fountains at Castello, but the part played by the figure sculpture is entirely different. At Castello the architectural forms are carefully articulated, and the figure sculpture is subordinate to the whole design. At Messina, on the other hand, the figure sculptures conceal the architectural forms, and establish visual tensions of their own. The cause of this is that Montorsoli was influenced, to the depth of his creative being, by Michelangelo, and that the figure sculpture on his fountain lives its own independent life, just as, on a higher plane, does the sculpture of the two Medici tombs.

The evidence of a connection between this fountain and the fountain in Florence is supplied by a letter written in 1550 by Baccio Bandinelli to the secretary of Cosimo I. 'Pray tell your master,' this letter reads, 'that to comply with his wishes I have carefully investigated the masters who have worked on the fountains at Messina, and I find they are magnificent. I promise His Excellency that, if my plans please him, I will make him a fountain which will not only surpass any that exist on earth, but I vow that the Greeks and Romans never had such a fountain.' Bandinelli then adds a sentence that casts a little shaft of light on Cosimo's principal limitation as a patron, his cupidity. 'If other lords have spent ten,' says Bandinelli, 'I will give such concise instructions that his Excellency will not spend five.' The fountain

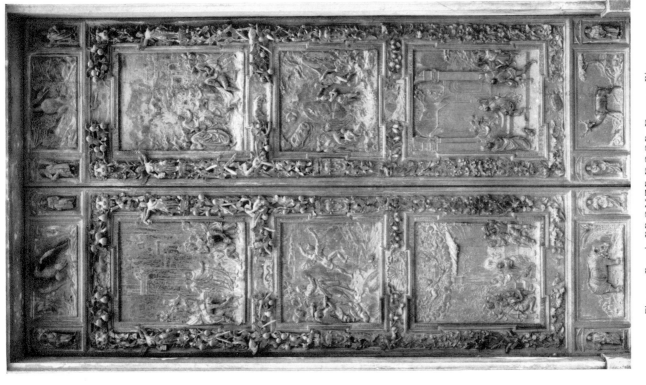

Fig. 91. Pagni: BRONZE DOOR. Duomo, Pisa.

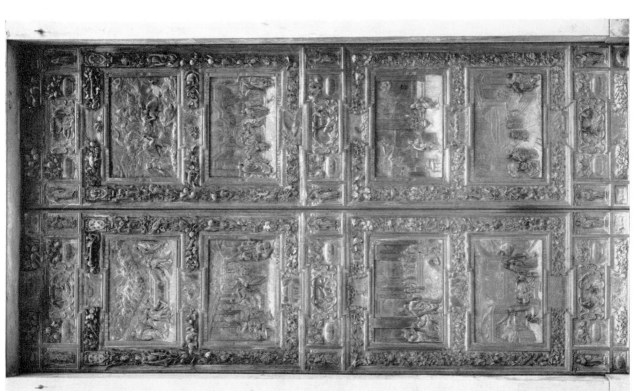

Fig. 90. Pagni: BRONZE DOOR. Duomo, Pisa.

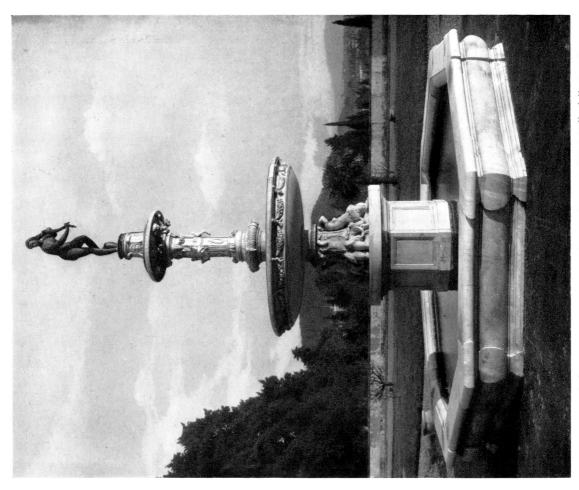

Fig. 93. Tribolo: FOUNTAIN OF THE LABYRINTH. Villa della Petraia.

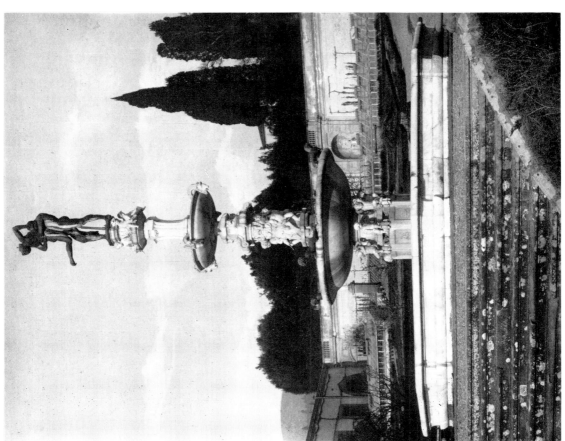

Fig. 92. Tribolo: FOUNTAIN OF HERCULES. Villa di Castello.

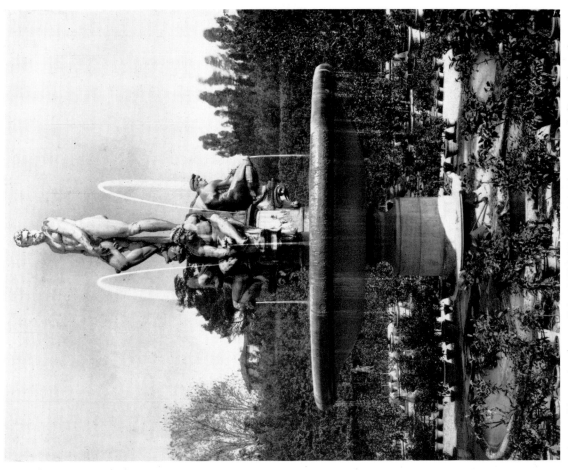

Fig. 95. Giovanni Bologna: FOUNTAIN OF OCEANUS. Boboli Gardens, Florence.

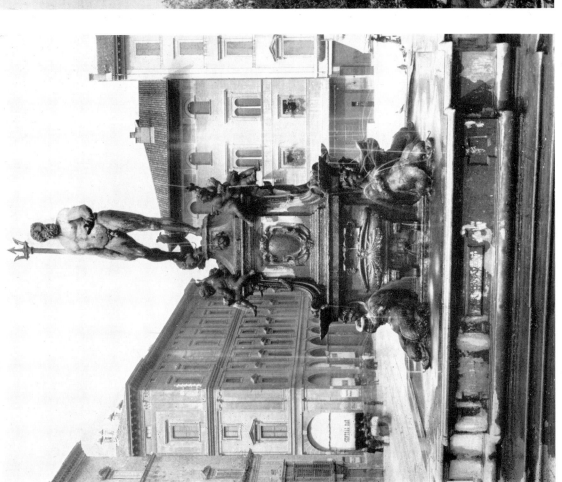

Fig. 94. Giovanni Bologna: FOUNTAIN OF NEPTUNE. Piazza Nettuno, Bologna.

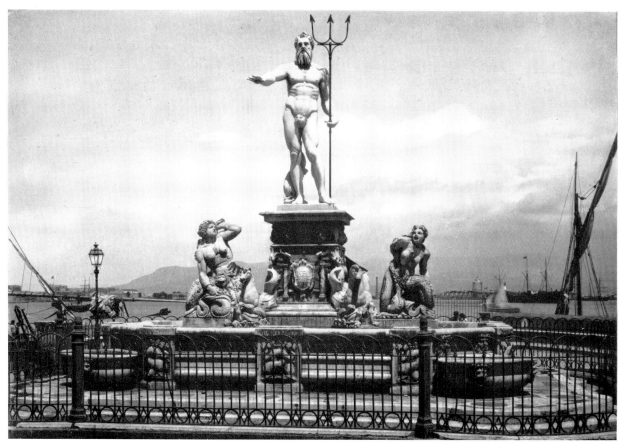

Fig. 96. Montorsoli: FOUNTAIN OF NEPTUNE. Messina.

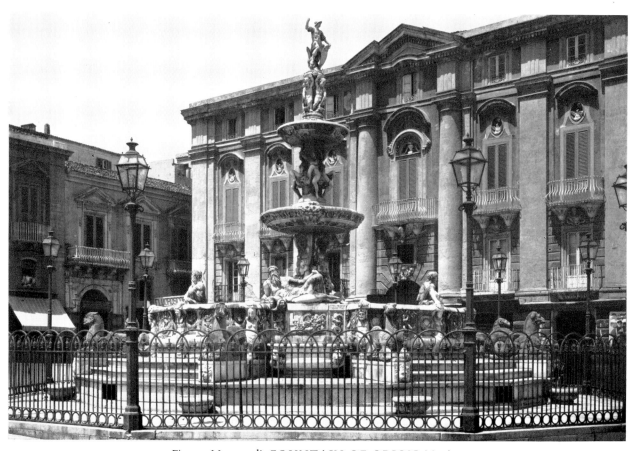

Fig. 97. Montorsoli: FOUNTAIN OF ORION. Messina.

required a flow of water, and laboriously pipes were laid from the Porta San Niccolò to the Piazza della Signoria. The completion of this task was commemorated by a medal with the head of Cosimo I on one side, and on the other a figure of Neptune drawn by sea-horses raising his trident. This is the first evidence that the subject of the fountain, the Fountain of Neptune, had been laid down. At this point there was a delay in Florence but not at Messina, where Montorsoli in 1557 completed a second fountain, the Fountain of Neptune (Fig. 96). It was smaller than the earlier fountain, and was entirely different in plan. It was dominated by a large marble figure of Neptune presiding over two smaller figures of Scylla (Plate 57) and Charybdis. Rumours of this fountain too must have reached Bandinelli, and very welcome they would have been, since his strength, in his own view, lay in the carving of colossal marble figures. Chance played into his hands, for in 1558 there was excavated at Carrara a block of marble more than ten braccia high, which was eventually purchased by Cosimo I. Marble blocks of exceptional size were some of the most sought-after artistic commodities in the sixteenth century. In an extremely practical fashion they represented opportunity. For this reason, as soon as it was known that the block at Carrara had been bought by the Duke, trouble began. It was caused by Cellini and Ammanati, who insisted that the commission for the fountain figure should be opened to a limited competition in which they and Bandinelli would take part. The Duke agreed, not because he felt any hesitation about Bandinelli's suitability for the commission, but because he hoped that rivalry would spur him on. This was a miscalculation. Bandinelli was old and defensive and irascible, and though he had had an extremely successful career, he was dogged by lack of the only currency he valued, the currency of popular acclaim. He was an hysteric, and when he learned about the competition, he hurried to Carrara and defaced the marble block. His intention was to make his rivals' task more difficult, and he succeeded in that to this extent, that it was no longer possible to show the Neptune with the right arm raised. Though he should properly have been disqualified, he would still have been awarded the commission but for an unforeseen eventuality, his death. The immediate result was that in 1560 the closed competition for the statue became an open one. Giovanni Bologna, who had arrived in Florence three years earlier, started to prepare a model, and so did four other sculptors. But as a foregone conclusion the victor of the competition was Ammanati, who was a highly experienced marble sculptor, and who had in his hand the most powerful string that any artist of the time could pull, the support of Michelangelo.

From written accounts the competition seems to have related only to the central figure. Designs for the fountain proper had been submitted ten years earlier by Bandinelli to the Duke, and the presumption is that these, in a modified form, are represented by the fountain as it stands to-day (Fig. 98). Its unsatisfactory appearance is indeed due to a central dichotomy between the arid open scheme of Bandinelli and the proclivities of the much more considerable sculptor by whom it was adapted and carried out. It is likely that Ammanati, when he won the competition and took charge of the fountain, was confronted by two irreversible

facts. The first was a ground-plan the size and form of which had been decided between Bandinelli and the Duke. The second was a block of marble which ensured that the central figure should be far too large for the basin in which it stood. The Neptune stands across the way from Bandinelli's Hercules and Cacus, and simply because both statues are white and overpowering, they tend to be associated in our minds. But it is planned in quite a different way from Bandinelli's group; it is posed more simply, and though it is free-standing, it is conceived with a flat front and back. Ammanati's taste and style were formed in Venice in the studio of Sansovino, and the closest parallel for the Neptune is to be found in the colossal sculptures for the Scala dei Giganti of the Palazzo Ducale on which Sansovino was working at this time. In one respect, however, the Neptune is a product of its place and time, in that its pedantic programme is characteristically Florentine. On the wheels of the chariot are the signs of the zodiac, and round the head is an incongruous wreath of metal fir-cones, introduced because the pine used for building ships was sacred to Neptune and a crown of fir-cones was proffered to the victors of the Isthmian Games. The meaning of the figures on the basin has not been deciphered, and all we know is that two of them represent the nymphs Thetis and Doris, while two of them are marine gods. These figures were made after the Neptune, between 1571 and 1575.

Visually the use of bronze in the supporting figures was a mistake, since bronze figures tend from a distance to look smaller than they are, and the disparity of scale between the perimeter figures and the Gigante in the centre was thereby accentuated. But as works of art the bronze figures on the corners are the most satisfactory features of the fountain. The best of them, and the only one that can be ascribed with confidence to Ammanati himself, is a bearded Marine God (Plate 74), which has something of the elevation and solidity of the Del Monte effigies. Very different is the schematic Nymph with a Shell, where the whole figure, instead of resting obliquely on its plinth, is aligned on the front plane of the base. At each side of the reclining figures are bronze fauns and satyrs, which sit on little ledges projecting from the basin as though they were (what they may actually have been) additions made to reinforce the angle figures.

The laborious process by which this fountain was evolved is in marked contrast to the single creative act that threw up the Fountain of Neptune at Bologna (Fig. 94). The decision to build the Bologna fountain was made in 1563, just after the fountain in Florence had been begun, and the design for it was prepared by the architect Tommaso Laureti. Laureti's scheme, however, was transformed and vivified by Giovanni Bologna. To Bologna he carried the trunk-load of ideas that he had salvaged from his rejected scheme for the Fountain of Neptune in Florence, and among them may have been a small clay model loosely based on Montorsoli's Neptune in Messina. In this the action of the arms has been reversed, but the weight still rests where it rests in the Messina Neptune, on the right leg. The effect is elegant but insecure, and is corrected in the next model, in bronze, where the right foot is retracted and the weight rests on the left. The head in this model is based on the Moses of Michel-

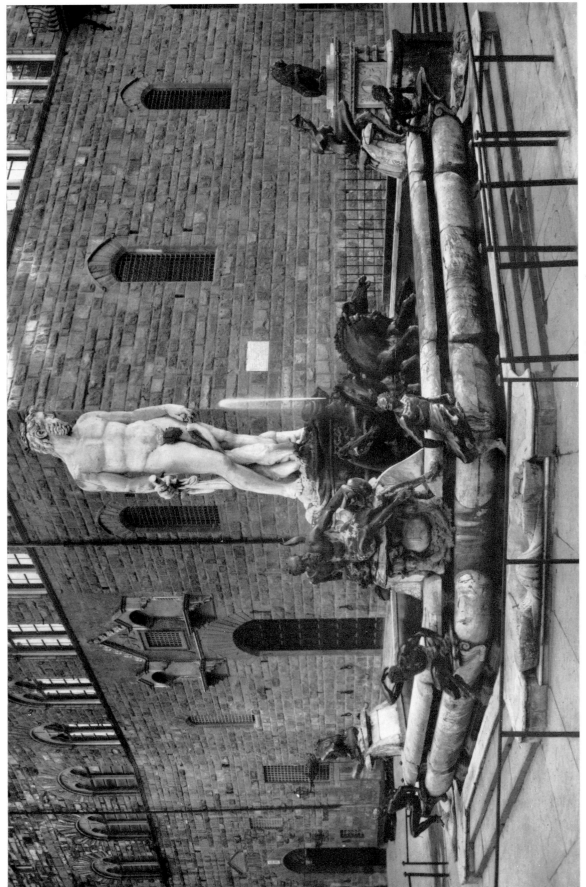

Fig. 98. Ammanati: FOUNTAIN OF NEPTUNE. Piazza della Signoria, Florence.

Fig. 99. Giovanni Bologna: MODEL FOR A RIVER GOD. Victoria & Albert Museum, London.

Fig. 100. Giovanni Bologna: APPENINE. Villa Demidoff, Pratolino.

angelo. But even so the figure must have appeared insufficiently substantial for a full-scale statue, and in the final version the head was changed once more, the swinging movement was checked, the right arm was brought in closer to the body and the left arm was moved forwards, so that the figure became heavier, more monumental and more compact. By the standard of the last large figure cast by a Florentine sculptor, Cellini's Perseus, the Bologna Neptune (Plate 81) must have looked even more vital and compelling than it does to-day.

Ammanati's fountain in Florence has upwards of seventy jets, but most of them are dissociated from the figure sculpture. In the Bologna fountain each figure is functionally justified, and the Neptune apart, there are no sculptures that do not contribute directly to the water pattern. In this respect Giovanni Bologna's fountain attains a level of sophistication that made it, when it was completed in 1566, the most advanced fountain in the whole of Italy.

In 1569 Giovanni Bologna completed in Florence a small fountain for the Casino Mediceo on which his Samson and a Philistine was set, and immediately after he received the commission for another fountain, this time for the garden behind the Palazzo Pitti. It was a commission from the Grand-Duke, and it had the rather intractable character of all of Cosimo I's artistic projects. As usual it hinged on something that was extraneous to the fountain as a work of art, a colossal granite basin which had been found by Tribolo on Elba in 1550 and in 1567 with great labour was brought to Florence. As we look at the fountain to-day (Fig. 95), we can only wonder that Giovanni Bologna reconciled himself to using it at all. He did so with great ingenuity. Obviously no figure sculpture could be placed beneath the basin unless it too was of colossal size. The fountain was therefore planned as an antithesis between a lower part in which the basin rested on a simple central support and the architectural forms were unadorned, and an upper part in which the architectural forms were concealed by figure sculpture. On the fountain the central figure of Oceanus has been replaced by a copy, and the original is now in the Bargello. By the standard of the Bologna Neptune it is a nerveless hulk carved in the studio from a model by the sculptor. But its design gives an intimation of circularity, a suggestion of potential movement, to which Ammanati on the Fountain of Neptune in Florence did not aspire. More vivid and more lively are the three River Gods (Plate 83), who pour water from their pitchers into the great basin below.

Once the Fountain of Oceanus had been installed outside the Palazzo Pitti, we should expect it to have remained there. But in the early seventeenth century taste in garden design changed, and work began on the construction of the so-called Isolotto in the Boboli Gardens, a flat circular island in the centre of a small lake surrounded by a balustrade with decorative sculptures. As planned by its architect Giulio Parigi, the Isolotto had in the centre a little temple of greenery. If it looks featureless now, it must have looked more featureless when it was new, and in 1618 this was redressed by the costly expedient of uprooting the Fountain of Oceanus from the setting for which it had been planned, and planting it in the centre of the island. As a result we see it now from a greater distance than Giovanni Bologna intended,

and in an open position for which it was not designed. More important, it was originally surrounded by a hexagonal balustrade, with figures on the corners facing inwards from whose mouths water poured into the pool. The balustrade was an integral part of the fountain, and the seated figures formed a visual complement to the outward facing River Gods.

The role of sculpture in a natural setting differs from that of sculpture in a street or square or church. It is surrounded by the living organisms of trees and plants, and from them it takes on a vicarious life, as though it too had grown organically where it stands. The first sculptor to sense that was Tribolo, in the beautiful figure of a River God in the Villa Corsini, which is compounded of every artifice known to sculptors in the second quarter of the cinquecento, but none the less has the timelessness of a natural phenomenon. But the sculptor who exploited this vein most fully was Giovanni Bologna, and the first work in which we are aware of it is the Fountain of Oceanus, where the age-old River Gods survey the world about them with immemorial detachment and maturity. This romantic quality was not something imposed upon the figures in their final phase, but was implicit in them from the start, as can be seen clearly enough in Giovanni Bologna's clay models for fountain statuary. In 1570 work began on the most famous of the Medici villas, Pratolino, which has as its dominant feature a giant figure carved from the living rock. At first the figure, which presides over a pool, was to show a River God, and the earlier of Giovanni Bologna's two clay models, that in London (Fig. 99), was made in preparation for this work. But the configuration of the ground at Pratolino was hilly, so almost at once the River God was set aside, and was replaced by a mountain God, the Appenine. The classical River Gods on which the first model was made had no applicability to the new theme, and Giovanni Bologna therefore prepared a second model, preserving the style and ethos and handling of the earlier sketch, but changing its whole form. This sketch, now in the Bargello, was copied faithfully in the colossal statue (Fig. 100). Giovanni Bologna is a Janus-faced artist, and when we look at his austere sculptures in Florence, it is important to remember their opposite, this deliquescent, richly imaginative work.

VENETIAN HIGH RENAISSANCE SCULPTURE

ONE of the consequences of the Sack of Rome was that the artists at the papal court dispersed through the peninsula. By accident rather than design the greatest of them arrived in Venice. Before the Sack forced him to flee, Jacopo Sansovino 'already had Rome in his hands', and when he came to Venice he was on his way to France. But as soon as he arrived his presence was brought to the notice of the Doge by Cardinal Grimani, to whom his work was known, and he was invited to report on the structure of St. Mark's. Sansovino was a proficient architect – in Rome he had designed the church of San Marcello, and had won the competition for the church of San Giovanni dei Fiorentini – and in 1529 he was appointed Protomagister of St. Mark's. Possibly he was influenced in his decision to remain in Venice by

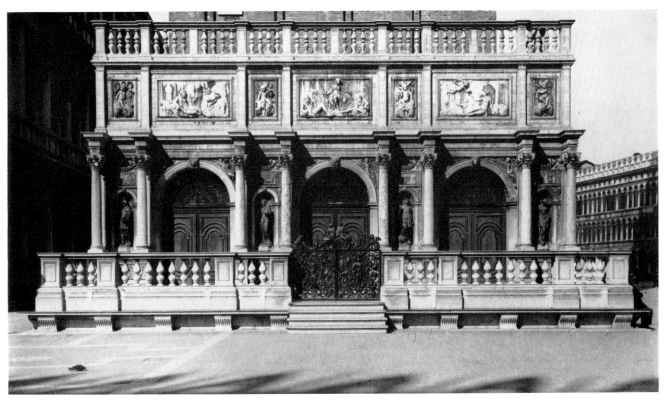

Fig. 101. Jacopo Sansovino: LOGGETTA. Piazza San Marco, Venice.

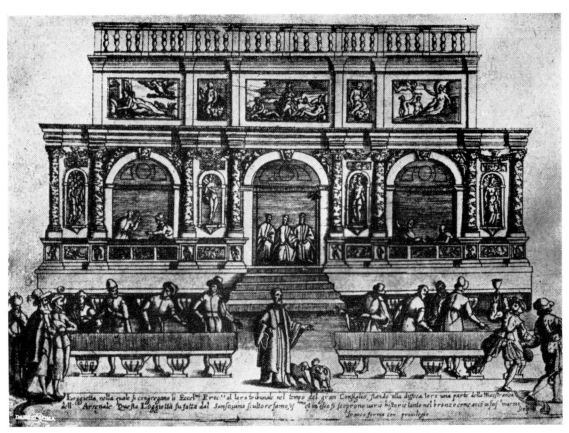

Fig. 102. Giacomo Franco: ENGRAVING OF THE LOGGETTA.

Fig. 103. Jacopo Sansovino: ALLEGORY OF VENICE. Loggetta, Venice.

Fig. 104. Danese Cattaneo: VENUS CYPRICA. Loggetta, Venice.

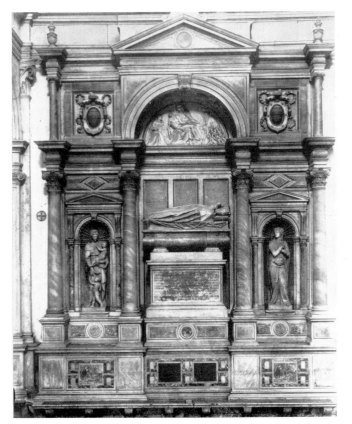

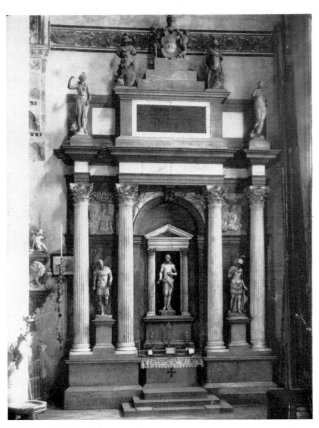

Fig. 105. Jacopo Sansovino: THE VENIER MONUMENT. S. Salvatore, Venice.
Fig. 106. Danese Cattaneo: THE FREGOSO ALTAR. S. Anastasia, Verona.

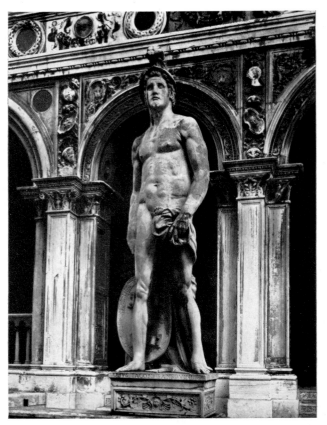

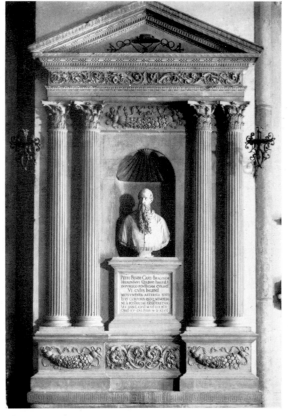

Fig. 107. Jacopo Sansovino: MARS. Palazzo Ducale, Venice.
Fig. 108. Danese Cattaneo: THE BEMBO MONUMENT. S. Antonio, Padua.

Fig. 109. Vittoria: ALTAR.
S. Francesco della Vigna, Venice.

Fig. 110. Vittoria: ALTAR OF THE LUGANEGHERI.
S. Salvatore, Venice.

Fig. 111. Rusconi: ALTAR OF THE SACRAMENT.
S. Giuliano, Venice.

Fig. 112. Grapiglia: THE LOREDANO MONUMENT.
SS. Giovanni e Paolo, Venice.

the poet Pietro Aretino, for whom he made a stucco copy of the Laocoon. Certainly it was Aretino who, a decade later, dissuaded him from returning to the papal court. 'The conceptions which spring from the heights of your genius,' wrote Aretino at this time, 'have added to the splendours of the liberal city we have chosen for our home. . . . Good has sprung from the evil of the Sack of Rome, in that in Venice, this place of God, you carve your sculptures and construct your buildings. It does not surprise me that cardinals and priests should pester you with invitations to return to Rome, but I should be astonished if you traded safety for insecurity, and abandoned the Venetian senators for servile priests.'

When he arrived in Venice, Sansovino was at once adopted as a member of what would now be known as the Establishment. He became a friend of Titian – we have an account of Sansovino and the humanist Priscianese looking out from Titian's garden at the boats thronging the lagoon towards Murano – he patronised Florentine artists when they came to Venice – Cellini describes a dinner at which 'he never stopped chattering about his great achievements, abusing Michelangelo and the rest of his fellow sculptors, while he bragged and vaunted himself to the skies' – and when in 1566, four years before his death, he became a fellow of the Florentine Academy, his portrait was painted by Tintoretto.

As an architect Sansovino changed the face of his adopted home. Vasari gives a careful list of his Venetian buildings – the Libreria, the Zecca, the Loggetta, the Scuola della Misericordia and many more – but devotes only a brief paragraph to his Venetian sculptures. Yet the importance of the sculptures was very great, and all the greater in that in Venice Sansovino stepped into a void. In 1525, when Tullio Lombardo delivered the second of his great marble reliefs for the Chapel of St. Anthony at Padua (Vol. II, Plate 142), Venetian sculpture was grinding to a halt. There was little possibility that Tullio at the close of his career would embark on a third narrative relief, and before 1528, when the Deputati invoked Sansovino's aid, it must have seemed that the decoration of the chapel would be completed by carvers of proved incapacity. In the circumstances any competent sculptor would have been assured of a warm welcome, but a special welcome was extended to an artist whose background, whose aesthetic convictions and the whole fabric of whose style marked him out as the natural heir of the Lombardi.

To Venice he brought the classical ideal of integrated sculptural and architectural forms which had been sketched out by Raphael in the painted sculptures of the School of Athens, and which, had Raphael lived, would have been realised in the Chigi Chapel. The work in which this message is most clearly to be read is the Loggetta beneath the Campanile (Fig. 101, 102). Begun in 1537, it was completed in three years, and in 1545 the four bronze statues destined for the niches on the front were put in place. The figures represent Pallas, Apollo (Plate 109), Mercury and Peace (Plate 108), and were intended by the sculptor as an allegory of the government of Venice. Pallas, he explained, was depicted as alert and fully armed because the wisdom of the Venetian senators was without peer. Mercury symbolised eloquence, and the part it played in the Venetian state. Apollo represented the freedom of

the Venetian constitution, and, through the analogy of music, the harmony with which it was administered, while Peace was the condition which had transformed the city into the metropolis of Italy. Such a programme would have been inconceivable in Medicean Florence, and so would the style of the sculptures through which it is expressed. The Sansovino of the Loggetta was the same lyrical, romantic artist who had carved the Bacchus for Giovanni Bartolini thirty years before. His opposition to Michelangelo was as firm as it had been when he started work on the St. James in Florence, and his admiration for Raphael as fervent as when he carved the Madonna del Parto in Rome. All this can be seen in his four statues. They were niche figures, and Sansovino's first concern was the integrity of the four silhouettes. A classical model was employed for the Apollo, but it was translated into terms of line. No less important was the placing of each figure in its niche. To Sansovino the rigid frontality of the statuettes beneath Cellini's Perseus would have seemed awkward and primitive, and on the Loggetta he paid close attention to the recession of the planes. The figures were, moreover, planned as a coherent plastic scheme, with the Apollo and Mercury orientated on the entrance, and the Pallas and Peace turning their backs on the two archways at the sides. More than any other works these statues determined the form of the bronze statuettes that were turned out in Venice in the later sixteenth century.

In the Venier tomb in San Salvatore (Fig. 105) the principles of the Loggetta are applied to the sepulchral monument. With its high triumphal arch housing the effigy, it derives from the Vendramin tomb of Tullio Lombardo, but the rich display of figure sculpture on the earlier monument is reduced to two marble figures of Hope and Charity in tabernacles at the sides. Were they less fine in quality, it might be felt that the quantity of figure sculpture was insufficient, but so moving is their imagery and so concentrated is their form, that their significance within the tomb is out of all proportion to their size. In the Hope, as later in a figure of St. John the Baptist in the Frari (Plate 114), Sansovino transmits to sculpture an inwardness and spiritual repose akin to Titian's.

The style of these figures and of the Loggetta statues is fundamental for the two colossal figures carved by Sansovino for the Ducal Palace (Plate 113, Fig. 107). Commissioned in 1554, they were described by Vasari when still incomplete as 'two most beautiful marble statues in the form of giants, each seven braccia high, a Neptune and a Mars, symbolising the power of the Republic by sea and land'. Thirteen years later they were installed on the stairway of the Palace. Nowadays both figures are weathered, and there is a temptation to look at them as though their function were merely decorative, but their flat, generalised forms give scarcely the least indication of the effect Sansovino intended to produce. The distinction between the figures he conceived and the figures that confront us now can be measured by means of certain protected areas at the back of Mars, where the original surface and modelling are preserved, and by the later of the two reliefs which Sansovino carved for the Chapel of St. Anthony at Padua (Plate 112). From the bearded figure on the left of this relief we can form some impression of how the Mars and Neptune were meant to look. Though they are

Fig. 113. Jacopo Sansovino: SACRISTY DOOR. St. Mark's, Venice.

Fig. 114. Jacopo Sansovino: THE MIRACLE OF THE MAIDEN CARILLA. S. Antonio, Padua.

Fig. 115. Campagna: THE RAISING OF THE YOUTH AT LISBON. S. Antonio, Padua.

free-standing, each of them postulates a single viewpoint as decisively as though it were en-
closed inside a niche, and their dramatic silhouettes are impaired by the indeterminate archi-
tectural setting against which they are shown. Tintoretto regarded them as the supreme
Venetian sculptures.

The classical synthesis of the Loggetta and the Venier monument was personal to Sanso-
vino. His style was an expression of his temperament, and though his supremacy was never
challenged during the forty-three years he worked in Venice, the pattern of Venetian sculpture
in the later sixteenth century is that of a reaction against his principles and personality. Initially
this is apparent in the work of his pupil, Danese Cattaneo, whose Fregoso altar in Sant'
Anastasia at Verona (Fig. 106) was completed in 1565. Supported by fluted columns taken over
from the architectural repertory of Sanmicheli, its central and lateral sections are uniform in
height, and since all three of them are narrow, the result is an exaggerated emphasis on vertical-
ity. Throughout the altar the figure sculpture is conceived in opposition to the architectural
frame. In the centre a black rectangle of stone is used to throw into relief a figure of the
suffering Christ (Plate 121), while at the sides the statues are raised on plinths two-thirds of
their own height. As with Sansovino, coloured marble is extensively employed, but it is
used to point a contrast between the figure sculpture and the delicate pink ground. The altar
differs from the Venier tomb not only in its form but in the ideas it illustrates; it is constructed
to an abstruse literary scheme, with statues of Jano Fregoso and Military Virtue, reliefs of
Minerva and Victory, spandrels with the instruments of the Passion, and at the top statues of
Eternity standing on a globe and Fame taking off in flight. Were this programme not recorded
with approval by Vasari, we should, from the statues alone, gain no impression of the meaning
of the tomb.

Simultaneously in Venice another Sansovino pupil, Vittoria, was experimenting along
somewhat the same lines. His altar in San Francesco della Vigna (Fig. 109), begun in 1561
and finished three years later, is more modest than the Fregoso altar, but it reveals the same
concern with height. Its two lateral sections consist of orthodox shell niches filled with
statues, but in the centre the shell is raised above the cornice so that the niche is a third higher
than those at the sides. This ratio is repeated in the statue of St. Anthony the Abbot in the
centre of the altar. The niches are treated as a background, and the statues, thrown forward on
little consoles, stand in opposition to the architectural forms. Again the sculptor invokes the
aid of colour, this time in the contrast between the white marble of the statues and their grey
stone ground.

With the abandonment of Sansovino's principle of integrated sculpture and architec-
ture, the way lay open to a type of tomb in which the designer and the sculptor were
different artists. This is the case with the colossal Loredano monument in the choir of Santi
Giovanni e Paolo (Fig. 112), where the portentous structure is due to the architect Grappiglia
and the sculpture (Plate 120) is largely by Cattaneo. Cattaneo's powers were failing when he
began work on this tomb, but even a sculptor in his prime might have quailed before

Grappiglia's awkward elevation and monstrous upper register. On a smaller scale, the design of Gian Antonio Rusconi's Altar of the Sacrament in San Giuliano (Fig. 111) offers the same hazards. In this case, however, they were successfully surmounted by Cattaneo's pupil, Girolamo Campagna, who filled the niches at the sides with figures in bronzed terracotta and for the centre carved a relief of the Dead Christ with Angels which recalls the work of Veronese.

The principle of opposition between the architecture and the figure sculpture, established by Cattaneo at Verona and by Vittoria in Venice, culminates in two great works. One is Vittoria's Altar of the Luganegheri in San Salvatore (Fig. 110), which is flanked by columns, two in a front and two in a rear plane. The only figure sculptures are two statues of Saints Sebastian and Roch, which are set against the outer columns and posed in so free and overtly emotional a fashion that for the first time we are justified in speaking of the liberation of the sculpture from architectural restraint. The second work is the high altar of San Giorgio Maggiore (Plate 123), executed by Campagna between 1591 and 1595 from a design by the painter Vassillacchi. In this case the construction of a conventional sculptured altarpiece was ruled out, since at the back there ran a double colonnade, and it was unthinkable that an alien architectural unit should block the view through this to Palladio's choir. The solution adopted by Vassillacchi was to employ the columns at the back as visual constituents in his scheme, and to fill the space in front of them with a pyramid of figure sculpture. What resulted was the central part of the high altar as it exists to-day, a globe supported by the four Evangelists, with on its face the Holy Ghost plunging down towards the crucified Christ and at its summit God the Father in benediction. The credit for its success must go in large part to Campagna, who translated this pictorial conception into bronze, modelling the four Atlas figures, weighed down by the great copper globe, with a vehemence worthy of Tintoretto.

These changes in the form of tomb and altar are reflected in the figure sculpture. The emphasis on verticality throughout the Fregoso altar affects the proportions of Cattaneo's suffering Christ, and the same proportions are preserved in the statues of the Loredano monument. Vittoria's St. Anthony the Abbot in San Francesco della Vigna is also, by the classical canon of Sansovino, unjustifiably attenuated. But paradoxically it was Vittoria who rescued Venetian sculpture from the arid mannerism of these works. Born in Trent, Vittoria came to Venice in 1543, joining the workshop of Sansovino. After nine years the two sculptors parted company, and though in 1561 they collaborated on the Venier monument, they continued to view each other with suspicion and mistrust. The rift was caused by Sansovino's disapproval of Vittoria's style. A fluent, sometimes facile artist, Vittoria was from the first incapable of the slow act of concentration, the close reasoning and self-criticism of Sansovino. He was inventive and impetuous, and his concern lay with appearances rather than with intrinsic quality. By temperament he was a modeller not a carver – his technique in marble sculpture was no more than adequate – and the large stucco statues he made for the Cappella del Rosario in Santi Giovanni e Paolo and for San Giorgio Maggiore are some of his most vivid works. Above all, he was attracted to the sculptures of Michelangelo. He repre-

sented, therefore, all those tendencies against which Sansovino protested early in the century, and which during his years in Venice he continued to oppose.

The first statue in which Vittoria employed motifs from Michelangelo is the St. Sebastian on the altar in San Francesco della Vigna (Plate 126). His model was the Dying Slave, which was despatched to France in 1544, and which he can have known only through a cast or statuette. His acquaintance with Michelangelo at this time was shallow, and this led him to modify, among many other features, the elevation of the left elbow and the position of the head. Oblivious of the weaknesses of this strange statue, Vittoria reproduced it twice as a bronze statuette. At this or at a rather later time he must also have obtained a copy of the Rebellious Slave, and when he carved a statue of St. Jerome for the Frari (Plate 128), he had studied it so thoroughly that he could invest his figure with a continuity of movement that is truly Michelangelesque. The two Slaves were not the only works by Michelangelo Vittoria knew – he was certainly familiar with the Rachel of the Julius monument which he used as the basis of statues of SS. Daniel and Catherine of Alexandria in San Giuliano, and also with the Dawn and Evening, which he adapted in two allegorical figures in the Palazzo Ducale – but he viewed the Slaves with an obsessive interest. In 1576, in a statue of St. Jerome in Santi Giovanni e Paolo (Plate 129), he returned to the Rebellious Slave once more, transcribing it this time from the end, and reproducing the torso, shoulders and right leg. Finally, in about 1600, he reverted to the Dying Slave, which inspired his most successful statue, the St. Sebastian in San Salvatore (Plate 127), where the magnificently modelled torso alone rests on the front plane of the block, the slack legs are threaded backwards round the tree-trunk, and the ecstatic head is shown upturned. These four statues mark Vittoria's progress from a schematic, external view of Michelangelo to a more profound understanding of his style.

From the time that he arrived in Venice a large part of Sansovino's sculptural thinking was devoted to relief. His first task was to complete an unfinished relief by Antonio Minelli for the chapel of St. Anthony at Padua, and this in turn was followed by six bronze reliefs for the tribunes of St. Mark's, the marble reliefs on the Loggetta, the sacristy door of St. Mark's, and a second relief for Padua. His links with painting were especially intimate. In Rome he was acquainted with Raphael and prepared a model for Perugino; in Florence he assisted Andrea del Sarto on the Scalzo frescoes; and in Venice he became the friend of Lotto, Titian and Tintoretto. He did not disdain to learn from painting and sometimes he translated pictorial motifs into relief, but he exercised a reciprocal influence on painters through the medium of his reliefs. In the six tribune reliefs Sansovino's task was to perform in Venice for the legend of St. Mark what Donatello had done in Padua for the legend of St. Anthony, and each of the six stories is told with an impetus and passion that stem from Donatello. But they are built up with strong diagonal accents in depth which Sansovino must have learned from Raphael's tapestries in Rome, and the visual expedients that are employed in the St. Mark casting out Demons (Plate 111), with its mass of violently activated figures, and the Miracle of the Slave, where the figure of the Saint flies forward through the whole depth of

the scene, explain much that would otherwise be puzzling in the early style of Tintoretto.

The second of Sansovino's relief commissions for St. Mark's, the bronze sacristy door to the left of the high altar (Fig. 113), was modelled in 1546 and assembled in 1569, but was not installed till 1572. Based on Ghiberti, the door constitutes a sixteenth-century critique of the Porta del Paradiso; the only features that have no precedent in Ghiberti are its concave shape, the pairs of classicising putti beside the Prophets and over the Evangelists, and the strips of decoration by which it is broken up. It has been contended that the second of Ghiberti's doors is inferior to the first in that its structure is sacrificed to figurated ornament. In Sansovino's door structure is reasserted by a framework of emphatic vertical and horizontal ribs. It has also been claimed that Ghiberti's relief system is ambiguous. With Sansovino, not only are the frame figures modelled in greater depth than the reliefs, but they gaze at one another across the door as though commenting on the two scenes. These scenes are the Entombment and the Resurrection. In the former Sansovino's thoughts went back to the Entombment of Raphael; none of the figures is exactly reproduced, but the tensions within the composition are those of Raphael's altarpiece. Raphael too lies at the heart of the companion scene (Plate 110). With its banner behind the central Christ and its ring of gesticulating soldiers, it proceeds from the world of the Stanza dell'Incendio. The intellectual context of these and of the six tribune reliefs is supplied by Dolce's *Dialogue on Painting* (1557), where Pietro Aretino praises Donatello as the greatest sculptor before Michelangelo, and exalts the genius of Raphael. Both to Aretino and to Sansovino the issues involved in the antagonism between Michelangelo and Raphael in the second decade of the century were still alive, and in 1550 the Raphaelesque style in which the Entombment and the Resurrection are composed had an almost polemical significance.

The style of the reliefs in the Chapel of St. Anthony at Padua was laid down by the Lombardi, but the second of the scenes carved for the chapel by Sansovino, the Miracle of the Maiden Carilla (Plate 112, Fig. 114), recalls the Resurrection in St. Mark's in so far as it takes place before a semi-circle of spectators with an onlooker in deep relief at either side. Commissioned in 1536, but carved in the main after 1557 and completed only in 1562, it is the unchallenged masterpiece of High Renaissance relief sculpture. In the earlier of his reliefs for Padua, Sansovino was hampered by the fact that Minelli had already carved almost two thirds of the scene, in the later he was his own master. The relief is carved with greater authority and confidence – such a figure as the mother kneeling over the drowned girl was beyond the reach of any sixteenth century Italian sculptor save Michelangelo – and is conceived with an epic nobility that raises it as narrative to the level of the finest Venetian subject paintings.

The most important of the marble sculptures on the Loggetta are three oblong allegorical reliefs. Two of them are by Sansovino's pupils Danese Cattaneo and Tiziano Minio, but in that in the middle (Fig. 103) the subtle gradations of the surface, the ambivalent movement of the central figure, and the pure classical forms of the reclining nudes all reveal Sansovino's hand. Cattaneo's less weighty personality is reflected in a more artificial relief style (Fig. 104)

and when, freed from his master's tutelage, he came to model the bronze allegorical reliefs for the Loredano monument (Plate 117), he rephrased Sansovino's relief on the Loggetta in the mannered language of Tintoretto. Before he died in 1573, he had prepared a model for the last of the reliefs for the Chapel of St. Anthony at Padua, St. Anthony resuscitating a dead Youth, and on his death the contract was transferred to his pupil Girolamo Campagna in the belief that he would imitate his master's manner and would carry out the work 'with more care and affec-tion than any other artist.' The design of the relief (Fig. 115) must be Cattaneo's, and its affinities are once more with Tintoretto; the heads project abruptly from the relief plane, and the figure in the centre is first cousin to the plague-stricken youth on the left of the Ministra-tion of St. Roch. Left to his own devices, Campagna proved a sensitive, rather placid relief sculptor, both in marble in the Dead Christ tended by Angels in San Giuliano (Fig. 111), and in bronze in the beautiful Annunciation designed for the Palazzo del Consiglio at Verona (Fig. 118), where the Angel (Plate 122), floating languidly to earth, and the attenuated Virgin at her lectern are disposed on the long diagonals that are familiar from Veronese's altarpieces. Vittoria, on the other hand, was blind to the possibilities of relief as an art form. To Sansovino's Venier monument he contributed a lunette with, in the centre, a coarse pastiche of the St. Peter's Pietà (Fig. 105), and in a later work, the Birth of the Virgin in San Giuliano, he debases himself to the level of a Venetian Bandinelli.

The story of the Venetian High Renaissance relief is brought to a close by two makers of bronze statuettes, Tiziano Aspetti and Roccatagliata. Aspetti (who was responsible for the Altar of St. Anthony at Padua and for two unadventurous bronze statues on Palladio's façade of San Francesco della Vigna) produced three reliefs, two in the Duomo at Padua (Fig. 135) and one in Santa Trinita in Florence. Unlike the tribune reliefs of Sansovino, they do not employ a consistent relief style, but are conceived as groups of statuettes attached to a flat ground. The treatment of the intermediate planes is lifeless, and even the figures in the round are stamped with a fatal flaccidity. Roccatagliata, a more varied and ambitious artist, modelled one major relief, the bronze antependium of the altar in the sacristy of San Moisè in Venice (1633). Containing an Allegory of Redemption (Fig. 136) with a dead Christ surrounded by exuberant putti, this marks the first tentative advance of a Venetian relief sculptor into the territory of baroque.

LOMBARD HIGH RENAISSANCE SCULPTURE

IN Lombardy the principal High Renaissance sculptor was an intruder. Of Aretine stock Leone Leoni was trained as a goldsmith and medallist, and when he came to Milan in 1542 it was as an engraver at the imperial mint. He had behind him a period at the papal mint in Rome, where he had come into collision with Cellini. Leoni's character was violent, vindic-tive and ungenerous, and though he was Cellini's intellectual superior – his letters reach an extremely high level of articulacy, and throughout his whole career he was on terms of

friendship with Pietro Aretino, Annibale Caro and other humanists – he was almost totally devoid of the disinterested artistic aspirations which supplied Cellini with his passport to immortality. What the two artists shared was an ambition to advance beyond the medal to sculpture in larger forms. The first evidence of this occurs in 1546, when the writer Muzio presses Leoni's claim to design the monument of Alfonso d'Avalos. Leoni's wish, writes Muzio, is to leave behind him one of those memorials through which other artists have made their names eternal. Everything that he has read or heard or seen of ancient and modern sculpture encourages him in the wish to emulate those on whom fortune conferred the boon of an occasion to display their gifts. Leoni possessed Cellini's pertinacity as well as his hot temper, and a few months later he turned to a new project. The emperors of antiquity, he explains in a letter to his patron Ferrante Gonzaga, had the foresight to order equestrian statues of themselves while they were still alive. If the present emperor should decide to follow their example, he would be ready to make a life-size horse with a figure fully armed, on a Doric pedestal with reliefs showing the emperor's victories. This plan for a bronze equestrian statue came to nothing – for one thing there was no reason to suppose that Leoni was capable of modelling a full-scale horse – but from it there grew the statue of Charles V restraining Fury (Fig. 141) in Madrid. The problem that confronted Leoni in this work was akin to that with which Cellini was confronted in the Perseus, and he solved it in the same manner, by using for the vanquished figure a motif from Donatello. But by nature he was a less heroic artist than Cellini, and his group is artificial and confused, a table-ornament expanded to a needlessly large size. Experience, however, brought him confidence, and between 1556 and 1564 he carried out a more successful work, the two-figure bronze group of Ferrante Gonzaga triumphant over Envy (Fig. 142) at Guastalla. On this occasion guidance came from Cellini (whose Perseus was installed in 1554), and the pose of the Medusa was adapted for the Satyr in Leoni's monument.

The statue of Ferrante Gonzaga was planned as an allegory of Gonzaga's triumph over the malign envy of his foes. This vision of life as an unremitting contest was central to Leoni's thought, and was elaborated by him in his most personal and most impressive work, the decoration of his house in Milan. Inspired by the house which Giulio Romano had built for himself at Mantua, it was decorated not with classicising paintings but with the artist's sculptures and with casts after the antique. In the middle of the courtyard, on a base supported by four columns, stood a cast of the Marcus Aurelius, and for the façade Leoni carved six prisoners in three-quarter length (Plate 105), each representing a barbarian tribe over which Marcus Aurelius had been victorious. The statue inside has disappeared, but the prisoners survive. An amalgam of the male herms on the pilasters of the Julius tomb and the standing figures on the Arch of Constantine, they are works of extraordinary imaginative force. Not a little of their effect is due to the fact that in each case the head is free of the wall surface, while beneath, instead of merging with the pilaster, the figure is severed at the knees, so that it reads as the body of a legless giant suspended on the surface of the house. The reliefs in the courtyard

include representations of the visual arts, and among them is the wheel of fortune revolved by the sculptor's eponymous emblem, the lion. Above the central window is the most remarkable feature of the building, a relief of two lions, again emblematic of the sculptor, devouring a satyr, again symbolic of envy or malignity (Plate 104). The fascination of this relief is not only that it is unashamedly autobiographical, but that the satyr is represented falling forwards out of the relief, convulsively clutching with one hand the pediment of the window beneath. This is the single case in the entire Renaissance in which the language of Giulio Romano's Sala dei Giganti at Mantua is translated into sculpture. Leoni's house was planned as the dwelling-place of a successful artist, but it is also the record of a tragedy, a proof that, had he in his other sculptures been less servile, less conventional, and less ambitious, and allowed his style to well up from the depths of his own temperament, he could have become one of the greatest sculptors of his day.

In 1567, two years after Leoni had secured possession of his house in the Via Moroni, Pellegrino Tibaldi (1527–96) was appointed architect of Milan Cathedral. A painter, designer and architect of exceptional distinction, his direct impact on sculpture was made through more than a hundred reliefs in the Cathedral, in which his essentially pictorial cartoons were carried out in marble, wood and stucco by other hands. Indirectly his influence was fundamental for the style of the most distinguished Milanese sculptor of the third quarter of the century, Annibale Fontana, and for its most distinguished sculptural complex, the façade of Santa Maria presso San Celso (Fig. 144). Completed in 1572, the façade made provision for a central relief over the main entrance, lateral reliefs over the two doorways at the sides, four figures in superimposed niche at the sides, and four small reliefs in the upper register, as well as for two sibyls on the pediment above the entrance and an Annunciation group above. Beside the lateral doorway were statues of Adam and Eve.

The first thought of the church authorities was to entrust the sculpture to a Tuscan artist, Stoldo Lorenzi. The Adam which Lorenzi delivered in 1575 is an elegant variation on the Adam carved by Bandinelli for the high altar of the Duomo in Florence, while the Annunciation, completed three years later, though free of the taint of Bandinelli, is again redolent of Florentine academism. Early in 1582 the sculptor returned to Tuscany. One of the factors in his resignation or dismissal was that he had been working since 1574 in competition with Fontana, who a year after the delivery of the Adam completed two statues of Prophets for the uppermost of the four niches, which conformed to the stylistic preconceptions of Tibaldi and to the tradition of Lombard sculpture. It must from the first have been apparent that there was a fundamental difference between the figures of Lorenzi – self-contained units that resulted from the cerebration of an undistinguished mind – and these freer, more adventurous statues. In his last work, a group of the Virgin of the Assumption with two Angels (Plate 102) inside the church, completed in 1586, a year before his death, Fontana advanced further along this path, achieving an image of transitory ecstasy which looks forward to the sculptures of Bernini.

The main scene of activity of Lombard sculptors in the later sixteenth century, however, was not Milan but Rome, where the period of Florentine supremacy came to an end soon after 1550 with Ammanati's Del Monte tombs, and taste thenceforth was formed by Lombard artists. The turning of the tide is marked by the rise, in or before 1546, of a sculptor of genius, Guglielmo della Porta. Employed at first on the repair or reproductions of antiques – his earliest Roman commission was for a head of Antoninus Pius – Guglielmo della Porta in 1547 succeeded the painter Sebastiano del Piombo in the sinecure office of Keeper of the Apostolic Seal, and in 1549 was entrusted with the most important commission awarded since the Julius monument, the tomb of Paul III.

Trained in Milan in the classicising circle of Bambaia, Guglielmo della Porta is first heard of in 1534 in Genoa, where he was engaged with his uncle, Gian Giacomo della Porta, and another sculptor, Niccolò da Corte, on the funerary chapel of Giuliano Cibo, Bishop of Girgenti, in the Cathedral. The seven figures on the Cibo altar (Fig. 143) are conceived as a dramatic unity. In a narrow central niche are St. Peter and St. Paul, with, between them, the Redeemer blessing the effigy, which originally projected at the front. At the sides, between paired columns, are figures of St. Jerome and St. John the Baptist, each crouching in a low niche, and at the outer edges, in front of the paired columns, are Abraham, pointing rhetorically backwards to the central niche, and Moses with the tablets of the law. The sculptures are unequal – like most works of their kind in Liguria and Lombardy they are collaborative – but one of them, the Abraham (Plate 98), is more powerful and more resilient than the rest, and this is due to Guglielmo della Porta.

In Genoa Guglielmo came in contact with the painter Perino del Vaga, and he was associated with Perino when he first arrived in Rome. But there a fresh experience awaited him, that of Michelangelo. He recognised that his debt to Michelangelo was very great: 'I too,' he wrote, 'believe that I should be numbered among his pupils.' The debt was personal, stylistic and technical. It was personal in that his success in Rome was due to Michelangelo's encouragement, stylistic in that his first scheme for the tomb of Paul III included eight reclining figures inspired by the allegories in the Medici Chapel, and technical in that his statues were produced in the same way as Michelangelo's. 'He does not work from models like other sculptors,' wrote Annibale Caro, as he watched the carving of the Justice for the papal tomb, 'but continues to uncover the complete limbs, so that the figure looks like a naked woman emerging from the snow.' Caro's influence is reflected in the classicising imagery of the tomb. If Justice was to be portrayed, she must be represented as the virgin daughter of Jupiter and Thetis, proud-eyed and formidable and with a certain melancholy dignity. If Abundance, she must be depicted as the classical Annona or, following a coin of Antoninus Pius, the goddess Ceres, and if Peace, she must be accompanied by Pluto, the god of riches, in the likeness of a blind child holding a purse.

Before his death at the end of 1549, the Pope bought from Guglielmo della Porta a bronze and marble base made for another tomb, and chose the classical sarcophagus in which his

Fig. 116. Jacopo Sansovino: MONUMENT OF TOMMASO RANGONE. S. Giuliano, Venice.
Fig. 117. Vittoria: DOGE NICCOLO DA PONTE. Seminario, Venice.

Fig. 118. Campagna: ANNUNCIATION. Palazzo del Consiglio, Verona (formerly).

Fig. 119. Francesco da Sangallo: GIOVANNI DALLE BANDE NERE. Museo Nazionale, Florence.
Fig. 120. Bandinelli: GIOVANNI DALLE BANDE NERE. Piazza San Lorenzo, Florence.

Fig. 121. Cellini: COSIMO I. Museo Nazionale, Florence.
Fig. 122. Cellini: BINDO ALTOVITI. Gardner Museum, Boston.

Fig. 123. Poggini: FRANCESCO DE' MEDICI. Museo Nazionale, Florence.
Fig. 124. Poggini: VIRGINIA PUCCI RIDOLFI. Museo Nazionale, Florence.

Fig. 125. Leone Leoni: THE EMPEROR CHARLES V. Prado, Madrid.
Fig. 126. Roman, second century A.D.: COMMODUS. Palazzo dei Conservatori, Rome.

Fig. 127. Leonardo da Vinci (after): MOUNTED WARRIOR. Szepmuveszetimuseum, Budapest.

Fig. 128. Pierino da Vinci (?): SAMSON AND TWO PHILISTINES. Louvre, Paris.
Fig. 129. Bandinelli: HERCULES. Museo Nazionale, Florence.
Fig. 130. Giovanni Bologna: ARCHITECTURE. Kunsthistorisches Museum, Vienna.

body was to rest. Less than a year later a wooden model was prepared, and in this Guglielmo della Porta returned to an idea with which Michelangelo had experimented in the early stages of the Julius tomb, that of a free-standing monument. The model was supported by eight terms, inside its chapel-like interior was the sarcophagus, on top was a seated life figure of the Pope, and round the sides were eight reclining statues, two on each face. Guglielmo's son, Teodoro della Porta, boasted that 'never since antiquity had a larger structure of this type been planned,' and the vicissitudes of the monument stemmed from that very fact. Their source was Michelangelo, who concluded that the tomb would violate the space and symmetry of the new church. He accordingly proposed that the free-standing tomb should be abandoned, and that the bronze statue of the Pope should be placed in a niche 'so that it should look like a judge on the Campidoglio.' The new Pope, Julius III, was sympathetic to his arguments, and in 1553 it was decided that the tomb should be replanned as a wall monu-ment. This was frustrated by the sculptor, who was wedded to his free-standing scheme. The death of Michelangelo removed the main impediment to the completion of the tomb, and Guglielmo della Porta, with the support of Pope Gregory XIII, arranged for it to be set up in the right aisle of the church. Its form was simpler than in the model – the conception of a funerary chapel was abandoned, and the eight terms and four of the allegories were elimin-ated – and in its new guise it consisted only of the sculptures which were already finished, the bronze statue of the Pope on its marble and bronze base above a marble plinth with paired reclining allegories at the front and back. The artist's amour propre was satisfied, but the effect, to judge from a drawing made of the tomb at about this time, was thoroughly unsatis-factory, not least because its crowning feature, the statue of the Pope (Plate 100), was planned as a flat silhouette. For this reason in 1587 it was treated as Michelangelo had recommended, and installed as a wall monument in one of the niches in the piers beneath the cupola, with two allegories in front and two more at the top sliding off the pediment. Forty years later it was moved to its final position in the tribune (Fig. 145), and the allegories from the pediment were transferred to the Palazzo Farnese. Our knowledge of it therefore is restricted to its con-stituent sculptures, the idealised statue of the Pope, the Justice (Plate 99), which in 1595 was covered with metal drapery, the aged Prudence, the loosely posed Abundance and the lyrical Peace.

Both in the tomb of Paul III and in two later monuments made for Giacomo della Porta's Cesi Chapel in Santa Maria Maggiore (Fig. 146), Guglielmo della Porta shows a North Italian bias towards polychromy. This was taken over and developed by another Lombard artist, Domenico Fontana, when in 1574 he started work on the tomb of Pope Nicholas IV (Fig. 148). Fontana was an architect, and the tomb of Nicholas IV is an architectural unit in which sculpture plays a secondary part. The interest of the tomb rests in its sensuous colour rather than in its three constricted statues by Leonardo da Sarzana; the veined white marble of the base merges with rosso antico and alabaster in the register above, and the portasanta columns and pilasters are offset by the lining of the niches and the austere black epitaph. Nicholas IV

(d. 1292) was a Franciscan, and his tomb was the first significant commission of a Franciscan cardinal, Felice Peretti, who in 1585 became Pope Sixtus V. Before he was elected Pope, Peretti commissioned from Fontana a second, more important work, the Cappella Sistina or Cappella del Presepio in the right transept of the church, and after his elevation to the papacy it was decided that two tombs should be constructed in this chapel, one for the Pope himself (Fig. 149) and the other for his predecessor, Pope Pius V (Fig. 150).

The papal tombs in the Cappella Sistina are far larger and more splendid than the tomb of Nichoias IV. They fill the whole width of the lateral walls to the full height of the piers, and form the principal decoration of the chapel. In each the main register is punctuated by four huge coloured marble columns, and has an arched niche in the centre and two rectangular spaces at the sides; above it is a deep cornice supporting an attic punctuated by four herms. More sculpture was naturally required than in the earlier tomb, and the rectangular spaces in the main register and the three spaces in the attic were therefore filled with narrative reliefs. The way to this solution had been pointed out by Bandinelli in the tombs of Leo X and Clement VII in Santa Maria sopra Minerva, where the upper register also contained three narrative scenes. Fontana, when he adopted it, must have been actuated by two considerations. One was iconographical, that in this way it was possible to enhance the commemorative character of the whole tomb, and the other was structural, that the use of a uniform system of relief emphasised the flat plane of the chapel wall. But in shape and style the reliefs are totally unlike those of Bandinelli. Though executed in the main by Flemish artists, they are late sixteenth-century revivals of Lombard narrative reliefs like those which had been carved for the Certosa at Pavia ninety years before. The reliefs on the tomb of Pius V illustrate historical events, while those on the Sixtus V tomb are largely allegorical, and the programmes are completed by figures in niches at right angles to the monuments, two Dominican saints beside the tomb of Pius V and two Franciscan saints beside that of his successor. Of the two portrait statues one, the Pius V by Leonardo da Sarzana, is timid and constrained; the other, the Sixtus V (Plate 135), is less conventional. Carved by a Lombard sculptor, Valsoldo, it shows the Pope kneeling in prayer before the Presepio in the centre of the chapel, and it was hoisted into place in the Pope's presence in the summer of 1589.

The pendant to the Cappella Sistina, the Cappella Paolina on the opposite side of the church, was founded by Pope Paul V three months after his election in 1605. Its structure was substantially complete by 1611, and the altar was finished two years later. The architect chosen by the Pope was a Milanese, Flaminio Ponzio, and the scheme that he adopted derived directly from the earlier chapel. The effect of Ponzio's chapel is more opulent and sensuous than Fontana's. In the seventeenth century opinion was divided as to their respective merits; Bellori, who praised architecture in the ratio of its restraint, admitted that the Pauline Chapel was the richer of the two, but thought it inferior in order and design, while Baglione considered that it far surpassed the earlier chapel. To Evelyn it seemed 'beyond all imagination

glorious and beyond description,' and in the richness of its orchestration it remained unchallenged through the whole lifetime of Bernini.

In the Pauline Chapel the lateral walls are again filled with tombs, on the right that of Clement VIII (Fig. 151) and on the left that of Paul V (Fig. 152). Architecturally speaking, Ponzio's tombs are faithful reproductions of Fontana's, but the effect they make upon the eye is rather different. The garlands above the reliefs in the main register are elaborated and enriched with cherub heads, and in the section above the staid herms of the earlier monuments are replaced by full-length caryatids with crossed feet and raised arms, which are shown in movement against the flat plane of the tomb. Similarly the reliefs are carved in greater depth, and are designed with stronger visual emphasis. The meaning of this change can best be judged if we compare the single scene that is common to both chapels, the Coronation relief in the centre of the upper register of all four tombs. Whereas in the tomb of Sixtus V the Pope is represented as a small figure seated slightly to the right of centre at the top of a wide flight of steps, in that of Paul V (Fig. 155) the figure is enlarged and centralised, and the supporting clerics are posed in such a way as to lead the eye towards it. In the tomb of Clement VIII the figure of the Pope is again set centrally (Fig. 156), but the cushion beneath his feet is asymmetrical, and in front three half-length figures in full relief conceal the foreground and protrude beyond the frame. This scene marks a decisive stage in the development of the Baroque relief.

The function of the Sistine Chapel was the display of the Cappella del Presepio in the centre of the chapel, while that of the Pauline Chapel was to house St. Luke's painting of the Virgin, which could be shown only on an altar on the rear wall. This difference of focus is reflected in the tombs. One of the two papal statues, that of Clement VIII, was diverted to the chapel from the Campidoglio, and is therefore posed frontally, but the other, that of Paul V, is turned towards the altar wall, as though participating in the Mass. This change of axis is also a Baroque device.

All the main sculptors active in Rome in the first decade of the seventeenth century are represented in the Pauline Chapel. Four of them are of particular importance. The first, Camillo Mariani, a native of Vicenza, had been trained in Venice in the workshop of Vittoria. A modeller rather than a carver, he brought to his figures of the two Saints John beside the altar recollections of Vittoria's stucco statues. The second, a Lombard, Stefano Maderno, modelled a bronze relief above the altar and carved on the tomb of Paul V the larger scene of Cardinal Serra leading the papal troops against the Turks. Maderno did a trade in terracotta statuettes after the antique, and in the relief he appears in his true colours as a listless, pedantic classicist. A few years earlier, however, he had been responsible for one of the most celebrated statues of his time, the St. Cecilia in Santa Cecilia in Trastevere (Plate 159), which commemorated the discovery of the Saint's body by Cardinal Sfondrato in 1599. The body was small – it measured only five and a half palms in length – and, according to Bosio's *History of the Passion of St. Cecilia*, lay on its right side, with the head turned towards the ground as if

in sleep. Charged with the task of representing it, Maderno returned to the antique, basing the pose on a Hellenistic statue of a dead Persian, in which the figure was also shown on its right side, with one leg contracted beneath the other and the left arm outstretched. Placed under the high altar in a black marble recess which reads as a sarcophagus or burial chamber, his statue was prophetic of the future, but the credit for it properly belongs to Cardinal Sfondrato, who laid down the terms of the commission, and not to the timid classicising sculptor by whom it was carried out.

The third sculptor, Niccolò Cordieri, was a native of Lorraine, who had scored his first considerable success with the effigies of the parents of Pope Clement VIII in the Aldobrandini chapel in Santa Maria sopra Minerva (Fig. 147). Cordieri was a restorer of antiques – two of his restitutions are still in the Borghese gallery – but through his make-up there ran a vein of Northern naturalism which prevented him from lapsing into the artifices of Maderno. He was a resilient marble sculptor, and his four statues in the Pauline Chapel (Plate 136) break new ground, in that they make use of open poses, and are not, like the statues in the chapel opposite, circumscribed by a containing silhouette. A generation later Cordieri's figures proved a fertile source of inspiration for Algardi.

The fourth sculptor is Pietro Bernini, the author of the caryatids and of the scene of the Coronation of the Pope (Fig. 156) on the Clement VIII monument. Pietro Bernini is an enigmatic artist, not because his sculptures are particularly rare or his style is particularly recondite, but because his importance for the art of sculpture was out of all proportion to the merits of the works he actually produced. His sculptures were adversely criticised; towards the end of his life an attempt was made to expel the best of them, a figure of St. John the Baptist (Plate 137), from the Barberini Chapel in Sant' Andrea della Valle, and the first version of the Coronation of Pope Clement VIII was rejected and replaced by the relief we know to-day. In the eyes of his contemporaries he was remarkable above all else for technical facility. One day in Naples Baglione watched him mark a block, and without further preparation carve three fountain figures. 'It was astonishing to watch him,' he writes, 'and if he had had more design, he would have made great progress.' A Florentine, Bernini was trained in his native town, but guided by the hope of personal advancement he moved first to Rome and then to Naples, where he carved a quantity of hesitant classicising statues. In 1594, however, he returned to Tuscany, collaborating with Caccini on a relief on the façade of Santa Trinita in Florence. Caccini's statues left a deep impression on his mind, which was reflected in the most important of the works he carved when he moved back to Naples, the statues of the Ruffo Chapel in the Gerolomini and two figures of Security and Charity (Fig. 154) on the Monte di Pietà. His feeling for tactility was more restricted than Caccini's, and he invariably planned his figures as though they were reliefs. But he possessed a lively imagination, and when in 1606 he returned to Rome, the first commission he received there, for a marble relief of the Assumption of the Virgin for Santa Maria Maggiore (Plate 138), gave full scope to this aspect of his work. Inspired by Lodovico Carracci, it portrays a variety

of emotions that no sculptor had attempted to depict before, and is carved with unusual enterprise, in that the forward figures are undercut and the surface textures differentiated. This emotive attitude to sculpture, this empirical approach to style, and this remarkable technical facility were among the gifts he handed on to his son Gian Lorenzo Bernini.

THE HIGH RENAISSANCE PORTRAIT

THE High Renaissance was a period of great portraiture. In painting it produced a host of portraitists of the first rank, for whom the problem of the portrait was not, as it had been for their predecessors in the fifteenth century, that of recording a specific physiognomy, but rather of projecting on to canvas the thoughts, the aspirations and the fears hidden within the mind. Throughout the fifteenth century the painted portrait lagged behind the portrait bust; in the sixteenth century the position was reversed. One reason was that no portrait sculptor in Florence was an artist of the stature of Pontormo or Bronzino, and that no sculptor in Venice was an artist of the magnitude of Titian. In Florence Cellini, and Cellini alone, was capable of the imaginative act that forms the prerequisite of living portraiture, but in this field as in others his opportunities were too restricted to enable him to realise all of his potentialities. Another reason was the nature of the High Renaissance portrait. The Early Renaissance portrait bust, Rossellino's Antonio Chellini or Benedetto da Majano's Pietro Mellini, is the confidential record of a private individual. The High Renaissance sculptured portrait, on the other hand, is more often than not a public affirmation, the portrayal of an office-holder not as he was but as he wished to be. This view of the portrait as an icon was entertained with particular rigidity in Medicean Florence, and was deeply incompatible with serious portraiture.

On two occasions Andrea Sansovino, in a rather simple-minded fashion, embarked on portrait sculptures. Jacopo Sansovino, who later emerged as a great portraitist, seems not to have made any portraits before he moved to Venice, but in Florence his contemporary Francesco da Sangallo was intermittently concerned with portraiture from 1522 until his death in 1576. His medium was the medal, but the medal in deep relief treated in a manner which leaves us in no doubt that it could only have been modelled by a large-scale sculptor. Sangallo was a heavy, insensitive artist, and when his image was enlarged, it lost in lifelikeness and in intensity. The most striking of his portraits occurs on the Marzi monument in the Annunziata (1546), where the effigy (Plate 55) is built up from enumerative detail, and is treated with the same pathetic emphasis as figures in paintings by Pontormo. Pontormo's portraits also supply a point of reference for Francesco da Sangallo's portrait bust of Giovanni dalle Bande Nere in the Bargello (Fig. 119). Representing its subject in half-length with the arms severed at the elbows, it belongs to a class of bust initiated by Verrocchio's Lady with the Primroses (Vol. II, Pl. 77).

Sangallo's bust offers a criterion of judgement for Bandinelli's Medicean portraits. Bandinelli was not a realistic portraitist; for him the portrait was an ideal image, which preserved only the general aspect of the sitter's face. The head of his statue of Giovanni dalle Bande Nere in Piazza San Lorenzo (Fig. 120) is, for example, several degrees further from reality than Sangallo's bust. The originator of the ideal portrait was Michelangelo. Writing in 1544, Niccolò Martelli declared that Michelangelo did not depict Giuliano and Lorenzo de' Medici 'as Nature had portrayed and composed them, but rather gave them a size, proportion and beauty . . . which he thought would bring them greater praise.' This theory was fundamental for the portrait sculptures of Bandinelli. When Cosimo I moved to the Palazzo Vecchio in 1540, he was urged by Bandinelli to perpetuate the memory of himself and of his forebears in sculpture, as had been the custom in antiquity. The result was the so-called Udienza (Fig. 86), a raised platform for public audiences at one end of the Sala Grande, with niches containing statues of Pope Leo X, Alessandro de' Medici, Giovanni dalle Bande Nere, and the reigning Duke. The secular figures wear classical armour, and are represented as historical abstractions not as living individuals. This was acceptable enough for the figures which belonged to history, but the inadequacy of the head of Cosimo I was apparent even to the members of his court; it did not, they protested, resemble the Duke in any way, and eventually the sculptor cut it off, with the intention of replacing it. Vasari tells us that when he was criticised for his incompetence, he defended himself by referring to the excellence of an earlier portrait he had made of Cosimo I. Ironically enough this earlier bust (Plate 68), which is now in the Bargello, also looks like a head cut from a statue; the cuirass terminates abruptly below the chest, and the arms are cut off below the shoulders, the left arm being slightly raised, so that if it were continued it would project like the left arms of the statues in the Udienza and the left arm of Francesco da Sangallo's Giovanni dalle Bande Nere. Where the bust differs from the statues is that Bandinelli carved it with greater pains; it forms indeed the high-water mark of his achievement as a marble sculptor. In particular the structure of the jaw and cheek-bone is rendered with great subtlety. But the notion that the portrait should reflect the living man would have struck the sculptor as heretical, and his bust, for all its skill, evades the challenge of the sculptured portrait.

Cellini's bust of Cosimo I (Fig. 121, Plate 69) illustrates not merely a different style, but a different notion of the role of portraiture. Writing after the bust was exiled to Portoferraio, he tells us that it was modelled in clay in the goldsmiths' workshop of the Palazzo Vecchio, and adds the deprecatory sentence: 'My sole object in making it was to obtain experience of clays suitable for bronze casting.' But if ever there was a portrait in which the sculptor's interest and imagination were wholeheartedly engaged, it is this bust. Cellini was a court artist whose self-realisation was contingent upon patronage, and a great part of his *Life* deals with his relations with his patrons, those semi-divine beings whose disfavour spelt frustration and whose favour represented opportunity. At the time that he left France he was planning a colossal apotheosis of Francis I as Mars on a fountain at Fontainebleau, and the first task

that occupied him after he reached Florence was a bust of his new master, not quite so large but still on an appropriately over life-size scale.

One distinctive feature of Cellini's bust is the treatment of the base. Its form is roughly semi-circular, and it is not finished off symmetrically, like Bandinelli's, but is handled in a way that suggests a body, and a body in movement, beneath. This effect is due in part to the cloak, which falls over the Duke's left shoulder and is caught up on his right arm. Bandinelli makes use of a conventional classical corselet of the type used by Michelangelo for the Giuliano de' Medici. Cellini, on the other hand, clothes the Duke in fantastic armour, decorated with a Medusa head. The neck of the corselet is circular; in this it recalls the suits in which Cosimo I is depicted by Bronzino, but with the close-fitting neck piece removed. This was an aesthetic device, designed to obviate the flatness of Bandinelli's bust. The keynote of the head is action. The locks of hair are not trained forwards and down, as they are by Bandinelli, but are swept back as though by movement, and the knitted brows, drilled eyes and tightened lips give an effect of ferocious momentary concentration that is far removed from the petulant, rather feminine expression captured by Bandinelli. That this proceeds from Cellini's conception of the portrait can be seen from a letter he addressed to Cosimo I in 1548, in which he declares that the bust meant more to him than did the Perseus, and that 'in accordance with the noble fashion of the ancients, there is given to it the bold movement of life'.

The only other bust that Cellini produced is a portrait of Bindo Altivoti in Boston (Fig. 122), which was made in Florence a few years after that of Cosimo I. To judge from a medal of Altoviti struck about the middle of the century this was a speaking likeness, and an effect of actuality is arrived at by precisely the same means as in the earlier bust. Again the base is asymmetrical, again a cloak is used to indicate the volume of the body and its continuance beneath the bust, and again the head is represented in arrested movement, as though interrupted in the act of speech. The tremulous beard and parted lips reveal the same aspirations as the blood spurting from the severed neck of Medusa in the Perseus. The bust makes its impact through the vitality of its detail, and this was observed by Michelangelo. 'My dear Benvenuto,' he wrote when he had seen it, 'I must tell you that Messer Bindo Altoviti took me to see his bust in bronze, and informed me that you had made it. I was greatly pleased with the work, but it annoyed me to notice that it was placed in a bad light; for if it were suitably illuminated, it would show itself to be the fine performance that it is.' Cellini was always an unlucky artist, and nowadays at Fenway Court the bust is even less well lit than when it stood in Bindo Altoviti's house.

This search for liveliness impaired Cellini's value as a court portraitist. Brilliant as was his bust of Cosimo I, it was not how the Duke wished to look. Better the impassive mask clamped on to his features by Bandinelli and Bronzino, better the porphyry reliefs of Tadda than this extravagant, ebullient portraiture. If Poggini, who likewise was a goldsmith and medallist, felt called to follow in Cellini's footsteps when he carved the portrait of Francesco de' Medici in 1564 (Fig. 123), he resisted the temptation, conforming instead to the

frigid idiom of Bandinelli, but replacing the classicising corselet with contemporary military costume. The employment of contemporary dress as a means of imposing a linear pattern on this portrait and on the charming bust of Virginia Pucci Ridolfi in the Bargello (Fig. 124) reflects the influence of Bronzino, though the heads are, by Bronzino's standard, relatively inarticulate.

Giovanni Bologna seems to have felt little interest in the portrait bust. He had, as is proved by the equestrian statue of Cosimo I, a gift for portraiture, but the idealist trend in his artistic make-up invariably led him in the completed work to deprive the life image of its authenticity. This occurred with the bust of Francesco I de' Medici carved from his model for the Palazzo Corsi, with the marble bust of Ferdinand I over the door of his own house in the Borgo Pinti, and most signally with the bronze bust of Ferdinand I in the Bargello, which must have been modelled at about the same time as the far more vivid head of the equestrian monument in the Piazza dell' Annunziata (Fig. 137). The bulk of the portrait commissions in the last quarter of the century went instead to Bandinelli's pupil, Giovanni Bandini, who carved the statue of Francesco Maria della Rovere in the Palazzo Ducale in Venice as well as a number of Medicean portraits, and to Giovanni Caccini, who produced a statue of Francesco I de' Medici in the Palazzo Vecchio and a quantity of stolid private busts. Fundamentally both sculptors remained faithful to the generalised portrait style of Bandinelli. The heads of Pietro Tacca's two statues in the Cappella dei Principi (Plate 97), on the other hand, are modelled with disconcerting individuality, and they suggest that Tacca, had he curbed a journalistic tendency to over-statement, might have become a major portrait sculptor.

By far the most prolific and experienced Tuscan portrait sculptor of the High Renaissance was Leone Leoni. His introduction to portraiture was through the medal, and in 1537 in Padua he completed an engraved portrait of Bembo, which was judged by Aretino, Sansovino and Titian to be much superior to the medal of Bembo by Cellini. 'I shall never believe,' wrote Aretino to Leoni, 'that Bembo is insufficiently clear-sighted to discern the difference.' In Milan the vision of imperial portrait sculptures that had long dangled before Leoni's eyes was translated into fact. In 1549 during a short visit to Brussels, he prepared life-size busts of the Emperor and of his sisters, Mary of Hungary and Eleanora of France, and these were later cast in Italy. From the portrait bust it was an easy transition to the portrait statue, and by the middle of September he had agreed to make for Mary of Hungary 'effigies entières de bronze'. In 1551, at Augsburg, he again for a few months rejoined the imperial court. Back in Milan, Leoni assiduously worked up the portraits he had taken during these brief visits, and by 1555 these resulted in the full-length statues of Charles V restraining Fury (Fig. 141), Philip II of Spain, the Empress Isabella, and Queen Mary of Hungary (Plate 106) which are now in the Prado in Madrid. All these statues resulted from life study except that of the Empress Isabella, which was based on a posthumous painting by Titian, and they form an equivalent in sculpture for Titian's imperial portraits. But the portrait statue was a cult image, and not simply a likeness, and when we compare Leoni's figure of Philip II of Spain with the great portrait in the Prado which Titian executed at precisely the same time, we find that it

Fig. 131. Ammanati: OPS.
Palazzo Vecchio, Florence.

Fig. 132. Poggini: PLUTO.
Palazzo Vecchio, Florence.

Fig. 133. Stoldo Lorenzi: AMPHITRITE.
Palazzo Vecchio, Florence.

Fig. 134. Bandini: JUNO,
Palazzo Vecchio, Florence.

Fig. 135. Aspetti: MARTYRDOM OF ST. DANIEL. Duomo, Padua.

Fig. 136. Roccatagliata: ALTAR FRONTAL. S. Moisè, Venice.

is lacking in all the psychological refinements that Titian commands with such success. This was not due to incapacity, for the medal of Martin de Hanna, the friend of Titian, is there to confirm Aretino's and Titian's confidence in Leoni's talent as a portraitist. It resulted rather from the deliberate suppression of some of the legitimate objectives of portraiture. The most impressive of the statues as a work of art is the Mary of Hungary, which is treated more naturalistically than the rest and relies for its effect on a strongly characterised pose, not on elaborate chiselling. There is nothing in these statues to suggest Leoni's deep and constant interest in the antique. He appears, however, to have had a special interest in Roman busts of the type of the Commodus in the Palazzo dei Conservatori (Fig. 126), which is cut off at the waist, and is raised on an allegorical base with two small figures of provinces. From this or from some similar bust he evolved the half-length portraits of Charles V (Fig. 125) and Philip II in Madrid, which also taper down to figurated plinths.

On two other occasions the giant personality of Titian impinged upon the sculptured portrait. On the first the sculptor was Guglielmo della Porta and the subject was Pope Paul III, a patron who had no predisposition towards conventionalised portraiture. The earlier of the two busts of the Pope carved by Guglielmo della Porta (Plate 101) seems to date from 1546-7, and when he made it he was almost certainly familiar with the portrait of the Pope which Titian had painted at Bologna in 1543. Titian's painting could not be translated into terms of sculpture, but it provided an interpretative standard which Guglielmo della Porta successfully imposed upon his bust. A profoundly truthful head, formulated like the head in Titian's painting, is framed in a great yellow cope inlaid with allegorical reliefs. What resulted is one of the noblest sculptured portraits of the sixteenth century. The Pope's family, and perhaps the Pope himself, were sensitive to the frailty of his appearance in the last years of his life – Titian's portrait group of 1546 was apparently left incomplete on that account – and when the sculptor came to model a seated figure for the Pope's tomb, he invested it with a synthetic animation that diminishes its value as a portrait. In Rome Guglielmo della Porta's successors were Taddeo Landini and the bronze caster Bastiano Torrigiani, whose three bronze busts of Pope Sixtus V (Plate 134) are the most penetrating portrait sculptures produced in Rome between the death of Paul III and the advent of Bernini.

Guglielmo della Porta can have encountered Titian no more than briefly in 1546, but in Venice from 1527 on Titian's infinitely rich and complex style supplied a background to the sculptures of Sansovino. In the portrait his indebtedness to Titian is particularly marked. Initially it can be traced in the six heads projecting from the border of the bronze door in St. Mark's (Fig. 113), which include portraits of Titian and Aretino and a self-portrait of the sculptor, built up impressionistically with a minimum of surface working. Only once did Sansovino experiment with a life-size portrait in the same style (Plate 116). Modelled in 1554, it forms part of the Rangone monument (Fig. 116), where, among the properties from a Venetian painting, a table and tablecloth, books, reading-desk and astrolabe, there is set the greatest and most elevated High Renaissance sculptured portrait.

Sansovino's pupil Cattaneo, though an efficient portrait sculptor, was lacking in interpretative weight. The finest of his portraits is the marble bust of Bembo, carved in 1547 as the central feature of Sanmicheli's Bembo monument (Fig. 108). Girolamo Campagna was a conventional portrait sculptor, and from the fifteen-sixties on the world of portraiture was dominated by Vittoria. Vittoria's extrovert bronze portrait of Rangone in the Ateneo Veneto (Plate 124) is very different from Sansovino's. Whereas in Sansovino's statue the planes are rendered smoothly and merge as they do in life, in Vittoria's bust the cheek bones are accentuated, so that they divide the cheek and the area beneath the eye into two sharply differentiated planes, while the treatment of the eyelids gives the eyes an illusory sense of depth, and the dome of the forehead is accentuated by the furrows which confer on so many of Vittoria's sitters an aura of wisdom and maturity.

Vittoria's modelled portraits are much superior to his marble busts. Among Venetian painters his sympathies lay with Palma Giovane, but the artist of whom he most forcibly reminds us in his portrait sculptures is Tintoretto, not only in the vigour with which the externals of character are rendered, but in his repeated recourse to formulae. Vittoria's are in the full sense of the term official portraits; his sitters are shown in their civic character, and on their faces are stamped the virtues they respected, prudence, sagacity and self-control. In Venice there was a vast demand for portrait busts, and Vittoria was nothing if not a prolific sculptor. The secret of his productivity was that the bodies of his busts were almost invariably conventionalised. In a few cases, of which the most notable is the Niccolò da Ponte in the Seminario Arcivescovile (Fig. 117), the majestic head has its corollary in sweeping folds of cloak, but these busts are exceptional, and their quality makes us all the more resentful of the blunted artistic conscience which led so gifted a sculptor to reject the portrait as an integrated work of art.

THE BRONZE STATUETTE

As a boy Michelangelo worked with the bronze sculptor Bertoldo, but neither then nor later did he share Bertoldo's enthusiasm for the making of bronze statuettes. The impediments to his doing so must have been twofold, that the medium of bronze was uncongenial, and that the natural movement of his mind was on a bolder scale. As a result he exercised no direct influence on the growth of the small bronze in the sixteenth century. Instead the deity who presided at its birth was Leonardo da Vinci, whose style is reflected in a number of small bronzes of horses and riding figures (Fig. 127). These bronzes have often been associated with the two equestrian monuments on which he worked in Milan, but their true reference is to the studies for the fresco of the Battle of Anghiari in the Palazzo Vecchio. The insecure stance and splayed rear legs of these little horses occur repeatedly in the drawings for the fresco but never in those for the two monuments, and the conclusion is inescapable that the statuettes were made in Florence about 1508. This was the time when Leonardo was

collaborating with Gian Francesco Rustici on the bronze group of the Preaching of the Baptist over the entrance to the Baptistry, and it is possible that the statuettes were a by-product of that work. The poses are fascinating, but the horses are cast models rather than small bronzes in their own right.

The same objection may be raised to the only small bronze based on a sketch by Michelangelo. The sketch was made about 1530 for the projected group of Samson and two Philistines, and the small bronze derived from it is wrongly ascribed to Pierino da Vinci (Fig. 128). How faithfully the model is reflected in the bronze we cannot tell, but for all the ingenuity with which it was adapted, the group that resulted is unmistakably a study for a larger statue and not a genuine bronze statuette. In this it differs from the single authenticated statuette by Tribolo, which dates from 1549. Showing a small figure of Pan seated on a vase (Plate 58), it impresses us at first as a miracle of spontaneity, and only when we look down from the smiling head to the oval base, with the legs disposed diagonally across it in counterpoint to the elbows above, do we notice the hard thinking that has gone into its seemingly innocent scheme. Tribolo after 1534 was working under the heavy shadow of Michelangelo, and there is something truly Michelangelesque in the structure and modelling of this bronze. It is an anti-climax to pass from Tribolo's small tribute to Michelangelo to the protests against his style that were committed to the small bronze by Bandinelli. The principles that Bandinelli advocated in his statuettes (Fig. 129) are the same as he proclaimed in marble on a larger scale. Sometimes the feet of his figures are retracted, sometimes they are advanced, but always the body is set flat across one plane, a linear theorem without physical reality. Bandinelli was a more successful artist on a small scale than on a large, but the concepts he translated into bronze none the less make an under-vitalised impression beside the work of Tribolo and of Cellini.

Our knowledge of Cellini as a maker of bronze statuettes is derived from the base of the Perseus, where there are four niches with bronze figures of Danae, the hero's mother, with the boy Perseus at her side, of his father Jupiter (Fig. 47), and of his benefactors, Athena (Fig. 48) and Mercury. These figures form Cellini's first excursion into this field. In France he was commissioned by the King to make twelve silver statues of Gods and Goddesses, of which four were modelled, and one, a Jupiter, was finished in 1544. The Jupiter beneath the Perseus is treated with the precision of a practised metalworker, and it perhaps reflects the lost Jupiter for Fontainebleau. The same thought may cross our minds with the figure of Athena, where the vacant head and the modelling of the breasts and shoulders closely recall a drawing for the Juno that Cellini made in France. It may indeed have been the wish to utilise the models for the silver figures that led him to the innovation of statuettes let into the Perseus base. In the statue above, his mind turned to Donatello, and in the base it reverted to the prophets in niches on Ghiberti's Gate of Paradise. Ghiberti's figures were reliefs, not statuettes, but from them Cellini learned one valuable trick, the raised arm that links so many of Ghiberti's figures to the rounded surface of the niche. The four statuettes are modelled with extraordinary refinement – above all the Danae, which is one of the most beautiful nude

figures of its time – and they carried a message for the future, for when Vasari decided that the Studiolo of the Palazzo Vecchio should be decorated with bronze statuettes, his source of inspiration was Cellini's Perseus base.

Work started on the Studiolo in 1570, a year before Cellini's death. One of a series of apartments planned by Vasari, it was intended to house a collection of precious and semi-precious objects 'such as jewels, medals, engraved gems and crystal, vases, instruments, and other similar things of moderate size, kept in cupboards each according to its kind.' Its programme was referred by Vasari to Vincenzo Borghini, the Prior of the Innocenti, who replied that in his view 'the whole invention should be dedicated to Nature and Science, and should include statues of those who were discoverers or causes, or (as the ancient poets believed) teachers and guides to the treasures of Nature.' The matter used by Nature in its operations consisted of the four elements, and one element should be depicted on each of the four walls. Provision had been made for two niches on each wall, and the four Elements had therefore to be represented by four pairs of statues. The two niches for Earth, declared Borghini, should be filled with 'the statue of Pluto, not the brother of Jupiter but another of the same name, believed by the poets to be the god of Wealth', and with a figure of Earth 'or Ops as she is called'. Water must be represented by two female figures, Venus and Amphitrite, and Air by Juno 'who was considered by the ancients mistress of the air', and Boreas, 'who would be a winged youth with a piece of crystal in his hand, since it solidifies with great cold.' Lastly Fire should be represented by Apollo, 'master of light and warmth, a beautiful youth', and Vulcan 'to stand for the hard metals such as steel and iron, in the working of which fire is a main agent.' Borghini's proposals were approved by Francesco de' Medici, and drawings were then made of the eight figures. They were submitted to Borghini, who protested that the wrong god Pluto was portrayed and that the male representative of Air was now Zephyr and not Boreas. The first of these mistakes was rectified, but the Aeolus or Zephyr was retained – the difficulty of designing a bronze figure holding crystal may well have appeared insurmountable – and Amphitrite was shown not as a mermaid but as a nymph. Where such pains were taken to impose a uniform programme on the figures, it might be supposed that an effort would also have been made to instil a common style. Each sculptor, however, consulted his own preferences. Giovanni Bandini's Juno (Fig. 134) derives from the small bronzes of Bandinelli, and the practice of Bandinelli is reflected once more in the heavy Vulcan of Vincenzo de' Rossi. Stoldo Lorenzi, in the Galatea (Fig. 133), avoids the clumsy frontality of these two figures with a form of elementary contrapposto, and Poggini represents the Pluto (Fig. 132) striding forwards in its niche. As niche figures all these are much inferior to the statuettes beneath the Perseus. Two more considerable sculptors applied their minds to the figures as silhouettes. One was Ammanati, who in the beautiful bronze of Ops (Fig. 131) adapted a classical model that he had previously used for a marble figure intended for the Palazzo Vecchio, and the other was Vincenzo Danti, who brought to his Venus Anadyomene (Plate 78) the sinuous grace of the Salome over the south door of the Baptistry.

The most beautiful of the eight figures is the Apollo (Plate 79), where we are confronted not with an aggregation of mannerisms but with a positive canon of design. On one side, with marvellous ingenuity, a firm vertical is constructed from the tree-trunk, lyre and left forearm, and on the other, opposing it, are the relaxed curves of the human form. The artist of the Apollo is Giovanni Bologna, the supreme exponent of the High Renaissance bronze statuette. As we look at Giovanni Bologna's small bronzes, we have the sense that, after the turmoil and stress of the middle of the century, the ship has come safely into shore. The clouds have dispersed, and the sun pours down on an unashamedly hedonist art. Perhaps the proportions of these ideal figures differ a little from those of figures as we know they are, yet they have an innate lifelikeness, a sensuality that marks them off from Ammanati and Danti, indeed from Cellini himself. Giovanni Bologna's bronzes have no programme; his favourite motif, a woman drying herself with a towel, is almost as uncommitted, as lacking in emotional overtones, as the ballet dancers of Degas. He was the first great advocate in sculpture of the doctrine of significant form, and so well founded was his faith and so consistent was its application that, from the time when they were made, his statuettes have never varied in their appeal. Long after the Renaissance was at an end, copies of his large statues found their way to Wrest Park and to Queluz, and among small bronzes the little Venuses that are not Venuses, the Rapes that are not Rapes, the Mercuries who bear no message, are the best-sellers of all time. For that reason they sometimes look a little tired and stale to us to-day. But there is a vast difference between Giovanni Bologna's ideas as they were realised by his assistants, and Giovanni Bologna's ideas as he presented them himself, and when we look at his few autograph bronzes, we find that at his touch the forms ignite.

Riccio, the great master of the Early Renaissance bronze, was active in Padua until 1532, and had a counterpart in Venice in Camelio, the author of a number of etiolated classicising statuettes. But after 1527 the style of both sculptors was superseded by that of Sansovino. There are not many autograph bronze statuettes by Sansovino. The finest of them, a Jupiter in Vienna (Plate 118), has the same flexibility of pose as the Mercury on the Loggetta, and is modelled with the classical precision of the Christ on the tabernacle door cast for St. Mark's (Plate 115). None the less, Sansovino, through the statues on the Loggetta, dominated the Venetian statuette. Without these figures the small bronzes of Campagna, of Aspetti, and even of Vittoria would have assumed an entirely different form. No less rare than Sansovino's are the small bronzes of Cattaneo, who in the Fortuna in Florence (Plate 119) and the Luna in Vienna develops the figures of the marble relief on the Loggetta and the bronze reliefs on the Loredano monument into free-standing statuettes. Evincing the feeling for material that distinguishes Venetian High Renaissance painting, Cattaneo's bronzes are modelled with a voluptuous warmth that is never met with in the middle of the sixteenth century in Florence.

Bronze sculpture in Venice in the later sixteenth century is dominated by four artists. The first of them, Campagna, produced a quantity of staid, undistinguished statuettes, none of which attains the animation of his monumental sculptures. The second is Tiziano Aspetti, a

mellifluous sculptor who devised a hieroglyph for the female figure that found its way on to countless doorknockers and into countless statuettes. Where Campagna was by temperament a large-scale artist, Aspetti was most at ease in works of modest size, and the sculptures he made for the altar of the chapel of St. Anthony at Padua are little more than expanded statuettes (Plate 132). The appeal of his bronzes is due as much to the richness of their facture as to the interest of their design. The third sculptor was the Genoese Roccatagliata, a more complicated and ambitious artist who was admired by Tintoretto. The statuettes of putti by which he is generally known are by no means his best works. His treatment of the human form is less constricted than Aspetti's, and in the ecstatic, swaying figure of St. Stephen in San Giorgio Maggiore (Plate 133) he breaks with the idiom of Sansovino, and reveals a zest for movement that offers a foretaste of baroque.

The fourth sculptor is Vittoria. In the small bronze, as in other fields, Vittoria is an unequal artist. Unlike his master, Sansovino, he had not been trained in the hard school of Florentine makers of free-standing statuary, and the small bronze, which of its very nature was free-standing, brought him face to face with problems he could not evade. He seems to have set special store by the figure of St. Sebastian (Plate 126) which he carved for San Francesco della Vigna in 1563, a small homage to Michelangelo in the Raphael-dominated cosmos of Sansovino. In 1566 he prepared a bronze reduction of this figure, and nine years later, in 1575, he made another, which was preserved in his studio and is mentioned in his will. One of these statuettes is now in the Metropolitan Museum in New York, and in it Vittoria makes a painstaking attempt to transform a statue with one face into a free-standing statuette. The development in his conception of the statue between the early St. Sebastian and the figure of the same saint in San Salvatore (Plate 127) is reflected in turn in the small bronze. Here the main document is the splendid figure of St. John the Baptist on a holy-water basin in San Francesco della Vigna (Plate 130), where the torso is modelled with unwonted energy and the pose is fully circular.

Vittoria made a number of small bronzes at this time, but only in one of them were all his sluggish faculties aroused. It shows Neptune stilling the waters to protect the Trojan fleet (Plate 131), and it has the dynamism of a figure from the Sistine ceiling cast in bronze. Rising not from the circular base that imposes a uniform pattern on so many of Vittoria's small sculptures, but from an oval base formed by a shell floating on the waves, the figure is set lengthwise, one foot in front and one behind, with a sea-horse between its legs. The effect of this design is remarkable enough when the bronze is looked at from the sides, but still more astonishing is its front view, where the heads of Neptune and the sea-horse appear in profile, turned on opposing axes, and the sweeping gesture of the right arm registers to the full. More unambiguously even than the marble St. Sebastian in San Salvatore, this statuette proclaims the imminent emergence of Bernini.

THE EQUESTRIAN STATUE

IN 1496 Verrocchio's Colleoni monument was unveiled in Venice, and ten years later, in Milan, Leonardo started work on the second of his equestrian statues. From these beginnings it might be supposed that the sixteenth century would leave behind it a large number of equestrian monuments, but it did not do this. From time to time we hear of projects for mounted statues – in 1546 Leoni sought permission to make one of the Emperor Charles V – but none was carried through, and the first significant commission for such a monument dates from 1587, ninety-nine years after Verrocchio's death and ninety-one years after the completion of the Colleoni statue.

The motive power behind the earlier equestrian monument was generated in North Italy, but the sculptors were invariably Florentines, and it was in Florence, under Medicean patronage, that the making of equestrian statues was resumed. A sign of interest in the riding commemorative figure occurs in 1539, when Cosimo I de' Medici married Eleanora of Toledo, and the nuptial decorations included a figure of Giovanni dalle Bande Nere on a horse twelve braccia high by Tribolo standing on a base painted by Bronzino. But more than forty years go by before we hear of any scheme for an equestrian monument in bronze. The first mention of it occurs in 1581 in a letter to the Duke of Urbino describing the commissions with which Giovanni Bologna was busy at the time. Giovanni Bologna, says this letter, impelled by a thirst for glory, is carving a three-figure group, the Rape of the Sabines, to be placed near the Judith of Donatello, and is planning, for a position opposite the David, a horse twice the size of the horse on the Campidoglio. The term used to describe this work, *un cavallo Traiano*, is ambiguous, but the reference to the Marcus Aurelius statue suggests that what was contemplated was an equestrian monument, and not just a colossal horse. Presumably the monument was approved by Francesco de' Medici, but it was commissioned only under his successor, Ferdinand I. It was to represent the founder of their dynasty, Cosimo I, and Bernardo Vecchietti, Giovanni Bologna's earliest Florentine patron, was named as supervisor of the work.

The statue of Cosimo I (Plate 90) was the first equestrian monument to be made in Florence, and Giovanni Bologna approached the task with even more than his usual deliberation. Projected in 1581 and commissioned in 1587, it was not unveiled till 1595. As the term *cavallo Traiano*, which is used of the project in its earliest stage, and the nomination of Vecchietti as its supervisor might lead us to expect, the statue derives from the antique. In the fifteen-fifties, when he first came to Rome, Giovanni Bologna had studied the Marcus Aurelius. He was by no means the first sculptor to do that – in the fifteenth century Donatello had studied it before him – but the conditions in which he looked at it were new. It was no longer in its informal setting outside St. John Lateran, but since 1538 stood where Michelangelo had placed it, on the Capitol (Vol. II, Fig. 84). This change of site affected its artistic character. By virtue of its new position in the centre of the Campidoglio it became a symbol

of imperial rule, and when in 1565 it was placed on the base that Michelangelo had planned for it almost twenty years before, it was elevated into a great work of art. For Giovanni Bologna, therefore, it was not the paragon of naturalism that it had seemed to Donatello, but a supreme commemorative monument, and when he began his preparations for the statue of Cosimo I, he was at pains to set it on a base that was recognisably related to Michelangelo's, and to maintain the same relationship between the riding figure and the plinth. For that reason, too, his attitude towards his model was more respectful than that of his predecessors in the fifteenth century; his horse's head curves outwards to the right, the right foreleg is raised, and the left rear hoof is suspended above the base. But his horse is not a servile copy of that in Rome. Through countless statuettes he had obtained a thorough understanding of the mechanism of the horse, and in connection with the statue he modelled an écorché bronze horse which is now in the Palazzo Vecchio. The relevance of the riding figure of the Emperor to that of Cosimo I was naturally less close. Giovanni Bologna none the less seized upon one feature of the mounted figure that had been ignored by both his predecessors, the long line of cloak that falls diagonally back on to the rear quarters of the left side of the horse. The cloak worn by Cosimo was necessarily short, but in the statue it is artificially extended by means of the scabbard at his side. The purpose of the statue was to immortalise the virtue and wisdom of the first of the Medici Grand-Dukes, and in its setting in the Piazza della Signoria it has a moral significance that is recognisably related to that of the statue on the Capitol.

The statue has a smoothness and a continuity of line that no equestrian monument had possessed before, and hardly was it finished than it became an archetype. In 1601 Giovanni Bologna started work on a statue of the Grand-Duke Ferdinand I, which was completed in 1608 by his pupil Pietro Tacca and installed in the Piazza dell'Annunziata (Fig. 137). This was an inversion of the earlier statue. In 1604, when this work was still incomplete, came a demand for an equestrian statue of Henry IV of France for the Pont-Neuf in Paris, and this was erected in 1611 by Francavilla, who modelled four bronze prisoners for its base (Plate 95). Two years later, in 1606, there followed a request from Spain, which resulted in 1616 in the statue of Philip III of Spain which was set up by Tacca in the Plaza Mayor in Madrid. The horses of both statues derived from that of Ferdinand I.

From these facts alone it might seem that Giovanni Bologna and his pupils had a monopoly of equestrian monuments, yet when the authorities of Piacenza decided to erect twin statues to the reigning Duke of Parma, Ranuccio Farnese, and to his father, Alessandro, in 1612, they turned not to Tacca or to Francavilla, but to another Tuscan sculptor, Francesco Mochi. The reason for this was that Mochi, as a youth of twenty-three, had attracted the notice of Mario Farnese, Duke of Latera – 'a boy I have had the good fortune to light on,' says Farnese in a letter, 'who seems to me the equal of all the younger artists' – to whom he owed his first important commission, for a marble group of the Annunciation at Orvieto (completed 1609). Mochi's concern lay with the rendering of movement; his Annunciatory Angel

Fig. 137. Giovanni Bologna: STATUE OF FERDINAND I. Piazza Annunziata, Florence.
Fig. 138. Pietro Tacca: STATUE OF PHILIP IV. Madrid.

Fig. 139. Mochi: STATUE OF RANUCCIO FARNESE. Piazza Cavalli, Piacenza.
Fig. 140. Mochi: STATUE OF ALESSANDRO FARNESE. Piazza Cavalli, Piacenza.

Fig. 141. Leone Leoni: CHARLES V RESTRAINING FURY. Prado, Madrid.
Fig. 142. Leone Leoni: FERRANTE GONZAGA TRIUMPHANT OVER ENVY. Piazza Roma, Guastella.

Fig. 143. Gian Giacomo della Porta: ALTAR OF THE APOSTLES. Duomo, Genoa.

sweeps down to earth, and his Virgin Annunciate shrinks back as though alarmed at the sound of the descent. This concern with movement dictated his attitude to the equestrian monument. Whereas in Giovanni Bologna's movement is no more than implied, in Mochi's Ranuccio Farnese (Fig. 139) it is explicit: the right foreleg of the horse presses down into the void at one end of the plinth, and the head is shown with frothing mouth turned to the right, and is balanced at the back by the huge curving tail. Giovanni Bologna's equestrian monuments are not mentioned in the documents relating to the statue, but in March 1616, after the horse was modelled but before it had been cast, Mochi, with the permission of his patron, visited Padua, to see the Gattamelata monument, and Venice, to study the bronze horses on St. Mark's and Verrocchio's Colleoni statue. What he saw did not affect his horse, but it may have influenced the riding figure which he modelled soon afterwards, in that the Duke is shown like Gattamelata with a baton in his raised right hand, and like Colleoni has his head turned outwards to the left.

This powerful and imposing monument was unveiled in November 1620, to the sound of a salute fired by musketeers, and Mochi thereupon directed his energies to the second statue. The first monument portrayed the living Duke, and was subject to considerations of decorum and life-likeness, but the second (Plates 162, 163, Fig. 140) was posthumous and was accordingly less circumscribed. It was stipulated in the contract that the horses should correspond, and the head of the second horse is for this reason turned to its left not to its right, and the tail sweeps out on the right side. By strict representational standards the horse is a little grotesque, but its long mane blowing in the wind and partially concealing the riding figure is a striking dramatic device, which is enhanced by the treatment of the cloak, folded across the rider's shoulder and blowing out behind, as though the Duke were represented on the battlefield caught up in a storm. The difference in the characterisation of the two figures is borne out by the reliefs beneath; those on the statue of Ranuccio Farnese are allegories of good government and peace, while those on the statue of Alessandro Farnese illustrate military scenes.

Mochi's wild, romantic statues have more than a little in common with the portraits of Rubens, and it was Rubens who was responsible at second hand for the last decisive step in the development of the equestrian monument. The proof of this is contained in a letter written by the Count-Duke of Olivares to the Florentine ambassador in May 1634, expressing a wish to commission a statue of the King, Philip IV, 'conforme a unos retratos de Pedro Pablo Rubens.' In Florence the request was referred to Tacca, who had carried out the statue of Philip III in Madrid, and by 1636 he had completed a small model of the statue and a large terracotta model of a pacing horse. But as soon as news of these reached Spain, it transpired that they were not what the King and the Count-Duke required. Instead they envisaged a horse in the act of galloping or rearing, with both its forelegs off the ground. To Tacca this problem was no novelty. Between 1619 and 1621 he had made a bronze equestrian statuette of Charles Emmanuel of Savoy with its two forelegs free (*con gambe dinanzi alzate in atto di*

corvettare). Nothing daunted by the difficulty of translating it to a full scale, Tacca requested that two paintings by Rubens, a small canvas of the King on horseback and a life-size head, should be sent to Florence. Probably the paintings he received were not originals by Rubens (who had left Madrid in 1636), but there can be no doubt from the sources that a painting by Rubens supplied the inspiration of the pose. The horse was cast in the course of 1639, and Tacca then busied himself with the riding figure, which must have been in large part complete by January 1640 when the second portrait of the King, in the light of which the features were to be modelled, arrived in Florence. In September 1640, shortly before Tacca's death, the statue was shipped to Spain, where it was erected in October 1642 by Ferdinando Tacca (Fig. 138). Tacca's biographer, Baldinucci, echoing the opinion of experts in manège, complained that the pose of the horse was ambiguous, but for the skill the sculptor showed in maintaining its equilibrium there was undivided praise, and in the eighteenth century it was this splendid work that inspired the last great equestrian statue, Falconet's Peter the Great at Leningrad.

BERNINI AND THE BAROQUE STATUE

GIAN Lorenzo Bernini was born in Naples in 1598. At that time Giovanni Bologna in Florence was completing his Hercules and the Centaur, and Vittoria in Venice was carving the St. Sebastian in San Salvatore; Campagna's altar in San Giorgio Maggiore in Venice and Fontana's Assumption in Santa Maria presso San Celso in Milan had been in existence for respectively three and thirteen years. In the year of his birth, therefore, in a number of different centres, sculptors whose styles were incompatible and who were not necessarily acquainted with each other's work, as though carried forward by a single impulse, were experimenting with the rendering of the human body in movement in the round. Whether it be Hercules in desperate conflict with the Centaur, or St. Sebastian writhing in agony against the column, or the Evangelists crushed by the imaginary weight of a huge globe, or the Virgin journeying towards heaven, the sculptures depict a transitory state. Bernini was the predestined agent by whom this tendency was welded into a coherent, universal style. Baldinucci, his biographer, describes how, as a boy, he was presented to Pope Paul V. The Pope, Baldinucci tells us, was so much impressed with Gian Lorenzo's promise that he ordered Cardinal Maffeo Barberini to supervise his work. 'Let us hope,' he exclaimed, 'that this youth may become the great Michelangelo of his century.' Bernini did not become a Michelangelo – his talent was more facile, and his spiritual horizon was more limited – but he grew up to exercise a greater influence on the art of his own time than any sculptor had exercised before.

Not since the youth of Michelangelo was the training of a sculptor scrutinised with such expectancy. His technique was learned in his father's studio, but his taste and his ambitions were directed by patrons determined to ensure that the great monuments of contemporary painting were supplied with an equivalent in sculpture. Foremost among them was Cardinal

Fig. 153. Cordieri: ST. GREGORY THE GREAT. S. Gregorio al Celio, Rome.
Fig. 154. Pietro Bernini: CHARITY. Monte di Pietà, Naples.

Fig. 155. Ippolito Buzio: THE CORONATION OF POPE PAUL V. S. Maria Maggiore, Rome.
Fig. 156. Pietro Bernini: THE CORONATION OF POPE CLEMENT VIII. S. Maria Maggiore, Rome.

Fig. 149. Domenico Fontana: TOMB OF POPE SIXTUS V. S. Maria Maggiore, Rome.
Fig. 150. Domenico Fontana: TOMB OF POPE PIUS V. S. Maria Maggiore, Rome.

Fig. 151 Flaminio Ponzio: TOMB OF POPE CLEMENT VIII. S. Maria Maggiore, Rome.
Fig. 152. Flaminio Ponzio: TOMB OF POPE PAUL V. S. Maria Maggiore, Rome.

Fig. 147. Giacomo della Porta: TOMB OF LUISA DETI ALDOBRANDINI. S.Maria sopra Minerva, Rome.

Fig. 148. Domenico Fontana: TOMB OF POPE NICHOLAS IV. S.Maria Maggiore, Rome.

Fig. 145. Guglielmo della Porta: TOMB OF POPE PAUL III. St. Peter's, Rome.

Fig. 146. Guglielmo della Porta: TOMB OF CARDINAL PAOLO CESI. S.Maria Maggiore, Rome.

Fig. 144. THE FAÇADE OF S. MARIA PRESSO S. CELSO, Milan.

Scipione Borghese, whose enlightened taste embraced the work of Reni and Caravaggio and who commissioned Domenichino's Diana at the Chase. Of Bernini's early secular groups one was made for the garden of the Villa Montalto, where it rose above a pool surrounded by Roman statues; three were made for the Villa Borghese, where they stood, as they still do to-day, among antiques; and one was installed in the Villa Ludovisi among the Roman sculptures which are now in the Museo delle Terme. During the time that he was working on them, Bernini was also engaged upon the restoration of antiques – the Borghese Hermaphrodite and the Ludovisi Ares are two of the works that he restored – and his earliest sculptures are invariably constructed round a classical motif. In the Pluto and Proserpine an antique fragment determined the posture of the Pluto, in the Apollo and Daphne the Apollo was based on the Apollo Belvedere, and in the David, the least successful and most academic of the statues, the stance was inspired by the Borghese Gladiator in the Louvre.

More important than this borrowing of motifs is the fact that Bernini felt strongly drawn towards a type of Hellenistic sculpture represented by the Vanquished Gaul slaying his Wife which forms part of the Ludovisi collection in the Museo delle Terme (Fig. 158). This group is planned with one main and two subsidiary views, and its plinth is not a neutral area, like the plinth of Giovanni Bologna's Rape of the Sabines, but is treated as a stage on which the figures move. As narrative it is incomparably vivid, and appeals directly to the emotional responses of the onlooker. The body of the woman is precariously balanced, about to slump on to the ground, and blood spurts from a self-inflicted wound in the throat of the standing warrior as he looks across his shoulder at an unseen foe. If we pass directly from this group to the Pluto and Proserpine (Plate 140) which Bernini carved for the Villa Ludovisi, we shall find first that it is built up in the same way, second that the plinth is also treated spatially, and third that it makes use of precisely the same narrative device; Proserpine cries vainly to the unseen figure of her mother Ceres as she is lifted from the ground.

Like the antiques from which they were derived, Bernini's early sculptures were intended to be shown against a wall. They are fully finished off behind, but they depend for their effect on the presence of a background, and have a single dominant view. The earliest, the Aeneas leaving Troy (Plate 139), was set on a cylindrical base, the back of which was cut away so that it fitted to the wall. The front face of the statue is the face illustrated in this book. Its two secondary faces, at right angles to the wall, are wider and less compact; one of them shows Aeneas looking across his shoulder with, above him, the statues of the tutelary gods, and the other the profiles of Anchises and of the young Ascanius. With the Rape of Proserpine the dominant aspect is the widest view, and this is enriched by carefully worked out three-quarter views, and by side views from which only one figure can be seen. The Apollo and Daphne (Plate 142) likewise creates its full effect only from the front, the single view from which the long diagonal that runs back from the extended right hand of Apollo to the raised right arm of Daphne registers as the sculptor intended that it should. In the course of preparation

of this book, the surprising fact transpired that the sculpture has not been illustrated from this view.

Not only were the groups placed against a wall, but they were shown close to the level of the eye. This set a premium on illusionism. Many years later, in conversation with Chantelou, Bernini touched upon this point. Michelangelo, he declared, was a greater architect than sculptor, because architecture consisted only in design; in sculpture he had never had the power to make his figures look like flesh, and they were beautiful only for their anatomy. The nature of Bernini's aspirations may have been determined by the blood pouring from the throat of the Dying Gaul, but by his early twenties his sleight of hand – as we can see it in the transparent tears coursing down the cheek of Proserpine and Pluto's fingers pressing into the soft surface of her thigh – was more accomplished than that of any Hellenistic artist. By temperament he was an illustrator; the form and subjects of his early groups may vary, but the intention behind all of them is uniform, to provide a visual embodiment of a literary text. Ovid's Pluto, like Bernini's, has been pierced by Cupid's dart, and is inspired by love, not lust. It is Ovid who describes the wind baring the limbs of Daphne and Apollo's hand feeling her pulse beneath the bark, and Ovid who pictures Triton rising from the water to sound his echoing conch as Neptune stills the flood. In the seventeenth century it was popularly held that painting was mute poetry. Bernini transposes this conception to the sister art of sculpture. In France he expressed his admiration for Poussin with the words *O il grande favoleggiatore*, and Poussin alone rivals the mythopoeic faculty, the gift for supremely sensitive narration, evident in his early groups.

The theory behind these groups was applicable also to religious sculpture, and in 1624, when the Apollo and Daphne was still unfinished, Bernini started work on a religious statue (Plate 143). The occasion was supplied by the discovery, in two glass receptacles, of the body of a martyred virgin, Santa Bibiana. The relics were inspected by the Pope – who, as Maffeo Barberini, had watched the carving of Bernini's early groups, and composed a distich for the base of the Apollo and Daphne – and on his instructions a statue of the Saint was commissioned for the church of Santa Bibiana from Bernini. Since the statue was to occupy a niche behind the altar, which was itself only a little higher than the nave (Fig. 162), the differentiated texture of the Borghese groups could be transferred to the new figure. Against the surface of the niche, moreover, contour could enjoy the same supremacy as in the earlier statues. What was lacking in the commission was the element of drama present in the mythologies, and this was rectified by a painted God the Father in the vaulting to which the Saint directs her eyes, and which explains the wondering gesture of her raised right hand.

Bernini might well have continued along the lines laid down by this restrained, subtle and incredibly proficient work. But fate decided otherwise, for the first artistic project that occupied Maffeo Barberini after his election to the papacy was the completion of St. Peter's, and his chosen agent was Bernini. Baldinucci tells the story of a visit paid to St. Peter's by Bernini as a boy in the company of Annibale Carracci. 'Believe me,' said Annibale Carracci

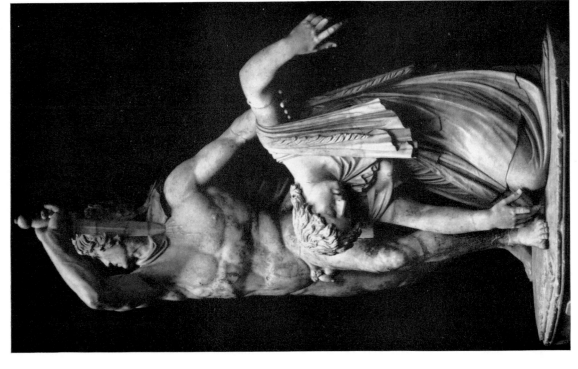

Fig. 158. Hellenistic, second century B.C.:
GAUL KILLING HIS WIFE IN FACE OF AN ENEMY.
Museo delle Terme, Rome.

Fig. 157. Bernini: DAVID. Galleria Borghese, Rome.

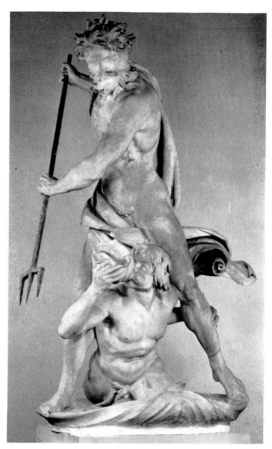

Fig. 159. Bernini: LONGINUS. St. Peter's, Rome.

Fig. 160. Bernini: NEPTUNE AND TRITON.
Victoria Albert Museum, London.

Fig. 161. Venturini: ENGRAVING OF THE PESCHIERA IN THE GARDEN OF THE VILLA MONTALTO.

on this occasion, 'a prodigious genius is still to come who will make, here beneath the cupola and there in the apse, two huge piles proportionate to the dimensions of this church.' To which Bernini replied, like Radamès in the opera *Aida*, *O fussi pure quello io*. In the summer of 1624 he received his first commission for the church, for a bronze baldacchino to replace the baldacchino set up by Paul V over the high altar, and in 1628, on the Pope's orders, he turned his mind to the piers beneath the cupola. This resulted in the commissioning of the Longinus and three companion figures for the niches in the piers. The significance of Bernini for St. Peter's falls outside the purview of this book. It can be argued that he was the only genius capable of furnishing the spaces of the church as they deserved. It can also be argued that his sympathies with Renaissance art were so restricted, and his creative processes so emotive and unintellectual, that he was temperamentally unfitted for the task. There can be no doubt, however, as to the significance of the commissions for Bernini. They transformed him from a sculptor of human dimensions to a sculptor of superhuman size; they precluded all the subtleties with which his earlier works were filled; and they compelled him to adopt a style which would be legible at a great distance from the eye. In short, they forced him to assume a scenographic attitude towards sculpture.

Of the four colossal statues in the piers beneath the cupola one, the Longinus (Fig. 159), was executed by Bernini, and two were allotted to sculptors with established reputations, the St. Veronica to Mochi (Plate 161) and the St. Andrew to Duquesnoy (Plate 160). The fourth and weakest of the statues is by Bernini's pupil Bolgi. Had the plan been set in motion a few years later, this figure might have been entrusted to Algardi, a Bolognese who had arrived in Rome in 1625, but who was still an unknown quantity in 1628 as far as large-scale sculpture was concerned. Duquesnoy's St. Andrew was the first of the statues to be begun. A Fleming, Duquesnoy was associated throughout the whole of his career in Rome with the rigid classicism of Domenichino and Poussin, and his St. Andrew reads like a figure by Domenichino invested with a third dimension and magnified. According to Bellori, whose sympathies lay with Duquesnoy rather than Bernini, it shows the Saint 'with head raised in the act of gazing up to heaven; behind his shoulders is the cross formed from two tree-trunks. He caresses one of them with his right hand, and stretches out his open left hand in token of divine love in the glory of his martyrdom.'

Mochi's St. Veronica is less placid and less refined. Based on a Niobid figure, it shows the Saint moving forwards, open-mouthed as though announcing the tidings of the miracle, with the veil held out in her excited hands. The most novel feature of the statue is its insecurity of stance, and it was attacked by another classicising critic, Passeri, on that account. Its motion, declared Passeri, was that of running; it was not stable and immobile, as statues ought to be, but showed a passer-by who would not stop. If the noun statue derived from the verb 'stare', argued Passeri, the figure violated one of the essential principles of statuary. Nowadays we would criticise the Veronica not for its movement, but for the haphazard relation between the statue and its niche, and the standard of our criticism would be the

Longinus of Bernini. Owing to their size, none of the statues could be carved from a single marble block. None the less, the Veronica is posed by Mochi in the same constricted fashion he would have adopted had he been carving a smaller figure from one block. The Longinus, on the other hand, is represented in an open pose, with arms outstretched across the niche, gazing up at an imaginary Christ; the drapery no longer clings to the contours of the body but is disposed with great bravura and audacity in a manner that is overtly rhetorical. In both respects the statue marks a break with the Hellenism of Bernini's early groups, and introduces a new view of religious sculpture as drama and of the statue as relief.

The motives which led Bernini in this and later works to explore the dramatic possibilities of sculpture are not difficult to reconstruct. He was a devout man, but his character, so far as we can judge, was free of the least trace of introspection. In his sculptures after the Longinus he remains the inspired illustrator of the mythologies, but the stories he recounts are hagiographical. He retained his interest in illusion, though the emphasis now shifted from surface illusion to illusion of a more far reaching kind. His object was to build up a convincing image not of the real world but of a world of unreality. The point at which this change occurs coincides with the emergence of his interest in the stage. While engaged on the Longinus, he was devising the celebrated sunrise for the comedy *La Marina* and was producing the *Inondazione del Tevere* with its famous depiction of a flood. This theatrical experience reacted on his sculptures, not in the sense that the sculptures became meretricious, but that he tended to invoke theatrical devices to perpetuate transitory effects. The supreme instance of this is the work which he himself regarded as the finest that left his studio, the Ecstasy of St. Teresa (Plates 150, 151, Fig. 163).

For the St. Teresa Bernini built not a simple aedicula flanked by paired columns and pilasters like that in Santa Bibiana, but a protruding polychrome tabernacle containing an elliptical stage. The stage is lit from above, and the daylight directed on the scene is given a celestial character by means of coloured glass, and metal rays which pour down on the vision of the Saint. Stendhal complained that the language of the group was that of profane love, and the relation between the Saint and Angel is indeed almost embarrassingly physical. But the analogy with profane love is implicit in the Saint's own narrative, and in their coloured marble tabernacle against a rich brown ground Bernini's figures take on a visionary quality that is perfectly consistent with the Saint's account of her own mystical experience. Just as the early groups mark the ne plus ultra of mythological narration, so the St. Teresa represents the climax of Baroque religious narrative.

In 1646, while the chapel for which the St. Teresa was designed was being built, but before the two figures were begun, Bernini embarked on a secular counterpart, an allegorical two-figure group. It represented Truth unveiled by Time, and only one of the two figures, the Truth (Plate 152), was carved. Most of what we know of Bernini's intentions for the Time derives from a conversation that he had in France. He proposed, he said, to depict Time flying through the air, and underneath to illustrate the consequences of its passage, in the

form of mausoleums and broken columns. Without these supports, he added jokingly, his Time would never fly, even though it were supplied with wings. Drawings prove that the figure of Time would have been shown in profile, holding a scythe, and that the drapery veiling the Truth would have been caught up in his right hand. As we see it in the Borghese Gallery to-day, the Truth is difficult to read. Her drapery, which would have been suspended from the second figure, stands up stiffly like an obelisk, and with her left hand she makes a gesture of surprise which becomes meaningful only when we remember that her naked form has been unexpectedly disclosed, and that her face is turned towards her deliverer. Had it been completed, the allegory would have corresponded exactly with the St. Teresa; its subject is momentary action, it has the character of a relief, and once more it is planned with a single view. Bernini intended the group for his own house. There is no evidence as to how he proposed that it should be displayed, but he may have intended to supply it with an architectural setting, and with its own illumination, in this case a window on the right.

Lest we should feel disposed, as from time to time we may, to question the validity of these devices, it is as well to examine the predicament of sculptors who rejected them. The most notable of them was Bernini's rival Algardi, who under Innocent X enjoyed a brief period of preferment at the papal court. The first works that Algardi carried out in Rome, two stucco statues in San Silvestro al Quirinale, are carefully meditated figures, the style of one of which derives from the Santa Bibiana of Bernini. But thereafter the two sculptors parted company. Algardi was an earnest, rather convention-ridden artist, who felt no temptation to break down the accepted categories of statue and relief. Of the two altars for which he was responsible one, in St. Peter's (Plate 167, Fig. 165), is executed in relief, and the other, at Bologna (Plate 168), is composed of two free-standing statues. In both cases transitory action forms the subject of the scene. At Bologna the figures of St. Paul and his executioner are placed beneath an open tabernacle, and can be inspected from the back and sides as well as from the front. The kneeling figure of St. Paul represents Algardi's work at its impressive best, but the executioner, shown with sword raised above his shoulder, fails to transmit the tension which the artist intended to convey. Algardi's second altar, which shows Attila cowering beneath the vision of St. Peter and St. Paul, was a substitute for an unfinished painting, and is one of the very largest reliefs that has ever been produced. The forward figures are carved almost in the round, but their effect is irretrievably impaired by static figures in the background, and only when we look at the altar across the whole width of the transept are we aware of the effect Algardi was endeavouring to create. Just as the nerveless figures of the Bologna altar explain why Bernini concentrated on a single viewing point and disregarded the conventional free-standing statue, so the altar in St. Peter's explains why he turned his back on the conventional relief.

The supreme achievement of Bernini the magician is the second of the two colossal works he executed for St. Peter's, the Cathedra (Fig. 166, Plates 154, 155). This project grew from comparatively simple origins. Under Urban VIII a new installation was devised for the relic

of St. Peter's Chair, and throughout the reign of his successor this was preserved. But no sooner was Bernini's patron Fabio Chigi elected to the papacy than it was decided to move the relic to the apse. The case for this change was a double one; it was doctrinal in so far as the relic formed a natural climax to the relics housed beneath the cupola and to St. Peter's tomb, and it was visual in so far as it offered an excuse for a monumental structure in the apse, the need for which Annibale Carracci had pointed out half a century before. The site selected was the central niche, which was flanked by the tombs of Pope Urban VIII and Pope Paul III. According to Bernini's initial plan (Fig. 167), the relic was to be installed inside the niche behind an altar, and was to be physically supported by four statues of the Doctors of the Church. This scheme was thought out in relation to the papal tombs, and the architecture of the niche therefore remained intact. But the niche was visible through the baldacchino, and by 1658 the logical inference was drawn, that the Cathedra must be conceived in relation to the baldacchino, not the tombs. The altar was accordingly brought forward, so that the foremost Doctors of the Church stood free of the flanking columns; the throne was represented as though mystically suspended in the air and was surmounted by two putti bearing the tiara; and the architecture of the upper part was neutralised by a pair of kneeling angels above the capitals and by a glory of rays between them. From this plan there emerged the Cathedra as we know it now. The whole structure, and not merely the forward figures, was set free of the columns, was broadened out, so that the niche became invisible, and was raised, so that the glory at the top penetrated to the level of the capitals of the great pilasters in the apse. This final change was achieved in two stages, not one, for when in 1660 a wooden model of the structure was set up, it was found to be too small, and the sketches which had been made for the angels beside the chair and for the Doctors of the Church had thereafter to be enlarged. Throughout this last phase in the evolution of the scheme, scenographic considerations were dominant, and the work was thought of as what it still remains to-day, the culminating feature of the church.

As Bernini's ambition swelled, the Cathedra outgrew not simply its architectural setting, but the accepted categories of design. It contained, in the foremost Doctors of the Church, figure sculpture of great distinction, and on the throne were three reliefs, but in its totality sculptural considerations played a secondary part. The glory of angels, part bronze, part stucco, belongs in the realm of theatrical production, not of sculpture, and the device of the dove on an oval of amber-coloured glass, striking as it must have seemed when it was planned, has no enduring significance. Bernini's temperament and his imagination, his facility and his ability to improvise, offered a constant temptation to expand beyond the scale fitted even to his own gigantic talents, and for all its brilliance and originality the Cathedra is, as design, fatally diffuse. There can be no question of the seriousness with which Bernini approached his task, but what resulted is something less than a great work of art.

In the Cathedra Bernini the sculptor is temporarily obscured by Bernini the magician, but as he aged it was the sculptor who came once more to the fore. Work on the Cathedra was

no more than begun when his attention was diverted to a second papal project, the Chigi Chapel in the Duomo at Siena. This work was carried out by the same assistants as the Cathedra – it was supervised by the painter Giovanni Paolo Schor, its bronzes were cast by Artusi, and two of its four marble sculptures were by Raggi and Ercole Ferrata – but Bernini made the models for two statues and himself carved one of them, a St. Jerome. Of the four niches in the chapel two beside the altar are visible from the body of the church, while two beside the entrance can be seen only from inside. It might have been expected that the artist of the Cathedra would reserve the altar niches for his own statues, but he chose instead to fill the niches on the entrance wall. In his youth he had looked upon the niche as a containing frame, but by the sixteen-fifties he considered it a background and nothing more. The implications of this change are already evident in the Chigi Chapel in Santa Maria del Popolo, where he filled the pre-existing niches with obstreperous figures of Daniel and Habakkuk that bulge out of their setting and violate the architectural scheme. In Siena there were no alien elements. The devout figure of St. Jerome (Plate 156) emerges from its niche as though from the entrance to a cave, and the architecture is twice broken on the right by the Saint's fluttering drapery and his extended hand.

In one subsequent commission this pattern recurs. In 1667 Alexander VII's successor in the papacy, Clement IX, intent upon leaving his own mark on the Roman scene, chose as his sphere of operation the principal bridge across the Tiber, the Ponte Sant'Angelo. His plan was to provide it with a balustrade, to remove the classicising stucco figures of Raffaello da Montelupo which had been placed there by Paul III, and to instal instead ten marble angels holding the instruments of the Passion. Bernini was the stage director of this enterprise, and the individual figures were allotted to sculptors in his orbit, but as at Siena he retained control over two statues. In 1669 the Pope inspected them, and gave instructions that copies should be substituted for them on the bridge, and to this we owe their preservation in Sant'Andrea della Fratte. Baldinucci describes how Bernini in old age, whenever he was not engaged in architectural projects, would work tirelessly till seven in the evening on his marble sculptures, with a boy beside him to ensure that in a moment of abstraction he did not tumble off the scaffolding. 'Let me be, I am in love,' he would reply when he was asked to rest, and such was his concentration that he seemed to be in ecstasy. It appeared, says Baldinucci, that the force to animate the marble was projected from his eyes. Before the Angels in Sant'Andrea delle Fratte all this is credible. One of them, the Angel with the Superscription (Plate 157), is fully autograph, while the other, the Angel with the Crown of Thorns, is in part by the same hand as the Magdalen at Siena, but both spring from a single impulse, and they speak to us, not with the boisterous egotism of the dramatist and the designer, but with the humble voice of the dedicated marble sculptor.

In these works the tide of drama which had carried forward so many of Bernini's earlier sculptures ebbs, and when in 1671 he began work on his last great sculpture, the Death of the Beata Lodovica Albertoni (Plate 158), he rejected the flamboyant idiom of the St. Teresa, and

cast it in a more restrained, more tranquil style. The scene is again set above the altar, and is again supplied with its own source of light, but the setting is now relatively simple, and at the back there is a painted altarpiece. Bernini's subject, the moment when the Saint's soul leaves her body, has more in common with the *Metamorphoses* illustrations of his youth than with the sculptures of his middle years, and the fact that the statue was intended to be shown almost at eye level enabled him to treat the surface with a softness and delicacy that recall the early groups. No longer was it necessary to force the figure forward on to a single plane, and instead it could be planned, like the Borghese groups, as an image that was fully in the round. Bernini himself set no store by the concept of 'style of old age'. Confronted in France with a late work by Poussin, his only comment was that 'at a certain age one must stop working.' But the Beata Lodovica Albertoni, which was carved when he was almost eighty, is treated with a mellowness and a disdain of ostentation that would have been unthinkable at any earlier time. It is on this sublime figure rather than on the St. Teresa that his claim to be accepted as the peer of the very greatest Italian artists must ultimately rest.

BERNINI AND THE PAPAL TOMB

AFTER the rebuilding of St. Peter's only two papal monuments were set up in the church. The first and more remarkable was Guglielmo della Porta's tomb of Paul III, which was moved in 1587 to the south-east niche beneath the cupola. The second, the tomb of Gregory XIII by Prospero Antichi, was demolished in the eighteenth century. A much less distinguished work, it conformed to Guglielmo della Porta's tomb in so far as its main feature was a seated statue of the Pope with two reclining figures on volutes at his feet. These tombs were joined in 1621 by Pollajuolo's monument of Innocent VIII (Vol. II, Fig. 71), reconstituted in accordance with the dictates of contemporary taste, with the seated statue of the Pope set over the sarcophagus.

In 1627, when it was decided to fill the niches beneath the cupola with statues, it became necessary to move the tomb of Paul III, and this roused in the reigning Pope an interest in his own tomb. The Sistine and Pauline Chapels in Santa Maria Maggiore had been erected as funerary chapels during the lifetimes of the Popes from whom they derived their names, and it was natural that Urban VIII, who had contributed so much to the interior of St. Peter's, should be commemorated there. At first the two projects were distinct; it was proposed to install the tomb of Paul III in a niche on the right side of the tribune opposite the papal throne, and to build a monument for Urban VIII between the tribune and the altar of St. Leo nearby. But before long they merged, and it was ruled that the tomb of Paul III should be installed in a niche on the left of the tribune, not the right (the reason for this was that the seated figure would otherwise have looked into the apse), and that the tomb of Urban VIII should fill the right-hand niche. Bernini was the instrument by whom this change was brought about.

Bernini seems to have modified the tomb of Paul III (Fig. 145) in two respects; he increased its height, so that the head and shoulders of the effigy projected above the cornice of the

niche, and he increased its width, so that the two allegories, instead of being close together in the centre of the base, were opened out. The effect of these changes was to transform the tomb into a triangle or pyramid, and this form was in turn imposed on the tomb opposite. If the two monuments were to correspond, the mediums used by Guglielmo della Porta – bronze for the statue of the Pope and marble for the supporting figures – must also be employed in the new tomb. The style of Guglielmo della Porta's figure sculptures was uncongenial, and for his papal portrait type Bernini turned back to the tomb of Gregory XIII. A drawing made before this tomb was destroyed proves that it showed the Pope with right hand raised and his left arm extended beneath his cope, in a pose that forms a precedent for that adopted by Bernini. The allegories on the tomb of Gregory XIII were set on volutes like those of Guglielmo della Porta, but their bodies were shown erect above the hips. From such figures it was only a short step to the standing Virtues of Bernini's tomb. If, however, the Virtues were to be shown standing, it was necessary to fill the space between them, and this led Bernini to introduce a feature that was present in neither of the earlier tombs, a sarcophagus in the form of an ornamented variant of the tomb-chests in the Medici Chapel. This had the advantage that the allegories could be shown leaning against its ends, so that their bodies fell along the sides of the notional triangle round which the tomb was planned.

It is wrong, however, to think of the tomb of Pope Urban VIII (Plate 146) as the outcome of a single inspiration. It was commissioned in 1627, was still unfinished when the Pope died in 1644, and was not completed till 1647, twenty years after it had been begun. The magnificently virile figure of the Pope was cast in 1631. The group of Charity, though blocked out in 1634, was not carved till after 1639, and work on the Justice did not start till 1644. While therefore the statue of the Pope dates from the period of the baldacchino, the two Virtues stand on the threshold of the Truth Unveiled and of the St. Teresa. The Justice is a relaxed figure, animated only by its profuse drapery, but the Charity (and in this it is typical of the time at which it was produced) is planned as a dramatic group, in which the attention of the female figure is momentarily caught by a child clutching at her skirt. A wooden model for the sarcophagus was prepared in 1630, but the form of the epitaph was not decided on till 1639, so that this also belongs to the dramatic world of Bernini's middle age; it shows a bronze skeleton inscribing the Pope's name in a book placed asymmetrically on the plinth. From this time too date the Barberini bees climbing up the base.

It was one thing to decide that St. Peter's should be adorned with tombs, another to discover persons who could be suitably commemorated in this way. One such was the Countess Matilda, the eleventh-century benefactress of the Holy See, and in 1633 the Pope sent to Mantua for her bones. Bernini's tomb of the Countess Matilda (Fig. 164) is a perfunctory work. In a statement of 1644 he claimed to have made models for all the figures, and to have carved certain of the marbles, but his models were in the main entrusted to assistants, and the tomb is lifeless in handling and relatively undistinguished in design. It includes one innovation of importance, a trapezoidal relief on the sarcophagus. Hardly was it begun than

this feature was taken over in the second supererogatory monument put up in the church, the tomb of Pope Leo XI who had reigned for just under a month in 1605. The Leo XI monument (Plate 166) is the first important work by Alessandro Algardi. Algardi approached his task in a less imaginative spirit than Bernini. He resisted the use of coloured marble and the mixed mediums of the Urban VIII tomb. The niche in which his monument is set is faced in white, and the tomb itself consists of three white marble figures and a white marble sarcophagus. He rejected the buoyant visual rhythms of Bernini's Virtues. His own figures of Majesty and Liberality stand erect against the edges of the niche, and one of them is based on a classical Athena in the Museo delle Terme for whose restoration he had been responsible. To the classical theorists of the Seicento Algardi seemed superior to Bernini because he was more orthodox, but the tomb of Leo XI is in fact a sadly uninventive work. None the less its influence was very great, for like all academic art it could be imitated, and its effects were felt as late as the middle of the eighteenth century in the tomb of Pope Benedict XIII.

Not till the last years of the reign of Alexander VII was Bernini again engaged upon a papal monument. He was almost seventy at the time, and Domenico Bernini tells us that he agreed to undertake the tomb 'on account of his gratitude to the memory of this prince . . . notwithstanding his age and the decline of his strength which made him daily less capable of such work.' Where the Urban VIII monument belongs to a traditional tomb type, the monument of Pope Alexander VII (Plate 147) is conceived as an apotheosis. In its early stages there was some doubt as to the destination of the tomb. At first it was intended for St. Peter's, but the architectural aspirations of Alexander VII's successor, Clement IX, centred upon Santa Maria Maggiore, and he devised a plan for reconstructing the choir of the basilica and installing in it his own and his predecessor's monuments. Fortunately he died before this barbarous scheme was realised, and his successor, Clement X, transferred the tomb once more to St. Peter's where it was completed in 1678 shortly before the sculptor's death. Unlike the Urban VIII tomb, which is contained within the framework of its niche, the tomb of Alexander VII has no specifically architectural character. When he designed it, Bernini had the experience of the Cathedra behind him, and to it he brought the same preconceptions. The area of the niche is treated like a stage, and the four supporting allegories are disposed in depth, like the Doctors of the Church below the Cathedra, with Charity and Truth in front and Justice and Prudence in half-length at the back. In the centre of the stage on a high plinth is the statue of the Pope, represented not in a conventional seated posture as a temporal ruler, but kneeling in an attitude of prayer. Praying statues were adopted in Santa Maria Maggiore for the tombs of Sixtus V and Paul V, and the decision to portray Alexander VII in the same way is a survival from the time when his monument was destined for this church. Over the front of the stage falls a Sicilian jasper shroud; Bernini intended that the Truth in the right foreground be shown naked enveloped in its folds. At the back of the niche was a door, which was brought forward and incorporated in the tomb, and from it there emerges a bronze skeleton placed immediately above in the centre of the shroud.

Fig. 163. Bernini: THE CORNARO CHAPEL. S. Maria della Vittoria, Rome.

Fig. 162. Bernini: HIGH ALTAR. S. Bibiana, Rome.

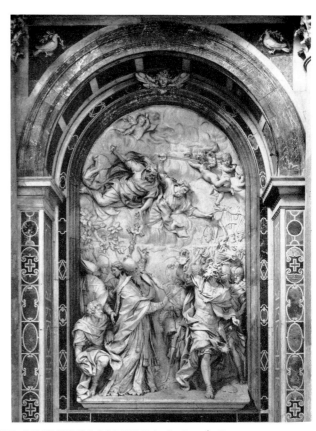

Fig. 164. Bernini: MONUMENT OF THE COUNTESS MATILDA. St. Peter's, Rome.
Fig. 165. Algardi: THE MEETING OF ATTILA AND POPE LEO THE GREAT. St. Peter's, Rome.

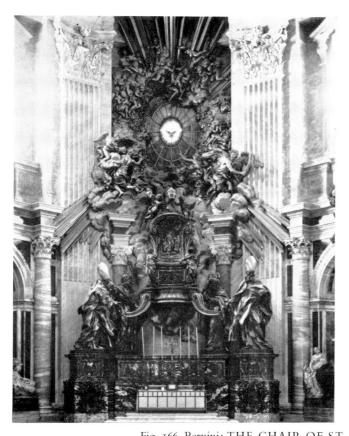

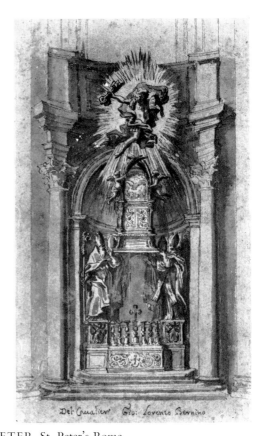

Fig. 166. Bernini: THE CHAIR OF ST. PETER. St. Peter's Rome.
Fig. 167. Studio of Bernini: DRAWING FOR THE CHAIR OF ST. PETER. H.M. The Queen, Windsor Castle.

The conception of the tomb is incomparably vivid, and might have given rise to one of the very greatest sepulchral monuments. But the merit of Bernini's sculptures is inseparable from the work he did on them himself, and though he made small models for the figures – two of them survive – he left their execution to other hands. The only areas in which he may himself have intervened are in the hands and forehead of the Pope. The statue of the Pope was entrusted to Michele Maglia assisted by two other sculptors; the Charity, the least insensitive of the supporting figures, was allotted to the Sienese Mazzuoli; the Truth was begun by Lazzaro Morelli and the Prudence by Giuseppe Baratta, and both were finished by Giulio Cartari, who also carved the Justice. It would be unreasonable in these circumstances to expect the sculptures to attain a significant level of expressiveness, and there remains a gulf between the monument as a celestial idea and the monument as earth-bound fact.

BERNINI AND THE BAROQUE FOUNTAIN

THROUGH the later sixteenth century the influence of Florentine fountain design spread southwards. In Sicily, where Montorsoli's fountains at Messina were already a familiar sight, a third Florentine fountain (Fig. 168) was installed in 1573. It had been commissioned in 1550 by Don Pedro da Toledo, the father of Eleanora of Toledo and the father-in-law of Cosimo I, for his villa outside Florence. Owing to the death of Tribolo it was entrusted to a minor sculptor, Camilliani. Two years after it had been begun, Don Pedro da Toledo himself died, and work was suspended till 1570, when the six hundred and fifty odd pieces of the fountain were bought from Don Garzia da Toledo by the city council of Palermo for use in the Piazza Pretorio. The fountain was added to in 1573, and there is some doubt as to which pieces formed part of the original, but one of them certainly was the central element, a shapely but uninspired derivative from the Tribolo fountains at Castello.

In Rome fountain design was the preserve of architects, not sculptors, and fountains were thought of mainly in architectural terms. Even the beautiful fountain at Loreto was originally planned (1604) by Fontana and Maderno without figure sculpture. In a few exceptional fountains a sculptural component was envisaged from the start. This was the case with the Fountain of the Tortoises (Fig. 169), the most distinguished Roman fountain of its time, which resulted from collaboration (1585) between Giacomo della Porta and the Florentine sculptor Landini. It is a work of great elegance and charm, in which the architecture and the figure sculpture coexist but are not satisfactorily merged. In the most elaborate of the fountains of Domenico Fontana, the Fountain of Neptune which was planned for a position near the Arsenale in Naples and is now in Piazza Bovio, the figure sculpture is again ancillary to the design. Among the artists who worked on this fountain was Pietro Bernini (1600–1). Gian Lorenzo Bernini undertook no fountain sculpture before the early sixteen-twenties, but by some strange coincidence his earliest fountain group was imposed upon a setting by Fontana, an oval pool known as the Peschiera or Peschierone designed in 1579–81 for the garden of

the Villa Montalto (Fig. 161). Built on the Viminal, the pool was cut into the hill, and was surrounded by a balustrade with a row of antique statues. The statues were a rather heterogeneous company – they included two Mercuries, an Apollo, two Roman emperors and some fauns – and had little in common save their psychological detachment from the pool. It was for this setting that Cardinal Montalto, the nephew of Pope Sixtus V, commissioned the Neptune and Triton in London (Fig. 160). For Bernini, fresh from the Borghese David, the commission offered an occasion to plan a figure which would perform an active role in relation to its site. He was working at the time on the group of Apollo and Daphne, which was drawn from the *Metamorphoses*, and a passage from the *Metamorphoses* supplied him with the inspiration for his fountain group. It describes how, after the flood, Jupiter orders the sea to be recalled. 'Then Neptune,' writes Ovid, 'called to the sea-god Triton, who rose from the deep . . . (and) bade him blow on his echoing conch-shell, and recall waves and rivers by his signal. He lifted his hollow trumpet, a coiling instrument which broadens out in circling spirals from its base. When he blows upon it in mid-ocean, its notes fill the furthest shores of east and west. So now too the god put it to his lips . . . and blew it, sending forth the signal for retreat as he had been bidden. The sound was heard by all the waters that covered earth and sea, and all the waves which heard it were checked in their course.' The water entered the pool from the high ground at the further end, and there, on a rocky plinth, Bernini depicted Triton blowing his conch-shell at Neptune's bidding, and the sea-god thrusting his trident downwards as he controlled the waves.

At only one place was the Roman fountain in the sixteenth century freed from the pedantic pattern imposed on it by Lombard architects. This was the Villa d'Este at Tivoli, where Ippolito II d'Este, before his death in 1572, planned or commissioned a whole series of fantastic fountains. The most widely publicised, the Water Organ, was begun in 1568, and in 1572 played to the delighted ears of Pope Gregory XIII. Its counterpart at the opposite end of the terrace, a Fountain of Neptune, in which Neptune was to be depicted driving a chariot with four sea-horses across the water, was never built, but in 1567 work started on the Fountain of Rome, which had as its centrepiece a reconstruction of the ancient city by Ligorio, and in 1569 there was built the Lane of the Hundred Fountains, adorned with stucco reliefs from the *Metamorphoses* and twenty-two stone boats. The fountains at Tivoli supply the background to the first independent fountains designed by Bernini. The most remarkable of these, the Fontana dell'Aquila in the Villa Mattei (1629), has been destroyed, but we know from engravings that it was set against a cliff, and consisted of a shallow, shell-like basin supported by three dolphins. In the basin stood three upright scallop shells, and above them, as though alighting on the rock, was a colossal eagle with outstretched wings. Another fountain in the same garden showed a Triton in a round basin, and this prepared the way, in the mid-thirties, for a more ambitious work of the same kind, the Fontana del Tritone (Fig. 170). In the Neptune and Triton for the Villa Montalto sculpture and water were still treated, as they had been through the sixteenth century, as opposing elements. But in

the Fontana del Tritone the barrier between them is broken down, and the whole body of the fountain becomes a natural form rising mysteriously from the water and liable once more to be submerged. The notion of architecture is abandoned, and the basin is a shell raised above the water by the united efforts of four dolphins, with, in its centre, a sea-god blowing on his conch. The effect of this change was to liberate not only the sculpture of the fountain but the water too. In a drawing at Windsor for the Fontana del Tritone (Fig. 171) we see an ideal water pattern for this fountain, with three powerful jets issuing from the conch, one thrown high into the air and the others pouring down in curtains of water at the sides. Water had a recurring attraction for Bernini. Years later in Paris, watching the water swirling under the Pont-Neuf, he complained of the meanness of the fountains at Saint-Cloud, and through his whole life he was fascinated by the possibility of using water to enhance the simulated movement of the sculpture with which it was juxtaposed.

The credit for harnessing Bernini's energies to a great public fountain belongs to Pope Innocent X, who after his election to the papacy in 1644 determined to improve the amenities of the Piazza Navona in which the palace of his family was set. In the centre of the square was a marble trough installed by Pope Gregory XIII, and the first thought of the Pope was to replace it with a fountain. For this purpose water was fed from the Acqua Vergine into the square. The designated architect of the new fountain was Borromini, who had been entrusted with the reconstruction of St. John Lateran in the preceding year. Meanwhile an event occurred which determined the form the new fountain would assume. This was the discovery near San Sebastiano of a colossal obelisk. One Thursday afternoon in April 1647 the Pope visited the obelisk, and decided to install it in the square. Contemporaries had no doubt of his motives in doing this; he was, they said, following in the footsteps of Pope Sixtus V, whose architect, Fontana, had erected the obelisk outside St. Peter's. From this visit there sprang the plan for a fountain crowned by an obelisk.

Bernini, as a Barberini protégé, was in disfavour with the Pope, and at first his name did not come into question for the commission. But at the suggestion of Prince Niccolò Ludovisi, a nephew by marriage of Innocent X, he made a model which was shown by a stratagem to the Pope. This model gained him the contract for the fountain, and re-established his relations with the papal court. If it was identical with an early model for the fountain that still survives, it showed the obelisk set on a rocky base, with pairs of seated figures lifting up the papal arms. In a drawing at Windsor (Fig. 173) which is probably a little later than this model the lifting motif is abandoned, and two seated figures are shown holding the papal shield with their arms lowered. But Bernini evidently felt that the function of the figures as supporters restricted the design. So in the final version (Fig. 174) the shields and figures were divorced, and the figures were shown lying down. This new scheme had two advantages; the figures could be set in a seemingly arbitrary fashion on the plinth, leaning outwards from the surface of the rock, and they could also be posed in such a way as to establish the circular horizontal rhythm that the base of so high a structure required. From the very first Bernini

intended to pierce the rocky base. The transverse views of the piazza in which this resulted were of no consequence, and the significance of the device was rather in relation to the obelisk, which must seem to have no proper support and to be poised precariously on the rock. The four figures contribute to this illusion, above all the Rio della Plata, which is shown staring in wonder at the obelisk balanced above.

The programme of the fountain was constant from the first, for the four seated figures in the model, like the reclining figures which succeeded them, represent the four great rivers of the world. As they were eventually carved, they show the Danube, with a lion, the Nile (Plate 153), with its head covered by a cloth denoting the obscurity which for so long covered the continent of Africa, the Ganges, with an oar indicating the extent of its navigable waters, and the Rio della Plata, accompanied by coins symbolising the riches of America. Bernini did not work extensively on any of these figures, and for that reason they are not uniform in style. The Rio della Plata (which was entrusted to Francesco Baratta, who had worked with Bernini in the Raimondi Chapel in San Pietro in Montorio) and the Nile (which was entrusted to another Italian assistant of the master, Giacomo Antonio Fancelli) show a close understanding of Bernini's intentions, whereas in the Ganges (which was carried out by Claude Poussin) Bernini's model is assimilated to the static norm of French academism. Once the programme of the fountain was established, it was natural that the figures of the rivers should become the source from which the water springs. But here too Bernini's solution was a novel one, for the water gushes out irregularly from the rocks beneath the figures in broad streams which widen and enlarge the base, and play a structural part in the design.

After the Fountain of the Four Rivers was unveiled, attention veered towards the smaller fountain at the south end of the square. Designed in the late sixteenth century by Giacomo della Porta, it was roughly octagonal in form, with semi-circular projections filled by sculptured tritons on the four main sides. By the standard of the new fountain, its ground-plan was complicated, static and inert. We learn from a drawing that Bernini at one time considered reshaping it with a circular basin like that of the large fountain, and resiting the four tritons so that they corresponded with the four Rivers and were no longer set axially to the square. But for a variety of reasons, of which the most important was economy, this scheme was not proceeded with, and Bernini was allowed to do no more than supply the existing fountain with a new central element. The first proposal was for the papal insignia elevated in the centre of the fountain on a shell, but before long this was replaced by a design derived from the Fontana del Tritone, which showed a large shell raised vertically on the intertwined tails of three dolphins, with water cascading from the top. This design was carried out in marble – there is a payment of 1652 for *la Lumaca di Marmo retta da tre pesci* – and the shell was placed in the centre of the fountain. To the Pope's eyes it appeared too small, and Bernini was instructed to substitute a statue. He thereupon worked up a new scheme, recorded both in a drawing and a terracotta model, in which the fish from the base of the earlier design were supported on the shoulders of two tritons with their tails waving in the air. But this too failed to

meet the Pope's requirements, and was replaced by a plan for a flat shell raised on dolphins with a large Neptune standing on the top. The objection to this solution was that it did nothing to correct, and may even have tended to exaggerate, the rigid symmetry of Della Porta's scheme. This danger was eliminated in the fourth design (Fig. 172), where a shell developed from the second project forms a platform for the central figure, which is posed in such a way as to invest the static basin with the illusion of circularity. A conceit from the third scheme is preserved in the fish writhing between the triton's legs and ejaculating water from its mouth. Bernini's concern is once more with instability, communicated in this case by the precarious balance of the shell, the fish lifted from the waters of the pool, and the animated figure of the sea-god revolving on its own axis with superhuman force.

BERNINI AND THE BAROQUE BUST

IT might be supposed that Counter-Reformation Rome would offer a rich field for portraiture. Yet in practice there is no Roman equivalent for Vittoria's portrait busts, and little evidence of any wish to perpetuate the features of living individuals. Under Pope Sixtus V the continuing tradition of the papal portrait recaptured some of its vitality, but papal portraiture apart, the Roman sculptured portrait in the later sixteenth century is confined to faces peering down from circular or oval apertures in sepulchral slabs. Sometimes the faces are more lifelike and sometimes less, but scarcely ever do they achieve the status of a work of art.

The first sign of impending change occurred in 1605, when a portrait relief by a boy of seven was shown by his father to the new Pope, Paul V. Bernini a year before, had carved his father's portrait, and his interest in portraiture must have been coterminous with his awakening interest in sculpture. About 1612 he made an independent sculptured portrait, a bust of Paul V in the Borghese Gallery (Fig. 175). Because of its small size – it is little larger than a statuette – the first impression of it is modest and undemonstrative. But as soon as we bend over it, we discover that it marks a break with the convention of the Roman portrait. The structure of the head is perceived with preternatural clarity, and below, the rumpled collar of the alb and the irregular edges of the cope invest it with a sense of movement that no bust carved in Rome had ever had before.

We know something of Bernini's theory of the portrait. If, he declared, a candle were placed so that it threw the silhouette of any person in shadow on the wall, the shadow could be identified, since in no two men was the head set on the shoulders in precisely the same way. The first task of the portrait sculptor was to seize this image (le général de la personne, as Chantelou transcribed it when he took this conversation down), and only later should he study his sitter in detail. The force of this doctrine can be seen in Bernini's caricature drawings, where the sitter's character is established by distortion of the silhouette. In the sculptured portrait, Bernini argued, faithful imitation would not alone produce a natural effect. The portrait sculptor was compelled, by his own terms of reference, to transpose a coloured

model into monochrome, and just as a human face which had been whitewashed would be unrecognisable, so would his bust lack individuality unless he were sufficiently resourceful to redress the colourlessness of his medium by means of an empirical technique. To create an illusion of colour on the diversified white surface was therefore one of his prime tasks. When Bernini started work in Paris on the bust of Louis XIV, he observed that one side of the King's mouth was different from the other, and that there were differences also between his eyes and cheeks. The King's eyes, he commented, were lustreless, though that was no great disadvantage in sculpture, but his mouth was exceptionally mobile, and this made it necessary to study his head carefully, so as to seize the moment at which the features appeared at their most favourable. The point at which the features should be caught, he added, was when the lips tightened before speaking or relaxed from speech.

Bernini's conception of mobility was not restricted to the face. His son, Domenico, tells us that when he was engaged upon a portrait, 'he did not require that his sitter should stay still, but preferred that he should move and talk in his customary way, since in that fashion it was possible to see all of his qualities, and to depict him as he was. If he were motionless, he was less true to himself than if he moved, because movement revealed all those qualities which were peculiar to him and not to others, and which give authenticity to portraits.' A member of the French court who saw the King's bust when it was almost finished observed that though it had no arms or legs, it seemed to move, and Bernini certainly spared himself no pains to produce precisely this effect. In the lower part of his life busts movement is invariably implied.

In Rome Bernini's only rival as a portrait sculptor was Algardi, and if Algardi had discussed the theory and practice of the portrait, he would have expressed himself in an entirely different way. He was an advocate of static portraiture, and even in the finest of his life busts, the splendid portrait of Cardinal Laudivio Zacchia in Berlin (Plate 164), what he is representing is a man seated in a chair. The head is rendered with great sensibility, without distortion and in meticulous detail, yet there is an almost total lack of the immediacy and the directness through which, in Bernini's busts, the essence of the individual is isolated. Seldom has the human face been represented more delicately or more faithfully than in Algardi's busts, but when we translate them into flesh and blood we rapidly become aware of their deficiencies. In their own lifetimes, none the less, the two ranked equally as portrait sculptors. In 1650 the Duke of Modena, anxious to commission busts of himself and his brother Cardinal Rinaldo d'Este, proposed that Bernini and Algardi should each execute a bust. 'I say frankly,' he wrote, 'I am indifferent whether Bernini makes my bust or that of your Eminence,' adding that if Bernini's price were unwarrantably high, he would entrust Algardi with both busts.

Not all busts in Seicento Rome were necessarily life portraits. Soon after the accession of Urban VIII in 1623, Bernini was commissioned to carve portraits of the new Pope's parents, his uncle Monsignor Francesco Barberini (Plate 144), who had died when Bernini was a child, and the founder of the fortunes of the family, Antonio Barberini. Algardi, in particular, was

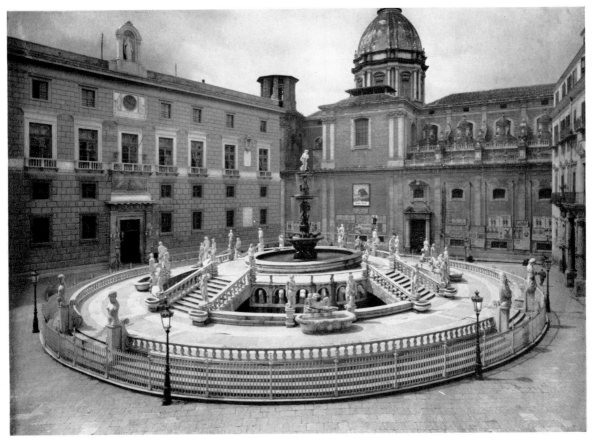

Fig. 168. Camilliani: FOUNTAIN. Piazza Pretorio, Palermo.

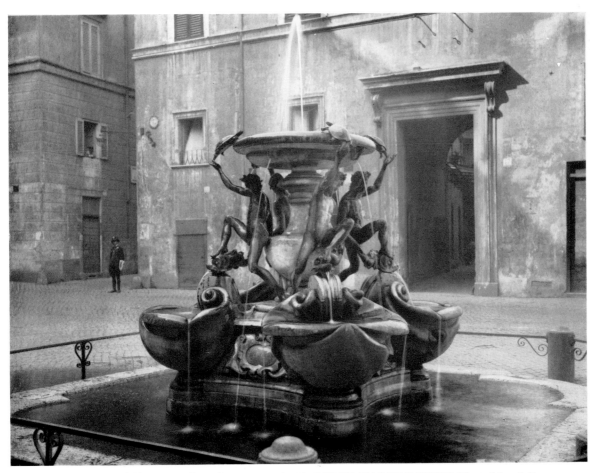

Fig. 169. Giacomo della Porta and Landini: FONTANA DELLE TARTARUGHE. Piazza Mattei, Rome.

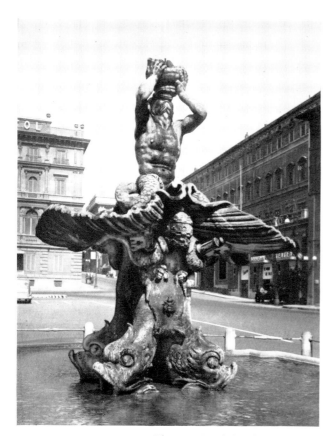

Fig. 170. Bernini: FONTANA DEL TRITONE. Piazza Barberini, Rome.
Fig. 171. Bernini: DRAWING FOR THE FONTANA DEL TRITONE. H.M. The Queen, Windsor Castle.

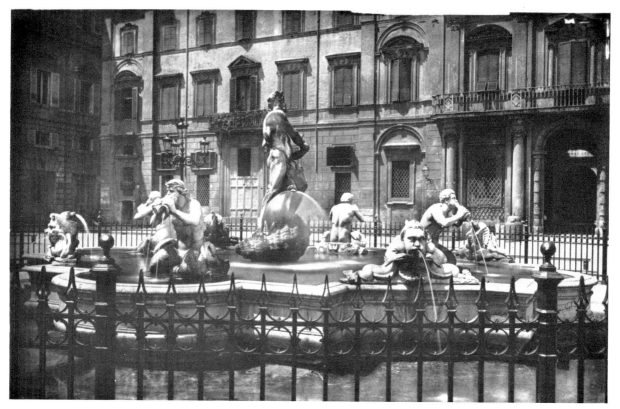

Fig. 172. Bernini: FONTANA DEL MORO. Piazza Navona, Rome.

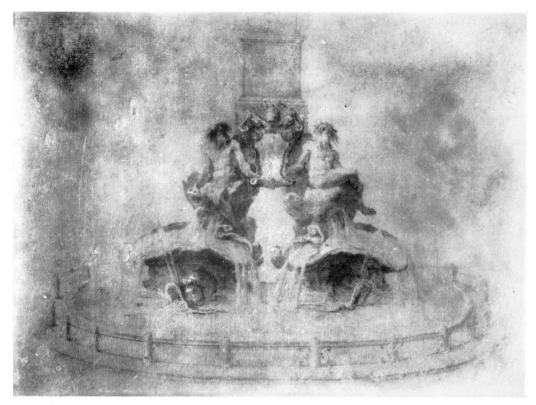

Fig. 173. Bernini: DRAWING FOR THE FOUNTAIN OF THE FOUR RIVERS.
H.M. The Queen, Windsor Castle.

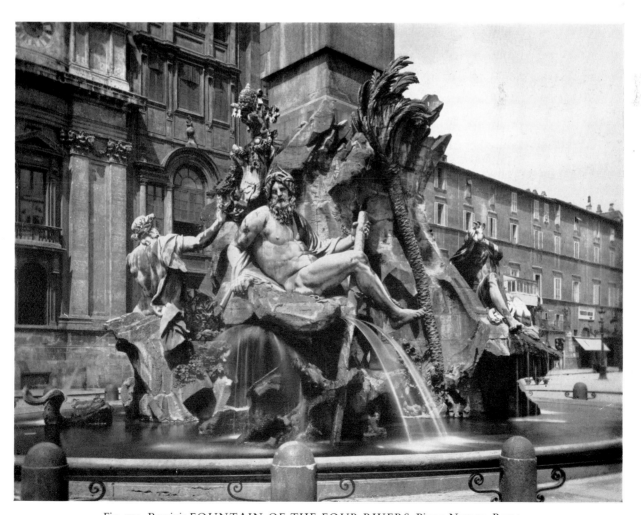

Fig. 174. Bernini: FOUNTAIN OF THE FOUR RIVERS. Piazza Navona, Rome.

Fig. 175. Bernini: POPE PAUL V.
Galleria Borghese, Rome.

Fig. 176. Bernini: COSTANZA BUONARELLI.
Museo Nazionale, Florence.

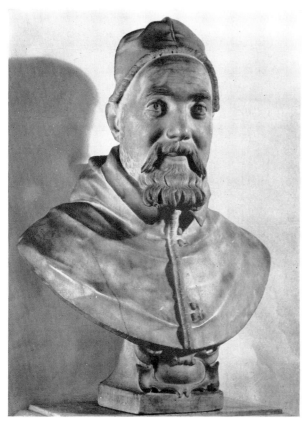

Fig. 177. Bernini: POPE URBAN VIII.
Prince Urbano Barberini, Rome.

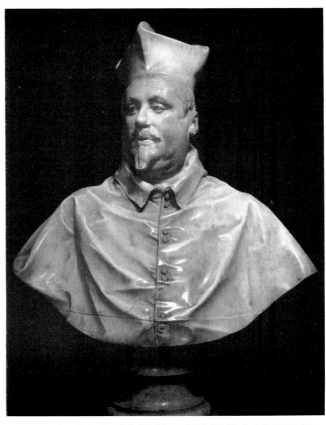

Fig. 178. Bernini: CARDINAL SCIPIONE BORGHESE.
Galleria Borghese, Rome.

a specialist in the carving of such portraits; one of the finest of them is the bust of Roberto Frangipane in San Marcello, and at the extreme end of his life he was engaged upon a bust of Laudivio Zacchia's brother, Paolo Emilio Zacchia, who had died in 1605 and whose features he was reconstructing from two paintings supplied by Zacchia's niece, Marchesa Rondanini. In the posthumous portraits of Algardi, the meticulous reproduction of detail comes to a sudden end, the features are generalised, and the body is handled with the freedom of figures in the Attila relief. Bernini's posthumous portraits, on the other hand, suffer from what can only be construed as loss. Marvellous as is the plastic continuity of the head of Francesco Barberini, and beautiful as is the contrast between the crumpled alb and the flat planes of the cassock that is worn over it, the bust lacks the intimation of direct experience that is the lifeblood of Bernini's portraiture.

There is another class of bust of which the subjects were indeed alive, but which were made without life sittings. The most celebrated of them is the lost bust of Charles I made from a portrait by Van Dyck, and they include the busts of Richelieu, probably after Philippe de Champaigne, and of Francesco I d'Este, after Sustermans (Plate 149). Bernini himself complained bitterly of the labour which these busts entailed. In one respect, however, they conferred on him a freedom he did not possess with the life portrait, the occasion to elaborate the meagre image offered by the painting with the free invention that was permissible in sculptures in other forms. The bust of Charles I (which for all its interest cannot have been one of Bernini's most significant achievements) was filled out with a scarf tied on the right shoulder and falling across the chest, while the superb bust of Francesco d'Este at Modena is enriched with drapery planned like that of St. Teresa, from which it takes on an adventitious emotive character. Indeed we may suspect that the long period of fourteen months which Bernini dedicated to the Este bust was not the outcome of necessity, but resulted from a disinterested fascination with the problems – the *recherche de particularités et délicatesses* in the face and flowing hair – that this extraordinary work involved.

Bernini's supreme achievements as a portrait sculptor none the less are his life busts, the Costanza Buonarelli in the Museo Nazionale in Florence, the twin busts of Cardinal Scipione Borghese, and the portraits of his first and greatest patron, Pope Urban VIII. These portraits are so direct, convey so strong a sense of speed in execution, and in one case, that of the second bust of Cardinal Scipione Borghese (Fig. 178), were indeed carved so rapidly, that they have sometimes been discussed as though they were the work of an inspired journalist. Not only is this view incorrect, but it may even be doubted whether there are any sculptured portraits in which the relation of the sculptor to his sitter is more intimate or more complete. Costanza Buonarelli (Fig. 176), Bernini's mistress for some years before his marriage in 1639, is a Latin sister of Saskia and Hélène Fourment. Cardinal Borghese was Bernini's patron for fifteen years before the portrait busts were carved, and Urban VIII, as Maffeo Barberini, had held the mirror for the self-portrait which Bernini introduced into his David, and impressed himself more strongly than any other individual on the sculptor's

consciousness. The expression of the sitter may be evanescent, and the action in which he is presented may be transitory, but neither was an arbitrary choice, and each bust presupposes a close knowledge not of the features only but of the mind behind the mask. By contrast the bust of Thomas Baker in London – an occasional portrait carved during the sixteen-thirties when Bernini was working on the bust of Charles I – does not transcend the level of excellent reporting.

The two busts of Cardinal Borghese seem to have been carved in 1632, and have their closest parallel in the statue of Charity on the Urban VIII monument which Bernini was cogitating at the time. The sitter's head is turned slightly to his right, so that on the right-hand side the corpulent neck projects beyond the level of the jaw, the biretta is set crooked, the lips are parted, and the sockets of the eyes are deeply cut. The sources unfortunately tell us nothing of the stages through which this extraordinary portrait (Plate 148) was evolved, nothing, that is, save that when it was complete a flaw was discovered in the marble across the forehead, and that Bernini thereupon, in fourteen days, produced a second version of the bust (Fig. 178). Not unnaturally the features in the second version are rather less lively than in the first. Where the two busts differ most strikingly is not in the head, but in the lower part, for the sculptor seems to have sensed that in the area of the chest and shoulders the forms were over-animated to the verge of triviality, and since fate offered him a second chance, he decided that they should be restrained and unified. In this sense the second bust constitutes a critique of the first.

Just as the transition from the Apollo and Daphne to the figures on the Urban VIII tomb can be charted in terms of finished statues, so the transition from the Francesco Barberini to the Borghese portraits can be charted in terms of finished busts, and of busts moreover of one sitter, Pope Urban VIII. Within the first week of Bernini's stay in France, Chantelou noted in his journal: *Le pape Urbain VIII, de qui il a été aimé et considéré dès sa plus tendre jeunesse, est cité par lui à tout propos.* Bernini's admiration for his patron found an outlet in eight portraits. Some of these busts are emblematic – a colossal bronze bust of the Pope at Spoleto, for example, conforms to the norm of papal portraiture – and the handling of others is inferior – a marble bust in the Galleria Nazionale in Rome is a case in point. But in the aggregate the psychological significance of this series of busts is very great. It opens in 1623 with a portrait in San Lorenzo in Fonte in Rome, in which the Pope is shown bare-headed and the treatment of the cope is still recognisably related to that of the small bust of Paul V. In the late twenties this is succeeded by a bust now in the collection of Prince Urbano Barberini (Fig. 177), in which the Pope looks outwards to his right with an expression of benign determination, his berrettino pushed back from his intellectual forehead, and his mozzetto cut in a semi-circle through the shoulders and the chest. Finally, about 1633, Bernini summed up his long relationship in a large bust (Plate 145), which is perhaps his finest sculptured portrait. In this the body is treated with extraordinary serenity, and is consolidated by means of an expedient taken over from the second bust of Cardinal Borghese, two horizontal folds running the whole

width of the chest. Above rises the majestic yet strangely introverted head, treated with an assurance and restraint, a sympathy and a compassion of which few sculptors have been capable.

For Bernini the art of sculpture was intuitive. In his youth he relived, as a spectator, the stories of classical mythology, and in his maturity he recreated the mystical experiences of the great figures of his age. His approach to portraiture was likewise through the imagination. For him the human personality was vibrant and alive, and could be captured only if the portrait bust were presented as the record of a reciprocal relationship. Each of his great portraits postulates the presence of a second figure, that of the sculptor, in the room. The standard by which his portraits must be judged is set not in Italy but in Spain and in the North by Velazquez and Rubens and Frans Hals, and in this exalted company it may be that Bernini, with his faith in portraiture as drama, was the most truthful portraitist of all.

THE HERITAGE OF BERNINI

BERNINI's death in November 1680 may seem an arbitrary point at which to bring this survey to an end. Why, it may be objected, is Baroque sculpture treated in so cursory a fashion, why are the contemporaries of Bernini not more fully dealt with, why are his followers not discussed? The answer to all three questions is implicit in the nature of Bernini's work. Bernini had a greater influence upon the art of his own time than any sculptor had ever exercised. He created a new type of religious sculpture, and so exactly did it meet the requirements of his age that it became an orthodoxy to which other artists, voluntarily or reluctantly, conformed. But his style, though widely imitated, was inimitable, because it presupposed a unique conjunction of great gifts. It presumed the ability to vitalise a more than life-size statue so that it retained the animation of a clay maquette. It presumed an imagination so vivid that the work, despite its enlarged scale, preserved its original intensity. It presumed the capacity to approach each commission freshly, and without reference to a preconceived repertory of forms. None of his contemporaries or followers measured up to these requirements. The most resourceful of them, Melchiore Caffà, in the Ecstasy of St. Catherine of Siena in Santa Caterina a Magnanapoli in Rome, explores no world of feeling that Bernini had not explored before. Ercole Ferrata, whose small models prove him to have been an artist of great inventiveness and sensibility, was unable, on the scale on which he was condemned to work, to invest his altars and sepulchral monuments with the least semblance of vivacity. In Naples Finelli relapsed on empty paraphrases of Bernini's style, and it was Bernini's idiom, shorn of its sensibility, that was carried to Florence by Foggini and to Venice by Parodi. The standard for criticism of these artists is supplied by the French sculptor, Puget, who, in the works he carved during a short residence in Genoa, evinces a more individual sense of form, a more personal imagination, and a more masterful technique.

Notable sculptures were, of course, produced after Bernini's death. The challenge of

Borromini's tabernacles in the nave of St. John Lateran provoked, in addition to a number of indifferent statues, two figures of exceptional quality, while Legros carved a beautiful relief altarpiece for Sant' Ignazio. But in the aggregate later Baroque sculpture is vapid and mannered and uninteresting. The reason for this is a simple one, that Bernini, who in his youth had created the mythologies of the Villa Borghese, weaned Italian sculptors from their age-old dependence upon the antique. Just as the classicising work of Puget is far superior to that of the native-born sculptors of his time, so the most distinguished statues produced in Rome in the middle of the eighteenth century are also by two Frenchmen, Slodtz and Houdon. Late in the century the breach was healed, when Canova, in Venice, worked out the synthesis we know as Neo-classicism, whereby the antique was once more called upon to play a part in the renewal of contemporary art. Canova was the last of the great artists who by this means brought about a revolution in Italian sculpture, and in that select company he was also the least talented. He was no Nicola Pisano or Donatello, no Michelangelo or Giovanni Bologna or Bernini. But though he was lacking in conviction and was fettered by the shackles of good taste, his historical importance is no less great than theirs. In our own time his work has slowly regained popularity, and in the not far distant future the neo-classic sculptures he inspired – those neglected statues in Italian parks and squares, those smooth, anonymous wall monuments – will be regarded with the same rather uncritical respect with which Baroque sculpture of less than the first rank is looked on now. It is here that the story of Italian sculpture after Bernini's death reaches its end, and the time has not yet come to write this book.

PLATES

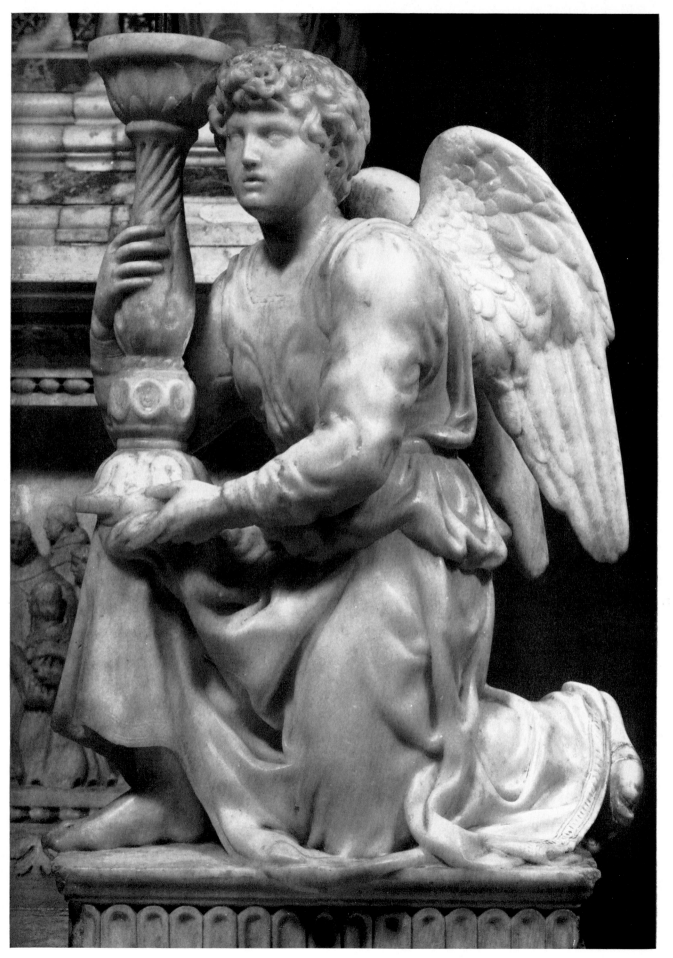

1. Michelangelo: ANGEL. S. Domenico Maggiore, Bologna. Marble (H. 51.5 cm.).

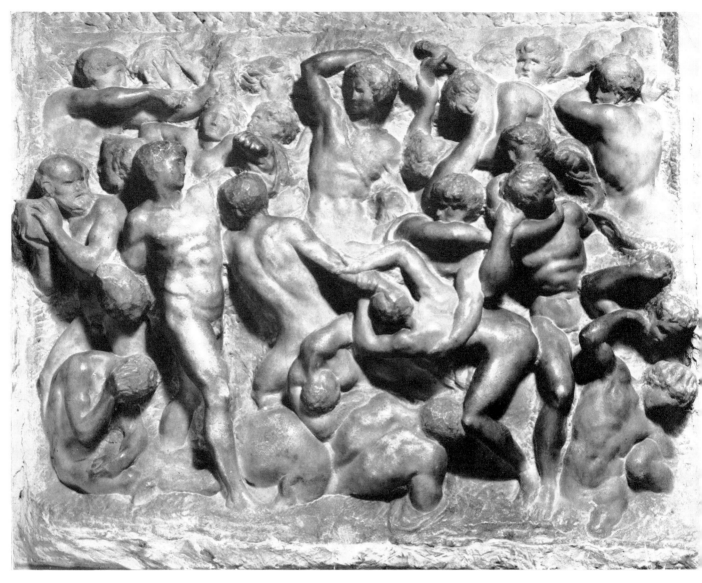

2. Michelangelo: THE BATTLE OF THE CENTAURS. Casa Buonarroti, Florence. Marble (84.5×90.5 cm. overall).

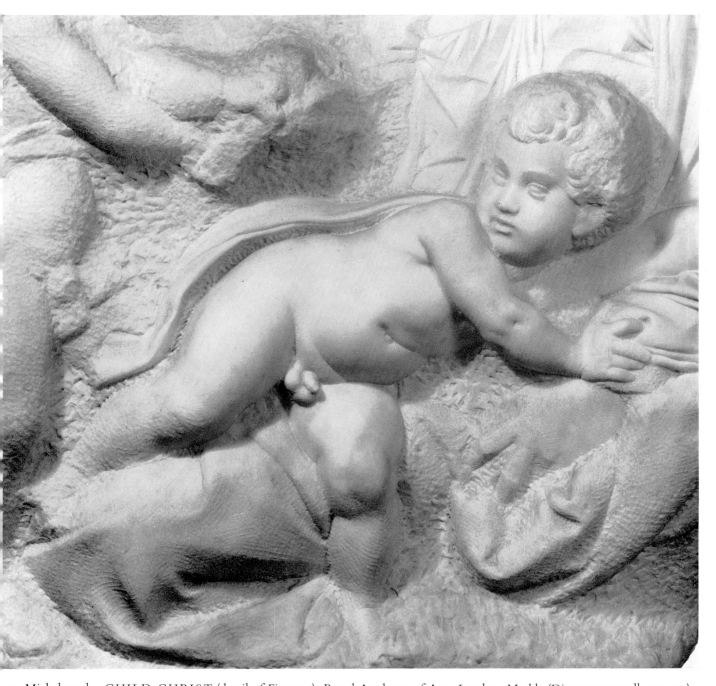

3. Michelangelo: CHILD CHRIST (detail of Figure 5). Royal Academy of Arts, London. Marble (Diameter overall 109 cm.).

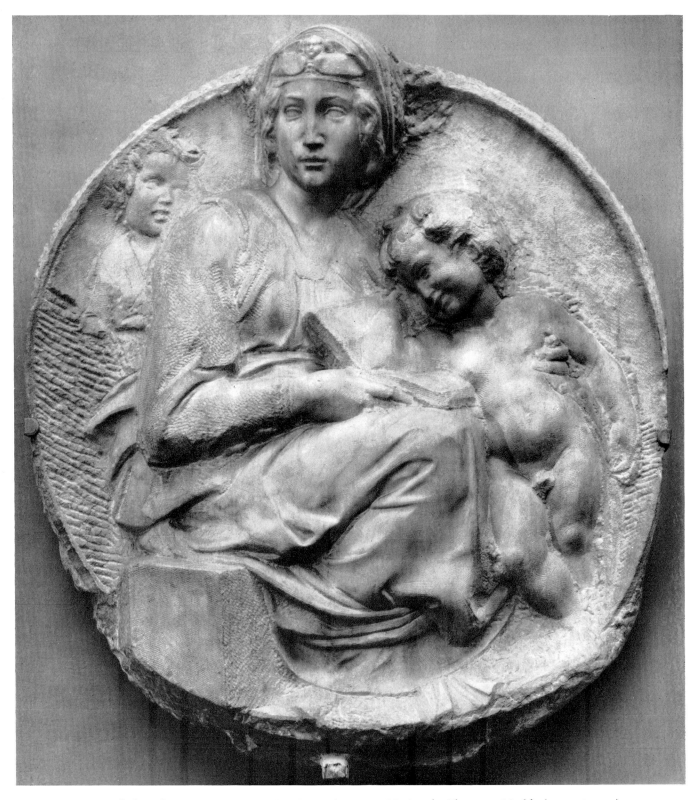

4. Michelangelo: THE PITTI MADONNA. Museo Nazionale, Florence. Marble (85.5 × 82 cm.).

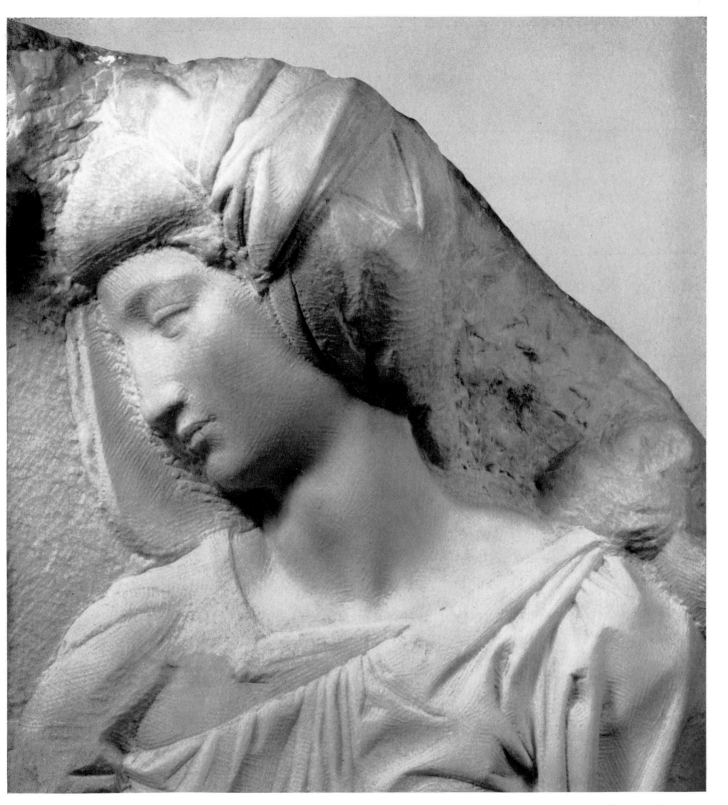

5. Michelangelo: VIRGIN (detail of Figure 5). Royal Academy of Arts, London. Marble (Diameter overall 109 cm.).

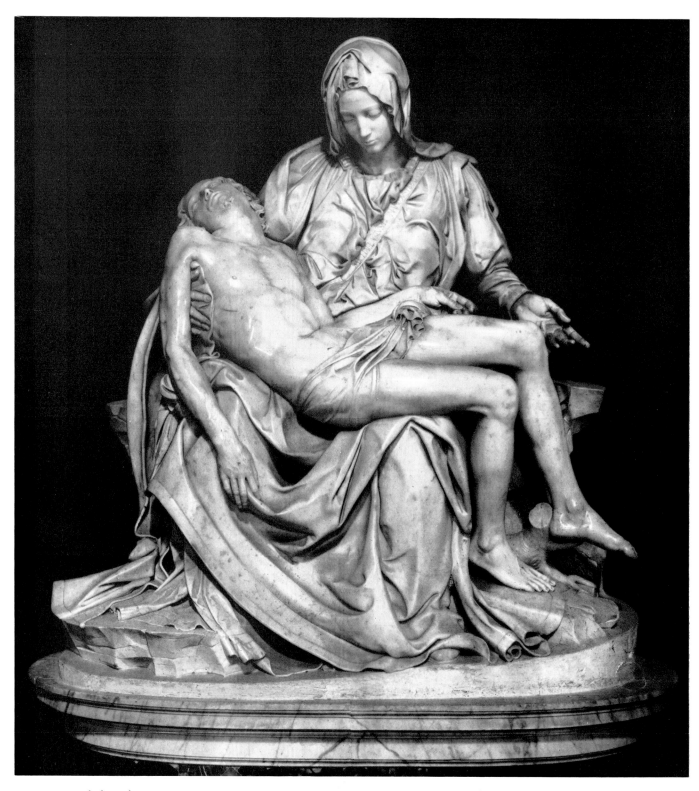

6. Michelangelo: THE VIRGIN WITH THE DEAD CHRIST. St. Peter's, Rome. Marble (H. 174 cm.).

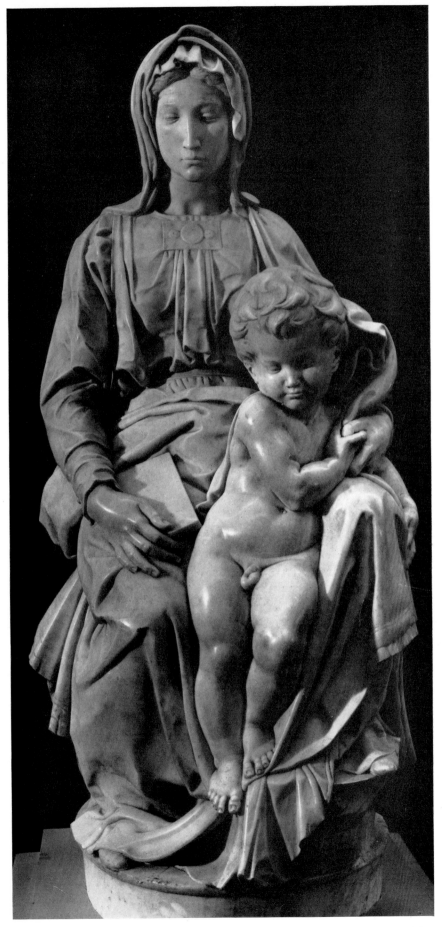

7. Michelangelo: VIRGIN AND CHILD. Notre Dame, Bruges. Marble
(H. with base 128 cm.).

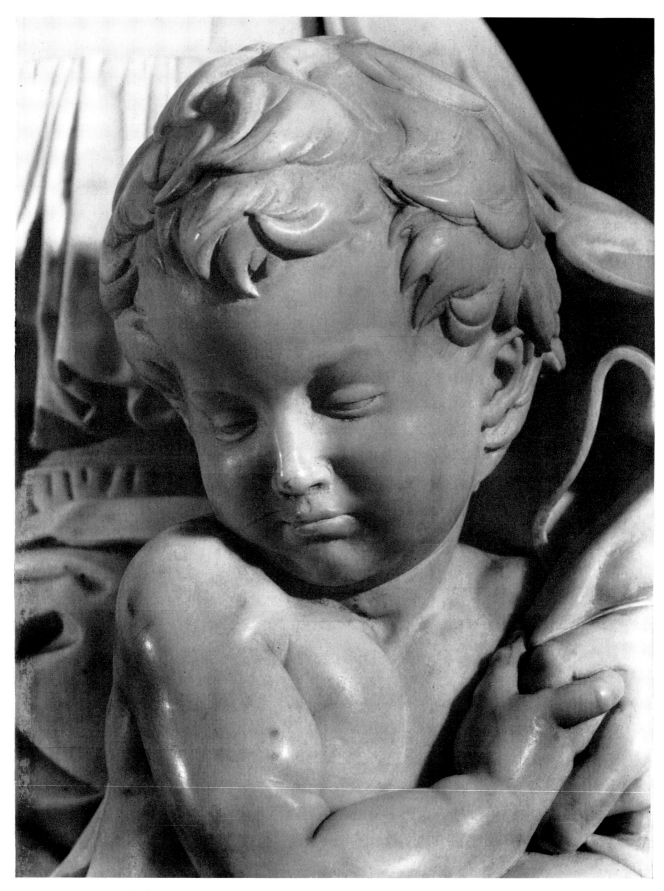

8. Michelangelo: CHILD CHRIST (detail of Plate 7). Notre Dame, Bruges. Marble.

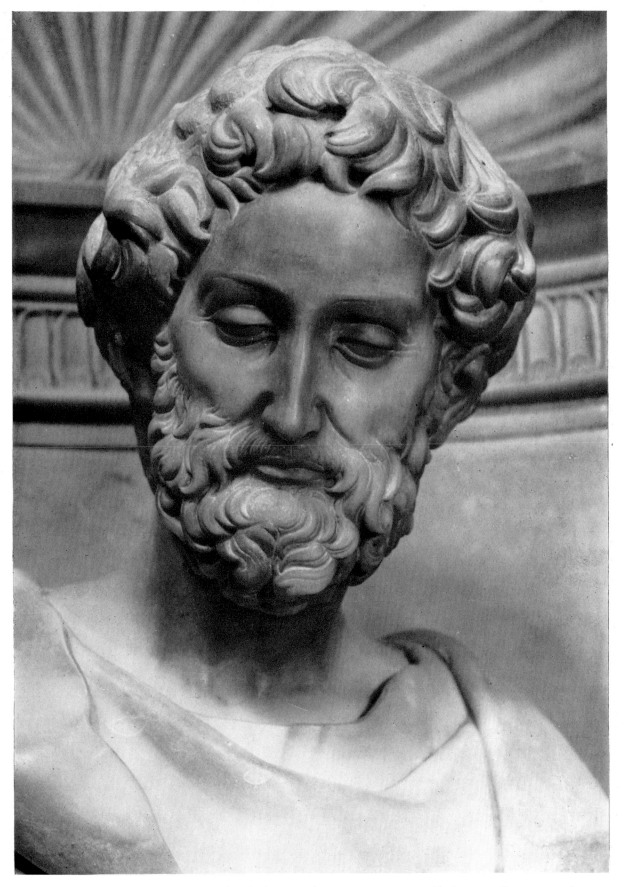

9. Michelangelo: ST. PETER (detail of Figure 4). Duomo, Siena. Marble (H. overall ca. 120 cm.).

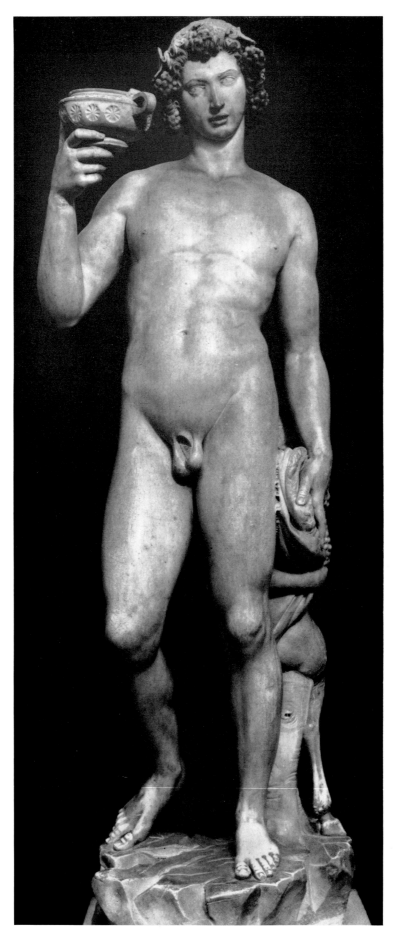

10. Michelangelo: BACCHUS. Museo Nazionale, Florence. Marble (H. 203 cm.).

11. Michelangelo: SATYR (detail of Plate 10). Museo Nazionale, Florence. Marble.

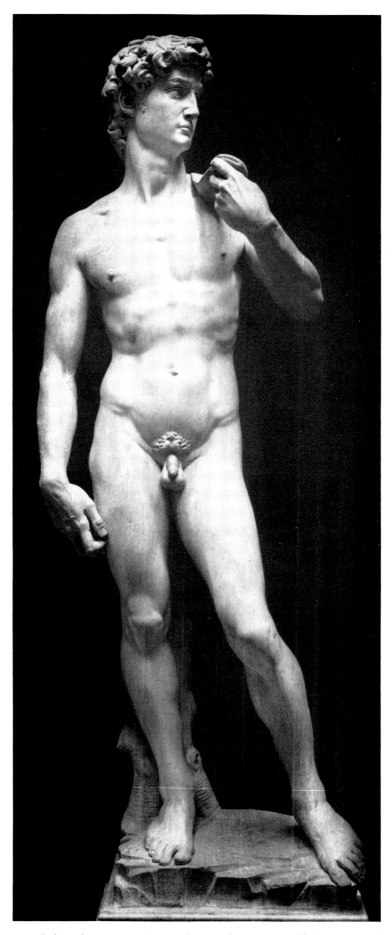

12. Michelangelo: D A V I D. Accademia, Florence. Marble (H. 434 cm.).

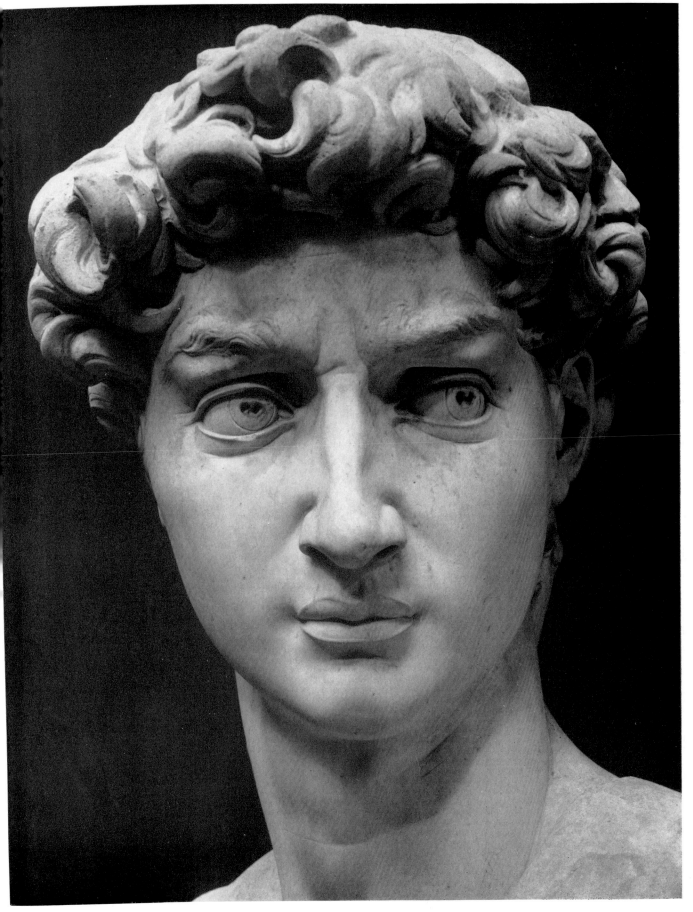

13. Michelangelo: HEAD OF DAVID (detail of Plate 12). Accademia, Florence.

14. Michelangelo: HEAD OF ST. MATTHEW (detail of Figure 9). Accademia, Florence. Marble (H. overall 271 cm.).

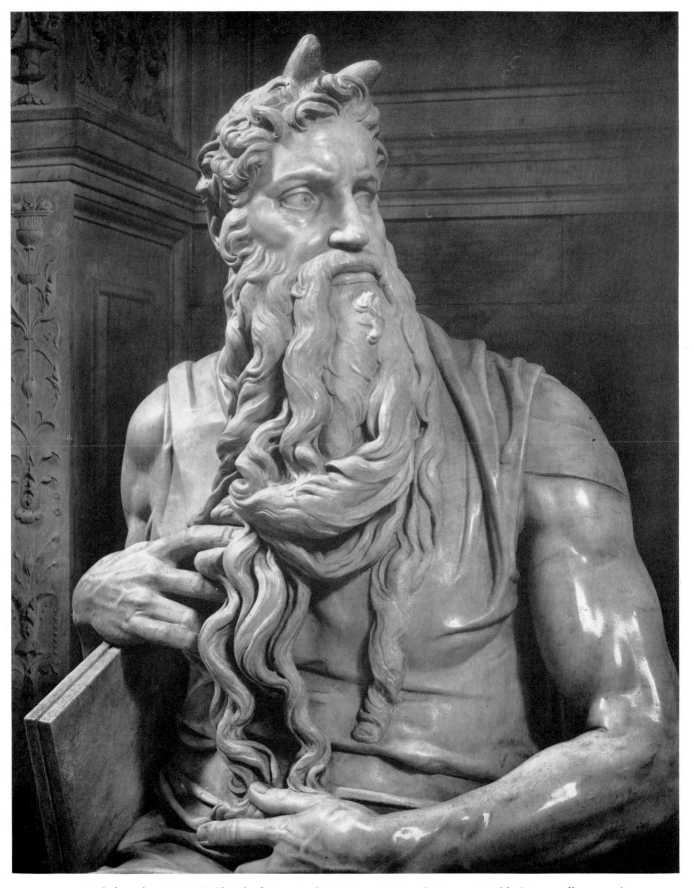

15. Michelangelo: MOSES (detail of Figure 30). S. Pietro in Vincoli, Rome. Marble (H. overall 235 cm.).

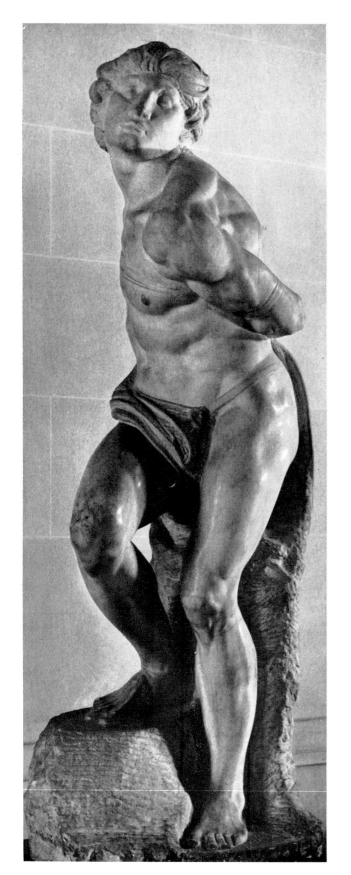
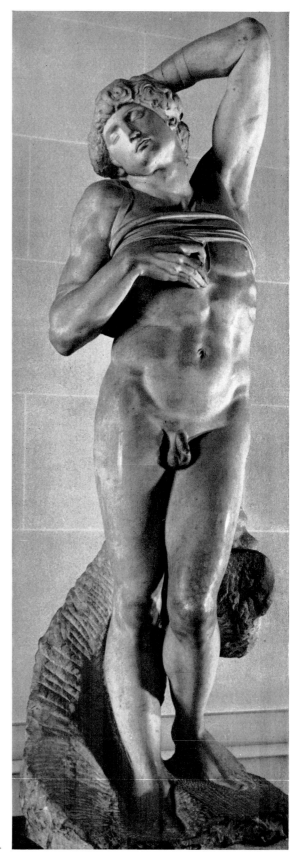

16A. Michelangelo: THE REBELLIOUS SLAVE. Louvre, Paris. Marble (H. 215 cm.).

16B. Michelangelo: THE DYING SLAVE. Louvre, Paris. Marble (H. 229 cm.).

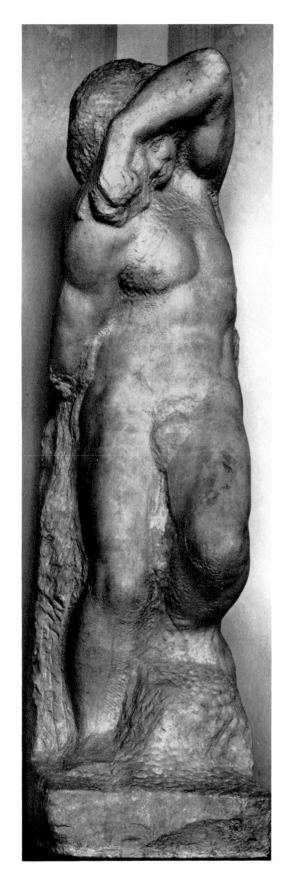

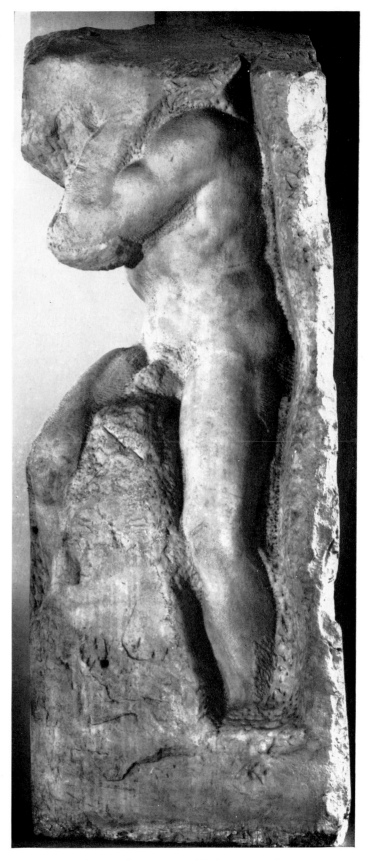

17A. Michelangelo: THE YOUNG SLAVE. Accademia, Florence. Marble (H. 256 cm.).

17B. Michelangelo: THE ATLAS SLAVE. Accademia, Florence. Marble (H. 277 cm.).

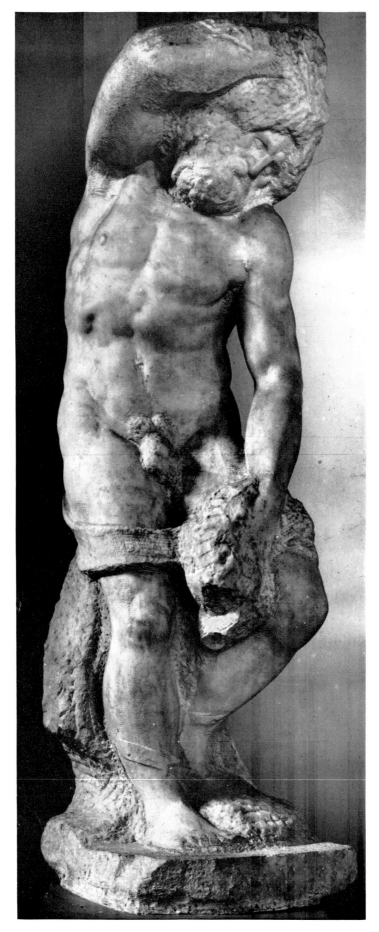

18. Michelangelo: THE BEARDED SLAVE. Accademia, Florence.
Marble (H. 263 cm.).

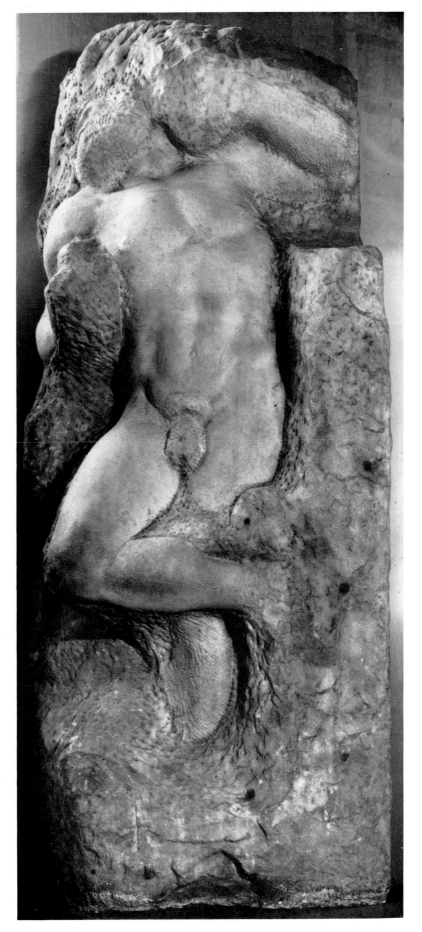

19. Michelangelo: THE AWAKENING SLAVE. Accademia, Florence.
Marble (H. 267 cm.).

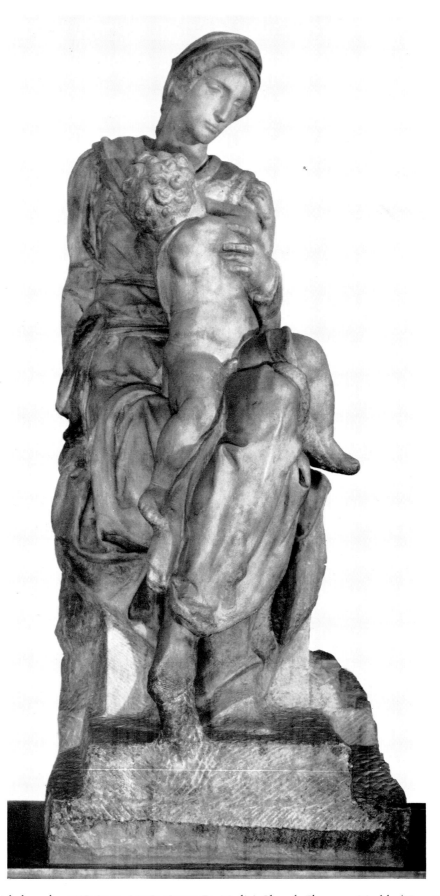

20. Michelangelo: VIRGIN AND CHILD. Medici Chapel, Florence. Marble (H. 226 cm.).

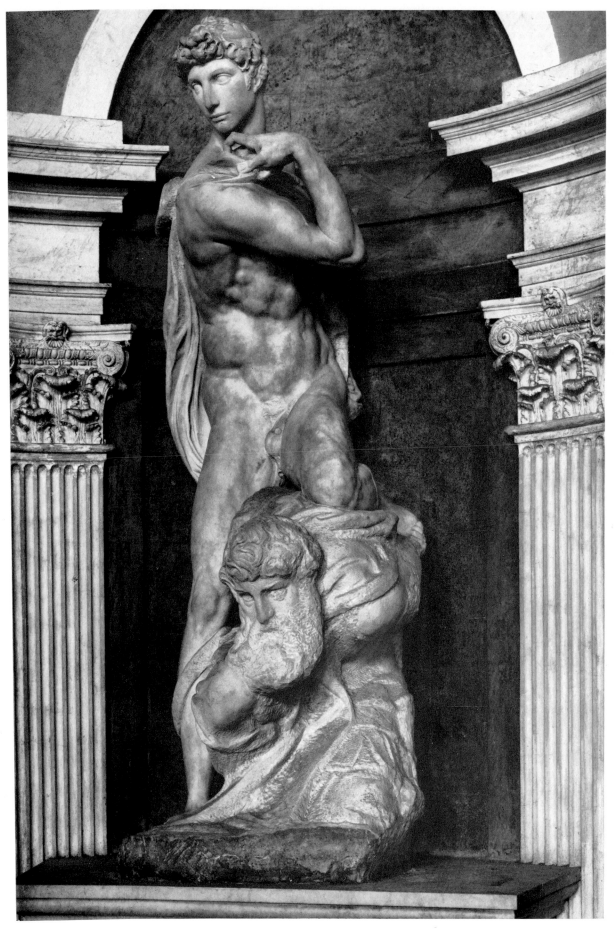

21. Michelangelo: THE GENIUS OF VICTORY. Palazzo Vecchio, Florence. Marble (H. 261 cm.).

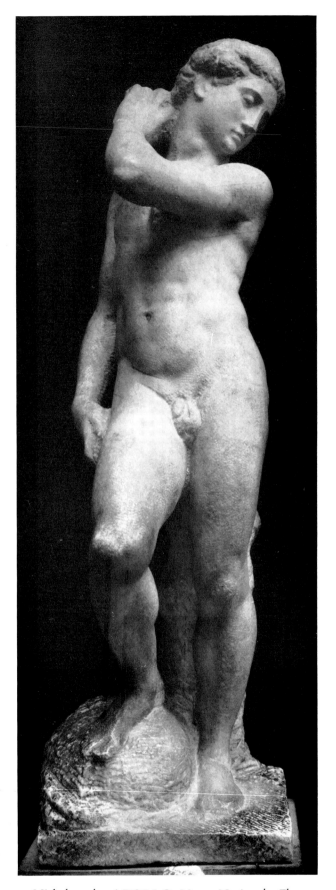

22. Michelangelo: APOLLO. Museo Nazionale, Florence.
Marble (H. 146 cm.).

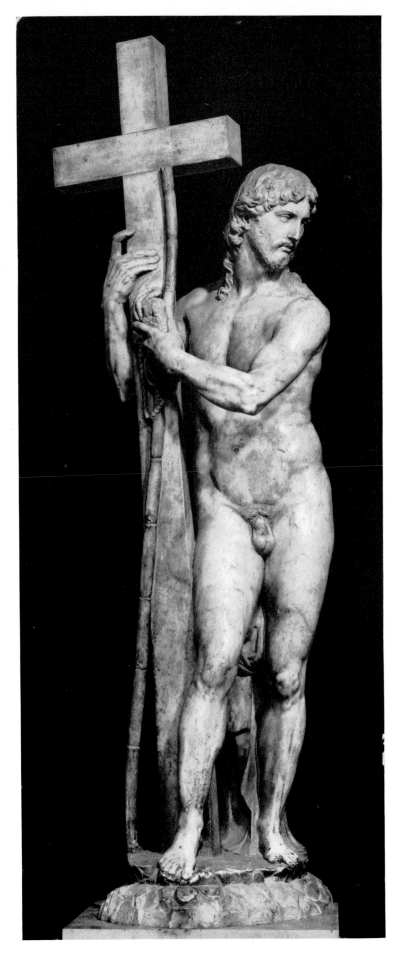

23. Michelangelo: CHRIST. S. Maria sopra Minerva, Rome.
Marble (H. 205 cm.).

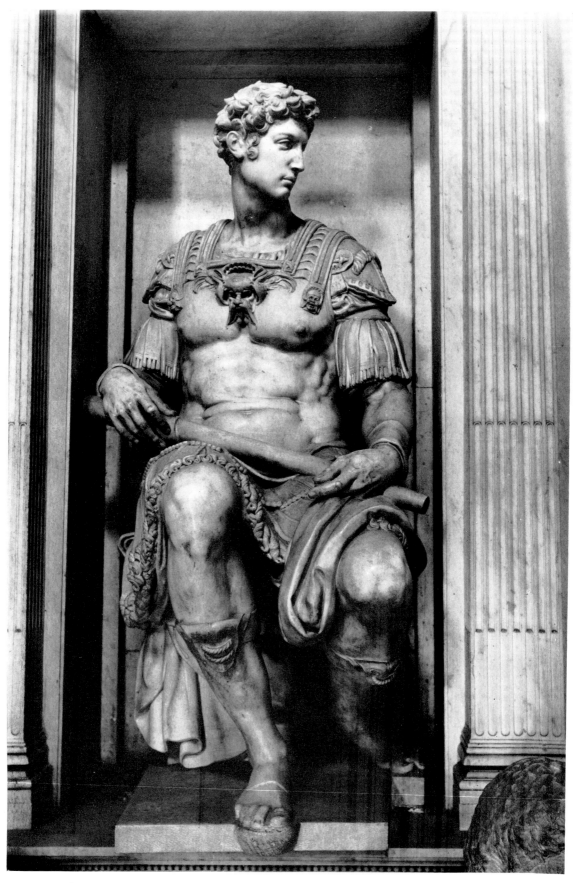

24. Michelangelo: GIULIANO DE' MEDICI (detail of Figure 17). Medici Chapel, Florence.
Marble (H. 173 cm.).

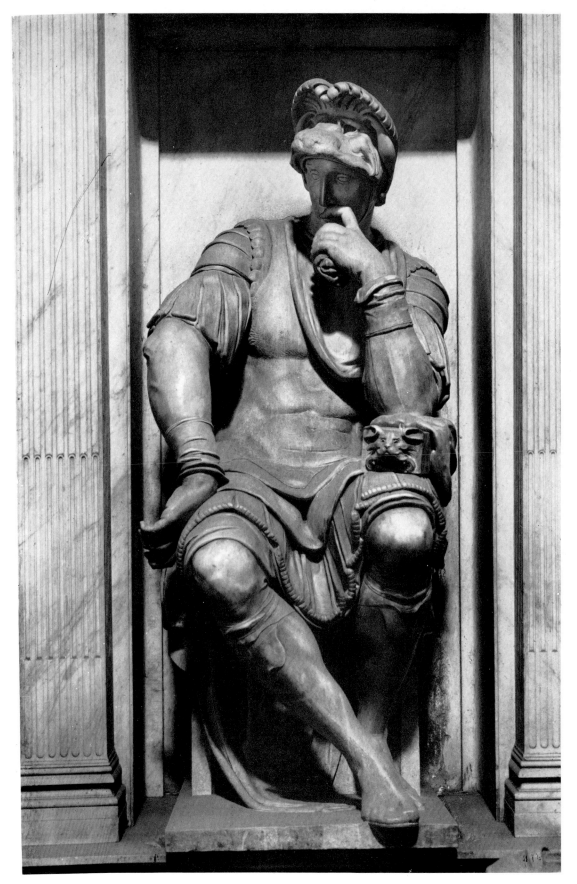

25. Michelangelo: LORENZO DE' MEDICI (detail of Figure 18). Medici Chapel, Florence.
Marble (H. 178 cm.).

26. Michelangelo: END OF SARCOPHAGUS (detail of Figure 17). Medici Chapel, Florence. Marble.

27. Michelangelo: BOX HELD BY LORENZO DE' MEDICI (detail of Plate 25). Medici Chapel, Florence. Marble.

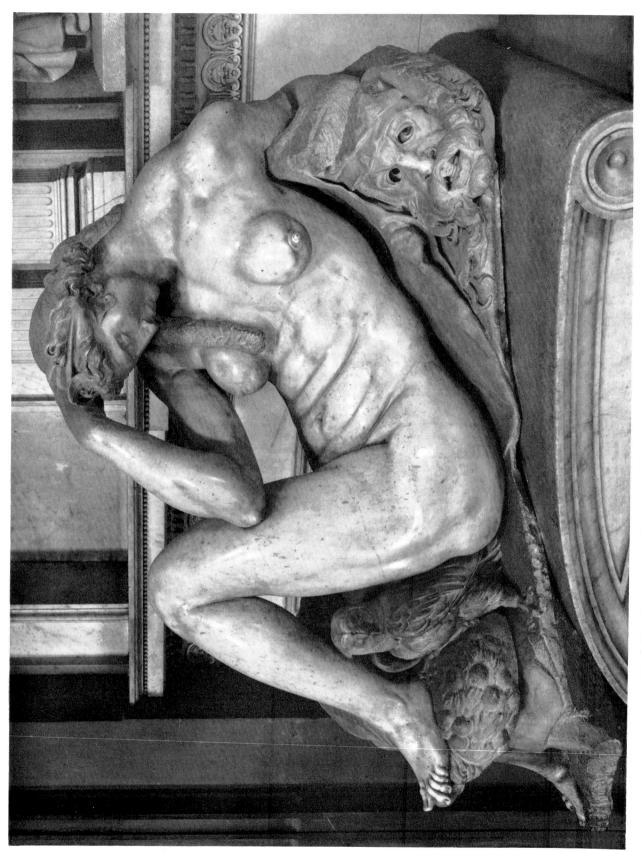

28. Michelangelo: NIGHT (detail of Figure 17). Medici Chapel, Florence. Marble (L. 194 cm).

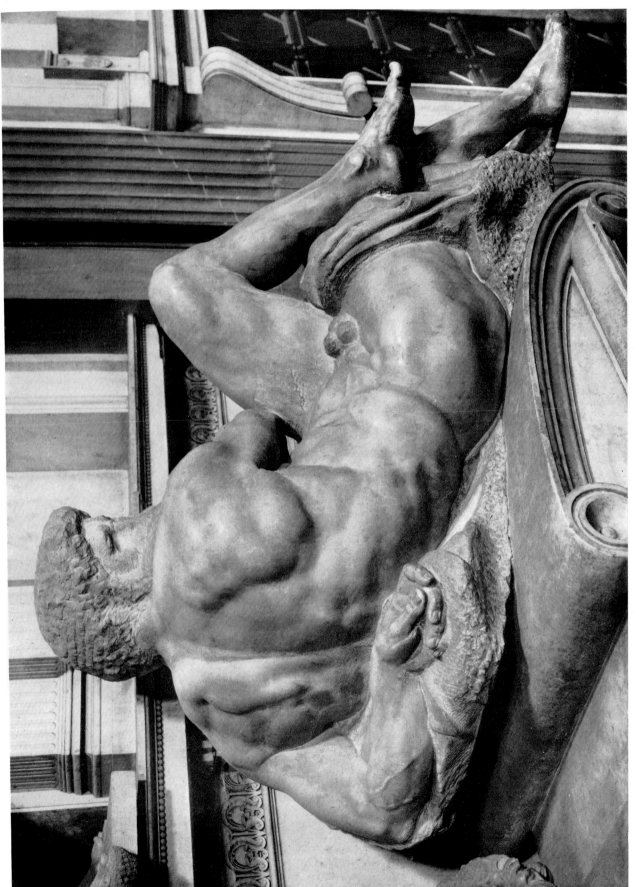

29. Michelangelo: DAY (detail of Figure 17). Medici Chapel, Florence. Marble (L. 185 cm.).

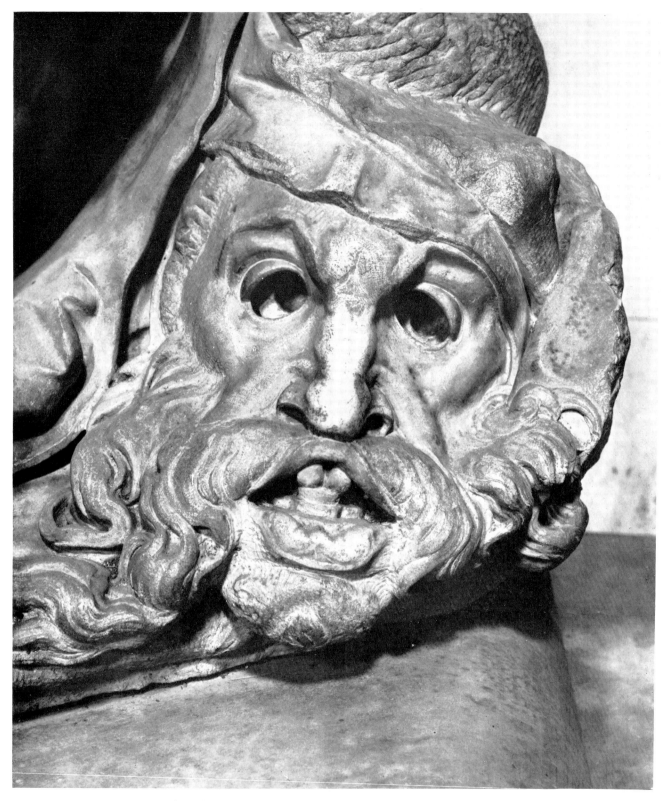

30. Michelangelo: MASK (detail of Plate 28). Medici Chapel, Florence. Marble.

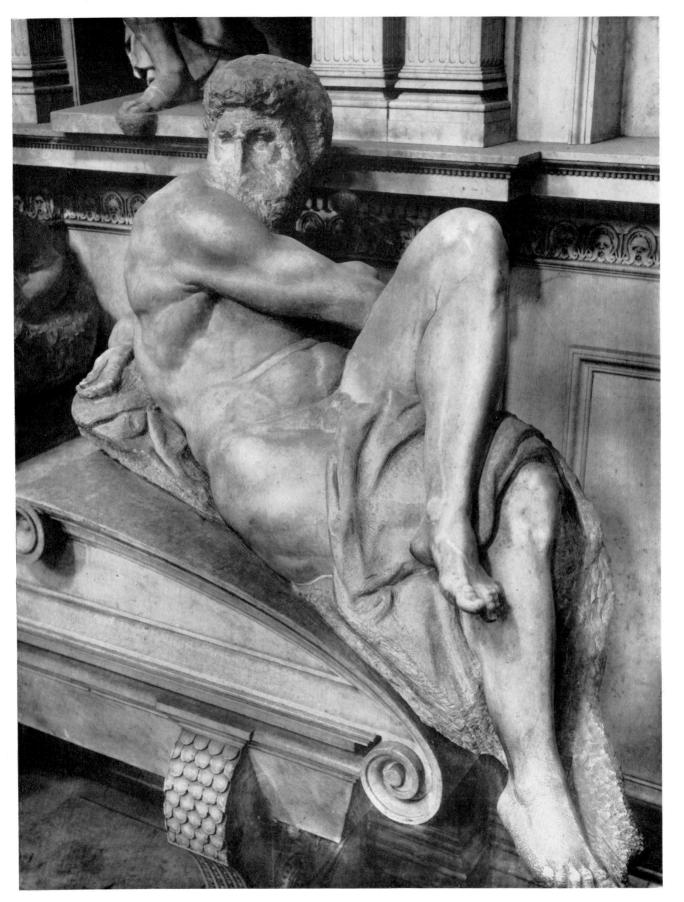

31. Michelangelo: DAY (detail of Figure 17). Medici Chapel, Florence. Marble.

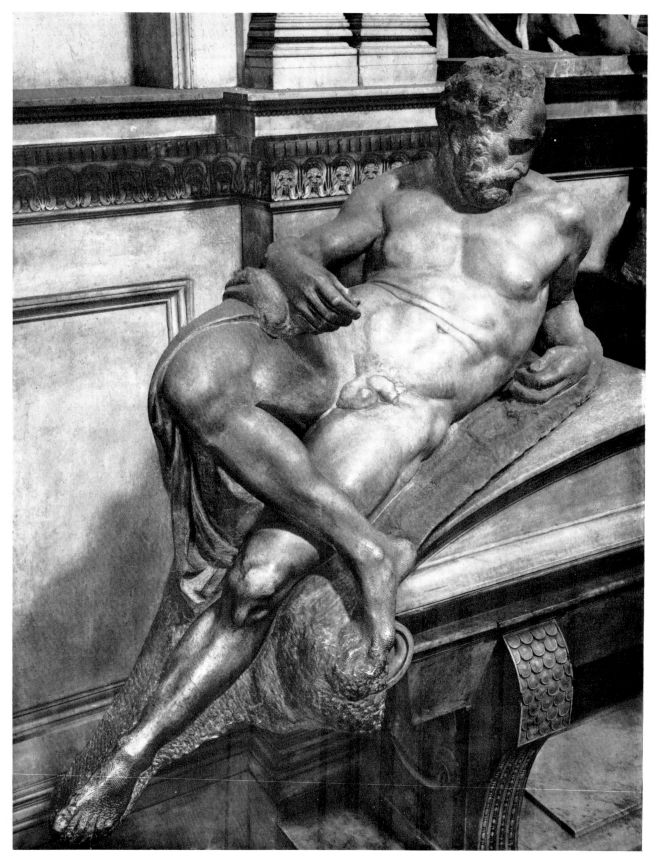

32. Michelangelo: EVENING (detail of Figure 18). Medici Chapel, Florence. Marble (L. 195 cm.).

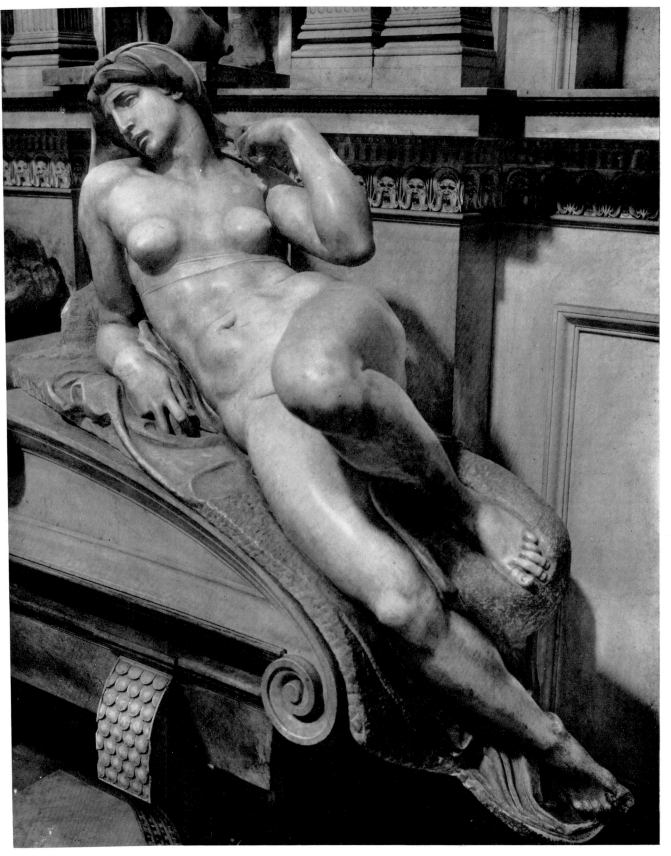

33. Michelangelo: MORNING (detail of Figure 18). Medici Chapel, Florence. Marble (L. 203 cm.).

34. Michelangelo: LEAH (detail of Figure 30). S. Pietro in Vincoli, Rome. Marble (H. 209 cm.).

35. Michelangelo: RACHEL (detail of Figure 30). S. Pietro in Vincoli, Rome. Marble (H. 197 cm.).

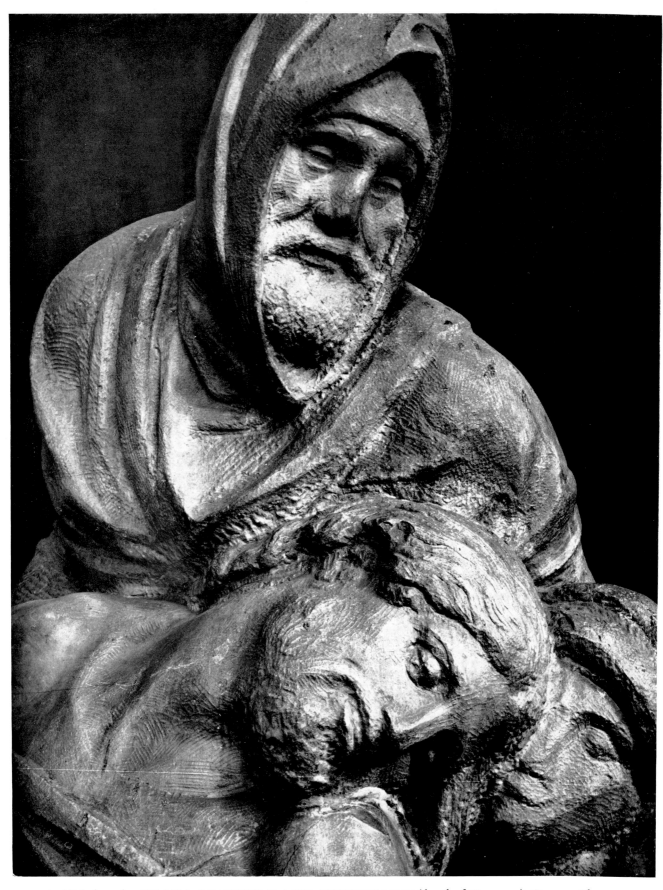

36. Michelangelo: HEADS OF CHRIST AND NICODEMUS (detail of Figure 35). Duomo, Florence. Marble (H. overall 226 cm.).

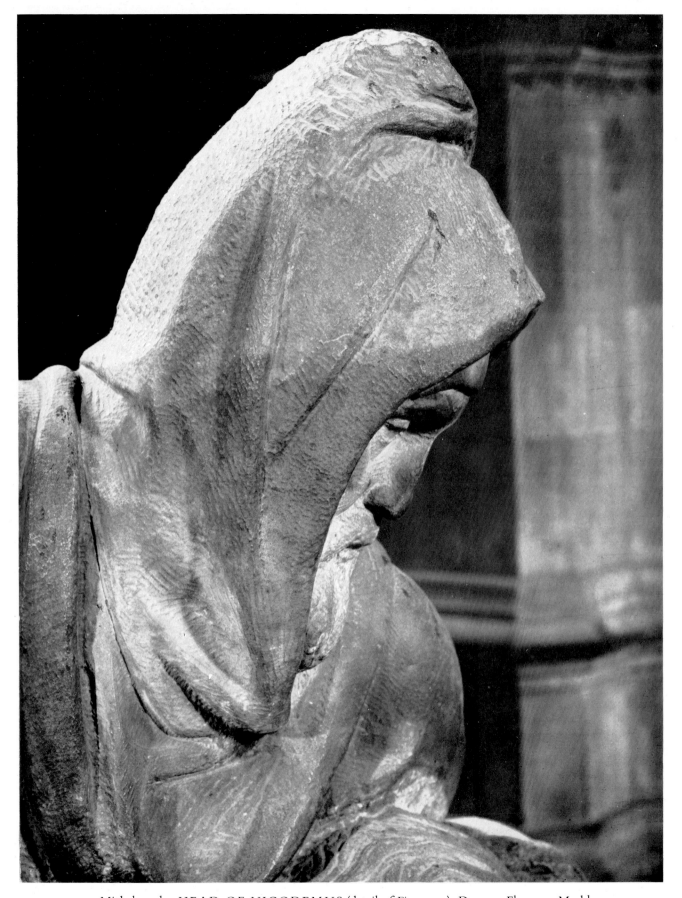

37. Michelangelo: HEAD OF NICODEMUS (detail of Figure 35). Duomo, Florence. Marble.

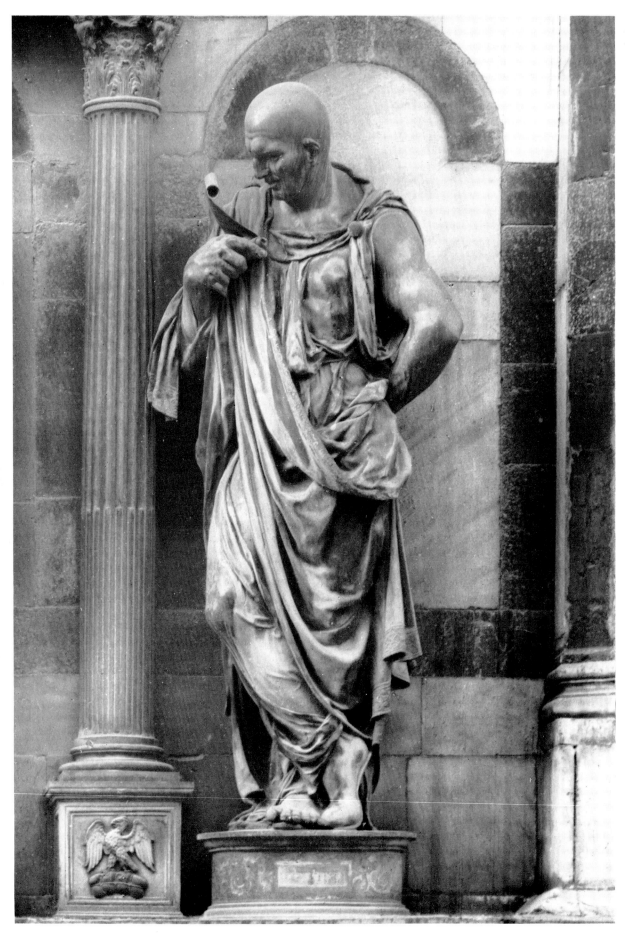

38. Rustici: A LEVITE (detail of Figure 39). Baptistry, Florence. Bronze (H. overall 265 cm. with base).

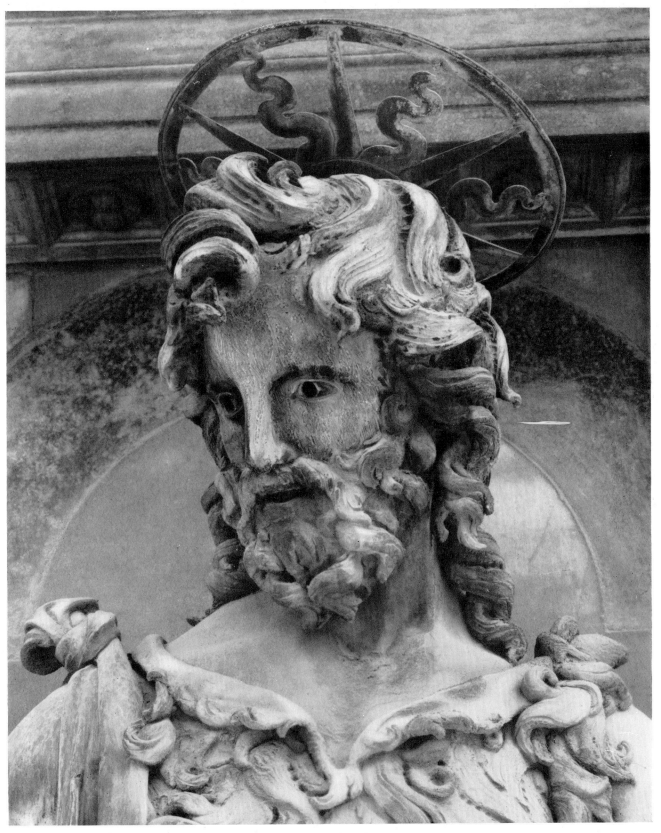

39. Rustici: HEAD OF ST. JOHN THE BAPTIST (detail of Figure 39). Baptistry, Florence.
Bronze (H. overall 265 cm. with base).

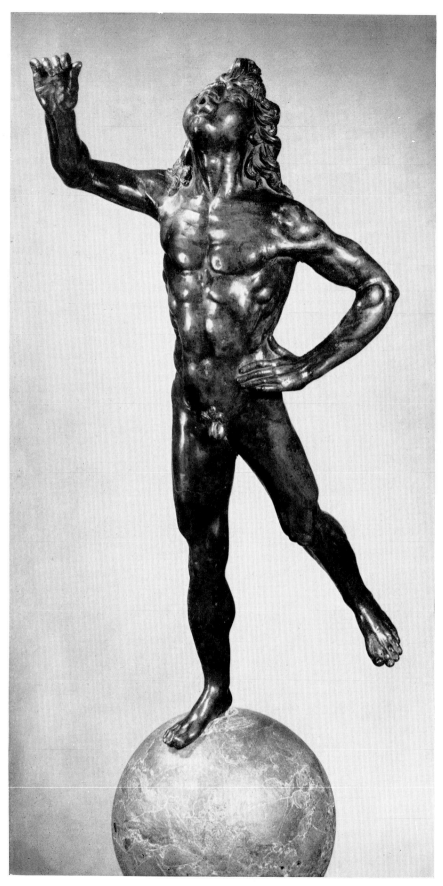

40. Rustici: MERCURY. Private Collection. Bronze (H. 49.5 cm.).

41. Lorenzetto: CHRIST AND THE WOMAN TAKEN IN ADULTERY (detail of Figure 79).
S. Maria del Popolo, Rome. Bronze (65.5×212 cm. overall).

42. Andrea Sansovino: VIRGIN AND CHILD. Duomo, Genoa. Marble.

43. Andrea Sansovino: THE BAPTISM OF CHRIST. Baptistry, Florence. Marble (H. of Christ 282 cm. with base; H. of Baptist 260 cm. with base).

44. Andrea Sansovino: TEMPERANCE (detail of Figure 58). S. Maria del Popolo, Rome. Marble (H. 121 cm.).

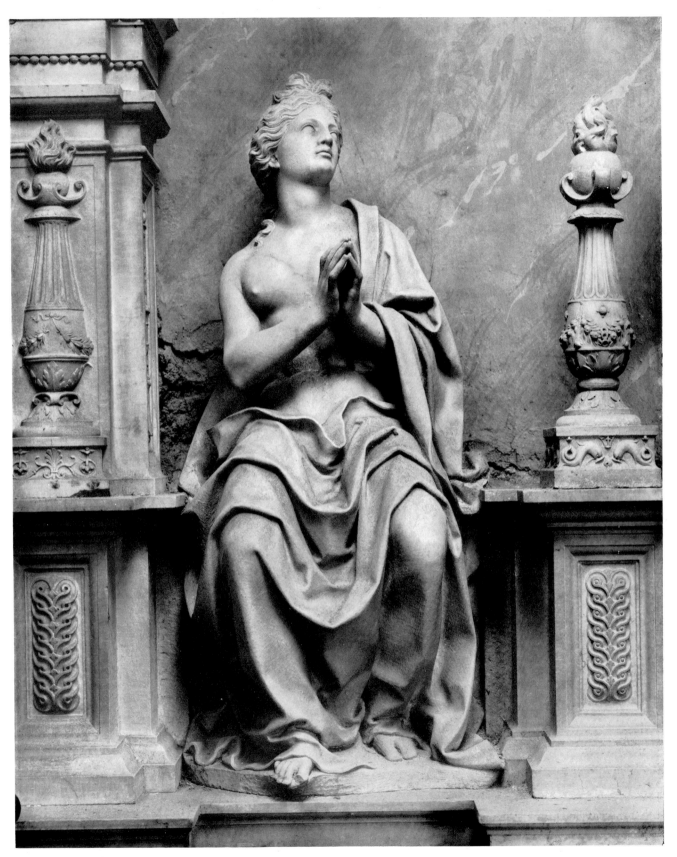

45. Andrea Sansovino: HOPE (detail of Figure 57). S. Maria del Popolo, Rome. Marble (H. 107 cm.).

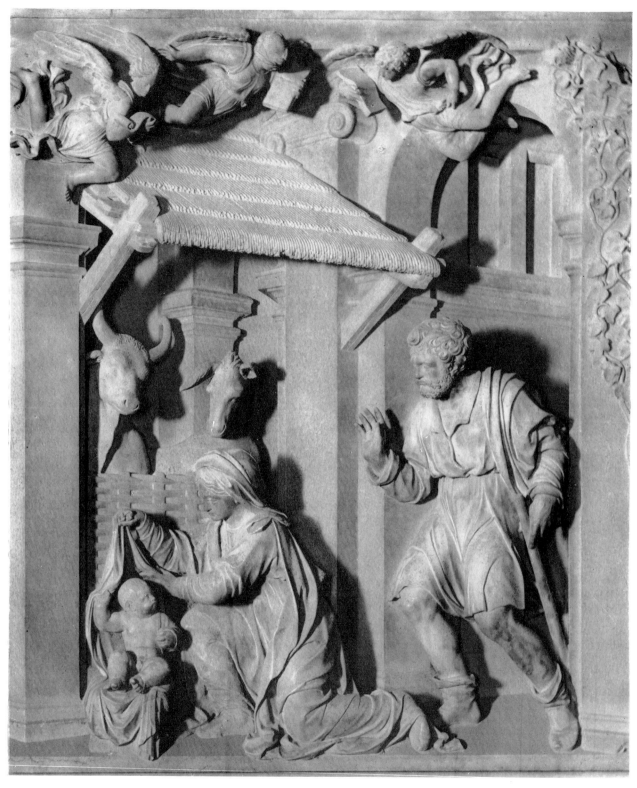

46. Andrea Sansovino: THE HOLY FAMILY (detail of Figure 81). Basilica della Santa Casa, Loreto. Marble.

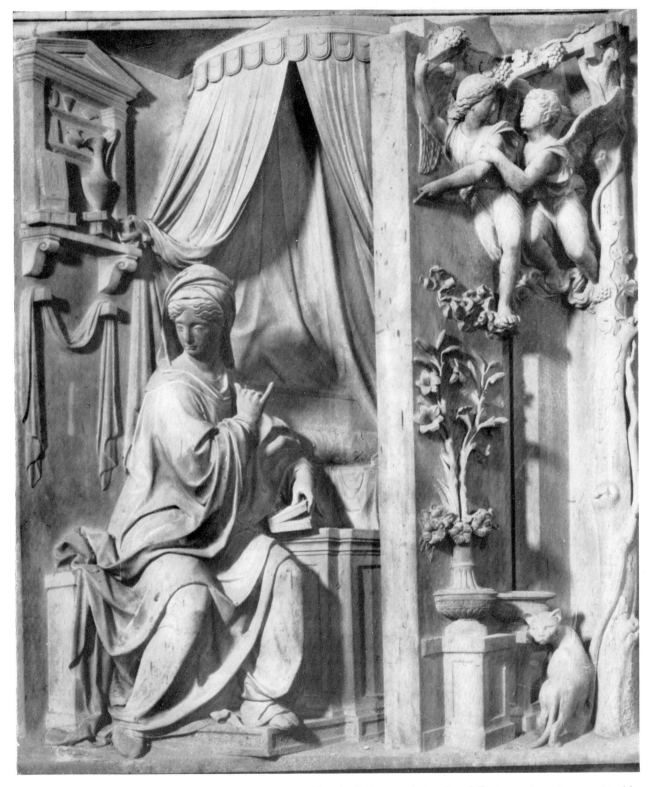

47. Andrea Sansovino: VIRGIN ANNUNCIATE (detail of Figure 80). Basilica della Santa Casa, Loreto. Marble.

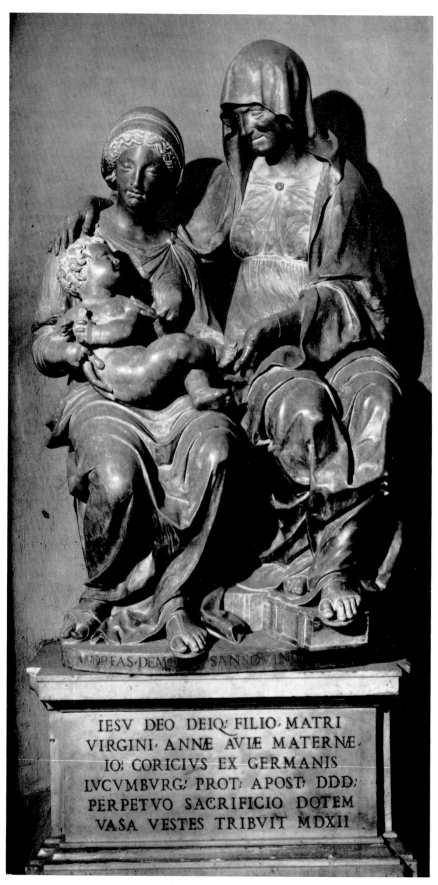

48. Andrea Sansovino: VIRGIN AND CHILD WITH ST. ANNE. S. Agostino, Rome.
Marble (H. of statue 125 cm.; H. with plinth 195 cm.).

49. Jacopo Sansovino: VIRGIN AND CHILD. S. Agostino, Rome. Marble.

50. Jacopo Sansovino: BACCHUS. Museo Nazionale, Florence. Marble (H. 146 cm.).

51. Jacopo Sansovino: ST. JAMES. Duomo, Florence. Marble.

52. Giovanni da Nola: MARIA OSORIO PIMENTEL (detail of Figure 64). S. Giacomo degli Spagnuoli, Naples. Marble.

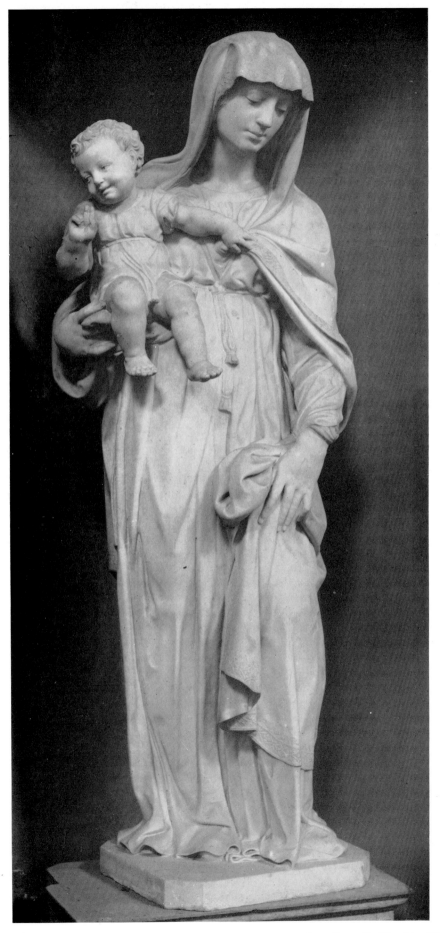

53. Girolamo Santacroce: VIRGIN AND CHILD. S. Maria a Cappella Vecchia, Naples.
Marble.

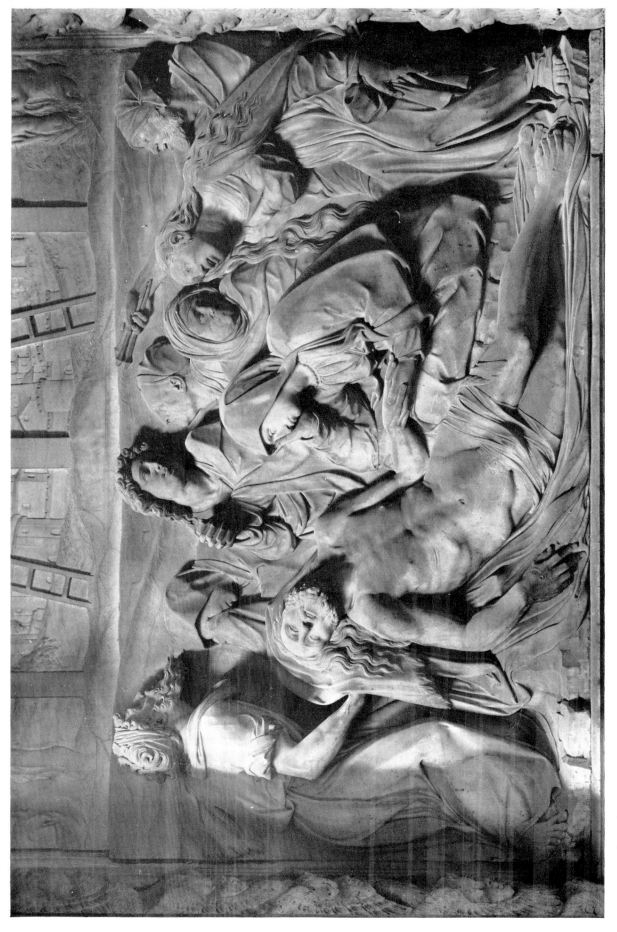

54. Giovanni da Nola: THE LAMENTATION OVER THE DEAD CHRIST. S. Maria delle Grazie a Caponapoli, Naples. Marble (figurated area 100×165 cm.).

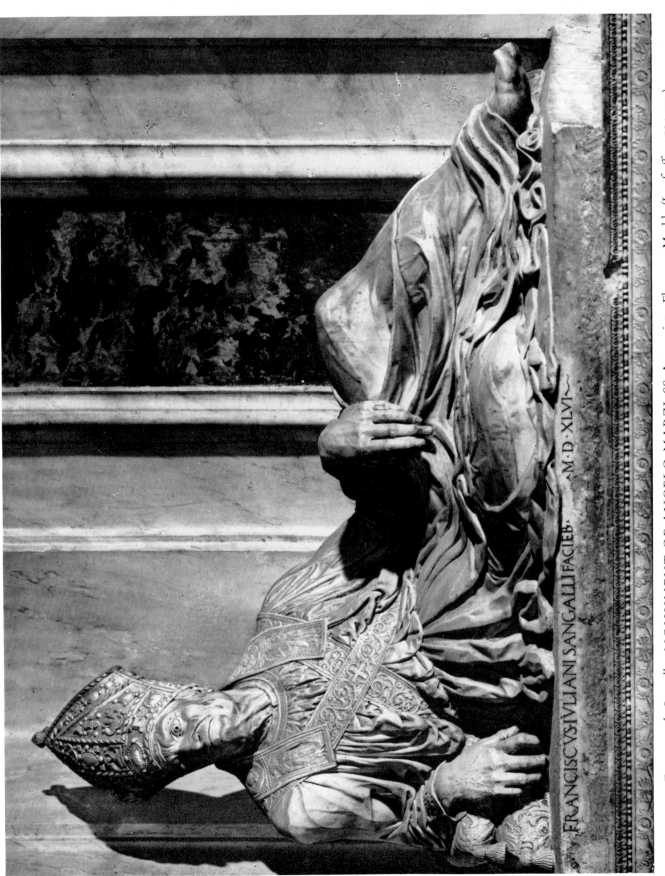

FRANCISCVS·IVLIANI·SANGALLI·FACIEB· ·M·D·XLVI·

55. Francesco da Sangallo: MONUMENT OF ANGELO MARZI. SS. Annunziata, Florence. Marble (L. of effigy 194 cm.).

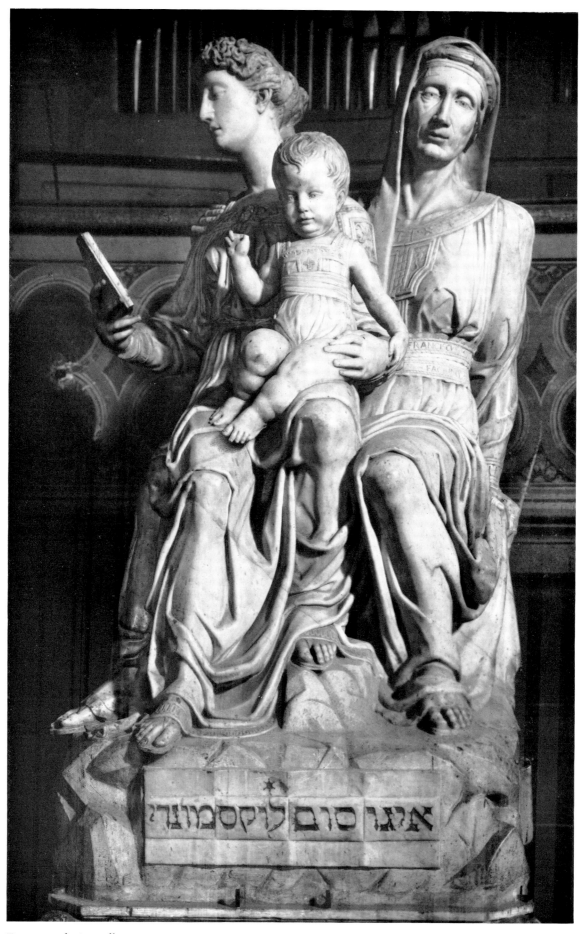

56. Francesco da Sangallo: VIRGIN AND CHILD WITH ST. ANNE. Or San Michele, Florence. Marble.

57. Montorsoli: S C Y L L A (detail of Figure 96). Museo Nazionale, Messina. Marble (H. 180 cm.).

58. Tribolo: PAN. Museo Nazionale, Florence. Bronze (H. 26 cm.).

59. Tribolo: PUTTI WITH GEESE (detail of Figure 92). Villa Reale di Castello. Marble.

60. Tribolo: THE ASSUMPTION OF THE VIRGIN (detail of Figure 83). S. Petronio, Bologna. Marble (W. irregular, ca. 250 cm.).

61. Pierino da Vinci: COSIMO I AS PATRON OF PISA. Museo Vaticano, Rome. Marble (73.5 × 160 cm.).

62. Pierino da Vinci: SAMSON AND A PHILISTINE. Palazzo Vecchio, Florence.
Marble (H. ca. 223 cm.).

63. Pierino da Vinci: RIVER GOD. Louvre, Paris. Marble (H. 135 cm.).

64. Bandinelli: HERCULES AND CACUS. Piazza della Signoria, Florence. Marble.

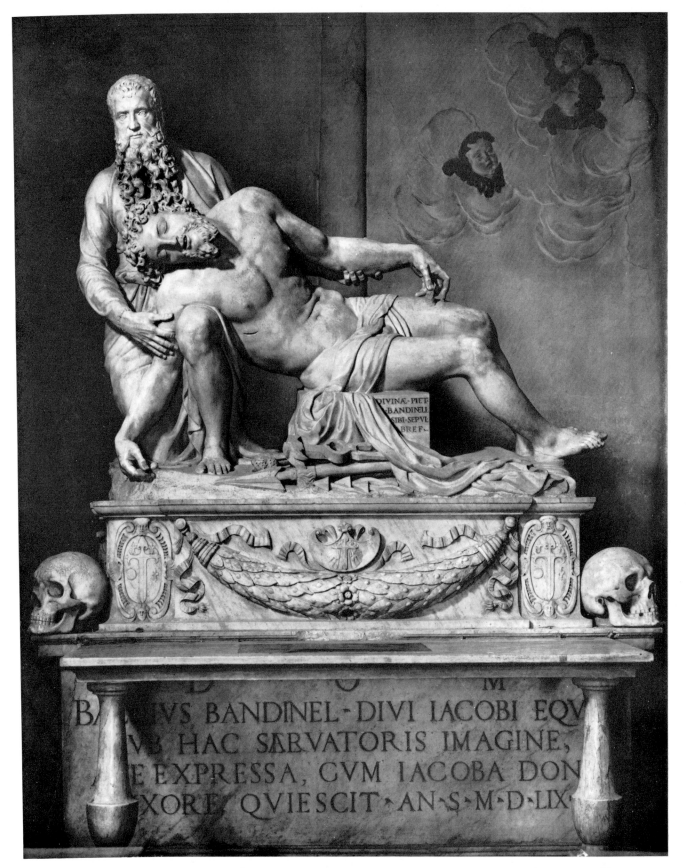

65. Bandinelli: THE DEAD CHRIST WITH NICODEMUS. SS. Annunziata, Florence. Marble.

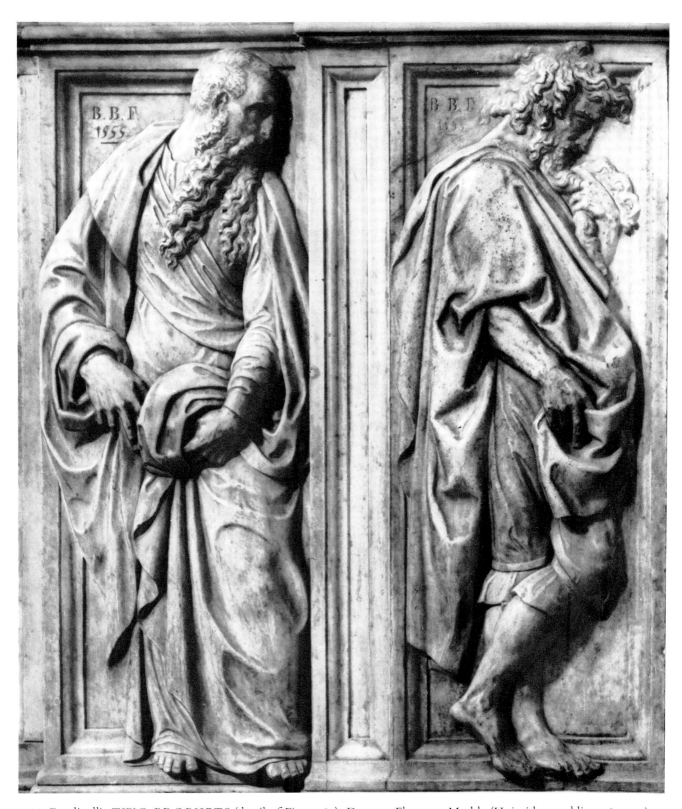

66. Bandinelli: TWO PROPHETS (detail of Figure 87). Duomo, Florence. Marble (H. inside moulding 96.5 cm.).

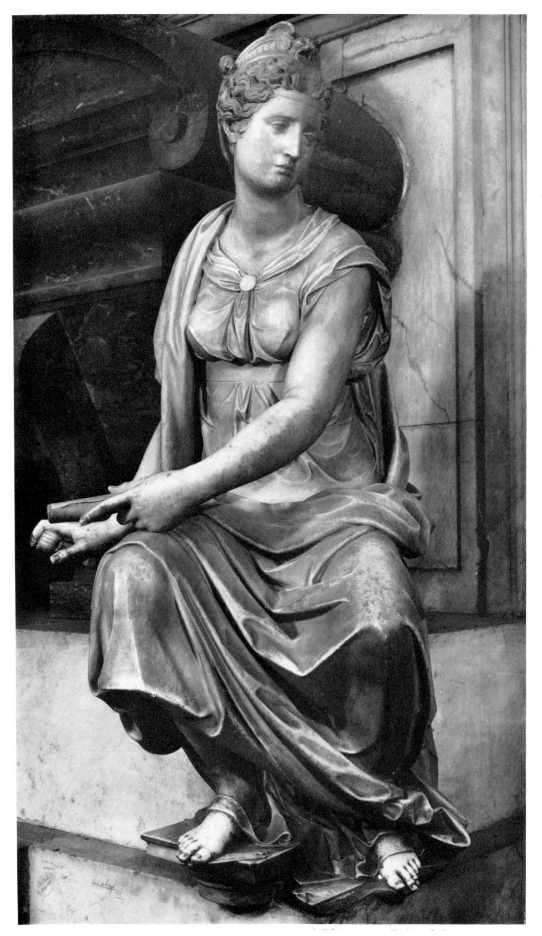

67. Giovanni Bandini: ARCHITECTURE (detail of Figure 67). S. Croce, Florence. Marble.

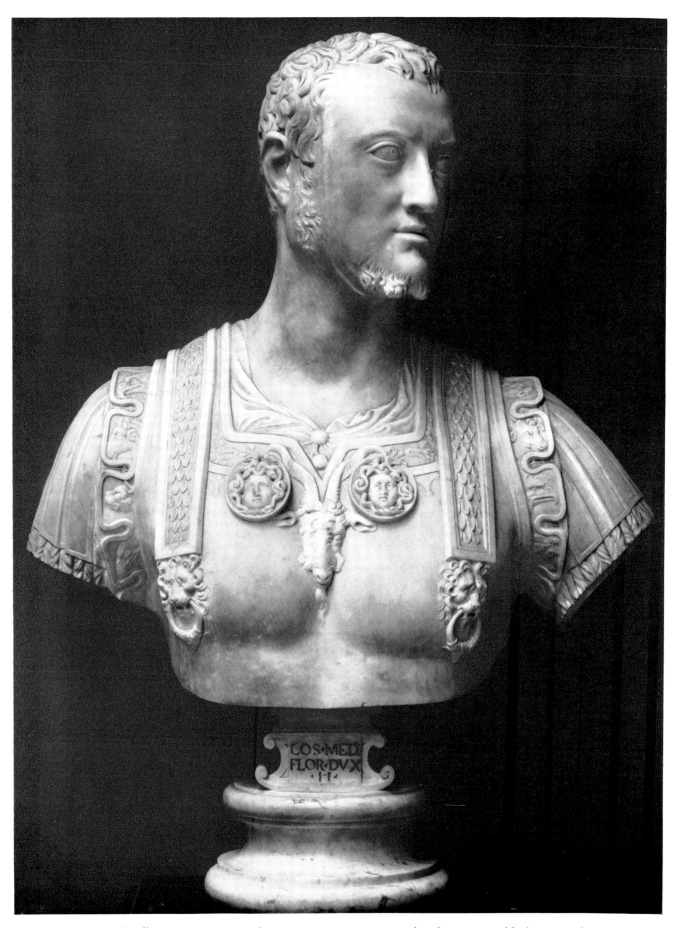

68. Bandinelli: COSIMO I DE' MEDICI. Museo Nazionale, Florence. Marble (H. 91 cm.).

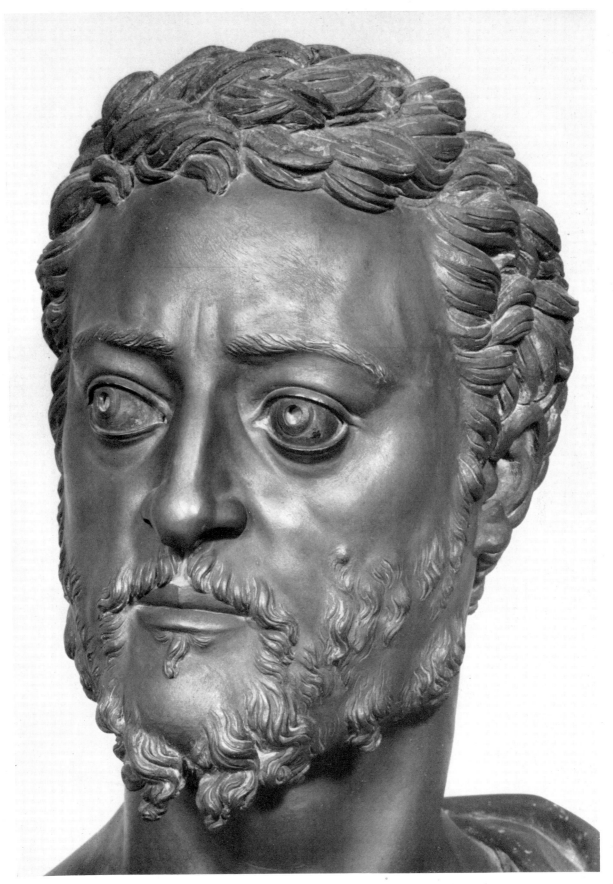

69. Cellini: COSIMO I DE' MEDICI (detail of Figure 121). Museo Nazionale, Florence. Bronze (H. 110 cm.).

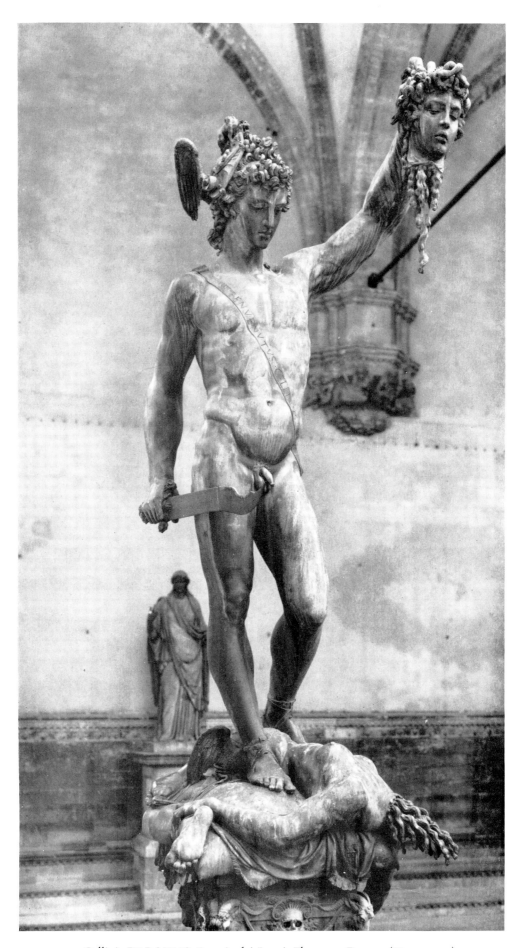

70. Cellini: PERSEUS. Loggia dei Lanzi, Florence. Bronze (H. 320 cm.).

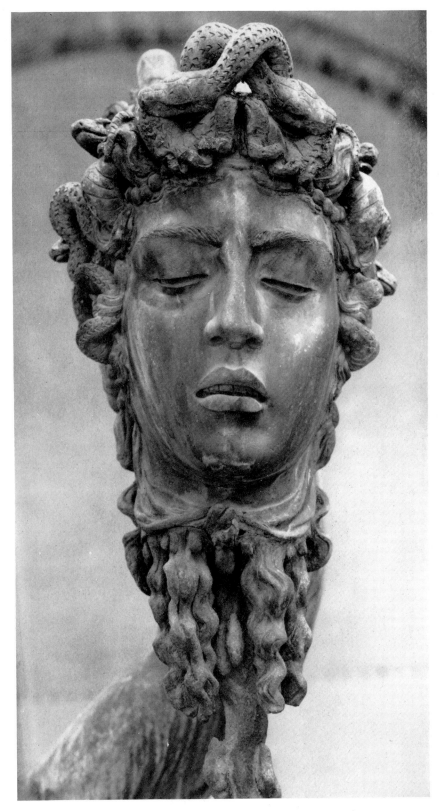

71. Cellini: HEAD OF MEDUSA (detail of Plate 70).
Loggia dei Lanzi, Florence. Bronze.

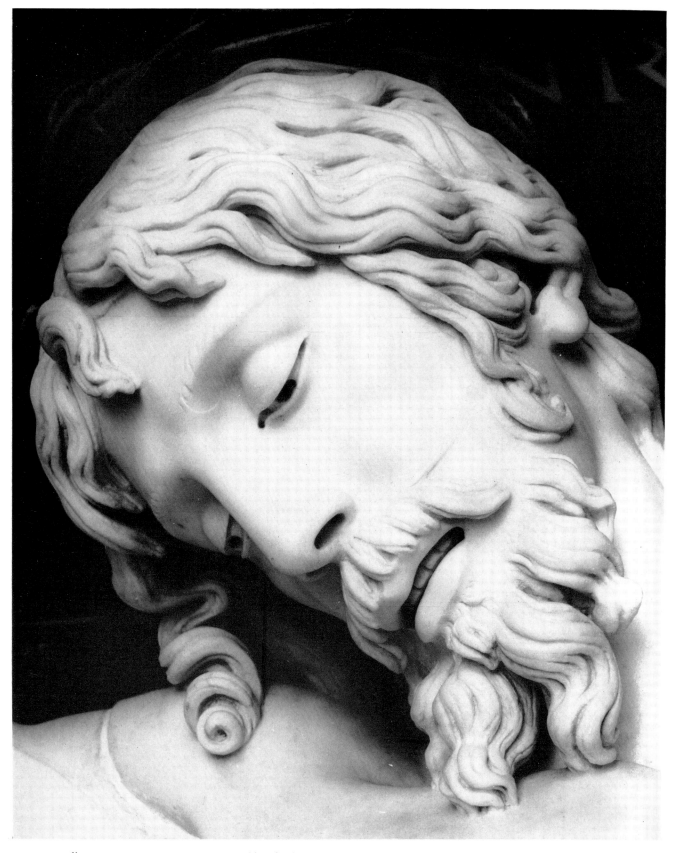

72. Cellini: CRUCIFIED CHRIST (detail of Figure 66). Church of the Escorial. Marble (H. overall 185 cm.).

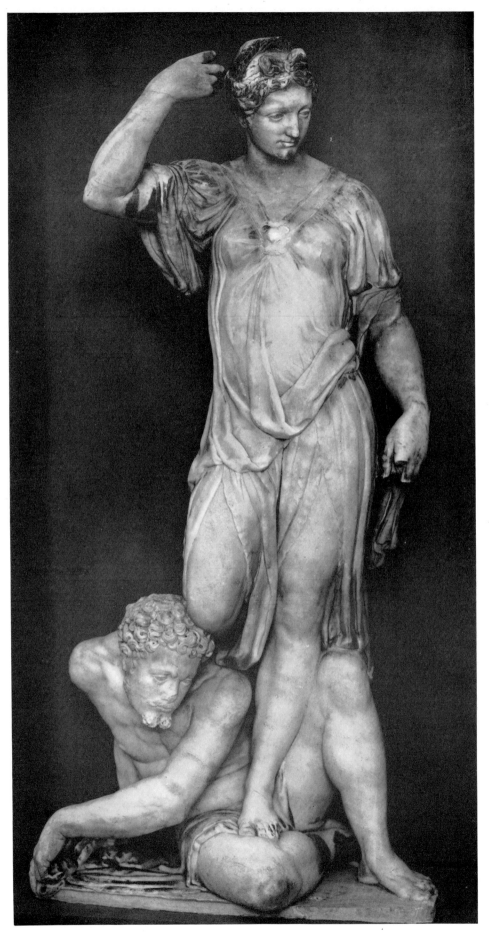

73. Ammanati: VICTORY. Museo Nazionale, Florence. Marble (H. 262 cm.).

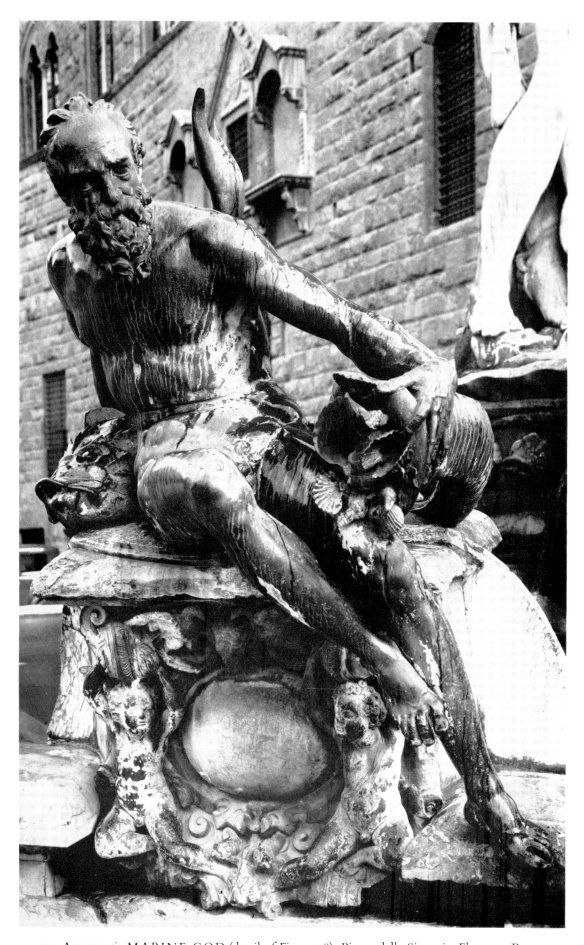

74. Ammanati: MARINE GOD (detail of Figure 98). Piazza della Signoria, Florence. Bronze.

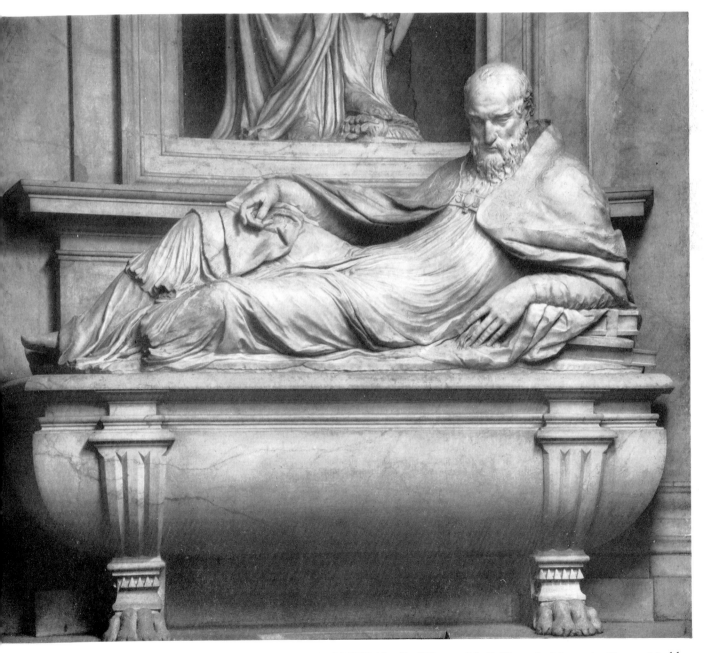

75. Ammanati: MONUMENT OF ANTONIO DEL MONTE (detail of Figure 69). S. Pietro in Montorio, Rome. Marble.

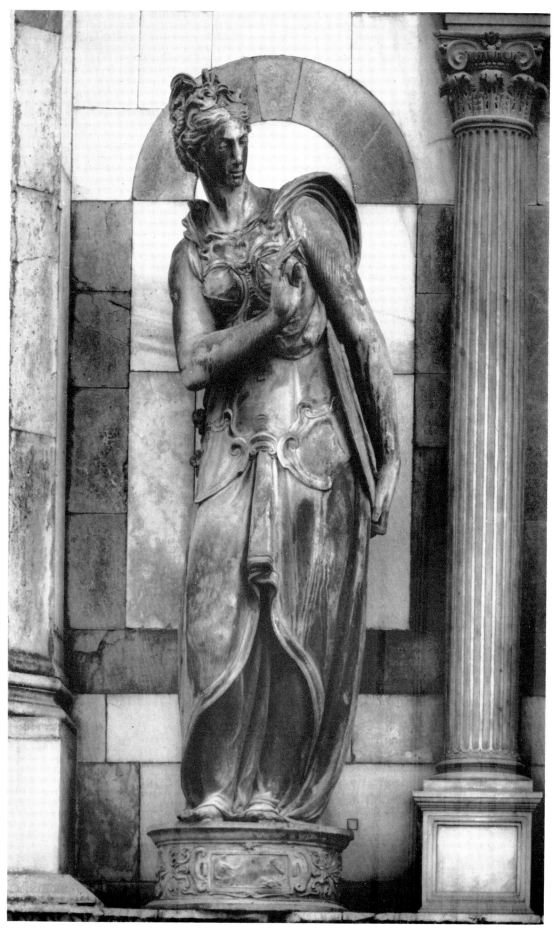

76. Vincenzo Danti: SALOME (detail of Figure 40). Baptistry, Florence. Bronze (H. 243 cm. with base).

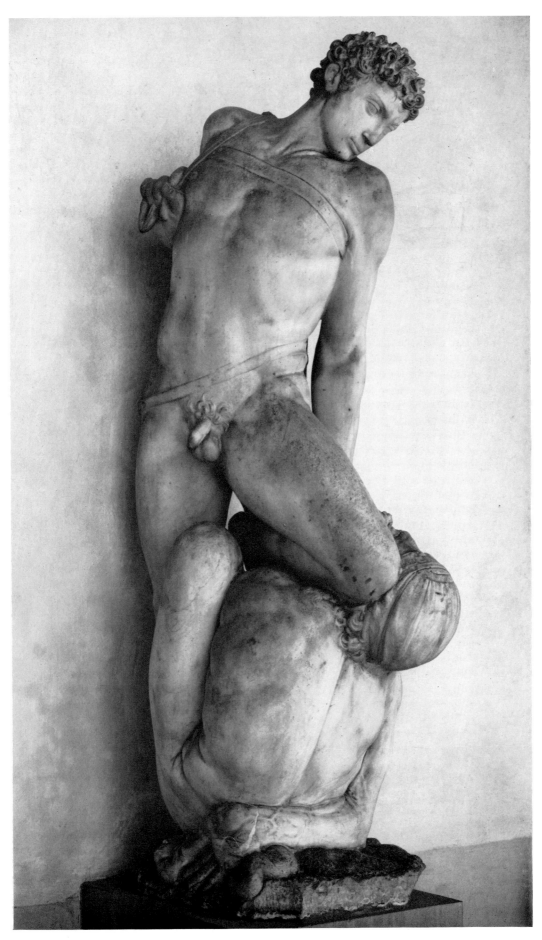

77. Vincenzo Danti: HONOUR TRIUMPHANT OVER FALSEHOOD.
Museo Nazionale, Florence. Marble.

78. Vincenzo Danti: VENUS ANADYOMENE. Palazzo Vecchio, Florence. Bronze (H. 98 cm.).

79. Giovanni Bologna: APOLLO. Palazzo Vecchio, Florence. Bronze (H. 88 cm.).

80. Giovanni Bologna: HEAD OF BACCHUS (detail of Figure 52). Borgo San Jacopo, Florence. Bronze (H. overall 228 cm.).

81. Giovanni Bologna: HEAD OF NEPTUNE (detail of Figure 94). Piazza Nettuno, Bologna. Bronze (H. of central figure ca. 335 cm.).

82. Giovanni Bologna: SAMSON AND A PHILISTINE. Victoria & Albert Museum, London.
Marble (H. 210 cm.).

83. Giovanni Bologna: THE RIVER EUPHRATES (detail of Figure 95). Boboli Gardens, Florence. Marble.

84. Giovanni Bologna: CHRIST (detail of Figure 73). Duomo, Lucca. Marble (H. ca. 230 cm.).

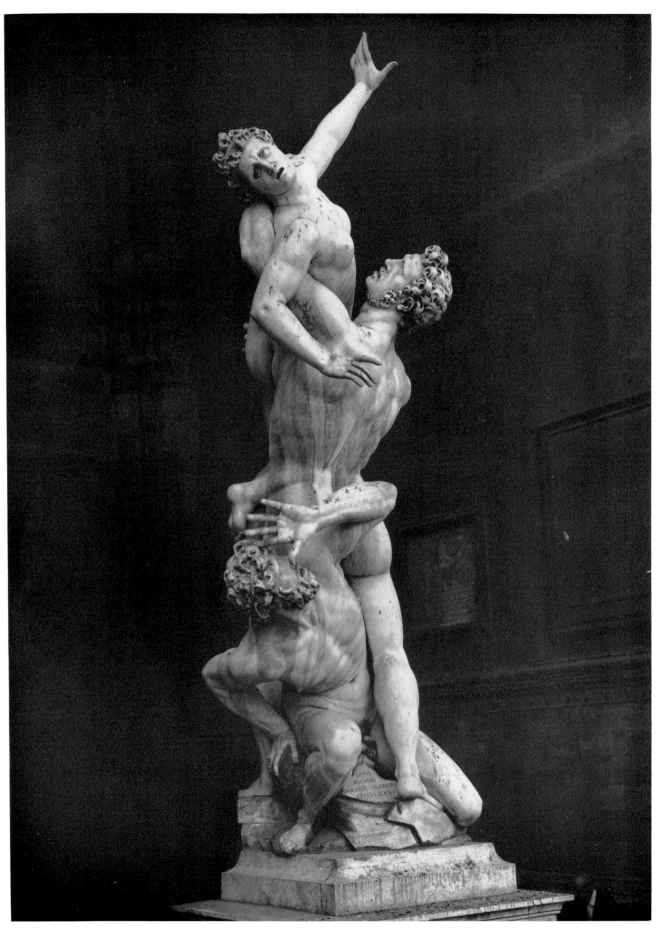

85. Giovanni Bologna: THE RAPE OF THE SABINES. Loggia dei Lanzi, Florence. Marble (H. ca. 410 cm.).

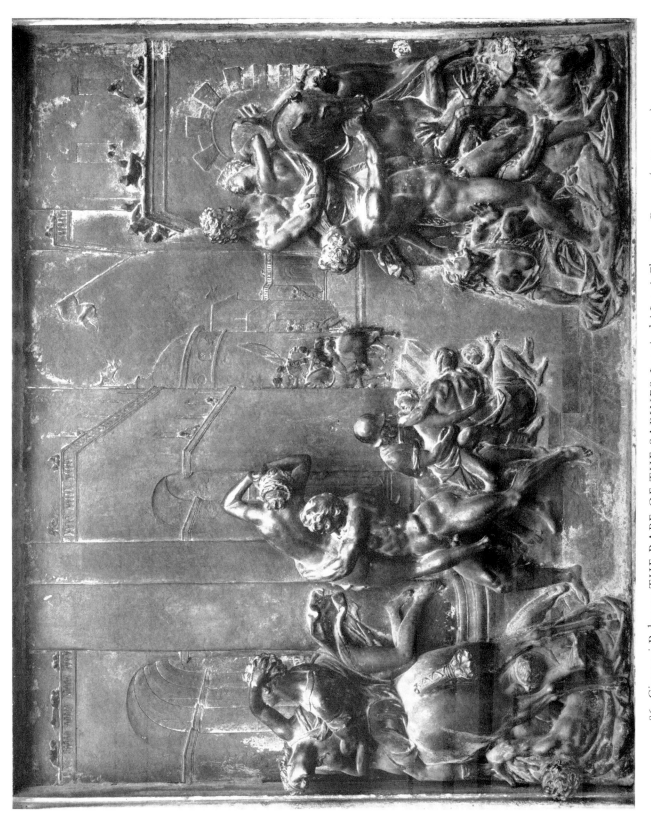

86. Giovanni Bologna: THE RAPE OF THE SABINES. Loggia dei Lanzi, Florence. Bronze (75×90 cm.).

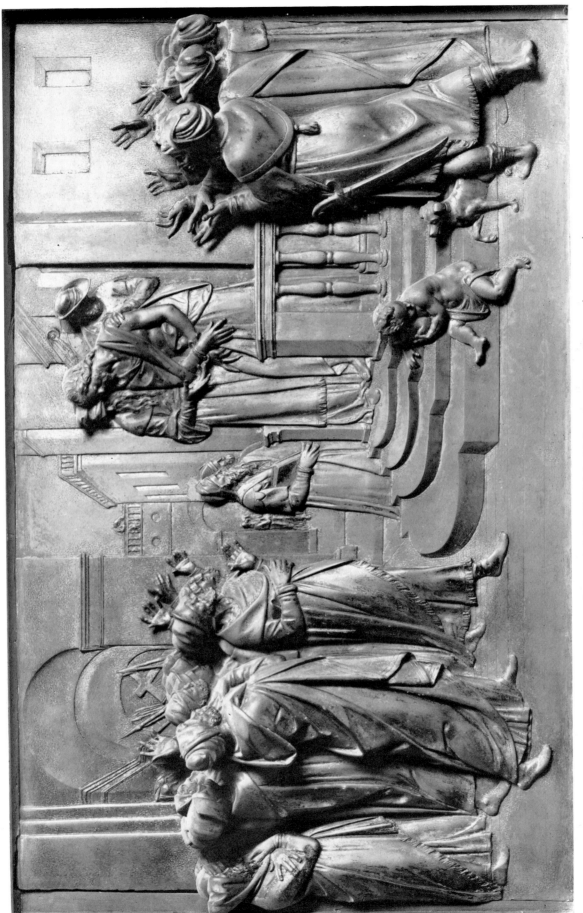

87. Giovanni Bologna: ECCE HOMO. University, Genoa. Bronze (47×71 cm.).

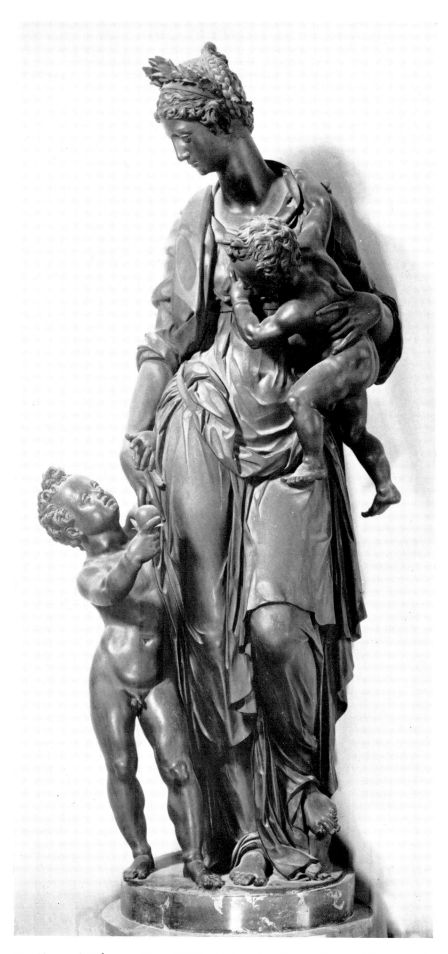

88. Giovanni Bologna: CHARITY. University, Genoa. Bronze (H. 175 cm.).

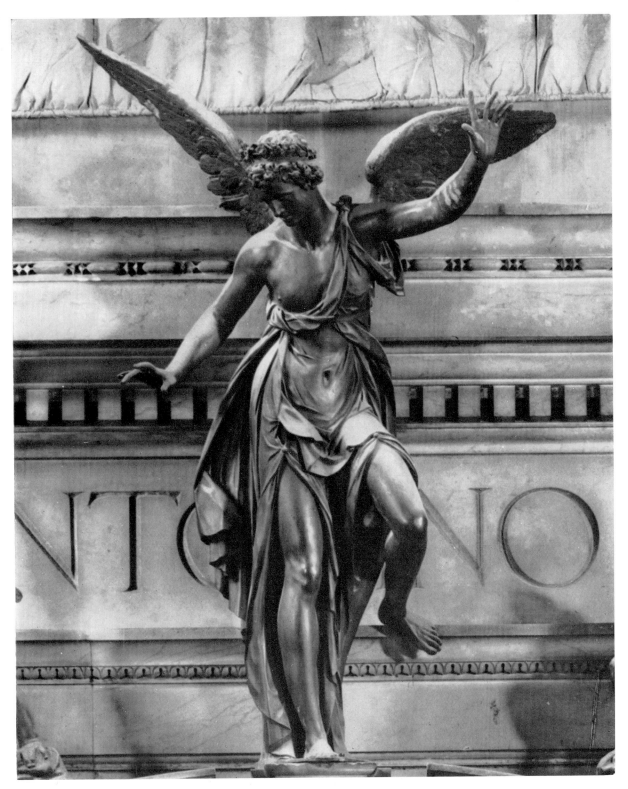

89. Giovanni Bologna: ANGEL (detail of Figure 75). S. Marco, Florence. Bronze.

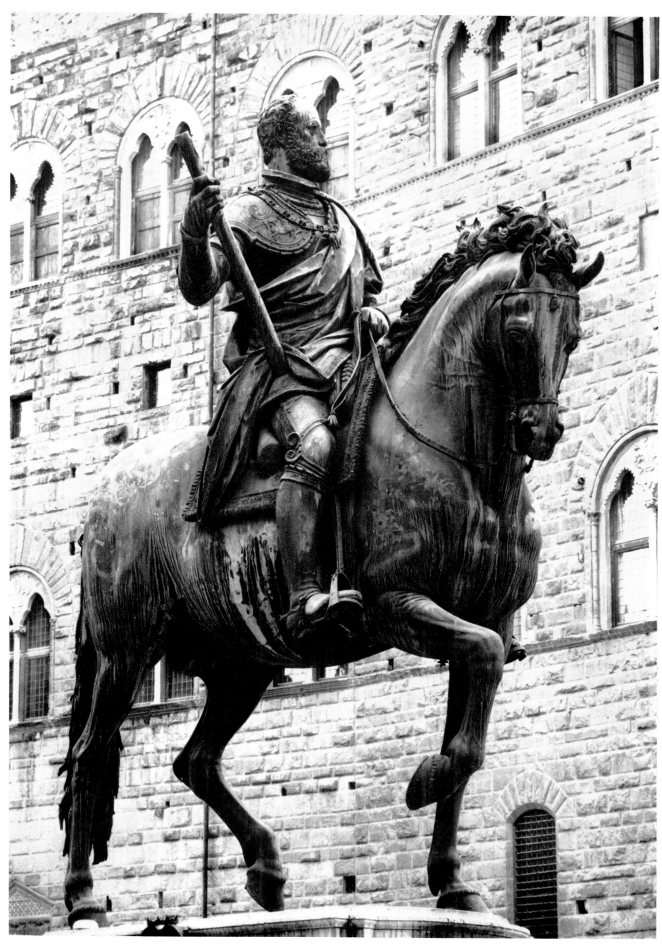

90. Giovanni Bologna: MONUMENT OF COSIMO I DE' MEDICI. Piazza della Signoria, Florence.
Bronze (H. ca. 450 cm.).

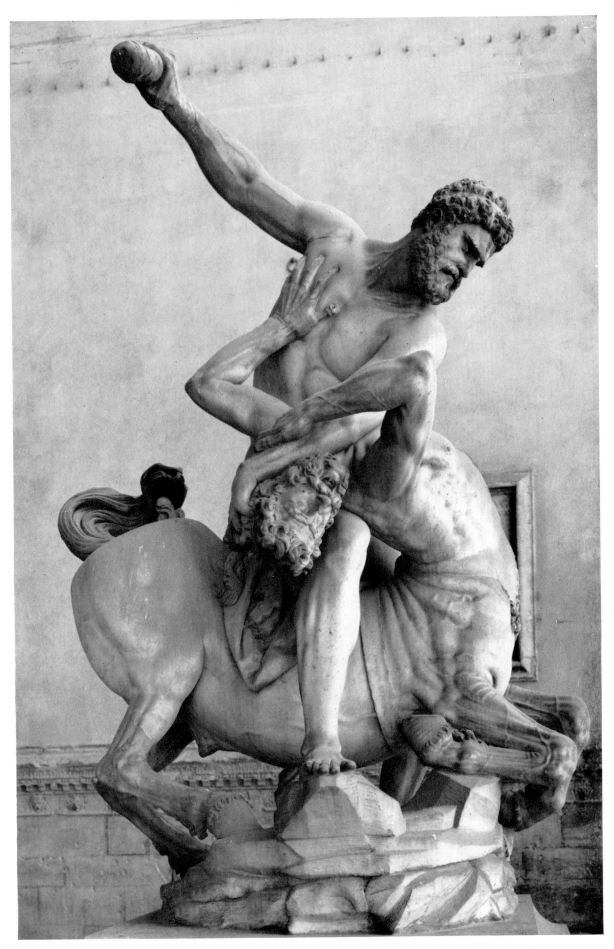

91. Giovanni Bologna: HERCULES AND THE CENTAUR. Loggia dei Lanzi, Florence.
Marble (H. ca. 270 cm.).

92. Giovanni Bologna: ST. ANTONINUS. S. Marco, Florence. Bronze (L. 179.5 cm.).

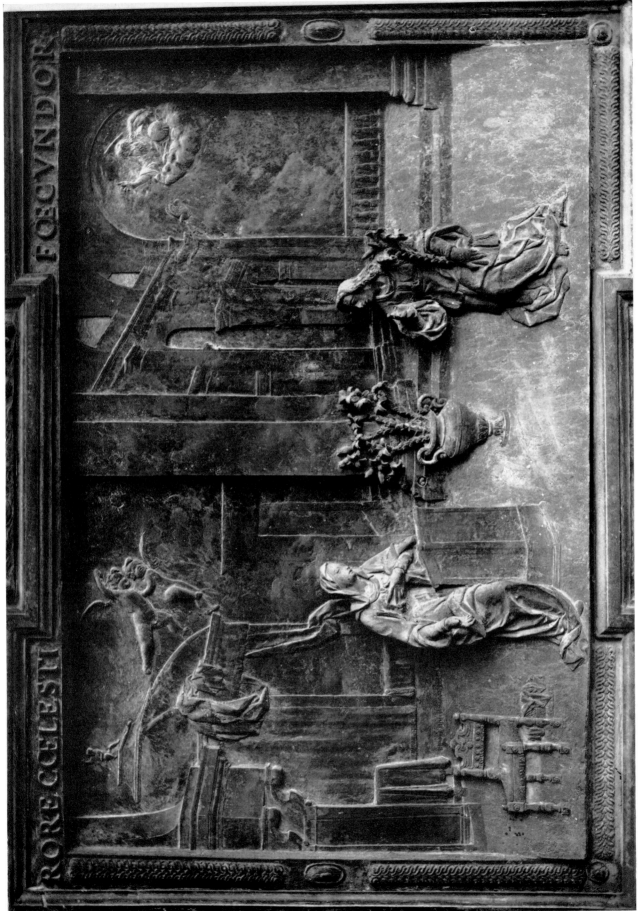

93. Giovanni Caccini: THE ANNUNCIATION (detail of Figure 90). Duomo, Pisa. Bronze.

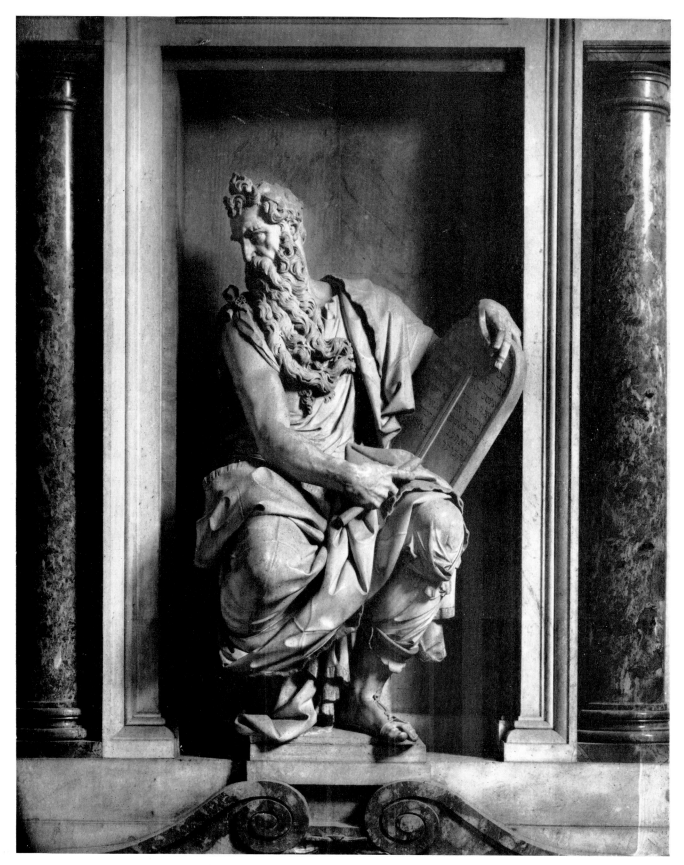

94. Francavilla: MOSES (detail of Figure 76). S. Croce, Florence. Marble.

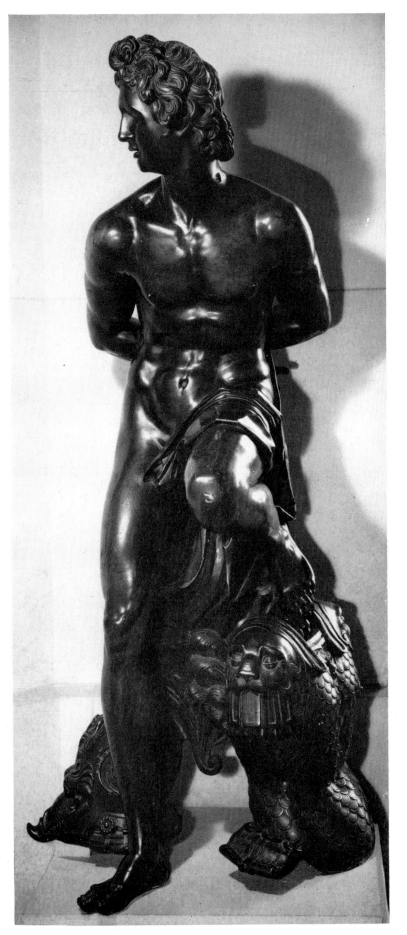

95. Francavilla: PRISONER. Louvre, Paris. Bronze (H. 155 cm.).

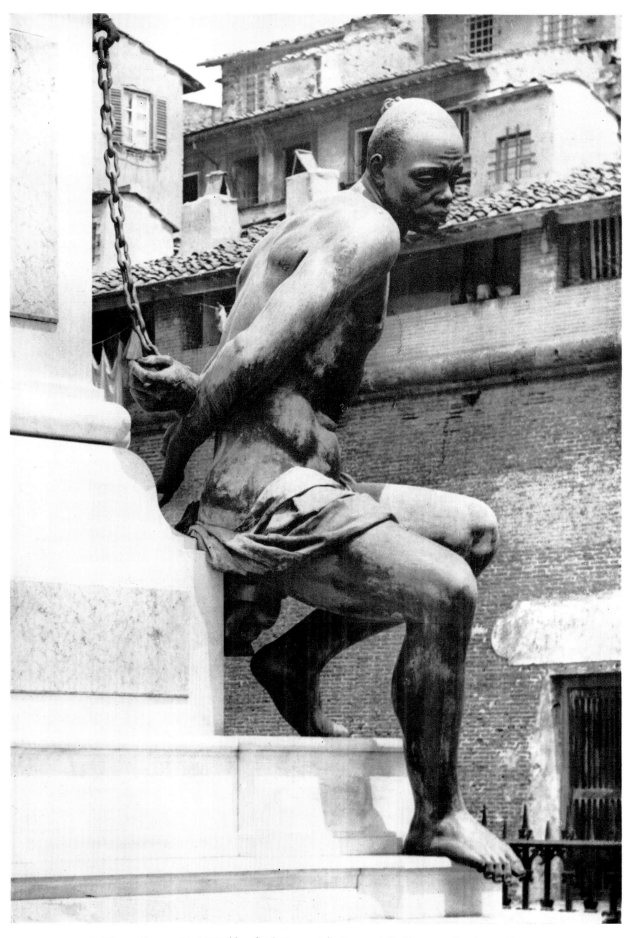

96. Pietro Tacca: SLAVE (detail of Figure 60). Piazza della Darsena, Leghorn. Bronze.

97. Pietro Tacca: FERDINAND I DE' MEDICI (detail of Figure 77). Cappella dei Principi, Florence. Gilt bronze.

98. Giacomo and Guglielmo della Porta: ALTAR OF THE APOSTLES (detail of Figure 143).
Duomo, Genoa. Marble.

99. Guglielmo della Porta: JUSTICE (detail of Figure 145). St. Peter's, Rome. Marble.

100. Guglielmo della Porta: POPE PAUL III (detail of Figure 145). St. Peter's, Rome. Bronze.

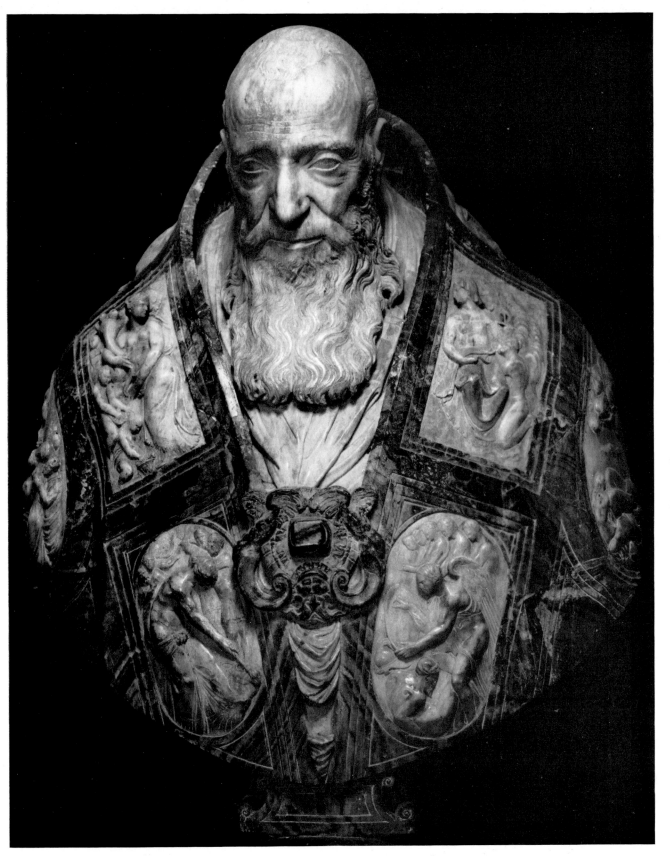

101. Guglielmo della Porta: POPE PAUL III. Museo Nazionale di Capodimonte, Naples. Marble (H. 75 cm.).

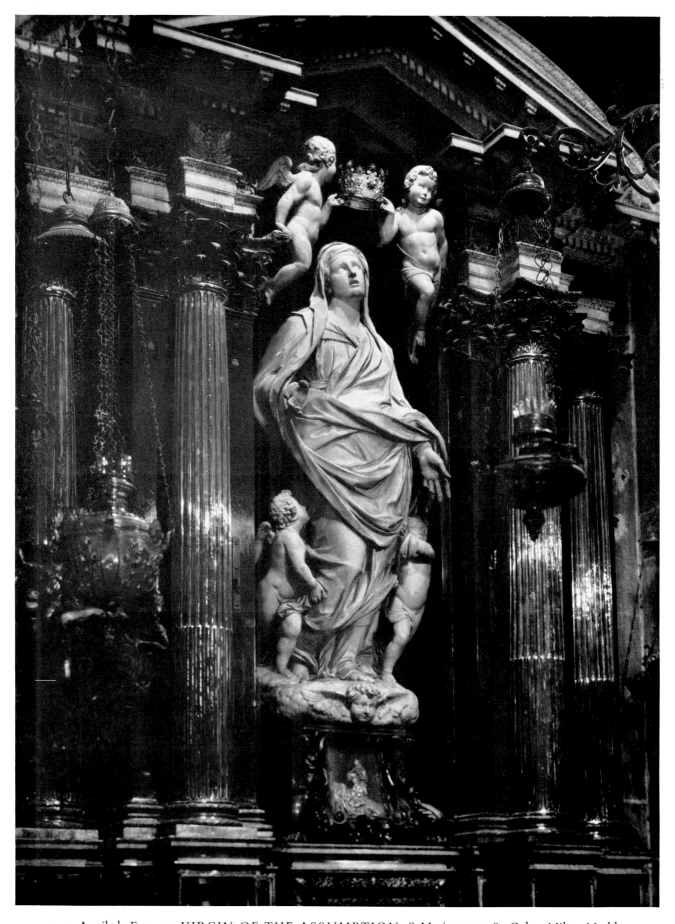

102. Annibale Fontana: VIRGIN OF THE ASSUMPTION. S. Maria presso S. Celso, Milan. Marble.

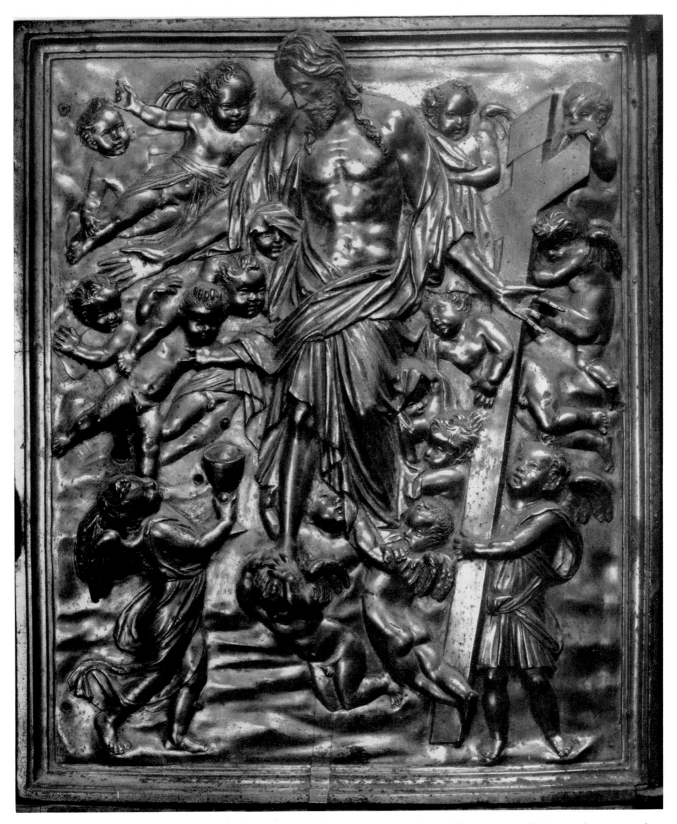

115. Jacopo Sansovino: ALLEGORY OF THE REDEMPTION. St. Mark's, Venice. Gilt bronze (43×37 cm.).

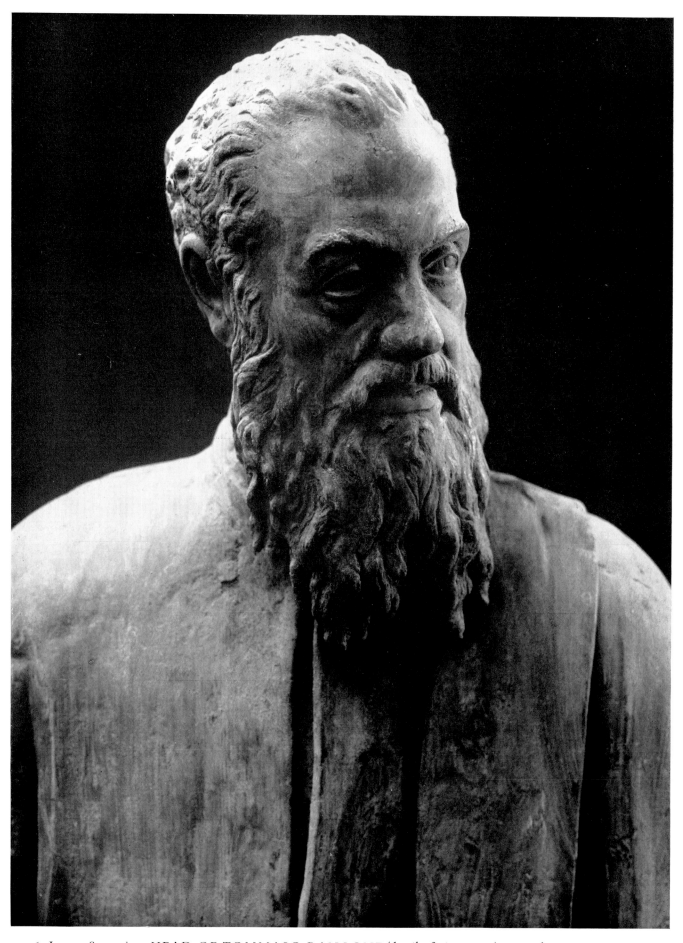

116. Jacopo Sansovino: HEAD OF TOMMASO RANGONE (detail of Figure 116). S. Giuliano, Venice. Bronze.

117. Danese Cattaneo: ALLEGORICAL SCENE (detail of Figure 112). SS. Giovanni e Paolo, Venice. Bronze (76×76 cm.).

118. Jacopo Sansovino: JUPITER. Kunsthistorisches Museum, Vienna. Bronze (H. 43 cm.).

119. Danese Cattaneo: FORTUNA. Museo Nazionale, Florence. Bronze (H. 50 cm.).

120. Danese Cattaneo and Girolamo Campagna: DOGE LEONARDO LOREDANO AND THE MILITARY
MIGHT OF THE VENETIAN REPUBLIC (detail of Figure 112). SS. Giovanni e Paolo, Venice. Marble.

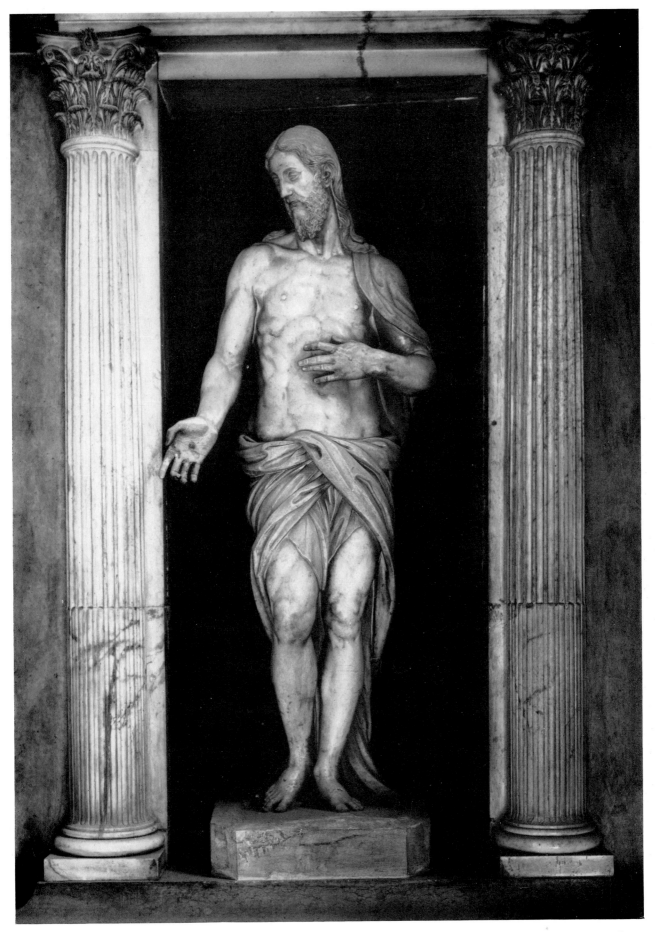

121. Danese Cattaneo: THE RISEN CHRIST (detail of Figure 106). S. Anastasia, Verona. Marble (H. 190 cm.).

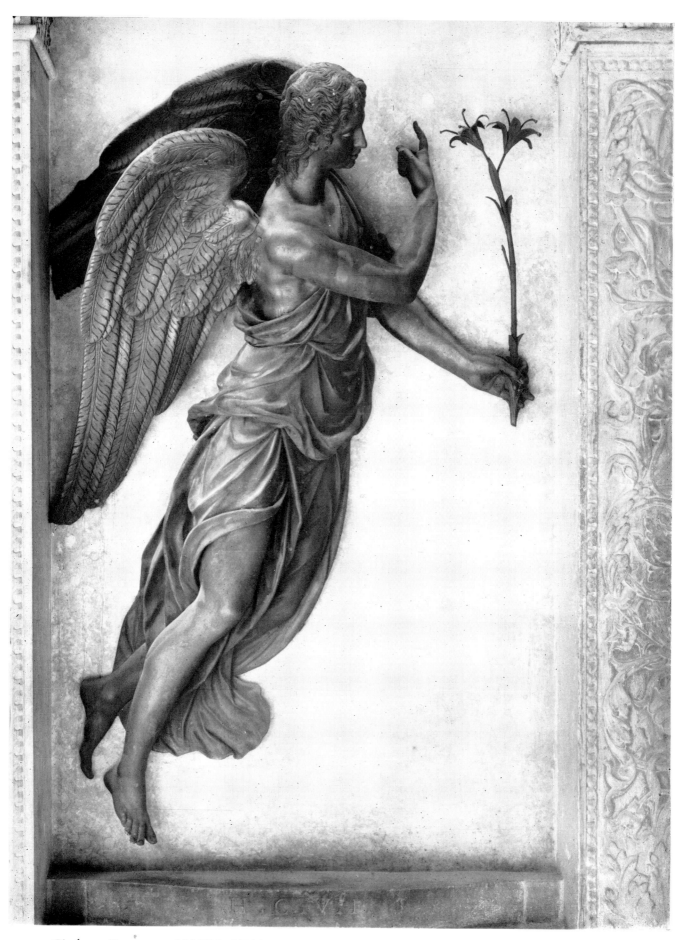

122. Girolamo Campagna: ANGEL OF THE ANNUNCIATION (detail of Figure 118). Castelvecchio, Verona.
Bronze (H. 213 cm.).

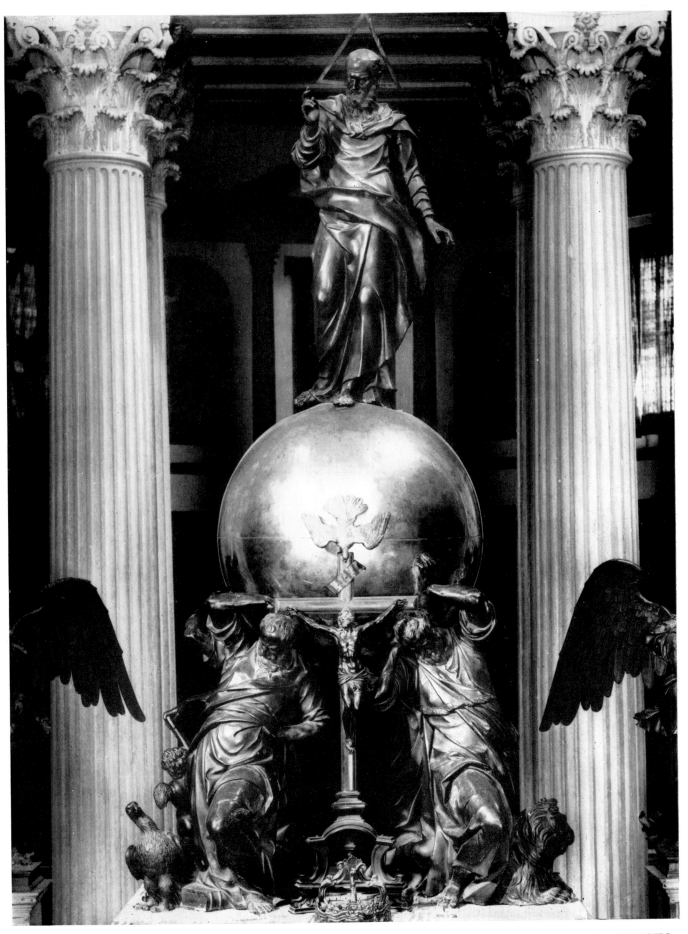

123. Girolamo Campagna: GOD THE FATHER IN BENEDICTION WITH THE FOUR EVANGELISTS.
S. Giorgio Maggiore, Venice. Bronze.

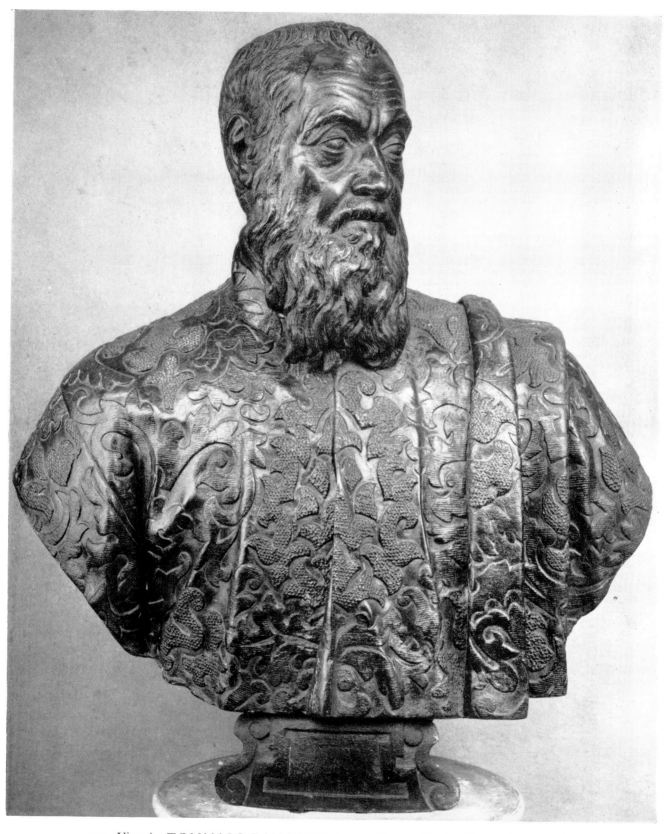

124. Vittoria: TOMMASO RANGONE. Ateneo Veneto, Venice. Bronze (H. 81 cm.).

VICTORIA

125. Vittoria: ST. ROCH (detail of Figure 110). S. Salvatore, Venice. Marble (H. 175 cm.).

126. Vittoria: ST. SEBASTIAN (detail of Figure 109). S. Francesco della Vigna, Venice.
Marble (H. 117 cm.).

127. Vittoria: ST. SEBASTIAN (detail of Figure 110). S. Salvatore, Venice.
Marble (H. 170 cm.).

128. Vittoria: ST. JEROME. S. Maria dei Frari, Venice. Marble (H. 192 cm.).

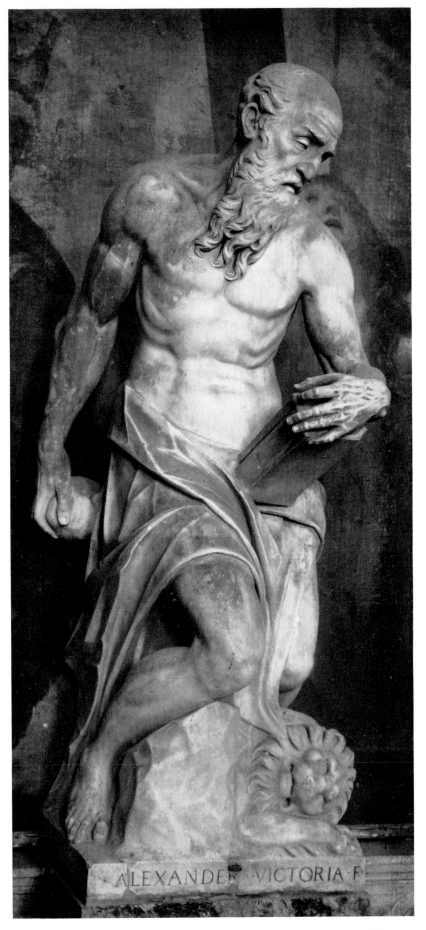

129. Vittoria: ST. JEROME. SS. Giovanni e Paolo, Venice. Marble (H. 169 cm.).

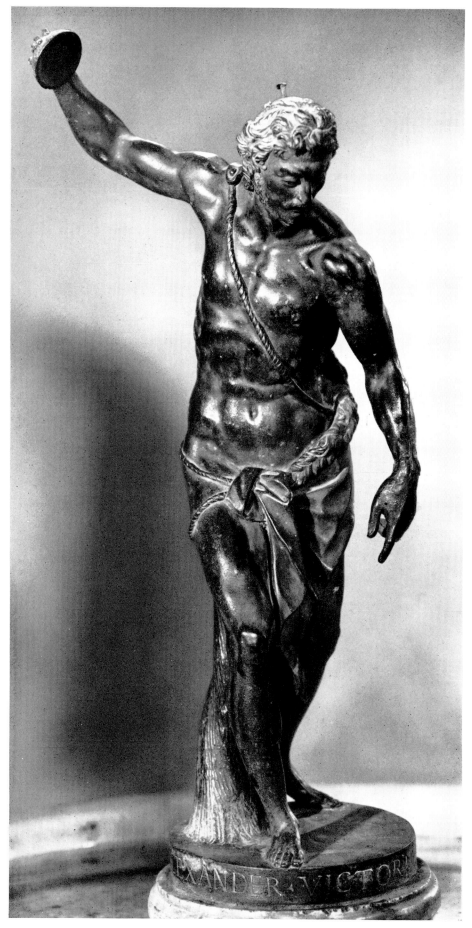

130. Vittoria: ST. JOHN THE BAPTIST. S. Francesco della Vigna, Venice.
Bronze (H. 71 cm.).

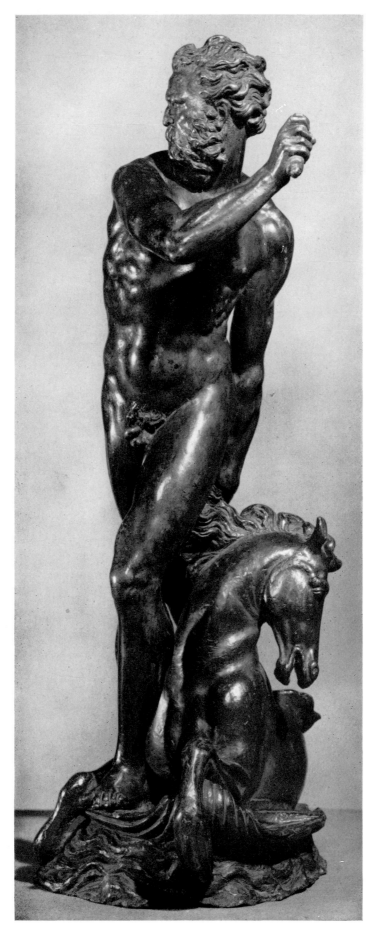

131. Vittoria: NEPTUNE WITH A SEA-HORSE.
Victoria & Albert Museum, London. Bronze (H. 49.5 cm.).

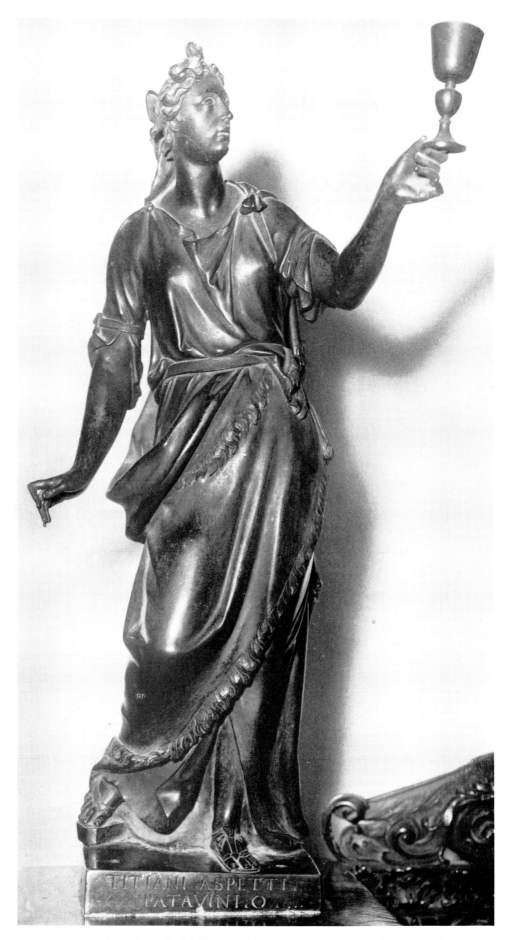

132. Tiziano Aspetti: FAITH. S. Antonio, Padua. Bronze (H. 100 cm.).

133. Niccolò Roccatagliata: ST. STEPHEN. S. Giorgio Maggiore, Venice. Bronze (H. 60.1 cm.).

134. Taddeo Landini: POPE SIXTUS V. Staatliche Museen, Berlin. Bronze (H. 70 cm.).

135. Valsoldo: POPE SIXTUS V (detail of Figure 149). S. Maria Maggiore, Rome. Marble.

136. Niccolò Cordieri: DAVID. S. Maria Maggiore, Rome. Marble.

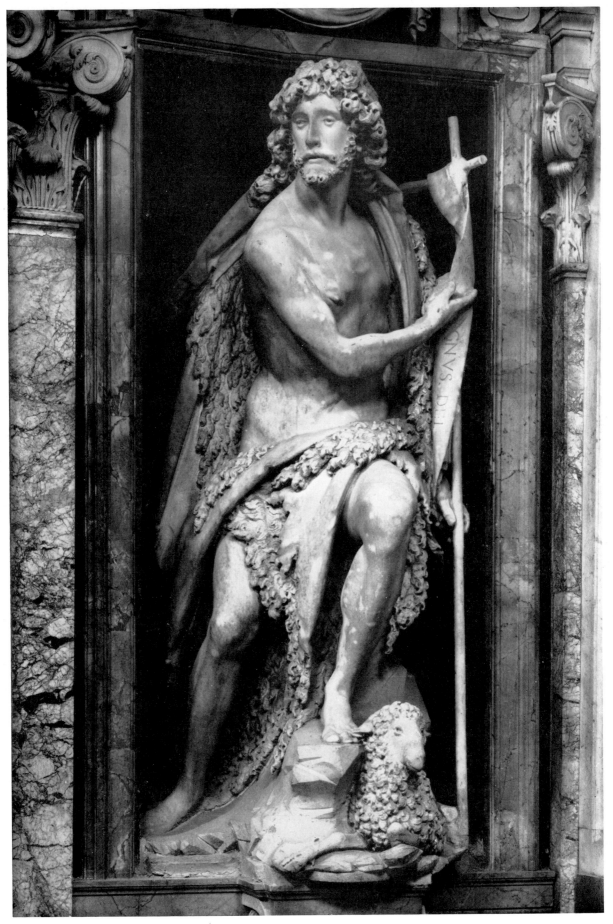

137. Pietro Bernini: ST. JOHN THE BAPTIST. S. Andrea della Valle, Rome. Marble.

138. Pietro Bernini: THE ASSUMPTION OF THE VIRGIN. S. Maria Maggiore, Rome. Marble.

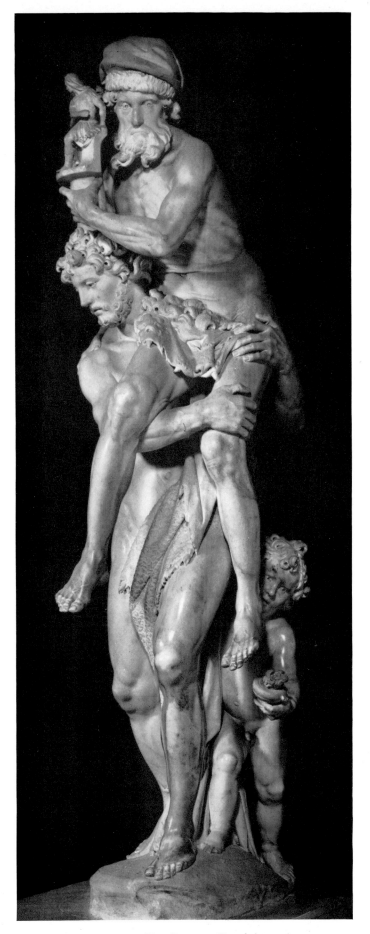

139. Gian Lorenzo Bernini:
AENEAS, ANCHISES AND ASCANIUS LEAVING TROY.
Galleria Borghese, Rome. Marble (H. 220 cm.).

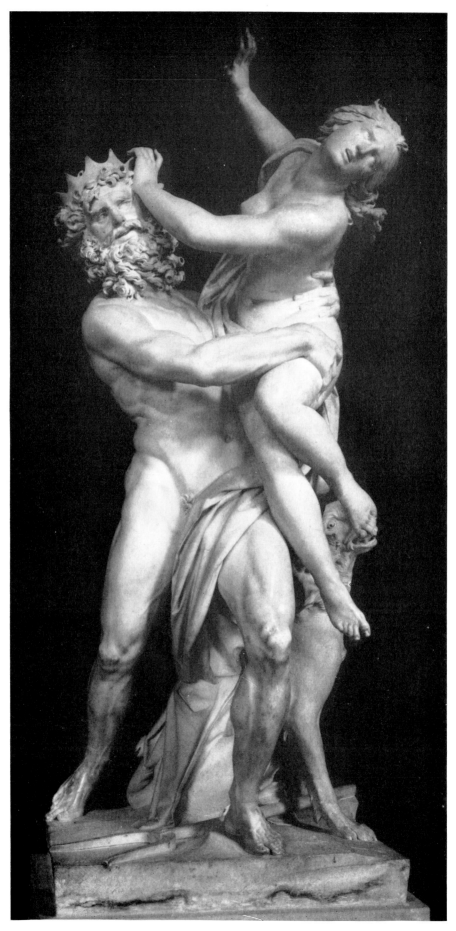

140. Gian Lorenzo Bernini: THE RAPE OF PROSERPINE.
Galleria Borghese, Rome. Marble (H. 225 cm.).

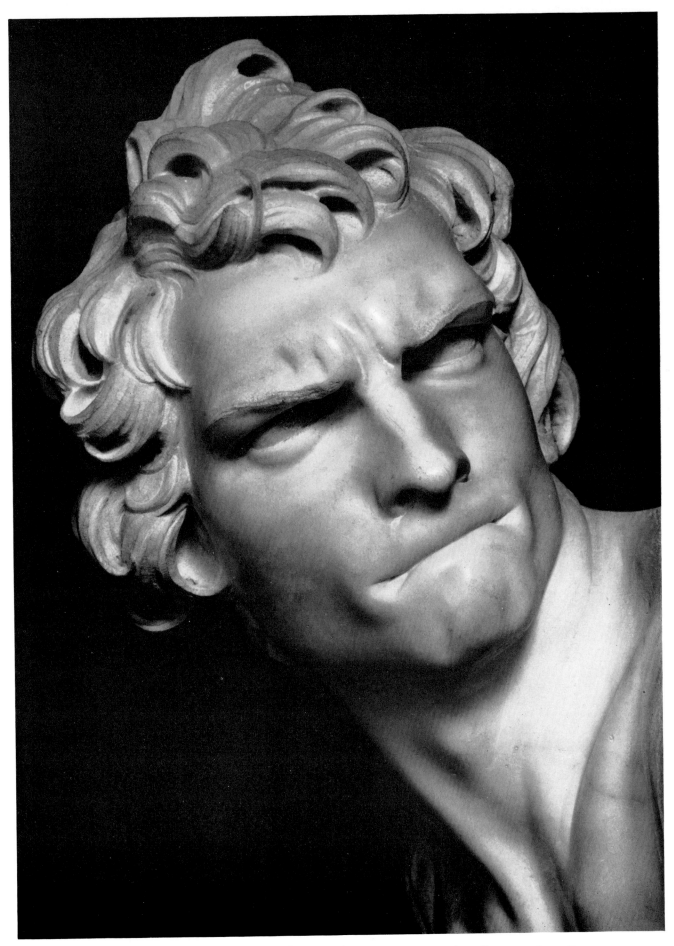

141. Gian Lorenzo Bernini: HEAD OF DAVID (detail of Figure 157). Galleria Borghese, Rome.
Marble (H. overall 170 cm.).

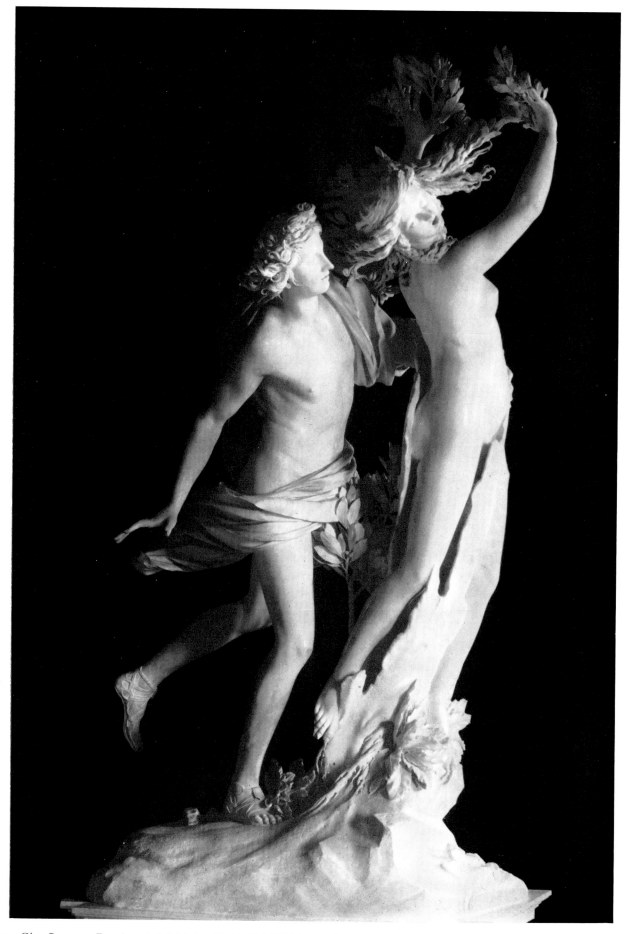

142. Gian Lorenzo Bernini: APOLLO AND DAPHNE. Galleria Borghese, Rome. Marble (H. without base 243 cm.).

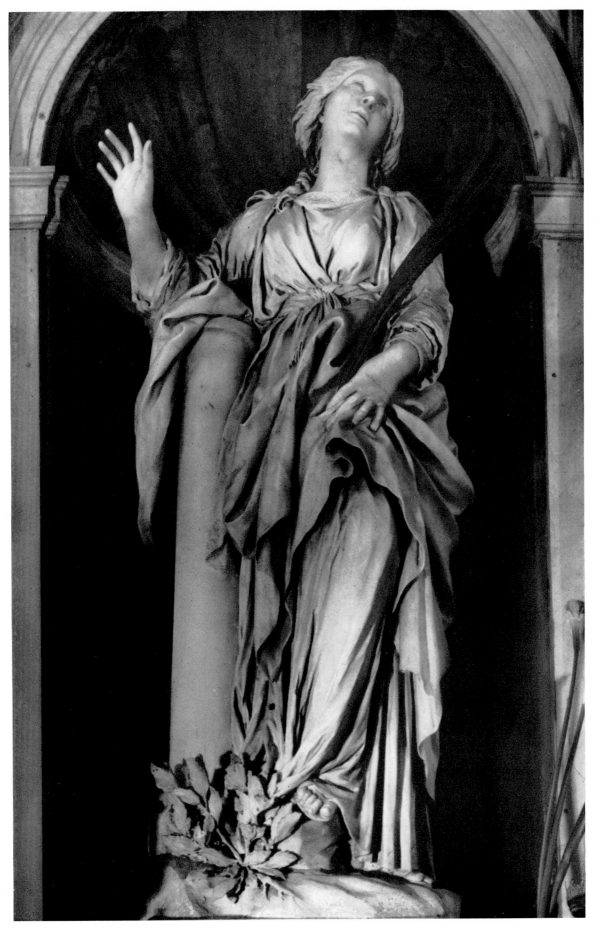

143. Gian Lorenzo Bernini: S. BIBIANA (detail of Figure 162). S. Bibiana, Rome. Marble.

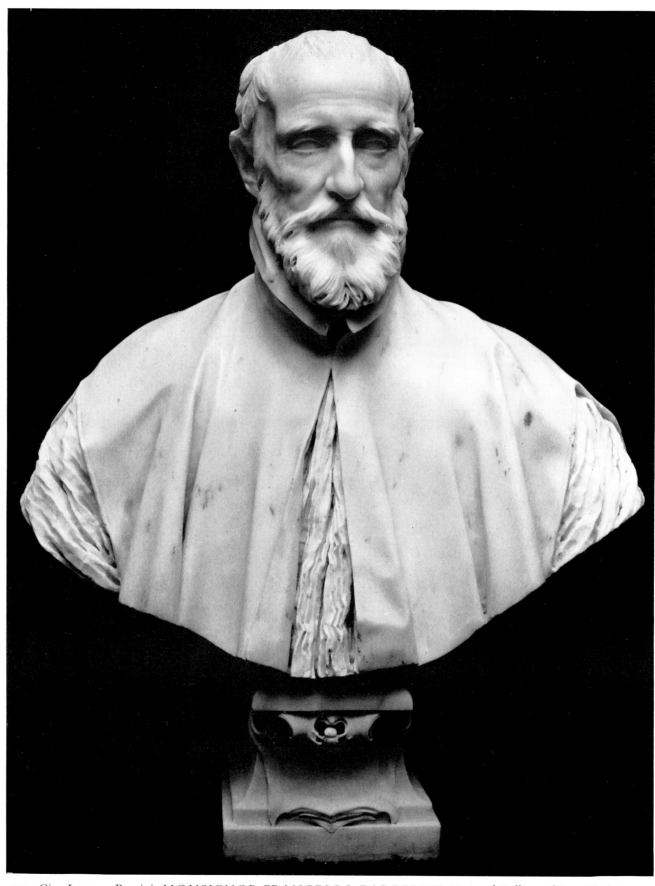

144. Gian Lorenzo Bernini: MONSIGNOR FRANCESCO BARBERINI. National Gallery of Art, Washington
(Samuel H. Kress Collection). Marble (H. 79.2 cm.).

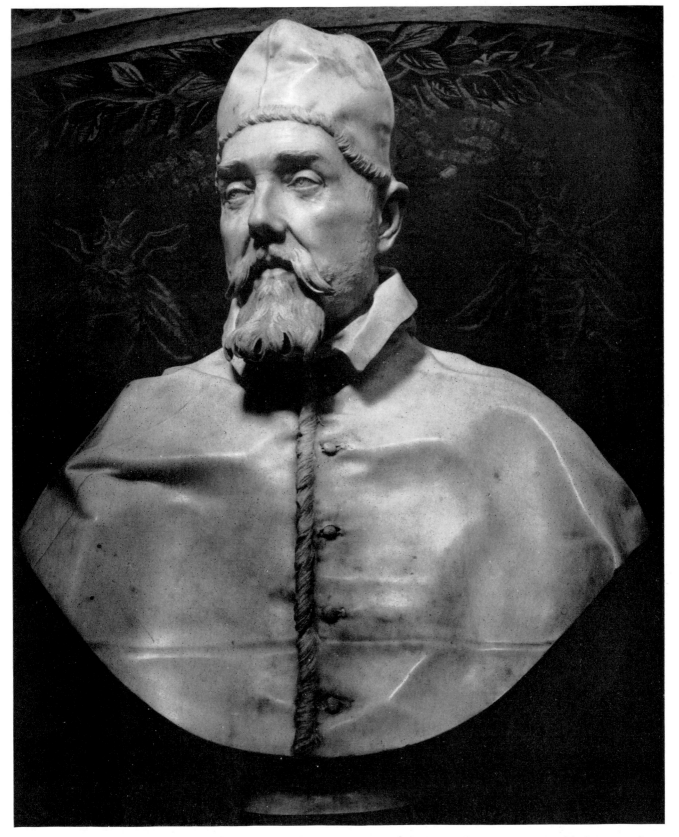

145. Gian Lorenzo Bernini: POPE URBAN VIII. Heirs of Prince Enrico Barberini, Rome. Marble (H. 83 cm.).

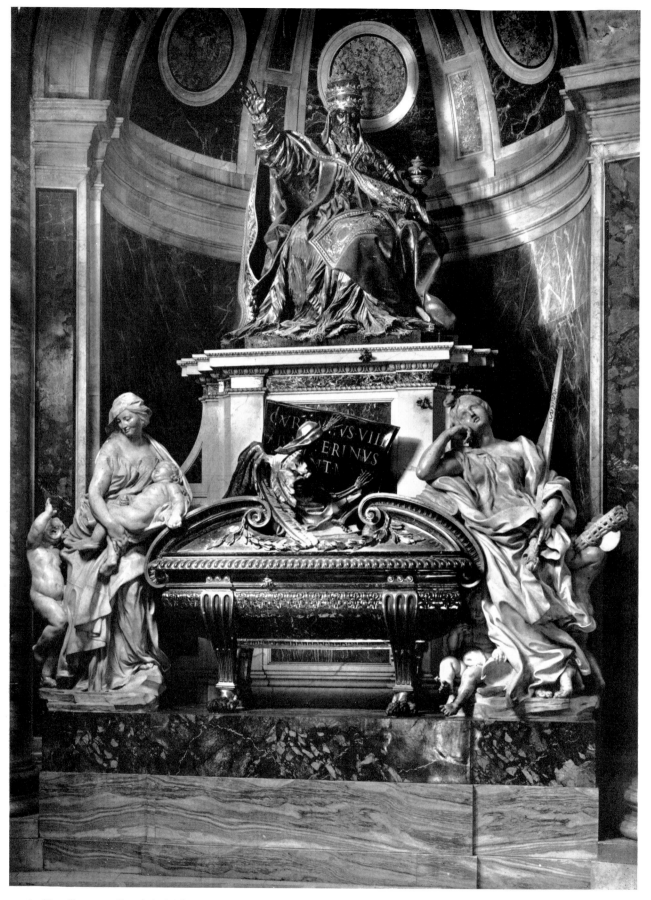

146. Gian Lorenzo Bernini: MONUMENT OF POPE URBAN VIII. St. Peter's, Rome. Marble and bronze.

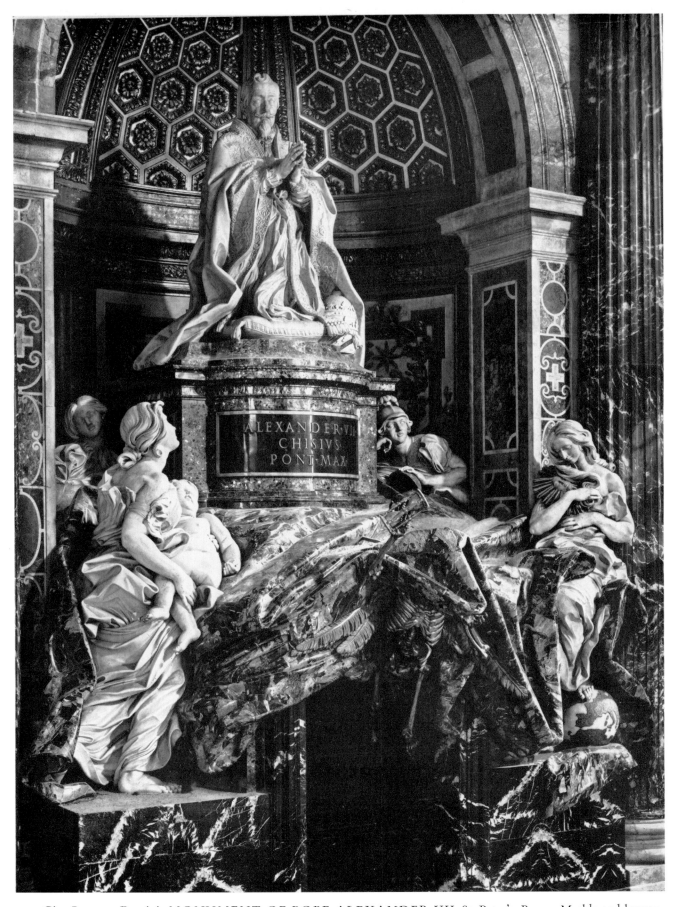

147. Gian Lorenzo Bernini: MONUMENT OF POPE ALEXANDER VII. St. Peter's, Rome. Marble and bronze.

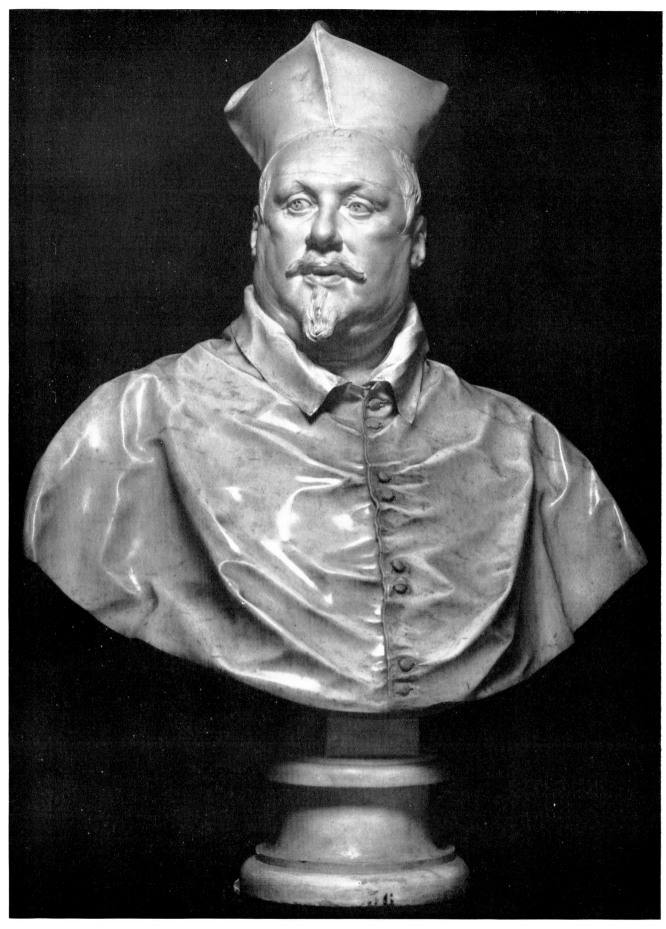

148. Gian Lorenzo Bernini: CARDINAL SCIPIONE BORGHESE. Galleria Borghese, Rome. Marble (H. 78 cm.).

149. Gian Lorenzo Bernini: FRANCESCO I D'ESTE. Pinacoteca Estense, Modena. Marble (H. with base 100 cm.).

150. Gian Lorenzo Bernini: ANGEL WITH A LANCE (detail of Figure 163). S. Maria della Vittoria, Rome. Marble.

151. Gian Lorenzo Bernini: HEAD OF ST. TERESA (detail of Figure 163). S. Maria della Vittoria, Rome. Marble.

152. Gian Lorenzo Bernini: TRUTH UNVEILED. Galleria Borghese, Rome. Marble (H. 280 cm.).

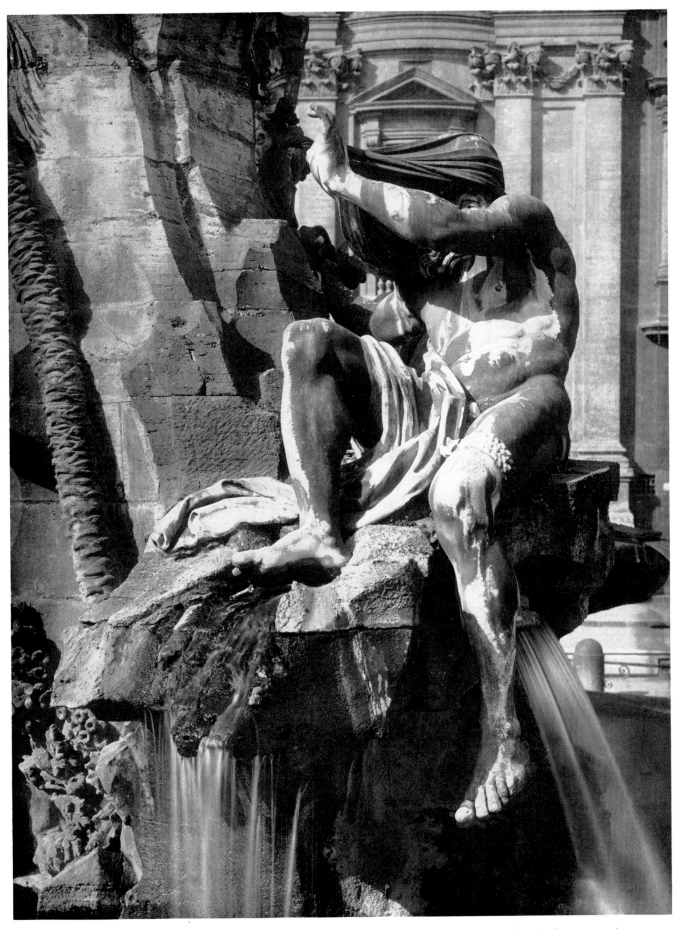

153. Gian Lorenzo Bernini and Giacomo Antonio Fancelli: THE RIVER NILE (detail of Figure 174).
Piazza Navona, Rome. Marble.

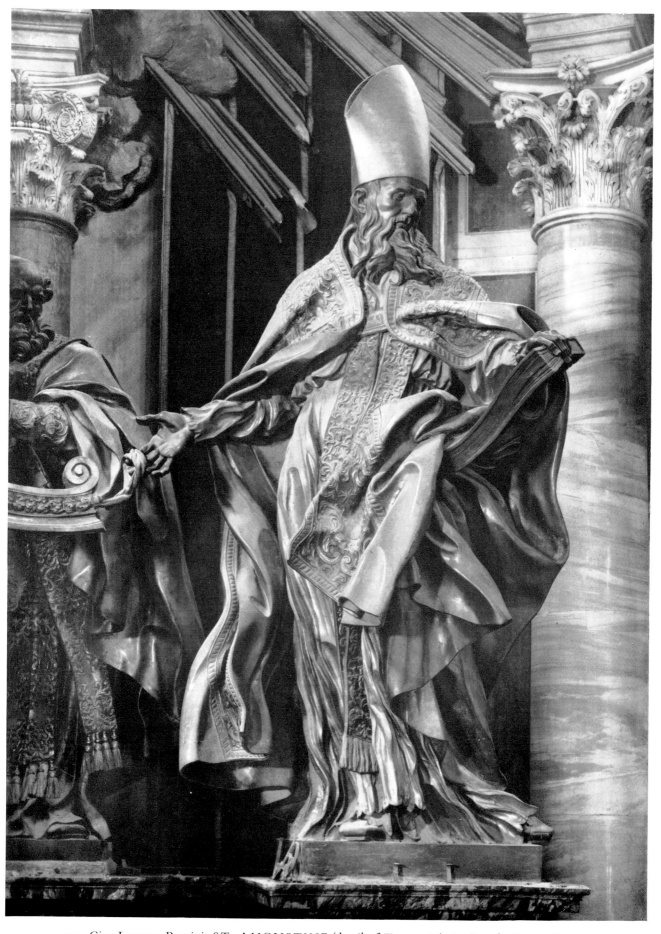

154. Gian Lorenzo Bernini: ST. AUGUSTINE (detail of Figure 166). St. Peter's, Rome. Bronze.

155. Gian Lorenzo Bernini: THE CHAIR OF ST. PETER (detail of Figure 166). St. Peter's, Rome. Bronze.

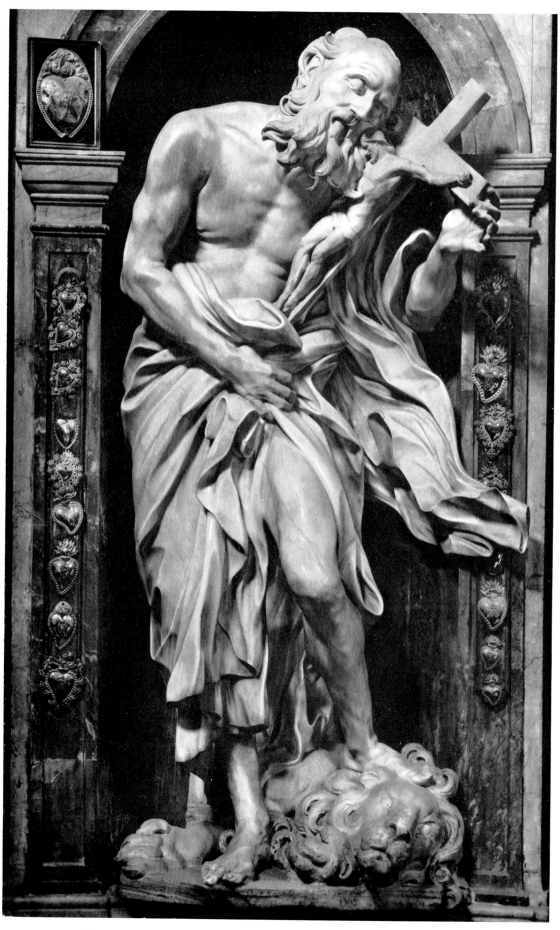

156. Gian Lorenzo Bernini: ST. JEROME. Duomo, Siena. Marble (H. 195 cm.).

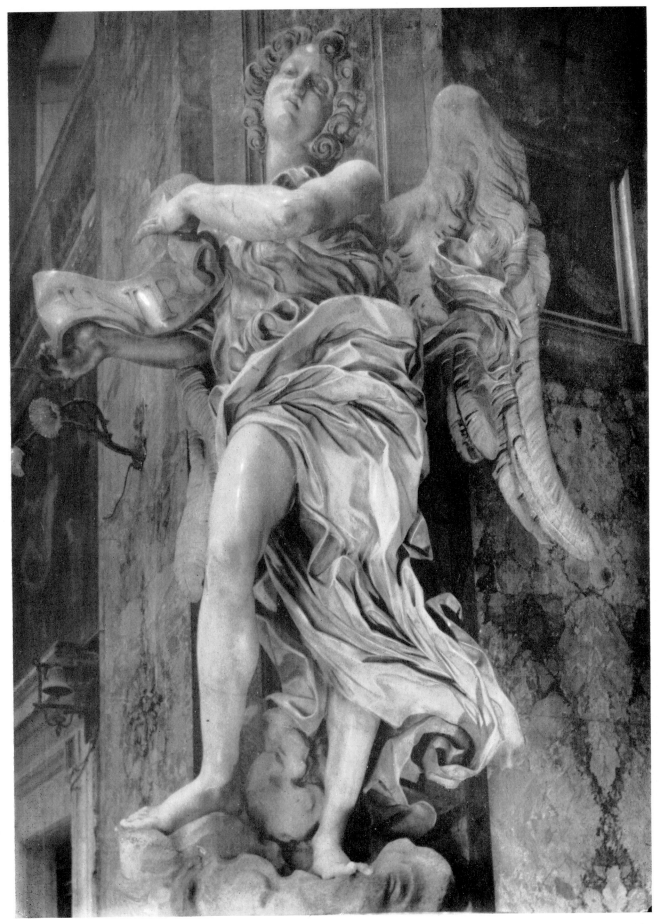

157. Gian Lorenzo Bernini: ANGEL WITH THE SUPERSCRIPTION. S. Andrea della Fratte, Rome. Marble.

158. Gian Lorenzo Bernini: THE DEATH OF THE BEATA LODOVICA ALBERTONI. S. Francesco a Ripa, Rome. Marble.

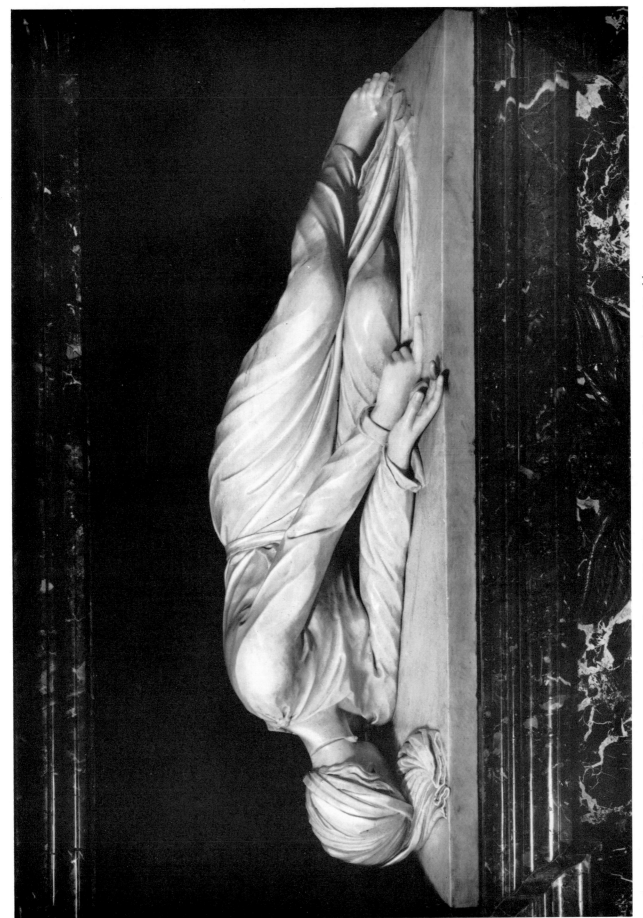

159. Maderno: ST. CECILIA. S. Cecilia in Trastevere, Rome. Marble.

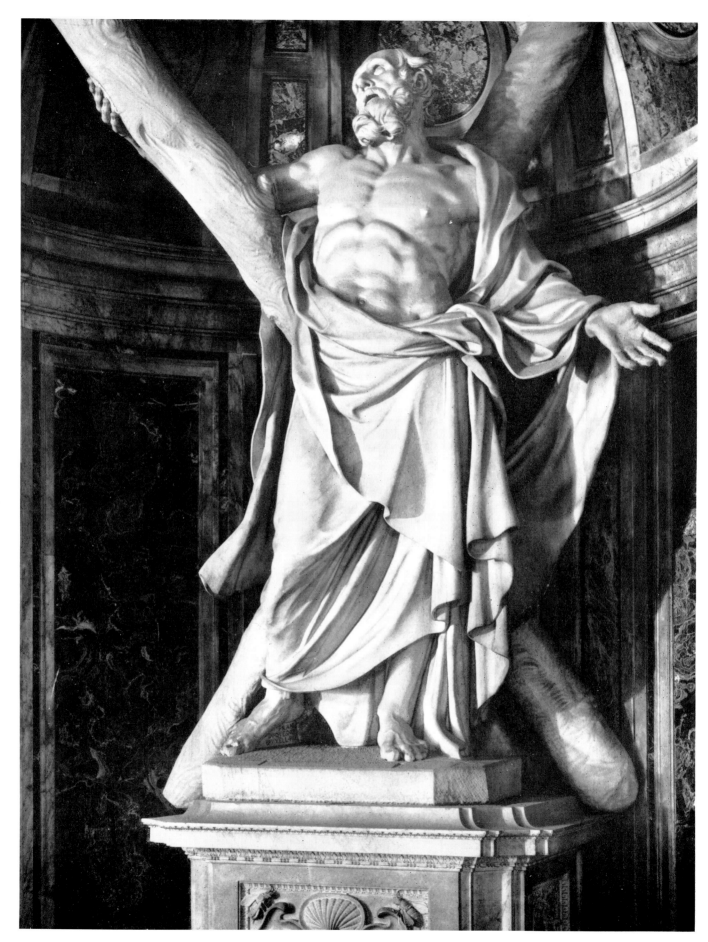

160. Duquesnoy: ST. ANDREW. St. Peter's, Rome. Marble.

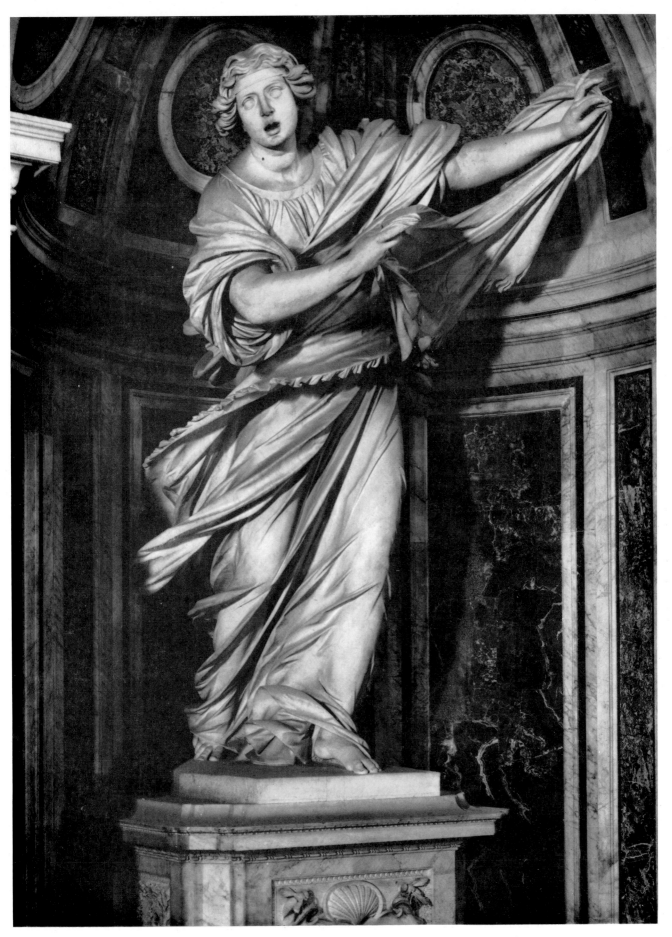

161. Francesco Mochi: ST. VERONICA. St. Peter's, Rome. Marble.

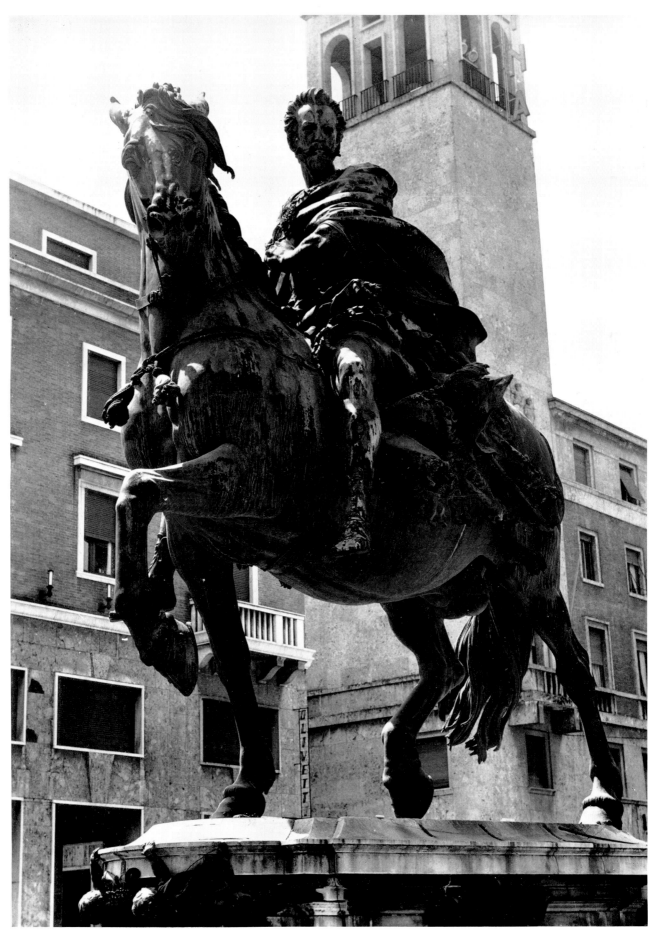

162. Francesco Mochi: EQUESTRIAN MONUMENT OF ALESSANDRO FARNESE (detail of Figure 140).
Piazza Cavalli, Piacenza. Bronze.

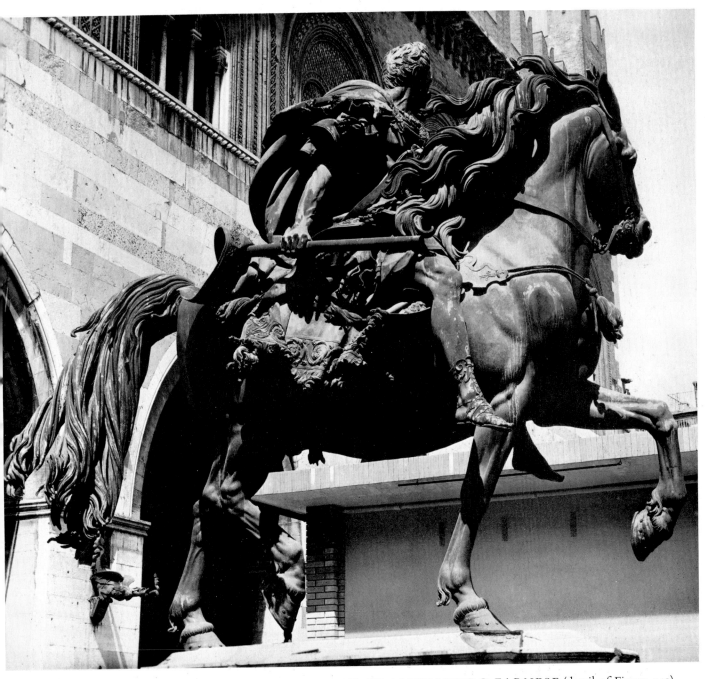

163. Francesco Mochi: EQUESTRIAN MONUMENT OF ALESSANDRO FARNESE (detail of Figure 140).
Piazza Cavalli, Piacenza. Bronze.

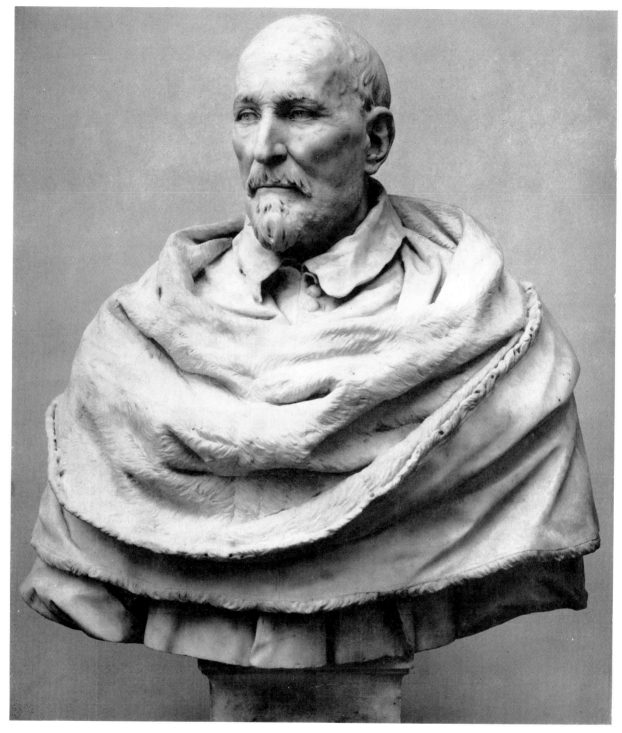

164. Algardi: CARDINAL LAUDIVIO ZACCHIA. Staatliche Museen, Berlin. Marble.
(H. without base 70 cm.).

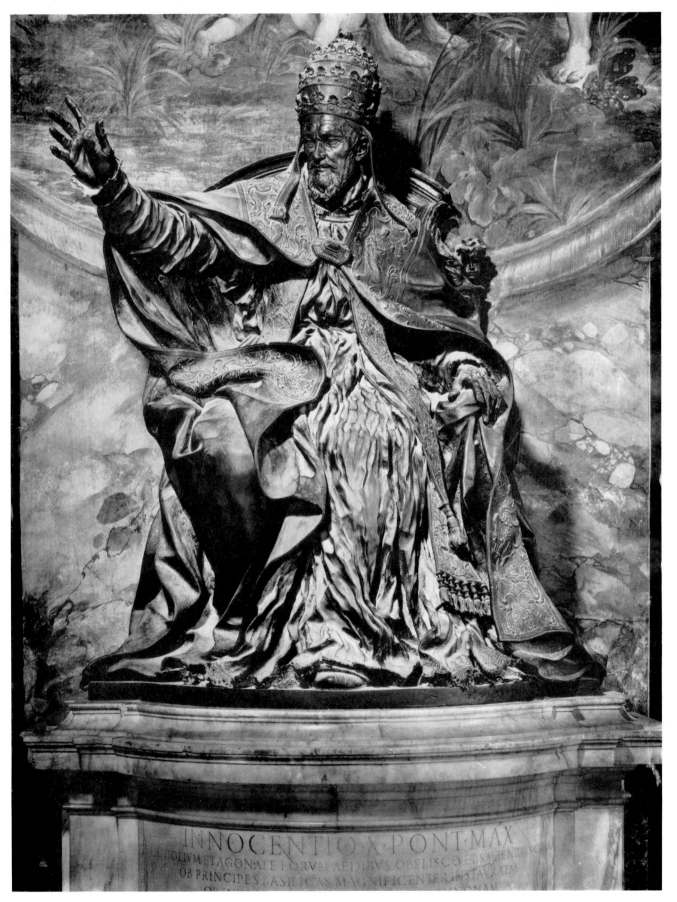

165. Algardi: POPE INNOCENT X. Palazzo dei Conservatori, Rome. Bronze.

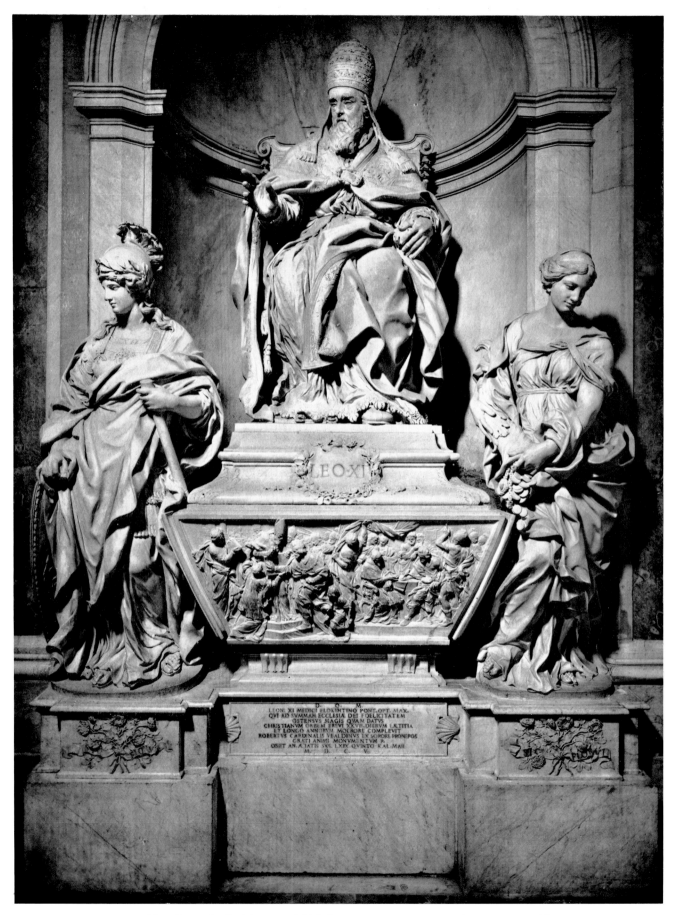

166. Algardi: MONUMENT OF POPE LEO XI. St. Peter's, Rome. Marble.

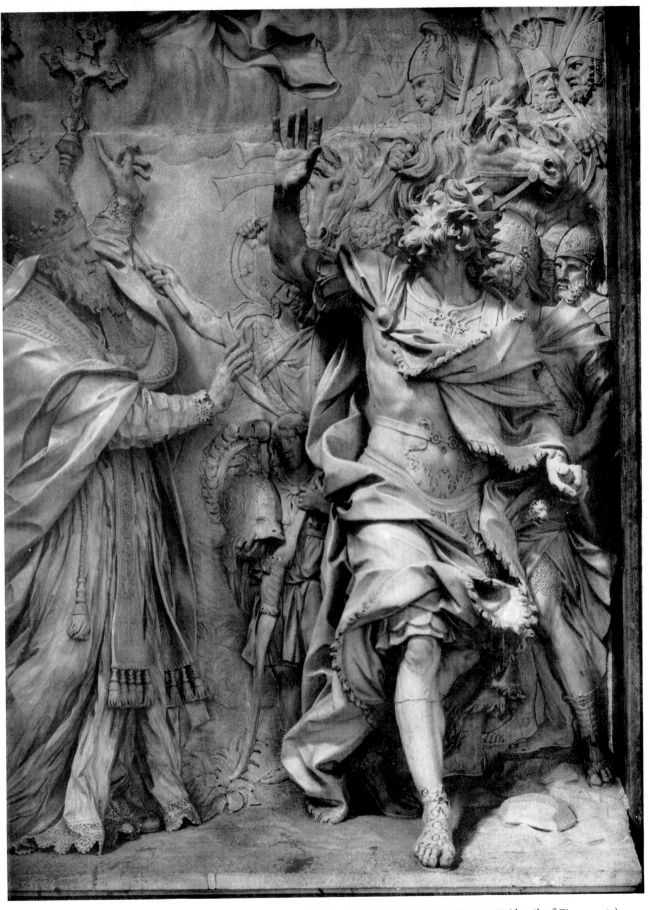

167. Algardi: THE MEETING OF ATTILA AND POPE LEO THE GREAT (detail of Figure 165).
St. Peter's, Rome. Marble.

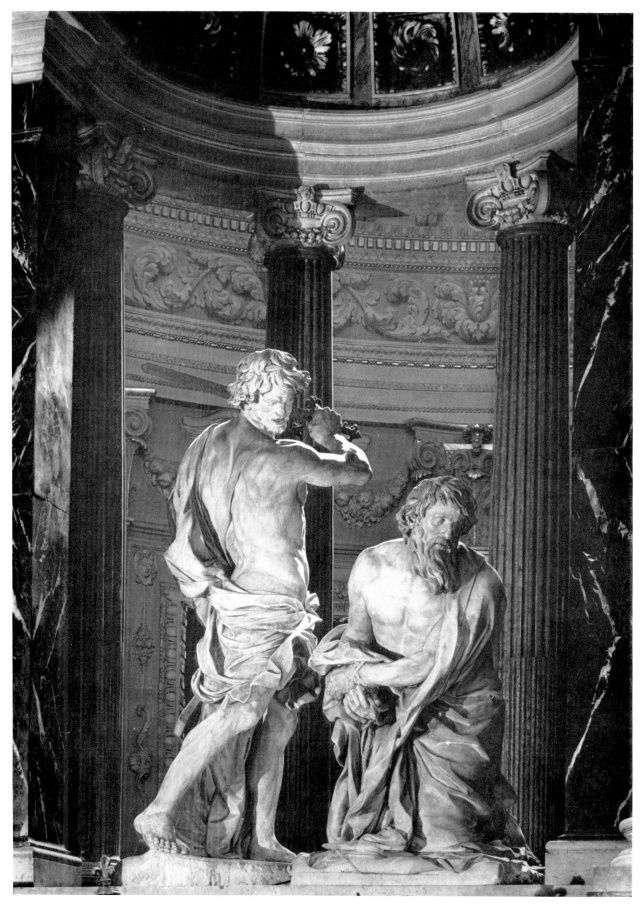

168. Algardi: THE MARTYRDOM OF ST. PAUL. S.Paolo, Bologna. Marble (H. with base 286 cm.).

NOTES ON THE SCULPTORS
AND ON THE PLATES

BIBLIOGRAPHICAL NOTE

The bibliographical and other references used throughout the text and notes of the present volume are for the most part self-explanatory. It should, however, be noted that:

(i) References to my own *Italian Gothic Sculpture* (London, 1955) are given in the form Vol. I, followed by page (p.), Plate (Pl.) or Figure (Fig.) numbers. References to my own *Italian Renaissance Sculpture* (London, 1958) are given in the form Vol. II.

(ii) Unless otherwise indicated, quotations from the *Vite* of Vasari are from the Milanesi edition of 1906.

(iii) The following bibliographical abbreviations are employed:

Baglione G. Baglione, *Le Vite de' pittori, scvltori et architetti dal pontificato di Gregorio XIII del 1572. In fino a' tempi di Papa Vrbano Ottauo nel 1642.* Rome, 1642.

Baldinucci F. Baldinucci, *Notizie de' professori del disegno da Cimabue in qua.* 5 vols. Florence, 1681–1728.

Bellori G. P. Bellori, *Le vite de' pittori, scultori et architetti moderni.* Rome, 1672.

Borghini R. Borghini, *Il Riposo.* Florence, 1584.

Gaye G. Gaye, *Carteggio inedito d'artisti dei secoli XIV, XV, XVI.* 3 vols. Florence, 1839–40.

Orbaan J. A. E. Orbaan, *Documenti sul barocco in Roma.* Rome, 1920.

Paatz W. and E. Paatz, *Die Kirchen von Florenz.* 6 vols. Frankfurt-am-Main, 1940–54.

Pascoli L. Pascoli, *Vite de' pittori, scultori, ed architetti moderni.* 2 vols. Rome, 1730–6.

Passeri J. Hess, *Die Künstlerbiographien von Giovanni Battista Passeri*, Römische Forschungen der Biblioteca Hertziana, xi. Leipzig/Vienna, 1934.

Pastor L. Pastor, *Geschichte der Päpste seit dem Ausgang des Mittelalters*, 14 vols. Freiburg, 1955–60.

Richa G. Richa, *Notizie istoriche delle chiese florentine.* 10 vols. Florence, 1754–62.

Ridolfi C. Ridolfi, *Le Maraviglie dell' Arte*, ed. Hadeln. 2 vols. Berlin, 1914, 1924.

Sansovino F. Sansovino, *Venetia città nobilissima et singolare.* Venice, 1581.

Temanza T. Temanza, *Vite dei più celebri Architetti, e Scultori Veneziani.* Venice, 1778.

Venturi A. Venturi, *Storia dell'arte italiana*, X-i, Milan, 1935. X-ii, Milan, 1936. X-iii, Milan, 1937

ACKNOWLEDGEMENTS

Figures 167, 171 and 173 are reproduced by gracious permission of Her Majesty the Queen.

No more than the first two volumes of this series could the present book have been prepared without the unstinting help of innumerable colleagues. Any list of individual acknowledgements would be invidious, but I must place on record my indebtedness to Professor Ottavio Morisani (to whom are due the photographs reproduced on Plates 42, 53 and 54), the authorities of the ehem. Staatliche Museen, Berlin, and of the Museo Nazionale di Capodimonte, Naples (who have been good enough to make new negatives of certain works), the Secretary of the Royal Academy of Arts (who has facilitated the rephotographing of the Taddei tondo of Michelangelo), Professor Ugo Procacci, Dr. Alessandro Bettagno, Dr. Terisio Pignatti and Mr. Hugh Honour, and to Mr. James Holderbaum. I have depended at every stage upon the generous co-operation of the staff of the Kunsthistorisches Institut in Florence. The translations used throughout the notes have been prepared by Mr. Michael Baxandall.

MICHELANGELO BUONARROTI
(b. 1475; d. 1564)

Michelangelo Buonarroti was born on 6 March 1475 at Caprese, where his father, Lodovico, was Podestà. He came of impoverished but noble stock ('di nobilissima stirpe'). Not long after his birth, his father returned to Settignano, near Florence, and in 1488 the boy was apprenticed for three years to the painters Domenico and Davide Ghirlandaio.

An attempt has been made to distinguish Michelangelo's hand in certain figures in the upper frescoes on the right side of the choir of S. Maria Novella, Florence, on which Ghirlandaio was engaged at this time. According to Vasari, Michelangelo also painted a St. Anthony the Abbot from an engraving by Schongauer, and made 'perfect copies of various old masters'. These included drawings after frescoes by Giotto and Masaccio. In 1489 he left the Ghirlandaio studio to work under Bertoldo in the Casino Mediceo (see text), where he attracted the notice of Lorenzo de' Medici. From 1490 till the death of Lorenzo de' Medici in 1492 he lived in the Palazzo Medici. The relief of the Battle of the Centaurs (see Plate 2 below) dates from this time. After Lorenzo's death, he executed a marble Hercules which was later sent to France (lost) and a wooden Crucifix for Santo Spirito.

In the first half of October 1494 he left Florence for Venice, and travelled thence to Bologna, where, through the good offices of Gianfrancesco Aldovrandi, he was employed on completing the Arca of St. Dominic (see Plate 1 below). Returning to Florence towards the end of 1495, he carved a Baptist for Lorenzo di Pierfrancesco de' Medici (lost) and a sleeping Cupid (lost), which was purchased by Cardinal Riario as an antique. Between 1496 and 1501 he was in Rome, where he carved the Bacchus (see Plate 10 below) and the Pietà in St. Peter's (see Plate 6 below). The only painting by him mentioned at this time is a cartoon for a Stigmatisation of St. Francis, which was overpainted by another hand and was preserved in S. Pietro in Montorio (lost). The years 1501–5, when he was again employed in Florence, were some of the most inspired and prolific of the artist's life; at this time he carved the marble David (see Plate 12 below), the Bruges Madonna (see Plate 7 below), the statues of the Piccolomini Altar in Siena Cathedral (see Plate 9 below), and the Pitti and Taddei Madonnas (see Plates 3, 4 below), received the commission for the Apostles in the Duomo (see Plate 14 below) and for a bronze David for Pierre de Rohan (lost), and prepared (1504) the cartoon for the fresco of the Battle of Cascina in the Palazzo della Signoria. In March 1505 he was summoned to Rome, and entrusted with the tomb of Pope Julius II (see Plate 15 below). After the drama of the first phase of the tomb, he fled to Florence, where he worked on the St. Matthew, and then rejoined the papal court at Bologna, where he prepared a bronze statue of the Pope for the façade of S. Petronio (completed 1508, destroyed). Prior to 10 May 1508 he was commissioned to paint the ceiling of the Sistine Chapel, on which he was engaged till October 1512. A relief known as the Madonna of the Steps in the Casa Buonarroti, Florence, appears to date from this time. After the death of the Pope, he resumed work on the papal tomb, executing the Moses and the figures known as the Dying and Rebellious Slaves. By the new Pope, Leo X, he was invested with the title of Conte Palatino; his first papal commission of the new reign was for the façade of S. Lorenzo in Florence (1516, annulled 1520). Between 1516 and 1519 he spent much time at Carrara and Pietrasanta procuring marble for this work. In or before 1520 he embarked on a new project, that for the Medici Chapel (see Plate 24 below). In April 1520 the death of Raphael removed his only rival at the papal court, but intent upon his sculptural commissions he remained in Florence. Under Pope Adrian VI (1522–3) pressure from the Della Rovere seems to have compelled him to return briefly to the sculptures for the papal tomb, but after the election of Cardinal Giulio de' Medici as Pope Clement VII (1523) the balance was once more weighted in favour of the Chapel and of the Biblioteca Laurenziana (after 1524).

After the Sack of Rome (May, 1527), a popular government was installed in Florence, and Michelangelo was charged (1529) with the fortification of Florence, for which drawings survive. The project for a group of Samson slaying a Philistine dates from this time (1528). After a temporary break with the republican authorities (autumn, 1529), he returned to Florence before the town capitulated to the papal forces, and in November 1530 was pardoned by Pope Clement VII. About this time he executed a painting of Leda for Alfonso d'Este (later in France, lost; cartoon in Florence also lost), a cartoon of the Noli Me Tangere for Alfonso d'Avalos (1531, lost; copies in Casa Buonarroti), and a cartoon of Venus and Cupid for Bartolommeo Bettini (copied by Pontormo). From 1531–3 date proposals for a tribune of relics at S. Lorenzo. The pressures under which Michelangelo was working at this time (see text) were exacerbated in 1532 by his meeting with Tommaso Cavalieri, which was among the factors that led him, in 1534, to abandon the Medici Chapel and move to Rome. The changed climate of the pontificate of Paul III (elected 1534) is directly reflected in Michelangelo's style, and found final expression in the fresco of the Last Judgement (cartoon 1535, begun spring 1536, completed autumn 1541). As in the years dedicated to the Sistine ceiling, he executed little sculpture at this time. A bust of Brutus (Museo Nazionale, Florence), carved for Cardinal Ridolfi and finished by Tiberio Calcagni, seems to have been executed after the year of the Giannotti Dialogues (1546) and before the death of Cardinal Ridolfi (1550). In the early stages of work on the Last Judgement, Michelangelo became acquainted with Vittoria Colonna; this friendship, which is described in the Dialogues of Francisco de Hollanda, is celebrated by many poems, and inspired a number of small religious works (known

through drawings or copies), was of importance for the artist's spiritual development. The most notable sculpture of this time is the statue of the Contemplative Life carved for the tomb of Pope Julius II, which was finally completed in 1545. In painting, the apocalyptic style of the Last Judgement was further developed in the frescoes of the Conversion of St. Paul and the Crucifixion of St. Peter in the Cappella Paolina of the Vatican (1542–50). In 1547 Michelangelo became chief architect of St. Peter's, and from about this time date the completion of the Palazzo Farnese and the systematisation of the Capitol. In extreme old age architecture took over an increasingly large part of Michelangelo's thought. A clay model for the cupola of St. Peter's was completed in 1557, and a wood model between 1558 and 1561. After 1559 he was occupied with the transformation of S. Giovanni dei Fiorentini; in 1561 he started work on S. Maria degli Angeli at the Baths of Diocletian; still later (1564) he planned the Sforza Chapel in S. Maria Maggiore; and in 1561 designed the Porta Pia. This activity forms the background to the great group of the Lamentation over the Dead Christ in the Duomo in Florence (see Plates 36, 37 below) and to the Rondanini Pietà in the Museo del Castello Sforzesco in Milan (Fig. 37), which seems to have been begun about 1552–3, to have been modified in 1555–6, and to have been revised once more in 1563–4. The Rondanini Pietà is certainly identical with a Pietà bequeathed by Michelangelo to Antonio del Francese in a will of 21 August 1561, and is described by Daniele da Volterra, in a letter 11 June 1564 to Michelangelo's nephew, Lionardo Buonarroti, as the last sculpture on which Michelangelo worked: 'Io non mi richordo se in tutto quello scritto io messo chome Michelangelo lavorò tutto il sabato della domenica di carnovale ellavorò in piedi studiando sopra quel corpo di pietà.' Michelangelo died in Rome on 18 February 1564, and was buried in S. Croce, Florence (see Plate 67 below).

The notes below cover the whole of Michelangelo's sculptural oeuvre with the exception of the Madonna of the Steps in the Casa Buonarroti, Florence, the Brutus in the Museo Nazionale, Florence, and the Rondanini Pietà in the Museo del Castello Sforzesco, Milan. The main works not by Michelangelo for which an attribution to the master is sometimes mistakenly maintained are the relief of the Crucifixion of St. Andrew in the Museo Nazionale, and the Palestrina Pietà in the Accademia, Florence.

BIBLIOGRAPHY: The primary sources for the life of Michelangelo are the two lives by Vasari (1550 and 1568) and the life by Condivi (1553). A comparative edition by Frey (Le Vite di Michelangelo Buonarroti, Berlin, 1887) has been superseded by an admirable and exhaustively annotated five-volume edition by P. Barocchi (Giorgio Vasari, La Vita di Michelangelo, nelle redazioni del 1550 e del 1568, Milan/Naples, 1962). In addition to Frey's edition of the Michelangelo poems (Die Dichtungen des Michelagniolo Buonarroti, Berlin, 1897), a modern critical edition is also available (Michelangelo Buonarroti, Rime, a cura di E. N. Girardi, Bari, 1960). For the letters and contracts see Milanesi (Le Lettere di Michelangelo Buonarroti, Florence, 1875, and Les correspondants de Michel-Ange, 1, Paris, 1890) and Frey

(Sammlung ausgewählter Briefe an Michelagniolo, Berlin, 1899). The letters to and from Michelangelo are combined in Il Carteggio di Michelangelo (edizione postuma di Giovanni Poggi a cura di Paola Barocchi e Renzo Ristori, i, Florence, 1965, ii, Florence, 1967) of which the first volume covers the period 1496–1518 and the second covers the period 1518–1523. A reliable and well edited English translation of the letters is also available (The Letters of Michelangelo, ed. E. H. Ramsden, 2 vols., London, 1963). A recension of the Michelangelo documents in the Archivio di Stato, Rome, by A. M. Corbo ('Documenti romani su Michelangelo,' in Commentari, xvi, 1965, pp. 85–97) is useful only for its accessibility. The Dialogues of Francisco de Hollanda are available in number of editions (e.g. A. M. Bessone Aurelj, I Dialoghi Michelangioleschi di Francisco d'Olanda, Rome, 1953), and the Dialogues of Donato Giannotti are available in a single edition by D. R. de Campos (Dialoghi di Donato Giannotti, ed. D. R. de Campos, Florence, 1939). A key to the Michelangelo literature before 1926 is supplied by E. Steinmann and R. Wittkower (Michelangelo-Bibliographie 1510–1926, Leipzig, 1927). In modern times the full range of Michelangelo studies is covered only in the monograph by C. de Tolnay (1. The Youth of Michelangelo, Princeton, 2nd ed., 1947; 2. The Sistine Ceiling, 2nd ed., 1949; 3. The Medici Chapel, 1948; 4. The Tomb of Pope Julius II, 1954; 5. The Late Works, 1960), to which present-day students, even where they dissent from its conclusions, owe an incalculable debt. The most satisfactory single-volume monographs are those by Tolnay (Michelangiolo, Florence, 1951, also available in French translation) and H. von Einem (Michelangelo, Stuttgart, 1959). None of these volumes, however, entirely supersedes the earlier Michelangelo monographs, and Thode's Michelangelo und das Ende der Renaissance (3 vols., Berlin, 1902–12) and Michelangelo: Kritische Untersuchungen über seine Werke (3 vols., 1908–13) in particular present an interpretation of Michelangelo's work which is remarkable for its consistency and is still in large part acceptable. In English J. A. Symonds' Life of Michelangelo Buonarroti (2 vols., 1893), though unsound from an academic standpoint, provides a worthy introduction to the artist and his work. A volume by Kriegbaum on the sculptures (Michelangelo Buonarroti, Die Bildwerke, Berlin, 1940) reveals signs of hasty preparation, but contains, alongside suggestions that are inadmissible, a number of fresh observations. A two-volume book on Michelangelo issued in connection with the fourth centenary of the artist's death (Michelangelo: artista, pensatore, scrittore, premessa di Mario Salmi, Novara, 1965) contains essays by C. de Tolnay ('Personalità storica ed artistica di Michelangelo,' i, pp. 7–71) and U. Baldini ('La Scultura,' i, pp. 73–147) and, more importantly, a bibliography of writings on Michelangelo since 1961 (P. Meller, 'Aggiornamenti bibliografici,' ii, pp. 597–605). No references have been included in this volume to M. Weinberger's Michelangelo the Sculptor, London/New York, 2 vols., 1967, an incomplete posthumous publication which does less than justice to its author's often interesting views on Michelangelo. From a critical standpoint some of the best writing on Michelangelo is due to Wölfflin (Die Jugendwerke des Michelangelo, Munich, 1891; Classic Art, London, 1952) and Berenson (The Drawings of the

Florentine Painters, 3 vols., Chicago, 1938). Berenson's book apart, the standard volumes on the drawings are those of Frey (*Die Handzeichnungen Michelangiolos Buonarroti*, Berlin, 1909–11) and Dussler (*Die Zeichnungen des Michelangelo*, Berlin, 1959); the latter, though sparsely illustrated, is particularly valuable. No contemporary work on Michelangelo, however, reveals so thorough and so intimate an understanding of his creative processes as the books and articles of J. Wilde; most of these are referred to individually in the notes below, but special reference must be made here to *Italian Drawings . . . in the British Museum: Michelangelo and his Studio* (London, 1953) and 'The Decoration of the Sistine Chapel,' in *Proceedings of the British Academy*, xliv, 1958, pp. 61–81. In the notes below reference is also made to A. Gotti (*Vita di Michelangelo Buonarroti*, Florence, 1875, 2 vols.), C. Justi (*Michelangelo: Beiträge zur Erklärung der Werke und des Menschen*, Leipzig, 1900, and *Michelangelo: Neue Beiträge zur Erklärung seiner Werke*, Berlin, 1909), Frey (*Michelangiolo Buonarroti: sein Leben und seine Werke*, i, Berlin, 1907), Panofsky (in *Art Bulletin*, xix, 1937, pp. 561–79, and *Studies in Iconology*, New York, 1939), and A. E. Popp (*Die Medici-Kapelle Michelangelos*, Munich, 1922). The supposedly lost early Crucifix for S. Spirito, now exhibited in the Casa Buonarroti, was identified in 1962 by M. Lisner (for this see M. Lisner, 'Michelangelos Crucifix aus S. Spirito in Florenz,' and U. Procacci and U. Baldini, 'Il restauro del Crocifisso di Santo Spirito,' in *Münchner Jahrbuch für Bildende Kunst*, 3 folge, xv, 1964, pp. 7–31, 32–36, reproduced in translation in *Atti del Convegno di Studi Michelangioleschi*, Rome, 1966, pp. 295–316, 317–321). For incorrect identifications of the Crucifix and other early works see A. Parronchi (*Opere Giovanili di Michelangelo*, Florence, 1968). The Rondanini Pietà in Milan, on which no note is included in this book, is discussed by Tolnay ('Michelangelo's Rondanini Pietà,' in *Burlington Magazine*, lxv, 1934, pp. 146–57), Baumgart ('Die Pietà Rondanini, ein Beitrag zur Erkenntnis des Altersstiles Michelangelos,' in *Jahrbuch der Preuszischen Kunstsammlungen*, lvi, 1935, pp. 44–56), D. Frey ('Die Pietà Rondanini und Rembrandts "Drei Kreuze" ', in *Kunstgeschichtliche Studien für Hans Kauffmann*, Berlin, 1956, pp. 208–32), and Perrig (*Michelangelos letzte Pietà-Idee*, Bern, 1960). For the wrongly ascribed Palestrina Pietà see J. Pope-Hennessy ('The Palestrina Pietà,' in *Stil und Überlieferung in der Kunst des Abendlandes*: Akten des 21. Internationalen Kongresses für Kunstgeschichte in Bonn, 1964, ii: Michelangelo, Berlin, 1967, pp. 105–114, and *Essays on Italian Sculpture*, London, 1968, pp. 121–131). Some useful observations on the iconography of the Medici Chapel are offered by F. Hartt ('The Meaning of Michelangelo's Medici Chapel', in *Essays in Honour of Georg Swarzenski*, 1957, pp. 145–55). An excellent survey of Michelangelo's architectural activity is supplied by J. Ackerman (*The Architecture of Michelangelo*, 2 vols., London, 1961). The quattrocento sources of Michelangelo's early works and his hypothetical connection with the studio of Benedetto da Majano are discussed by M. Lisner ('Das Quattrocento und Michelangelo,' *Stil und Überlieferung in der Kunst des Abendlandes*: Akten des 21. Internationalen Kongresses für Kunstgeschichte in Bonn, 1964, ii: Michelangelo, Berlin, 1967, pp. 78–89).

Plate 1: ARCA OF ST. DOMINIC
S. Domenico Maggiore, Bologna

On 2 March 1494 the Bolognese sculptor Niccolò dell'Arca (Vol. II, pp. 343–4) died, leaving his work on the lid of the Arca of St. Dominic (Vol. I, Fig. 48) incomplete. Later in the year Michelangelo, who had left Florence before 14 October 1494 travelling to Bologna by way of Venice, was invited to supply the missing statuettes. The circumstances of the commission are described by Condivi: 'Un giorno, menandolo per Bologna, lo condusse a veder l'arca di S. Domenico nella chiesa dedicata al detto Santo. Dove mancando due figure di marmo, cioè un San Petronio ed un angelo in ginocchioni con un candeliere in mano, domandando (a) Michelangelo se gli dava il core di farle, e rispondendo di sì, fece che fossero date a fare a lui: delle quali gli fece pagare ducati trenta, del San Petronio diciotto, e dell'agnolo dodici. Eran le figure d'altezza di tre palmi, e si posson vedere ancora in quel medesimo luogo . . . Stette con messer Gianfrancesco Aldrovandi poco più d'un anno' (One day, when he was taking him round Bologna, he took him to see the shrine of St. Dominic in the church dedicated to that Saint. Two marble figures were missing from the work, a St. Petronius and a kneeling angel holding a candlestick; and he asked Michelangelo if he had the spirit to make them, and, when he replied that he had, he arranged that they should be commissioned from him. He had him paid 30 ducats for them – 18 for the St. Petronius, and 12 for the angel. The figures were three palmi high, and they may still be seen in that place . . . He stayed with Master Gianfrancesco Aldovrandi rather more than a year). Condivi's account is repeated by Vasari, who likewise refers only to an angel and a figure of St. Petronius, and does not mention the figure of St. Proculus. Local sources, however, (for which see Bonora, *L'Arca di San Domenico e Michelangelo-Buonarroti*, Bologna, 1875 and S. Bottari, *L'Arca di S. Domenico in Bologna*, Bologna, 1964, pp. 75–81) ascribe all three figures to Michelangelo. The most reliable of these is a passage in the *Memorie* of Fra Lodovico da Prelormo, who is stated by Bonora to have had charge of the shrine from 1527 till 1572: 'Sciendum tamen est quod Imago Sancti Petronii quasi totta, et totta Imago Sancti Proculi, et totta Imago illius Angeli qui genua flectit et è posto sopra il parapeto che fece Alphonso scultore, quale si è verso le fenestre, queste tre Imagine ha fatto quidam Juvenis florentinus nomine Michael angelus imediate post mortem dicti M.ri Nicolai' (Almost all the figure of St. Petronius and the whole of the figure of St. Proculus and of the kneeling angel, which stand above the balustrade made by the sculptor Alfonso towards the windows, were made by a certain young Florentine called Michelangelo, immediately after the death of Master Niccolò). The three figures are mentioned again by Leandro Alberti (*De Divi Dominici Calguritani obitu et sepultrua*, Bologna, 1535, f. 9: 'videlicet simulachrum divi Petronii, Proculi, et alterius Angeli') and by Pio *Uomini illustri*, 1588: 'vi fece fare dall'eccellente e famoso Scultore et Pittore Michele Angelo Buonaroti la statua di S. Procolo, quella d'un Angelo, et buona parte di quella di S. Petronio, prima rimasa imperfetta') (he had made by the excellent and famous sculptor and painter Michelangelo

Buonarroti the statue of St. Proculus, that of an angel, and a large part of that of St. Petronius, which had been left unfinished before). They are also referred to by Lamo (*Graticola di Bologna*, 1560 publ. 1844: 'E sopra laltar vi sono dui Angilj E Michelagnolo ne fece uno qual'E a man dirita E lavoro in uno san petronio Cioe neli pani') (Over the altar there are two angels: Michelangelo made one of them, the one on the right, and did some work on a St. Petronius, on its drapery). Since the St. Proculus is not mentioned by Vasari or Condivi, it has been suggested (Frey) that this statuette wa sbegun by Niccolo dell' Arca and retouched by Michelangelo. This theory cannot be substanciated from examination of the figure. On the other hand, local evidence is conclusive that the St. Petronius (Fig. 3) was at least blocked out by the earlier sculptor, and there is nothing in its stance or pose that would preclude this hypothesis. The Angel of Michelangelo and the corresponding Angel of Niccolò dell'Arca were wrongly identified in the nineteenth century, and the latter was cast in plaster as a work of Michelangelo. Wölfflin observes that the figure of St. Petronius is influenced by Jacopo della Quercia. It is suggested by Frey that Michelangelo first completed the St. Petronius and subsequently undertook the Angel and the St. Proculus, and by Tolnay that the Angel precedes the other statuettes. The working sequence postulated by Frey is more probable, but since Michelangelo returned to Florence late in 1495, the time interval between the figures was in any event very short. The head of the St. Petronius has been broken and replaced: the St. Proculus was damaged on 4 August 1572 (for this see Fra Lodovico da Prelormo, loc. cit.: 'la roppe e cascata sopra la salegata fu fatta in piu pezzi'), and subsequently reconstituted.

Plate 2: THE BATTLE OF THE CENTAURS
Casa Buonarroti, Florence

The relief is described by Condivi in the following terms: 'Era nella medesima casa (Palazzo Medici) il Poliziano, uomo, come ognun sa, e piena testimonianza ne fanno i suoi scritti, dottissimo ed acutissimo. Costui conoscendo Michelagnolo di spirito elevatissimo, molto lo amava e di continuo lo spronava, benchè non bisognasse, allo studio, dichiarandogli sempre e dandogli da far qualche cosa. Tra le quali un giorno gli propose il ratto di Deianira e la zuffa de' Centauri, dichiarandogli a parte per parte tutta la favola. Messesi Michelagnolo a farla in marmo di mezzo rilievo, e così la'mpresa gli succedette, che mi rammenta udirlo dire, che quando la rivede, cognosce quanto torto egli abbia fatto alla natura a non seguitar prontamente l'arte della scultura, facendo giudizio per quell' opera, quanto potesse riuscire. Nè ciò dice per vantarsi, uomo modestissimo, ma perchè pur veramente si duole d'essere stato così sfortunato, che per altrui colpa qualche volta sia stato senza far nulla dieci o dodici anni, il che di sotto si vedrà. Questa sua opera ancora si vede in Firenze in casa sua, e le figure sono di grandezza di palmi due in circa. Appena aveva finita quest'opera, ch'l Magnifico Lorenzo passò di questa vita' (In the same house lived Politian, a man who, as everyone knows and as his writings prove, was most learned and shrewd. He, recognising

that Michelangelo was of a most lofty spirit, loved him much and continually urged him on in his studies, even though there was no need of this; and he was always explaining things to him and giving him things to do. Among which he suggested to him one day the Rape of Deianira and the Battle of the Centaurs, explaining the whole story to him, passage by passage. Michelangelo began doing it in marble in half-relief; and the attempt succeeded so well, that I remember hearing him say that, when he saw it again later, he realised how mistaken he had been about his natural bent, in not following eagerly the art of sculpture – inferring from that work what great success he would have had. He did not say this to boast, for he is a man of great modesty, but rather because he was truly grieved at having been so unfortunate as sometimes to have passed, through others' fault, ten or twelve years without doing any sculpture, as will be seen later. This work of his is still to be seen in his house in Florence, and the figures are about two palmi high. He had scarcely finished this work when Lorenzo the Magnificent passed from this life). The relief is also described by Vasari: 'Michelagnolo fece in un pezzo di marmo, datogli da quel signore (Lorenzo de' Medici), la battaglia di Ercole coi Centauri, che fu tanto bella, che talvolta, per chi ora la considera, non par di mano di giovane, ma di maestro pregiato e consumato negli studi e pratico in quell'arte. Ella è oggi in casa sua tenuta per memoria da Lionardo suo nipote, come cosa rara che ell'è' (Michelangelo made from a piece of marble given him by that lord (Lorenzo de' Medici) the Battle of Hercules with the Centaurs, which was so beautiful that, to those who examine it now, it sometimes seems from the hand not of a youth, but of a celebrated master, perfected by study and experienced in the art. It is now in his house, kept in memory of him by his nephew Leonardo as a rare thing, as it indeed is). If Condivi's account of the origin of the relief is to be believed, it was carved in the early months of 1492 and completed before the death of Lorenzo de' Medici on 8 April of that year. The relief was continuously in Buonarroti ownership, though an attempt seems to have been made to purchase it in 1527 for the Gonzaga collection (for this see Luzio, *La Galleria dei Gonzaga venduta all'Inghilterra nel 1623–28*, Milan, 1913, p. 248). Condivi's and Vasari's accounts of the iconography of the relief are mutually exclusive. It has been suggested (i) that the relief is based on Hyginus, and shows Deianira freed by Hercules (Strygowski) or is a fusion of two myths (Frey, Thode); (ii) that it depends from Ovid and shows the abduction of Hippodameia (Wickhoff, Wölfflin, Tolnay). Tolnay identifies the figures as Theseus (left, holding a rock), Pirithous (with back turned) attempting to rescue Hippodameia (right centre), and the centaur Eurythion (centre back). The style of the carving depends from classical battle sarcophagi, but no specific relationship has been established between the relief and a surviving sarcophagus. An attempt to establish a connection with Hellenistic gems (Hebler) is inconclusive. The relief has been made up in clay at the bottom, and a wide horizontal strip is uncarved at the top. This has been explained by the alternative assumptions (Kriegbaum) that an architectural background was originally planned, and (Tolnay) that Michelangelo 'à cause de son amour pour le marbre' was unwilling to mutilate the block.

Plate 3: VIRGIN AND CHILD WITH
THE YOUNG ST. JOHN
Royal Academy of Arts, London

The earliest references to the relief occur in 1564 in the *Orazione* of Varchi and in 1550 in the *Vite* of Vasari (for the latter see Plate 4 below). According to Vasari, the tondo was executed for or presented to Taddeo Taddei. In the early nineteenth century it was in the Wicar collection in Rome, from which it was purchased in 1823 by Sir George Beaumont and presented to the Royal Academy of Arts. It is claimed by Tolnay that the composition was inspired by a circular bronze relief ascribed to Donatello; this is improbable. The Child Christ, however, depends from a classical Medea sarcophagus (Horn, Tolnay). The relief is dated by Tolnay ca. 1505–6, and is regarded by Wölfflin and most other students as later in date than the Pitti tondo. This sequence is reversed by Kriegbaum. There is explicit evidence for the dating of the present relief in a sheet in the British Museum containing studies for the figure of St. John (Frey). A detailed analysis of the drawing by Wilde proves that these are contemporary with studies on the same sheet for the Bruges Madonna and must therefore be assigned to the years 1503–4. Wittkower (in *Burlington Magazine*, lxxviii, 1941, p. 133) observes that the surface 'has been almost completely gone over by a pupil'. This view is also adopted by Tolnay, who claims that 'in its details, see, for example, the faces or the right arm of the Christ Child, and the folds of the Madonna's cloak, it seems to have been retouched by the hand of an apprentice'. The apparent differences in technique between the two reliefs are due to the fact that the greater part of the figure of Christ and the head of the Virgin are more fully worked up than the corresponding parts of the Pitti Madonna.

Plate 4: VIRGIN AND CHILD WITH
THE YOUNG ST. JOHN
Museo Nazionale, Florence

The earliest reference to the relief occurs in the first edition of the *Vite* of Vasari: 'Et ancora in questo tempo abbozzò et non finì due tondi di marmo, uno a Taddeo Taddei, oggi in casa sua, ed a Bartolommeo Pitti ne cominciò un altro; il quale da Fra Miniato Pitti di Monte Oliveto, intendente e raro nella cosmografia ed in molte scienzie, e particolarmente nella pittura, fu donato a Luigi Guicciardini, che gli era grande amico. Le quali opere furono tenute egregie e mirabili' (And at this time also he began, but did not finish, two roundels of marble, one for Taddeo Taddei, which is now in his house, and another which he began for Bartolommeo Pitti. This one was given by Fra Miniato Pitti of Monte Oliveto, a man with a rare understanding of cosmography and many other sciences, particularly of painting, to Luigi Guicciardini, a great friend of his. These works were considered excellent and admirable). The relief was bought for the gallery of Florence in 1823, and was transferred in 1873 to the Bargello. A pen sketch possibly for the Virgin in this relief is identified by Tolnay at Chantilly.

It is observed by Tolnay that the pose and drapery of the Virgin are inspired by the Prudentia of Jacopo della Quercia on the Fonte Gaia at Siena, and that the composition contains reminiscences of the tondo by Signorelli in the Uffizi, Florence. These analogies are insubstantial, and represent parallelisms rather than sources of influence. The pose of the Child Christ, however, derives from the Phaedra sarcophagus at Pisa (for this see J. Wilde, in *Mitteilungen des Kunsthistorischen Institutes in Florenz*, iv, 1932, p. 41 ff.). The relief is regarded by Thode, Justi, Wölfflin, Tolnay and most other students, as earlier in date than the Taddei tondo (q.v.), and is generally assigned to the years 1504–5. This sequence is inverted by Kriegbaum, who dates the present relief ca. 1508. In favour of the inverted sequence, though not necessarily of so late a dating, are (i) the fact the relief is planned with a concave, not with a flat ground; (ii) the more diversified relief style; and (iii) the compressed pose of the central figure (which is interpreted by Wölfflin as a 'Vorgängerin' of the Delphic Sibyl on the Sistine ceiling and is more evolved than the Virgin of the Taddei tondo). The left side of the relief is imperfectly legible, and the formal motivation of the figure of St. John (apparently with the right hand resting on a wall) is unexplained. The coarse parallel chisel strokes in this area belong to an early stage of the carving, and traces of them occur again above the left shoulder of the Child Christ. The background is fully excavated only in the right upper section of the relief. In technique the worked up sections (confined in the main to the Virgin's head, throat and robe) are indistinguishable from those of the Taddei tondo. A precedent for the concave ground occurs in a relief by Francesco di Simone in the North Carolina Museum of Art.

Plate 6: THE VIRGIN WITH
THE DEAD CHRIST
St. Peter's, Rome

The group is signed on the ribbon across the breast: MICHAEL-AGELVS. BONAROTVS. FLORENTIN. FACIEBAT. It was commissioned by Cardinal Jean Villier de la Grolaie (Abbot of Saint-Denis 1474: Cardinal of Santa Sabina 1493; d. 6 August 1499), and is described by Condivi in the following terms: 'Poco dipoi, a requisizione del cardinal di San Dionigi, chiamato il cardinal Rovano, in un pezzo di marmo fece quella maravigliosa statua di Nostra Donna, (la) qual'è oggi nella Madonna della Febbre, avvengachè da principio fosse posta nella chiesa di Santa Petronilla, cappella del re di Francia, vicina alla sagrestia di San Piero, già secondo alcuni tempio di Marte, la quale per rispetto del disegno della nuova chiesa fu da Bramante rovinata. Questa se ne sta a sedere in sul sasso, dove fu fitta la croce, col Figliuol morto in grembo, di tanta e così rara bellezza, che nessun la vede che dentro a pietà non si commuova. Immagine veramente degna di quella umanità, che al Figliuol d'Iddio si conveniva ed a cotanta Madre. Sebben sono alcuni, che in essa Madre riprendano l'esser troppo giovane, rispetto al Figliuolo. Del che ragionando io con Michelagnolo un giorno: "Non sai tu, mi rispose, che le donne caste molto più fresche si mantengono che le non caste? Quanto maggiormente una vergine,

nella quale non cadesse mai pur un minimo lascivo desiderio, che alterasse quel corpo? Anzi ti vo' dir di più, che tal freschezza e fior di gioventù, oltracchè per tal natural via in lei si mantenesse, è anco credibile che per divin'opera fosse aiutato a comprovare al mondo la verginità e purità perpetua della Madre. Il che non fu necessario al Figlio; anzi piuttosto il contrario, perciocchè volendo mostrare che'l Filigiuol di Iddio prendesse, come pure, veramente corpo umano, e sottoposto a tutto quel che un ordinario uomo soggiace, eccettochè al peccato, non bisognò col divino tener indietro l'umano, ma lasciarlo nel corso ed ordine suo, sicchè quel tempo mostrasse che aveva appunto. Pertanto non t'hai da maravigliare, se per tal rispetto io feci la Santissima Vergine, Madre d'Iddio, a comparazione del Figliuolo assai più giovane di quel che quell'età ordinariamente ricerca e il Figliuolo lasciai nell'età sua" ' (A little later, at the request of the Cardinal of Saint-Denis, called the Cardinal Rovano, he made in marble that marvellous statue of Our Lady which is today in the chapel of the Madonna della Febbre. It was placed at first in the church of S. Petronilla in the chapel of the King of France, near the sacristy of St. Peter's and formerly, according to some, a temple of Mars; but this building was destroyed by Bramante, on account of his design for the new church. The figure sits on the rock where the Cross was set up, with her Son dead in her lap; and it is of so great and rare beauty, that no one sees it without being moved to pity. It is an image truly worthy of that humanity proper to the Son of God and to such a Mother. However, there are some who criticise the Mother for being too young in relation to her Son. I was discussing this one day with Michelangelo, and he replied to me: 'Do you not know that chaste women stay fresh much more than those who are not chaste? How much more in the case of a Virgin, who had never experienced the least lascivious desire that might change her body? Moreover, it is likely that such freshness and flower of youth, besides being maintained in her by natural means, were assisted by act of God, to prove to the world the virginity and everlasting purity of the Mother. This was not necessary in the case of the Son. On the contrary, in order to show that the Son of God might truly take on, as he did, a human body, and be subjected to all that an ordinary man suffers, except sin, there was no need to restrain the human in him by means of the divine; rather was it necessary to leave it to take its own course and order, so that time might show exactly how long he had lived. So you need not be surprised if I made, for this reason, the Holy Virgin, Mother of God, seem much younger in relation to her Son than a woman of that age usually appears, and left the Son of God at his proper age'). Vasari's accounts in the editions of 1550 and 1568 differ only in detail, and stress the naturalism displayed in the body of Christ. Vasari explains the presence of Michelangelo's signature on the group by the fact that he had overheard onlookers ascribing it to the Milanese sculptor, Cristoforo Solari. The earliest reference to the group occurs in a letter from the Cardinal to the Anziani of Lucca of 18 November 1497, containing a request for 'ogni aiuto e favore' for Michelangelo on a forthcoming visit to Carrara to choose marble for the group ('una Vergine Maria vestita con Cristo morto, nudo in braccia'). On 10 March 1498 Michelangelo was still in Rome, but at the end of March

he appears to have left for Carrara. A letter of 7 April 1498 from the Cardinal to the Signoria of Florence asks the Signoria to recommend Michelangelo to Marchese Alberico Malaspina, lord of Carrara. This was acknowledged on 18 April 1498, when a letter was also despatched by the Signoria to Malaspina. After the block had been procured, a contract was signed between the Cardinal and the sculptor (Milanesi, pp. 613–4): 'Die xxvij mensis augusti 1498. Sia noto et manifesto a chi legerà la presente scripta, come el reverendissimo cardinal di San Dionisio si è convenuto con mastro Michelangelo statuario fiorentino, che lo dicto maestro debia far una Pietà di marmo a sue spese, ciò è una Vergene Maria vestita, con Christo morto in braccio, grande quanto sia uno homo iusto, per prezo di ducati quattrocento cinquanta d'oro in oro papali, in termino di uno anno dal dì della principiata opera. Et lo dicto reverendissimo Cardinale promette farli lo pagamento in questo modo, ciò è: Imprimis promette darli ducati centocinquanta d'oro in oro papali, innanti che comenzi l'opera: et da poi principiata l'opera promette ogni quattro mesi darli ducati cento simili al dicto Michelangelo, in modo che li dicti quatro cento cinquanta ducati d'oro in oro papali siano finiti di pagarli in uno anno, se la dicta opera sarà finita; et se prima sarà finita, che la sua reverendissima Signoria prima sia obligato a pagarlo del tutto. Et io Iacobo Gallo prometto al reverendissimo Monsignore che lo dicto Michelangelo farà la dicta opera in fra uno anno et sarà la più bella opera di marmo che sia hoge in Roma, et che maestro nisuno la faria megliore hoge. Et si versa vice prometto al ditto Michelangelo che lo reverendissimo Cardinale la farà lo pagamento secundo che de sopra è scripto. Et a fede io Iacobo Gallo ho facta la presente di mia propria mano, anno, mese, et dì sopradito. Intendendosi per questa scripta esser cassa et annullata ogni altra scripta di mano mia, o vero di mano del dicto Michelangelo, et questa sola habia effecto. Hane dati il dicto reverendissimo Cardinale a me Iacobo più tempo fa ducati cento d'oro in oro di Camera et a dì dicto ducati cinquanta d'oro in oro papali' (27 August 1498. Let it be known and clear to the reader of this document that the Rev. Cardinal of Saint-Denis has agreed with Master Michelangelo, the Florentine sculptor, that he, the said Master, is to make at his expense a life-size marble Pietà, that is, a draped Virgin Mary with the Dead Christ in her arms, for a fee of 450 gold papal ducats, within one year of the day of commencement of the work. And the said Rev. Cardinal undertakes to make the payment to him in the following way: He undertakes firstly to give him 150 gold papal ducats before he begins the work; he undertakes, further, once the work has been begun, to give Michelangelo 100 of the same ducats every four months, so that the 450 gold papal ducats will have been fully paid up within one year, if the work is finished; and if it has been finished before that date, His Rev. Lordship will be obliged to pay him the complete amount before the date also. And I, Iacopo Gallo, promise the Rev. Monsignor that Michelangelo will make the work within one year, and that it will be the most beautiful marble work presently in Rome, and that no other present master would do it better. And, in turn, I promise Michelangelo that the Rev. Cardinal will make the payments according to this agreement. And in good faith I, Iacopo Gallo,

have drawn up this deed with my own hand on the above date. It is understood that, through this deed, all other deeds, either from my hand or from Michelangelo's, are made null and void, and this one alone is effective. The Rev. Cardinal some time ago gave me, Iacopo, 100 gold Camera ducats and 50 gold papal ducats).

The date of completion of the group is not recorded; it is generally assumed to have been finished in 1499 (Tolnay) or 1500 (Kriegbaum). Four fingers on the left hand of the Virgin were restored in 1736 by Giuseppe Lirioni; it has been claimed alternatively that the restored fingers are incorrect and rhetorical (Wittkower) or generally exact (Tolnay). Tolnay observes of the Pietà that 'almost all the leading Florentine artists of the day, both painters and sculptors, had treated the subject'. This is true of painting (e.g. the Lamentation over the Dead Christ, commissioned from Filippino Lippi on 7 March 1495 for the Certosa at Pavia, and the altarpiece of the same subject painted by Sellajo in 1483 for the Confraternity of San Frediano), but not of sculpture. Precedents cited for the group include a German sculptured Pietà in San Domenico at Bologna (Tolnay), Northern Vesperbilder (Kriegbaum), and French sculptured Pietàs (Justi). The fact that the group was commissioned by a French Cardinal suggests that these last groups may have been in the donor's (though not necessarily in the sculptor's) mind. The group was first installed in the Chapel of S. Petronilla, a circular Roman mausoleum adjacent to the south transept of St. Peter's, which was selected and decorated by the Cardinal as his funerary chapel (for this see Ciaconius, iii, p. 169), was moved in 1517 to the Secretarium of the Cappella della Vergine Maria della Febbre (for this and subsequent movements see D. Redig de Campos, 'Un nuovo aspetto della Pietà di Michelangelo in S. Pietro,' in Capitolium, xxxviii, 1963, pp. 188–191), where it was seen by Vasari and Condivi, was transferred in 1568, under Pope Gregory XIII, to the Chapel of Sixtus IV, was placed in 1609 on the altar of SS. Simon and Jude, was moved in 1626 to the choir, where it remained till 1730, and under Benedict XIV (1749) was placed in the first chapel to the right of the entrance. At this time it was placed high above the altar, and the right side was raised 9 cm., so that the Virgin occupied an almost vertical and the Christ an almost horizontal position. The group has now been somewhat lowered, and the elevation has been rectified. According to calculations by D. Redig de Campos, it originally stood approximately 1·20 m. from the ground. The stylistic differences between Michelangelo's Pietà and the copy made of it by Nanni di Baccio Bigio for S. Maria dell'Anima, Rome (1532) are admirably analysed by Whittkower ('Nanni di Baccio Bigio and Michelangelo,' in Festschrift Ulrich Middeldorf, Berlin, 1968, pp. 248–62).

Plate 7: VIRGIN AND CHILD
Notre Dame, Bruges

The group is not mentioned in the 1550 edition of Vasari, and is wrongly described by Condivi as in bronze: 'Gittò anco di bronzo una Madonna col suo figliuolino in grembo, la quale da certi mercanti fiandresi de' Moscheroni, famiglia nobilissima in casa sua, pagatagli ducati cento, fu mandata in Fiandra' (He cast in bronze a Madonna with her baby son in her lap, which was sent to Flanders by some Flemish merchants called Mouscron, a very noble family in their native country; and they paid him 100 ducats for it). This passage is the source of a mistaken description in the 1568 edition of the Vite of Vasari: 'Fece ancora di bronzo una Nostra Donna in un tondo, che lo gettò di bronzo a requisizione di certi mercatanti fiandresi de' Moscheroni, persone nobilissime ne' paesi loro che pagatogli scudi cento, la mandassero in Fiandra'. The group has been wrongly identified with a Virgin and Child mentioned by Michelangelo in a letter to his father of 31 January 1506: 'L'altra è quella Nostra Donna di marmo, similmente vorrei la facessi portare costì in casa e non la lasciassi vedere a persona. Io non vi mando e' danari per queste dua cose, perchè stimo che sia picola cosa' (The other is the marble Madonna, and I would like this brought home too without anyone being allowed to see it. I am sending no money for these two things, as I think it will be a small matter). The work to which this letter refers was evidently of small dimensions, and is tentatively identified by Milanesi with the Madonna of the Steps. The only firm indication of the date of the Bruges Madonna is supplied by a letter of 13 August 1506 written by Giovanni Balducci to Michelangelo. This refers to the despatch of the group in the following terms: 'Resto avvisato come Francesco del Pugliese avrebbe comodità al mandarla a Viareggio, e da Viareggio in Fiandra. . . . E quando con lui siate d'accordo, l'adirizzate in Fiandra, cioè a Bruggia, a rede di Giovanni e Alessandro Moscheroni e comp., come cosa loro' (I gather Francesco del Pugliese will have an opportunity to send it to Viareggio, and from Viareggio to Flanders. . . . And when you have agreed with him, send it to Flanders, that is to Bruges, to the firm of Jean and Alexandre Mouscron & Co., as their own). The firm of Mouscron bought and sold English cloth, and had establishments in Rome and Florence. The context for which the group was planned is elucidated (i) by a document in the Archives at Bruges (quoted by Tolnay, 'Michelangelostudien', in Jahrbuch der Preuszischen Kunstsammlungen, liv, 1933, p. 113n.), according to which 'Alexander Mosaren . . . helft te maken eenen nieuwen outaer ende daerbouen te stellene eene sumptuose tabernekele met eene der excellente beelde van Marie seer rikelic ende costelic, de velcke beelde men niet verstellen en sal moghen in toecomende tyden' (Alexander Mouscron . . . commissions a new altar, and also the erection of a sumptuous tabernacle with an excellent statue of the Virgin Mary, very handsome and costly, which is not to be moved in future), and (ii) by a passage from Marcus van Waernewyck (1560) quoted by Thode (Kritische Untersuchungen, i, p. 60) which states that the statue cost four thousand gulden and that 'on doit l'entourer d'un retable, dont Jan de Heere de Gent a donné le plan et son fils Lucas le dessin'. The black and white marble setting to which the second passage refers was completed in 1571. The statue was seen and described by Dürer during his visit to the Netherlands on 7 April 1521. It has been correctly pointed out (Wilde) that the statue is set wrongly on its plinth in the altar, and that the principal viewpoint is about 30° to the right of the one pre-

scribed by its present pedestal. There is no literary evidence for the date at which the statue was begun, and it has been assumed to have been carved concurrently with the Pietà (Thode), in the spring or summer of 1501 before the David (Tolnay, Kriegbaum), and concurrently with the David (Wölfflin). The arguments on which these hypotheses rest are purely stylistic. Two drawings in the British Museum, however, (Wilde, Nos. 4 and 5) contain studies for the Bruges Madonna, in one case accompanied by the inscription 'chose di bruges ch.' in another hand than Michelangelo's. Since No. 5 also includes studies for the fresco of the Battle of Cascina, it has been inferred (Wilde) that the drawings date from 1503–4 and that the statue was begun in 1504–5. This is very probable. A sheet of drawings in the Uffizi (No. 233F, B.B. 1645A) contains three studies apparently referring to an early stage in the evolution of the design; the autograph character of this sheet is maintained by Wilde, but its evidential value is not materially affected if it is assumed (Berenson, Dussler) to be a copy of a lost sheet by Michelangelo.

Plate 9: THE PICCOLOMINI ALTAR
Duomo, Siena

The first reference to the Piccolomini Altar in Siena Cathedral occurs in a letter of 15 May 1481 from Platina to Lorenzo de' Medici. The altar was constructed by 1485, and is mentioned in 30 April 1503 in the will of Cardinal Francesco Todeschini-Piccolomini, where it is stated that the chapel had been commissioned as a memorial to the Cardinal himself and to his uncle Pope Pius II, and that in the event of the Cardinal dying in Siena it was to become his place of burial. The Cardinal was elected Pope as Pius III on 22 September 1503, and died in Rome on 18 October of the same year. On 22 May 1501 negotiations were begun with Michelangelo to provide sculptures for the niches of the altar, and in June of the same year a contract was signed by the Cardinal, the sculptor and Jacopo Galli (Milanesi, pp. 615–9). By this Michelangelo was required to carve fifteen statues 'di più bontà, meglio conducte, finite et a perfectione, che figure moderne sieno hogi in Roma' (of higher quality and better workmanship, finish and perfection than any modern figures now existing in Rome) in a term of three years. The figures were to comprise a Christ at the top two and a half braccia high 'per la distantia dell'ochio' (to allow for its distance from the eye of the spectator), a Christ in the central tribune flanked by figures of St. Thomas and St. John each two braccia in height, two angels 'in lo extremo dei cornici con le tronbette in mano minori quattro dita di due braccia' (on the ends of the cornice, with trumpets in their hands . . . (four dita less than two braccia)), and other figures still to be determined. A figure of St. Francis begun by Torrigiani 'non essendo quello finito di pannamenti et testa' (unfinished in the drapery and head) was to be finished by Michelangelo in such a way that it did not appear different from the other figures. After the Pope's death, the contract was reaffirmed by his heirs in a document of September 1504, according to which four statues had already been supplied by Michelangelo. At this point Michelangelo abandoned work on the statues. A letter

of 28 June 1510 from Lodovico Buonarroti to Michelangelo refers to four pieces of marble 'che fecie venire più tempo fa . . . per fare quelle figure del Chardinale di Siena e che non le volendo tu, gliele faciesti dare a Baccio demonte Lupo' (which you had brought some time ago . . . to make those figures for the Cardinal of Siena, and which, as you did not want them, you had given to Baccio da Montelupo). This is cited by Tolnay as evidence that the figures on the altar were carved by Baccio da Montelupo; it relates, however, to the disposal of four blocks (for which payment was made by Baccio da Montelupo) after work on the altar had been broken off. In 1537 Antonmaria Piccolomini requested Michelangelo to furnish designs for the completion of the altar, and at the extreme end of his life, in 1561, Michelangelo's thoughts reverted to the broken contract. Presumably at his own request he was, before 30 November 1561, absolved by Francesco Bandini Piccolomini, Archbishop of Siena, from his outstanding obligations. An inventory of 1511 states that the four figures carved by Michelangelo represented Saints Peter, Paul, Pius and Gregory. Despite this cumulative evidence of Michelangelo's responsibility for the sculptures, their authorship is challenged by Tolnay and most earlier students save Thode and Schmarsow. Their readmission to the Michelangelo oeuvre is due to Kriegbaum ('Le statue di Michelangelo nell'altare dei Piccolomini a Siena', in Michelangelo Buonarroti nel IV Centenario del Giudizio Universale, Rome, 1940, p. 86 ff.). Omitting the St. Francis (which was begun by Torrigiani and completed by Michelangelo), the statuettes comprise figures of Saints Paul, Pius, Peter and Gregory the Great. It is assumed by Kriegbaum that the St. Paul is the earliest of the figures, and occupies a median point in style between the St. Peter's Pietà and the Bruges Madonna. Work on the figures would then have been delayed by the carving of the David. The latest of the four figures is the St. Pius, which is datable about 1504; this figure may have been included in the scheme after the election of the Cardinal as Pope in the preceding year. Between these statuettes there intervene the St. Peter (Fig. 4) (datable ca. 1502) and the somewhat less mellifluous St. Gregory. It is inferred by Tolnay that of the figures (which with the St. Francis would have numbered sixteen in all) three were destined for the central niche, six for the lateral niches, two for the extremities of the cornice, and five for the superstructure of the altar. A number of interesting rear and side views of the figures on the Piccolomini Altar are published by E. Carli (Michelangelo e Siena, Siena, 1964).

Plate 10: BACCHUS
Museo Nazionale, Florence

The statue was carved for Jacopo Galli, and is described in the Galli garden in Aldovrandi's Delle statue antiche (written 1550, published 1556, pp. 172–3): 'Più à dentro in uno giardinetto si trova un bel Bacco ignudo in pie con ghirlanda di hellera, ò di vite in capo: ha da man manca un satirello sopra un tronco assiso, e con amendue le mani si pone in bocca de'grappi de l'uva, ò hellera, che ha il Bacco in mano: Il Satirello ha i piè di capra, e le orecchie medesimamente, ha le corna anche e la

coda. Questa è opera moderna di Michele Agnelo fatta da lui, quando era giovane' (Further inside, in a small garden, is a beautiful nude standing Bacchus, with a wreath of ivy or vines on its head. On its left it has a little satyr, sitting on a tree-trunk and using both hands to put in its mouth some of the grapes on the vine or ivy branch which the Bacchus has in its hand. The little satyr has the feet of a goat and ears likewise, and the horns and tail too. This is a modern work, made by Michelangelo when he was young). The figure is described in 1550 in the first edition of Vasari in the following terms: 'un Bacco di marmo, maggior ch'el vivo, con un satiro attorno; nel quale si conosce ch'egli ha voluto tenere una certa mistione di membra maravigliose: et particularmente avergli dato la sveltezza della gioventù del maschio, e la carnosità et tondezza della femmina. Cosa tanto mirabile, che nelle statue mostrò essere eccellente più d'ogni altro moderno, il quale sino all'ora avesse lavorato' (A marble Bacchus, over life-size, with a satyr by it. One can see that he wished to have a certain marvellous blend of the limbs in it, particularly to give them both the slenderness of a young man and the fleshiness and roundness of a woman. This is so wonderful, that he shows himself in these figures to excel any other sculptor of the modern age who has worked up to the present time). In the second edition of the *Vite* this account is somewhat amplified, apparently in the light of a passage in Condivi (1553) dealing with the statue. The latter reads as follows: 'Non però mancò chi tal comodità conoscesse e di lui si servisse; perciocchè messer Iacopo Galli, gentiluomo romano e di bello ingegno, gli fece fare in casa sua un Bacco di marmo di palmi dieci, la cui forma ed aspetto corrisponde in ogni parte all'intenzione delli scrittori antichi. La faccia lieta e gli occhi biechi e lascivi, quali sogliono essere quelli di coloro che soverchiamente dall'amor del vino son presi. Ha nella destra una tazza, in guisa d'un che voglia bere, ad essa rimirando, come quel che prende piacere di quel liquore, di ch'egli è stato inventore; per il quale rispetto ha cinto il capo d'una ghirlanda di viti. Nel sinistro braccio ha una pelle di tigre, animale ad esso dedicato, come quel che molto si diletta dell'uva; e vi fece piuttosto la pelle che l'animale, volendo significare che per lasciarsi cotanto tirar dal senso e dall'appetito di quel frutto e del liquor d'esso, vi lascia ultimamente la vita. Colla mano di questo braccio tiene un grappolo d'uva, qual un satiretto, che a piè di lui è posto, furtivamente si mangia allegro e snello, che mostra circa sette anni, come il Bacco diciotto. Volle anco detto messer Iacopo ch'egli facesse un Cupidine; e l'una e l'altra di queste opere oggidì si veggono in casa di messer Giuliano e messer Paolo Galli, gentiluomini cortesi e da bene, coi quali Michelagnolo ha sempre ritenuta intrinseca amicizia' (Michelangelo did not lack someone to recognise his ability and make use of him; for Master Iacopo Galli, a Roman gentleman of great intelligence, had him make in his house a marble Bacchus, 10 palmi high, the form and appearance of which correspond in every particular to the meaning of the ancient writers. The face is joyful, and the eyes squinting and wanton, as are the eyes of those who are too much addicted to love of wine. He has a cup in his right hand, as if about to drink, and is gazing at it like one who takes pleasure in that liquor, which he discovered; and because he was its discoverer, Michelangelo has

bound his head with a wreath of vine. On his left arm he has the skin of a tiger, an animal which is dedicated to him because it takes much delight in the grape; and he carved the skin there, rather than the animal, because he wished to signify that, if one lets oneself be drawn by the senses and by desire of that fruit and its juice, one ends by losing one's life. In the hand of this arm he holds a bunch of grapes, which a lively and nimble little satyr at his feet is slyly eating; the satyr seems to be about seven years old, and Bacchus about eighteen. Master Iacopo also wished him to make a Cupid; and both of these works are nowadays to be seen in the house of Master Giuliano and Master Paolo Galli, courteous and worthy gentlemen, with whom Michelangelo has always maintained a close friendship).

A drawing by Heemskerck of the Galli garden (Kupferstichkabinett, Berlin), datable in the years 1532–5, shows the statue without the goblet and right hand. There is contributory evidence that the right hand was missing at this time. It is, however, described in 1553 by Condivi, and was presumably replaced before the latter year. A reduced bronze copy by Pietro da Barga in the Museo Nazionale, Florence, shows the statue as it is to-day. The Bacchus was bought from the Galli family by Francesco de' Medici in 1572 for 240 ducats, and was transferred to the Bargello in 1873. The statue was carved after Michelangelo's arrival in Rome on 25 June 1496 and before his return to Florence in the spring of 1501. There is some disagreement as to the exact date to which it should be assigned within this bracket of years, and in particular as to its relationship to the Pietà (commissioned 27 August 1498). It has been argued (i) (Wilde, Tolnay) that it is identical with a statue of unspecified subject carved for Cardinal Raffaello Riario to which reference is made in letters of Michelangelo of 2 July 1496 and 1 July 1497, and was purchased by Galli only after it had been rejected by Riario; (ii) (Frey) that it is not identical with this statue and must have been begun after this time because it is not mentioned in a letter of 18 August 1497; (iii) (Kriegbaum) that it was carved concurrently with the Pietà and is therefore datable between 1497 and 1501; (iv) (Wölfflin) that it must on stylistic grounds be dated after the Pietà. The identification with the statue carved for Cardinal Riario is conjectural, and the argument in (ii) has some force. The probability, therefore, is that the statue was begun after 18 August 1497 and was completed before the commencement of the Pietà in the following year. The possibility that the Bacchus is identical with 'una figura per mio piaciere' which is mentioned by Michelangelo in the letter of 19 August 1497 cannot, however, be wholly ruled out. It has not been established on which classical Bacchus statue the figure is based; discussion has centred in the main (Wickhoff, Lanckorońcka, Tolnay) on groups in the Albani collection and in the Museo Chiaramonte of the Vatican. As noted by Tolnay, the effeminate body of the Bacchus is inspired by literary sources. The poles of interpretation of the statue vary between those of Wölfflin ('er habe hier ganz ohne Zwang gearbeitet') and Tolnay, who identifies its subject as 'the inner essence of the god Bacchus as a cosmic symbol', and explains the three heads as representing death (the animal mask), the renewal of life (the satyr) and the decline of life (Bacchus). The permissible limits of interpretation of the

figure are those established by Condivi. Tolnay assumes that the surface of the statue was 'originally polished (but) has lost its smooth polish', while Frey describes it as 'nach spätrömischer Art polirt und, wie gewöhnlich, getönt'. It is known that the Sleeping Cupid purchased by Cardinal Riario was toned to simulate an antique, and there is a presumption that the Bacchus was treated in the same way. The authenticity of the present right hand and of the cup is contested by Wind ('A Bacchic Mystery by Michelangelo,' in *Pagan Mysteries in the Renaissance*, New Haven, 1958, pp. 147–57), who connects the expression of the face with the 'demonic Alcibiadic spirit' revealed in the *Phaedrus* of Sadoleto, a dialogue set in the villa of Jacopo Galli.

Plate 12: DAVID
Accademia, Florence

The earliest account of the David occurs in the 1550 edition of Vasari: 'Gli fu scritto di Fiorenza d'alcuni amici suoi, che venisse: perche non era fuor di proposito, che di quel marmo ch'era nell'opera guasto, egli, come gia n'ebbe volontà ne cavasse una figura, il quale marmo Pier Soderini gia Gonfaloniere in quella città, ragionò di dare a Lionardo da Vinci: et era di nove braccia bellissimo; nel quale per mala sorte un Maestro Simone da Fiesole aveva cominciato un' gigante. Et si mal concia era quella opera, che lo aveva bucato fra le gambe, et tutto mal condotto, et storpiato di modo che gli operai di Santa Maria del fiore, che sopra tal cosa erano, senza curar di finirlo, per morto l'avevano posto in abbandono: et gia molti anni era cosi stato, et era tuttavia per istare. Squadrollo Michele Agnolo un giorno; et esaminando potersi una ragionevole figura di quel sasso cavare, accomodandosi al sasso ch'era rimaso storpiato da maestro Simone: si risolse di chiederlo a gli operai; da i quali per cosa inutile gli fu conceduto, pensando che ogni cosa, che se ne facesse, fosse migliore, che lo essere, nel quale allora si ritrovava: perche ne spezzato, ne in quel modo concio, utile alcuno alla fabbrica non faceva. La onde Michele Agnolo fatto un modello di cera, finse in quello, per la insegna del palazzo, un Davit giovane, con una frombola in mano. A cio che si come egli aveva difeso il suo popolo: et governatolo con giustizia, cosi chi governava quella città dovesse animosamente difenderla, et giustamente governarla. Et lo cominciò nell'opera di Santa Maria del Fiore: nella quale fece una turata fra muro et tavole et il marmo circondato: et quello di continuo lavorando, senza che nessuno il vedesse, a ultima perfezzione lo condusse. Et perche il marmo gia da Maestro Simone storpiato et guasto, non era in alcun luoghi tanto, ch'alla volontà di Michele Agnolo bastasse, per quel che averebbe voluto fare: egli fece, che rimasero in esso delle prime scarpellate di maestro Simone nella estremità del marmo, delle quali se ne vede alcuna. Et certo fu miracolo quello di Michele Agnolo far risuscitare uno, ch'era tenuto per morto . . . veramente che questa opera hà tolto il grido a tutte le statue moderne et antiche, o Greche o Latine che elle si fossero. Et si puo dire, che ne 'l Marforio di Roma ne il Tevere, o'l Nilo di Belvedere, ne il giganti di Monte Cavallo, le sian simil'in conto alcuno con tanta misura, et bellezza e con tanta bontà la fini Michel'Agnolo. Perche in essa sono contorni di gambe bellissime, et appiccature, e sueltezza di fianchi divine: ne mai piu s'e veduto un posamento si dolce, ne grazia che tal cosa pareggi; ne piedi ne mani, ne testa, che a ogni suo membro di bontà, d'artificio et di parita ne di disegno s'accordi tanto. E certo chi vede questa, non dee curarsi di vedere altra opera di scultura fatta nei nostri tempi o ne gli altri da qual si voglia artefice. N'ebbe Michel'Agnolo da Pier Soderini per sua mercede scudi DCCC. et fu rizzata l'anno MDIIII' (Some of his friends wrote to him from Florence, telling him to return, since it was possible he might, as he had wished, carve a figure from the spoiled block of marble in the Opera; Piero Soderini, Gonfalonier of the city, had talked of giving the marble to Leonardo da Vinci. It was nine braccia of the most beautiful marble, but one Maestro Simone da Fiesole had unfortunately started a large figure in it. And the work had been done so badly, that he had made a hole between the legs; and it was altogether bungled and ruined, so much so that the Operai of S. Maria del Fiore, who were in charge, had given it up for dead without bothering to finish it. It had been like this for many years, and was likely to remain so. Michelangelo measured it up one day and considered whether it was possible to carve a reasonable figure from this block, left ruined by Maestro Simone. He decided to ask the Operai for it, and they granted it to him as a thing of no use, thinking that whatever he might make of it would be better than the state it was in then; for it was of no use to their building, either in pieces or in that condition. So Michelangelo made a wax model and portrayed in it, as a device for the palace, a young David with a sling in his hand: as he had defended his people and governed them with justice, so might whoever governed the city defend it bravely and govern it justly. He began it in the Opera of S. Maria del Fiore; he made an enclosure of wood and masonry to surround the marble, and worked on it continuously, without anyone seeing it, and brought it to complete perfection. Because the marble had been spoiled and mutilated by Maestro Simone, it was not in some places sufficient to satisfy Michelangelos' wishes for what he would have liked to do with it. He therefore let some of the old marks of Maestro Simone's chisel remain on the outside of the marble, and one can still see some of them. It was indeed a miracle on Michelangelo's part to resurrect a thing considered dead . . . this work has surpassed all other statues, modern and ancient, Greek and Roman. One can say that neither the Marforio in Rome, nor the Tiber or the Nile in the Belvedere, nor the Giants of Monte Cavallo equal it in any way, with such proportion, beauty and excellence did Michelangelo finish it. For one can see in it the legs turned most beautifully, and an articulation and a slenderness of the hips that are god-like. Nor has there ever been seen a pose so fluent, or a gracefulness equal to this, or feet, hands and head so well related to each other with quality, skill and design. Certainly, whoever has seen this work need not bother to see any other work made in sculpture, either in our own or other times, by any craftsman. Michelangelo was paid 800 scudi for it by Piero Soderini, and it was set up in 1504). Condivi's account reads as follows: 'Fatte queste cose, per suoi domestici negozi fu sforzato tornarsene a Firenze, dove dimorato alquanto, fece quella statua, ch'è posta infin a oggi

innanzi alla porta del Palazzo della Signoria, nell'estremo della ringhiera, chiamata da tutti il Gigante. E passò la cosa in questo modo. Avevano gli Operai di santa Maria del Fiore un pezzo di marmo d'altezza di braccia nove, qual'era stata condotto da Carrara di cento anni innanzi da un artefice, per quel che veder si potea, non più pratico che si bisognasse. Perciocchè per poterlo condur piu comodamente e con manco fatico l'aveva nella cava medesima bozzato, ma di tal maniera che nè a lui, nè ad altri bastò giammai l'animo di porvi mano per cavarne statua, non che di quella grandezza, ma nè anco di molto minor statura. Poichè di tal pezzo di marmo non potevano cavar cosa che buona fosse, parve a un Andrea dal Monte a San Savino di poterlo ottener da loro, e gli ricercò che gliene facessero un presente, promettendo che aggiungendovi certi pezzi ne caverebbe una figura. Ma essi, prima che si disponessero a darlo, mandarono per Michelagnolo, e narrandogli il desiderio e'l parer d'Andrea, ed intesa la confidenza che'egli aveva di cavarne cosa buona, finalmente l'offerirno a lui. Michelagnolo l'accettò e senza altri pezzi ne trasse la già detta statua, così appunto che, come si può vedere nella sommità del capo e nel posamento, n'apparisce ancor la scorza vecchia del marmo . . . Ebbe di quest'opera ducati quattrocento e condussela in mesi diciotto' (When he had done these things, he was compelled for private reasons to return to Florence, where he stayed for a time and made the statue which stands to this day at the end of the balustrade, before the door of the Palazzo della Signoria, and is called by all 'il Gigante'. It came about in the following way. The Operai of Santa Maria del Fiore had a piece of marble 9 braccia high; it had been brought from Carrara a hundred years before by a craftsman who, judging by what one can see, was no more skilful than he should have been. For, so that he might be able to transport it more conveniently and with less labour, he had blocked it out in the quarry itself; but he had done it in such a way, that neither he nor anyone else had had the heart to put hand to it and carve a statue, either of that great size or much smaller. As they could not carve anything good from this piece of marble, a certain Andrea from Monte San Savino thought he could get it from them, and asked them to give it to him, promising to carve a figure from it by adding to it some pieces of marble. But before deciding to give it to him, they sent for Michelangelo, told him of Andrea's desire and opinion, and that they had heard of Michelangelo's confidence that he could carve something good from it, and finally offered it to him. Michelangelo accepted it and, without adding any more pieces, worked from it this statue, with such precision that one can still see the original surface of the marble appearing on the top of the head and on the base . . . He received 400 ducats for this work, and executed it in 18 months).

The 1568 edition of Vasari amends the price to the figure quoted by Condivi, adds a reference to Andrea Sansovino (also deriving from Condivi), and introduces a now well-known story of Soderini's criticism of the statue and of Michelangelo's reply. The block from which the David is carved was originally destined for one of the Giganti on the Cathedral. Between 16 April and 23 November 1463 'uno gughante overo Erchole per porre in sullo edificio et chiesa di sancta Maria del Fiore' was carved by Agostino di Duccio. On 18 August 1464 a second

'gughante e in vece et nome . . . profeta per porre in summo degli sproni di s. Maria del Fiore d'atorno alla tribuna di detta chiesa' was commissioned. It was originally intended that this should be made of four pieces, but on 20 December 1466 a block was quarried which enabled it to be carved in a single piece. According to Milanesi in Vasari, vii, (p. 153 n.), this block was spoiled not by Agostino di Duccio but by Bartolommeo di Pietro detto Baccellino, who was entrusted with blocking out the figure at Carrara. On 6 May 1476 the block was allotted to Antonio Rossellino, who died not long afterwards. From a record of the meeting of the Operai of the Duomo on 2 July 1501 (Milanesi, pp. 620–3), it appears that the figure represented was from the first to have been a David: 'Operarii deliberaverunt quod quidam homo ex marmore vocato David male abozatum et sculptum existentem in curte dicte Opere, et desiderantes talem gigantem erigi, et elevari in altum per magistros dicte Opere in pedes stare, ad hoc ut videatur per magistros in hoc expertos, si possit absolvi et finiri' (The Operai considered the marble male figure known as 'David', which had been badly blocked out and carved, and now lies in the courtyard of the Opera; they wish this giant figure to be erected and raised by the masters of the Opera, so as to stand upright, so that it may be seen by masters experienced in this whether it can be carried through and finished). Condivi's statements make it clear that the pose of the figure was determined by a cavity between the legs, and that the top of the head was also carved. In view, however, of the reference in 1501 to finishing the statue, it is likely that the whole block had been more extensively carved than Condivi suggests. The commission was allotted to Michelangelo on 16 August 1501: 'Spectabiles etc. viri Consules Artis Lane una cum dominis Operariis adunati in Audientia dicte Opere, elegerunt in sculptorem dicte Opere dignum magistrum Michelangelum Lodovici Bonarroti, civem florentinum, ad faciendum et perficiendum et perfecte finiendum quendam hominem vocato Gigante abozatum, brachiorum novem ex marmore, existentem in dicta Opera, olim abozatum per magistrum Augustinum grande de Florentia, et male abozatum, pro tempore et termino annorum duorum proxime futurorum, incipiendorum kalendis septembris proxime futuri, et cum salario et mercede qualibet mense florenorum sex auri latorum de moneta; et quicquid opus esset eidem circa dictum edificium faciendum, Opera teneatur eidem presare et conmodare et homines dicte Opere et lignamina, et omnia quecumque alia quibus indigeret: et finito dicto opere et dicto homine marmoreo, tunc Consules et Operarii qui tunc erunt, iudicabunt an mereatur maius pretium; remictentes hoc eorum conscientiis. (*In the margin:* Incepit dictus Michelangelus laborare et sculpere dictum gigantem die 13 settembris 1501, et die lune de mane, quamquam prius . . . die eiusdem uno vel duobus ictibus scarpelli substulisset quoddam nodum quem habebat in pectore: sed dicto die incipit firmiter et fortiter laborare, dicto die 13 et die lune primo mane)' (The honourable Consuls of the Arte della Lana, together with the Masters of the Opera, having met in the council-room of the Opera, elected as sculptor of the Opera the worthy Master Michelangelo Lodovici Buonarotti, Florentine citizen. He is to make, carry through and complete the male figure known as the Giant,

which was blocked out in marble nine braccia high and stands in the Opera; it was formerly blocked out by Master Agostino grande of Florence, and badly blocked out. He is to do it within the next two years, as from the next 1st. September, and at a monthly salary and reward of six broad golden florins cash; and whatever he needs for this, the Opera undertakes to lend and supply, whether it is workmen from the Opera, or timber, or anything else he requires. When this work and marble figure have been finished, the Consuls and Operaii who then hold office will judge according to their consciences whether it deserves a higher price. The said Michelangelo began working and carving this Giant on 13 September 1501, Monday morning, though . . . a day earlier he had removed a certain knob which there was on the figure's breast, with one or two strokes of the chisel; but it was on that day that he began to work steadily and strongly, the 13th, early Monday morning).

On 25 January 1504 it was reported that the statue was 'quasi finita', and a number of Florentine artists were consulted as to the position in which it should be installed. The views expressed fell broadly into three classes (i) a minority (headed by a wood-carver Francesco Monciatto and supported by Botticelli) that it should be shown on or in the vicinity of the Cathedral; (ii) a widely held opinion that it should replace the Donatello Judith outside the Palazzo della Signoria or the Donatello David in the Cortile; (iii) a majority view (led by Giuliano da San Gallo and supported by Leonardo da Vinci, Michelangelo Bandinelli and Piero di Cosimo) that 'veduto la imperfectione del marmo, per lo essere tenere e chotto, et essendo stato all'acqua' (in view of the imperfection of the marble, as it was weak and brittle, and had stood in water), it should be shown under cover in the Loggia dei Lanzi either in the left (east) bay or at the back of the central bay. It was proposed by Giuliano da San Gallo that in the latter event it should be placed in a black niche. Two artists, one of whom was Filippino Lippi, suggested that the sculptor should be consulted on the placing of the statue. It has been claimed (Borghini, Panofsky) that the figure was planned as a niche figure. The fact that the back is less highly worked up than the front certainly supports the view that it was intended to be seen against a wall surface. It was eventually decided that the David should replace the Judith outside the Palazzo della Signoria, and the necessary instructions were issued on 28 May 1504. On 11 June 1504 a base was ordered for the statue ('Deliberaverunt quod . . . quam citius fieri potest facere faciant basam marmoream subtus et circum circa pedes gigantis ad presens ante portam eorum palatti existentis modo et forma et prout designabitur per Simonem del Pollaiuolo et Antonium de Sancto Gallo, architectores florentinos') (They decided that . . . they should make as quickly as possible a marble base under and around the feet of the Giant, at present in front of the gate of the Palazzo, the base to be in the style and shape designed by Simone del Pollaiuolo and Antonio da Sangallo, architects of Florence). The statue was disclosed on 8 September 1504. It was moved to its present site in the Accademia in 1873. An interesting, though not wholly convincing, account of the iconographical sources and of the contemporary significance of the statue as 'an image of personal and corporate freedom and essentially one of righteousness' is given by C. Seymour (*Michelangelo's David: a Search for Identity*, University of Pittsburgh, 1967).

Plate 14: SAINT MATTHEW
Accademia, Florence

The unfinished statue of St. Matthew (Figs. 9, 10) is listed by Condivi among a number of miscellaneous works ('un San Matteo in Firenze, il qual cominciò volendo far dodici Apostoli, quali dovevano andare dentro a' dodici pilastri nel Duomo'), and is described in greater detail in the 1568 edition of Vasari ('Ed in questo tempo ancora abbozzò una statua di marmo di San Matteo nell'Opera di Santa Maria del Fiore; la quale statua così abbozzata mostra la sua perfezione, ed insegna agli scultori in che maniera si cavano le figure de'marmi, senza che venghino storpiate, per potere sempre guadagnare col giudizio, levando del marmo, ed avervi da potersi ritrarre e mutare qualcosa, come accade, se bisognassi') (He blocked out at this time too a marble figure of St. Matthew in the Opera of S. Maria del Fiore. Even in its blocked out state it shows its perfection; and it is a lesson to sculptors in how to carve marble figures without spoiling them, by always managing to proceed with judgement in cutting away the marble, and by keeping a possibility of revising and changing things if necessary, as happens sometimes). The statue was the first of twelve projected figures which were intended to replace frescoes of the Apostles executed in the Duomo by Bicci di Lorenzo. A contract for the twelve statues was signed by Michelangelo on 24 April 1503 (Milanesi, pp. 625–6). According to this, 'spectabiles viri Consules Artis Lane . . . locaverunt Michelangelo Ludovici de Bonarrottis, sculptori et civi florentino, presenti et acceptanti, statuas duodecim Apostolorum fiendorum de marmore carrariensi albo, altitudinis brachiorum quatuor et unius quarti quolibet statua dictorum duodecim Apostolorum, per dictum Michelangelum in honorem Dei, famam totius civitatis, et in ornamentum dicte civitatis et dicte ecclesie Sancte Marie del Fiore' (The honourable Consoli of the Arte della Lana have commissioned from Michelangelo Lodovici Buonarotti, sculptor and citizen of Florence, in his presence and with his agreement, twelve statues of Apostles. Each of the aforesaid twelve statues of the Apostles is to be made of white Carrara marble, $4\frac{1}{4}$ braccia high, by the aforesaid Michelangelo, to the glory of God, the fame of the whole city, and the ornament of the city and of the church of S. Maria del Fiore). A term of twelve years was fixed for the completion of the work, 'et videlicet anno unam absolutam et perfectam ad minus' (that is, at least one completed and finished a year), and Michelangelo was to go to Carrara forthwith to obtain the necessary marble blocks. Michelangelo was to be paid his own and his assistant's expenses on the twelve Apostles, but not for more than one assistant. The sculptor was to receive 'florenos duos auri largos in auro quolibet mense, durantibus dictis XII annis libere et absque aliqua retentione' (two broad golden florins in gold each month during the twelve years, freely and promptly). In addition the Consuls agreed 'dare et tradere et consignare Michelangelo predicto situm unum per eos hodie emptum in angulo

vie Pinti. ... Super quo solo, prefati Consules et Operarii predicti teneantur murare unam domum pro habitatione dicti Michelangeli ... secundum modellum factum vel fiendum per Simonem del Pollaiuolo' (to give, make over and consign to Michelangelo a building site which they bought today on the corner of the Via Pinti ... on which ground the aforesaid Consoli and Operai are obliged to build a house for the residence of Michelangelo ... according to the design either made or to be made by Simone del Pollaiuolo). The cost of the erection of the house up to a total of six hundred florins was to be paid by the Consuls, and the balance, if any, by Michelangelo, whose rights over the house would increase in the ratio of the number of statues executed. References to the quarrying and transport of five blocks for the Apostle statues occur in 1504, and in April 1505 four of them arrived in Florence. In March 1505 Michelangelo left Florence for Rome to begin work on the tomb of Pope Julius II, spent eight months at Carrara, and in December 1505 returned to Rome once more. On 18 December 1505 it was agreed that the contract for the twelve Apostles should be annulled. The relevant document reads as follows: 'Deliberaverunt domum olim concessam Michelangelo Bonarroti pro faciendis et fiendis apostolis, et prout in locatione constat, absolvi et finiri in modo et forma prout dictis operariis videbitur, et eam locare etc. absque eorum preiudicio; et hoc adeo fecerunt postquam dicti apostoli non sculpti sunt, nec videtur vel apparet qualiter sculptantur vel sculpiri possint' (They decided that the house which had been consigned to Michelangelo Buonarotti in return for his making the Apostles should, as agreed in the contract, be completed and finished in the manner and form the said Operai think best, and that it should be leased etc. without prejudice. They have done this because the said Apostles have not been carved, nor does it seem as if they either are being, or can be, carved). In April 1506 Michelangelo fled from Rome to Florence, and in a letter from Piero Soderini of 27 November 1506 recommending Michelangelo to his brother, the Cardinal of Volterra, the Apostles are mentioned once more (Gaye, ii, pp. 91-2): 'Cardinali Valaterrano. Lo apportatore sarà Michelagnolo, scultore, il quale si manda per compiacere e satisfare alla Santità di nro. Signore. Noi certifichiamo la S.V. lui essere bravo giovane, et nel mestieri suo l'unico in Italia, forse etiam in universo. Non possiamo più strectamente raccomandarlo: lui è di modo che colle buone parole et colla carezza, se li fanno, farà ogni cose; bisogna monstrargli amore, et farli favore, et lui farà cose che si maraviglierà chi le vedrà. Significando alla S.V. che ha principiato una storia per il pubblico che sarà cosa admiranda, et così XII apostoli di braccia 4½ in v l'uno, che sarà opera egregia. Iterum alla S.V. quelo più possiamo lo raccomandiamo. die XXVII Novemb. 1506' (To the Cardinal of Volterra. The bearer of this letter is Michelangelo, the sculptor, who is coming to oblige and satisfy His Holiness. We assure Your Lordship that he is an excellent young man, and the best in his craft in Italy, perhaps even in the world. We can hardly recommend him more highly. He is of such a nature that, if you treat him with kind words and affection, he will do anything; you must show him love and favour, and he will make things that are wonderful to see. I inform Your Lordship that he has begun a

scene for the Palazzo della Signoria which will be remarkable, and also twelve Apostles, each of them 4½ braccia high, which will be an excellent work. We again recommend him as strongly as we can to Your Lordship. 27 November 1506). Michelangelo seems to have wished to occupy the house in the Via Pinti once more in March 1508, but he was at once summoned to Rome and on 15 June of this year the lease was finally disposed of. Years later the commission is referred to by Michelangelo in a letter of January 1524 to Giovanni Francesco Fattucci in the following terms: 'Perchè quando (Papa Iulio) mandò per me a Firenze, che credo fussi el secondo anno del suo Pontificato, io avevo tolto a fare la metà della sala del Consiglio a Firenze. ... E de' dodici Apostoli che ancora avevo a fare per Santa Maria del Fiore n'era bozato uno, come ancora si vede; e di già avevo condotti la maggior parte di marmi. E levandomi papa Iulio di qua, non ebbi nè dell'una cosa nè dell'altra niente' (Because when Pope Julius sent to Florence for me – I think it must have been in the second year of his Pontificate – I had undertaken to do half of the Sala del Consiglio in Florence ... And of the twelve Apostles that I still had to do for S. Maria del Fiore, one had been blocked out, as you can still see; I had already worked most of the marble. When Pope Julius took me away from there, I had nothing from either of these things). If Michelangelo's letter is accepted literally, it is necessary to assume with Wölfflin that St. Matthew was carved in 1504. It has been argued alternatively (Ollendorf, 'Der Laokoon und Michelangelos gefesselter Sklave', in *Repertorium für Kunstwissenschaft*, xxi, 1898, pp. 112-5) that (on the evidence of the statement by the Consuls of the guild) the statue had not been begun by December 1505, and must therefore, as Soderini's letter might in itself suggest, have been carved in the summer of 1506. The latter argument has been widely accepted (Thode, Tolnay, Wilde), and is almost certainly correct. A sheet in the British Museum (Wilde No. 3: 1895-9-15-496) contains on the *recto* and *verso* studies of three standing figures, which have been generally connected with the Apostles commission. If for the St. Matthew, these can hardly be contemporary with the statue as executed, and it is suggested (Wilde) that they represent an early stage in the evolution of its design and were made ca. 1503-4. The pose of the figure has been explained by reference to the discovery of the Laocoon in 1506 (Ollendorf), to the Pasquino (Grünwald), and to the project of 1505 for the Slaves on the Julius monument (Tolnay). It is claimed by Justi that the statue represents the moment of St. Matthew's call by Christ, and by Tolnay that 'Michelangelo ... has represented a primordial suffering, the moment when the soul is seized by superhuman cosmic forces, which destroy its individuality.' It is difficult to assess the character of the complete image towards which Michelangelo was working from the figure in its present quarter completed state.

Plates 15-21, 34-5:
THE TOMB OF POPE JULIUS II
S. Pietro in Vincoli, Rome

The story of the tomb of Pope Julius II, originally destined for

St. Peter's and eventually erected in S. Pietro in Vincoli, is longer and more complex than that of any other sculptural monument. It underwent six separate structural phases, and these are best analysed individually.

Project of 1505

In March 1505 Michelangelo was summoned to the papal court. According to Condivi, he was left for some months without employment ('Venuto dunque a Roma, passaron molti mesi primachè Giulio II si risolvesse in che dovesse servirsene. Ultimamente gli venne in animo di fargli fare la sepoltura sua'), but it is likely that he went to Rome specifically to undertake the tomb. Vasari states that the commission for the tomb was procured for Michelangelo by Giuliano da San Gallo ('Nel ritorno di Giuliano in Roma si praticava se'l divino Michelagnolo Buonarroti dovesse fare la sepoltura di Giulio'). The contract does not survive, but is alluded to by Michelangelo in a letter of January 1524 to Giovanni Francesco Fattucci (Milanesi, pp. 429–30: 'Ne' primi anni di papa Iulio, credo che fussi el secondo anno ch'io andai a star seco, dopo molti disegni della sua sepultura, uno gniene piacque, sopra'l quale facemo el mercato; e tolsila a fare per dieci mila ducati, e andandovi di marmi ducati mille, me gli fece pagare, credo da' Salviati in Firenze; e mandommi pe' marmi') (In the first years of Pope Julius, I think it was the second year I went into his service, after I had made a great number of designs for his tomb, one of them pleased him, and we made an agreement. I undertook to make it for 10,000 ducats, and as 1000 ducats went on marble, he paid me that through, I think, the Salviati in Florence; and he sent me to get marble). From April to December 1505 Michelangelo was at Carrara procuring the marble. The documentation of this period is restricted to two contracts, one of 12 November 1505 (Milanesi, p. 630) providing for the shipment from Avenza to Rome of '34 carratas marmorum, inter quas sunt due figure, que sunt 15 carrate' (34 carrate of marble, including two figures which come to 15 carrate), and the other of 10 December 1505 (Milanesi, pp. 631–2) with two stonemasons at Carrara providing for the supply of 'carrate sessanta di marmi all'uso di Carrara; ciò è dumila cinque cento libre la carrata; e infra i detti marmi s'intende essere quatro pietre grosse, dua d' otto carrate l'una, e dua di cinque' (64 carrate of marble, Carrara weight, i.e. 2500 libbre the carrata; it is understood that there should be four large blocks among this marble, two of 8 carrate each, and two of 5). On 31 January 1506 Michelangelo reported to his father (Milanesi, pp. 6–7) that he was awaiting the arrival of the marble: 'De' casi mia di qua io ne farei bene, se e' mia marmi venissino: ma in questa parte mi pare avere grandissima disgrazia, che mai poi che io ci sono, sia stato dua dì di buon tempo' (My affairs here would be fine, if only my marble would come; but here I think I have had very bad luck, there not having been two days of good weather since I have been here). On the arrival of the marble in Rome, difficulties appear to have arisen about payment. These are described in a letter written by Michelangelo in October 1542 to an unnamed Monsignor: 'Seguitando pure ancora circa la sepoltura di papa Iulio, dico che poi ch'ei si mutò di fantasia, cioè del farla in vita sua, come è detto, et venendo certe barche di marmi a Ripa, che più tempo inanzi avevo ordinato a Carrara, non possendo avere danari dal Papa, per essersi pentito di tale opera' (Continuing the story of Pope Julius' tomb, I say that he changed his mind about making it in his lifetime, as has been said; some boat-loads of marble which I had ordered some time before came to the Ripa, and I could get no money from the Pope, as he had repented of the project). The sum necessary to pay for the marble, one hundred and fifty or two hundred ducats, was advanced to Michelangelo through the bank of Jacopo Galli. Michelangelo's letter continues: 'et avendo fornita la casa che m'aveva data Iulio dietro a Santa Caterina, di letti e altre masserizie per gli omini del quadro e per altre cose per detta sepultura, mi parea senza denari essere molto impacciato' (and as I had furnished the house Pope Julius had given me behind S. Caterina with beds and other goods for the masons, and for other work on the tomb, I was much troubled for lack of money). In a later passage in the same letter Michelangelo describes the circumstances in which work on the monument was broken off: 'Stringiendo il Papa a seguitare il più che potevo, mi fece una mattina che io ero per parlargli per tal conto, mi fece mandare fuora da un palafreniere. Come uno vescovo luchese che vidde questo atto, disse al palafreniere: "Voi non conoscete costui?" E'l palafreniere mi disse: "Perdonatemi, gentilomo, io ò commessione di fare così." Io me ne andai a casa, e scrissi questo al Papa: – "Beatissimo Padre: io sono stato stamani cacciato di Palazzo da parte della vostra Santità; onde io le fo intendere che da ora innanzi, se mi vorrà, mi ciercherà altrove che a Roma." E mandai questa lettera a messere Agostino scalco che la déssi al Papa' (The Pope made me attend on him as much as I could, and one morning when I was there to speak to him about this, he had me put out by a chamberlain. A bishop from Lucca, seeing this, said to the chamberlain: 'Do you not know who this is?' And the chamberlain said to me: 'Excuse me, sir, but I have orders to do this.' I went home and wrote to the Pope as follows: 'Blessed Father, I was thrown out of the Palace this morning on Your Holiness' orders, so I am letting you know that if you want me from now on, you will have to look elsewhere than Rome.' I sent this letter to Messer Agostino, the steward, who gave it to the Pope). According to the same letter, five horsemen, despatched by the Pope, caught up with Michelangelo at Poggibonsi, and presented him with a missive from the Pope ordering him to return immediately to Rome. Rejecting this, he continued his flight to Florence. In Florence the Signoria received three briefs from the Pope regarding the sculptor's return, in the third of which, on 8 July 1506, he was assured that on his return he would not be molested in any way. The Signoria encouraged Michelangelo's return, and at the end of November, bearing a letter of recommendation to the Cardinal of Volterra from Piero Soderini, he left for Bologna to meet the Pope. Thereafter further work on the tomb was abandoned in favour first of a bronze statue of the Pope executed at Bologna (destroyed) and second of the painting of the ceiling of the Sistine Chapel, which is mentioned for the first time on 10 May 1506 and was allocated to Michelangelo in March or April 1508. Work on the blocking out of marbles at Carrara seems, however, to have continued, and in June 1508 the stonemason Matteo di Cucarello da Carrara embarked upon 'la

figura de la Santitade del Nostro Signore'. Michelangelo, in a letter of 2 May 1506 to Giuliano da San Gallo, hints that, in addition to the reasons given above, there was another reason for his flight from Rome: 'Ma questo solo non fu cagione interamente della mia partita; ma fu pure altra cosa, la quale non voglio scrivere; basta ch'ella mi fe' pensare s'i'stavo a Roma, che fussi fatta prima la sepultura mia, che quella del Papa. E questa fu cagione della mia partita subita. Ora voi mi scrivete da parte del Papa; e così al Papa legierete questa: e intenda la Sua Santità come io sono disposto, più che io fussi mai, a seguire l'opera; e se quella vole fare la sepultura a ogni modo, no'gli debbe dare noia dov'io me la facci, purchè in capo de' cinque anni che noi siano d'acordo, la sia murata in Santo Pietro, dove a quella piacerà, e sia cosa bella, come io ò promesso: che son certe, se si fà, non à la par cosa tutto el mondo' (But this was not the only reason for my departure; there was something else, which I do not want to write about. Enough that it made me think that, if I stayed in Rome, my tomb would be made before the Pope's. This was the reason for my sudden departure. Now you are writing to me on behalf of the Pope, and will read him this letter: let His Holiness understand that I am more than ever disposed to continue the work. If he really wishes to have the tomb built, there is no need for him to make trouble about where I do it, provided that it is, within the five years we agreed on, erected in St. Peter's in whatever position he wants, and that it is a beautiful work, as I have promised. I am sure that, if it is carried out, there will be nothing equal to it in the world). This letter contains a suggestion that the sculptures for the tomb should be carved in Florence. Tolnay interprets the 'cagione' referred to in this letter as the acceptance of Bramante's plan for St. Peter's. This explanation is conjectural, and is not consistent with the terms employed in the letter. Condivi's account of the 1505 project attributes the change in the Pope's plan to Bramante, who persuaded him that it was unlucky to order a tomb in his own lifetime, and it is likely that the reference is to some real or imaginary plot on Bramante's side.

The primary source for the reconstruction of the 1505 project is an account given by Condivi: 'E per darne qualche saggio, brevemente dico che questa sepoltura doveva aver quattro facce: due di braccia diciotto, che servivan per fianchi, e due di dodici per teste; talchè veniva ad essere un quadro e mezzo. Intorno intorno di fuore erano nicchie, dove entravano statue, e tra nicchia e nicchia termini, ai quali, sopra certi dadi, che movendosi da terra sporgevano in fuori, erano altre statue legate come prigioni, le quali rappresentavano l'Arti Liberali, similmente Pittura, Scultura e Architettura, ognuna colle sue note; sicchè facilmente potesse esser conosciuta per quel che era, denotando per queste, insieme con papa Giulio, essere prigioni della Morte tutte le Virtù, come quelle che non fossero mai per trovare da chi cotanto fossero favorite e nutrite quanto da lui. Sopra queste correva una cornice, che intorno legava tutta l'opera; nel cui piano eran quattro grandi statue, una delle quali, cioè il Moisè, si vede in San Pietro ad Vincula, e di questa si parlerà al suo luogo. Così ascendendo l'opera, si finiva in un piano, sopra il quale erano due Agnoli, che sostenevano un'arca; uno d'essi faceva sembiante di ridere, come quello che si rallegrasse che l'anima del papa fosse tra gli beati spiriti ricevuta;

l'altro di piangere, come se si dolesse che'l mondo fosse d'un tal uomo spogliato. Per una delle teste, cioè per quella che era dalla banda di sopra, s'entrava, dentro alla sepoltura in una stanzetta a guisa d'un tempietto, in mezzo della quale era un cassone di marmo, dove si doveva seppellire il corpo del papa; ogni cosa lavorata con maraviglioso artificio. Brevemente, in tutta l'opera andavano sopra quaranta statue, senza le storie di mezzo rilievo fatte di bronzo, tutte a proposito di tal caso, e dove si potevan vedere i fatti di tanto pontefice' (To give some description of this tomb, I will briefly say that it was to have four faces: two of 18 braccia, serving as the sides, and two of 12 braccia as the ends. It consisted therefore of a square and a half. Around the outside were niches in which statues were to go, and between the niches, terms; and to these, above plinths projecting as they rose from the ground, other statues were bound like captives. These represented the Liberal Arts, such as Painting, Sculpture and Architecture, each with its attributes for easy recognition of what it was. He meant by these that all the arts had, with Pope Julius, become prisoners of Death, since they would never find anyone by whom they would be so favoured and nourished as they had been by him. Above these ran a cornice, binding the whole work round, and on the level of this were four large statues; one of them, the Moses, can be seen in S. Pietro in Vincoli and I will speak of it in its place. Ascending in this way, the work ended in another storey, above which were two angels holding up a bier. One of these seemed to be laughing, as if rejoicing that the soul of the Pope should be among the blessed spirits; the other weeping, as if grieving that the world should be deprived of such a man. Through one of the ends, the one on the upper side, one entered a chamber inside the tomb, in the form of a small temple; in the middle of this was a marble tomb-chest in which the Pope's body was to be placed, and everything was worked with marvellous skill. Briefly, there were over forty statues in the whole work, not counting the scenes in relief, cast in bronze; all of these were connected with the purpose of the tomb and were to show the deeds of this great Pope).

Vasari, whose account of 1550 is corrected in this passage, incorporated the dimensions and certain facts given by Condivi in his edition of 1568 with further elaboration. This account, which is less authoritative than Condivi's and does not distinguish clearly between the projects of 1505 and 1513, reads as follows: 'Aveva un ordine di nicchie di fuori a torno a torno, le quali erano tramezzate da termini vestiti dal mezzo in su, che con la testa tenevano la prima cornice, e ciascuno termine con strana e bizzarra attitudine ha legato un prigione ignudo, il qual posava coi piedi in un risalto d'un basamento. Questi prigioni erano tutte le provincie soggiogate da questo pontefice, e fatte obbediente alla Chiesa Apostolica; ed altre statue diverse, pur legate, erano tutte le virtù ed arte ingegnose, che mostravano esser sottoposte alla morte, non meno che si fussi quel pontefice che sì onoratamente le adoperava. Su'canti della prima cornice andava quattro figure grandi, la Vita attiva e la contemplativa, e San Paulo e Moisè. Ascendeva l'opera sopra la cornice in gradi diminuendo con un fregio di storie di bronzo, e con altre figure e putti e ornamenti a torno; e sopra era per fine due figure, che una era il Cielo, che ridendo sosteneva in sulle spalla una bara

insieme col Cibele dea della terra, pareva che si dolessi, che ella rimanessi al mondo priva d'ogni virtù per la morte di questo uomo; ed il Cielo pareva che ridessi che l'anima sua era passata alla gloria celeste. Era accomodato che s'entrava ed usciva per le teste della quadratura dell'opera nel mezzo delle nicchie; e drento era, caminando a uso di tempio, in forma ovale; nel quale aveva nel mezzo la cassa dove aveva a porsi il corpo morto di quel papa: e finalmente vi andava in tutta quest'opera quaranta statue di marmo, senza l'altre storie, putti ed ornamenti, e tutte intagliate le cornici e gli altri membri dell'opera d'architettura' (It had a row of niches going right round the outside, and these were separated by terms clothed from the middle upwards; these supported the first cornice with their heads, and each term had bound to it, in a strange and bizarre attitude, a nude captive standing on a projection of the base. These captives were all provinces subjugated by this Pope, and made obedient to the Apostolic Church. And there were various other statues, also bound, of all the liberal arts and sciences, which were shown to be subject to death no less than the Pope, who had used them with such honour. On the corners of the first cornice four large figures were to go, the Active and the Contemplative Lives, St. Paul and Moses. The work went on upwards above the cornice in gradually diminishing steps, with a frieze of scenes in bronze, and with other figures, putti and ornaments all round it. And as a top above this were two figures, one of which was Heaven, smiling and supporting a bier on her shoulder, together with Cybele, Goddess of the Earth, who seemed to be grieving that she should be left in a world robbed of all virtue by the death of this man; and the Heaven seemed to be smiling because his soul had passed to heavenly glory. It was so arranged that one entered and came out through the ends of the square structure, between the niches; and the interior was in the shape of an oval, curving like a temple. In the middle of it was the tomb-chest in which the Pope's dead body was to be put. Lastly, there were to be forty marble statues in the whole of this work, not counting the other scenes, putti and ornaments, the carved cornices and the other architectural elements in the work).

The dimensions recorded by Condivi give a width of 7.2 m. across the front and back, and 10.8 m. along the sides. On the narrower faces at front and back the surface seems to have been divided by four pilasters with herms, before each of which, on a protruding pedestal, stood a prisoner or slave. Two alternative hypotheses have been advanced regarding the longer faces at the sides, which were either divided in two bays separated by a historical relief (Schmarsow, Bürger, Thode) or into three bays in the proportion of five to three (Panofsky). Over and above the written evidence, there exist a number of drawings which throw an oblique light on the first version of the tomb. These are (i) a much damaged drawing in Berlin, of which the upper part is associable with the project of 1513 but the lower part is conjecturally related to the project of 1505, (ii) a copy of this drawing by Jacopo Rocchetti, also in Berlin, and (iii) a drawing in the Uffizi (No. 1740) ascribed to Aristotile da San Gallo, which appears also to show the lower register of the project of 1505. The evidence for the upper register in the 1505 project is less firm. It has been argued (Panofsky) that the figure of the

Pope was represented seated, and that the term 'bara' is synonymous with 'sella gestatoria'. This argument is recapitulated in a later volume by Panofsky (*Tomb-Sculpture: four lectures on its changing aspects from Ancient Egypt to Bernini*, New York, 1964, pp. 88–90), which concludes that 'the composition of 1505 . . . was dominated by the wish to glorify the Pope as a kind of Pantocrator'. Conversely it has been inferred (Tolnay) that the effigy was a recumbent frontal figure. Support for the first view is supplied by a seated figure of St. Gregory the Great by Niccolò Cordieri in S. Gregorio al Celio which is carved from the same block as the papal statue listed in the inventory of the studio of Michelangelo (for this see Hess, 'Michelangelo and Cordier', in *Burlington Magazine*, lxxxii, 1943, pp. 55–65). Support for the second view is afforded by a drawing by Zanobi Lastricati in the Ambrosiana, Milan, of the catafalque of Michelangelo, with the inscription: 'catafalco quadrato in isola, alla forma del Settizonio di Severo presso a(lle) Antoniane e come da Michel Angelo era stato prima disegnato il Sepolcro di Giulio II in San Piero in Vincoli benchè non fussi poi così eseguito . . . haveva fatto il Pa(pa) in iscorcio' (freestanding and rectangular catafalque, in the shape of that of Septimius Severus near the Antoniane, and as the tomb of Julius II in S. Pietro in Vincoli was first designed by Michelangelo, though it was not afterwards executed in this manner . . . he had represented the Pope in a foreshortened view). It has been suggested (Panofsky) with some plausibility that the front of the 1505 project was inspired by a sarcophagus from the Villa Montalto-Negroni-Massimi now in the Vatican.

Not only was Giuliano da San Gallo instrumental in securing Michelangelo the commission for the tomb, but he was also responsible for encouraging the Pope to erect a special chapel in which it could be housed. This in turn led to the adoption of Bramante's scheme for the reconstruction of the entire church. The first evidence of a centralised plan for the new St. Peter's occurs on 10 November 1505, and the first stone was laid on 18 April 1506. Though a connection must be postulated between the scheme for the tomb and the rebuilding of the church, it is hazardous to presume (Tolnay) that 'the new St. Peter's was conceived on a gigantic scale as a funerary chapel to house the tomb of Julius II as its centre', and that the tomb was therefore planned in 1505 as a 'double commemorative monument in honor of both the Prince of the Apostles and of his spiritual descendant', a 'mausoleum of the eternal Pope'. Condivi's description of the interior sarcophagus ('un cassone di marmo, dove si doveva seppellire il corpo del papa') is inconsistent with the view that this was designed to commemorate St. Peter. Programmatically there is no general agreement on the meaning of the first version of the tomb, though there is a tendency throughout the Michelangelo literature to dismiss the relatively simple explanations of Condivi in favour of the more elaborate iconographical scheme postulated by Vasari or of conjectural explanations of a still more complex character. Thus the 'wahrhaft titanische Idee' (Gregorovius) of the monument is explained by Tolnay as an 'abbreviated image of the Universe' and a 'grandiose pyramid of Catharsis conceived according to the idea of the *Scala Platonica*'. The most ambitious interpretation is that of Tolnay, according to whom the lower

section represented the triumph of the Apostolic Church over paganism, the seated figures in the central zone symbolised the instauration and diffusion of the true faith, and the summit showed the Empyrean with an apotheosis of the Church personified by the Apostle-Pope. Justi explains the herms as a 'Todessinnbild'.

Project of 1513

The second phase in the evolution of the monument is described by Condivi in the following terms: 'Perciocchè, venendo a morte (papa Iulio), ordinò che gli fosse fatta finir quella sepoltura, che già aveva principiata, dando la cura al Cardinale Santi Quattro vecchio e al cardinale Aginense suo nipote. I quali però gli fecer fare nuovo disegno, parendo loro il primo impresa troppo grande. Così entrò Michelagnolo un'altra volta nella tragedia della sepoltura, la quale non più felicemente gli successo di quel di prima; anzi molto peggio, arrecandogli infiniti impacci, dispiaceri e travagli, e, quel ch'è peggio, per la malizia di certi uomini, infamia; della quale appena dopo molti anni s'è purgato. Ricominciò dunque Michelagnolo di nuovo a far lavorare, condotti da Firenze molti maestri, e Bernardo Bini, ch'era Depositario, dava danari, secondo che bisognava. Ma non molto andò innanzi, che fu con suo gran dispiacere impedito, perciocchè a Papa Leone, il qual successe a Giulio, venne voglia d'ornare la facciata di San Lorenzo di Firenze con opera e lavori di marmo' (Wherefore being on the point of death, Pope Julius ordered that he should be commissioned to finish the tomb he had begun, putting the old Cardinal Santiquattro and his nephew Cardinal Aginensis in charge of it. They therefore had a new design made by him, as they considered the first undertaking too large. So Michelangelo entered a second time into the tragedy of the tomb, and he did not succeed any more easily than the first time; much worse, indeed, for it brought him infinite trouble, unpleasantness, difficulty and, what is worse, disgrace on account of the malice of certain men. And after many years he has hardly cleared himself of it. Michelangelo, therefore, began work again, having brought many masters from Florence; and Bernardo Bini, the depositary, gave him money as he needed it. But he had not got far with it before he was hindered, to his great distress; for Pope Leo, who succeeded Julius, conceived a desire to decorate the front of S. Lorenzo in Florence with a marble façade and sculpture). The account given of this phase in the 1568 edition of Vasari's *Vite* is incorrect in a number of material respects. The death of Julius II occurred on 21 February 1513, and following the election of his successor, Leo X, a new contract was drawn up on 6 May 1513 by Julius II's executors, Cardinal Aginensis and Lorenzo Pucci, Cardinal of Santi Quattro. This stipulated that Michelangelo should undertake no other work than that on the tomb, that the tomb should be completed in seven years, and that Michelangelo should receive for it 16,500 ducats (of which 3,500 had already been paid), at the rate of 200 ducats a month for two years and 136 ducats a month thereafter until the complete sum was paid off. An annexe (Milanesi, pp. 636–7) gives an account of the new form of the tomb: 'Sia noto a qualunche persona com'io Michelagniolo, scultore fiorentino, tolgo a fare la sepultura di papa Iulio di marmo da el cardinale d'Aginensis e dal Datario,

e' quali sono restati dopo la morte sua seguitori di tale opera, per sedici migliaia di ducati d'oro di Camera e cinquecento pur simili; e la composizione della detta sepultura à essere in questa forma ciò è:

Un quadro che si vede da tre facce, e la quarta faccia s'apicca al muro e non si può vedere. La faccia dinanzi: cioè la testa di questo quadro à essere per larghezza palmi venti e alto quattordici, e l'altre dua facce che vanno verso el muro dove s'apiccha detto quadro, anno a essere palmi trenta cinque lunge e alte pur quattordici e in ognuna di queste tre facce va dua tabernacoli, e' quali posano in sur uno imbasamento che ricignie attorno el detto quadro e con loro adornamenti di pilastri, d'architrave, fregio e cornicione, come s'è visto per un modello piccolo di legnio. In ognuno de' detti sei tabernacoli va dua figure magiore circa un palmo del naturale che sono dodici figure, e innanzi a ogni pilastro di quegli che mettono in mezo e' tabernacoli, va una figura di simile grandeza: che sono dodici pilastri; vengono a essere dodici figure; e in sul piano di sopra detto quadro viene un cassone con quatro piedi, come si vede pel modello, in sul quale à a essere il detto papa Iulio, et a capo à a essere i'mezo di due figure ch'el tengono sospeso ed a piè i' mezo di du' altre; che vengono a essere cinque figure in sul cassone tutte e cinque magiore che'l naturale, quasi per dua volte el naturale. Intorno al detto cassone viene sei dadi, in su quali viene sei figure di simile grandeza, tutte e sei a sedere: poi in su questo medesimo piano dove sono queste sei figure, sopra quella faccia de la sepultura che s'apicca al muro, nascie una capelletta, la quale va alta circa trenta cinque palmi, nella quale va cinque figure maggiore che tutte l'altre, per essere più lontane dall'ochio. Ancora ci va tre storie o di marmo o di bronzo, come piacerà a'sopra detti seguitori, in ciascuna faccia de la detta sepultura fra l'un tabernacolo e l'altro, come nel modello si vede. E la detta sepultura m'obrigo a'dar finita tutta a mie spese col sopradetto pagamento, faccendomelo in quel modo che pel contratto aparirà, in sette anni; e mancando finito i sette anni qualche parte della detta sepultura che non sia finita, mi debba esser dato da' sopra detti seguitori tanto tempo quanto sia possibile a fare quello che restassi, non possendo fare altra cosa' (Let it be known to all that I, Michelangelo, sculptor of Florence, undertake the execution of a marble tomb for Pope Julius from the Cardinal Aginensis and the Datary, who have become since his death the executors to complete this work, for 16,500 gold Camera ducats. The composition of the tomb shall be in the following form:

A rectangle, visible from three sides, with the fourth side attached to the wall and not visible. The front face – that is, the head of the rectangle – shall be 20 palmi broad and 14 high; and the other two sides running back to the wall shall be 35 palmi long and 14 high. Each of these three faces shall contain two tabernacles, resting on a base carried round the rectangle, and shall be decorated with pilasters, architrave, frieze and cornice, as shown in the small wooden model. In each of these six tabernacles there shall be two figures, about one palmo larger than life-size, making twelve in all; and in front of each of the pilasters flanking the tabernacles there shall be one figure of the same size. This makes twelve pilasters and twelve figures in all. On the platform above the rectangle there shall be

coffer with four feet, as in the model, upon which the figure of Pope Julius shall be put, supported between two angels at his head and two more at his feet: this makes five figures on the coffer, all of them over life-size, almost twice the natural size. Round the coffer there will be six plinths, and on these will go six figures of the same size, all of them in a sitting position. Further, on the same level as these six figures, above the face of the tomb attached to the wall, there shall open a small chapel, about 35 palmi high, containing five figures larger than all the others, because they are further from the eye. There shall also be three histories, either of bronze or of marble as may please the executors, on each face of the tomb, between one tabernacle and the next, as in the model. I bind myself to deliver the tomb finished at my expense for the above-mentioned sum, to be paid to me, according to the contract, within seven years. If some part of the tomb has not been finished at the end of the seven years, the executors are to give me as much time as I need to do what remains, if no other arrangement is possible).

So far as can be judged from this contract (for an alternative transcription of which see S. Prete, *The Original Contract with Michelangelo for the Tomb of Pope Julius II dated May 6, 1513*, New York, 1963), the tomb of 1513 was a reduction of the project of 1505 in so far as the back rested against the wall and the forty-seven figures envisaged in 1505 were reduced to forty (Panofsky). No mention is made in the new contract of the central burial chamber, but the four seated figures in the second register appear to have been increased to six and the figures round the Pope from two to four, and the upper register is transformed by the addition of a 'cappelletta' 7.8 m. high containing a Virgin and Child. It is probable (Panofsky) that the new scheme was related to, but not identical with, that shown in the drawing for the tomb in Berlin. In letters of January 1524 to Giovanni Francesco Fattucci and of October 1542 to an unnamed Monsignor, Michelangelo refers to the new project as an enlargement of the old. The tone of these letters is self-justificatory, and neither can be accepted at its face value. The first reads as follows (Milanesi, p. 428): 'Dipoi venne la morte di papa Iulio: e a tempo nel prencipio di Leone, Aginensis volendo accrescere la sua sepultura, cioè far maggiore opera che il disegno ch'io avevo fatto prima, si fece uno contratto. E non volendo io che'e'vi mettessino a conto della sepultura i detti tre mila ducati ch'io avevo ricievuti, mostrando ch'io avevo avere molto più; Aginensis mi disse, che io ero un ciurmadore' (Then Pope Julius died, and at the beginning of Leo's pontificate Aginensis wanted to enlarge the tomb, to make it a greater work than the plan I had made before, and a contract was drawn up. And when I did not want the 3000 ducats I had received put down as settlement for the tomb, and showed I was owed much more, Aginensis told me I was a swindler).

The second runs (Milanesi, pp. 491–2): 'Poi dopo detta morte di Iulio, Aginensis volse seguitare detta sepultura, ma maggior cosa; ond'io condussi e' marmi al Maciello de' Corvi, et feci lavorare quella parte che è murata a Santo Pietro in Vincola, et feci le figure che ò in casa. In questo tempo papa Leone non volendo che io facessi detta sepultura, finse di volere fare in Firenze la facciata di San Lorenzo et chiesemi a Aginensis; onde

e'mi dette a forza licenzia, con questo, che a Firenze io facessi detta sepultura di papa Iulio. Poi che io fui a Firenze per detta facciata di San Lorenzo, non vi avendo marmi per la sepultura di Iulio, ritornai a Carrara et stettivi tredici mesi, et condussi per detta sepultura tutti e'marmi in Firenze, et mura' vi una stanza per farla, et cominciai a lavorare. In questo tempo Aginensis mandò messer Francesco Palavisini, che è oggi il vescovo d'Aleria, a sollecitarmi, et vidde la stanza, et tutti i detti marmi e figure bozzate per detta sepultura, che ancora oggi vi sono. Veggiendo questo, cioè ch'i'lavoravo per detta sepultura, Medici che stava a Firenze, che fu poi papa Clemente, non mi lasciò seguitare' (After the death of Julius, Aginensis wanted to carry on the tomb, but as a larger affair. So I brought the marble to the Macello de' Corbi, had the part that has been built in S. Pietro in Vincoli worked, and made the figure I have in my house. At this time Pope Leo, as he did not want me to make the tomb, pretended he wanted to build the façade of S. Lorenzo in Florence, and begged me of Aginensis; the latter was compelled to give me leave, on condition that I went on with Pope Julius' tomb in Florence. While I was in Florence for the façade of S. Lorenzo, I did not have enough marble there for Julius' tomb, so I returned to Carrara and stayed there thirteen months, and brought all the marble for the tomb to Florence; I built a room there to make it in and began work. At this time Aginensis sent Messer Francesco Pallavicini, now Bishop of Aleria, to urge me on; and he saw the room and all the marble and blocked out figures for the tomb, and these are still there. The Medici who was then in Florence, later Pope Clement, saw that I was working on the tomb and did not let me continue with it).

Michelangelo's statement that he was compelled to abandon work on the tomb in order to undertake the façade of San Lorenzo is untrue; a letter of Domenico Buoninsegni to Baccio d'Agnolo of 7 October 1516, seems to indicate that prior to this time he had taken the initiative in expressing his willingness to undertake the façade. Between 1513 and 1516, however, there is evidence of continuous work on the tomb sculptures. In a letter to his brother Buonarroto of 16 June 1515 (Milanesi, p. 115) Michelangelo writes: ' . . . qua mi bisognia fare sforzo grande questa state di finire presto questo lavoro, perchè stimo poi avere a essere a'servizi del Papa. E per questo ò comperato forse venti migliaia di rame per gittar certe figure' (. . . I shall have to make a great effort this summer to finish this work quickly, because I think I shall be in the Pope's service soon afterwards. I have bought about 20,000 pounds of copper for this, to cast some figures). A second letter (Milanesi, p. 121) reads: 'Io poi che tornai di costà non ò mai lavorato: solo ò atteso a far modegli e a mettere a ordine e'lavoro, i'modo che io possa fare uno sforzo grande e finirlo in due o tre anni per forza d'uomini' (Since I returned from Florence I have done no work; I have only managed to prepare models and arrange for the work, so that I can make a great effort to finish it in two or three years). On 9 July 1513 Michelangelo signed a contract (Milanesi, p. 640) with Antonio da Pontassieve for 'la faccia che viene dinanzi, cioè una facciata larga palmi trenta circa, diciassette alta, secondo che sta il disegno' (the front face, namely a façade about 30 palmi wide and 17 high, as it is in the design), and in a letter of May 1518 to the Capitano di Cortona (Milanesi,

p. 391) he writes, with reference to the first year of the pontificate of Leo X: 'trovommi che io lavoravo in sur una figura di marmo, ritta, alta quatro braccia, che à le mani drieto' (I was working on an upright marble figure, 4 braccia high, with its hands behind it). The pieces of the tomb executed at this time were (A) the Rebellious Slave (Louvre), to which this passage refers, (B) the Dying Slave, and (C) the Moses.

Project of 1516

The contract for the façade of S. Lorenzo was preceded by a new contract for the tomb. This was signed on 8 July 1516, and involved a further reduction in the size of the tomb, an extension of the period of completion to nine years, and permission to Michelangelo to work on the sculptures where he chose. The sculptor bound himself to undertake no other major works than the façade and the tomb. The contract (Milanesi, pp. 644–51) includes a description of the new form of the tomb: 'El modello è largo ne la faya dinanzi brachia undeci fiorentine vel circa; ne la qualle largueza si move in sul piano de la terra uno inbasamento con quatro zocholi o vero quatro dadi colla loro cimasa ch ricignee per tutto; en su quali vano quatro figure tonde di marmo tre bracia et mezo l'una et drieto alle dicte figure in su uogni dado viene il suo pilastro, su che vano alti insino alla prima cornice; la quale va alta dal piano dove possa l'imbasamento, in su bracia sei, et dua pilastri co' lor socoli da uno de' lati metto in mezo uno tabernaculo, el quale è alto al vano bracia quatre et mezo: et similmente da l'altre bande metto in mezo uno altro tabernaculo simile che vengono ad essere dua tabernaculi ne la facia dinanci da la prima cornice in giù, ne quali in ogni uno viene una figura simile a le supradicte. Di poi fra l'uno tabernaculo e l'altro resta uno vano di bracia duo et mezo alto per infino alla prima cornice, nel quale va una historia di bronzo. Et la dicta opera va murata tanto discosto al muro, quanto la largeza d'uno de' tabernaculi, che sono ne la facia dinanci: et nelle rivolte de la dicta facia che vano al muro, coè nelle teste, vano duo tabernaculi simili a queli dinanzi co' loro zocoli et colle lor figure di simile grandessa che vengono ad essere figure dondeci et una storia, come è decto dalla prima cornice in su sopra e'pilastri che mettono in mezo el tabernaculo di socto, vieni altri dadi co' loro adornamenti, suvi meze colone che vano insino a l'ultima cornice, coè vano alte bracia octo dalla prima a la seconda cornice, ch' è suo finimento; et da una de le bande in mezo de le duo colonne, viene uno certo vano, nel quale va una figura a sedere, alta asedere braccia tre et mezo fiorentine: el simile viene fra l'aitre dua colone da l'altra banda. Et fra il capo de le dicte figure e l'ultima cornicie, resta uno vano di circa a tre braccia simile per ogni verso, nel quale va una storia per vano, di bronzo: che vengono ad essere tre storie ne la facia dinante: et fra l'una figura a sedere et l'altra dinante, resta uno vano che viene sopra il vano de la storia del mezo di socto, nel quale viene una certa tribuneta, ne la quale viene la figura del morto, cioè di papa Iulio, con dua altre figure che la metono in mezo. Et una Nostra Dona pure di marmo alta bracia quatro simili, et supra e' tabernaculi de le teste o vero delle rivolte de la parte di supra, ne le quali in ogni uno de le dua viene una figura a sedere in mezo de dua meze colone con una storia di supra a quelle

dinanti' (The front face of the design is about 11 Florentine braccia wide. Within this breadth there is a base at ground level with four plinths or cubes and their moulding binding it right round. On these there are four marble figures in the round, each of them 3½ braccia high. On each plinth or cube, behind these figures, there is a pilaster going up as high as the first cornice, which is 6 braccia above the level of the base. On one side, two pilasters and their plinths flank a tabernacle, its opening 4½ braccia high; and similarly on the other side the two other pilasters flank a similar tabernacle. This makes two tabernacles in the front face beneath the first cornice, and a figure similar to those mentioned above goes in each of them. Between the two tabernacles is an opening of 2½ braccia and as high as the first cornice, and in this there is a bronze history. The work is built to project from the wall as much as the breadth of one of the tabernacles in the front face; and in the returns going to the wall from the front face, that is to say in the ends, there are two tabernacles like those in front, with plinths and figures of the same size. This makes twelve figures and one history below the first cornice. Above the first cornice, and over the pilasters flanking the tabernacles beneath, there are more decorated bases; and on these are half-columns going up as far as the last cornice, that is to say going up 8 braccia from the first to the second cornice, where they finish. On one side, between the two columns, there is an opening in which a sitting figure goes, 3½ Florentine braccia high as it sits; and the same goes between the other two columns on the other side. Between the top of these figures and the highest cornice there is an opening of about 3 braccia each way, and in this goes a bronze history in relief. This makes three histories on the front face. Between the one sitting figure and the other comes an opening over the space with the history in relief beneath, and in this there is a small tribune in which the figure of the deceased, that is of Pope Julius, goes, together with two more figures on each side of him; and above these there is a marble Madonna, 4 braccia high. Over the tabernacles on the ends, or returns, of the lower part, come the returns of the upper part; in each of these goes a sitting figure between two columns, with a history above, like those on the front).

By this contract the tomb was reduced to a wall monument proper, with returns at the sides equal in depth to the unit of the tabernacle and hermae pilasters on the front. A bronze relief was planned for the centre of the front. The upper half was reduced in height, and widened to extend over the whole width of the lower register, with half columns corresponding to the pilasters beneath. There were thus twelve figures in all in the lower register. The seated figures in the upper register were reduced to two, with, between them, a figure of the Pope supported by two other figures, and a Virgin and Child behind. The architrave above the hermae pilasters was suppressed. In September 1516 Michelangelo went to Carrara to choose new blocks for the statues. A letter of 9 August from his representative in Rome, Leonardo Sellaio, urged him to complete the work, and a year later (December 1517) Sellaio reported that he had informed Cardinal Aginensis that the monument would be completed in two years. In February 1518 blocks for the statue were sent to Florence, and on 5 February Sellaio wrote to Michelangelo regarding the figures which remained in his

studio in Rome ('Perche non mi pare stia a proposito, dua tenghino le chiave di chasa, per la gelosia di quelle fighure, parendovi, daro loro tutte le chiave, coe di sotto, sichche rispondetemi la volonta vostra'). On 23 October 1518 Cardinal Aginensis reminded Michelangelo that he was expecting to see two figures by a stipulated date ('Et cum desiderio aspectamo vedere le doe figure al tempo che ne haveti promesse'), and a week later (31 October 1518) Sellaio impressed on Michelangelo the importance of completing at least one figure on time ('E sopra a tutto la fighura sia fornita al tenpo promesso'). In December Cardinal Aginensis was informed by Jacopo Sansovino that Michelangelo was not working; this is reported in a letter of 18 December 1518 from Sellaio to Michelangelo: 'El chardinale . . . a mandato per me e dettomi, chome uno gran maestro l'è stato a vicitare e dettogli, chome voj non lavorate e mai finirete el suo lavoro, e che io gl' o dette le bugia' (The Cardinal . . . sent for me, and told me a great master (Sansovino) had been to visit him and told him you are not working and will never finish his work, and that I have told him lies). Michelangelo meanwhile had purchased a lot in the Via Mozza for the construction of a studio, and by 21 December 1518 had ordered 'una bella stanza, dov'io potrò rizare venti figure per volta' (a fine room, in which I shall be able to have twenty figures up at a time). In the same letter occurs the passage: 'Io muoio di dolore, e parmi essere diventato uno ciurmatore contro a mia voglia' (I am dying of grief, and feel I have become a swindler against my will). On 13 February 1519 Sellaio stated that Cardinal Aginensis had been informed by Jacopo Salviati 'voi questa state farete per ogni modo 4 fighure; che ne sta tutto alegro' (you will make at any rate 4 figures this summer; he is very glad about that). The four figures in question are identified by Justi and Kriegbaum with the unfinished Slaves now in the Accademia. On 31 May 1519 Pallavicini, representing Aginensis, informed the Cardinal that he had visited Michelangelo's studio and had seen 'figure bozzate e tutti marmi'. During the whole of this period Michelangelo had been engaged in work on the S. Lorenzo façade, the contract for which was cancelled on 10 March 1520. This phase in the history of the tomb terminates with the death of Cardinal Aginensis on 27 September 1520, and with the initiation, in November 1520, of plans for the Medici tombs.

Project of 1525–26

With the death of Leo X on 6 December 1521 there opens a new period in the story of the monument. Francesco Maria della Rovere, who had been deprived of the Duchy of Urbino by Leo X, was restored by his successor Adrian VI, who insisted that Michelangelo should complete his obligations. A letter of 1523 from Michelangelo to Giovanni Francesco Fattucci (Milanesi, pp. 421–2) reporting an interview with Cardinal Giulio de' Medici reads: 'Io vi andai subito, stimando volessi parlare delle sepulture; lui mi disse: "Noi vorremo pure che in queste sepulture fussi qualcosa di buono, cioè qualcosa di tuo mano" . . . Ora voi sapete come a Roma el Papa è stato avisato di questa sepultura di Iulio, e come gli è stato fatto un moto proprio per farlo segnare e procedermi contro e domandarmi quello che io ò avuto sopra detta opera, e

danni e interessi: e sapete come el Papa disse, che questo si facci, se Michelagniolo non vuole fare la sepultura. Adunque bisogna ch'io la facci, se non voglio capitar male, come vedete che è ordinato' (I went there at once, thinking he wanted to speak of the tombs. He said: 'We desire that there should be some good things in these tombs, that is to say something from your own hand.' As you know, the Pope in Rome has been told of this tomb of Julius, and a motu proprio has been made out for his signature, authorising proceedings against me, and demanding from me what I have had for this work, and damages and interest also. And you know the Pope said that this would be done if Michelangelo was unwilling to make the tomb. So I have to make it if I do not want to end up in trouble, as you see the order has been made out). Pope Adrian VI died in the autumn of 1523, and was succeeded by Pope Clement VII. In December 1523 the Della Rovere heirs insisted once more on the completion of the tomb, and on 22 December Fattucci requested Michelangelo for a detailed statement on the sums that had been paid to him and the work that had been done. Two self-justificatory letters were drafted by the sculptor in January 1524. According to these, a further 8000 ducats would be required to complete the tomb. At this point the second of Julius II's executors, Cardinal Santiquattro, became the protagonist in the negotiations, and the requirements of the executors were modified. Fattucci reported to Michelangelo on 22 March 1524 that 'Santiquatro vole intendere da voi, se vi piace, o che e'u'aspettino tanto che voi abbiate servito N.S., o che voi vi contentiate, che la facia il Sansovino o altri. Et conterannosi tutti vostri marmi et figure nove milia cinque cento ducati, con questo che e'vorebe, che voi facessi ancora di vostra mano la Nostra Donna che vi va' (Santiquattro wants to hear from you whether you want them to wait until you have finished work for His Lordship, or whether you will be willing for Sansovino and others to do it. They would value all your marbles and figures at 9500 ducats, on condition that you still make with your own hand the Madonna to go there). Michelangelo was apparently unresponsive to the generous terms proposed by Santiquattro, and on 4 September 1425 wrote to Fattucci that he preferred restitution to the heirs to completing the tomb. In the same letter, however, he mentioned the possibility of a further drastic reduction in the size of the monument: 'Del fare detta sepultura di Iulio al muro, come quelle di Pio mi piace, e è cosa più breve che in nessun altro modo' (As to making the tomb of Julius against the wall, like that of Pius, I am in favour; and it is quicker to carry out than in any other way). A reply of 14 October 1525 from Fattucci seems for the first time to envisage large scale studio participation: 'Solo basta che e' si dica, che voi vi atendiate et vegiatela qualche volta; et se non vorrete fare ne il papa (Iulio) ne la Nostra Donna, sara rimessa in voi' (It is enough for him to be told that you would watch over and supervise it sometimes; and if you do not want to do the effigy of the Pope or the Madonna, that is left to you). A year later, on 16 October 1526, a drawing of the reduced tomb was received by Fattucci. This was rejected by the executors, and in a letter of 1 November 1526 Michelangelo comments: 'questa è la mala disposizione che ànno e'parenti di Iulio verso di me: e non senza ragione' (this is the ill-will Julius' relatives feel

towards me; and not without reason). Further discussion was interrupted in 1527 by the Sack of Rome. Two drawings in the British Museum and the Casa Buonarroti are tentatively connected by Tolnay with this project; they show a wall tomb façade without returns, and are connected with the scheme subsequently adopted for Bandinelli's tombs of Leo X and Clement VII in S. Maria sopra Minerva.

Project of 1532

At this point there is a gap in the history of the monument until 1531, when, on 29 April, Sebastiano del Piombo in Rome reported to Michelangelo a conversation with the painter Genga, according to whom Francesco Maria della Rovere was reluctant to supply further funds for the tomb. The Pope, meanwhile, expressed a preference for a return to the 1516 project, and in June offered to mediate between Michelangelo, who was insistent upon restitution, and the Della Rovere. The latter rejected as dishonest a proposal of Michelangelo that he should sell the house in Rome made available to him by Cardinal Santiquattro and use the proceeds to complete a reduced version of the tomb. Clement VII, meanwhile, who was primarily interested in the Medici Chapel in Florence, was prepared to countenance an arrangement whereby the tomb figures were only nominally by Michelangelo. This is reported by Sebastiano del Piombo in the following terms: 'Compare mio, io trovo el Papa ogni di più dessideroso de farvi apiacere che mai, et vi vuole un grandissimo bene. . . . Et àmi dito che non accade a dir al Ducca nè ai soi agenti, che la vogliate far finire ad altri; che basta bene che fate desegni et modelli et che l'ordinate vui, che se contentarano troppo. Li havete facto troppo de man vostra, si possono contentare' (My dear friend, I find that the Pope is every day more than ever desirous of doing you favours, and he wishes you very well. . . . He said to me that there is no need to tell the Duke or his agents that you want to get other people to finish the tomb; and that it is quite enough for you to do the designs and models and to supervise it, and they will be more than content. You have already done too much with your own hand, and they can be content with that). By August Michelangelo was veering towards abandoning the blocks and paying 2000 ducats for the completion of the work by other sculptors. In November Francesco Maria della Rovere renounced the 1516 project, and demanded that a reduced tomb should be completed in three years, that the figures in Florence should be transferred to Rome, and that the house in Rome should be sold and the proceeds used for the completion of the tomb. The Pope insisted that the monument should be completed. Sebastiano del Piombo, in a letter of 21 November 1531, reports that he had visited the Pope, who had refused a proposal that sculptures from the tomb should be used for the Medici Chapel: 'de modo che con parolle et effeti mi fece toccar con mano che Sua Santità era tanto desideroso che facesti quest'opera, quanto la sua: solamente per satisfatione vostra. Et mi disse ancora: lo faremo renjovenire de 25 anni' (so that I came to recognise in what he said and did that His Holiness wishes you to do this work quite as much as his own, purely for your own satisfaction. He said to me: 'We will make him 25 years younger'). On the same day

the Pope issued a brief that Michelangelo was to work only on the two commissions. Michelangelo however on 1 December 1531, expressed his willingness to design but not to supervise the tomb. It was stressed by Sebastiano del Piombo that all the sculptures for the tomb need not be handed over to the Della Rovere, since 'loro non sanno quello c'è particularmente'. On 29 April 1532, at the instance of the Pope, a new contract was signed (Milanesi, pp. 702–6), of which the relevant passages read as follows: '. . . il detto maestro Michelangelo promesse fare et dare nuovo modello o ver disegno del detto sepolcro ad suo piacere, nella composizione del quale porrà et darà come dar promesse sei statue marmoree cominciate et non finite in Rome o vero in Firenze existenti, qui in Roma, di sua mano et opera finite: similmente ogni altra cosa appartenente a detto sepolcro. Et oltre alle predette cose, detto maestro Michelangelo per fabricare detto sepolcro promesso in fra tre anni proximi, a kalende d'agosto incominciarsi, pagare et sborsare per insino a la somma di duo milia ducati d'oro di Camera, compresa et computata ne' detti duo milia ducati la casa posta in Roma apresso al Macello de' Corbi, nella quale sono certe statue marmoree per il detto sepolcro, et tutto quel più che oltra a detti duo milia ducati, per construire et fare detto sepolcro fussi di necessità' (The said Michelangelo undertakes to make and provide a new model or design for the said tomb, as he wishes it. Into its composition he will put and provide, as he promised, six marble statues begun but not finished, which are at present in Rome or Florence, and will be finished here in Rome with his own hand and labour; and so will everything else belonging to the tomb. Further, the said Master Michelangelo has promised to build the said tomb within the next three years, starting from 1 August; and to pay and lay out up to 2000 gold Camera ducats. Included and counted in the said 2000 ducats is the house in Rome near the Macello de' Corbi – in which there are some marble statues for the tomb – and anything necessary for making and erecting the said tomb over and beyond the said 2000 ducats). Michelangelo was to work for approximately two months of the year, in Rome, and the figure sculpture was to comprise six statues by Michelangelo and five by other masters. The bronze reliefs were suppressed. It has been suggested alternatively that the six statues to be handed over were the Moses, the two Slaves in the Louvre, the Virgin, Prophet and Sibyl, or the Moses, the four Slaves now in the Accademia and the Victory (Tolnay). The unfinished seated statue of the Pope from the 1505 tomb may, however, also have been involved. After the signature of this contract Michelangelo divided his time between Rome (where he was from August 1532 to June 1533, and from October 1533 to May 1534) and Florence (where he was from June to October 1533, and from May to September 1534). On 25 September 1534 Pope Clement VII died. Early in 1532 the decision was taken to erect the monument not in St. Peter's but in San Pietro in Vincoli. This is referred to in a letter of 30 April 1532 from Giovanni Maria della Porta to the Duke of Urbino (Gotti, ii, pp. 78–9): 'Non si potendo mettere in San Pietro, come non si può, ad ognuno parebe convenientissimo, che si metesse in San Pietro in Vincula come loco proprio della casa, che fu il titolo di Xisto ancora, e la chiesa fabricata da Giulio, che vi condusse gli frati che vi

stano: pur ho detto di scriverne a Vostra Signoria per saperne la volontade sua. Al Popolo sarebbe stata bene, come in loco più frequentato, ma non v'è loco capace nè lumi al proposito, secondo Michelangelo' (As it could not be put in St. Peter's, it seemed to everyone most suitable to put it in S. Pietro in Vincoli, for it is the family's own building, Sixtus (IV) having been a member of it too, and the Church was built by Julius, who also brought there the friars who are there now. I have therefore had a letter sent to Your Lordship about it, so that we may know your will. It would have gone well in the Popolo, as more people go there, but according to Michelangelo there is no site there to take it, and no suitable lighting). Work in connection with the erection of the monument in S. Pietro in Vincoli began in the summer of 1533.

Project of 1542

On the death of Pope Clement VII a new figure impinges on the history of the tomb in the person of Pope Paul III, who on 1 September 1535 appointed Michelangelo supreme architect, sculptor and painter at the papal court ('Itaque te supremum architectum, sculptorem, et pictorem eiusdem Palatii nostri Apostolici auctoritate apostolica deputamus'). For the new Pope the tomb was no more than an obstacle to the execution of commissions of which the first, planned by Clement VII, was the fresco of the Last Judgement in the Sistine Chapel (cartoon completed before September 1535; execution begun April/May 1536; completed October 1541). According to Condivi, Michelangelo in the early part of this period continued to work secretly on the monument ('Michelagnolo . . . fingendo d'occuparsi, come faceva in parte, nel cartone, secretamente lavorava quelle statue che dovevano andare alla sepoltura'). At this time he contemplated retiring to a Badia of the Bishop of Aleria, near Carrara, or to Urbino. Condivi describes a visit paid by the Pope to the sculptor's studio: 'Dove il reverendissimo Cardinale di Mantova, ch'era presente, vedendo quel Moisè, di che già s'è scritto e qui sotto più copiosamente si scriverà, disse: "Questa sola statua è bastante a far onore alla sepoltura di papa Giulio." Papa Paolo, avendo visto ogni cosa, di nuovo l'affrontò che andasse a star seco, presenti molti cardinali e'l già detto reverendissimo ed illustrissimo di Mantova. E trovando Michelagnolo star duro: "Io farò, disse, che'l duca di Urbino si contenterà di tre statue di tua mano, e che le altre tre, che restano, si dieno a fare ad altri." In questo modo procurò con gli agenti del duca che nascesse nuovo contratto, confermato dall'eccellenza del duca, il qual non volle in ciò dispiacere al papa. Così Michelagnolo, ancorchè potesse fuggire di pagare le tre statue, disobbligato per vigore di tal contratto, nondimeno volle far la spesa egli, e depose per queste e per il restante della sepoltura ducati mille cinquecento ottanta. Così gli agenti di Sua Eccellenza le dettero a fare, e la tragedia della sepoltura e la sepoltura ebber fine' (The very reverend Cardinal of Mantua, who was present, seeing the Moses which I have already mentioned and will describe more fully later, said: 'This statue alone is enough to do honour to the tomb of Pope Julius'. Pope Paul, when he had seen everything, again asked him if he would enter his service; and, apart from the aforesaid most reverend and illustrious Cardinal of Mantua,

there were many other cardinals present. When he found that Michelangelo stood firm, he said: 'I will see that the Duke of Urbino is content with three statues from your hand, and that the other three remaining are given to others to make.' In this way he arranged with the Duke's agents that a new contract should be made, and confirmed by His Excellency the Duke, who did not wish to displease the Pope in this matter. So Michelangelo, although he could have avoided paying for the three statues, having been released from the obligation by the contract, wished to pay for it himself; and he deposited for these and for the rest of the tomb 1580 ducats. In this way the agents of His Excellency commissioned them, and both the tomb and the tragedy of the tomb had an end). The facts behind this telescoped narrative are that on 17 November 1536 the Pope issued a motu proprio freeing Michelangelo from his obligations to the Della Rovere heirs. Francesco Maria della Rovere died in October 1538, and on 7 September 1539 his successor as Duke of Urbino, Guidobaldo, wrote to Michelangelo (Gotti, i, pp. 263–4) agreeing to the completion of the Last Judgement 'con ferma opinione et speranza però, che, espeditovene, abbiate poi a voltarve tutto al finimento di detta sepoltura, radoppiandovi la vostra diligenza et sollecitudine, per ricompensare ogni perdita di tempo' (with the firm understanding and hope that, when it is finished, you will then turn altogether to the completion of the tomb, redoubling your efforts and diligence to make up lost time). In 1541, on the completion of the Last Judgement, Michelangelo was forthwith diverted by the Pope on to work in the Cappella Paolina. On 23 November 1541 Cardinal Ascanio Parisani wrote to the Duke of Urbino (Gaye, ii, pp. 290–1), 'mostrando che avendo (Michelangelo) a dipignere la cappella, non si potrà per lui lavorare la sepoltura, per esser vechio e risoluto, finita detta cappella (se tanto vivrà), non poter più lavorare, e vi correrà tre o quattro anni, e bisognerà che per altra via vi si provveda' (explaining that, as Michelangelo had to paint the Chapel, he would not be able to work the tomb for him, as he was old and had decided that, when the Chapel was finished (if he lived so long), he would not be able to work any more; it would take three or four years, and other arrangements would have to be made). It is proposed in this letter that the tomb should be completed in accordance with the last design and contract, but with the following proviso: 'Io non ci cognosco altra differenza che questa, che le sei statue, quali si doveano fare di mano del predetto Michelagnolo, si faranno per mano di un altro maestro con il modello e disegno suo, benchè si farà diligenza per veder se di queste sei statue se ne potra avere qualcuna o fatta o abozzata di sua mano. Di che ne fo dubbio, perchè Nostro Signore pare che se ne voglia valere a ornamento pubblico di detta cappella, asserendo che per lo nuovo disegno de la sepoltura non potriano servir quelle. Io vedo che se ora non si piglia questa risoluzione per la sepoltura di Papa Giulio nel modo detto, non la vedremo più fornita a li dì nostri' (The only difference I see is this: that the six statues which were to be made by Michelangelo will now be made by some other master after his models and designs, though care will be taken to discover if among these six statues it is possible to have something made or blocked out by his hand. I doubt if this will be possible, as His

Holiness seems to want to use them for public decoration of the Chapel, and says they cannot be used for the new design of the tomb. I can see that, if we do not take this decision over the tomb of Pope Julius, we will not see it completed in our time). The Duke refused to accept this proposal, and on 6 April 1542 wrote to Michelangelo (Gaye, ii, pp. 289–90) urging that the tomb should contain three autograph statues: 'Son contentissimo facendo voi porre le tre statue intieramente condotte e finite di man' vostra, comprendendovi in questo numero quella del Moyse, nela sepoltura della santa memoria di Papa Giulio mio zio . . . laltre tre statue in quel mezo potiate far lavorare per mano d'altro buono e lodato Maestro, con il disegno però et assistentia della persona vostra' (I am content if you put three statues worked and finished entirely by your hand, including the Moses, in the tomb in memory of Pope Julius, my uncle . . . you could then have the other three statues worked by the hand of some other good and reputable master, after your designs and with your personal assistance). On 20 July 1542 a petition based on this agreement was submitted to Michelangelo to the Pope (Milanesi, pp. 485–7): 'Onde per dare esecuzione a detto accordo, il prefato messer Michelagnolo allogò a fornire le dette tre statue, quali erano molto innanzi, cioè una Nostra Donna con il Putto in braccio, ritta, et uno Profeta et una Sibilla a sedere, a Raffaello da Montelupo, fiorentino, aprovato fra e'migliori maestri di questi tempi, per scudi quattrocento. . . et il resto del quadro et ornamento della sepoltura, eccetto l'ultimo frontispitio, alsì allogò a maestro Giovanni de' Marchesi et a Francesco da Urbino, scarpellini et intagliatori di pietre, per scudi settecento. . . . Restavagli a fornire le tre statue di sua mano, cioè un Moises et dua prigioni: le quali tre statue sono quasi fornite. Ma perche li detta dua prigioni furno fatti quando l'opera si era disegnata che fussi molto maggiore, dove andavano assai più statue; la quale poi nel sopradetto contratto fu risecata et ristretta: per il che non convengono in questo disegno, nè a modo alcuno ci possono stare bene; però detto messer Michelagnolo per non mancare a l'onore suo, dètte cominciamento a dua altre statue che vanno dalle bande del Moises, la Vita contemplativa et la attiva, le quali sono assai bene avanti, di sorta che con facilità si possono da altri maestri fornire' (Therefore, in order to carry out this agreement, Michelangelo allotted the making of three statues which were well forward – a standing figure of Our Lady with the Child in her arms, and seated figures of a Prophet and a Sibyl – to Raffaello da Montelupo, a Florentine, considered one of the best masters of the time, for 400 scudi . . . and the rest of the masonry and decoration of the tomb, apart from the topmost pediment, were allotted to Master Giovanni de' Marchesi and Francesco da Urbino, stone-cutters and carvers, for 700 scudi. . . . There remained the three figures he was to make with his own hand, that is, a Moses and two Captives; these three figures are almost finished. But as the two Captives were made when it was intended to erect the tomb on a much larger scale and with many more statues; and as this design has been cut down and reduced in the aforesaid contract: for these reasons, these statues are not suitable for this new design, and could in no way go well in it. Michelangelo, so as not to fall short of his obligations, has begun two more statues to go on

each side of the Moses – the Contemplative Life and the Active Life; and these are so well forward, that they could easily be finished by other masters). Michelangelo at the conclusion of this petition asks permission to entrust the completion of the two remaining statues to Raffaello da Montelupo and stipulates that a sum of 1100–1200 scudi will be required for the completion of the tomb (200 scudi to Raffaello da Montelupo for the completion of the Vita Attiva and Contemplativa, 300 scudi to the same sculptor for the three upper figures, 500 scudi for the quadro and ornament, and 100 scudi for the frontespizio). During the summer a final contract was drawn up on the basis of these proposals. There is evidence, however, that practical steps towards the implementation of these proposals had been taken at an earlier date. On 27 February 1542 an agreement was signed between Michelangelo and Raffaello da Montelupo, whereby the latter agreed to finish 'tre figure di marmo maggiore che'l naturale, bozzate di mia mano'. This contract envisages the autograph completion of the Active and Contemplative Life ('per la presente sono contento, non ostante tal convenzione, che detto messer Michelangelo possa fornire da sè dette dua statue'). On 16 May 1542 a further contract was signed with Giovanni de' Marchesi (who was later relieved) and Francesco da Urbino. In August 1542 a parallel contract was drawn up between the representative of the Duke of Urbino and Raffaello da Montelupo providing for 'cinque statue di marmo che vanno in detta sepoltura et che erano prima sbozzate e quasi finite dal prefato messer Michelangelo Bonarruoti; le quali sonno, videlicet, una Nostra Donna con il Putto in braccio, una Sibilla, un Propheta, una Vita activa et una Vita contemplativa . . . le quali statue esso maestro Raphaello ha da dar finite del tutto nella stanza dove sono in casa del prefato messer Michelangelo Bonarruoti, nel modo et secondo che giornalmente li ordinarà et commetterà il detto Michelangelo, a cui obedienza ha da stare'(five marble statues to go in the said tomb, which were earlier blocked out and almost finished by the aforesaid Michelangelo Buonarroti. These are: a Madonna with the Child on her arm, a Sibyl, a Prophet, an Active Life and a Contemplative Life. . . . Master Raffaello is to complete these statues entirely in the room where they stand in the house of the aforesaid Master Michelangelo Buonarroti, in the manner that and according as the said Michelangelo instructs and orders day by day; and he must obey him). On 5 October 1542, the terms on the pilasters were subcontracted by Raffaello da Montelupo to 'Jacomo mio garzone' (probably Jacopo del Duca). Michelangelo, in a letter of October 1542 to Luigi del Riccio (Milanesi, p. 488) complains that at that time the contract had not been ratified by the Duke. The latter seems to have refused to ratify the contract, and as a result, in October 1542, Michelangelo determined to complete the Active and Contemplative Life personally ('Io mi son resoluto, poiché ò visto che la retificagione non viene, di starmi in casa a finire le tre figure come son d'acordo col Duca . . . e chi si vuol crucciar, si crucci') (I have decided, as the ratification has not come, to stay at home and finish the three figures, as I have agreed with the Duke . . . if anyone grumbles, let them). Raffaello da Montelupo's statues were installed on the monument on 25 January 1545, and

Michelangelo's in February of the same year ('Io credo giovedì dare ordine da tirar le figure a San Piero in Vincula').

The following sculptures were made in connection with the monument:

A) MOSES (Plate 15, Fig. 30). San Pietro in Vincoli, Rome. H. 235 cm.

A figure of Moses opposed to a figure of St. Paul seems to have been projected from the first phase of the monument. The pose of the figure as executed is, however, radically different from that shown on the two drawings in Berlin. The figure was consistently intended for the central register of the tomb, and the decision to place it in 1542 on eye level in the lowest register is a violation of its essential character. Though it has been suggested (Thode, Brinckmann) that the figure was carved for the first version of the monument, perhaps as early as 1506, the balance of probability is that it was begun in connection with the project of 1513, and its style would be inexplicable at any earlier time. The figure appears to have been left unfinished in 1516, and is one of the three figures alluded to in a letter of October 1542 from Michelangelo to Luigi del Riccio. Prior to 1816, when it was cast, the figure was set more deeply in its niche than it is now. Condivi describes it in the following terms: 'Tra le quali maravigliosa è quella di Moisè, duce e capitano degli Ebrei, il quale se ne sta a sedere in atto di pensoso e savio, tenendo sotto il braccio destro le tavole della Legge e con la sinistra mano sostenendosi il mento, come persona stanca e piena di cure. . . . È la faccia piena di vivacità e di spirito, e accomodata ad indurre amore insieme e terrore, qual forse fu il vero' (Among these is the marvellous statue of Moses, leader and captain of the Jews. He is seated in the attitude of one wise and thoughtful, holding under his right arm the Tables of the Law, and supporting his chin with his left hand, like a man tired and full of cares. . . . His face is full of vitality and spirit, apt to arouse both love and terror; and this was perhaps the truth). The position of the right arm is discussed, with inconclusive results, by H. W. Janson ('The Right Arm of Michelangelo's Moses,' in *Festschrift Ulrich Middeldorf*, Berlin, 1968, pp. 241–7). It has been pointed out (Panofsky) that the grouping of Moses with St. Paul is of Neoplatonic origin, and is explained by a passage in Pico della Mirandola: 'Con questo viso vidde Moyse, vidde Paolo, viddono molti altri eletti la faccia di Dio, et questo e quello che nostri Theologi chiamano la cognitione intelletuale, cognitione intuitiva' (With such a vision did Moses, Paul, and many others of the elect see the face of God; it is what our theologians call intellectual or intuitive cognition). The four figures projected for the platform of the monument of 1505, therefore, represented 'the powers which assure immortality by acting as intermediaries between the terrestrial and the translunary world'.

(B) DYING SLAVE (Plate 16B). Louvre, Paris. H. 229 cm.

C) REBELLIOUS SLAVE (Plate 16A). Louvre, Paris H. 215 cm.

Both figures appear to have been begun in 1513, (B) being designed for a position in front of the pilaster to the left of the centre of the front face of the tomb, and (C) for one of the two angle pilasters of the front, either on the left (Tolnay) or the right (Wilde). A sketch for a pendant to (B) to be set against the right centre pilaster is in the Louvre (Tolnay). It was subsequently proposed (1532) that the two figures should occupy the niches on the front of the monument, but this was abandoned in 1542 on grounds of size. About 1546, after the completion of the tomb, the two Slaves were given by Michelangelo to Ruberto Strozzi, by whom they were presented to Francis I of France. Later they passed to the Connetable Anne de Montmorency, and thence to Richelieu. In the middle of the seventeenth century they decorated the portal of the Château de Richelieu, but were moved to Paris before 1749, and in 1794 were purchased for the French state. According to Condivi, the two figures represented liberal arts. This explanation is dismissed as 'lächerlich' by Ollendorf ('Michelangelos Gefangene im Louvre', in *Zeitschrift für Bildende Kunst*, n.f. ix, 1898, pp. 273–81), who regards the figures as symbols of the Platonic concept of 'die menschliche Seele auf der Erde wie in Gefangenschaft'. Panofsky regards the figures as personifications of 'the human soul as enslaved by matter, and therefore comparable to the souls of dumb animals'. Condivi's interpretation is also rejected by Tolnay on the ground that it is opposed (i) to the traditional personification of the Liberal Arts, and (ii) to the traditional use of the slave in Christian art as a symbol of the pagan world. The Slaves are regarded by Vasari as prisoners, and are interpreted by Justi as occupied provinces, in allusion to the war projects of Julius II. Vasari's explanation was also adopted in 1577 by Paolo Mini (*Difesa della Città di Firenze e dei Fiorentini*, Lyon, 1577, p. 212): 'e di due prigioni che il s. Ruberto Strozzi presentò al Re Francesco.' An interpretation on these lines is untenable, since the 1505 project for the tomb incorporated similar figures at a time when Julius II's military adventures had not been begun. Condivi's explanation is accepted by Thode, Kriegbaum and Janson. Thode (*K.U.*, pp. 183–4) observes that the two figures are 'nicht heidnische, sondern mittelalterliche Vorstellungen . . . die hier eine freilich ganz neue, von antiken Eindrücken bestimmte Ausdrucksform gewonnen haben.' (B) is accompanied by an ape, and is accepted by Kriegbaum and Janson as a personification of Painting. As noted by Panofsky, an ape also appears in (C); this does not, however, invalidate the interpretation of the ape as 'ars simia naturae', but precludes the explanation of (C) as Architecture (Kriegbaum) rather than Sculpture (Janson). The block on which the foot of (C) rests is identified by Kriegbaum as an unfinished capital. The meaning of the gestures of the two figures remains in doubt. According to Condivi, the Liberal Arts were to be shown bound in order to signify that they, like the Pope, were the prisoners of death. For this reason (B) was regarded by Grimm as a representation of 'der Augenblick des Sterbens'. The figures are, however, loosely fettered, and it is possible that the sculptor's intention was to show the Liberal Arts freed by the Pope. In this case (B) would represent awakening rather than death or sleep. Formally (B) has been related (Justi) to the prisoners on a drawing by Giuliano da San Gallo of a lateral view of the triumphal arch at Orange, and (C) (Tolnay) to figures on a Gigantomachia sarcophagus in the Vatican.

(D) VICTORY (Plate 21). Palazzo Vecchio, Florence. H. 261 cm.

In the initial projects for the tomb, the niches in the lowest register appear to have been filled with female Victory figures, the designs for which seem to be reflected in the Victory figure carved by Ammanati for the Nari monument (see Plate 73 below). At a later date (see below) this plan was changed, and provision was made for two male Victory groups, of which the present group was alone executed. It is assumed by Kriegbaum that the group was begun about 1506, and that the lower figure was worked on again in the second decade of the sixteenth century. On grounds of style and for other reasons this early dating is impossible. The figure has also been assigned to ca. 1519 (Thode), ca. 1524 (Bürger), 1527 (Popp, in *Burlington Magazine*, lxix, 1936, p. 207), after 1530 (Wilde), and ca. 1532–4 (Tolnay). The only valid basis of dating is supplied by the sculptures in the Medici Chapel, and the balance of probability is that the work was executed ca. 1521–3. The fact that oak leaves, an emblem of the Della Rovere, appear in the hair of the standing figure, suggests that the group should be interpreted as a political allegory (Justi), rather than as a 'spiritual self-portrait' (Tolnay) or 'eine Allegorie des Eros' (Brinckmann). There is no reason for supposing that the group refers to the relationship between Michelangelo and Tommaso Cavalieri. The group was carved in Florence and remained in the studio in Via Mozza. It was presented to the Grand-Duke Cosimo I by Lionardo Buonarroti, and was installed in the Regio Salone (Salone dei Cinquecento) by Vasari. Its site is established by Bocchi-Cinelli (1677): 'La statua, che è nel mezzo di questa sala, posta allato alla porta, onde si via poscia alla Segreteria, è una Vittoria, marmo del divin Buonarroti' (The statue in the middle of this room, beside the door to the Segreteria, is a figure of Victory, a marble of the divine Buonarroti). It was moved in 1868 to the Bargello, and in 1920 was installed on its present plinth at the end of the Salone dei Cinquecento. In the 1532 project for the tomb the Victory was to have been accompanied by a second Victory group. Two main theories regarding this have been advanced: (i) that the scheme of the projected figure is recorded in Vincenzo Danti's Honour triumphant over Falsehood (Tolnay), and (ii) that a fragmentary model in the Casa Buonarroti, generally regarded as a bozzetto for the Hercules and Cacus group for the Piazza della Signoria, is a study for the companion figure (Wilde, Laux). A number of cogent arguments have been advanced in favour of this second contention, but the general character of the scheme would be more readily consistent with a free-standing than with a niche group, and the first theory is the more plausible.

(E) YOUNG SLAVE (Plate 17A). Accademia, Florence. H. 256 cm.

(F) BEARDED SLAVE (Plate 18). Accademia, Florence. H. 263 cm.

(G) ATLAS SLAVE (Plate 17B). Accademia, Florence. H. 277 cm.

(H) AWAKENING SLAVE (Plate 19). Accademia, Florence. H. 267 cm.

There is no general agreement as to the date of the four unfinished Slaves in the Accademia in Florence. It has been assumed that the Slaves are the four figures referred to in Sellajo's letter of 13 February 1519 ('voi questa state farete per ogni modo 4 fighure') (Justi, Thode, Kriegbaum, Laux). They have also been dated ca. 1525 (Wilde), and ca. 1530–34 (Tolnay). The year 1534 is the latest admissible date, since the figures were carved in Florence and remained in the Via Mozza studio with the Victory. A sheet of studies for figures of Slaves for the tomb in the Ashmolean Museum, Oxford, is dated by Dussler (No. 194) ca. 1516. The unfinished condition of the figures make them extremely difficult to date with any confidence, but the balance of evidence is in favour of a dating ca. 1519. Michelangelo's authorship of the four unfinished figures is accepted by all students save Hildebrandt (*Gesammelte Aufsätze*, Strassburg, 1916, 3rd ed., pp. 119 ff.) and Kriegbaum (pp. 36–7), according to whom the figures were substantially blocked out by studio assistants and subsequently in part reworked by Michelangelo. Kriegbaum denies Michelangelo's intervention in (G) and (H) and limits his intervention in (E) and (F). This view is greatly exaggerated, but the less finished areas are none the less looser and more rudimentary than, e.g., those of the St. Matthew, for the carving of which Michelangelo was personally responsible. The weakest of the figures are (F) and (H); the most clearly autograph area is the torso of (G). In March 1544 an attempt was made by Cosimo I to purchase the studio in the Via Mozza with the Slaves, and after Michelangelo's death these were presented to him by Lionardo Buonarroti. On 22 May 1564 Cosimo I was advised to accept this gift. No action regarding their display was taken until a considerably later date, when Buontalenti was instructed by Francesco I to incorporate them in the Grotto of the Boboli Gardens. They are shown in the grotto in old photographs, and are described there by Soldini (*Il reale giardino di Boboli*, Florence, 1798, p. 32) in the following terms: 'Negli angoli di questa Grotta sonovi piantate quattro grandi statue di marmo, abbozzate di mano del famoso Michel'Angiolo Buonarroti; le quali vi stanno in atto di sostenere gran quantità di spugne petrificate, accordando si bene la rozzezza di quei naturali scherzi col ruvido di quegli abbozzi, che il tutto pare che sia stato operato dalla natura medesima' (In the corners of this grotto stand four great marble statues, sketched out with the hand of the famous Michelangelo Buonarroti; they stand there supporting a great mass of petrified sponge, and the coarseness of these sports of Nature goes so well with the roughness of the blocked out figures, that the whole seems made by Nature herself). The figures were moved in 1908 to the Accademia. It is inferred by Tolnay that (G) was intended for the left angle of the front as a pendant to (C). For the relevance of the four figures to (B) and (C) see text pp. 33–4. A subsequent attempt of Tolnay ('Contributi Michelangioleschi,' in *Commentari*, xvi, 1965, pp. 85–97) to identify a fifth slave in a late sixteenth or early seventeenth century unfinished sculpture formerly in the Piazzale di Bacco of the Palazzo Pitti and now in the Casa Buonarroti, results from a misreading of the source material, and is incorrect.

(I) RACHEL (Plate 35). San Pietro in Vincoli, Rome. H. 197 cm.

(J) LEAH (Plate 34). San Pietro in Vincoli, Rome. H. 209 cm.

The first of the two figures is described by Condivi in the following terms: 'Una donna di statura più che'l naturale, ma di bellezza rara, con un ginocchio piegato, non in terra, ma sopra d'uno zoccolo, col volto e con ambe le mani levate al cielo, sì che pare che in ogni sua parte spiri amore' (A woman in stature larger than nature, but of rare beauty, with one knee bent, not on the ground, but on a plinth; her face and both her hands are raised to heaven, so that she seems to breathe forth love from every part). Condivi describes the second figure as: 'Dall'altro canto, cioè dalla sinistra del Moisè, è la Vita Attiva, con uno specchio nella destra mano, nel quale attentamente si contempla, significando per questo le nostre azioni dover esser fatte consideratamente, e nella sinistra con una ghirlanda di fiori. Nel che Michelagnolo ha seguitato Dante, del qual'è sempre stato studioso, che nel suo Purgatorio finge aver trovata la contessa Matilda, qual'egli piglia per la Vita Attiva, in un prato di fiori' (On the other side, on the left of the Moses, is the Active Life, with a mirror in her right hand in which she is attentively looking at herself, meaning that our actions should be done with consideration; and she holds a garland of flowers in her left. In this, Michelangelo has followed Dante, whom he had always studied; for in his Purgatory he pretends to have found the Countess Matilda, whom he takes for the Active Life, in a field of flowers). Condivi's description of the objects in the hands of the second figure is incorrect; that in the right hand is not a mirror but a diadem (Thode, Tolnay, Kriegbaum) and that in the left hand is a laurel wreath. Vasari, in the edition of 1568, describes the two figures as Rachel and Leah: 'Que' quattro termini mettevano in mezzo tre nicchie, due delle quali erano tonde dalle bande, e vi dovevano andare le Vittorie; in cambio delle quali, in una messe Lia figliuola di Laban, per la vita attiva, con uno specchio in mano per la considerazione si deve avere per le azioni nostre; e nell'altra, una grillanda di fiori, per le virtù che ornano la vita nostra in vita, e dopo la morte la fanno gloriosa. L'altra fu Rachel sua sorella, per la vita contemplativa, con le mani giunte, con un ginocchio piegato, e col volto par che stia elevata in ispirito. Le quali statue condusse di sua mano Michelagnolo in meno di un anno' (These four terms framed three niches, of which the two at the sides were round, and were to hold the Victories. Instead of these, he placed in one of the niches Leah, the daughter of Laban, representing the Active Life; in one hand she holds a mirror to signify the consideration we should give our actions, in the other a garland of flowers to represent the virtues which adorn our life while it lasts and glorify it after death. The other figure was her sister Rachel, representing the Contemplative Life, with her hands clasped, her knee bent, and her expression one of ecstasy). It is suggested by Wilde that the Active Life (Leah) 'might well have been conceived in 1532–3, possibly as one of those new statues for the monument for which the artist at that time wanted to prepare full-size clay models'. The execution of the second figure seems to date from a considerably later time, and is associable with the contract of 1542. Both statues are regarded by Venturi as in large part by Raffaello da Montelupo. It has also been postulated (Tolnay) that the hair

of the Active Life was finished by this sculptor. The Contemplative Life (Rachel) is certainly autograph (Kriegbaum, Tolnay), and the two statues are regarded by Justi as 'seine letzten ganz von ihm selbst vollendeten Marmorwerke'.

(K) VIRGIN AND CHILD. San Pietro in Vincoli, Rome.

The figure of the Virgin and Child above and behind the sarcophagus appears to have been conceived by Michelangelo in connection with the project of 1532, was continued by Sandro di Giovanni Fancelli (1537), and was completed by or under the direction of Raffaello da Montelupo.

(L) PROPHET. San Pietro in Vincoli, Rome. H 204 cm.

The figure of an unnamed Prophet on the right of the upper register of the completed monument was planned and perhaps blocked out by Michelangelo ca. 1532–5 (Justi, Tolnay), and was finished by or under the direction of Raffaello da Montelupo.

(M) SIBYL. San Pietro in Vincoli, Rome. H. 210 cm.

The same procedure seems to have been followed as with the Prophet (L). It has been rightly noted (Justi) that of the four upper figures, it is in this that Michelangelo's presence is most clearly felt.

(N) EFFIGY. San Pietro in Vincoli, Rome. L. 174 cm.

Executed by Tommaso di Pietro Boscoli.

Plate 22: APOLLO
Museo Nazionale, Florence

The statue is mentioned by Vasari in the 1550 edition of the Vite: 'Cominciò ancora una figuretta di marmo per Baccio Valori, d'uno Apollo, che cavava una freccia del turcasso, acciò col favor suo, fosse mezano in fargli fare la pace col Papa, et con la Casa de' Medici, la quale era da lui stata molto ingiuriata' (He began a small marble figure of Apollo taking an arrow from his quiver for Baccio Valori, so that this latter would use his credit as a mediator in making his peace with the Pope and the Medici family, who had been much wronged by him). The figure is alluded to by Condivi, and is described once more in the 1568 edition of the Vite: 'Dove assicurato, Michelagnolo cominciò, per farsi amico Baccio Valori, una figura di tre braccia di marmo, che era uno Apollo che si cavava del turcasso una freccia, e lo condusse presso al fine; il quale è oggi nella camera del principe di Fiorenza; cosa rarissima, ancora che non sia finita del tutto' (Thus established, Michelangelo, in order to make a friend of Baccio Valori, began a marble figure, three braccia high, of Apollo taking an arrow from his quiver, and he brought it almost to completion. It is to-day in the apartment of the Prince of Florence, a precious thing, even if not quite finished). An inventory of 1553 (for which see C. Conti, La prima reggia di Cosimo I de' Medici, Florence, 1893, p. 35) lists the figure in the fourth chamber of the Duke's quarters in the Palazzo Vecchio along with the Bacchus of Bandinelli and the Bacchus of Sansovino: 'uno David del Buonarroto imperfeto'. It was subsequently placed in a niche

of the amphitheatre of the Boboli Gardens, and was later moved first to the Uffizi and then to the Bargello. An undated letter from Baccio Valori to Michelangelo (Frey, pp. 323–4), which can be assigned with some confidence to April 1532, refers to the statue: 'Inoltre io non voglio sollecitarvi della mia fighura, perche mi rendo certissimo, per l'affetione conosco mi portate, non ha bisogno di sollecitudine. Vi ricordo bene, che a satis-fatione dell'animo mio non ho cosa che io desideri piu che questa. Et bisognandovi danari o altra cosa che voi pensiate che per me si possa, advisate, che non vi manchero in conto alcuno' (Besides, I do not want to bother you for my figure, because I am sure there is no need, on account of the affection I know you bear me. I assure you that there is nothing I desire more than this for the satisfaction of my mind. And if you need money, or anything else you think I could manage, let me know, so that you lack nothing). There has been extensive discussion both of the date and subject of the figure. On the strength of the inventory reference the figure is accepted as a David by Knapp, Mackowsky, Thode and Popp (the latter with the untenable suggestion that it was made in 1525–6 for the Medici Chapel). The protuberance at the back of the base is interpreted by these students as the head of Goliath. It is accepted as an Apollo by Kriegbaum (with the suggestion that the pro-tuberance represents the sun), and is regarded by Tolnay as David which was transformed into an Apollo at the request of Valori. A drawing after the figure in the Scholz collection ascribed to Rosso is consistent only with the view that it was an Apollo. It may be noted that a number of other works in the 1553 inventory of the Palazzo Vecchio are inaccurately described. Tolnay follows Popp in assigning the figure on stylistic grounds to 1525–6. There is, however, no compelling reason to doubt the twice repeated statement of Vasari that it was begun for Baccio Valori in the middle of 1530, and was from the first designed as an Apollo.

Plate 23: CHRIST
S. Maria sopra Minerva, Rome

The statue is mentioned in 1550 in the first edition of Vasari's *Vite*: 'Mandò in questo tempo Pietro Urbano Pistolese suo creato a Roma, a mettere in opra un Christo ignudo, che tiene la croce, il quale è una figura miracolosissima, che fu posto nella Minerva allato alla cappella maggiore per M. Antonio Metelli' (He sent his assistant, Pietro Urbano of Pistoia, to Rome at this time, to work up a nude Christ holding the Cross; it is a miraculous figure, and was put by Metello Vari in the Minerva, by the high altar). In the second edition of the *Vite* (1568) the word 'mirabilissima' is substituted for 'miracolosissima'. The contract for the statue (Milanesi, pp. 641–2) was signed on 14 June 1514. The relevant passages read as follows: 'Sia noto e manifesto a chi legerà la presente scritta, come messere Bern-ardo Cencio canonico di San Piero e maestro Mario Scappucci e Metello Vari ànno dato a fare a Michelagniolo di Lodovico Simoni scultore una figura di marmo d'un Cristo grande quanto el naturale, ignudo, ritto, con una croce in braccio, in quell'attitudine che parrà al detto Michelagniolo, per prezo di

ducati dugento d'oro di Camera. . . . La quale figura el detto Michelagniolo promette farla in termine di 4 anni prossimi da venire' (Let it be known and manifest to the reader of this document that Master Bernardo Cencio, canon of St. Peter's, Master Mario Scapucci and Metello Vari have commissioned from Michelangelo di Lodovico Simoni, sculptor, a marble figure of Christ, life-size, nude, standing, holding a cross, and in whatever attitude the said Michelangelo thinks best, for a price of 200 gold Camera ducats. . . . The said Michelangelo undertakes to make this figure within the next four years). The first version of the statue was begun by Michelangelo in Rome, but was abandoned in 1516 when he returned to Flor-ence, 'essendogli riuscito nel viso un pelo nero ovvero linea' (a black line or flaw having appeared on the face). On 26 Sept-ember 1517 Michelangelo demanded a sum of 150 scudi in connection with the statue, and on 3 October 1517 this was despatched. A letter of 13 December 1517 from Vari to Michel-angelo in Florence enquires after the progress of the statue: 'Questa è per advisarve, como io ve feci intendere per via de Siena gia molti di sonno, che, attento la inportantia delle cose mee sopra al facto della cappella della Minerva, volessete expedire, che gia ne era tempo et piu che tempo; del che non ho hauto resposta alcuna. Ultimamente havete mandato per denari; uelli ho facto dare per non mancare al debito mio e sempre son stati a uostra petitione dal primo die e nientedimeno delle cose mee io non intendo cosa alcuna. Me saria parso, fussi honesto, gia tre anni et sette mesi me fecessino intendere almanco per un verso, se volete aspecti piu per un Cristo nudo. El che non havendo voi scripto, stimai fossi, perche essendo facta l'opera, non bisognassi altre lettere. Pertanto ho expectato dicta opera die per die, et non venendo, per lo interesse grande che me inporta supra la heredita, com voi sapete, ve ho rescripto la presente' (This is to inform you, as I let you know through Siena many days ago, that you should make haste, in view of the importance of my commission in the chapel in the Minerva; for there has been time, more than enough time, for it. And I have had no reply at all. Recently you sent for money; I had it paid to you, in order to fulfil my obligations, and I have always, even from the first day, been open to your requests. And yet, in spite of this, I know nothing at all about the state of my commission. I would have thought that, after three years and seven months, it would have been no more than proper for you to let me know, even though just in a line, if you want me to wait longer for the nude Christ. When you did not write, I assumed it was because the work had been finished and letters were thus not needed. I have been expecting the work each day, and as it has not come I have written you this letter, on account of the great importance to me of the inheritance, which you know). Other protests were sent by Vari on 26 July and 24 Nov-ember 1518; in the latter he asked that the statue should be completed by Easter. On 21 December 1518 Michelangelo admitted to Leonardo Sellajo (Milanesi, p. 398) that the marble for the statue had not yet arrived in Florence, and that work on it had therefore not been begun: 'Io sono ancora sollecitato da messer Metello Vari della sua figura, che è anche là in Pisa e verrà in queste prime scafe. Io non gli ò mai risposto, nè anche voglio più scrivere a voi, finchè io non ò cominciato a lavorare;

perchè io muoio di dolore e parmi essere diventato uno ciurmatore contro a mia voglia' (I have been asked again by Master Metello Vari for his figure, which is also in Pisa and will come in the first boats. I never replied, and I do not want to write to you either, until I have begun to work on it. For I am dying of grief, and feel I have become a swindler against my will). On 19 March 1519 Vari wrote to Michelangelo suggesting that if the new figure had not been begun, the flawed figure should be completed: 'Sonno molti jorni che ve o fatto scrivere per solicitatione sopra lo fatto della figura, aprisimandose lo tempo, et non sapevo niente, e la inportanzia esser grave. Son forzato, se non o risposta, andarme dove state et vedere quell meglio partito se possa fare, per non cadere in tanto preiuditio: per tanto ve prego, se pregar vi posso, mandarme uno verso de lettera, acio possa de miglio voglia dormire. Et se la figura li non la havete fatta, al manco farete finire questa de Roma; o vero se ne havete nisunna fatta in altra figora e sia allo proposito, puro mene havisarete. Et questo se fa per farve piacere et per la inportanzia della cosa. Non altro' (It is many days since I wrote to ask you about the state of the figure, since the date was drawing near, and I knew nothing about it, and it was highly important. Unless I receive a reply, I shall be compelled to come to where you are and see, if I can, what the best solution is, so as not to fall into prejudice. However, I beg you as strongly as I can to send me a line, so that I may sleep easier. And if you have not done the figure in Florence, at least have this one in Rome finished; or, if you have done nothing, let me know of any other suitable figure. This is to convenience you and because the matter is important. That is all). On 6 April 1519 Metello Vari wrote to Michelangelo once more: 'Credo piu et piu lettere haverve scripto et de nisunna haveva mai hauta risposta, del che ne sonno molto maravigliato' (I have, I think, written you very many letters, and have never had a reply to any of them, which surprises me very much). On 13 January 1520 he wrote again, on receiving news from Leonardo Sellajo that the figure was virtually complete: 'Ad questi di passati messer Lionardo selari me dette nova, che voi havevate per finita la figora, del che lo hebj molto ad caro, atento che lo tempo senne vene' (In the last few days Master Leonardo Sellajo has given me the news of your having finished the figure. It was very welcome, seeing that the date has passed). By March 1520 a pupil of Michelangelo, Federigo Frizzi, was making preparations for a tabernacle for the figure in Santa Maria sopra Minerva. In April Leonardo Sellajo informed Metello Vari that the figure was finished, and that Michelangelo was anxious to have the balance of his fee. This was refused by Vari, who stipulated, in a letter of 24 April, that the figure should first be delivered in Rome: 'Ve prego etc., la fate vinire et subito, nanzi sia gionta, faremo cio, che seranno pagati li vostri denari senza nisunna dilazione' (I beg you to send it, and as soon as it has arrived we will have you paid your money without any delay). The figure was retained by Michelangelo, and on 25 October 1520 Vari agreed to pay the sum required. The money was despatched to Florence on 30 January 1521, and on 31 March 1521 Michelangelo's pupil, Pietro Urbano, reported from Rome that the statue had arrived at Santa Severa and was awaited in Rome, and that the form of Frizzi's tabernacle had been agreed

upon. The statue arrived in Rome in June or July 1521, when Pietro Urbano writes: 'O levata la fighura darripa; o auto grande noia . . . perche volevano che Christo paghasse ghabella di entrare in Roma' (I have brought the figure up from the Ripa. I had great trouble . . . because they wanted Christ to pay duty to enter Rome). It was apparently unfinished in repect of certain details, and on these Pietro Urbano worked. An unfavourable report on Urbano's activities was sent to Michelangelo on 6 September 1521 by Sebastiano del Piombo, who alleges that: 'Credo siate stracco sentir nove del vostro Pietro Urbano . . . : per l'amor io ve porto son forzato a farvi intendere parte de' suoi boni portamenti . . . tucto quello ha lavorato, ha stroppiato ogni cossa, maxime ha scortato el piede drito che si vede manifestamente ne le ditta che lui l'à mozze, ancora ha scortate le ditta de le mane maxime quela che tiene la croce che è la drita che'l Frissi dice che par che lì habi lavorato colloro che fano le zanbele; non par lavorata de marmo, par il habi lavorato coloro che lavorano di pasta, tanto sonno stentate: . . . questo ve dico che si vede manifestamente che l'à lavorato ne la barba, ch'el' mio putto credo haveria havuto più descretione che par habi lavorato con un cortel che non habi ponta a fiilar quella barba: ma facilmente se li potrà remediare. Ancora à moza una nara del naso che pocco più era guastato el naso che altri che Dio l'averia conzo' (I think you will be tired of hearing news of your Pietro Urbano . . . : out of the love I bear you I am bound to let you know about his fine behaviour . . . he has bungled everything he has done; above all, he has shortened the right foot, which one clearly sees in the toes he has mutilated. He has also shortened the fingers, particularly of the right hand holding the Cross – Frizzi says they look as if biscuit-makers have worked them; they are so thin that they look more as if they were worked from paste than from marble. . . . It is clear to see that he has worked on the beard, and I think my little boy would have shown more judgement – he seems to have carved it with a knife with no point. But it could easily be remedied. He has mutilated one of the nostrils too, almost ruining the nose). The completion of the statue was entrusted to Frizzi, and on 29 December it was unveiled. The movements of the figure in the church are analysed by W. Lotz ('Zu Michelangelos Christus in S. Maria sopra Minerva,' in *Festschrift für Herbert von Einem*, Berlin, 1965, pp. 143–150); it was originally destined for a pier in the nave, but on 19 October 1521 was lowered and moved to its present position. The tabernacle commissioned for it from Frizzi on 30 March 1521 is shown in a woodcut in *Le Cose Maravigliose dell'Alma Citta di Roma* (1600), and stood over an altar bearing the inscription:

METELLVS VARVS ET PAVL.
CASTELLANVS ROMANI MAR-
TIAE PORTIAE TESTAMENTO
HOC ALTARE EREXERVNT CVM
TERTIA PARTE IMPENSARVM
ET DOTIS. QVAM METELLVS
DE SVO SVPPLENS, DEO OPT.
MAX DICAVIT.

Leonardo Sellajo reported to Michelangelo on 12 January 1522 that: 'La fighura, chome vi dissi, è schoperta e riesce benissimo;

ma nonnestante questo o detto e fatto dire, dove a me è parsso a proposito, nonn essere di vostra mano. Che bene è vero, voj l'avete in alchuno luogho ritocha, dove Pietro l'aveva istorpiata' (The figure, as I told you, has been unveiled and is most successful; but nevertheless I have spread it about, where it seemed suitable, that it is not from your hand. It is true, you retouched it in some places where Pietro had mutilated it). Michelangelo meanwhile had offered to carve a new statue for Vari, who refused his proposal but expressed the wish to receive the spoiled version of the figure. This is alluded to in a letter from Leonardo Sellajo to Michelangelo of 14 December 1521: 'I'o una vostra chon una a messer Metello, laquale o mandata. Lui nonno posuto vedere, per l'esere le chose nel termine che sono, sono stato chol Frizi. Lui mi dice, Metello vuole quel Christo chominciato che è in chasa; el che a mio chonsiglio nollo darei, perche bisogna lo faca finire, e meteremoci del nostro onore, a fillo voi vi farebe troppo tenpo. Ora schrivendovi lui, fate quello vi pare; a me pare chosi, e chosi vi chonforto' (I have your letter, with the one for Metello, which I have sent on. I was not able to see him, things being as they are, but I was with Frizzi. He tells me Metello wants the Christ which you had begun and is in the house; my advice is not to give it to him, as you would have to finish it and we would be on our honour to do so, and it would take you too much time. When he writes to you, do what you think best; but that is my opinion and advice). On 12 January 1522 Michelangelo agreed to present the figure to Vari. It is recorded in Vari's possession by Aldovrandi (*Delle statue antiche*, 1556, p. 247): 'In una corticella overo orticello, vedesi un Christo ignudo con la Croce al lato destro non fornito per rispetto d'una vena che si scoperse nel marmo della faccia, opera di Michiel Angelo: & lo donò a M. Metello, & l'altro simile a questo, che hora è nella minerva lo fece fare a sue spese M. Metello a detto Michel Angelo' (In a small court or garden there is a nude Christ, with the Cross on his right; it was not finished on account of a vein which appeared on the face. It is a work of Michelangelo's, and he gave it to Master Metello; the other one, similar to this, which today is in the Minerva, was commissioned by him from Michelangelo). A drawing made in preparation for the first version of the figure is in the Brinsley Ford collection, London. The figure in S. Maria sopra Minerva attained exceptional popularity, and in 1546 Primaticcio was instructed by Francis I of France to obtain a cast. The figure as it stands is substantially by Michelangelo. The cross and instruments of the Passion seem to have been executed by a studio hand, and the hair is comparatively weakly carved. Special admiration was expressed by Sebastiano del Piombo for the carving of the knees. The fact that the figure is relatively ineffective is due not to extensive studio intervention, but to the fact that it is a replica of a lost work.

Plates 24–33: THE MEDICI CHAPEL
S. Lorenzo, Florence
General
Following the deaths of Giuliano de' Medici, Duc de Nemours, brother of Leo X, in 1516 and of the Pope's nephew, Lorenzo de' Medici, Duke of Urbino, in 1519, it was decided to construct,

on the north side of the church of S. Lorenzo, a funerary chapel corresponding to the Sagrestia Vecchia of Brunelleschi in the south transept of the church. The initiative in this project seems to have been taken by Cardinal Giulio de' Medici. It has been claimed (Fabriczy, Tolnay) that the lower part of the structure of the New Sacristy was built under the supervision of Brunelleschi and is contemporary with the north transept of the church. The case against this view is stated by Wilde ('Michelangelo's Designs for the Medici Tombs', in *Journal of the Warburg and Courtauld Institutes*, xviii, 1955, pp. 54–66), and rests (i) on a drawing of S. Lorenzo by Leonardo da Vinci in the Institut de France, datable to the year 1502, which shows the north transept of the church without the sacristy, (ii) on structural analysis of the building, and (iii) on the evidence of Cambi and Vasari that the plan envisaged the creation of a new and not the completion of an old structure. Though there is no evidence of Michelangelo's connection with the project before November 1520, it is possible that he assumed control of it before March of this year. Conversely it has been argued (Ackerman) that 'the style of the interior shows that Michelangelo's active intervention as an architect began only at the pendentive level.' In the first case the building would have been planned from the beginning in relation to the tombs in the interior. In the second a pre-existing scheme would have been modified to accommodate the tombs.

Interior Architecture
The treatment of the interior depends from that of the Sagrestia Vecchia of Brunelleschi. The introduction of an intermediate zone between the lower register and the lunettes recalls the sacristy of S. Spirito of Giuliano da San Gallo. The scheme deviates from tradition, first in the use of strips of pietra serena on the inner sides of the central pilasters to provide a firm frame for the sepulchral monuments, and second in the original form of the windows in the lunettes. The architecture of the lower register introduces one major innovation, in the juxtaposition of a system of marble wall decoration with the pietra serena articulation. The doors surmounted by tabernacles which fill the outer extremities of all four walls appear to have been suggested by the doors surmounted by tabernacles on the altar wall of the Sagrestia Vecchia, where, however, the forms of the doorframes and tabernacles are altogether different. Two drawings in the Archivio Buonarroti offer evidence (Tolnay) that at one point the treatment of the wall surfaces and of the altar bay was to have been more closely related to the Sagrestia Vecchia than it eventually became. There is proof that the cupola was painted by Giovanni da Udine (1532–3), but that this decoration was subsequently eliminated (1556). It has also been argued (Popp, Tolnay, Panofsky) that the chapel was to include frescoes of the Resurrection, Judith and Moses and the Brazen Serpent. The evidence for this is ambiguous. A letter of 17 July 1533 from Sebastiano del Piombo to Michelangelo reveals, however, that it was intended to decorate the small cupola in the interior of the lantern with a fresco. The form of the dome (Wilde) depends from that of the Pantheon.

Medini Tombs
When Michelangelo assumed control of the project for the

tombs, the form of the tombs, and therefore of the interior architecture of the chapel, was still undetermined. The principal written evidence for this phase in the development of the chapel is provided by three letters. The first of these, written by Cardinal Giulio de' Medici to Michelangelo on 28 November 1520, reads as follows: 'Respondemo brevemente . . . in vero ne piace el modo havete pensato de mittere le IIII sepulture in mezo della capella; et quando li cassoni delle sepulture possino venire al mancho III braccie longhi, credemo torneranno bene, faciendo poi li altri ornamenti che accompagnino il tutto in quel modo saprete pensare che stia bene. Ma in questo mi nasce una difficolta, che non so pensare, come in IIII braccie di spaccio, designato per voi di largeza per ogni verso, possino capere dicte sepulture con li ornamenti et poi avanzare octo braccie per ogni verso della capella: pure ne siamo per remittere ad quello pensarete che stia bene' (Indeed, I like the way in which you have thought of putting the four tombs in the middle of the Chapel. And if the coffers of the tombs can be at least 3 braccia long, we think they will turn out well; the other accompanying decoration can be made in whatever way you think good. But a difficulty arises for me here: I cannot think how the tombs and their decoration will fit in the space of 4 braccia, which you have laid down as the breadth of each side, and then leave 8 braccia on each side of the Chapel. However, we will agree with whatever you think good). The project for a free-standing central tomb is mentioned again in a letter of 14 December 1520 from Domenico Buoninsegni to Michelangelo: 'Io ò parlato con el Cardinale del disegno che voi facievi circa el mettere le sepulture in mezzo la cappella, c'assai li piacie, ma dubita non si occupi lo spazio di tal cappella che non li pare che quattro braccia di larghezza basti. Agli detto che quando fussino braccia sei che avanzarebbe braccia sette per banda d'andare all'intorno. Diciemi che vi priega li mandiate un poco di schizzo d'una sola di quelle quattro faccie fatto in el modo che disegneresti che le fussino mettendole in mezzo; e così dicie anche o vogliatele mettere in el mezzo in el modo che dite o pure nelle faccie della cappella, che re ne rapporterà a voi . . . ' (I talked with the Cardinal about the plan you made for putting the tombs in the middle of the Chapel. He likes it very much, but he fears it may fill the space of the Chapel, and does not think 4 braccia is wide enough. I said that, even if it was 6 braccia, there would be 7 braccia left on each side round it. He told me to beg you to send him a small sketch of just one of the faces, done according to your plan of putting them in the middle. He also says that, whether you want to put them in the middle, as you say, or on the walls of the Chapel, he leaves it to you . . .). This enquiry was repeated on 17 December, and on 28 December 1520 Buoninsegni wrote again: 'ò avuto el disegno della faccia della sepultura, el quale disegno subito portai al Cardinale, e li detti la vostra lettera e la lesse tutta, e tutto li piace. Ma dubita che quello spazio dintorno non resti meschino. E per questo aveva pensato se in tutta la macchina della sepultura fussi da fare in el mezzo uno arco che traforassi, che verrebbe a essere in ogni faccia uno arco, e intersecherebbonsi li anditi di questi archi in el mezzo e passerebbesi sotto; e in detto mezzo disegnava che in terra fussi la sepultura sua, e le altre sepulture li pare deverebbono stare alte sopra li detti archi' (I have received the drawing of the face of the tomb, and

took it at once to the Cardinal; I gave him your letter and he read it all, and is altogether pleased. But he fears the space around the tomb would be mean. For this reason he has been wondering whether an arch could be made, piercing the whole structure of the tomb; there would be an arch in each face, and the passages of these arches would cross in the middle, so that one could pass underneath it. He planned that his own tomb would be on the ground in the middle, and he thinks the other tombs should stand high above the arches). From these letters we learn (i) that Michelangelo in November 1520 was engaged on two alternative projects, one for a central tomb with four faces and the other for four wall monuments, (ii) that the Cardinal required the measurements of the proposed central tomb to be enlarged, (iii) that he was then dissatisfied with the relation of the free-standing tomb to the area in which it stood, and (iv) that for this reason he proposed a pierced central tomb in the form of a double arch.

The visual evidence for these projects is supplied by a number of drawings in the British Museum, London, the Archivio Buonarroti, Florence, and the Kupferstichkabinett at Dresden, which have been frequently studied with contrary results and are best analysed by Wilde. The projects include:

(A) Designs for a free-standing monument, contained on a sheet in the British Museum (1859-6-25-545, Wilde No. 25r.). These comprise: (i) An octagon with alternate long and short sides, in which the long sides contain pairs of coupled columns with rectangular recesses between surmounted by segmental pediments and the short sides contain niches surmounted by triangular pediments. On the long sides above the entablature is an attic with coupled pilasters corresponding with the coupled columns beneath. A second version of this scheme appears on a drawing in the Casa Buonarroti (Frey, No. 267b). (ii) A structure square on plan, with, in the centre of the lower story, a sarcophagus rising from a projection of the lower plinth to a cornice surmounted by a segmental pediment. The sarcophagus rests on two claw feet, and the bottom is curved outwards with figures of mourners seated beside it. The upper register is framed by pairs of coupled pilasters with, between them, oblong panels with splayed sides. (iii) A structure square on plan with the sarcophagus on a step, the lid in the form of inverted consoles or volutes. In the upper register are three bays separated by pilasters, those at the sides in the form of narrow round-headed niches and that in the centre in the form of a square panel with a circular panel beneath. A simplified version of this scheme appears in a drawing in the Casa Buonarotti (Frey, No. 125a). (iv) A structure square on plan with in the centre a round-headed niche cutting into the pedestal of the upper story and containing the sarcophagus. A second drawing for this project is in the Casa Buonarroti (Frey, No. 267b). A drawing for a variant of this scheme is in the Casa Buonarroti (Frey, No. 267c), and this in turn appears to have formed the basis of a scale drawing in the Kupferstichkabinett at Dresden. It is established by Wilde that project (ii) provided for a length of 4 ells (2.40 m.), and that the mourning figures were therefore roughly of the size of the Valori Apollo. In (iv) and the scale drawing at Dresden the length of the side of the structure has, in compliance with the Cardinal's request, been increased to

$5\frac{3}{5}$ ells. The Dresden drawing seems in turn to have inspired the Cardinal's proposal for a pierced tomb. The floor space in the Chapel for which these projects were designed is $19\frac{1}{2}$ ells square.

(B) A number of early designs for wall monuments, produced concurrently with or prior to the designs enumerated in A. These comprise three studies in the Casa Buonarroti (Frey, No. 70 top left, Frey, No. 70 bottom left, Frey, No. 125a centre). The second of these alone is of importance, in that it shows a scheme related to A (ii) with reclining figures on the sarcophagus.

(C) Designs for double wall monuments, apparently produced early in 1521 after the rejection of the free-standing tomb, with the intention of placing two pairs of tombs on the two lateral walls of the Chapel. These are contained on two sides of a sheet in the British Museum (1859-5-14-822, Wilde, Nos. 26r., 26v.), and comprise: (i) A wall monument with a sarcophagus supported on consoles returned against the piers, and, above, an aedicule crowned by a pediment. Beneath the sarcophagus is a River God, and on the lid is a second reclining figure. (ii) A wall monument with a similar sarcophagus supported on feet with a reclining figure on the lid. Above the sarcophagus is a square panelled podium with two standing mourners, and above this is a tablet with a segmental pediment. Projects (i) and (ii) represent variants of a single scheme, and are joined by a central pilaster with a large standing figure in front of it. (iii) A wall monument similar to (ii) with the lid of the sarcophagus in the form of two reversed halves of a segmental pediment, and, above, a tablet superimposed on a square panelled pedestal. (iv) Two adjacent monuments in which the sarcophagi have lids in the form of triangular pediments. (iii) is interpreted by Wilde as a scheme for placing the four tombs in front of the side sections of the lateral walls of the Chapel, which was presumably abandoned on account of the symmetry of the entrances, and (i) and (iv) represent a somewhat later scheme for placing the pairs of tombs in the centre of each wall. The figure on the sarcophagus lid in (ii) is related to the tombs as executed.

(D) Design for a single wall monument, contained on a sheet in the British Museum (1859-5-14-823, Wilde, No. 27r). This drawing shows a wall monument, the body of which is divided vertically into three parts. The sarcophagus rests on a plinth or step, to right and left of which are reclining figures. The lid of the sarcophagus is formed by two scrolls or volutes with an upright shell between them. On both volutes there are reclining figures. At the sides of the pedestal are rectangular recesses, of which that on the left is filled with a seated figure. The central section of the upper story is framed by coupled pilasters with square and oblong panels between them, and at the sides are tabernacles with segmental pediments and oblong or oval panels above. In the attic is a trophy with, at the sides, swags with crouching figures in relief beneath. It is established by Wilde that this study is for the final plan of the tombs as executed, and that the ratio of width to height is virtually the same as in the completed monuments. In the completed monuments, however, the lower and main stories were raised at the expense of the attic, the side sections were widened at the expense of that in the centre, the central sections of the main and lower registers were brought forward, the square central panel was replaced by a rectangular recess, the panels over the lateral tabernacles were eliminated, the rectangular recesses beside the sarcophagus were replaced by rectangular panels, the cornice of the attic was removed, the forms of the thrones at the top were changed, and the decoration of the sarcophagus and attic was simplified. The trophies projected in this drawing were executed in part by Silvio Cosini, and were not used in the monuments; they are now in the corridor leading to the Chapel. The shells on the sarcophagi were abandoned only in the summer of 1524. Three related drawings of secondary importance are in the Casa Buonarroti.

(E) Design for a double wall monument intended for the tombs of the Magnifici on the wall facing the altar, contained on two sides of a sheet in the British Museum (1859-6-25-543, Wilde, Nos. 28r, 28v). 28r shows the two sarcophagi on a high step, with the centre of that on the left beneath the centre of the niche above, and the outer ends of the sarcophagi projecting beyond the edge of the tomb. Above the podium is a pedestal story supporting the main order, which has a tall recessed central niche with a segmental pediment. In the central niche is a Madonna and in the outer niches are standing figures. Below the central niche, against the central rectangle of the podium, is a figure of Fame, with, at the sides, swags and labels. In 28v the latter are replaced by figures in square recesses. A drawing in the Louvre (Frey, No. 90) contains a more elaborate version of 28r, and shows two figures on the sarcophagi. The two columns shown beside the central niche in 28v appear to have been increased to four in the final design. The plain base now installed on this wall of the Chapel is that planned by Michelangelo; the remains of the Magnifici were interred beneath it in 1559. It was intended either that the figures of SS. Cosmas and Damian should be set above the Virgin and Child in niches on the level of those above the lateral doors (Wilde), or that they should be set on the level of the Virgin and Child and surmounted by niches with smaller standing figures. Drawings show that the figures of the Saints have been reversed, and were originally designed to look outwards towards the lateral monuments.

Sequence of Work

It is stated by Cambi that the chapel was under construction in March 1520. This is confirmed by an Atto Capitolare of 1 March 1520 quoted by Moreni ('muraglia ordinata di fare dal Reverendissimo Cardinale della nuova Sagrestia'). According to Tolnay, Michelangelo would have been approached by Pope Leo X for the first time on 6 September 1520 in connection with the Chapel, and agreed to take charge of it between 27 October and 6 November of this year. But there are good reasons for supposing (Wilde) that Michelangelo may from the first have been responsible for the whole project. By 28 December 1520 a small model by Michelangelo for the interior of the building was complete. It has been inferred (Tolnay) that the final form of the tombs must have been decided upon by 14 December 1520 when work on the pietra serena articulation of the lowest zone of the interior was under way. By 20 April 1521 work in the interior had been completed up to the pietra serena architrave. On 10 April 1521 Michelangelo visited Carrara, and there (April

22 and 23) signed two contracts with stone cutters providing (i) for the delivery within eighteen months of certain marbles 'et spetialmente fare delli dicti marmi figure tre, et più se più potranno' (and, in particular, for making three figures from these blocks of marble, and more, if possible), and (ii) for the delivery within twelve months of certain marbles 'et spetialmente fare delli dicti marmi una figura di Nostra Donna a sedere secondo è disegnata, et più altre figure secondo dicte misure, se più potranno' (and, in particular, for making from these blocks of marble a figure of Our Lady, sitting according to the design, and more figures of this size, if possible). By the time of these contracts the form of the tombs of the Capitani and of the two Magnifici must have been agreed upon.

The first blocks destined for the figure sculptures were shipped from Carrara to Florence in June 1521. Further correspondence relating to the extraction of marble continues through 1522 and 1523. The bulk of the marble had been quarried and shipped by March 1524. On 17 March 1524 Topolino, Michelangelo's representative at Carrara, writes to the sculptor (Tolnay): 'Avisovi come e marmi sono al fine, salvo che due coperchi che non sono ancora cavati, ma credo che inanzi Pascua saranno cavati: si che in brieve tempo sarebbe ogni cosa finita. E marmi sono tutti alla marina' (The marbles are finished, except for two lids which are not yet quarried, but I think they will be before Easter; so everything should be finished soon. The marbles are all at the coast). The reference here is to the covers or lids of the two sarcophagi. A week later (25 March 1524) it was reported from Carrara that the marble destined for one of the lids was damaged (Tolnay: 'Sapiate che lo coperchio è guasto, che avevano cavato: non ci manca se non e dua casoni. La figura è trovata, e ò cominciato a cavare de' marmi de le porte e de' tabernacoli, e n'è già abozati parechi pezi') (The lid they had quarried is damaged; only two coffers are missing. The figure has been found, and I have started quarrying marble for the doors and tabernacles, and have already blocked out some pieces). Towards the end of April marble for the lids had still not been found (21 April 1524: 'Ancora non s'è potuto cavare e dua coperchi e una figura che vanno a piè de' detti coperchi. Ma io credo, se piace a Dio, che in quindici dì, se nonne accade rotture o altre tristizie saranno cavate') (It has still not been possible to quarry two of the lids and a figure to go at the bottom of these lids. But I think, if God wills, they will have been quarried in a fortnight, if no breakages or other accidents occur). Further references to marble for the sarcophagus lids occur in letters of 21 June 1524 and 13 August 1524 ('Bisogna che voi mandiate a dirmi come volete io abozzi quelli due coperchi. . . . Se voi gli volete sanza quello rilievo, ci sono d'abozare in un tratto, che sono de' marmi medesimi de' cassoni') (You must let me know how you want me to block out the two lids. . . . If you want them without the relief, there are some that could be blocked out at once, of the same marble as the coffers). Later in the month (24 August 1524) Topolino was involved in a search for marble for the nude figures ('io spero che noi àremo in pochi dì marmi per le figure nude'). The Ricordi of 1524 (Milanesi, pp. 592–5) contain a number of payments for 'e' modegli delle figure di San Lorenzo'. Meanwhile Michelangelo in Florence had begun work on the tombs. On 21 April 1524

Topolino learned 'che voi avete cominciato a lavorare e che vi manca quatro pezzi di marmo' (You have begun to work, and four pieces of marble are missing), and by 7 June 1524 the architecture of one tomb was already far advanced; this can be inferred from a letter of Fattucci to Michelangelo, in which the former refers to a plan for putting the tombs of Leo X and Clement VII in place of the two tombs of the Capitani 'ma per averne quasi fatta di quadro una, non ci è ordine'. It has been suggested (Popp) that one of the allegories, the Aurora (see below) was begun in 1521. The documents, however, support the conclusion (Tolnay) that none of the allegories was begun before the late summer of 1524. That difficulty was experienced in procuring marble for these figures is suggested by a Ricordo of Michelangelo of 27 October 1524 (Milanesi, p. 597) referring to the transport of a block of marble from the workshop in the Via Mozza to the sacristy 'che mi serve per una figura di quelle che vanno in su cassoni delle sepulture dette che io fo' (which will do for one of the figures to go on the tomb-chests I am making). The marble for four figures was extracted between 10 August 1524 ('due figure grosse et due piccole') and 24 October of this year. For further knowledge of the progress of the sculptures we are dependent on letters passing between Florence and Rome. On 14 October 1525 Fattucci enquired about the sculptures in the following terms (Frey, pp. 260–2): 'Datemi aviso, come va l'opera, et se avete messo mano ad altre figure che a quelle quatro, et quando cominciarete e fiumi' (Tell me how the work is going, whether you have put hand to any figures other than those four, and when you are going to begin the river-gods). Ten days later (24 October 1525) Michelangelo replied: 'Alla vostra ultima, le quattro figure conciate non sono ancora finite, e évvi da fare ancora assai. Le quattro altre per Fiumi non sono cominciate, perchè non ci sono e' marmi: e pure ci sono venuti' (In reply to your letter, the four figures which have been begun are not yet finished, and there is still much to do on them. The four others of river-gods have not been begun, because the marble for them was not here; however, it has come now). On 10 March 1526 Michelangelo's representative in Rome, Leonardo Sellajo, reported that he had reassured the Pope about the progress of the work (Frey, pp. 276–8): 'E avevi fatti e modegli delle 8 fighure, che non si gettono in forma; . . . E dissigli, chome m'avevi detto e promesso, per infino a settembre le 8 fighure sarebbono alla perfezione, che le 4 da finir le presto, se non v'era dato fastidio di nuove materie di disengni o modegli: . . . Fecilo ridere, che mi disse, gli era suto detto, era rotto una delle 4 fighure, e per quello stavi adirato: Risposi, non era vero, ma per levare dintorno e cichaloni, che vorebbono vedere, voi medesimo alle volte dicevi simile cose per parere adirato: che tanto rise. . . .' (And you had done the models for the eight figures which are not being cast. . . . And I told him that you had told me and promised that the eight figures would be finished by September, and four of them soon, but for trouble about new material, designs and models . . . I made him laugh when he said to me that he had been told that one of the four figures had been broken and you were angry about it. I replied that it was not true, but that you sometimes said things like this so as to seem angry and get rid of gossips who wanted to see the work).

In the summer (17 June 1526, Milanesi, p. 453, misdated) Michelangelo sent a report to Fattucci: 'Di questa settimana che viene, farò coprire le figure di Sagrestia che vi sono bozzate, perchè io voglio lasciare la Sagrestia libera a questi scarpellini de' marmi, perchè io voglio che comincino a murare l'altra sepultura a riscontro di quella che è murata; che è squadrata tutta, e credevo io che con gente assai la si facessi in dua o in tre mesi: non me ne intendo. . . . Io lavoro el più che io posso, e in fra quindici dì farò cominciare l'altro Capitano: poi mi resterà di cose d'importanza solo e' quattro Fiumi. Le quattro figure in su cassoni, le quattro figure in terra che sono e' Fiumi, e dua Capitani e la Nostra Donna che va nella sepultura di testa, sono le figure che io vorrei fare di mia mano: e di queste n'è cominciate sei' (Next week I shall cover up those figures for the Sacristy which have been blocked out, because I want to give the marble-cutters the run of it. For I want to start building the second tomb, opposite the one that has already been built. It has all been squared out, and I thought that, with a large number of workmen, I should do it in two or three months; I am not sure about it . . . I am working as hard as I can, and in a fortnight will begin the second Capitano; then the only things of importance left for me to do will be the four river-gods. The figures I intend to do with my own hand are: the four figures on the coffers, the four river-gods on the ground, the two Capitani, and the Madonna to go on the end tomb; and I have begun six of these). The interpretation of these letters is of fundamental importance in establishing the sequence of the sculptures; it is a reasonable inference that the four figures referred to in the correspondence of March 1526 as virtually complete included one of the two statues of the Capitani and two of the four Allegories (see below), and that the six figures mentioned in the later letter included two further Allegories. The Pope meanwhile had become restive at the slow rate of progress on the Chapel, and on 12 September 1526 Michelangelo was urged from Rome to proceed with the assembly of the second tomb. At the beginning of May 1527 there occurred the Sack of Rome, and at the end of the same month a republican regime was installed in Florence. In August 1528 Michelangelo received the commission for a group outside the Palazzo della Signoria, and thereafter he was involved with the fortifications of the city. On 21 September 1529 he fled from Florence, returning on 20 November. In August 1530 the city capitulated to Clement VII, and work on the Medici Chapel was resumed. A letter of 19 November 1530 (Gaye, ii, p. 221) records the Pope's satisfaction at the continuance of work on the statues. On 16 June 1531 Sebastiano del Piombo recorded the substance of an interview with the Pope: 'Et se stupì quando el lesse la vostra littera in mia presentia, de le figure ditte che son finite, et disse che mai fu el mazor lavorante de' vui quando volete: tutto l'opposito delle cichale!' (He was astonished when he read in my presence your letter about the figures, which you say are finished; and he said that there is no better worker than you when you feel like it – quite the opposite of what the gossips say). Two months later (19 August 1531) Sebastiano del Piombo reported again: 'Et (quando) li mostrerò la post (scripta) vostra, che havete finita la seconda figura et sete (entrato) nela terza, el jubilarà tucto, ma non ge la voglio mostrare in sino la recevuta de l'altra' (When I show him your postscript, saying that you have finished the second figure and begun the third, he will be overjoyed; but I do not want to show it to him until the other has come). At this time Michelangelo was working under great pressure, as is recorded in a letter of Giovanbattista di Paolo Mini to Bartolomeo Valori of 29 September 1531 (Gaye, ii, pp. 228–30): 'E questo siè che michelagnolo, suo iscultore, è più mesi nolavevo veduto, respetto alesere suto in chasa per paura dela peste, e dattre settimane in qua è venuto dua volte la sera per un pocho di pasatempo a trovarmi a chasa chol bugiardino e chon antonio mini, mio nipotte e suo diciepolle; dopo molti ragionamenti delarte rimasi dandare a vedere le dua femine, chosì fece altro dì, e infati sono cosa di grande maraviglia, e so che V.S. vide la prima, che figura per la notte cho la luna in capo elncielo notturno; apresso questa sichonda la pasa per tutti e chonti di beleza, chosa mirabilissima; e di presente finiva uno di que' vechi cheio non credo si posa vedere meglio' (I had not seen Michelangelo, his sculptor, for some months, as I had stayed at home through fear of the plague. During the last three weeks he has twice come in the evening to visit me at home for a little relaxation, with Bugiardini and Antonio Mini, my nephew and a pupil of his. After much discussion of art, I had still not seen the two female figures, but I did so the other day. They are indeed marvellous. I know that you saw the first, the figure of Night, with the moon on its head and the owl; the second surpasses it in beauty in every respect, and is a marvellous thing. At present he has been finishing one of the old men; I do not think one could see anything better). The letter reports on Michelangelo's physical condition, and states that he is eating little, sleeping badly, and suffering from headaches and vertigo, and will not live unless some steps are taken about his health. It recommends first that Michelangelo should be relieved of his obligations on the Julius monument, and secondly that he should be prevented from working in winter in the sacristy: 'potrebbe lavorare nel altra istanzetta e finire quela nostra donna, tanto belissima cosa, e fare la statua de la felicie memoria del duca Lorenzo en questo verno. In ditta sagrestia si potrebe murare elavoro del quadro de le sepulture, e cominciare a metervi su le fighure finite e anche la mezate; si potrebe poi finire la su, e a questo modo si salverebe luomo e tirebe inanzi e lavore' (This winter he could work in the other small room, and finish the Madonna, a most beautiful work, and do the memorial statue of Duke Lorenzo. In the Sacristy the masonry of the tombs could be built, and they could start putting up the finished statues, and even the half-finished ones, to be finished later up there. In this way the man would be kept safe and the work pushed on). From this point on work in the Chapel was beset by interruptions. In April 1532 Michelangelo visited Rome, thereafter returning to Florence, and in August went to Rome once more, staying there till the summer of 1533. In June 1533 he returned to Florence for four months, from October 1533 to May 1534 he was again in Rome, and in the summer of 1534 he returned briefly to Florence, which he left for the last time in September of the same year. The death of the Pope on 25 September 1534 brought work in the Chapel to a temporary close. During this last phase, at the Pope's instigation, extensive use was made of assistants, notably

Tribolo, Raffaello da Montelupo and Montorsoli. Vasari describes how the Pope (who had seen Tribolo's models for the prophets for the niches of the Holy House at Loreto) 'deliberò che tutti, senza perdere tempo, tornassino a Firenze per dar fine, sotto la disciplina di Michelagnolo Buonarroti, a tutte quelle figure che mancavano alla sagrestia e libreria di San Lorenzo, ed a tutto il lavoro, secondo i modelli e con l'aiuto di Michelagnolo, quanto più presto; acciò, finita la sagrestia, tutti potessero, mediante l'acquisto fatto sotto la disciplina di tant'uomo, finir similmente la facciata di San Lorenzo. E perchè a ciò fare punto non si tardasse, rimandò il papa Michelagnolo a Firenze, e con esso lui Fra Giovanni Agnolo de'Servi, il quale aveva lavorato alcune cose in Belvedere, acciò gli aiutasse a traforar i marmi, e facesse alcune statue, secondo che gli ordinasse Michelagnolo; il quale gli diede a far un San Cosimo, che insieme con un San Damiano allogato al Montelupo doveva mettere in mezzo la Madonna. Date a far queste, volle Michelagnolo che il Tribolo facesse due statue nude, che avevano a metter in mezzo quella del duca Giuliano che già aveva fatta egli; l'una figurata per la Terra coronata di cipresso, che dolente ed a capo chino piangesse con le braccia aperte la perdita del duca Giuliano; e l'altra per lo Cielo, che con le braccia elevate, tutto ridente e festoso, mostrasse esser allegro dell'ornamento e splendore che gli recava l'anima e lo spirito di quel signore' (decided that they should all return without losing time to Florence, in order to finish under the direction of Michelagnolo Buonarroti all the figures needed for the Sacristy and Library of S. Lorenzo, and all the rest of the work, after Michelangelo's models and with his help, as quickly as possible; this was done so that, when they had finished the Sacristy, they might all be able, through the new skill they had acquired under the direction of so great a man, to finish the façade of S. Lorenzo also. To avoid any delay, the Pope sent Michelangelo back to Florence, and with him Fra Giovanni Angelo de'Servi, who had worked some things in the Belvedere, to help him carve the marbles and to make some statues, according to Michelangelo's instructions; and Michelangelo had him make a St. Cosmas which, with a St. Damian allotted to Montelupo, was to stand at the side of the Madonna. When these commissions had been given, Michelangelo wished Tribolo to make two nude statues to stand on each side of that of Duke Giuliano, which he himself had already made; one of them was to represent Earth crowned with cypress, mourning and lamenting with bowed head and outstretched arms the loss of Duke Giuliano, and the other was to represent Heaven, with arms raised, smiling and joyful, showing that she rejoiced at the adornment and splendour which the soul and spirit of that lord were bringing her). According to Vasari, ill-health overtook Tribolo, but 'così indisposto, fece di terra il modello grande della statua della Terra; e finitolo, cominciò a lavorare il marmo con tanta diligenza e sollecitudine, che già si vedeva scoperta tutta dalla banda dinanzi la statua; quando la fortuna, che a' bei principi sempre volentieri contrasta, con la morte di Clemente, allora che meno si temeva, troncò l'animo a tanti eccellenti uomini che speravano sotto Michelagnolo con utilità grandissime acquistarsi nome immortale e perpetua fame' (Though he was unwell, he made a large clay model for the statue of Earth; and when he

had finished it, he began working it in marble with such diligence and care, that the statue could be seen already cut in front. But then Fortune, always apt to oppose good beginnings, through the death of Clement when it seemed least likely, cut short the hopes of all those excellent masters who had hoped to acquire under Michelangelo great profit, undying renown and everlasting fame). Tribolo received his instructions to proceed to Florence on 26 July 1533, and arrived there in August. A letter of Michelangelo of 15 October 1533 (Milanesi, p. 470) refers to small models for Tribolo's two figures. Raffaello da Montelupo's St. Damian was carved from a large-scale model by Michelangelo between August 1533 and September 1534. It has been suggested (Popp) that Michelangelo's small model for the St. Cosmas was made in Rome in 1532–33. By 17 July 1533 Montorsoli was working, in Michelangelo's studio, on a large model for this statue, the head and arms of which were modelled by Michelangelo. Work on this was broken off at the Pope's death, and it was completed only in 1536–37. A letter of Sebastiano del Piombo of 25 July 1533 refers to rumours in Rome that Michelangelo had entrusted Montorsoli with the completion of the statue of Giuliano de' Medici, and a further letter of 16 August 1533 from the same correspondent describes Montorsoli as 'soprastante a la sepoltura doppia de la sacrestia', that is the double tomb of the Magnifici. Silvio Cosini was paid, apparently for the frieze of masks, on 10 August 1532. Before he left for Rome in September 1534, Michelangelo installed the statues of the Capitani in the niches destined for them, leaving the Allegories on the Chapel floor. The Chapel was, however, visited by Charles V on 4 May 1536. On the death of Pope Clement VII Tribolo and Raffaello da Montelupo were diverted by Alessandro de' Medici to other work. After the murder of Alessandro de' Medici (5 January 1537) it was decided by his successor, Cosimo I, that work in the Chapel should be completed and that the dead Duke and Lorenzo de' Medici should be interred in the same sarcophagus. A number of unsuccessful attempts were made to induce Michelangelo to return to Florence. The Allegories were placed on the sarcophagi in 1546. On 3 June 1559 the bodies of the two Magnifici were installed in the base of the unfinished monument on the entrance wall, and at the same time the floor and entrance wall was systematised by Vasari.

The order in which the sculptures in the Medici Chapel were executed cannot be established with any confidence, since some of the statues were worked on concurrently and all of them save the Giuliano de' Medici were left incomplete. In April 1524 Michelangelo seems to have started work on the carving of the Allegories. The block brought from the Via Mozza in October 1524, which is mentioned in connection with the Allegories, was perhaps used for the Day, which is somewhat shorter than the three other figures, the blocks for which were cut to Michelangelo's specifications at Carrara. For reasons given below this figure and the Night must precede the corresponding Allegories on the Lorenzo de' Medici tomb; a contrary case is argued by Wölfflin, Popp and Tolnay, and, in an able review of the first edition of this book, by I. Lavin (in Art Bulletin, xlvii, 1965, pp. 378–83), who infers that the two female figures were completed before their two male counterparts. The Dawn

was presumably completed or in course of execution by September 1531, when Giovanbattista di Paolo Mini saw 'le dua femine'. The Evening seems to have been begun in this year or after. A letter of June 1526 refers to the imminent inception of 'l'altro Capitano', and one of the two figures of the Capitani must have been far advanced by this time. It is likely that the earlier figure was the Giuliano de' Medici. The opposite inference is drawn by W. Goez ('Annotationes zu Michelangelos Mediciergraben,' in *Festschrift für Harald Keller*, Darmstadt, 1964, pp. 235-54). It has been observed that the dolphin motif which appears above the tabernacles of the Lorenzo de' Medici monument is omitted from that of Giuliano, and that there may have been an interval between the execution of architectural sections of the two tombs. The evidence for this is contradictory; on the one hand the unfinished patere at the ends of the Lorenzo tomb (related to those in the tabernacles over the doorways) are omitted in the Giuliano monument, while on the other the attic of the Giuliano monument (notably the panels with military trophies and oil jars) is the more richly executed of the two.

GIULIANO DE' MEDICI, DUC DE NEMOURS. H. 173 cm. Like the companion figure of Lorenzo de' Medici, the statue of Giuliano de' Medici (d. 1516) is described by Niccolò Martelli (see below) as an idealised likeness. It is not, however, a 'porträt-lose Statue' (Borinski), and its dissimilarity from the authenticated portraits of Giuliano de' Medici is exaggerated both by this writer and Tolnay. The head differs from the bearded portraits by Raphael (Metropolitan Museum of Art, New York) of about 1515 and in a dated medal of this year (for these see O. Fischel, 'Porträts des Giuliano de' Medici, Herzogs von Nemours', in *Jahrbuch der Preuszischen Kunstsammlungen*, xxviii, 1907, pp. 117-30), but is in general agreement with two beardless medals of 1513. A posthumous description of Giuliano in the chronicles of Cerretani (1494-1519) reads as follows: 'Grande, bianco, di collo lungo, appiccato innanzi, le braccia lunghe, gli occhi azzurri, grave non solo nell'andare ma nel parlare, benigno, umano, piacevole, gentile, ingegnoso, bonario, amicabile, di debole complessione, misericordioso e liberalissimo' (Tall, pale, long-necked, stooping, with long arms and blue eyes, serious both in gait and speech, kindly, humane, affable, courteous, witty, mild, amiable, of a weak constitution, compassionate, and most liberal). The figure is shown in classical armour, holding the baton of Captain of the Church, in a pose which has been related (Steinmann, Panofsky, Hartt) to a Byzantine relief of St. George on St. Mark's in Venice. The coins held in the left hand have been interpreted alternatively as an emblem of magnanimity or as the oboloi of departed souls. The imagery of this figure is apparently connected with the ceremony of 1513 (for which see M. A. Altieri, *Giuliano de' Medici eletto cittadino Romano ovvero il Natale di Roma nel 1515*, ed. Pasqualucci, Rome, 1881) in which Giuliano de' Medici, and in absentia Lorenzo, were invested with the privileges of Roman citizenship. On this occasion the stage was decorated with the inscription KARITAS PUBLICA S.P.Q.R.E., and Giuliano de' Medici was presented with a privilegio with a gold seal having on one side the letters S.P.Q.R. 'e dall'altro lato una Magnifica

figura che mostrava sedersi sopra molte spoglie militari'. A letter of Sebastiano del Piombo to Michelangelo of 25 July 1533 (Milanesi, *Corr.*, p. 108) quoted above refers to rumours current in Rome that at that time Montorsoli was in course of finishing the statue. The sense of Sebastiano del Piombo's letter is that rumours of Montorsoli's intervention in the statue had been denied. It is assumed by Tolnay that the hands, knees and face are by Michelangelo but that the surface was polished by Montorsoli who was also responsible for certain details of the cuirass and mask. Montorsoli's parts of the Sannazaro monument in S. Maria del Parto in Naples do not substantiate this view. The statue is regarded as an autograph work of Michelangelo by Kriegbaum. Like the companion figure of Lorenzo de' Medici, it was placed in its niche before September 1534.

LORENZO DE' MEDICI, DUKE OF URBINO. H. 178 cm. The relationship of the head to the portraits of Lorenzo de' Medici (cf. a portrait in the Uffizi ascribed to Bronzino reproduced by Steinmann) is less close than with the companion figure. On Lorenzo's antipathy for his uncle Giuliano, whom he succeeded as Captain of the Church in 1516, see G. Fatini (*Giuliano de' Medici duca di Nemours, Poesie*, Florence, 1939). Like Giuliano de' Medici, Lorenzo is dressed in classical armour. The coin box under the left arm must have the same significance as the coins in the left hand of the corresponding figure. Vasari records a tradition that this and the Giuliano statue were polished and modified by Montorsoli. The Lorenzo de' Medici is less highly worked than the companion figure. The back of the niche was excavated to accommodate the figure when it was installed before September 1534. It is assumed by Tolnay that details of the armour and helmet and the bat's head on the coin box were carved by Montorsoli. The inference has frequently been drawn (Tolnay, Panofsky and others) that the figures of Giuliano and Lorenzo de' Medici represent the Active and the Contemplative Life. The representation of Giuliano de' Medici in an active and Lorenzo de' Medici in a contemplative pose would, however, represent an inversion of their historical roles, and it has been suggested (Grimm) that the two statues have been wrongly identified. This explanation is untenable, and it is likely that the secondary interpretation of the figures as the Active and the Contemplative Life arises from a misreading of their imagery. The dubious hypothesis is, however, advanced by I. Lavin (in *Art Bulletin*, xlvii, 1965, pp. 378-83) 'that it was the idea of a contrast between the two tombs that preexisted, and that what Michelangelo cared not very much about was who was buried where'.

NIGHT. L. 194 cm. The area above the mask and the left arm below the shoulder are unfinished. The pose is related to that of the Leda executed in 1529-30 for Alfonso d'Este, and appears to depend from a figure in a lost Leda sarcophagus in the Domus Corneliorum in Rome, recorded in the sixteenth-century Codex Pighianus (for this see Michaelis, 'Michelangelos Leda und ihr antikes Vorbild', in *Strassburger Festgrüsse an A. Springer*, Stuttgart, 1885, pp. 31 ff). Doni (*I Marmi*, iii, Venice, 1552, p. 23) records that the original left arm of the figure was spoiled, and was then recarved in its present position by Michelangelo: 'la Notte

riposì giù la testa, & nel muover che la fece la guastò la prima attitudine del sinistro braccio, che Michelagniolo gli haveva sculpito, cosi fu forzato a rifarne un'altro come voi vedete, in un'altra attitudine che stessi più vaga, più comoda, e meglio; che da se aconciata non s'era . . . ' (Night inclines her head downwards. When the figure was being moved, the left arm, in the original position in which Michelangelo had carved it, was damaged; he was thus compelled to make a new one, as you see, in a different position, and this is more graceful, more apt and better than it was before). Doni's evidence is accepted by Kriegbaum, and is associated by him with an enquiry made by the Pope in 1526 (see above) as to a statue reported to have been damaged. The condition of the top of the mask tends to substantiate this tradition. The diadem worn by the figure is decorated with the moon and stars, and beside it is an owl, an unfinished garland (perhaps of poppies) and a mask, interpreted alternatively as symbolic of dreams (Steinmann) and deceit (Panofsky). The figure is described by Fichard in 1536 as a Minerva.

DAY. L. 185 cm. The head and right hand are unfinished. As has been widely observed, the pose derives from the Belvedere torso. The Day is shorter and larger in scale than the other three Allegories, and like the Night is constructed with an almost flat base which has been roughly adapted to the form of the sarcophagus lid. It was argued by Grimm ('Die Sarkophage der Sacristei von San Lorenzo', in *Jahrbuch der Preuszischen Kunstsammlungen*, i, 1880, pp. 17–29) that the volutes of the lid of the sarcophagus of Giuliano de' Medici were originally to have had the form of those of the Paul III monument of Guglielmo della Porta. This point was subsequently taken up by Petersen ('Zu Meisterwerken der Renaissance', in *Zeitschrift für Bildende Kunst*, i, 1906, pp. 179–87) and Gottschewski (in *Mitteilungen des Kunsthistorischen Institutes in Florenz*, i, 1911, p. 81), who inferred first that the Day and Night were earlier than the Morning and Evening, second that they were intended to be set horizontally and face to face, third that they were therefore carved for the Magnifici sarcophagi shown on a drawing in the British Museum, and fourth that they offered evidence for a radical change in the planning of the monuments at a relatively late stage. This theory was subsequently revived by Kriegbaum. The view that the two Allegories were made for any other monument than that of Giuliano de' Medici cannot be seriously entertained in face (i) of a well-known prose fragment by Michelangelo in which the statue of Giuliano is associated with the Night and Day, and (ii) of a drawing by a garzone of Michelangelo in the Archivio Buonarroti (X, f. 627v.) published by Tolnay. On the other hand, the attempt to explain the disparity between the Night and Day and the Morning and Evening in aesthetic terms (Riegl, Wölfflin), or as a contrast between 'rotatory movement' and 'downward flowing movement' (Tolnay) are unconvincing, and the different form and scale of the two pairs of figures are consistent only with the view that the Day and Night were carved before the Morning and Evening at a time when the form of the sarcophagus lids had not been finally decided on. Whereas the Night, Morning and Evening are uniform in so far as they are designed to be set at their present heights, in the Day a lower viewpoint is postulated. There is a presumption, therefore, that it was executed earlier than the other figures.

MORNING. L. 203 cm. The feet and the sheet beneath the figure are unfinished. The figure was presumably in large part complete by the end of September 1531, since Giovanbattista di Paolo Mini in a letter of 29 September to Bartolomeo Valori (Gaye, ii, pp. 228–30) mentions a visit to the Chapel to see 'le dua femine'. The veil is interpreted by Steinmann as a symbol of mourning. Interpretations of the figure vary between those of Justi, who describes it as greeting the day, and Ollivier, who writes: 'Warum, o mein Gott, scheint sie zu sagen, machst du die Nacht nicht ewig?' Both the Morning and Evening are set diagonally on the sarcophagus lid. It is assumed by Tolnay that this is the placing intended by Michelangelo: it is possible, however, that the figures were originally designed to be set parallel with the wall.

EVENING. L. 195 cm. The head, hands and feet are incomplete. Classical sources for the figure are noted by Stendhal and Cicognara. Kriegbaum ('Michelangelo und die Antike', in *Zur Florentiner Plastik des Cinquecento*, Munich, n.d.) observes that there is no authority in Michelangelo's written works for the identification of this and the companion figure as Morning and Evening, and that the designation is a 'typisch höfische und sehr allgemeine Ausdeutung' which originates with Vasari. Since it appears during Michelangelo's lifetime in the first edition of Vasari's *Vite* (1550) and is not contradicted by Condivi, it cannot be dismissed.

VIRGIN AND CHILD. H. 226 cm. The block from which the Virgin and Child for the Magnifici monument was to be carved is mentioned for the first time in 1521. Three drawings of a scheme for the Magnifici tombs by garzoni of Michelangelo in Oxford, the Uffizi and the Louvre show a seated Virgin with the Child standing in front of her in a pose developed from that of the Bruges Madonna. That this scheme corresponds with Michelangelo's intention is confirmed by a summary autograph sheet in the British Museum. It has been argued (best analysis by Kriegbaum) that the present group was evolved from the group shown in these drawings. This is improbable, because the group shown in the drawings was clearly intended for a rectangular niche and shows a general correspondence with the Capitani statues, whereas the present group is asymmetrical. Technical and formal resemblances to the Victory suggest the possibility that it was carved about 1521–3 for the tomb of Pope Julius II, and may have been introduced only at a late stage into the Medici Chapel in substitution for a Madonna figure work on which had been broken off. In 1549 (Doni) it was not in the Chapel, like the other figures destined for this complex, but was in the artist's workshop. It is, however, described in the Chapel in 1550 by Vasari. The group, the scheme of which depends in reverse from the Vatican Penelope, is wrongly regarded by W. Friedlaender ('Die Entstehung des antiklassischen Stiles', in *Repertorium für Kunstwissenschaft*,

xlvii, 1925, pp. 55 ff.) as evidence of the influence on Michelangelo of Florentine Mannerist painting.

CROUCHING YOUTH. Hermitage, Leningrad. H. 58 cm. The figure, which appears originally to have been in Medici possession, was transferred to the Hermitage in 1851. It is connected by Popp with a drawing for the Magnifici tombs in the British Museum (Wilde, No. 27r), which shows two crouching youths facing each other in profile above the entablature on the left. Wölfflin regards the profile of the figure as its main view; this is debatable. An early dating ca. 1497–1500 proposed by Frey is rejected by Popp and Tolnay in favour of a dating ca. 1524. A dating ca. 1525–6 is proposed by Kriegbaum. It is supposed by Tolnay that garzoni worked on the feet, hands and hair, and by Wittkower (in *Burlington Magazine*, lxxviii, 1941, p. 133) that the figure is by Pierino da Vinci. The latter attribution is untenable. It is possible, however, that the figure was worked on by Tribolo. The subject is identified as a mourning genius (Tolnay), and, less plausibly, as a tired warrior (Kriegbaum). If the figure were worked up by a pupil from a model by Michelangelo, it is likely to date from 1533–4. An unfinished crouching female figure in left profile (H. 56 cm.), published by Kieslinger ('Ein unbekanntes Werk des Michelangelo', in *Jahrbuch der Preuszischen Kunstsammlungen*, xlix, 1928, pp. 50–4) was possibly designed for a position above the entablature on the right side of the tomb.

RIVER GOD. Accademia, Florence. L. 180 cm. The figure, which is made of stucco or unbaked clay, is headless; the right arm is severed above the elbow, and the right leg beneath the knee. It is known that in 1549 two models for figures of River Gods were shown beneath the tomb of Lorenzo de' Medici in the Medici Chapel; the evidence for this derives from A. F. Doni (*I Marmi*, iii, Venice, 1552, p. 24), where the question is asked 'Che stupendo bozze di terra sono queste qui basse?' and the reply is given 'Havevano a essere due Figuroni di marmo che Michelagniolo voleva fare'. A model of a River God by Michelangelo four braccia in length was presented by Ammanati to the Accademia in 1583, and is presumably identical with the present figure, which was discovered in the Accademia in 1906. The length of the figure when complete would have been of the order of four braccia (240 cm.). It is, moreover, known from a Medici inventory of 1553 (Gottschewski, 'Ein Flussgott Michelangelos', in *Zeitschrift für Bildende Kunst*, i, 1906, pp. 189–93) that the Medici collection included 'un torso di bronzo ritratto da un Fiume di mano di Michelagnolo'. Two small bronze variants of the present model are in the Bargello. The authenticity of the model is, however, doubted by Frey and Popp, by the latter of whom it is ascribed to Ammanati. The present model is for the River God on the left side of the tomb of Lorenzo de' Medici. A working drawing for the figure of a River God in the British Museum (1859-6-25-544, Wilde, No. 35) is identified (Popp, Wilde) as a study for the figure projected for the right side of the tomb of Giuliano de' Medici. This sheet can be dated to the autumn of 1525. A letter of Michelangelo to Fattucci of 24 October 1525 (Milanesi, p. 450) explains that at that time the River Gods had not been begun

'perchè non ci sono e' marmi'. It is observed by Wilde that the figure in the drawing is larger than that in the model, and that a decision to increase the size of the River Gods may have been taken by Michelangelo in 1525, thus necessitating the procurement of new blocks. In this event the Accademia model would date from 1524.

OTHER SCULPTURES

It has also been argued (Popp) that the Apollo of Baccio Valori in the Bargello was originally carved as a figure of David for a niche in the upper part of the Magnifici tomb, and that the Active Life and Contemplative Life utilised for the final version of the Julius II tomb depend from the figures planned for the lateral niches of the Lorenzo de' Medici monument. The first of these hypotheses is improbable, but it is possible (Wilde) that the Active Life (though not the companion figure) was begun for the Lorenzo de' Medici tomb.

Interpretation and Iconography

The principal sixteenth-century sources for the interpretation and iconography of the Medici Chapel are as follows:
(A) Condivi (1553): 'Il che intendendo Michelagnolo, uscì fuore e, sebbene era stato intorno a quindici anni che non aveva tocchi ferri, con tanto studio si messe a tale impresa, che in pochi mesi fece tutte quelle statue che nella Sagrestia di San Lorenzo si veggiono, spinto più dalla paura che dall'amore. È vero che nessuna di queste ha avuta l'ultima mano; però son condotte a tal grado, che molto bene si può veder l'eccellenza dell'artefice, nè il bozzo impedisce la perfezione e la bellezza dell'opera . . . sopra i coperchi delle quali giacciono due figurone, maggiori del naturale, cioè un uomo e una donna, significandosi per queste il Giorno e la Notte, e per ambedue il Tempo, che consuma il tutto. E perchè tal suo proposito meglio fosse inteso, messe alla Notte, ch'è fatta in forma di donna di meravigliosa bellezza, la civetta ed altri segni a ciò accomodati; così al Giorno le sue note. E per la significazione del Tempo voleva fare un topo, avendo lasciato in sull'opera un poco di marmo, il qual poi non fece, impedito; perciocchè tale animaluccio di continuo rode e consuma, non altrimenti che'l Tempo ogni cosa divora. Ci son poi altre statue, che rappresentano quelli, per chi tai sepolture furon fatte, tutte in conclusione divine, più che umane; ma sopra tutte una Madonna, col suo figliuolino a cavalcioni sopra la coscia di lei, della quale giudico esser meglio tacere che dirne poco; però me ne passo' (When Michelangelo heard this he came forth, and although it was fifteen years since he had touched a chisel, set about the undertaking with such zeal, that he made within a few months all those statues which are to be seen in the Sacristy of S. Lorenzo, spurred on more by fear than by love. It is true that none of these statues have received their final touch; but they have been brought to such a pitch, that the excellence of the craftsman can be seen, and their sketchy condition does not prevent the work from being beautiful and perfect . . . above the lids of the tombs lie two great figures, over life-size, one man and one woman; by these he represented Day and Night, and, by the two together, Time, which consumes everything. So that his meaning might be better

understood, he gave to Night, who is made in the form of a woman of marvellous beauty, the owl and other attributes proper to her; and to Day, his. To signify Time he intended to carve a mouse, and had left a small piece of marble for it on the work, but he did not make it later, as he was prevented from it; he intended to do this because that little animal gnaws and consumes continually, just as Time devours everything. There are also other statues, representing those for whom the tombs were made; all of them are more divine than human, but especially a Madonna, with her little son astride her thigh. I think it is better to say nothing about this than to say little, so I will pass on). It is established by Panofsky ('The Mouse that Michelangelo failed to carve,' in *Essays in Memory of Karl Lehmann*, New York, 1964, pp. 242–251) that precedents for the mouse referred to in this passage occur in Etruscan paintings.

(B) Vasari (1550): 'chiamato Michele Agnolo (papa Clemente) e ragionando insieme di molte cose, si risolsero cominciar la sagrestia nuova di S. Lorenzo di Fiorenza. Laonde partitosi di Roma voltò la cupola, che vi si vede . . . Fecevi dentro quattro sepolture per ornamento nelle facce per li corpi de padri de' due Papi Lorenzo Vecchio e Giuliano suo fratello, e per Giuliano fratel di Leone, et per il Duca Lorenzo suo nipote' (Pope Clement summoned Michelangelo and they discussed many things together, deciding to begin the new sacristy of S. Lorenzo in Florence. Michelangelo therefore departed from Rome, and raised the cupola that is to be seen there. . . . Inside he made four tombs, to decorate the walls and to contain the bodies of the fathers of the two Popes, the elder Lorenzo and his brother Giuliano, and also for Giuliano, Leo's brother, and for Duke Lorenzo, his nephew). Vasari goes on to describe the architecture of the chapel ('Onde gli artefici gli hanno infinito et perpetuo obligo; avendo egli rotti i lacci et le catene delle cose, che per via d'una strada comune eglino di continuo operavano') (Therefore craftsmen owe him an infinite and everlasting debt; for he broke the bonds and chains on account of which they had always worked along a groove of convention), and the sculptures ('l'una è la Nostra Donna, la quale nella sua attitudine sedendo manda la gamba ritta addosso alla manca, con posar ginocchio sopra ginocchio: et il putto inforcando le cosce in su quella che è più alta, si storce con attitudine bellissima in verso la madre, chiedendo il latte, et ella con tenerlo con una mano, et con l'altra appoggiandosi si piega per dargliene, ancora che non siano finite le parti sue, si conosce nell'esser rimasta abozzata e gradinata, nella imperfezzione della bozza, la perfezzione dell'opra . . . egli pensassi, che non solo la terra fussi per la grandezza loro bastante a dar loro onorata sepoltura: ma volse che tutte le parti del mondo vi fossero, et che gli mettessero in mezo et coprissero il lor' sepolcro quattro statue: a uno pose la notte et il giorno; a l'altro l'Aurora et il crepuscolo. Le quali statue sono con bellissime forme di attitudini et artificio di muscoli lavorate, convenienti se l'arte perduta fosse a ritornarla nella pristina luce . . . Ma che dirò io de la Aurora femmina ignuda et da fare uscire il maninconico dell'animo, et smarrire lo stile alla scultura: nella quale attitudine si conosce il suo sollecito levarsi sonnacchiosa, svilupparsi da le piume, perchè par' che nel destarsi ella abbia trovato serrati gl'occhi, a quel gran Duca. Onde si storce con amaritudine,

dolendosi nella sua continovata bellezza in segno del gran dolore . . . Notte . . . conoscendosi non solo la quiete di chi dorme, ma il dolore et la maninconia di chi perde cosa onorata et grande') (One is Our Lady, who is in a sitting attitude, with her right leg over her left and one knee on the other; and the Child, with his thighs astride the upper leg, turns with a most beautiful attitude towards his Mother, seeking milk. She, holding him with one hand and supporting herself with the other, leans forward to give it to him; and, although not all the parts of the figure are finished, one recognises the perfection of the work even in its sketchy state and with the marks of the chisel on it . . . he considered that earth alone was not sufficient to give them honourable burial equal to their greatness; he wished all the parts of the world to be there, and their tombs to be surrounded and covered by four statues. On one he put Night and Day, on the other Dawn and Dusk. These statues are worked with the most beautifully formed attitudes and skilful treatment of the muscles, and would be sufficient, if art were lost, to bring it back to its former glory . . . But what shall I say of the Dawn, a nude woman, such as to rouse melancholy in the soul and overthrow the style of sculpture? One can see in her attitude the effort to rise, heavy with sleep, and unfold herself from her bed; and she seems, in waking, to have found the eyes of the great Duke closed. Therefore she is tormented with bitter sadness, grieving in unchanging beauty in token of great sorrow . . . In Night . . . one recognises not only the stillness of someone sleeping, but the sorrow and melancholy of a person who has lost something great and honoured).

(C) Niccolò Martelli in a letter of 28 July 1544 (*Il primo libro delle lettere di Niccolò Martelli*, Florence, 1546) relating to the statues of the two Capitani: 'Havendo (Michelangelo) . . . a scolpire i Signori illustri della felicissima casa de' Medici, non tolse dal Duca Lorenzo, ne dal Sig. Giuliano il modello apunto come la natura gli avea effigiati e composti, ma diede loro una grandezza, una proportione, un decoro . . . qual gli parea che più lodi loro arrecassero, dicendo che di qui a mille anni nessuno non ne potea dar cognitione che fossero altrimenti' (When Michelangelo . . . had to carve the noble lords of the fortunate house of Medici, he did not use as his models Duke Lorenzo and Lord Giuliano as Nature had portrayed and composed them, but rather gave them a size, proportion and beauty . . . which he thought would bring them more praise; for, he said, in a thousand years nobody would know they had been different).

(D) Varchi (*Due Lezioni*, Florence, 1549, p. 117): 'Ma chi potrà mai non dico lodare, ma meravigliarsi tanto, che baste dell' ingegno, et del giudizio di questo huomo? che devendo fare i sepolcri al Duca di Nemors, & al Duca Lorenzo de' Medici, spresse in quattro marmi, à guisa, che fa Dante ne' versi, il suo altissimo concetto, percio che volendo (per quanto io mi stimo) significare, che per sepolcro di ciascuno di costoro, si conveniva non solo un'Emisperio, ma tutto'l Mondo, ad uno pose la Notte, e'l giorno, & à l'altro l'aurora, e'l crepuscolo, che gli mettessero in mezzo, & coprissero, come quegli fanno la terra; la qual cosa fu medesimamente osservata in piu luoghi da Dante' (Who could ever sufficiently, not just praise, but wonder at the genius and judgement of this man? For, when he had to make the tombs of the Duke of Nemours and Duke Lorenzo de'

Medici, he expressed his high conception in four marbles, in the same way as Dante does in his verses. He intended, I think, to signify that not just a hemisphere, but rather indeed the whole world, was proper tomb for each one of them. By one he put Night and Day, by the other Dawn and Dusk, stationed on each side of them, and covering them as they cover the earth. Dante made the same observation in several places).

(E) Gandolfo Porrini in a poem cited by Varchi (loc. cit.), the last lines of which refer to the subjects of the River Gods:

'E i Magnanimi Re del Tebro & d'Arno
I gran sepolcri aspettaranno indarno.'
(The noble kings of the Tiber and Arno
The great tombs will await in vain.)

(F) Borghini (Il Riposo, Florence, 1584): 'Inventione ben osservata si può chiamar quella di Michelangnolo nella bellissima figura da lui per la Notte finta; percioche oltre al farla in atto di dormire, le fece la luna in fronte, e l'uccello notturno a' piedi; cose che dimostrano la Notte, se bene altramente la dipinsero gli antichi; conciosiache la fingessero una donna con due grandi ali nere con ghirlanda di papaveri in capo . . . piu propria al pittore che allo statuario' (One may call Michelangelo's invention in the beautiful figure representing Night well-considered. As well as showing her sleeping, he made a moon on her forehead and an owl at her feet. These things identify Night, even though the ancients depicted her differently: they represented her as a woman with two great black wings and a wreath of poppy on her head . . . more suitable for a painter than a sculptor). Borghini elsewhere refers to the 'figure giacenti con bellissime attitudini, le quali comeche sieno di marmo, di vera carne appariscono, e lo spirito sol manca loro, e niente più' (reclining figures in beautiful attitudes; though of marble, they seem to be of real flesh, and they only lack breath, nothing else).

(G) A prose fragment of Michelangelo on a drawing in the British Museum for the tomb of the Magnifici (Frey, Dichtungen, XVIII; Girardi, Rime, 13) apparently dating from 1520–21: 'La fama tiene gli epitafi a giacere; non va ne inanzi ne indietro, perche son morti, e e' loro operare e fermo' (Fame holds the epitaphs, reclining; it moves neither forward nor backward, because they are dead, and their action is stilled).

(I) An epigram written by Giovanni di Carlo Strozzi, with a reply by Michelangelo (Frey, Dichtungen, CIX 17; Girardi, Rime, 247) dating from 1545–46:

La Notte, che tu vedi in sì dolci atti
dormir, fu da un Angelo scolpita
in questo sasso, e, perchè dorme, ha vita;
Destala, se nol credi, e parleratti.
Caro m'è'l sonno et più l'esser di sasso
Mentre che'l danno et la vergogna dura;
Non veder, non sentir m'è gran ventura
Però non mi destar, deh, parla basso.

(Night, seen sleeping here in such sweet attitude, was carved by an Angel in this stone; and since she sleeps, she must have life. If you do not believe it, wake her and she will speak to you.

Sleep is dear to me, and being stone is even more so, as long as misfortune and dishonour remain. Not to see, not to hear, is great good fortune for me. So do not wake me: speak low.)

In the nineteenth and twentieth centuries the iconography of the Medici Chapel has been interpreted on many different lines. It has been regarded as a political allegory, has been treated subjectively (Justi), and has been related to Ambrosian hymns (Brockhaus), to a carnival song (Steinmann; for the case against the latter view see Wickhoff, Abhandlungen, Vorträge, und Anzeigen, ii, Berlin, 1913, pp. 385–7), and to the Phaedo of Plato (Oeri). In recent times emphasis has been placed on a Neoplatonic interpretation, which was first advanced by Borinski (Die Rätsel Michelangelos, Munich, 1908), and has been elaborated by subsequent students, notably Tolnay and Panofsky. According to the former, the Chapel represents 'an abbreviated image of the universe, with its spheres hierarchically ranged one above the other', the zone of the River Gods representing Hades, the intermediate zone of the allegories and effigies the terrestrial sphere, and the upper zone of the lunettes and cupola the celestial sphere. In this interpretation the eight doors of the Chapel, five of which are blind, become the doors of Hades, and the four Rivers of Hades are represented beneath the tombs. The tomb architecture is an idealised palace façade, 'the house of the dead decorated with the emblems of death', and the frieze of laughing masks is 'a symbol of derision of the fear of death'. The two seated figures depict the immortal souls of the two Capitani in 'calm stoic contemplation of the supreme truth', and mark a break with the tradition of portrait naturalism in so far as they do not portray the empirical personalities of the two Dukes. The nude figures destined for the lateral niches of the Giuliano de' Medici tomb would have shown the two contrasting souls of man, or the genii of the Capitani. Tolnay's interpretation of the Allegories differs from Panofsky's in that it retains an element of nineteenth-century subjectivism. Thus with the Morning 'physical lassitude seems to paralyse her. . . . The awakening of someone who is aware of the futility of existence and of the trials which await him at the new day'; the Evening 'has abandoned all vain struggle. . . . The pose and the forms of the body incarnate directly a psychic condition'; for the Night 'sleep is not repose, but unfulfilled desire'; and the Day 'an incarnation of physical eruption, and not merely a body animated by anger'.

For Panofsky each of the tombs also depicts 'an apotheosis as conceived by Ficino and his circle: the ascension of the soul through the hierarchies of the Neoplatonic universe'. The River Gods once more represent the Rivers of Hades, 'the fourfold aspect of matter enslaving the human soul at the moment of birth', and the four Allegories of the times of day again represent the terrestrial world. In Panofsky's reading, however, as in that of Steinmann, both River Gods and Times of Day have secondary meanings, the former as denoting the four elements, or the fourfold aspect of matter as a source of potential evil, and the latter as denoting the four humours, whereby the conception of life on earth as a state of actual suffering is transmitted through an 'impression of intense and incurable pain'. Panofsky adopts Tolnay's interpretation of the statues of the

Capitani, as depicting the antithesis between the active and the contemplative life. The trophies originally destined for the monuments are regarded by Panofsky as symbols of ultimate triumph over the lower forms of existence; the crouching children presumed to have stood on the architrave present 'unborn souls destined to descend into the lower spheres'; and the empty thrones indicate 'the invisible presence of an immortal'. In a later restatement of this interpretation (*Tomb Sculpture: four lectures on its changing aspects from Ancient Egypt to Bernini*, New York, 1964, pp. 90–93) stronger emphasis is thrown upon the empty thrones, 'an obvious reference to the Roman ceremony known as *sellisternium*, wherein an empty throne was held in readiness for gods and, after the death of Caesar, for deified emperors.'

There is no evidence in contemporary sources that the monuments should or can be interpreted along these lines. The only contemporary reference to the River Gods (see E above) states that these represented the Tiber and Arno, and it is known that this imagery was also employed at the investiture of Giuliano de' Medici in 1513 (Altieri, op. cit., p. 28: 'Nell' intavolatura, sopra la man destra, era un immagine e quella molto eccessiva dello Dio Tiberino di grandezza, bellezza et artificio si dimostrava di eccellente e singolare magisterio. Dalla man sinistra l'immagine del Fiume Arno d'ornato et artificio coeguale al detto Tiberino'). The celestial zone, with its frescoed lunettes, is wholly conjectural. There is, moreover, no reason to doubt the statement of Vasari that Earth and Heaven were represented in the projected lateral figures of the Giuliano tomb, the less so that they are named by Michelangelo in an autograph sheet in the Archivio Buonarroti (Frey, No. 162). Contemporary warrant is supplied by Condivi and Vasari for interpreting the four Allegories as the Times of Day, with specific reference to the corrosive effects of time, but there is no contemporary warrant for any secondary interpretation. The two Dukes are represented in classical armour as Captains of the Church. According to Niccolò Martelli, both likenesses were idealised in a form which the sculptor thought appropriate for posterity; in all probability this type of portraiture was inspired not by a wish to portray the soul but by the generalised images in antique portrait statues. As noted by Tolnay, the classicising decorative detail (dolphins, garlands, oil jars, shells, trophies and masks) has throughout a funerary character. Panofsky relates the empty thrones to thrones used in expiatory ceremonies in ancient Rome.

Plates 36, 37: THE LAMENTATION OVER THE DEAD CHRIST
Duomo, Florence

The Lamentation over the Dead Christ in the Duomo in Florence is mentioned in the first edition of Vasari's *Vite* (1550), and must thus have been begun before that year. It is described in 1553 by Condivi in the following terms: 'Ora ha per le mani un' opera di marmo, qual egli fa a suo diletto, come quello che pieno di concetti, è forza che ogni giorno ne partorisca qualcuno. Quest'è un gruppo di quattro figure più che al naturale, cioè un Cristo deposto di croce, sostenuto così morto dalla sua Madre. La quale si vede sottentrare a quel corpo col petto, colle braccia e col ginocchio in mirabil atto, ma però aiutata di sopra da Nicodemo, che ritto e fermo in sulle gambe lo solleva sotto le braccia, mostrando forza gagliarda, e da una delle Marie della parte sinistra. La quale ancor che molto dolente si dimostri, nondimeno non manca di far quell'uffizio, che la Madre per lo estremo dolore prestar non può. Il Cristo abbandonato casca con tutte le membra relassate, ma in atto molto differente e da quel che Michelangnolo fece per la Marchesana di Pescara e da quel della Madonna della Febbre. Saria cosa impossibile narrare la bellezza e gli affetti, che ne' dolenti e mesti volti si veggono, sì di tutti gli altri, sì dell'affannata Madre; però questo basti. Vo' ben dire ch'è cosa rara, e delle faticose opere, che egli fino a qui abbia fatte; massimamente perchè tutte le figure distintamente si veggono, nè i panni dell'una si confondono co' panni dell'altre' (He has in hand at present a marble work which he is doing for his own pleasure; for a man who is full of ideas is forced to work at something every day. It is a group of four figures, over life-size: a Christ taken down from the Cross and held up, dead as he is, by his Mother. She is shown sinking under the weight of the body, with her breast, arms and knee in an admirable attitude; but she is being helped from above by Nicodemus, who is upright and steady on his legs, and supports the body under the arms, showing a robust strength. And the Virgin is also assisted by one of the Marys, on the left; she, although she is shown full of grief, does not fail to fulfil that duty which the Mother, on account of her great grief, cannot. The dead Christ falls with all his limbs relaxed, but in an attitude very different from that Michelangelo made for the Marchioness of Pescara and from that of the Madonna della Febbre. It would be impossible to describe the beauty and emotions which show in the sad and grieving faces, both of the afflicted Mother and of all the others; so let this be enough. I would say that it is a rare object, and one of the most painstaking works he has yet made, above all because all the figures are distinctly visible, and the drapery of one figure does not mingle with the drapery of another). The description of the group in the 1568 edition of Vasari's *Vite* follows a letter of 1564 and is as follows: 'Lavorava Michelagnolo, quasi ogni giorno per suo passatempo, intorno a quella Pietà che s'è già ragionato, con le quattro figure; la quale egli spezzò in questo tempo per queste cagioni: perchè quel sasso aveva molti smerigli, ed era duro, e faceva spesso fuoco nello scarpello, o fusse pure che il giudizio di quello uomo fussi tanto grande, che non si contentava mai di cosa che e' facessi: e che e' sia il vero, delle sue statue se ne vede poche finite nella sua virilità. . . . Questa Pietà, come fu rotta, la donò a Francesco Bandini. In questo tempo Tiberio Calcagni, scultore fiorentino, era divenuto molto amico di Michelagnolo per mezzo di Francesco Bandini e di messer Donato Giannotti; ed essendo un giorno in casa di Michelagnolo, dove era rotta questa Pietà, dopo lungo ragionamento li domandò per che cagione l'avessi rotta, e guasto tante maravigliose fatiche; rispose, esserne cagione la importunità di Urbino suo servidore, che ogni dì lo sollecitava a finirla; e che, fra l'altre cose, gli venne levato un pezzo d'un gomito della Madonna, e che prima ancora se l'era recata in odio, e ci aveva avuto molte disgrazie

attorno di un pelo che v'era; dove scappatogli la pazienza la roppe, e la voleva rompere affatto, se Antonio suo servitore non se' gli fussi raccomandato che così com' era gliene donassi. Dove Tiberio, inteso ciò, parlò al Bandino che desiderava di avere qualcosa di man sua; ed il Bandino operò che Tiberio promettessi a Antonio scudi 200 d'oro e pregò Michelagnolo che se volessi che con suo aiuto di modelli Tiberio la finissi per il Bandino, saria cagione che quelle fatiche non sarebbono gettate in vano; e ne fu contento Michelagnolo: là dove ne fece loro un presente. Questa fu portata via subito, e rimessa insieme poi da Tiberio, e rifatto non so che pezzi; ma rimase imperfetta per la morte del Bandino, di Michelagnolo e di Tiberio. Truovasi al presente nelle mani di Pierantonio Bandini, figliuolo di Francesco, alla sua vigna di Montecavallo' (Michelangelo used to work almost every day, as a pastime, on the Pietà with four figures, of which I have already spoken. He broke it to pieces at this time, either because the stone was difficult to work and hard, and often sparked under the chisel, or because his judgement was so great that he was never content with anything he made. This is shown to be true by the fact that there are few finished statues of his to be seen from the period of his maturity. . . . He gave this Pietà, when it was broken, to Francesco Bandini. At this time Tiberio Calcagni, a Florentine sculptor, had become a great friend of Michelangelo through Francesco Bandini and Donato Giannotti. One day he was in Michelangelo's house, where the broken Pietà was, and after a long conversation asked him why he had broken it up and destroyed such marvellous work. He replied that the reason was the importunity of his servant Urbino, who had been urging him every day to finish it; and that, among other things, a piece of one of the elbows of the Madonna had broken away, and even before that he had taken a dislike to it, and had had many mishaps with it on account of a flaw. For these reasons he had lost patience and broken it, and he would have broken it up completely if his servant Antonio had not begged him to give it to him as it stood. When Tiberio heard this, he spoke to Bandini, who wished to have something from Michelangelo's hand; and Bandini had Tiberio promise Antonio 200 gold scudi, and begged Michelangelo to let Tiberio finish it for him with the help of his models, pointing out that in this way his labours would not be wasted. Michelangelo agreed to this, and gave it to them. It was taken away at once, and then put together again and reconstructed by Tiberio with I know not how many new pieces; but it was left unfinished through the deaths of Bandino, Michelangelo and Tiberio. At present it is in the hands of Pierantonio Bandini, Francesco's son, at his villa on Monte Cavallo). Urbino died on 3 December 1555, and the incident reported by Vasari must therefore have occurred before this year. A letter from Vasari to Lionardo Buonarroti of 18 March 1564 (Frey, *Vasaris Literarischer Nachlass*, No. CDXXXVI) states that the group was intended by Michelangelo for his own monument in Santa Maria Maggiore: 'E venutomi consideratione, che Michelagniolo, dudita io, et che lo sa anche Daniello et messer Tomao Cavalieri et molti altri suoi amici, che la pietà delle cinque figure, chegli roppe, la faceva per la sepoltura sua; et vorrei ritrovare, come suo erede, in che modo laveva il Bandino: Perche se la ricercherete per servirvene per detta sepoltura, oltre

che ella e disegniata per lui, evvi un vechio che egli ritrasse se, non sendo stato poi tolta da Tiberio, procurerei di averla et me ne vorrei servire per cio' (It has occurred to me that Michelangelo made, I think, the Pietà with five figures, the one which he broke up, for his tomb; Daniello and Messer Tomaso de' Cavalieri and many other friends of his know this too. You should discover, as his heir, how Bandini came to have possession of it. If you seek it out to use it for the tomb, quite apart from its being designed for that, there is an old man in it which is a self-portrait, if it was not removed by Tiberio. Try and get it, and do make use of me for that purpose). Among the advantages of this proposal, according to Vasari, were the facts (i) that Michelangelo had intended the group for his own tomb, and (ii) that if the Pietà were handed over for the monument, Cosimo I would be left with the contents of Michelangelo's Florentine studio. Pierantonio Bandini refused, however, to respond to this appeal, and in 1652 the group was still in the Bandini villa. Between this date and 1674 it was moved to Florence at the instance of Cosimo III, who refused to allow it to be installed in the Medici Chapel, and instead placed it in the crypt of San Lorenzo. In 1721 it was installed behind the high altar of the Duomo in substitution for the Adam and Eve of Bandinelli, and in the 1930s was moved to its present position on an altar in the north transept of the Cathedral. It was transferred to the Accademia in 1946 for cleaning, and was replaced behind its altar in 1948 in a different position in which the front left corner projects and the placing is no longer determined by the front plane of the block (for this see P. Pavlinov, 'La sistemazione della Pietà di S. Maria del Fiore e il metodo creativo di Michelangelo,' in *Arte Lombarda*, x, 1965, p. 115–142). A statement of Kriegbaum (p. 42) that the sculpture was in the master's workshop at the time of his death is incorrect. Parts of the group are considerably broken, and there is no unanimity of view as to whether certain of these are original parts that have been replaced or additions by Calcagni. Both arms appear to be original. Von Einem ('Bemerkungen zur Florentiner Pietà Michelangelos', in *Jahrbuch der Preuszischen Kunstsammlungen*, lxi, 1940, pp. 77–99) reaches an opposite conclusion. There is a repair (presumably by Calcagni) on the breast of Christ and in one finger of the left hand of the Virgin. The left hand of Christ has also been ascribed to Calcagni (Grünwald, Tolnay). It is suggested by Tolnay that the missing left leg of Christ was carved from a separate piece of marble; this would have been highly uncharacteristic of the master. The 'outright carnality of the symbolic slung leg' is discussed by L. Steinberg ('Michelangelo's Florentine *Pieta*: The Missing Leg,' in *Art Bulletin*, 1, 1968, pp. 343–53) and is related, implausibly, to 'a vast mediaeval tradition concerning the erotic association of Christ and the Magdalene.' The group has been extensively modified on the left side, and the whole of the figure of the Magdalen is by Calcagni. D. Levi ('La Tomba della Pellegrina a Chiusi' in *Rivista del R. Istituto d'Archeologia e Storia dell'Arte*, iv, 1932, pp. 9–60) draws attention to a sarcophagus with the Death of Patroclus, now in the Museo Archeologico in Florence and formerly in the Casa Buonarroti, two figures in which present analogies to the Christ and Nicodemus in the present group.

GIOVANNI FRANCESCO RUSTICI
(b. 1474; d. 1554)

Born on 13 November 1474, Rustici is stated by Vasari to have been a pupil of Verrocchio. He was later closely associated with Leonardo da Vinci. His first dated work is a marble bust of Boccaccio in the Collegiata at Certaldo (1503). Between 1506 and 1511 he was engaged on the bronze group of the Preaching of the Baptist over the north entrance to the Baptistry in Florence (see Plates 38, 39 below), and in 1510 he executed a bronze candlestick, also for the Baptistry (lost; sometimes wrongly identified with a candlestick in the Museo Nazionale, Florence). In 1514 he was employed on Verrocchio's Forteguerri Monument for the Duomo at Pistoia, carving or completing the kneeling figure of the Cardinal, and in 1515 he had a share in the decorations for the entry of Pope Leo X into Florence. As a result of these he was commissioned to execute a bronze statuette of Mercury for the Palazzo Medici (see Plate 40 below) and a terracotta statue of David (lost) to replace the bronze David of Donatello which had been moved to the Palazzo della Signoria. On the expulsion of the Medici (1528) he left Florence for France with an introduction from Giovanni Battista della Palla to Francis I. Before leaving Florence he executed an enamelled terracotta altarpiece of the Noli Me Tangere for S. Lucia (identified by Burckhardt and De Nicola with a relief in the Museo Nazionale, Florence) with a lunette of St. Augustine, and a marble tondo of the Virgin and Child with the young Baptist for the Arte della Seta (Fig. 8, identified by De Nicola with a relief in the Museo Nazionale, the attribution of which is rejected by Loeser), both described by Vasari, as well as an altarpiece of the Annunciation and a number of classicising terracotta roundels for the Villa Salviati. Four terracotta groups of fighting horsemen (Louvre, Paris; Museo Nazionale and Palazzo Vecchio, Florence) reflect the influence of Leonardo, to whom they have sometimes been mistakenly ascribed (for these see Loeser). Rustici's principal task in France was an equestrian monument of the King, work on which was suspended at the King's death in 1547. Other works conjecturally ascribed to this phase of his career are a bronze relief known as the Fontainebleau Madonna in the Louvre (Kennedy and Middeldorf), a bronze statue of Apollo with the Serpent Python from Saint-Cloud, also in the Louvre (Valentiner), and a popular bronze statuette of Virtue overcoming Vice (Frick Collection, New York, and elsewhere). The second of these attributions is doubtful, and the third is incorrect. A relief of St. George and the Dragon in Budapest (Middeldorf) is not exactly datable, but finds a point of reference in the Villa Salviati carvings; a number of works in terracotta (Middeldorf) seem to be of earlier date.

BIBLIOGRAPHY: The main source for the activity of Rustici is the life of the sculptor by Vasari. This is supplemented by articles by De Nicola ('Notes on the Museo Nazionale of Florence-I', in *Burlington Magazine*, xxviii, 1915-6, pp. 171-8), Loeser ('Gianfrancesco Rustici', in *Burlington Magazine*, lii,

1928, pp. 260-72), Middeldorf ('New Attributions to G. F. Rustici', in *Burlington Magazine*, lxvi, 1935, pp. 71-81), and Valentiner ('Rustici in France', in *Studies in the History of Art dedicated to W. E. Suida*, 1959, pp. 205-17). M. Ciardi Duprè ('Giovan Francesco Rustici,' in *Paragone*, xxx, 1963, No. 157, pp. 29-50) proposes a largely unacceptable chronology for the undated works and some further misattributions.

Plates 38, 39: ST. JOHN THE BAPTIST PREACHING TO A LEVITE AND A PHARISEE
Baptistry, Florence

Rustici's bronze group (Fig. 39) occupies its original position over the north door of the Baptistry. It shows (*centre*) St. John the Baptist beneath a tabernacle, with (*left*) a Pharisee and (*right*) a Levite. The three figures are raised on circular bronze plinths. The group is described by Vasari in the following terms: 'Per quest'opere essendo venuto in molto credito Giovanfrancesco, i consoli dell'arte de' Mercatanti avendo fatto levare certe figuracce di marmo, che erano sopra le tre porte del tempio di San Giovanni, già state fatte, come s'è detto, nel mille dugento e quaranta, ed allogate al Contucci Sansovino quelle che si avevano in luogo delle vecchie a mettere sopra la porta che è verso la Misericordia; allogarono al Rustico quelle che si avevano a porre sopra la porta che è volta verso la canonica di quel tempio, acciò facesse tre figure di bronzo di braccia quattro l'una, e quelle stesse che vi erano vecchie, cioè un San Giovanni, che predicasse, e fusse in mezzo a un Fariseo ed a un Levite. La quale opera fu molto conforme al gusto di Giovanfrancesco, avendo a essere posta in luogo si celebre e di tanta importanza; ed oltre ciò, per la concorrenza d'Andrea Contucci. Messovi dunque subitamente mano, e fatto un modelletto piccolo, il quale superò con l'eccellenza dell'opera, ebbe tutte quelle considerazioni e diligenza che una si fatta opera richiedeva: la qual finita, fu tenuta in tutte le parti la più composta e meglio intesa, che per simile fusse stata fatta insino allora, essendo quelle figure d'intera perfezione e fatte nell'aspetto con grazia e bravura terribile. Similmente le braccia ignude e le gambe sono benissimo intese, ed appiccate alle congiunture tanto bene, che non è possibile far più: e per non dir nulla delle mani e de' piedi, che graziose attitudini e che gravità eroica hanno quelle teste! Non volle Giovanfrancesco, mentre conduceva di terra quest' opera, altri attorno che Lionardo da Vinci, il quale nel fare le forme, armarle di ferri, ed insomma sempre, insino a che non furono gettate le statue, non l'abbandonò mai; onde credono alcuni, ma però non ne sanno altri, che Lionardo vi lavorasse di sua mano, o almeno aiutasse Giovanfrancesco col consiglio e buon giudizio suo. Queste statue, le quali sono le più perfette e meglio intese che siano state mai fatte di bronzo da maestro moderno, furono gettate in tre

volte, e rinnette nella detta casa, dove abitava Giovanfrancesco nella via de' Martelli; e così gli ornamenti di marmo che sono intorno al San Giovanni, con le due colonne, cornici, ed insegna dell'arte de' Mercatanti. Oltre al San Giovanni, che è una figura pronta e vivace, vi è un zuccone grassotto che è bellissimo; il quale, posato il braccio destro sopra un fianco, con un pezzo di spalla nuda, e tenendo con la sinistra mano una carta dinanzi agli occhi, ha sopraposta la gamba sinistra alla destra, e sta in atto consideratissimo per rispondere a San Giovanni, con due sorti di panni vestito; uno sottile, che scherza intorno alle parti ignude della figura, ed un manto di sopra più grosso, condotto con un andar di pieghe, che è molto facile ed artifizioso. Simile a questo è il Fariseo, perciochè portasi la man destra alla barba, con atto grave si tira alquanto a dietro, mostrando stupirsi delle parole di Giovanni' (After Giovanfrancesco had come into great credit through these works, the Consuls of the Guild of Merchants had certain clumsy marble statues removed, which were above the three doors of the Temple of S. Giovanni and had been made, as I have already said, in 1240; and while they allotted to Contucci Sansovino the job of making those that were to be put in place of the old ones above the door opposite the Misericordia, they allotted to Rustici the ones to be put above the door facing the canonical buildings of that temple, the conditions being that he should make three bronze figures, that they should each be four braccia high, and that they should represent the same persons as the old ones – St. John preaching between a Pharisee and a Levite. This work was much to the taste of Giovanfrancesco, both because it was to be put up in so celebrated and important a place, and because of the competition with Andrea Contucci. So he set his hand to it at once, making a small model which he improved on in the work itself, and took all the thought and pains that such a work demanded; and when it was finished it was considered in every part the best composed and best conceived thing of its kind to be made up to that time, because the figures were altogether perfect and had a graceful and impressively forceful appearance. In the same way, the nude arms and legs are very well conceived, and articulated at the joints so well that it is impossible to do better; and, not to mention the hands and feet, what graceful poise and noble weight have those heads! While he was shaping this work in clay, the only person Giovanfrancesco would have near him was Leonardo da Vinci, who, during the making of the moulds, the strengthening of them with irons, and in fact until the statues were cast never left him; and for this reason some people believe, although they know no more than this, that Leonardo worked on them with his own hand, or at least helped Giovanfrancesco with his advice and good judgement. These statues, which are the most perfect and best conceived ever to have been carried out in bronze by a modern master, were cast in three stages, and cleaned in that house in the Via de' Martelli where Giovanfrancesco lived; and so were the marble ornaments around the St. John, with the two columns, the cornice and the emblem of the Guild of the Merchants. As well as the St. John, which is an alert and lively figure, there is a rather fleshy bald man, who is beautifully done: he has rested his right arm on his hip, with part of his shoulder bare, and, holding in his left hand a piece of paper in front of his eyes, has

crossed his left leg over his right, and stands in a very thoughtful attitude to answer St. John; and he is clad in two kinds of drapery, one of them delicate, playing around the nude parts of the figure, the other a coarser mantle on top, done with a very fluent and clever movement of the folds. Equal to this is the Pharisee, who while he brings his right hand to his beard, draws himself back a little with a weighty movement, showing himself astonished at John's words). The documents relating to the group are published by Milanesi (*Sulla storia dell'arte toscana: scritti varj*, Siena, 1873, pp. 247–61). Two supplementary documents are printed by E. Müller-Walde ('Beiträge zur Kenntnis des Leonardo da Vinci–iii', in *Jahrbuch der Preuszischen Kunstsammlungen*, xix, 1898, pp. 247–9). According to these, the commissioning of the group was first discussed on 3 December 1506 (four years after Andrea Sansovino's Baptism of Christ had been contracted for). The subject of the group, like that of the Baptism of Christ, was dictated by pre-existing marble statues by or from the workshop of Tino di Camaino. The relevant document reads: 'Considerato tre figure di marmo che sono sopra la porta dirimpetto all'opera di San Giovanni di detto tempio, quelle essere tanto goffe e mal fatte a comparazione delle porte et altro cose degne sono in detto tempio, pare che più tosto rechino vergogna stare et esser in detto luogo evidente, che onore e riputazione alla città e vostra Università; et ancora sono tanto consumate che in qualche parte anno cominciato a rovinare et quando dette figure si facessino di bronzo e belle, sarebbono corrispondenti alle porte di bronzo di detta chiesa' (Having considered the three marble figures which stand above that door of S. Giovanni which is opposite its office of works, and the fact that they are so clumsy and ill made in comparison with the doors and other fine things in that temple, it seems that, by standing and being in that conspicuous place, they bring shame rather than honour and fame to the city and to your guild; and besides they are so worn down that they have begun in some places to fall to pieces, and if these figures were beautiful and made of bronze they would be in character with the bronze doors of the church). A contract for the figures (for which see Müller-Walde) was signed on 10 December 1506: 'Mr. Gio. franc° l'anno 1506 sotto dì 10 Dicembre rog° Ser Gio. Gherardini còuenne di fare tre figure di bronzo per douersi porre sopra la Porta di S. Gio. rincontro all'Opera ed hauerle finite in due anni libro d° 266. Se li paga f. 700 l'anno 1524 per de figure libro d° 64' (Master Giovanni Francesco, 10 December 1506, witness Giovanni Gherardini, undertook to make three bronze figures to be put up above the door of S. Giovanni opposite the Opera, and to have finished them within two years. . . . In 1524 he was paid 700 florins for these figures. . . .).On 9 March 1509, when the two year time limit had already expired, the sculptor was granted an extension of time in which to complete the statues. Terracotta models were ready for casting in bronze by 18 September 1509, when a contract for casting was entered into by the sculptor with Bernardino da Milano. The group was installed and exhibited on 24 June 1511. Payment for the group, to a total of 1200 florins, was not completed until 21 January 1523. The date of completion and exhibition is confirmed by Landucci's *Diario*; an attempt of Müller-Walde to advance the date of exhibition is unwarranted. The part

played by Leonardo da Vinci in the planning or production of the statues has not been satisfactorily defined, but in view of the weight of tradition connecting Leonardo's name with them this cannot have been negligible. Thus Vasari, in his life of Leonardo, states: 'E nella statuaria fece prove nelle tre figure di bronzo che sono sopra la porta di S. Giovanni dalla parte di tramontana, fatte da Gio. Franc. Rustici, ma ordinate col consiglio di Lionardo' (And he showed his ability in sculpture in the three bronze figures over the north door of S. Giovanni, which were carried out by Giovan Francesco Rustici, but designed with Lionardo's advice). Leonardo appears to have been in Florence in the first half of 1508, when a note in Arundel Ms. 263 (British Museum) reads: 'cominciato in Firenze in casa Pino di braccio Martelli addì 22 di marzo 1508.' Since the figures were not ready for casting till September 1509, it is possible that Leonardo, in 1508, played a decisive part in determining their form. For analyses of the Leonardesque characteristics of the statues see particularly F. Malaguzzi-Valeri, *Leonardo da Vinci e la scultura*, Bologna, 1922, and K. Clark, *Leonardo da Vinci: an Account of his Career as an Artist*, Cambridge, 1939.

Plate 40: MERCURY
Private Collection

According to Vasari, Rustici was commissioned by Cardinal Giulio de' Medici in 1515 to execute a small figure of Mercury for the fountain in the Cortile of the Palazzo Medici. The commission was prompted by the Cardinal's interest in the decorations made by Rustici for the entry of Pope Leo X into Florence: 'le quali, perchè piacquero a Giulio cardinale de' Medici, furono cagione che gli fece far sopra il finimento della fontana che è nel cortile grande del palazzo de' Medici, il Mercurio di bronzo alto circa un braccio, che è nudo sopra una palla in atto di volare: al quale mise fra le mani un instrumento che è fatto, dall'acqua che egli versa in alto, girare. Imperochè, essendo bucata una gamba, passa la canna per quella e per il torso; onde, giunta l'acqua alla bocca della figura, percuote in quello strumento bilicato con quattro piastre sottili saldate a uso di farfalla, e lo fa girare. Questa figura, dico, per cosa piccola, fu molto lodata' (And as these statues pleased the Cardinal, he therefore had Rustici make, for the top of the fountain in the great court of the Medici Palace, the bronze Mercury about one braccio high, nude, poised on a ball, and about to take flight, and spouting water, whereby a mechanical device which it held in its hands was made to spin. The pipe, by entering one of the legs, which was pierced, passed through the torso and led to the mouth, whence the water beat against this instrument, that had four delicate wings, like those of a butterfly, attached to it, and was thereby made to revolve. This figure, as I say, though a small thing, was much praised). The identification of the present bronze as Rustici's Mercury is due to its former owner, Henry Harris. The mouth is bored to emit water.

LORENZO LOTTI (LORENZETTO)
(b. 1490; d. 1541)

Born in Florence in 1490, Lorenzetto was employed in 1514 on the completion of Verrocchio's Forteguerri monument at Pistoia (Vol. II, pp. 314–5). In 1519 he was entrusted under the will of Agostino Chigi with the sculptures of the Chigi Chapel in S. Maria del Popolo, Rome (see Plate 41 below). He owed this commission (which was ratified in 1521 after Chigi's death) to the favour of Raphael. Moving back to Florence after the election of Pope Adrian VI, he was once more in Rome by 1523, when he was engaged with an assistant, Raffaello da Montelupo, on the Elias for the Chigi Chapel, and a standing Virgin and Child for the tomb of Raphael in the Pantheon. In 1524 he received the commission for the tomb of Bernardino Cappella in S. Stefano Rotondo. After this time he carved a large statue of St. Peter for the Ponte Sant'Angelo, on the commission of Pope Clement VII, and was involved, in a subsidiary capacity, in the execution of non-figurated carvings for the papal monuments of Bandinelli in S. Maria sopra Minerva. Lorenzetto, whose interest as a sculptor derives solely from his contact with Raphael, died in 1541. Vasari describes Lorenzetto's activity in Rome as a decorator and architect and as a restorer of antiques, and records that the garden of Cardinal della Valle, for which Lorenzetto was responsible, and which was decorated with antique figures and reliefs, had a formative influence on taste in Rome.

BIBLIOGRAPHY: Venturi (X-i, pp. 302–16).

Plate 41: THE CHIGI CHAPEL
S. Maria del Popolo, Rome

The funerary chapel designed by Raphael for Agostino Chigi in S. Maria del Popolo is described in Vasari's life of Raphael: 'Fece l'ordine delle architetture delle stalle de' Ghigi; e nella chiesa di Santa Maria del Popolo, l'ordine della cappella di Agostino sopradetto: nella quale, oltre che la dipinse, diede ordine che si facesse una maravigliosa sepoltura; ed a Lorenzetto scultor fiorentino fece lavorar due figure, che sono ancora in casa sua al macello de' Corbi in Roma' (He designed the architecture of the stables of the Chigi, and also the chapel of the above-mentioned Agostino in the church of S. Maria del Popolo; in this, as well as painting it, he had a marvellous tomb made, having Lorenzetto, the Florentine sculptor, carry out two figures, which are still in his house in the Macello de'

Corbi in Rome). A second, more detailed reference occurs in Vasari's life of Lorenzetto: 'Dopo essendogli allogata da Agostino Ghigi, per ordine di Raffaello da Urbino, la sua sepoltura in Santa Maria del Popolo, dove aveva fabricato una cappella, Lorenzo si mise a questa opera con tutto quello studio, diligenza e fatica che mai gli fu possibile, per uscirne con lode, per piacere a Raffaello, dal quale poteva molti favori ed aiuti sperare, e per esserne largamente rimunerato dalla liberalità d'Agostino, uomo ricchissimo. Nè cotali fatiche furono se non benissimo spese, perchè aiutato dal giudizio di Raffaello condusse a perfezione quelle figure; cioè un Iona ignudo, uscito del ventre del pesce, per la resurrezione de' morti, ed uno Elia che col vaso d'acqua e col pane subcinerizio vive di grazia sotto il ginepro. Queste statue, dunque, furono da Lorenzo a tutto suo potere con arte e diligenza a somma bellezza finite; ma egli non ne conseguì già quel premio che il bisogno della sua famiglia e tante fatiche meritavano, perciocchè avendo la morte chiusi gli occhi ad Agostino e quasi in un medesimo tempo a Raffaello, le dette figure per la poca pietà degli eredi d'Agostino se gli rimasono in bottega, dove stettono molti anni. Pure oggi sono state messe in opera nella detta chiesa di Santa Maria del Popolo, alla detta sepoltura' (He was commissioned by Agostino Chigi, on the instructions of Raphael of Urbino, to make his tomb in S. Maria del Popolo, where he had built a chapel. Lorenzo applied himself to this work with all possible zeal, diligence and labour, so that he might come out of it with credit and please Raphael, from whom he could hope for great favour and help, and also so that he might be generously rewarded by the liberality of Agostino, a very rich man. His labour was very well spent, for with Raphael's advice he brought the figures to perfection: namely, a nude Jonah delivered from the belly of the whale, symbolising the resurrection from the dead, and an Elias living by grace, with cruse of water and bread baked in the ashes, under the juniper tree. These statues, then, Lorenzo brought to completion most beautifully with all his art and diligence, but he did not at all gain the reward for them that such labour and the needs of his family deserved. For, when death closed the eyes of Agostino and, almost at the same time, those of Raphael, the figures stayed, on account of the deficient piety of Agostino's heirs, in Lorenzo's workshop and remained there for many years. Only in our own day have they been put on the tomb in the church of S. Maria del Popolo).

The early history of the sculptures in the chapel and of the tomb is reconstructed by D. Gnoli ('La sepoltura d'Agostino Chigi', in *Archivio storico dell'arte*, ii, 1889, pp. 317–26). The first allusion to the chapel occurs on 28 August 1519 in the will of Agostino Chigi, who enjoined that after his death the chapel should be completed along lines of which Raphael and the goldsmith Antonio da San Marino were fully apprised. After the deaths of Raphael (6 April 1520) and Agostino Chigi (10 April 1520), Sigismondo Chigi entered into a contract with Lorenzetto for the construction of his brother Agostino's tomb. The original contract is untraced, but it is known that on 10 February 1521 Lorenzetto bound himself to construct the tomb 'decenter, ornate et magistraliter, intra 30 menses proximos a die de. cedule computan'. Between 10 July 1521 and 8 April 1522 it was agreed that Lorenzetto should execute a second

monument on the right wall of the chapel for Sigismondo Chigi. By the latter date Lorenzetto had left Rome for Florence, and both monuments were virtually complete, the little work remaining to be done on them being entrusted by Chigi's heirs to Bernardino da Viterbo. The sculptures planned for the chapel comprised, in addition to the two tombs, four statues, only two of which, the Jonah (Fig. 44) and Elias, were executed. A passage in the autobiography of Raffaello da Montelupo (Vasari, *Vite*, ed. Milanesi, iv, pp. 557–8) proves that the Elias was completed in Lorenzetto's studio by this sculptor in the early years of the pontificate of Clement VII: 'Arivati a Roma, andai a trovare li sopradito mastro Lorenzo, che stava al macello de' Corvi. Così, parlatoli, mi parse mi vedessi volentieri, e mi disse che mi piglierebbe . . . e poi mi fece finire un'altra figura che pure era bozata asai presso al fine, coè uno Elia che sta a sedere, ed è alla capella de' Chigi al Popolo' (When we arrived in Rome, I went to find the above-mentioned Master Lorenzo, who was in the Macello de' Corvi. And when I had spoken with him, he gave me the impression of being glad to see me and told me he would employ me . . . and then he made me finish another figure which had also been sketched out almost to completion, namely a sitting Elias, and it is in the Chigi Chapel in S. Maria del Popolo). In 1552, eleven years after the death of Lorenzetto (1541), the heirs of Agostino Chigi once more turned their attention to the chapel, and an assessment of the completed sculptures was prepared by Raffaello da Montelupo and Tommaso del Bosco. This shows that at that time two of the statues and one of the tombs was complete ('e diciamo che delle quattro statue che era obligato di fare ne sono fatte dua, cioè Jona e Elia, apresso delle dua piramide di che era obligato di fare troviamo esserne facta una, e se bene li mancha quelle piastre dorate in la testa de la colonna diciamo suplire per questo li tre termini che sono facti di più, e la testa di messer Agostino che sta in casa di quello che tiene la scrittura di messer Lorenzo Chigi. Cosi diciamo esserne facta una interamente finita de le dicte piramide o vero sepolture') (. . . and we declare that we find that one of the four statues he had undertaken to make has been made; and though the gilded medallions on the top of the column are missing, we declare that this is compensated for by the three additional terms, and by the head of Master Agostino which is in the house of Master Lorenzo Chigi's accountant. We therefore declare that one of the tombs or pyramids in question has been entirely completed). The base of the second tomb was complete, and the marble for the pyramid was available. The completion of the outstanding paintings was entrusted to Salviati, and the chapel was opened in 1554. Between the death of Agostino Chigi's son Lorenzo in 1573, and the arrival in Rome of Fabio Chigi (later Pope Alexander VII) in 1626, Chigi interest in the chapel lapsed. A description prepared by Fabio Chigi in the latter year shows that the statues of Jonah and Elias were in the niches on the entrance wall, that the niches beside the altar were vacant, and that the left wall of the chapel was occupied by the tomb of Agostino Chigi, 'una cassa alta due braccia e mezzo, con bassorilievo di bronzo davanti e dalla testa che guarda l'entrata, essendo vacua la testa che mira l'altare. E sopra detta cassa una piramide large di pianta quanto la cassa, e che termina con la estremità nell'arco, incrostata di marmo, con

uno spatio di un tondo votio, ove poteva stare o una testa, o un'arme, e sottovi disegnata una cartella per la iscrittione' (a tomb-chest two and a half braccia high, with a bronze relief in front and on the end facing the entrance, while the end facing the altar is empty. And above this tomb-chest a pyramid, the base of which is as wide as the coffer; it finishes with its tip inside the arch and is inlaid with marble, and it has an empty circular space which would serve for a head or a coat-of-arms, and underneath this a scroll for the inscription). A drawing by Dosio in the Uffizi (reproduced by Gnoli, loc. cit.) shows the monument in this state. In 1652 Fabio Chigi became a Cardinal, and the completion of the chapel in S. Maria del Popolo was entrusted by him to Bernini, who, among much other work, transferred the Jonah to the niche to the left of the altar and supplied for the vacant niches two figures of Daniel and Habak-kuk. A relief portrait was carved at this time for the medallion on Agostino Chigi's monument, the space destined for the inscription was filled in and a new inscription substituted, and the two bronze reliefs in the base were removed and replaced with coloured marble. The smaller of the two reliefs has disappeared, but the larger (Fig. 79), representing Christ and the Woman taken in Adultery, was built into the altar of the chapel. The tomb in its modified state was for long regarded as an original work by Bernini. There can be no reasonable doubt that the design, with its use of the classical obelisk, is due to Raphael, not Lorenzetto, and it has been repeatedly suggested that the relief now on the altar also depends from a design by Raphael. Whether a drawing by Raphael does or does not lie behind Lorenzetto's relief cannot be established. It is, however, pointed out by E. Loewy ('Di alcune composizioni di Raffaello', in *Archivio storico dell'arte*, 2a. serie, ii, 1896, pp. 246–51) that the adulterous woman and a second female figure on the extreme left depend from corresponding figures in the Neo-Attic relief known as the Borghese Dancers in the Louvre, and that the correspondence of size and detail is such as to suggest that casts may have been employed. It cannot be assumed (as Loewy infers) that this practice would be inconsistent with Raphael's authorship of the design. The Jonah is also traditionally supposed to depend from a sketch-model by Raphael. Moreover, it is known that two circular bronze reliefs of Christ in Limbo and the Incredu-lity of St. Thomas by Lorenzetto in the Abbazia di Chiaravalle (Milan), which were designed for the Chigi Chapel in S. Maria della Pace, are based on drawings by Raphael (for this identifi-cation see M. Hirst, 'The Chigi Chapel in S. Maria della Pace,' in *Journal of the Warburg and Courtauld Institutes*, xxiv, 1961, pp. 161–85). The subject of the bronze relief has been explained alternatively as Christ and the Woman of Samaria. A good analysis of the sculptures is provided by J. Shearman ('The Chigi Chapel in S. Maria del Popolo,' in *Journal of the Warburg and Courtauld Institutes*, xxiv, 1961, pp. 129–60).

ANDREA SANSOVINO
(b. ca. 1467; d. 1529)

According to Vasari (1568), Sansovino was born about 1460, was the son of a labourer, Domenico Contucci of Monte San Savino, and was trained by Antonio Pollajuolo. It has, how-ever, been established (Girolami) that Andrea's father was named Niccolò di Menco de' Mucci, that his parents married in June 1465, and that he had an elder brother Piero; his birth must therefore have occurred ca. 1467–70. Vasari (1550) gives his date of birth as 1471. His name was inscribed in the Arte dei Maestri di pietra e legname in 1491. There is no visual evidence to support Andrea's supposed apprenticeship with Pollajuolo, and it is unlikely that he was trained in the shop of a bronze sculptor. His first major documented work is the Baptism of Christ on the Baptistry in Florence (see Plate 43 below), and the reconstruction of his style before this time rests on Vasari's statements that he modelled terracotta heads of Galba and Nero and two terracotta altarpieces for Monte San Savino, carved two capitals for the sacristy of S. Spirito, where he was also employed in the ante-sacristy, was subsequently en-trusted with the Corbinelli altar in S. Spirito, and afterwards worked for nine years in Portugal. The terracotta head of Galba, apparently glazed at Caffagiuolo, is in the Casa Vasari at Arezzo, and is consistent in handling with an enamelled terra-cotta Virgin and Child with four Saints in S. Chiara at Monte San Savino, but there is some doubt whether these are early or late works. The affinities of the Corbinelli altar (begun after 1485, probably ca. 1490) are with two contemporary altars carved by Andrea Ferrucci for Fiesole (Duomo, Fiesole, and Victoria & Albert Museum, London), and it is possible that Andrea Sansovino, like Andrea Ferrucci, was trained in the Ferrucci studio. A tabernacle in S. Margherita a Montici appears to have been carved at this or at a somewhat earlier time. None of the works ascribed to Sansovino in Portugal can be reconciled with the style of these two works, and it has been questioned (Girolami) whether Vasari's account of a period of activity in Portugal is correct. Stylistically there is no break between the Corbinelli altar and the tabernacle and Sansovino's next docu-mented work, a baptismal font at Volterra (commissioned 9 June 1502). The Baptism of Christ on the Baptistry in Florence and the statues of the Baptist and the Virgin and Child in the Cathedral at Genoa (see Plate 42 below) mark the emergence of Sansovino as a large-scale sculptor. Sansovino married on 26 May 1504, and in that year was commissioned to undertake the Altar of the Sacrament in the Duomo in Florence and a statue of the Redeemer for the Sala del Gran Consiglio. In the course of the year 1505 he moved from Florence to Rome, and on 6 December 1505 arranged for the transport to Rome

of marble from Avenza for use in the Sforza and Basso monuments in S. Maria del Popolo (see Plate 44 below). In Rome he carved the pedimental group on Giuliano da Sangallo's façade of S. Maria dell'Anima (1507?), and the group of the Virgin and Child with St. Anne in S. Agostino (1512, see Plate 48 below). In the latter year he was allocated two of the statues of apostles for the Duomo in Florence (SS. Thaddeus and Matthew). Appointed Capo e maestro generale della fabbrica Loretana by Leo X (22 June 1513), he was thereafter largely occupied with the decoration of the Holy House (see Plate 46 below). In 1523 and 1524 he was active at Monte San Savino, and he returned there when he left Loreto on 29 June 1527. Sansovino's death took place between 30 March and 11 April 1529.

BIBLIOGRAPHY: The standard monograph on Andrea Sansovino (G. H. Huntley, *Andrea Sansovino*, Cambridge, 1935) must be used in conjunction with a documentary article by C. Girolami ('In margine ad una monografia su Andrea Sansovino,' in *Atti e memorie della Reale Accademia Petrarca di lettere, arti e scienze*, XXX–XXXI, 1941, Arezzo, 1942). For the documentation of Sansovino's early work see especially Fabriczy ('Ein unbekanntes Jugendwerk Andrea Sansovinos,' in *Jahrbuch der Preuszischen Kunstsammlungen*, XXVII, 1906, pp. 79–105). The Galba relief is discussed by Girolami ('Il Porsenna e il Galba di Andrea Sansovino,' in *Rivista d'Arte*, xviii, 1936, pp. 179–91) and A. del Vita ('Di una ceramica di Andrea Sansovino,' in *Bolletino d'Arte*, xii, 1919, pp. 30–2). The available misinformation on Sansovino's activity in Portugal is assembled by Battelli (*Il Sansovino in Portogallo*, Coimbra, 1929). Sansovino's drawings are analysed by Middeldorf (in *Münchner Jahrbuch der Bildenden Kunst*, n.f. x, 1933, pp. 138–46, *Art Bulletin*, xvi, 1934, pp. 107–15, and *Burlington Magazine*, lx, 1932, pp. 236–45, and lxiv, 1934, pp. 159–64).

Plate 42: VIRGIN AND CHILD AND ST. JOHN THE BAPTIST
Duomo, Genoa

The two statues by Sansovino in the Cappella di S. Giovanni in the Duomo at Genoa are mentioned by Vasari (1568): 'fu quasi forzato andare a Genoa; dove fece due figure di marmo, un Cristo ed una Nostra Donna, ovvero San Giovanni, le quali sono veramente lodatissime' (. . . he was more or less forced to go to Genoa, where he made two marble figures, a Christ and a Madonna, or rather St. John Baptist; and they are very praiseworthy indeed). The two figures occupy niches on the facing wall to right and left of the altar of the Chapel, and are inscribed on their bases SANSOVINVS FLORENTINVS FACIEBAT. The commission for the chapel of S. Giovanni was awarded on 4 May 1448 to Domenico Gaggini (*La Cattedrale di Genova*, n.d., Turin), and work on its construction continued till 1465. In 1494 Giovanni d'Aria da Como was commissioned to cover the lateral walls with marble and to prepare niches for statues (Alizeri, *Guida illustrativa del Cittadino e del forestiero per la città di Genova*, Genoa, 1875, p. 17). Through the good offices of Davide Grillo, the Genoese commissioner at Sarzana, the

statues for the Chapel were commissioned from Matteo Civitali, who supplied six figures representing (*left*) Isaiah, Elizabeth, and Eve, and (*right*) Habakkuk, Zacharias, and Adam. There is no evidence that the Virgin and Child and the Baptist, which were necessary to complete this programme, were commissioned from Civitali, but this is probable. The date 1496 is inscribed beneath the lunette reliefs of the Banquet of Herod and the Decollation of the Baptist, which seem to have been carved in the workshop of Civitali. The corresponding reliefs on the facing wall are by Pace Gaggini. On Civitali's death in 1501 the contract for the missing figures was presumably transferred to Sansovino. When Louis XII of France entered Genoa and visited the Cathedral on 29 August 1502, Jean d'Autun recorded the presence of two empty niches on the altar wall. The statues were completed by the end of 1503, since on 13 January 1504 the Dieci di Balìa in Florence sent a formal notification of the despatch of the figures through Pisan territory to Genoa (Gaye, ii, p. 62): 'E si trova qui uno Andrea dal monte a Sto. Savino, scultore, quale ha lavorato certe figure di marmo per Genova; et per condurre decte figure, che saranno due, a luogo destinato, ha obtenuto salvocondotto da' Pisani, per mezzo de' Genovesi, di poter condurre decte figure in Pisa' (And Master Andrea from Monte a Sansovino, the sculptor, is here, and he has carved some marble figures for Genoa; and to bring these figures, which are two in number, to their destination, he has obtained through the Genoese a safe-conduct from the Pisans, so that he can bring these figures to Pisa).

Plate 43: THE BAPTISM OF CHRIST
Baptistry, Florence

The group of the Baptism of Christ over the central (eastern) door of the Baptistry, is described by Vasari in the following terms: 'Arrivato in Fiorenza, cominciò nel MD un San Giovanni di marmo che battezza Cristo, il quale aveva a essere messo sopra la porta del tempio di San Giovanni, che è verso la Misericordia; ma non lo finì, perchè fu quasi forzata andare a Genoa. . . . E quelle di Firenze così imperfette si rimasono, ed ancor oggi si ritruovano nell'Opera di San Giovanni detto' (After his arrival in Florence, he began in 1500 a marble group of St. John baptizing Christ, to be put above the door of the Temple of S. Giovanni that faces the Misericordia; but he did not finish it because he was more or less forced to go to Genoa. . . . And those figures at Florence remained in this way unfinished, and they are still in the office of works of S. Giovanni today). The figures of Christ and St. John are alone mentioned in the documents, and were originally destined as replacement for the marble group of the Baptism of Christ by Tino di Camaino over the south door of the Baptistry. On 28 April 1502 the Consiglio dell'Arte de' Mercanti agreed that a contract for 'la figura di Nostro Signore e quella di San Giovanni Batista, quando si battezorono, di marmo' should be awarded to Andrea Sansovino, and on 29 April 1502 the agreement was signed. The last payments for the figures date from 31 January 1505 (for this and other documents see Milanesi, 'Documenti riguardanti le statue di marmo e di bronzo fatte per le porte di

San Giovanni da Firenze da Andrea del Monte San Savino e da Giovanni Francesco Rustici', in *Giornale storico degli archivi toscani*, 1860, iv, pp. 63–75). On 27 January 1511 orders were given that the two marble statues should be transferred from the Opera di S. Maria del Fiore to the Opera di S. Giovanni (Frey, *Vasari*, i, 1911, pp. 347–8), and at the time of the second edition of Vasari's *Vite* (1568) they were still in the Opera di S. Giovanni. Between this date and the publication of Borghini's *Riposo* (1584), the figures were installed over the central (east) door of the Baptistry. The relevant passage in Borghini reads as follows: 'Ma di cui furon mano da principio le due statue sopra la porta di S. Giovanni, che mi sembrano molto belli, dove è Cristo battezzato da S. Giovanni? Furon fatte da Andrea dal Monte a Sansovino (rispose il Sirigatto) ma perchè egli non le lasciò del tutto finite, le finì poi Vincenzio Danti Perugino, come sapete, e son degne di considerazione, come si vede' (But by whose hand was a beginning made on the two statues, which seem to me very fine, over the door of S. Giovanni, the ones in which Christ is shown being baptised by St. John? They were made by Andrea dal Monte a Sansovino, answered Sirigatto, but as he did not leave them quite finished, Vincenzo Danti of Perugia completed them later, as you know; and they deserve to be admired, as you see). According to the *Diario* of Lapini, the figures were exhibited in their present position on 23 June 1569. The presence of a third figure, an angel holding a towel, is first mentioned by Lapini (for this see Paatz, 'Seit wann gehört zu Sansovinos Taufgruppe am Baptisterium eine Engelfigur?', in *Mitteilungen des Kunsthistorischen Institutes in Florenz*, iv, 1933, p. 141). A statement of Huntley (pp. 44–8) that the figure of an angel is first mentioned by Del Migliore (*Firenze città nobilissima*, Florence, 1684, p. 91) is incorrect. The angel is variously described as made of stucco and terracotta, and was presumably executed by Danti. In 1791 (Follini-Rastrelli, *Firenze antica e moderna*, Florence, 1791, iii, p. 30) this angel was removed, and the present marble Angel by Innocenzo Spinazzi was installed in the following year. The extent of the work undertaken by Vincenzo Danti on Sansovino's two figures cannot be determined. It is presumed by Paatz (ii, p. 198) that the tabernacle and columns behind the group were planned by Andrea Sansovino. In form the tabernacle is ill adapted to a two figure group, and seems, like the Rustici tabernacle over the north door, to presume the presence of a third figure which is not mentioned in the documents. The suspension of work on the group appears to have been due to Sansovino's departure for Rome, and not to the commission for the Genoa statues (see Plate 42 above), which were carved in Florence.

Plates 44, 45: MONUMENTS OF CARDINALS ASCANIO SFORZA AND GIROLAMO BASSO DELLA ROVERE
S. Maria del Popolo, Rome

The monument of Ascanio Sforza (d. 28 May 1505) is situated on the left wall of the choir of S. Maria del Popolo (Fig. 57). Its central section is constructed in the form of a triumphal arch,

with, in the centre, an effigy of the Cardinal reclining on a sarcophagus raised on a rectangular base inscribed, on a circular slab in the centre: ANDREAS SANSOVINVS FACIEBAT. Above is a lunette of the Virgin and Child. At the sides in niches are statuettes of (*left*) Justice and (*right*) Prudence, with above seated figures of (*left*) Faith and (*right*) Hope. Above the central element is a seated figure of God the Father flanked by candle-bearing angels. The base is decorated at the sides with the Cardinal's arms and impresa. In the centre is a recessed slab inscribed with the words:

DOM

ASCANIO MARIAE SF. VICECOMITI FRANCISCI SFORTIAE INSVBR: DVCIS F. DIACONI CARD: S.R.E. VICECANCELLAR IN SECVNDIS REB: MODERATO INADVERSIS SVMMO VIRO VIX. ANN: L. MENS: II.D.XXV
IVLIVS II PONT: MAX: VIRTVTVM MEMOR. HONESTISSIMA CONTENTIONVM OBLITVS SACELLO A FVNDAMENTO: ERECTO
POSVIT M.D.V.

(To Ascanio Maria Sforza Visconti, son of the Duke of Milan, Francesco Sforza, Cardinal Deacon, Vice-chancellor of the Holy Church of Rome. Modest in good fortune, he was yet an excellent man in adversity. He lived 50 years, 2 months and 25 days. Pope Julius II, remembering his qualities and forgetting their disagreements, when this chapel was being built from its foundation, put up this monument. 1505.)

In the corresponding position on the right wall of the choir is the monument of Cardinal Girolamo Basso della Rovere (d. 1507) (Fig. 58). This is similar in scheme to the Sforza tomb save that in the centre the direction of the effigy is reversed and the relief of the Virgin and Child in the lunette is differently composed. The lateral niches are filled by figures of (*left*) Fortitude and (*right*) Temperance, with, above, seated figures of Faith and Hope which differ in pose from the corresponding figures on the Sforza tomb. In the base is the inscription:

DOM

HIERONYMO BASSO SAVONENSI XISTI IIII PONT. MAX. SORORIS FILIO EPISCOPO SABINENSI CARD. RICINAT IN OMNI VITA CONSTANTI INTEGRO RELIGIOSO IVLIVS. II. PONT. MAX. AMITINO SVO B.M. POSVIT
M.D.VII.

(To Girolamo Basso of Savona, nephew of Pope Sixtus IV, Bishop of Recanati, and Cardinal of Santa Sabina. In his whole life he was steadfast, virtuous and devout. Pope Julius II erected this in memory of his worthy cousin. 1507).

The history of the Sforza monument can be reconstructed in some detail. The project for the tomb is first mentioned in a brief of 12 June 1505 (Vatican libr. brev. 22, f. 327, summarised by Pastor, iii, p. 783 n.), in which Pope Julius II informs Gundisalvo Fernandi, Duke of Terranuova, of his intention to erect a tomb to the memory of his erstwhile adversary Ascanio Sforza. Sforza, a son of Francesco Sforza and a brother of Lodovico il Moro, had been taken prisoner by the Venetians and the French in 1500 and had returned to Rome after the election of the Pope. The reference to adversity in the epitaph on the monument is an allusion to this fact. The marble for the monument was forth-

with selected at Carrara (safe conduct of 16 October 1505), was shipped from Avenza to Rome (6 December 1505), and was granted a papal safe-conduct on its arrival (28 December 1505). Though Girolamo Basso della Rovere did not die until 1507, it is likely that the second monument was constructed concurrently with or immediately after the Sforza tomb. Both tombs must have been completed by 3 June 1509, since they are mentioned by Francesco Albertini (*Francisci Albertini Opusculum de Mirabilibus novae urbis Romae*, ed. Schmarsow, Heilbronn, 1886, p. 45: 'In ecclesia S. Mariae de Populo sunt multa sepulchra Cardinalium variis picturis et statuis exornata. In maiori vero capella sunt duo sepulchra marmorea pulcherrima, quae tua sanctitas Ascano Mariae, Vicecancellario, et Hieronymo Saonensi Card. ben. mer. posuit manu Andreae Sansuini Flor. excell. statuarii') (In the church of S. Maria del Popolo there are a large number of tombs of cardinals, decorated with various paintings and statues. But in the larger chapel there are two particularly fine marble tombs which Your Holiness had raised, by Andrea Sansovino, the distinguished Florentine sculptor, for Ascanio Maria Sforza, the Vice-chancellor, and for the worthy Cardinal Girolamo of Savona). Some supplementary information on the second monument is supplied by Mazzini (in *Giornale storico e letterario della Liguria*, v, 1904, pp. 438–40). O. Förster (*Bramante*, Vienna, 1956, pp. 206–8) plausibly suggests that the Pope's motives for assuming responsibility for the construction of the Sforza monument were in part political. There was, however, a secondary motive, in that the two tombs formed part of a large scale remodelling of the choir of S. Maria del Popolo undertaken by Bramante at about this time. Thus on 29 May 1509 the Pope authorised a payment of 'Duc. venti tre, b. septe e mezzo . . . a m. Alberto da Piacenza per coprire la tribuna della cappella facta in Sancta Maria del Popolo secondo l'ordine e stima di maestro Bramante.' The frescoes undertaken by Pinturicchio on the roof of the choir in 1509–10 and the glass windows commissioned from Guillaume de Marcillat formed an integral part of the same scheme. In these circumstances the question arises whether Bramante was not responsible for, or did not exercise some influence upon, the scheme of the two tombs. This view is rejected without argument by Huntley, who regards the scheme of the monuments as a development from that of the Corbinelli altar, but is argued with some force by Geymüller (*Die ursprünglichen Entwürfe für Sanct Peter in Rom*, Vienna/Paris, 1875, pp. 82–5) and is accepted among others by Bertaux (*Rome*, Paris, 1916, p. 7) and Förster (loc. cit.). Geymüller's case rests (i) on formal analysis of the monuments, (ii) on the close connection between Ascanio Sforza and Bramante in Lombardy, and (iii) on the later collaboration of Bramante and Sansovino at Loreto (see Plate 46 below). The two tombs are described by Vasari in the following terms: 'Fu poi condotto a Roma da Papa Giulio II, e fattogli allogazione di due sepolture di marmo poste in Santa Maria del Popolo, cioè una per il cardinale Ascanio Sforza, e l'altra per il cardinale di Ricanati, strettissimo parente del papa; le quali opere così perfettamente da Andrea furono finite, che più non si potrebbe desiderare, perchè così sono elleno di nettezza, di bellezza e di grazia, ben finite e ben condotte, che in esse si scorge l'osservanza e le misure dell'arte.

Vi si vede anco una Temperanza che ha in mano un oriuolo da polvere, che è tenuta cosa divina; e nel vero, non pare cosa moderna, ma antica e perfettissima: ed ancora che altre ve ne siano simili a questa, ella nondimeno, per l'attitudine e grazia, è molto migliore; senza che non può esser più vago e bello un velo ch'ell' ha intorno, lavorata con tanta leggiadria, che il vederlo è un miracolo' (He was then summoned to Rome by Pope Julius II, and was given the commission for two marble tombs put in S. Maria del Popolo: one for Cardinal Ascanio Sforza, the other for the Cardinal of Recanati, a close relative of the Pope. These works were finished by Andrea so perfectly, that one could desire no more; for they are so well finished and carried out, and with such purity, beauty and grace, that one recognises in them the rules and measure of art. You see there too a figure of Temperance, holding an hour-glass in her hand, which is considered to be a god-like work; and indeed it does not seem a modern work, but ancient and quite perfect. And although there are other figures there like it, it is much the best because of its attitude and grace; and besides, nothing could be more charming and beautiful than the veil she has round her, done with such delicacy that it is marvellous to see). A sheet containing a putative preparatory drawing or alternative scheme for the Sforza monument (Victoria & Albert Museum, London) is published by U. Middeldorf ('Two Drawings by Andrea Sansovino', in *Burlington Magazine*, lxiv, 1934, pp. 159–64).

Plates 46, 47: THE HOLY HOUSE
Duomo, Loreto

The Holy House is a rectangular structure punctuated at the sides and ends by Corinthian columns, and decorated with reliefs of scenes from the life of the Virgin and niches containing statues and statuettes. The reliefs are as follows:

North face (left) *The Birth of the Virgin.* Begun by Baccio Bandinelli (1524–5), completed by Raffaello da Montelupo (1533).

(right) *The Marriage of the Virgin.* Begun by Andrea Sansovino (1524), one quadro finished by 24 June 1527 and completed by Tribolo (1533), second quadro carved by Tribolo (1533) from Andrea Sansovino's model.

West face (above) *The Annunciation.* Carved by Andrea Sansovino, one quadro carved between 23 November 1518 and 30 December 1520, second quadro begun 1520 and completed May 1524.

(below left) *The Visitation.* Carved by Raffaello da Montelupo (completed 1533).

(below right) *The Virgin and St. Joseph completing the Census.* Carved by Francesco da Sangallo (completed 1533).

South face (left) *The Annunciation to the Shepherds and the Adoration of the Shepherds.* Carved by Andrea Sansovino, one quadro carved between 23 November 1518 and 30 December 1520, second quadro begun 1520 and completed May 1524.

(right) *The Adoration of the Magi.* Carved by Raffaello da Montelupo (completed 1533).

East face (above) *The Dormition of the Virgin.* Carved by Domenico Aimo, initially at Loreto (1520?–1523) and subsequently at Ancona (1523 till 5 August 1525). Later (1536) finished by Domenico Aimo, Tribolo and Francesco da Sangallo.

(below) *The Translation of the Holy House.* One quadro carved by Tribolo (1533), the other by Francesco da Sangallo (1533).

The design of the Holy House is due to Bramante, and appears to be contemporary with the strengthening of the cupola of the Cathedral (1509) and the designing of the Palazzo Apostolico (1510). In 1510 a model for the Holy House was prepared to Bramante's design by Antonio Peregrini (for this and other documents see Vogel, *De Ecclesiis Recanatensi et Lauretana*, Recanati, 1859, i, p. 256, and H. von Geymüller, *Die ursprünglichen Entwürfe für Sanct Peter in Rom von Bramante*, Vienna/Paris, 1875, pp. 93–6). Following a visit paid by Julius II to Loreto in June 1511 to see 'le ruine e le fabbriche intraprese dal suo architetto nominato Bramante o piuttosto *Rovinante*' (Paris de Grassi), the task of superintending the work was entrusted to the sculptor Gian Cristoforo Romano; at this time it was intended that he should also be responsible for carving the reliefs. Gian Cristoforo Romano died on 31 May 1512, and was succeeded as 'architector et reveditor de la fabrica' by Pietro Amoroso. In 1507 the Sanctuary had been removed by Julius II from the jurisdiction of the Bishops of Recanati, and in 1512 Antonio del Monte was appointed first Cardinal Protector of the shrine. On 22 June 1513 a brief was issued nominating Andrea Sansovino not merely to undertake the carvings of the Holy House, but as the successor of Amoroso. It has been inferred from the terms of the appointment that Sansovino was not compelled to follow Bramante's designs for the Holy House, but this is hypothetical. Sansovino was paid at the rate of 15 gold ducats a month when at Loreto or on official business elsewhere, and was allowed a four month vacation each year at a reduced salary of 6 ducats. Documents show that he was in residence at Loreto after 6 February 1514. At the end of 1514 the progress of work was, however, thought to be unsatisfactory, and on 8 December 1514 Cardinal Bibbiena was appointed as Cardinal Protector. From this time on Sansovino's administrative responsibilities seem to have declined. On 18 January 1517 Antonio da Sangallo was ordered by Pope Leo X to inspect and report on the work at Loreto, and following this visit Sansovino was deposed from his position as Capomaestro and replaced by Cristoforo Resse, retaining control of the sculpture. The position is defined in a brief of 20 January 1521 naming Sansovino as 'capo maestro dell'opera del scarpello, tanto nell'adornamento de la cappella, quanto in ogni altra cosa dove havera intervenire lo scarpello'. Following this administrative change, Sansovino's salary was reduced by one third. The decoration of the Holy House may have been begun as early as 1513 (Vogel), when marble for it was obtained from Carrara, but work on the figure sculptures started only in 1517–18. Probably at this time, though possibly not before 1520, Domenico Aimo da Varignana joined Sansovino at Loreto. Baccio Bandinelli also moved to Loreto at about this time. Loreto was greatly disliked by the artists who were required to work there – it is described by

Gian Cristoforo Romano as 'quanto tiene il tempio, bestialissimo quanto si può dire' – and after a time both Domenico Aimo and Bandinelli moved to Ancona with the sculptures on which they were engaged, the former at the end of 1523 and the latter in 1524–5. The extent to which Bandinelli was responsible for the design of his own relief is not made clear. According to Vasari, 'Baccio, fatto il modello, dette principio all'opera: ma come persona che non sapeva comportar compagnia e parità, e poco lodava le cose d'altri, cominciò a biasimare con gli altri scultori che v'erano, l'opera di maestro Andrea, e dire che non aveva disegno; ed il simigliante diceva degli altri: intanto che in breve tempo si fece mal volere da tutti' (Baccio, when he had made the model, began the work; but, because he was a person who could not endure a colleague or an equal, and praised other men's works little, he began to disparage the works of Master Andrea to the other sculptors who were there, saying he had no power of design; and he said the same of the others, so that he very soon made himself disliked by everybody). Other sculptors whose names occur in connection with the Holy House at about this time are Benedetto da Rovezzano, Ranieri Nerucci da Pisa, and Simone Cioli. Bandinelli abandoned his relief in Ancona in an unfinished state ('la quale storia, o vero due quadri, non li ha finiti, come al presente si vegano in la nostra chiesa lauretana'). After the death of Pope Leo X, and the election as Pope of Adrian VI, the funds from the sanctuary were diverted to Rome, and work on the Holy House and Duomo ceased. At this time (1522–3) Sansovino was absent at Monte San Savino. On the election of Clement VII, Giuliano Ridolfi was reappointed as protector of the sanctuary, and Sansovino was confirmed as Capomaestro delle sculture, with extended powers which in effect gave him full control. In 1523–4 he entered into abortive negotiations with Michelangelo, offering to work in a subordinate capacity under Michelangelo in Florence. He was at Loreto spasmodically in 1525 and 1526; the last record of his presence there is on 29 June 1527. At the time of the Sack of Rome the entire resources of the treasury were diverted to the Pope, and activity at Loreto temporarily ceased. After the death of Sansovino and the re-establishment of papal authority, work on the Holy House was resumed. In October 1533 Raffaello da Montelupo received 1,500 ducats for the relief of the Adoration of the Magi 'fatto da tutto punto da lui', 600 ducats for finishing the Birth of the Virgin and 400 for a small relief of the Visitation. At the same time Tribolo received 250 ducats for completing the quadro of the Sposalizio left unfinished by Sansovino, 750 ducats for the remaining quadro of this scene, 350 ducats for five putti, and 750 ducats for one quadro of the Translation of the Holy House. Francesco da San Gallo received 740 ducats for the second quadro of the Translation of the Holy House and 400 ducats for the small scene of the Virgin and St. Joseph registering at the Census. Between 1533 and 1535 Simone Cioli was paid for ornamental carving and one marble putto, and on 31 December 1536 sums of 400 ducats were paid jointly to Domenico Aimo, Tribolo and Francesco da Sangallo for completing the Dormition of the Virgin and 140 ducats to Tribolo, Raffaello da Montelupo and Francesco da Sangallo for two further putti. The monumental casing of the House was installed in 1532–4,

and the balustrade was added in 1537. The twenty niches on the four faces were still vacant at this time, and were later filled with ten seated Sibyls and ten Prophets by Giovanni Battista and Tommaso della Porta, and Girolamo and Aurelio Lombardo. Four of the Lombardo prophets were executed between 1543 and 1548. The bronze doors on the north and south sides of the Holy House, containing eight scenes from the life of Christ, were executed by Girolamo and Lodovico Lombardo, Tiburzio Vergelli and Antonio Calcagni between 1568 and 1576. Of the narrative scenes which form the most important sculptural feature of the monument the Annunciation and Annunciation to the Shepherds and Adoration of the Shepherds are autograph works by Andrea Sansovino. The left half of the Marriage of the Virgin was completed by Andrea Sansovino, with the exception of the figure of St. Joseph which is by Tribolo, and the right half of this scene was carved by Tribolo to Sansovino's design. On stylistic grounds it seems reasonably certain that the schemes of the Birth of the Virgin and the Dormition of the Virgin (though not the formulation of the figures) also originated with Andrea Sansovino; the presence in the Uffizi (Huntley) of drawings by Bandinelli related to the Birth of the Virgin does not in itself constitute an argument against this view. It is possible that the right half of the Adoration of the Magi was also planned by Sansovino. Three reliefs, the Translation of the Holy House, the Visitation, and the Virgin and St. Joseph completing the Census reveal no trace of Sansovino's style. Sansovino's reliefs are described by Vasari, whose information on the authorship of individual scenes is, however, inexact. The importance of Sansovino's scenes, and especially of the Annunciation, for Florentine style in the third quarter of the sixteenth century, transpires from a letter written by Vasari in August 1570 (Frey, *Vasaris literarischer Nachlass*, ii, No. DCCXLVII): 'Crederei che chi volesse durar fatica a trovare qualche bel casamento, come fece M. Andrea Sansovino a Loreto, nella facciata dinanzi la cappella della Madonna, in quella sua Nunciata, dov'è un casamento di colonne in piedistalli, gittando archi, fa un isfuggimento di trafori molto bello, ricco e vario; oltre che quell'angelo che è accompagnato d'altri che volano, ed a piè con esso, ed in aria quelle nuvole piene di fanciulli, che fa un vedere miracoloso, con quello Spirito Santo' (I think that someone who is willing to exert himself can contrive as fine a setting as Master Andrea Sansovino did at Loreto, on the side of the Chapel of the Madonna. In that Annunciation of his there is a setting of columns on pedestals, throwing out arches, which makes a very fine and rich and varied sequence of apertures; not to mention the angel accompanied with others flying and walking, and the clouds full of boys in the air, which, with the Holy Spirit, makes a marvellous sight).

Plate 48: VIRGIN AND CHILD WITH ST. ANNE
S. Agostino, Rome

The group of the Virgin and Child with St. Anne, now situated in the second chapel on the left of the church of S. Agostino, is signed on its base: ANDREAS. DEMONTE SANSOVINO. On the plinth, which is carved separately from the main figure are the words:

IESV DEO DEIQ: FILIO MATRI
VIRGINI. ANNAE AVIAE MATERNAE
IO: CORICIVS EX GERMANIS
LVCVMBVRG: PROT: APOST: DDD:
PERPETVO SACRIFICIO DOTEM
VASA VESTES TRIBVIT MDXII

(To Jesus, God and Son of God, to the Virgin his Mother, and to Anne his grandmother, Johann Goritz from Germany, native of Luxemburg, Apostolic Protonotary, gives and dedicates this. As endowment he makes over goods in perpetual sacrifice. 1512).

The group was originally set beneath Raphael's fresco of Isaiah against the third pier on the left of the nave of the church, and is described in this position by Vasari: 'Fece di marmo in Santo Agostino di Roma, cioè in un pilastro a mezzo la chiesa, una Sant' Anna che tiene in collo una Nostra Donna con Cristo, di grandezza poco meno che il vivo; la quale opera si può fra le moderne tenere per ottima; perchè sì come si vede nella vecchia una viva allegrezza e proprio naturale, e nella Madonna una bellezza divina; così la figura del fanciullo Cristo è tanto ben fatta, che niun' altra fu mai condotta simile a quella di perfezione e di leggiadria; onde merito che per tanti anni si frequentasse d'appicarvi sonetti, ed altri vari e dotti componimenti, che i frati di quel luogo hanno un libro pieno, il quale ho veduto io con non piccola maraviglia. E di vero ebbe ragione il mondo di così fare, perciocchè non si può tanto lodare questa opera, che basti' (In S. Agostino at Rome, on a pilaster in the middle of the church, he did a group in marble of St. Anne with her arm round the neck of a Madonna with the Child, little less than life-size. One may well consider this work to be the best in modern times; because just as one sees in the old woman a lively and altogether natural happiness, and in the Madonna a divine beauty, so the figure of the Infant Christ is done so well that no other was ever carried out with such perfection and delicacy. For this reason it was fitting that for so many years people came to attach to it sonnets and various other compositions; the friars of that place have a book full of them, which I have seen myself with considerable astonishment. And truly the world was right to do this, because one can never praise this work enough). Johann Goritz, protonotary apostolic, by whom the present group and Raphael's Isaiah were commissioned, was a native of Luxembourg, and formed the centre of a humanist circle frequented by Sadoleto, Bembo, Castiglione, Giovio, Erasmus and other notable figures of the time. The commissions to Raphael for the Isaiah and to Andrea Sansovino for the present group form a manifestation of Goritz' devotion to St. Anne. The fresco bears a Greek dedication to St. Anne, the Virgin and Christ, and the Hebrew scroll held by the Prophet is inscribed with Isaiah xxvi, 2 ('Open ye the gates that the righteous nation which keepeth the truth may enter'). According to Vasari, Raphael's fresco was remodelled in the spirit of the Sistine ceiling of Michelangelo. The first half of the Sistine ceiling was disclosed in August 1510, but it is possible that the reference is to the later Prophets on the ceiling.

There is a presumption that Sansovino's statue and Raphael's fresco were commissioned simultaneously. Goritz (for whom see Pastor, iv-2, p. 429, and D. Gnoli, 'Le origine di maestro Pasquino', estratto dalla *Nuova Antologia*, xxv, ser. iii, 1890, pp. 25–8) customarily entertained at his Vigna above the Forum of Trajan on the feast of St. Anne (26 July), and on this occasion poems were delivered by his fellow humanists both to his villa, where they were attached to lemon trees and classical sculptures, and to S. Agostino, where they were attached to boards set up before Sansovino's group. Not long after the completion of the group the four boards were increased to five. In 1524 a selection of the poems (in which the work of a hundred and thirty poets is represented) was printed under the title *Coriciana* (Rome, dated July, 1524).

JACOPO SANSOVINO
(b. 1486; d. 1570)

Jacopo Tatti was born in Florence, and baptised on 3 July 1486. In 1502 he entered the workshop of Andrea Sansovino, whose name he assumed, and in 1505–6 he followed Andrea to Rome, where he was engaged principally on the restoration of antiques, made a copy of the Laocoon, and may have assisted Andrea Sansovino in work on the S. Maria del Popolo monuments. In Rome he attracted the notice of Bramante and Raphael, and made a wax model of the Deposition for the use of Perugino (now in the Victoria & Albert Museum, London). In 1511 he returned to Florence, where he received commissions for the St. James in the Duomo (Plate 51 below) and the Bacchus in the Museo Nazionale (Plate 50 below). At this time he shared a joint studio with the painter Andrea del Sarto, for whom he prepared models. He participated in the decorations for the entry of Pope Leo X (1515). As a result of these he appears to have been promised a share in the sculptural decoration of the façade of S. Lorenzo, but his proposed participation was rejected by Michelangelo, to whom he wrote a bitter letter of protest on 30 June 1517. Returning to Rome in 1518, he undertook a number of sculptures, of which the most important are the Madonna del Parto in S. Agostino (see Plate 49 below), the St. James for S. Giacomo degli Spagnuoli, now in S. Maria di Monserrato (1519–20?) and the tomb of the Cardinal of S. Angelo (d. 1511) in S. Marcello (Fig. 62). In the year of the Sack (1527) he moved from Rome to Venice, which he may already have visited in 1523 before the death of Cardinal Grimani (27 August 1523). At this time he was responsible for the monument of Gelasio Nichesola (d. 2 September 1527) in the Duomo at Verona, the Virgin and Child from which was reproduced in Sansovino's workshop as a bronze statuette (examples at Leningrad, Ashmolean Museum, Oxford, and elsewhere). In 1528 he was charged with the completion of a relief begun by Antonio Minelli for the chapel of St. Anthony in the Santo at Padua (final payment 1534). A letter of Pietro Aretino of 6 October 1527 refers to a project for a statue of Venus to be carved by Sansovino for Federigo Gonzaga, Duke of Mantua. Sansovino appears to have visited Mantua in 1528–9, and in the latter year became Protomagister of St. Mark's. A statue of the Virgin and Child at the entrance of the Arsenale is signed and dated 1534. A stucco relief with a Sacra Conversazione in Berlin must have been executed about this time, since a figure from it was copied by Sansovino's pupil Tiziano Minio (1536). On 3 June 1536 Sansovino signed the contract for a second marble relief for Padua (see Plate 112 below). To this period belong the tribune reliefs in St. Mark's (see Plate 111 below), the Loggetta (see Plates 108–9 below), and the commencement of work on the sacristy door of St. Mark's (see Plate 110 below). The four bronze Evangelists on the balustrade of the high altar of St. Mark's were installed on 30 January 1553. To the fifties belong a number of marble sculptures which include the much damaged Hercules at Brescello (commissioned by Ercole II d'Este in 1550), the Neptune and Mars on the Scala dei Giganti of the Palazzo Ducale (see Plate 113 below), and the Venier monument in S. Salvatore (1556–61) (Fig. 105) as well as the Rangone monument on the façade of S. Giuliano (see Plate 116 below). Throughout the whole of his residence in Venice Sansovino was also active as an architect. He died on 27 November 1570.

BIBLIOGRAPHY: The contemporary sources for Sansovino's career are headed by Vasari (edition of Lorenzetti, Florence, 1913). None of the modern monographs on Sansovino is worthy of its theme; the most interesting is that of Weihrauch (*Studien zum bildnerischen Werke des Jacopo Sansovino*, Strassburg, 1935), and the best illustrated is an otherwise unreliable volume by L. Pittoni (*Jacopo Sansovino scultore*, Venice, 1909). For a criticism of the latter book see Lorenzetti (in *Nuovo Archivio Veneto*, xx, 1910, pp. 318–40). A good chapter on Sansovino in Planiscig's *Venezianische Bildhauer der Renaissance* (Vienna, 1921, pp. 349–86) is vitiated by the inclusion of a number of wrongly attributed bronze and terracotta statuettes, mainly in Viennese private collections. A small book by G. Mariacher (*Il Sansovino*, in Bibl. Moderna Mondadori No. 717, Milan, 1962) provides an adequate record of essential facts, and a brochure by A. Paolucci (*Jacopo Sansovino*, in I Maestri della Scultura, No. 37, Milan, 1966) contains good colour photographs. For Sansovino's part in the Florentine decorations of 1515 and his relations with Raphael see Pope-Hennessy (in *Burlington Magazine*, ci, 1959, pp. 4–10). The interaction of the styles of Sansovino and Sarto is discussed by J. Shearman (*Andrea del Sarto*, Oxford, 1965, i, pp. 29–31 and 62–4) and S. Freedberg (*Andrea del Sarto*, Cambridge, 1963, pp. 31, 43). In the former book Sarto's indebtedness to Sansovino's models is

underestimated, in the case both of the Chiostro dello Scalzo frescoes and of the Madonna of the Harpies (1517), and undue weight is thrown on a wrongly ascribed model of the Virgin and Child at Budapest.

Plate 49: VIRGIN AND CHILD
S. Agostino, Rome

The Virgin and Child, known as the Madonna del Parto, is noted by Vasari: 'E così avendo tolta a fare per Giovan Francesci Martelli fiorentino una Nostra Donna di marmo, maggiore del naturale, la condusse bellissima col putto in braccio; e fu posta sopra un altare dentro alla porta principale di Santo Agostino, quando s'entra, a man ritta. Il modello di terra della quale statua donò al prior di Roma de' Salviati, che lo pose in una cappella del suo palazzo sul canto della piazza di San Piero al principio di Borgo nuovo' (And so, having agreed to make a Virgin in marble above life size for Giovan Francesco Martelli, he made it most beautiful with the Child in her arm; and it was placed on an altar inside the main entrance of S. Agostino, to the right as one goes in. He gave the terracotta model of this statue to the Prior of Rome Salviati, who placed it in a chapel in his palace at the side of the Piazza di S. Pietro at the beginning of the Borgo Nuovo). Sansovino is last mentioned in Florence in May 1518, and arrived in Rome before 15 December of this year. Vasari's text implies that the commission for the Madonna del Parto preceded that for the St. James in S. Giacomo degli Spagnuoli, and it was therefore presumably commissioned in 1518-9. If Vasari is correct in stating that the two statues were carved while Sansovino was engaged on the rebuilding of S. Marcello (reconstructed after the fire of 22 May 1519), work on the group is likely to have continued through 1520. The classical prototype on which the figure of the Virgin is based – perhaps an Agrippina – has not been identified. The connection of the drapery forms with those of a painting by Fra Bartolommeo in the Uffizi (Weihrauch) is remote. The niche in which the figure rests was designed by Sansovino.

Plate 50: BACCHUS
Museo Nazionale, Florence

Vasari, after describing a marble Venus made by Sansovino in Florence for Giovanni Gaddi, two putti made for Giovanni Francesco Ridolfi, and a fireplace with representations of Vulcan and other deities made for Bindi Altoviti, continues as follows: 'Per lo che Giovanni Bartolini, avendo fatto murare nel suo giardino di Gualfonda una casotta, volse che il Sansovino gli facesse di marmo un Bacco giovinetto, quanto il vivo: perchè dal Sansovino fattone il modello, piacque tanto a Giovanni, che, fattogli consegnare il marmo, Iacopo lo cominciò con tanta voglia, che lavorando volava con le mani e con l'ingegno. Studiò, dico, quest'opera di maniera, per farla perfetta, che si mise a ritrarre dal vivo, ancor che fusse di verno, un suo garzone, chiamato Pippo del Fabbro, facendolo stare ignudo

buona parte del giorno. Condotta la sua statua al suo fine, fu tenuta la più bella opera che fusse mai fatta da maestro moderno, atteso che 'l Sansovino mostrò in essa una difficultà, non più usata, nel fare spiccato intorno un braccio in aria che tiene una tazza del medesimo marmo, traforata tra le dita tanto sottilmente, che se ne tien molto poco; oltre che per ogni verso è tanto ben disposta ed accordata quella attitudine, e tanto ben proporzionate e belle le gambe e le braccia attaccate a quel torso, che pare, nel vederlo e toccarlo, molto più simile alla carne; intanto che quel nome, che gli ha, da chi lo vede, se gli conviene, ed ancor molto più. Quest'opera, dico, finita che fu, mentre che visse Giovanni, fu visitata in quel cortile di Gualfonda da tutti i terrazzani e forestieri, e molto lodata. Ma poi, essendo Giovanni morto, Gherardo Bartolini suo fratello la donò al duca Cosimo; il quale come cosa rara la tiene nelle sue stanze, con altre bellissime statue che ha di marmo' (For this reason Giovanni Bartolini, who had had a house built in his garden of Gualfonda, wanted Sansovino to make him a young Bacchus in marble, life-size. When Sansovino had made the model for it, Giovanni liked it so much, that he had him supplied with the marble, and Iacopo began it with such enthusiasm that his hands and brain flew as he worked. He took such pains, I say, over this work in order to make it perfect, that he set himself to portray from the life, even though it was winter, an assistant of his called Pippo del Fabbro, making him stand naked for a good part of the day. When the statue had been completed, it was considered the most beautiful work ever to have been made by a modern master; for Sansovino displays in it a difficulty not elsewhere tried, making an arm, detached on each side and raised in the air, which holds a cup made of the same marble and so finely hollowed out between the fingers, that the contact is very slight. Besides, the attitude is so well composed and balanced on every side, and the legs and arms attached to the torso are so well proportioned, that it seems, both to see and to touch, much more like living flesh; so the reputation it has among all who see it is deserved, and even much more. This work, I say, when it was finished, while Giovanni was alive, was visited in the courtyard of Gualfonda by every native and foreigner and much praised. But later, when Giovanni was dead, Gherardo Bartolini his brother gave it to Duke Cosimo, who keeps it as a rare thing in his private rooms, together with other most beautiful marble statues of his). The statue was gravely damaged by fire in 1762, but was subsequently pieced together into its present state, and in 1880 was transferred from the Uffizi to the Museo Nazionale. The Giunti edition of Vasari (III-ii, c. 795), contains a supplementary account of the statue and of Pippo del Fabbro, from whom it was modelled: 'Il quale Pippo sarebbe riuscito valente uomo, perchè si sforzava con ogni fatica d'imitare il maestro: ma o fusse lo star nudo e con la testa scoperta in quella stagione, o pure il troppo studiare e patir disagi, non fu finito il Bacco che egli impassò in sulla maniera del fare l'attitudini; e lo mostrò, perchè un giorno che pioveva dirottamente chiamando il Sansovino Pippo, ed egli non rispondendo, lo vidde poi salito sopra il tetto in cima d'un camino ignudo che faceva l'attitudine del suo Bacco. Altre volte pigliando lenzuola o altri panni grandi, i quali bagnati se li recava addosso all'ignudo, come

fusse un modello di terra o cenci, e acconciava le pieghe; poi salendo in certi luoghi strani, e arrecandosi in attitudini or d'una or d'altra maniera di profeta, d' apostolo, di soldato o d'altro, si faceva ritrarre, stando così lo spazio di due ore, senza favellare, e non altrimenti che se fosse stato una statua, immobile. Molte altre simili piacevoli pazzie fece il povero Pippo; ma sopra tutto, mai non si potè dimenticare il Bacco che aveva fatti il Sansovino, se non quando in pochi anni si morì' (This Pippo would have turned out a capable fellow, for he was striving with every effort to imitate his master; but, whether from standing naked with his head uncovered at that season, or from studying too much and suffering discomforts, before the Bacchus was finished he went mad and took to copying the poses of the figure. He did so one day when it was pouring with rain. When Sansovino called out 'Pippo', he did not answer, and Sansovino saw him finally, mounted on the top of a chimney on the roof, naked and striking the pose of his Bacchus. On other occasions he took a sheet or other large piece of cloth wetted it, wrapped it round his naked body, as if he were a model of clay or rags, and arranged the folds; then, climbing up into various odd places, and settling himself into one and another attitude – as a Prophet, Apostle, warrior or something else – he would have himself drawn, standing in this way without speaking for as long as two hours at a time, just as if he had been a motionless statue. Poor Pippo played many other amusing mad tricks of this kind; but, above all, he could never forget the Bacchus that Sansovino had made, until he died a few years later). It is clear from Vasari's account that the Bacchus was produced after Sansovino's return to Florence (1511) and before his second departure for Rome (1518); a dating between 1511 and 1514 is presumed by Lorenzetti and Planiscig, and a dating between 1513 and 1518 by Weihrauch. The statue can, however, be assigned with complete confidence to the years 1511-12, since payment for it was made in the latter year (document cited by L. Ginori Lisci, *Gualfonda: un antico palazzo ed un giardino scomparso*, Florence, 1953: 'Jacopo d'antonio detto el sansovino schultore . . . per fattura d'uno bacco di marmo con suo marmo fece a Giovanni Bartolini'). It was set up in 1519 in the garden courtyard on a red and white marble base by Benedetto da Rovezzano. The classical model is identified by M. Horster ('Antike Vorstufe zum Florentiner Renaissance Bacchus', in *Festschrift Ulrich Middeldorf*, Berlin, 1968, pp. 218-24) with a Bacchus in the Museo Torlonia, which is recorded in the seventeenth century in the Palazzo Farnese (for this see Jacobus Marchuccius, *Antiquarum Statuarum*, Rome, 1623).

Plate 51: SAINT JAMES THE GREAT
Duomo, Florence

The contract between the Opera del Duomo and Michelangelo for the provision of twelve over life-size statues of Apostles for the Duomo (see Plate 14 above) was abrogated on 18 December 1505, and no further action regarding the statues seems to have been taken for six years. In 1511, however, the project was revived, according to Vasari at the instance of Cardinal Giulio de' Medici, and on 2 June 1511 a statue of St. James the Great was commissioned from Jacopo Sansovino. A year later, on 28 December 1512, two figures of SS. Matthew and Thaddeus were commissioned from Andrea Sansovino, who was then working in Rome; the contract for these statues (for which see Fabriczy, 'Ein unbekanntes Jugendwerk Andrea Sansovinos', in *Jahrbuch der Preuszischen Kunstsammlungen*, xxvii, 1906, pp. 88-9) was conditional upon ratification by the sculptor in a period of two months, and neither figure was executed. On 28 September 1512 a fourth figure, St. John the Evangelist, was commissioned from Benedetto da Rovezzano. Shortly afterwards, on 15 October 1512, a statue of St. Andrew was allotted to Andrea Ferrucci, and in 1515 an attempt was made to procure another statue from Ferrucci. On 25 January 1515, on the intervention of Giuliano de' Medici, a St. Peter was allotted to Bandinelli. At this point the commissions were allowed to lapse, and the figures remained in the Opera del Duomo until, in 1565, on the instructions of Cosimo I, the interior of the church was whitewashed for the marriage of Joanna of Austria and Francesco de' Medici, and the four completed figures were temporarily installed. The coloured marble tabernacles in which they are now shown were designed in 1563-65 by Ammanati. Thereafter four further figures were commissioned, two from Giovanni Bandini and two from Vincenzo de' Rossi. The eight figures are now displayed as follows:

(i) *Last pier of nave on left.* Jacopo Sansovino: St. James (see below).

(ii) *Last pier of nave on right.* Vincenzo de' Rossi: St. Matthew (installed 1580).

(iii) *Right entrance wall of right tribune.* Giovanni Bandini: St. Philip (completed before 12 October 1577, when the construction of the tabernacle was begun).

(iv) *Left entrance wall of right tribune.* Giovanni Bandini: St. James the Less (completed before 22 October 1576, when the construction of the tabernacle was begun).

(v) *Right entrance wall of central tribune.* Benedetto da Rovezzano: St. John the Evangelist (Fig. 43) (contract dated 28 September 1512, statue assessed 30 October 1513).

(vi) *Left entrance wall of central tribune.* Baccio Bandinelli: St. Peter (Fig. 41) (contract dated 25 January 1515, statue assessed by Lorenzo di Credi 4 June 1517. Exhibited between 1565 and 1580 in the position now occupied by Vincenzo de' Rossi's St. Matthew, as a counterpart to the St. James of Sansovino).

(vii) *Right entrance wall of left tribune.* Andrea Ferrucci: St. Andrew (Fig. 42) (contract dated 13 October 1512, presumably completed by 1514).

(viii) *Left entrance wall of right tribune.* Vincenzo de' Rossi: St. Thomas (undocumented: prior to 1580).

Letters written by Ammanati to the Grand-Duke in 1563 reveal considerable hesitancy on the part of the Florentine Academicians at the Grand-Duke's proposal to instal the four completed figures in the Cathedral. In a letter of 8 October 1563 (for this see Gaye, iii, pp. 118-20) Ammanati expresses the opinion that only two of the figures, the St. James of Sansovino and the St.

Peter of Bandinelli, deserved to be placed in the Cathedral, a view which was reaffirmed by the painter Bronzino. In the same letter he draws attention to the difficulty of devising tabernacles which would conform to the architecture of the church: 'ma che era ben vero che le figure belle davano tanto diletto che le si comportavano in ogni luogo, e che havendole pure a mettere, bisognava far un basamento solo per la figura: ma perchè dubito ch'ella non paia povera, farò un modelletto e mandarollo a V.E.I., et ella lo giudicherà' (I said . . . that it was certainly true the beautiful figures gave such pleasure that they went well in any position, and since they had to be put somewhere it was necessary to make simply a base for the figure. But as I suspect the appearance may be poor, I will make a small model and send it for Your Highness to judge). On 6 November 1563 Ammanati reported to the Grand-Duke (Gaye, iii, p. 122) that he had placed the matter before a meeting of the Academy: 'Dissi che le due figure manco buone non ce le metterei, e che per ragione d'architettura non si poteva legar nulla a quei pilastri, ma che il men male era mettervele, non ci sendo luogo più comodo, e le buone figure fanno bel veder per tutto. Dissi che io avevo fatto un modelletto, e un'altro presso che finito del modo del porle' (I said that I would not put the two less good figures there, and that for architectural reasons one could not fix anything to the pilasters; but that the least bad solution was to put them there, as there was no more suitable place, and good figures look fine anywhere. I said I had made one small model and almost finished another, showing how to place them). At this meeting Francesco da San Gallo seems to have proposed that the unfinished St. Matthew of Michelangelo should also be shown in the church. Finally, on 22 December 1563 (Gaye, iii, pp. 123–4), Ammanati informed the Grand-Duke that he and Francesco da Sangallo had placed alternative models for the tabernacles before the Academy; these had been discussed in the absence of the two sculptors, and his own had been selected, and would therefore be submitted for approval to the Grand-Duke.

From the beginning it was accepted that Sansovino's St. James was superior to the other statues. Thus it is described by Vasari in the following terms: 'Onde, fatto il modello d'un San Iacopo, il quale modello ebbe (finito che fu l'opera) messer Bindo Altoviti, cominciò quella figura, e continovando di lavorarla con ogni diligenzia e studio, la condusse a fine tanto perfettamente, che ella è figura miracolosa, e mostra in tutte le parti essere stata lavorata con incredibile studio e diligenzia ne' panni, nelle braccia e mani traforate, e condotte con tant'arte, e con tanta grazia, che non si può nel marmo veder meglio. Onde il Sansovino mostrò in che modo si lavoravano i panni traforati, avendo quelli condotti tanto sottilmente e sì naturali, che in alcuni luoghi ha campato nel marmo la grossezza che'l naturale fa nelle pieghe, ed in su' lembi, e nella fine de' vivagni del panno: modo difficile, e che vuole gran tempo e pacienza, a volere che riesca in modo che mostri la perfezione dell'arte' (So, having made the model of a St. James – a model which Messer Bindo Altoviti had when the work was finished – he began the figure and, continuing to work on it with all diligence and care, he carried it through so perfectly, that it is a miraculous figure and shows in every part that it was worked with incredible care and diligence in the drapery and the undercut arms and hands; they are carried through with such art and such grace, that there is nothing better to be seen done in marble. In this way Sansovino showed how undercut drapery should be worked, having made it so delicately and naturally, that in some places he has managed to get in the marble the natural thickness of the folds, edges and hem of the cloth; this is a difficult procedure, and needs much time and patience if you wish it to succeed in showing the perfection of art). In contrast to this passage Vasari praises the St. Peter of Bandinelli in terms of studied moderation ('benchè non con tutta la perfezione della scultura, nondimeno si vede in lui buon disegno'), which are only slightly less cool than those applied to the St. John the Evangelist of Benedetto da Rovezzano ('figura assai ragionevole e lavorata con buon disegno e pratica') and the St. Andrew of Ferrucci ('Andrea, dunque, condusse la sua con più bella pratica e giudizio che con disegno: e n'acquistò, se non lode quanto gli altri, nome di assai buono e pratico maestro'). The St. James of Sansovino (for the documents concerning which see Weihrauch, pp. 88–9) was moved on 26 May 1513 from the Spedale di S. Onofrio, where it had been carved, to the Opera del Duomo, and was completed in 1518.

GIOVANNI DA NOLA
(b. ca. 1488; d. 1558)

Giovanni da Nola, or Giovanni da Mirigliano (so-called from his birthplace Marigliano, a town in the province of Caserta not far from Nola), was trained initially by the wood-carver Pietro Belverte (d. 1513). A reference in the will of Tommaso Malvito (2 July 1508) shows that at this time he was already active as a marble sculptor, carving the frame of a door for the Hospice of the Annunziata. Giovanni da Nola's name is mentioned in receipts for payments issued by Belverte at this time. The most important of Giovanni da Nola's early works in wood is the Nativity group in S. Maria del Parto, Naples.

A celebrated letter from Summonte in Naples to Marcantonio Michiel in Venice of March 1524 mentions that at this time Giovanni da Nola was engaged on the tomb of Don Ramon da Cardona (probably begun 1522). In 1528 he completed the high altar of S. Lorenzo Maggiore, and about 1530 the tomb of Antonia Gaudino in S. Chiara. A lost figure of Medea slaying her Children is praised in an epigram by Iano Anysio (1531–2). In 1535 Giovanni da Nola prepared the clay model for the tomb of Guida Fieramosca (d. 1532) for Montecassino. The altarpieces of the Liguoro Chapel in the church of Monte-

oliveto at Naples (1532) and the Chapel of the Madonna della Neve in S. Domenico (1536) date from this time. In 1539 he received the commission for the three tombs of Jacopo, Sigismondo and Ascanio Sanseverino in SS. Severino e Sossio (final payment 1546), some of his most original sepulchral monuments, and these appear to have been followed by the monument of Don Pedro da Toledo (see Plate 52 below). The relief of the Lamentation over the Dead Christ in S. Maria delle Grazie a Caponapoli (see Plate 54 below) was executed after 1540 and before 1549. The last recorded payment to Giovanni da Nola, in connection with work on the high altar of S. Patrizia, dates from 1551.

BIBLIOGRAPHY: De Rinaldis ('Note su Giovanni da Nola,' in *Napoli Nobilissima*, n.s. ii, 1921, pp. 16–20), Venturi (X-i, pp. 715–44), Weise ('Il problema dell'opera personale di Giovanni da Nola,' in *Bollettino di Storia dell'Arte dell'Istituto Universitario di Magistero, Salerno*, ii, 1952, pp. 65–79), and especially Morisani (in *Archivio storico per le provincie napoletane*, n.s. xxvii, 1941, pp. 283–327).

Plate 52: MONUMENT OF DON PEDRO DA TOLEDO
S. Giacomo degli Spagnuoli, Naples

The monument (Fig. 64) has the form of a raised platform, at the corners of which are figures of Justice, Prudence, Temperance and Fortitude. In the centre, on an elevated plinth, are the kneeling figures of Don Pedro da Toledo and his wife, Maria Osorio Pimentel. Beneath them is the inscription:

PETRVS TOLETVS
FREDERICI DVCIS ALVE FILIVS
MARCHIO VILLE FRANCHE REG. NEAP. PROREX
TVRCAR. HOSTIVMQ. OMNIVM SPESVBLATA
RESTITVTA IVSTITIA VRBE MENIIS ARCE FOROQ.
AVCTA MVNITA ET EXORNATA DENIQ. TOTO REG. DIVITIIS
ET HILARI SECVRITATE REPLETO MONVMENTVM
VIVENS IN ECCLESIA DOTATA
ET A FVNDAMENTIS ERECTA PON. MAN.
VIXIT ANN. LXXIII REXIT XXI OB. MDLIII VII KAL.
FEBRVARII
MARIE OSORIO PIMENTEL CONIVGIS CLARIS IMAGO
GARSIA REG. SICILIE PROREX MARISQ.
PREFECTVS PARENTIB. OPT. P. MDLXX.

Round the sides and back are three reliefs representing (i) Don Pedro da Toledo's expedition of 1538 against the Turks, (ii) an operation in the waters of Baia in 1544 against the pirate Barbarossa, (iii) Don Pedro da Toledo awaiting the Emperor Charles V by the Porta Capuana (1535). Don Pedro, the father-

in-law of the Grand-Duke Cosimo I, died at Florence, and was buried in the Duomo, where his tomb still survives. The tomb in Naples is described by Vasari: 'A costui (Giovanni da Nola) fece lavorare Don Pietro da Toledo, marchese di Villafranca, ed allora vicere di Napoli, una sepoltura di marmo per se e per la sua donna: nella quale opera fece Giovanni una infinita di storie delle vittorie ottenute da quel signore contra i Turchi, con molte statue che sono in quell'opera tutta isolata e condotta con molta diligenza. Doveva questo sepolcro esser portato in Ispagna; ma non avendo ciò fatto mentre visse quel signore si rimase in Napoli' (From him Don Pietro da Toledo, marquess of Villafranca, and at that time Viceroy of Naples, commissioned a marble tomb for himself and his wife. In this work Giovanni made an infinite number of stories of the victories won by the viceroy against the Turks, with many statues in the work which stands isolated and is conducted with great diligence. This tomb was to have been transported to Spain; but since Don Pietro had not arranged for this while he was alive, it remained in Naples). According to another passage in Vasari, the marble for the monument was sent to Naples by Cosimo I from the quarries at Pietrasanta. The inscription on the front of the monument confirms that it was ordered in the Viceroy's lifetime, and Vasari's statement that it was destined to be sent to Spain may be correct. It is not mentioned by De Stefano in a description (1560) of S. Giacomo degli Spagnuoli, and must therefore have been installed in the church by Don Garzia da Toledo between this year and 1570, the date inscribed on the monument. A poem by Tansillo cited by Croce ('Memorie degli Spagnuoli nella città di Napoli,' in *Napoli Nobilissima*, iii, 1894, pp. 122–4) throws little light on the date of the commission, which was presumably awarded after the date of the latest of the scenes shown in the reliefs (1544). The quality of the portrait statues is consistently high, and attempts to assign them to Giovanni da Nola's workshop (Frizzoni and others) appear to be unwarranted.

Plate 54: THE LAMENTATION OVER THE DEAD CHRIST
S. Maria delle Grazie a Caponapoli, Naples

The Altar of the Deposition in S. Maria delle Grazie a Caponapoli (for which see Filangieri, *Santa Maria delle Grazie a Caponapoli*, Naples, 1888, pp. 120–9) consists of a richly carved architectural surround with, in the centre, a relief of the Lamentation over the Dead Christ, of which the lower half is fully figurated and the upper half shows the three vacant crosses with ladders against them. It forms part of the funerary chapel of the Giustiniani family, and was endowed by Nicoletta Spinola in 1549.

GIROLAMO SANTACROCE
(b. ca. 1502; d. 1537)

The birth-date of Girolamo Santacroce is deducible from a passage in the celebrated letter written by Summonte to Marcantonio Michiel in March 1524, in which the sculptor is described as 'di anni circa ventidue . . . che prima fu aurifice; poi s'è voltato in marmo con tanta excellenzia de ingegno che senza dubbio, vivendo, sarà grande nella sua arte'. According to Summonte, he had at this time made a marble statue of Apollo (lost) and a medal of Sannazaro (for this and for a contemporary medal by Santacroce of Andrea Caraffa see Hill, *A Corpus of Italian Medals of the Renaissance before Cellini*, London, 1930, No. 350). It has been claimed (Venturi, on the basis of documents published by Filangieri, *Documenti per la storia, le arti e le industrie delle provincie napoletane*, Naples, 1891) that in 1517 Santacroce was employed on the monument of Giovanni Antonio Caracciolo in the church of the Annunziata, Naples, and (De Rinaldis) that he worked in 1517–8 in the Caracciolo di Vico Chapel in S. Giovanni a Carbonara as an assistant of Ordonez. The sources of his style are, however, the work of Giovanni Tommaso Malvito and the Neapolitan sculptures of Benedetto da Maiano (Vol. II, p. 308). In 1520 he went, with his associate Gian Giacomo da Brescia, to Carrara, where he was engaged, in conjunction with Raffaello da Montelupo, in carving two statues of Doctors of the Church for the Ximenes de Cisneros monument at Alcala de Henares. Returning to Naples in 1522, he assumed responsibility, on 7 February 1525, with Gian Giacomo da Brescia and Antonio Caccavello, for an altar in S. Domenico, and in 1526 designed an Altar of the Sacrament for the Annunziata. His principal work of this time, the Del Pezzo Altar in S. Anna dei Lombardi, is inscribed with the date 1524, and was presumably begun in this year. The Sinicalco Altar in S. Maria delle Grazie a Caponapoli, with a relief of the Incredulity of St. Thomas, was certainly executed after 1528, and perhaps in 1536 (Padiglione, *Memorie storiche artistiche del tempio di S. Maria delle Grazie*, Naples, 1855, p. 101). A relief of St. Jerome from a disassembled altar is in S. Agnello a Capo napoli. The latest of Santacroce's surviving works is the monument of Carlo Gesualdo in the Museo di S. Martino, Naples.

BIBLIOGRAPHY: De Rinaldis' edition of Vasari's life of Santacroce (Florence, 1912), Angelo Borzelli (*Gerolamo Santacroce*, Naples, 1924), and the relevant chapter of Venturi (X-i, pp. 745–57). The best critical account of Santacroce's work is that of Morisani ('Geronimo Santacroce,' in *Archivio storico napoletano*, n.s. xxx, 1944–6, pp. 3–17). For the letter of Summonte see Nicolini (*L'arte napoletana del rinascimento e la lettera di P. Summonte a M. A. Michiel*, Naples, 1925) and for the Ximenes de Cisneros monument Justi (in *Jahrbuch der Preuszischen Kunstsammlungen*, xii, 1891, pp. 66–90).

Plate 53: VIRGIN AND CHILD
S. Maria a Cappella Vecchia, Naples

The figure, along with statues of SS. John the Baptist and Benedict, formed part of an altar carved by Santacroce for · S. Maria a Cappella Vecchia, which was broken up in the seventeenth century, when two statues were transferred to the church of the Ascension. In style it is related (Morisani) to a Virgin and Child by Giovanni Tommaso Malvito in S. Maria delle Grazie a Caponapoli. The statues are traditionally supposed to have been commissioned by Abbate Commendatario Fabrizio di Gennaro (d. 1541), who was responsible for the restoration of the church (1506).

FRANCESCO DA SANGALLO
(b. 1494; d. 1576)

Son of the architect and sculptor Giuliano da Sangallo, Francesco was born on 1 March 1494. At the age of ten he was taken by his father to Rome (1504), where he was present (1506) at the identification of the Laocoon. A letter written towards the close of Sangallo's life (1567) describes this event (for this see C. Fea, *Miscellanea filologica critica e antiquaria*, Rome, 1790, p. 329). His earliest dated work is a Virgin and Child with St. Anne in Or San Michele of 1522–26 (see Plate 56 below). It has been plausibly suggested (Middeldorf) that a bust Giovanni delle Bande Nere (d. 1526) in the Museo Nazionale, Florence, and a standing figure of St. John the Baptist, formerly ascribed to Donatello, in the same museum, date from about this time In 1531–3 Francesco was active at Loreto, where he worked, with Tribolo, on a relief of the Dormition of the Virgin for the Holy House. He took part in the preparation of decorations for the entry of Charles V into Florence in 1536, and in 1540 was commissioned to carve the tomb of the Abbess Colomba Ghezzi (formerly in S. Martino alla Scala, now in the Museo Bardini). A self-portrait relief in S. Maria Primerana at Fiesole is dated 1542. At this or at a rather earlier time he was active in St. Peter's, Rome, and in 1543 succeeded Baccio d'Agnolo as Capomaestro and architect of the Duomo in Florence. In 1540

he received the commission for the monument of Antonio Fiodo in the church of Monteoliveto at Naples (executed in collaboration with Bernardino del Boro da Siena), and in 1546 was engaged in work for SS. Severino e Sosio at Naples. The Marzi monument in the Annunziata (see Plate 55 below) dates from this year. Outside Florence Francesco was also responsible for statues of SS. Peter and Paul for the monument of Piero di Lorenzo de' Medici in the Badia at Montecassino (commissioned 1532, statues completed 1547, installed 1559). In 1552 he was engaged on a fountain for the Villa di Papa Giulio in Rome. The impressive tomb slab of Leonardo Bonafede (d. 1545) in the Certosa di Galluzzo was commissioned in 1539 and completed in 1550, and was followed by the monument of Paolo Giovio (d. 1552) in the cloister of S. Lorenzo (dated 1560, installed 1575). Francesco's last work is a relief of Francesco del Fede in S. Maria Primerana at Fiesole (1575). He died on 17 February 1576.

BIBLIOGRAPHY: The standard account of the work of Francesco da Sangallo is that of Middeldorf (in Thieme *Künstlerlexikon*, xxix, 1935, pp. 404–6). A later article by Middeldorf ('Portraits by Francesco da Sangallo', in *Art Quarterly*, i, 1938, pp. 109–38) deals with Sangallo's sepulchral monuments as well as with his portrait busts. Venturi (X-i, pp. 243–59) includes a clever, and in the main acceptable, survey of Francesco da Sangallo's style, and provides a useful corpus of illustrations. An unsophisticated volume by G. Clausse (*Les San Gallo: iii, Florence et les derniers San Gallo*, Paris, 1902, pp. 139–261) contains some peripheral material not available elsewhere. New ground is broken by D. Heikamp in an article ('Ein Madonnenrelief von Francesco da Sangallo', in *Berichte aus den ehem. Preuszischen Kunstsammlungen*, n.f. viii, 1958, pp. 34–40), correctly identifying a terracotta Virgin and Child in Berlin, currently ascribed to Jacopo Sansovino, as a study for a lost marble relief by Francesco da Sangallo described in a letter of Niccolò Martelli of 14 November 1546.

Plate 55: MONUMENT OF ANGELO MARZI, BISHOP OF ASSISI
SS. Annunziata, Florence

Signed on the base: FRANCISCVS IVLIANI SANGALLI FACIEB. M.D.XLVI. The monument, which is set on the left of the presbytery of the church, shows a life-image of Marzi reclining on a high plinth with a heavy moulding. The front of the sarcophagus contains an incised epitaph flanked by coats of arms, which reads: ANGELVS MARTIVS ASSISIENSIS/EPVS. AC XXXIIII ANOS A SECRETIS AVG/VSTAE MEDICVM DOMVS ILLIVS Q ALVNVS/ET IN EAM OB PROBITATEM FIDEMQ A SCITVS/HOC SIBI VIVENS SEPVLCHRVM CONFECIT/DEFVNCTVS VT SIBI VIVAT CVM ANTE MO/RTEM

AMICIS . VIXIT AN. LXX . OBIIT/ANN. D. M.D.XXXXVI. (Angelo Marzi, Bishop of Assisi, who was for 34 years secretary to the noble family of the Medici and member of their household, and was known in it for his honesty and fidelity, had this tomb made for himself while he was still alive in order that, when he died, he might go on living with the friends of his lifetime. He lived 70 years and died in 1546). Angelo Marzi (for whom see Clausse, op. cit., pp. 171–7) was born at San Gimignano in 1476. After a period as private chancellor of Piero Soderini, he served as secretary successively to Cardinal Giovanni de' Medici (Pope Leo X), Giuliano de' Medici, duc de Nemours, and Lorenzo de' Medici, Duke of Urbino. After the election of Cardinal Giulio de' Medici as Pope Clement VII, he was appointed Bishop of Assisi, and was subsequently closely associated with Alessandro and Cosimo I de' Medici, officiating in 1541 at the baptism of Francesco de' Medici. In reward for his services to the Medici, he was allowed to assimilate the Medici arms in the form shown in the stemme on the monument. The style of the monument is defined by Middeldorf as 'eine völlige Absage an den klassischen Stil des Sansovino und eine rückhaltlose Hingabe an den Realismus'.

Plate 56: VIRGIN AND CHILD WITH ST. ANNE
Or San Michele, Florence

Signed on the belt of St. Anne: FRANCISCVS FACIEBAT, and dated on the back of the socle MDXXVI. The cult of St. Anne in Florence derived its popularity from the expulsion of the Duke of Athens on the feast of St. Anne 1343. An altar to St. Anne was erected in Or San Michele in the following year. Francesco da Sangallo's group was commissioned on 12 February 1522 (for the relevant document see Milanesi, in Vasari, vii, p. 624) in substitution for a wooden group of the Virgin and Child with St. Anne which then stood on the altar. The original wooden altar was replaced by the present marble altar in 1586. The group is described by Vasari: 'le tre figure di marmo alquanto maggiori del vivo, che sono sopra l'altare della chiesa d'Orsanmichele, Sant'Anna, la Vergine e Cristo fanciullo, che sono molto lodate figure' (the three marble figures of St. Anne, the Virgin and the Infant Christ, a little larger than life, which stand over the altar of the church of Orsanmichele and are very much praised). The iconography of the figure and its relation to the group of the same subject by Andrea Sansovino (see Plate 48 above) are discussed by H. Riegel ('Die Darstellungen der heiligen Anna selbdritt, besonders zu Florenz,' in *Beiträge zur Kunstgeschichte Italiens*, Dresden, 1898, pp. 117–8). A sound formal analysis of the group is supplied by H. Hoffmann (*Hoch-Renaissance, Manierismus, Frühbarock*, Zurich, 1939, pp. 105–6). For the relation of the group to the Leonardo cartoon of the Virgin and Child with St. Anne and cognate drawings see L. H. Heydenreich ('La Sainte Anne de Léonard de Vinci', in *Gazette des Beaux-Arts*, 6e. période, Tome X, 1933, pp. 205–19).

GIOVANNI ANGELO MONTORSOLI
(b. 1507?; d. 1563)

Born in or about 1507, Montorsoli is stated by Vasari to have been trained in the shop of Andrea Ferrucci. After a brief period of employment in Rome on the fabric of St. Peter's, he appears as an assistant of Silvio Cosini in work on the Maffei monument in S. Lino at Volterra (1522). Thereafter he was employed by Michelangelo in the Medici Chapel (for Montorsoli's work in the chapel at this and at a later time see under Michelangelo). Developing a religious vocation, he was received first at the church of the Gesuati outside the Porta Pinti in Florence (1529) and subsequently (1530-1) became a member of the Servite order at the Annunziata, where he modelled wax votive portraits of members of the Medici family to replace those destroyed in 1528. In 1532 he was recommended by Michelangelo to undertake the restoration of the Laocoon and other antiques for Pope Clement VII, of whom he carved a portrait (lost). His second period of activity in the Medici Chapel (when he carved the statue of St. Cosmas) dates from after this time. To the fifteen-thirties belong a number of commissions, of which the most important are for a kneeling figure of Alessandro de' Medici in the Annunziata, large stucco statues of Moses and St. Paul for the Sala del Capitolo of the Servi, the former, a sculptural transcription of the Jeremiah on the Sistine Ceiling of Michelangelo, and the tomb of Angelo Aretino (d. 1522) in S. Pietro at Arezzo. After participating in the preparations for the entry of Charles V into Florence in 1536, Montorsoli later in the year visited Naples, where he received the commission for the Sannazaro monument in S. Maria del Parto (Fig. 63) (executed in Tuscany in conjunction with Ammanati). The tomb of Mauro Maffei in the Duomo at Volterra dates from 1536-7, and at about the same time Montorsoli started work on a marble group of Hercules and Antaeus for the garden at Castello (see plate 59 below).

In 1539 he was commissioned to complete Bandinelli's unfinished statue of Andrea Doria at Genoa (of which fragments survive), and in 1543 he undertook his most important sculptural complex, the Pietà and statues in S. Matteo in Genoa and the tomb of Andrea Doria in the crypt of the same church. In 1547 he left Genoa to become Capomaestro of the Duomo at Messina, where he completed the Fountain of Orion (1550) (Fig. 97), the Altar of the Apostles in the Duomo (1552?), and the Fountain of Neptune (1557, see Plate 57 below). Between 1558 and 1561 he was employed at Bologna on the high altar of the Servi (Fig. 71). He died on 31 August 1563.

BIBLIOGRAPHY: Competent surveys of Montorsoli's work are given by Vasari, and by Venturi (X-ii, pp. 107-53). His style has, however, received less detailed study than it deserves, and the critical literature of the Genoa sculptures is specially inadequate. For the Sannazaro monument see Ciardi Dupré ('La prima attività dell' Ammanati scultore', in *Paragone*, 1961,

No. 135, pp. 7-13), and for the Messina sculptures S. Bottari ('Giovanni Angelo Montorsoli a Messina', in *L'Arte*, xxxi, 1928, pp. 234-45). Montorsoli's activity as a portrait sculptor is reviewed by M. Weinberger ('Portrait busts by Montosorli,' in *Scritti di storia dell'arte in onore di Mario Salmi*, iii, Rome, 1963, pp. 39-48) in connection with the bust of Tommaso Cavalcanti in the Cavalcanti Chapel in S. Spirito, Florence, which dates from ca. 1558 and whose authorship is recorded by Vasari, and with a bronze bust of a woman at Chicago.

Plate 57: THE FOUNTAIN OF NEPTUNE
Messina

The later of the two fountains executed by Montorsoli at Messina, the Fountain of Neptune (Fig. 96), was commissioned for a position in the harbour, and is described by Vasari in the following terms: 'E perchè ella piacque molto a' Messinesi, glieno feciono fare un'altra in sulla marina, dov'è la dogana, la quale riuscì anch'essa bella e ricchissima; ed ancor che quella similmente sia a otto facce, è nondimeno diversa della sopradetta; perciocchè questa ha quattro facce di scale che sagliono tre gradi, e quattro altre minori messe tonde, sopra le quali, dico, è la fonte in otto faccie: e le sponde della fontana grande disotto hanno al pari di loro in ogni angolo un pie-distallo intagliato, e nelle faccie della parte dinanzi un altro in mezzo a quattro di esse. Dalla parte poi, dove sono le scale tonde, è un pilo di marmo aovato, nel quale per due maschere, che sono nel parapetto sotto le sponde intagliate, si getta acqua in molta copia; e nel mezzo del bagno di questa fontana è un basamento alto a proporzione, sopra il quale è l'arme di Carlo quinto, ed in ciascun angolo di detto basamento è un cavallo marino, che fra le zampe schizza acqua in alto; e nel fregio del medesimo sotto la cornice, di sopra sono otto mascheroni che gettano all'ingiù otto polle d'acqua; ed in cima è un Nettuno di braccia cinque, il quale avendo il tridente in mano, posa la gamba ritta accanto a un delfino. Sono poi dalle bande, sopra due altri basamenti, Scilla e Cariddi in forma di due mostri, molto ben fatti, con teste di cane e di Furie intorno' (As it greatly pleased the people of Messina, they employed Agnolo to make another on the sea shore where the customs house is, which is also rich and beautiful, and although octagonal it differs from the first, having four faces of three steps and four lesser ones, and the edges of the great fountain have a carved pedestal and another inside. By the round steps is a marble cistern, oval in shape, which receives water from two masks on the parapet below the carved edge. In the middle of the basin is a pedestal of proportionate height, with the arms of Charles V, and at the angles are sea-horses which spout water between their hooves. On the frieze under the upper cornice are eight masks spouting

water, and at the top a Neptune, five braccia high, holding a trident, and a dolphin resting beside his right foot. On two side pedestals are Scylla and Charybdis as two monsters with dogs' heads surrounded by furies, very well made). As noted by Wiles, the fountain has a mistilinear basin and steps. A drawing after the fountain in the Uffizi, Florence, shows the original play of water, described by Vasari, with eight jets falling from the central pedestal, and four jets rising from the hooves of the sea-horses. Both the complete fountain and the individual sculptures have been seriously damaged, the former by the earthquake of 1908, as a result of which the fountain is now beneath the level of the pavement. The figure of Neptune at present on the fountain was copied by Zappala from Montorsoli's original, and the figure of Scylla (which was damaged by a bomb in 1848 and is now in the Museo Nazionale, Messina) is a copy by Letterio Subba. Montorsoli arrived at Messina to execute the fountain of Orion (which had been allotted initially to Raffaello da Montelupo) in September 1547, and the commission for the Fountain of Neptune dates from after the completion of this work (1551?). The Neptune fountain was finished in 1557 (see Wiles, loc. cit., and S. Bottari, 'Giovanni Angiolo Montorsoli a Messina', in *L'Arte*, xxxi, 1928, pp. 234–44).

NICCOLO TRIBOLO
(b. 1500; d. 1550)

Born in 1500 and trained under Nanni Unghero and subsequently under Jacopo Sansovino, Tribolo is encountered as an independent artist in Rome, where he worked on the tomb of Pope Adrian VI in S. Maria dell'Anima (probably 1524) (Fig. 61). In 1525–7 he was engaged on sculptures for the façade of S. Petronio. Moving to Pisa, he collaborated with Stagio Stagi (1528). A statue of Natura in the Louvre, carved for Giovanni Battista della Palla as a stand for an antique vase and presented to Francis I of France, dates from this early time (Holderbaum). After a brief return to Florence (1529), he established himself at Loreto, where he was employed in the decoration of the Holy House (see Plate 46 above). Summoned to Florence to assist Michelangelo in the completion of the Medici Chapel (for his share in this see Plate 24 above), he left for Venice after the death of Pope Clement VII brought work in the Chapel to an end. After a brief stay in Venice, where he again came in contact with Jacopo Sansovino, he settled in Florence, where he was extensively employed on the decorations prepared for the entry of the Emperor Charles V (1536). In the same year he contracted to carve the Assumption relief now in S. Petronio at Bologna (see Plate 60 below). Attracting the notice of Cosimo I, he received the commission for the fountains at Castello (see Plate 59 below), and in 1546 was responsible for installing the Allegories and other sculptures in the Medici Chapel. Between 1544 and 1548 he designed the Matteo Corte monument in the Campo Santo at Pisa. He died in August or September 1550.

BIBLIOGRAPHY: The chapter on Tribolo in Venturi (X-i, pp. 188–214) is competent though incomplete, and should be supplemented by reference to articles by Wiles ('Tribolo in his Michelangelesque Vein', in *Art Bulletin*, xiv, 1932, pp. 59–70) and Holderbaum ('Notes on Tribolo', in *Burlington Magazine*, xcix, 1957, pp. 336–43, 364–72). The best available account of Tribolo's style is that given in Holderbaum's articles. For the fountains see Wiles (*The Fountains of Florentine Sculptors*, Cambridge, 1933), and an excellent article by H. Keutner ('Niccolo Tribolo und Antonio Lorenzi: Die 'Äskulapbrunnen im Heilkräutergarten der Villa Castello bei Florenz,' in *Studien zur Geschichte der Europäischen Plastik: Festschrift für Theodor Müller*, Munich, 1965, pp. 235–44) which discusses the fountain designed by Tribolo for the Giardino de' Semplici at Castello (statue executed by Antonio Lorenzi after the death of Tribolo, in 1553–4; basin in Palazzo Medici) and publishes a drawing in the Cabinet des Dessins of the Louvre for the bronze Pan in the Bargello (see Plate 58 below), and for Tribolo as a maker of bronze statuettes Pope-Hennessy ('A small Bronze by Tribolo', in *Burlington Magazine*, ci, 1959, pp. 85–9). M. Ciardi Duprè ('Presentazione di alcuni problemi relativi al Tribolo scultore,' in *Arte Antica e Moderna*, vii, 1961, pp. 244–7) restates the case for accepting a number of doubtful unfinished sculptures, among them the Martyrdom of St. Andrew in the Museo Nazionale, Florence, and the Apollo and Marsyas in the National Gallery of Art, Washington, as the work of Tribolo. For a number of drawings by Tribolo for sculpture see C. Lloyd ('Drawings attributable to Tribolo,' in *Master Drawings*, vi, 1968, pp. 243–5).

Plate 58: PAN
Museo Nazionale, Florence

The bronze, which was wrongly assigned by Planiscig to a Paduan studio of the first half of the sixteenth century, is correctly identified by Holderbaum ('Notes on Tribolo – 1, A Documented Bronze by Tribolo', in *Burlington Magazine*, xcix, 1957, pp. 336–43) with a cast made from a model by Tribolo by the bronze caster Zanobi Portigiani in 1549. The relevant document (Florence, Archivio di Stato, Conventi 103, S. Marco, vol. 328) reads: 'Et a di 18 di aprile 1549 ebbe il Tribolo uno satiro di bronzo peso libbre trenta'.

Plate 59: THE FOUNTAIN OF HERCULES
Villa Reale di Castello, near Florence

In the painting by Vasari of Cosimo I with the Artists of his Court (Palazzo Vecchio), Tribolo is represented holding models of his most important works, the two fountains (Figs. 92, 93) executed for the garden of the Ducal villa at Castello. The earlier and smaller, the Fountain of the Labyrinth, was transferred to the garden of the nearby villa of Petraia; the larger and later, the Fountain of Hercules, is still in place. Both fountains are described by Vasari. The Fountain of the Labyrinth rises from an octagonal basin on a small octagonal base. Over this is an element decorated with marine figures supporting a large tazza, procured from the villa of Antella and carved beneath the lip with putti and garlands. Above is an element carved with masks and figures in low relief, which was executed, according to Vasari, by Tribolo's pupil Pierino da Vinci: 'alcuni satiri di basso rilievo, e quattro maschere mezzane, e quattro putti piccoli tutti tondi che seggono sopra certi viticci' (some satyrs in low relief, four masks in half relief, and four small putti in full relief sitting on some tendrils). Vasari records Tribolo's intention that the fountain should be crowned by a bronze figure of Florence, and states that the model for this was made: 'una statua di bronzo alta tre braccia, figurata per una Fiorenza, a dimostrare che dai detti monti Asinaio e Falterona vengono l'acque dell' Arno e Mugnone a Fiorenza; della quale figura aveva fatto un bellissimo modello, che spremendosi con le mani i capelli ne faceva uscir acqua' (a bronze statue three braccia high, representing Florence, and showing that the waters of the Arno and Mugnone come to Florence from the above-mentioned Mounts Asinaio and Falterona; he had made a most beautiful model of this figure, pressing its hair with its hands to make water pour from it). A figure conforming to this description was later made for the fountain (ca. 1560–61) by Giovanni Bologna. The Fountain of Hercules is a larger and more ambitious work with richer figure carving and an ampler flow of water. In this the basin and base are again octagonal; between the base and the tazza are seven putti seated on claws. On the lip of the tazza are four bronze putti. The element above it is carved with four standing putti squeezing water from the necks of geese. Above this again is a small tazza with goat masks, and at the top, beneath the crowning group of Hercules and Antaeus, is a further base with four small seated putti. The essential parts of Vasari's description read as follows: 'sopra il quale seggono otto putti in varie attitudini, e tutti tondi e grandi quanto il vivo . . . E perchè l'aggetto della tazza, che è tonda, ha di diametro sei braccia, traboccando del pari l'acqua di tutta la fonte, versa intorno intorno una bellissima pioggia a uso di grondaia nel detto vaso a otto facce; onde i detti putti che sono in sul piede della tazza, non si bagnano, e pare che mostrino con molta vaghezza, quasi fanciullescamente essersi là entro, per non bagnarsi scherzando, ritirati intorno al labro della tazza. . . . Sono dirimpetto ai quattro lati della crociera del giardino quattro putti di bronzo a giacere scherzando in varie attitudini, i quali se bene sono poi stati fatti da altri, sono secondo il disegno del Tribolo. Comincia sopra questa tazza un altro piede, che ha nel suo principio sopra alcuni risalti quattro putti tondi di

marmo, che stringono il collo a certe oche che versano acqua per bocca; e quest'acqua e quella del condotto principale che viene dal laberinto, la quale apunto saglie a questa altezza. Sopra questi putti è il resto del fuso di questo piede, il quale è fatto con certe cartelle che colano acqua con strana bizzaria, e ripigliando forma quadra, sta sopra certe maschere molto ben fatte. Sopra poi è un'altra tazza minore, nella crociera della quale, al labro, stanno appicate con le corna quattro teste di capricorno in quadro, le quali gettano per bocca acqua nella tazza grande insieme con i putti per far la pioggia che cade, come si è detto, nel primo ricetto, che ha le sponde a otto faccie. Seguita più alto un altro fuso adorno con altri ornamenti e con certi putti di mezzo rilievo, che risaltando fanno un largo in cima tondo, che serve per basa della figura d'un Ercole che fa scoppiare Anteo; la quale secondo il disegno del Tribolo è poi stata fatta da altri . . . dalla bocca del quale Anteo, in cambio dello spirito, disegnò che dovesse uscire, ed esce per una canna, acqua in gran copia; la quale aqua è quella del condotto grande della Petraia' (On this are seated eight putti in different attitudes, in full relief and life-size . . . and since the bowl, which is round, overhangs with a diameter of six braccia, the water of the whole fountain overflows the sides and throws a most beautiful rain, like water dripping from a roof, into the octagonal basin; so the putti at the foot of the bowl do not get wet and seem to be like children sheltered under the lip of the bowl playing there inside, in a very charming way so as not to get wet. . . . Facing the four converging paths of the garden are four bronze putti, lying and playing in various attitudes; they are after designs by Tribolo, although they were carried out by others. Above this bowl another pedestal begins, which, on some projections at the bottom, has four marble putti in full relief, squeezing the necks of some geese which spout water from their beaks; and this water is that of the main conduit from the labyrinth, and rises just to this height. Above these putti is the rest of the shaft of this pedestal, made with some cartouches which give out jets of water in a bizarre way; then, becoming square again, it continues upwards beyond some well contrived masks. Above this, again, is another smaller bowl, on the sides of which, on the lip, four heads of goats are fixed by the horns, making a square; and these throw water through their mouths into the large bowl, like the putti, making in this way the rain which falls, as I have already said, into the first octagonal basin. Another shaft follows higher up, decorated with other ornaments and with putti in half relief; these project and form at the top a circular area, and this serves as the base for the figure of Hercules crushing Antaeus, designed by Tribolo and carried out by others . . . he intended that, from Antaeus' mouth, instead of his last breath, a large volume of water should gush forth through a pipe, as it in fact does; the water is from the large conduit of Petraia). So far as concerns the authorship of individual sections of the fountain, it should be noted (i) that Vasari states that the four bronze putti on the lip of the tazza were modelled by Pierino da Vinci and cast by Zanobi Lastricati ('il Vinci per commissione del Tribolo gli fece di terra: i quali furono poi gettati di bronzo da Zanobi Lastricati scultore molto pratico nelle cose di getto, e furono posti non è molto tempo intorno alla fonte, che sono cosa bellissima a vedere'); (ii) that the eight putti beneath

the tazza were regarded by Borghini (1584) as autograph works by Tribolo ('son di sua mano gli otto fanciulli tutti tondi, che seggono in varie attitudini'); and (iii) that, after the death of Tribolo, Antonio and Stoldi Lorenzi between 19 November 1552 and 28 February 1555 receive intermittent payments for work on the fountain (for these see Wiles, loc. cit.), one of which relates to the 'fine del fuso della fontana grande del giardino di Castello'. This confirms a statement of Vasari that Antonio Lorenzi 'condusse ... quattro putti che sono nella fonte maggiore di detto luogo', and seems to relate to the four putti at the top of the stem. Middeldorf ('Additions to the Work of Pierino da Vinci', in *Burlington Magazine*, liii, 1928, pp. 299–306) ascribes the four putti with geese to Pierino da Vinci; there is no documentary warrant for this, and the putti are returned to Tribolo by Gamba ('Silvio Cosini', in *Dedalo*, x, 1929–30, pp. 236–7). The group of Hercules and Antaeus at the top of the fountain is by Ammanati (cast 1559–60). The work appears initially to have been planned in marble and was entrusted to Montorsoli (Vasari). According to an undated letter of Montorsoli to Cosimo I (Gaye, ii, pp. 422–3), Montorsoli's marble figures were found in S. Lorenzo by Bandinelli, and destroyed by him. A wax model for a Hercules group for the fountain was also made by Vincenzo Danti and is mentioned by Vasari. There is no reason to doubt Vasari's statement that the present Hercules and Antaeus was adapted from a model by Tribolo.

Plate 60: THE ASSUMPTION OF THE VIRGIN
S. Petronio, Bologna

The relief of the Assumption by Tribolo in the Cappella delle Reliquie of S. Petronio (Fig. 83) was carved for the church of the Madonna di Galliera, and is described by Vasari in the following terms: 'In tanto ebbe lettere il Tribolo da Bologna, mentre si facevano le nozze; per le quali messer Pietro del Magno, suo grande amico, lo pregava fusse contento andare a Bologna a far alla Madonna di Galliera, dove era già fatto un ornamento bellissimo di marmo, una storia di braccia tre e

mezzo pur di marmo. Perchè il Tribolo, non si trovando aver allora altro che fare, andò; e fatto il modello d'una Madonna che saglie in cielo, e sotto i dodici Apostoli in varie attitudini, che piacque, essendo bellissima, mise mano a lavorare; ma con poca sua sodisfazione, perchè essendo il marmo che lavorava di quelli di Milano, saligno, smeriglioso, e cattivo, gli pareva gettar via il tempo senza una dilettazione al mondo, di quelle che si hanno nel lavorare i quali si lavorano con piacere, ed in ultimo condotti mostrano una pelle che par propriamente di carne' (While the wedding was being celebrated, Tribolo received letters from Bologna; in these Messer Pietro del Magno, a great friend of his, begged him to agree to go to Bologna, so that he might make for the Madonna di Galliera, where a most beautiful marble ornament had already been carried out, a scene three and a half braccia in size, also in marble. So Tribolo, as he happened to have nothing else to do at the time, went. He made a model of a Madonna ascending to Heaven, with the twelve Apostles standing below in various attitudes; it won approval, as it was very beautiful, and he set his hand to the work. But it was with little satisfaction to himself, because the marble he was carving was the Milanese variety, sweaty, difficult to work, and altogether bad; and he felt he was wasting time, getting none of that delight one gets from working marbles that are pleasant to work, and which, when quite finished, show a surface like the real living flesh). The relief was completed in 1537, and is inscribed: TRIBOLO FLORENTINUS FACIEBAT ANNO MDXXXVII. A payment of 170 scudi to Tribolo for the relief (Archivio di Stato di Bologna, Demniale Padri Filippini, $\frac{112}{5995}$, transcribed by F. Malaguzzi-Valeri, 'La chiesa della Madonna di Galliera in Bologna', in *Archivio storico dell'arte*, vi, 1893, pp. 32–40) dates from 17 April 1540. The relief (for which see also F. Filippini, 'Opere di Tribolo in Bologna', in *Il Commune di Bologna*, March, 1929, p. 5, n. 1), was moved from the Madonna di Galliera to the Cappella Zambeccari of San Petronio in 1746, and the glory of angels in stucco in the upper part was added at this time (for this see I. B. Supino, *L'arte nelle chiese di Bologna*, Bologna, 1938, p. 60).

PIERINO DA VINCI
(d. 1554)

Pierino da Vinci's birth-date is variously given as 1520–1 and 1531. According to Vasari, he died in 1554 at the age of twenty-three. Milanesi infers that his death occurred at the age of thirty-three. Placed at the age of twelve in the workshop of Bandinelli, he was soon after transferred to that of Tribolo, whom he assisted on the fountains at Castello (see Plate 59 above). In 1548 he visited Rome, where he became familiar with the works and technical procedure of Michelangelo, and on his return to Pisa (1549) carvedo the group of Samsn and a Philistine now in the courtyard of the Palazzo Vecchio in

Florence (see Plate 62 below), the relief of Cosimo I as Patron of Pisa (see Plate 61 below) and a statue of Dovizia at Pisa, as well as the River God now in the Louvre (see Plate 63 below). Other works by Pierino da Vinci mentioned by Vasari are a stone Bacchus carved at the same time as the Castello fountains and purchased by Bongianni Capponi (lost), a model for the tomb of Francesco Bandini in S. Croce (lost), a Crucifixion after a drawing by Michelangelo, a bronze base for a classical head and a marble relief of Venus made for Cardinal Ridolfi, a wax reduction from Michelangelo's Moses, and a relief of the

Death of Count Ugolino, a subject suggested to him by Luca Martini (terracotta version in Gherardesca ownership, preliminary version in Ashmolean Museum, Oxford, bronze described by Vasari lost). At his death he was engaged on the tomb of Baldassare Turini in the Duomo at Pescia (figure on left carrying a flaming urn by Pierino).

BIBLIOGRAPHY: The only connected account of Pierino da Vinci's career is supplied by Venturi (X-ii, pp. 327–43), which contains a number of questionable attributions. See also U. Middeldorf ('Additions to the Work of Pierino da Vinci,' in *Burlington Magazine*, liii, 1928, pp. 299–306), E. Kris ('Zum Werk des Pierino da Vinci,' in *Pantheon*, iii, 1929, pp. 94–8), W. Gramberg ('Beiträge zum Werk und Leben Pierino da Vincis,' in *Jahrbuch der Preuszischen Kunstsammlugen*, lii, 1931, pp. 223–8), and A. M. Vandelli ('Contributo alla cronologia della vita di Pierino da Vinci,' in *Rivista d'Arte*, xv, 1933, pp. 109–13).

thus probably executed after the sculptor's return from Rome in 1549. A post-Roman dating is accepted by Gramberg ('Beiträge zum Werk und Leben Pierino da Vincis', in *Jahrbuch der Preuszischen Kunstsammlungen*, lii, 1931, pp. 225–6). The iconography of the relief is explained by E. Steinmann ('Zur Ikonographie Michelangelos', in *Monatshefte für Kunstwissenschaft*, i, 1908, pp. 40–52, as Ammanati), who points out that the scene relates to the refoundation of the University of Pisa in 1542, its reopening in the following year, and the institution in 1547 of the Uffizio de' Fossi, whereby conditions were improved both in the University and in the city as a whole. There is no record of the whereabouts of the relief between 1568 (when it is mentioned in the second edition of the *Vite* of Vasari) and 1772 when it was owned by Cavaceppi, the friend of Winckelmann, and was reproduced in his *Raccolta d'antiche statue* (Pl. 60) as a work of Michelangelo. It appears in the Museo Pio-Clementino of the Vatican in 1792.

Plate 61: COSIMO I AS PATRON OF PISA
Museo Vaticano

The subject of the relief is described by Vasari: 'Messe dipoi mano a una istoria in marmo di mezzo e basso rilievo, alta un braccio e lunga un braccio e mezzo, nella quale figurava Pisa restaurata dal duca, il quale è nell'opera presente alla città ed alla restaurazione d'essa sollecitata dalla sua presenza. Intorno al duca sono le sue virtù ritratte, e particolarmente una Minerva figurata per la Sapienza e per l'Arti risuscitate da lui nella città di Pisa; ed ella è cinta intorno da molti mali e difetti naturali del luogo, i quali a guisa di nimici l'assediavano per tutto e l'affligevano. Da tutti questi è stata poi liberata quella città dalle sopradette virtù del duca. Tutte queste virtù intorno al duca e tutti que'mali intorno a Pisa erano ritratti con bellissimi modi ed attitudini nella sua storia dal Vinci: ma egli la lasciò imperfetta, e desiderata molto da chi la vede, per la perfezione delle cose finite in quella' (He then set to work on a marble history, partly in half-relief and partly in low-relief, one braccio high and one and a half wide. In this he represented the restoration of Pisa by the Duke, who is in the work present in the city and at its restoration, which is being urged on by his presence. Round the Duke his virtues are portrayed, particularly a Minerva, representing Wisdom and the Arts, which had been revived by him in the city of Pisa; and it is surrounded by many evils and natural deficiencies of the place, which in the manner of enemies besiege it all round and attack it. From all these the city has since been freed by the above-mentioned virtues of the Duke. All the virtues round the Duke and all the evils round Pisa were portrayed by Vinci in this history of his with the most beautiful movements and attitudes; but he left it unfinished, much to the regret of the spectator, on account of the perfection of the things in it which were finished). A closely similar description appears in Borgini (*Il Riposo*, 1584). The relief is mentioned by Vasari after the statue of Dovizia in the Piazza Cairoli at Pisa, and was

Plate 62: SAMSON SLAYING A PHILISTINE
Palazzo Vecchio, Florence

The group is stated by Vasari to have been carved by Pierino for Luca Martini after his return from Rome: 'Mandò dipoi Luca a Carrara a far cavare un marmo cinque braccia alto e largo tre; nel quale il Vinci, avendo già veduto alcuni schizzi di Michelangnolo d'un Sansone che ammazzava un Filisteo con la mascella d'asino, disegnò da questo suggetto fare a sua fantasia due statue di cinque braccia. Onde, mentre che'l marmo veniva, messosi a fare più modelli variati l'uno dall'altro, si fermò a uno: e dipoi venuto il sasso, a lavorarlo incominciò e lo tirò innanzi assai, immitando Michelagnolo nel cavare a poco a poco de' sassi il concetto suo e'l disegno, senza guastarli o farvi altro errore. Condusse in questa opera gli strafori sotto squadra e sopra squadra, ancora che laboriosi, con molta facilità, e la maniera di tutta l'opera era dolcissima' (Luca next sent to Carrara for a marble block five braccia by three for Vinci to make two statues of five braccia on the subject of Samson slaying a Philistine with the jawbone of an ass, for which he had seen some sketches by Michelangelo. Before the marble arrived, he busied himself making more models, each different from the rest, and at length he settled on one. After the arrival of the block he at once set to work, imitating Michelangelo in gradually excavating his idea and design from the block, without damaging it in any way or making any errors. He made the perforations, difficult as they were, with great facility, and the manner of the whole work was very sweet). This passage in Vasari is the sole basis for the incorrect ascription to Pierino of a small bronze of Samson and two Philistines after a model by Michelangelo, of which examples exist in the Frick Collection, New York, and elsewhere (for these see Pope-Hennessy, *Essays on Italian Sculpture*, London, 1968, pp. 189–90, and *Catalogue of Sculpture in the Frick Collection*, i, New York, 1969.

Plate 63: RIVER GOD

Louvre, Paris

The figure is identified by Middeldorf ('Additions to the Work of Pierino da Vinci', in *Burlington Magazine*, liii, 1928, pp. 299–306) with a figure of a River God stated by Vasari to have been carved by Pierino da Vinci at Pisa for Luca Martini. The passage in Vasari reads: 'Venuto addunque in Pisa, trovò che'l marmo era già nella stanza acconcio, secondo l'ordine di Luca: e cominciando a volerne cavare una figure in piè, s'avvedde che'l marmo aveva un pelo, il quale lo scemava un braccio. Per lo che risoluto a voltarlo a giacere, fece un fiume giovane che tiene un vaso che getta acqua; ed è il vaso alzato da tre fanciulli, i quali aiutano a versare l'acqua il fiume, e sotto i piedi a lui molto copia d'acqua discorre, nella quale si veggono pesci guizzare ed uccelli aquatici in varie parti volare. Finito questo fiume, il Vinci ne fece dono a Luca, il quale lo presentò alla duchessa, ed a lei fu molto caro; perchè allora essendo in Pisa Don Grazzia di Toledo suo fratello venuto con le galee, ella lo donò al fratello, il quale con molto piacere lo ricevette per le fonti del suo giardino di Napoli a Chiaia' (Arrived in Pisa, he found the marble already in his room, prepared according to the orders of Luca; but, when he began carving a standing figure from it, he saw that the marble had a crack that diminished it by a braccio. So, deciding to turn it into a recumbent figure, he made a young River God holding a vase pouring out water, the vase being held up by three children helping the River to pour the water; and under his feet runs a large quantity of water, in which one sees fishes darting and water birds flying in different directions. When he had finished this River God, Vinci gave it to Luca, who presented it to the Duchess, to whom it was very dear. Since her brother Don Garzia di Toledo was then in Pisa, having come by galley, she gave it to him, and he received it with great pleasure for the fountains in his garden at Naples in the Chiaia). The principal discrepancies between this account and the figure in the Louvre are (i) that the River God is not reclining, and (ii) that the Louvre statue shows two putti and not three. The original block of marble, however, as noted by Middeldorf, is stated by Vasari to have been three braccia in height, and the height of the present figure (1.35 m.) is approximately two braccia, that is the original height of the block less one braccia waste. Since the statue was despatched to Naples, there is no reason to suppose that Vasari was closely familiar with it in the original. The figure reached the Louvre with the Schlichting collection, for which it was secured from the Palazzo Balzo, Naples. The attribution to Pierino da Vinci and a dating ca. 1548 are accepted by Gramberg ('Beiträge zum Werk und Leben Pierino da Vinci's', in *Jahrbuch der Preuszischen Kunstsammlungen*, lii, 1931, p. 225), Wiles (*The Fountains of the Florentine Sculptors*, Cambridge, 1935, p. 86) and A. Venturi (X-ii, p. 329), who also (X-i, p. 209) reproduces the statue as Tribolo. It is likely that the figure was presented to Don Garcia di Toledo in 1551.

BACCIO BANDINELLI
(b. 1493; d. 1560)

Born in Florence in 1493, Baccio Bandinelli was trained by his father, Michelangelo di Viviani de' Bandini, a goldsmith patronised by the Medici, and later entered the workshop of Rustici. In 1515, through the agency of Giuliano de' Medici, Duc de Nemours, he received the commission for his first major marble sculpture, a St. Peter for the Duomo (see Plate 51 above). At this time he also undertook part of the decorations prepared for the entry of Leo X into Florence; according to contemporary sources his work was adversely criticised. A statue of Orpheus and Cerberus, commissioned by Cardinal Giulio de' Medici and now in the courtyard of the Palazzo Medici, seems to date from 1519. In 1520 Bandinelli was commissioned to execute for Cardinal Giulio de' Medici a full size copy of the Laocoon (completed 1525), formerly in the Palazzo Medici and now in the Uffizi, Florence. On the expulsion of the Medici (1527) Bandinelli moved first to Lucca and then to Genoa, where he began work on a commemorative statue of Andrea Doria and presented a bronze relief of the Crucifixion to the Emperor Charles V. Before 1529 a statue of the young Mercury by Bandinelli (lost) was bought by Giovanni Battista della Palla for Francis I of France. At this time Bandinelli (as a result of negotiations described in his Memoriale) was made a Knight of S. Iago. In 1531 he worked at Loreto (see Plate 46 above). Three years later he completed his major work, the controversial group of Hercules and Cacus, designed in competition with Michelangelo and still in its original position outside the Palazzo Vecchio in Florence (see Plate 64 below). In 1536 Bandinelli received a contract for the tombs of Popes Leo X (Fig. 65) and Clement VII in S. Maria sopra Minerva, Rome, and in 1540 contracted to undertake the monument of Giovanni dalle Bande Nere in S. Lorenzo in Florence (seated figure and relief now outside the church, Fig. 120). A letter of 6 April 1541 from Baldassare Turini to Cosimo I de' Medici describes negotiations in Rome with Bandinelli regarding the two papal tombs. In 1540 Bandinelli also embarked on the Udienza of the Palazzo Vecchio, and this was followed in 1547 by a project for a new choir and high altar for the Cathedral (see Plate 66 below). The sculptor died on 7 February 1560. By virtue first of Vasari's vivid life of Bandinelli, second of the references to Bandinelli in Cellini's autobiography, and third of the Memoriale (or account of his own family and career) which he prepared for his descendants, we know more about the character of Bandinelli than about that of any other sixteenth century sculptor save Cellini. His most successful work is the

Dead Christ supported by Nicodemus in his own memorial chapel in the Annunziata, which was begun by his son Clemente (see Plate 65 below).

BIBLIOGRAPHY: An excellent edition of Vasari's life of Bandinelli by D. Heikamp (Giorgio Vasari: *Vita di Baccio Bandinelli scultore fiorentino*, con introduzione e note a cura di Detlef Heikamp, Edizioni per il Club del Libro, Milan, 1964) is marred only by an incorrect birth-date (1488). For the correct date (12 November 1493) and a first-rate analysis of Bandinelli's early style see J. Holderbaum ('The Birth Date and a Destroyed Early Work of Baccio Bandinelli,' in *Essays in the History of Art presented to Rudolf Wittkower*, London, 1967, pp. 93–7). Bandinelli's Memoriale is published by Colasanti ('Il Memoriale di Baccio Bandinelli', in *Repertorium für Kunstwissenschaft*, xxviii, 1905, pp. 406–43). A connected account of Bandinelli's career is supplied by Jansen ('Baccio Bandinelli', in *Zeitschrift für Bildende Kunst*, xi, 1875–6, pp. 65–73, 97–105, 139–45, 203–9, 239–51), and a critical account of Bandinelli's style is given by Venturi (X-ii, pp. 187–239). A thorough survey of the material relating to the high altar of the Duomo in Florence is supplied by D. Heikamp ('Baccio Bandinelli nel Duomo di Firenze,' in *Paragone*, 1964, No. 175, pp. 32–42), who has also reprinted ('Poesie in vituperio del Bandinelli,' in *Paragone*, 1964, No. 175, pp. 59–68) a number of vituperative poems directed to the artist. A number of Bandinelli's drawings for sculpture are published by M. Ciardi Dupré ('Per la cronologia di Baccio Bandinelli (fino al 1540),' in *Commentari*, xvii, 1966, pp. 146–70, and 'Alcuni aspetti della tarda attività grafica del Bandinelli,' in *Antichità Viva*, i, 1966), who also reproduces ('Il modello originale della "Deposizione" del Bandinelli per Carlo V,' in *Festschrift Ulrich Middeldorf*, Berlin, 1968, pp. 269–75) a putative gesso model at San Marino for the lost bronze relief known in a version by Susini in the Louvre. The history of the Leo X and Clement VII monuments in S. Maria sopra Minerva is reconstructed from drawings in the Uffizi, the Academia di S. Fernando, Madrid, the Albertina and the Ashmolean Museum by D. Heikamp ('Die Entwurfszeichnungen für die Grabmäler der Mediceer-Päpste Leo X und Clemens VII,' in *Albertina-Studien*, iv, 1966, pp. 134–54). For the work of Clemente Bandinelli see Heikamp ('Die Bildwerke des Clemente Bandinelli,' in *Mitteilungen des Kunsthistorischen Institutes in Florenz*, ix, 1960, pp. 130–5).

Plate 64: HERCULES AND CACUS
Piazza della Signoria, Florence

The story of Bandinelli's Hercules and Cacus goes back to the year 1508, when a marble block nine and a half braccia high and five braccia wide was ordered by Piero Soderini for the use of Michelangelo. The block was intended from the first for the Piazza della Signoria, for which Michelangelo was to carve a counterpart to the David in the form of a group of Hercules and Cacus. The marble was not delivered till 1525, when, on the instructions of Pope Clement VII, it was handed over to Bandinelli. According to Vasari, the principal agent in effecting

the transfer of the block from one sculptor to the other was Domenico Buoninsegni, who had been alienated by Michelangelo, and who persuaded the Pope that his requirements would be met more expeditiously if the rivalry between the two sculptors were stimulated. Bandinelli thereupon made a wax model of his intended group; this represented 'Ercole, il quale avendo rinchiuso il capo di Cacco con un ginocchio tra due sassi, col braccio sinistro lo strigneva con molta forza, tenendoselo sotto fra le gambe rannicchiato in attitudine travagliata; dove mostrava Cacco il patire suo e la violenza e'l pondo d'Ercole sopra di sè, che gli faceva scoppiare ogni minimo muscolo per tutta la persona. Parimente Ercole con la testa chinata verso il nimico oppresso, e digrignando e strignendo i denti, alzava il braccio destro, e, con molta fierezza rompendogli la testa, gli dava col bastone l'altro colpo' (Hercules who, having gripped the head of Cacus between two stones with one knee, grasped him with great force with the left arm, and held him crouched under his legs in a tortured attitude; in this Cacus showed his suffering and the strain and weight of Hercules above him, bursting every smallest muscle in his whole body. In the same way Hercules, with his head bent down towards his crushed enemy, grinding and gnashing his teeth, raised his right arm and gave him another blow with his club, fiercely dashing his head to pieces). Vasari records that Michelangelo at this time endeavoured to dissuade the Pope from his decision without success, while Bandinelli boasted of his intention to surpass the David. After a number of practical difficulties, the marble block was moved to Florence, where its dimensions proved to be unsuited to Bandinelli's model (which was, however, preserved in 1568 in the Guardaroba of Cosimo I). Bandinelli therefore made a number of further models, of which 'uno più degli altri ne piacque al papa, dove Ercole aveva Cacco fra le gambe, e presolo pe' capelli, lo teneva sotto a guisa di prigione' (the Pope liked best the one in which Hercules had Cacus between his legs and, taking him by the hair, held him down as if imprisoned). It was agreed that this model should be adopted for the statue, and a full-scale clay model was prepared. According to Vasari, this showed less boldness and vivacity than the rejected scheme. At some time between this date and 1527 Bandinelli began work on the marble block. In 1528, however, Michelangelo, who was employed under the popular government on the fortifications of Florence, was shown the newly worked marble block with a view to ascertaining whether the preliminary work of Bandinelli was such as to preclude its use for a new two- or three-figure group. The answer appears to have been in the negative, and Michelangelo thereupon began to prepare models for a group of Samson and two Philistines. After the return of the Medici, however, Michelangelo was instructed to resume work on the Medici Chapel and Bandinelli was required to continue the Hercules. The group was completed in 1534, and is signed on the base BACCIVS BANDINELL. FLOR. FACIEBAT. MDXXXIIII. It was removed from the Opera del Duomo, where it had been carved, on 1 May 1534, and was installed by Baccio d'Agnolo and Antonio da Sangallo il Vecchio on its base in the Piazza della Signoria. Bandinelli, seeing the group in the open air, considered that the muscles

appeared 'troppo dolci', and after re-erecting screens round the statue resumed work on it, and 'affondando in più luoghi i muscoli, ridusse le figure più crude che prima non erano' (deepened the muscles in several places, and made the figures cruder than they had been before). The group was much criticised and lampooned when it was unveiled; according to Vasari the authors of some of the lampoons were imprisoned by Alessandro de' Medici. A terracotta sketch-model in the Kaiser Friedrich Museum, Berlin (H. 73 cm.) is convincingly identified by Brinckmann (*Barock-Bozzetti*, Frankfurt-am-Main, 1923, i, pp. 44–5) as a model made in connection with Bandinelli's initial project for the statue, and agrees closely with Vasari's description of the proposed group.

Plate 65: THE DEAD CHRIST SUPPORTED BY NICODEMUS
SS. Annunziata, Florence

The group is set behind the altar of the first chapel to the right of the tribune of the church. It shows the dead Christ supported on tha left knee of Nicodemus and on a rectangular marble block inscribed with the words: DIVINAE.PIET./B. BANDINELL./H.SIBI.SEPVL./FABREF. On the ground in front are the spear, sponge, hammer, the instrument for extracting the nails and the nails. The group is set on a marble base carved with swags and stemme, with, at the corners, four skulls. At the back are portrait reliefs of the sculptor and his wife. On the marble plinth which supports the group and from which the altar projects, is the epitaph:

D. O. M
BACCIVS BANDINEL. DIVI IACOBI EQVES
SVB HAC SAL[ER]VATORIS IMAGINE,
A SE EXPRESSA, CVM IACOBA DONIA
VXORE QVIESCIT. AN.S.M.D.LIX.

(Baccio Bandinelli, Knight of the Order of St. James, rests with his wife Jacopa Doni beneath this image of the Saviour, which he made himself. 1559).

The chapel in which the group is placed was formerly that of the Pazzi family and was dedicated to St. James. In 1559, however, it was transferred to Bandinelli, and rededicated to the Pietà. Work on the group seems to have been begun in 1554, and according to Vasari was carried out initially by Bandinelli's son Clemente: the head of Nicodemus is an idealised portrait of Bandinelli. In carrying the monument through its initial stages, Clemente Bandinelli seems to have followed a model by his father, which is mentioned on 11 March 1563 in a letter from Vincenzo de' Rossi to Cosimo I (Gaye, iii, pp. 107–8: 'un modello del Cristo che il Cavaliere fe' nella Nuntiata'). The group is discussed in more detail in a second passage of Vasari: 'Mentre che queste cose si andavano preparando, venne volontà a Baccio di finire quella statua di Cristo morto tenuto da Niccodemo, il quale Clemente suo figliolo aveva tirato inanzi, perciocchè aveva inteso che a Roma il Buonarrotto ne finiva uno, il quale aveva cominciato in un marmo grande, dove erano cinque figure, per metterlo in

Santa Maria Maggiore alla sua sepoltura. A questa concorrenza, Baccio si messe a lavorare il suo con ogni accuratezza, e con aiuti, tanto che lo finì; ed andava cercando in questo mezzo per le chiese principali di Firenze d' un luogo, dove egli potesse collocarlo, e farvi per sè una sepoltura. Ma non trovando luogo che lo contentasse per sepoltura, si risolvè a una cappella nella chiesa de' Servi, la quale è della famiglia de' Pazzi. I padroni di questa cappella, pregati della duchessa, concessono il luogo a Baccio, senza spodestarsi del padronato e delle insegne che v'erano di casa loro; e solamente gli concessono che egli facesse uno altare di marmo, e sopra quello mettesse le dette statue, e vi facesse la sepoltura a' piedi. . . . In questo mezzo faceva Baccio murare l'altare ed il basamento di marmo per mettervi su queste statue; e finitolo, disegnò mettere in quella sepoltura, dove voleva esser messi egli e la sua moglie, l'ossa di Michelagnolo suo padre, le quali aveva nella medesima chiesa fatto porre, quando e' morì, in uno deposito' (While these preparations were going on, Baccio was taken by the desire to finish the statue of the Dead Christ supported by Nicodemus which his son Clemente had carried forward; for he had heard that Buonarroti was finishing one in Rome, which he had begun on a large block of marble, with five figures, intending to put it on his tomb in S. Maria Maggiore. In emulation of this Baccio set to work on his with great keenness and with the help of assistants, until he finished it. Meanwhile he was going round the principal church of Florence, looking for a place where he could set it up and make a tomb for himself. Not having found a place for the tomb which would satisfy him, he decided on a chapel belonging to the Pazzi family in the Church of the Servites. The owners of the chapel, at the request of the Duchess, granted the place to Baccio, but without divesting themselves of ownership or of the emblems of their family which were there; and they only allowed him to make a marble altar there, to put the statues above it and make his tomb at its foot. . . . Meanwhile Baccio had the altar and the marble base built, so that he might put the statues on it; and, when he had finished it, he decided to transfer to the tomb, in which he himself and his wife were to be laid, the bones of Michelagnolo his father, which he had placed in a tomb in the same church when he died). Bandinelli was buried in the chapel on 7 February 1560. It seems at one time to have been the sculptor's intention that the group of the Dead Christ supported by Nicodemus should be accompanied by statues of St. John and St. Catherine of Siena. Provision for this was made by Bandinelli in the following terms (see A. Colasanti, 'I Memoriali di Baccio Bandinelli', in *Repertorium für Kunstwissenschaft*, xxviii, 1905, pp. 442–3): 'Se avanti alla morte mia . . . non avessi dato fine d'ornare la cappella nostra della Sma. Nontiata, quale era già della nobile famiglia de' Pazzi, vi prego e comando di tirarla a fine col mettere sopra l'altare la Pietà, fatta a quest'effetto nell' Opera, e collocare da man dritta il bellissimo S. Giovanni che per questo ho condotto in casa mia, e da mano manca S. Caterina da Siena, che sarà con la Pietà finita in breve, ornandola con le mie armi e con quella inscritione che più vi piacerà, non avendo il maggiore desiderio che di finirla avanti al fine mio, ma sia rimesso il tutto nel Signore, quale (si come in terra io vi benedico) vi dia la Sua benedition in cielo e nella stessa terra, acciò, vivendo bene et

operando da nobilmente nato, viviate lungamente felici e nel cielo co' padri nostri nel secolo de' secoli' (If before my death ... I have not completed the decoration of our chapel in SS. Annunziata, which once belonged to the noble family of the Pazzi, I beg and command you to complete it by putting above the altar the Dead Christ, done for this purpose in the Opera, and by placing on the right the fine St. John, which I executed for this in my own house, and on the left the St. Catherine of Siena, which, like the Dead Christ, will soon be finished. Decorate the chapel with my arms and whatever inscription you like best. I have no greater wish than to complete it before my death, but let all lie in the hands of Our Lord. And may He, just as I give you my blessing on earth, give you His both in heaven and on earth; so that, living virtuously and acting as befits your noble birth, you may live long and happily and afterwards in heaven be with our forefathers for ever).

Plate 66: CHOIR RELIEFS
Duomo, Florence

Up to the middle of the sixteenth century the choir of the Duomo at Florence was an octagonal wooden structure of 1435 based on a model by Brunelleschi (Paatz, iii, p. 408) corresponding in form to the interior of the cupola. This choir is depicted in the medal by Bertoldo commemorating the Pazzi conspiracy. Early in the sixteenth century it was proposed by Cardinal Francesco Soderini that the central choir should be demolished, and replaced by a subterranean chapel dedicated to St. Zenobius, approached by steps from the level of the nave. This proposal came to nothing, and the choir was left intact until 1547, when Bandinelli placed before Cosimo I his plans for the construction of a new choir. Drawn up by the sculptor and by Giuliano di Baccio d'Agnolo, these plans provided for the building of a new high altar, for the provision of reliefs and statues, and for the construction of two marble pulpits. The octagonal form of the old choir was retained, but in its new guise it consisted of a balustrade, with reliefs of Prophets and Philosophers, and of an upper section composed of columns and pilasters with a cornice surmounted by a 'grillanda di candelieri'. Each of the four main faces of the choir had a central arch, the two lateral arches being destined for the pulpits (which were not executed) and the rear arch being filled by statues of Adam and Eve (see below). On the altar was a Pietà, with, above it, a colossal statue of God the Father. Engravings of the altar and choir screen as they were executed are contained in Sgrilli, *Descrizione di Santa Maria del Fiore*, Florence, 1733, pl. xiv. In the form in which they were carried out both the altar and choir represented a simplification of Bandinelli's original scheme, which provided, according to Vasari, for a figure of the Dead Christ with two Angels, two kneeling Angels, a bronze predella more than a braccia high with Passion reliefs, and a large relief beneath the Adam and Eve with the story of the Fall. It was at one time proposed that Cellini should be associated with this work (see Camesasca, *Tutta l'opera di Cellini*, Milan, 1955, pp. 61–2), and models for the two pulpits, as well as a

wax relief of Adam and Eve, were prepared by him. Vasari, who is our main source for Bandinelli's intentions, gives an unfavourable account of the choir, which he condemns in the words: 'Ma non le cose assai ed i molti ornamenti son quelli che abbelliscono ed arricchiscono le fabbriche; ma le buone, quantunque sieno poche, se sono ancora poste ne' luoghi loro e con la debita proporzione composte insieme, queste piacciono e sono ammirate, e fatte con giudizio dall'artefice, ricevono dipoi lode da tutti gli altri. Questo non pare che Giuliano e Baccio considerassino nè osservassino; perchè presono un suggetto di molta opera e lunga fatica, ma di poca grazia, come ha l'esperienza dimostro' (But it is not the profusion of parts and ornaments that makes a construction beautiful and rich, but rather their quality; however few they may be, as long as they are put in their proper places and arranged together with due proportion, good ones please and are admired and, because they have been executed with judgement by the craftsman, receive praise from everyone else. This Giuliano and Baccio do not seem to have considered or observed, for they took a subject involving much labour and effort, but with little grace, as experience has shown). The principal source for the progress of work on the choir is the *Diario Fiorentino* of Lapini. According to this source, work was begun in October 1547 when the wooden choir was removed and the construction of the new choir started on the side facing the Old Sacristy. On 13 August 1552 the figure of Christ on the High Altar was unveiled, as well as the Adam and Eve at the back. The latter figures in particular seem to have caused the sculptor some difficulty, and were preceded by two rejected figures carved in 1549, an Adam later transformed into a Bacchus (now in the Palazzo Vecchio) and a seated Eve later transformed into a Ceres (now in the Boboli Gardens). On 21 October 1552 the God the Father was disclosed. When Bandinelli died in 1560 the choir was still unfinished. It had been the original intention that the upper section of the choir screen, like that below, should be constructed predominantly of white marble. In 1569, however, a quarry of coloured marble was discovered at Seravezza, and instructions were given by the Grand-Duke that the white marble should be removed, and replaced by marble from the new source. According to Lapini, 'A' dì 14 di giugno 1569 si messono le prime colonne di marmo mistio, cioè rosse e bianche, e d'altri varj colori, intorno al bel coro di marmo bianco di S. Maria del Fiore, e si levorno certe colonne di marmo bianco incannellate, che vi erono state qualche anno' (On 14 June 1569 the first columns of multi-coloured marble, red and white and various other colours, were put in place round the fine white marble choir in S. Maria del Fiore, and certain fluted columns of white marble which had been there for some years were taken away). By 23 May 1572 the structure of the choir was complete, and on 14 June 1572 the installation was begun of 'le belle e varie tavole di marmo mistio, insieme colle figure di marmo bianco di mezzo rilievo, che furono tenute una cosa bella' (The fine and varied slabs of multi-coloured marble, together with the white marble figures in half-relief, which were considered a fine thing). The choir appears from the first to have been the object of some dissatisfaction, and Bernini, when consulted by the Grand-Duke Ferdinand II, recommended that it should be

dismantled, on the grounds that it narrowed the church and blocked the nave. The figures of Adam and Eve were removed in 1722 on account of their nudity, and were deposited initially in the Salone dei Cinquecento and later in the Museo Nazionale, being replaced in the choir by the Michelangelo Pietà. In 1842 the choir was reduced to its present form (Fig. 90), the upper part of the screen being removed and the balustrade contracted to its present size by the removal of twenty-four figurated reliefs which are now in the Museo dell'Opera del Duomo. The Christ tended by an Angel from the High Altar was transferred at this time to the Baroncelli Chapel of Santa Croce, and the God the Father was moved to the cloister of the same church. Only a relatively small number of the balustrade reliefs were executed by Bandinelli; these include reliefs on the east side of the choir (some of which are signed with the sculptor's initials and dated 1555) and six of the reliefs in the Museo dell' Opera del Duomo. The bulk of the remainder were executed by Bandinelli's pupil, Giovanni Bandini. A. Venturi (X-ii, fig. 214) reproduces three signed reliefs by Bandinelli as works of Bandini. The God the Father was executed in large part by Vincenzo de' Rossi. Three wax Passion scenes in the Museo Nazionale are convincingly identified by Middeldorf ('An erroneous Donatello Attribution', in *Burlington Magazine*, liv,

1929, pp. 184–8) as sketch-models by Vincenzo de' Rossi for the bronze predella of the altar; these appear to have been put temporarily in place pending the preparation of the bronze reliefs, which were not executed.

Plate 68: COSIMO I DE' MEDICI
Museo Nazionale, Florence

The bust is not dated, but is certainly identical with a bust mentioned by Vasari in a room on the upper floor of the Palazzo Vecchio. It is described in an inventory of 1553 (C. Conti, *La prima reggia di Cosimo I de' Medici*, Florence, 1893, p. 60) in the 'camera di Penelope'. Vasari's account implies that the bust was carved before the unsuccessful statue of Cosimo I for the Udienza of the Palazzo Vecchio. It is assumed by Venturi to be somewhat later in date than a small bronze bust of Cosimo I by Bandinelli in the Museo Nazionale, Florence, in which the features are those of a younger man. The present bust is dated by Heikamp ca. 1544 on the strength of a portrait engraving of Cosimo I by Niccolò della Casa. Its style and its relationship to the bronze bust by Cellini are discussed independently by Heikamp ('In margine alla "Vita di Baccio Bandinelli" del Vasari,' in *Paragone*, 1966, No. 191, pp. 51–62).

GIOVANNI BANDINI
(b. 1540; d. 1599)

A pupil of Bandinelli, Bandini, popularly known as Giovanni dell' Opera, completed (1572) the choir screen of the Cathedral in Florence after Bandinelli's death (see Plate 66 above). In 1564 he prepared part of the decorations of the catafalque of Michelangelo, and as a result received the commission for one of the three seated figures on the tomb of Michelangelo (see Plate 67 below). In 1573 he was entrusted with two of the statues of Apostles for the Duomo (SS. Philip and James), and modelled the bronze figure of Juno for the Studiolo of Francesco de' Medici in the Palazzo Vecchio (see Plate 78 below). In 1576–7 he executed the reliefs of the Gaddi Chapel in Santa Maria Novella. After 1582 he was active at Urbino in the service of Francesco Maria della Rovere, for whom he carved his finest work, a group of the Virgin with the dead Christ (1585–6) in the Oratorio della Grotta beneath the Duomo at Urbino, as well as a portrait statue, now in the courtyard of the Palazzo Ducale in Venice (completed 1587). In 1595 he was entrusted with the statue of Ferdinand I de' Medici at Leghorn (see Plate 96 below), and in 1598 he signed a statue of Meleager (Private collection). Bandini died in Florence on 18 April 1599.

BIBLIOGRAPHY: A comprehensive account of Bandini's work is given by Middeldorf ('Giovanni Bandini, detto Giovanni dell'Opera', in *Rivista d'Arte*, xi, 1929, pp. 481–50). See also Venturi (X-ii, pp. 241–70).

Plate 67: ARCHITECTURE
S. Croce, Florence

After the death of Michelangelo (18 February 1564), his body was brought from Rome to Florence, where it arrived on 10 March.
Two days later it was transferred to S. Croce. Four members of the Florentine Academy, Bronzino, Vasari, Cellini and Ammanati, were appointed to supervise a solemn commemorative service in S. Lorenzo (for which see *The Divine Michelangelo: the Florentine Academy's Homage on his Death in 1564*, a facsimile edition of *Esequie del divino Michelangelo Buonarroti*, Florence, 1564, introduced translated and annotated by Rudolf and Margot Wittkower, London, 1964). This took place on 14 July 1564. Some impression of the importance that attached to it is provided by a letter from Vasari to Lionardo Buonarroti of 18 March 1564 (Frey, *Vasaris Litterarischer Nachlass*, ii, No. CDXXXVI: 'Et credo, che sara cosa che ne papi ne glinperatorj ne re non l'anno auta mai. Basta, che se voi avessi mandato qua il corpo dj San Piero e San Pauolo, non saresti maj tanto lodato e auto obbligo da questi princjpi, da questi cittadinj, dal arte nostra et da tutto questo popolo') (And I think it will be something not even Popes or Emperors or kings have ever had. Let me say simply that if you had sent the bodies of Saints Peter and

Paul here, you would not be so much praised and held a benefactor by the princes, the citizens, our guild, and the whole people). At the funeral the catafalque was surmounted by a figure of Fame (Zanobi Lastricati); in front of it were reclining statues of the Arno (Battista di Benedetto) and Tiber (Giovanni Bandini), and on the pedestal were four allegorical groups by Vincenzo Danti, Valerio Cioli, and Lorenzo and Antonio Calamech. Above on socles were sculptured representations of Architecture (Giovanni di Benedetto da Castello), Painting (Battista del Cavaliere), Sculpture (Antonio Lorenzi) and Poetry (Domenico Poggini). At the top was a pyramid with two relief portraits of Michelangelo (Santi Buglioni). These temporary decorations form the background against which plans were formed for the permanent commemoration of Michelangelo by means of a sepulchral monument. A letter addressed by Vasari to Lionardo Buonarroti on 4 March 1564 (Frey, op. cit., ii, No. CDXXXII) alludes to the intention of the Grand-Duke to erect a commemorative monument with a bust of Michelangelo in the Duomo, but this proposal seems to have been rapidly abandoned, and thereafter the Grand-Duke interested himself in the monument to be erected at the expense of Lionardo Buonarroti in S. Croce. According to a letter of Vasari of 26 March 1564 (Frey, op. cit., ii, No. CDXXXIX), the tomb in S. Croce was initially regarded as the responsibility of Lionardo Buonarroti ('l Academia ora a da fare in San Lorenzo quel che tocha allej, et voj in Santa Croce farete quel che uj piacera'), but in practice control of the S. Croce monument was retained in Florence. The genesis of the tomb is described in a letter of 22 March 1564 written by Lionardo Buonarroti to the Grand-Duke (Gaye, iii, pp. 131–2), offering to allow the unfinished marbles in Michelangelo's house in the Via Mozza to be incorporated in the tomb: 'Da perchè detto Michelagnolo per l'amore avea alla fabricha di S. Pietro à speso tutto el suo tempo inonoralla, nè à posuto co l'opera in vita mostrare lo amore portava alla Eccellenza V. Il., come desiderava, à mandato in morte di essere sepellito nella chiesa di Santa Croce nella vostra felicissima città di Firenze, per esservi cole ossa al servizio di quella; e per non si essere trovato cosa alcuna di suo in casa sua, come era il desiderio mio, per farne parte a Vostra Eccellenza Illma., et esendosene ito senza lasar molto, salvo le cose costì di via moza, le quale piacendo alla Vostra Eccellenza Illma., quella mi farà grandissimo favore di servirsene, e se di qua sarà possibile recuperare niente, ne farò ogni opera per servitio di quella etc., etc.' (Because Michelangelo, on account of his love for the building of St. Peter's, spent all his time in doing it honour, and could not in his lifetime show, as he wished, with his work the love he bore Your Excellency, he wished in death to be buried in the church of S. Croce in your fortunate city of Florence, so that he could serve it with his bones. Since nothing was found in his house to allot to Your Excellency, as I should have wished, and since he died without leaving much except for the things in the Via Mozza, if it pleases Your Excellency, I shall be much obliged if they are used; and, if it is possible to recover nothing from here, I will do anything to be of service, etc.). At this time Lionardo Buonarroti and Daniele da Volterra were jointly engaged in Rome in preparing plans for a monument in S. Croce embodying the Victory and the

four unfinished Slaves then in the Via Mozza. Vasari from the first seems to have had some reserve about this plan, and on 10 March 1564 (Frey, op. cit., ii, No. CDXXXII) asked Lionardo Buonarroti that two schemes should be prepared in Rome 'uno con la figura di via Mozza et un altro senza' (one with the figure from the Via Mozza and another without it). An attempt had been made by Cosimo I to purchase the house in Via Mozza with its marbles as early as 1544, and the reluctance of Vasari to allow the Victory to be placed on the tomb in S. Croce seems to have arisen from his wish to use it in the Sala Regia of the Palazzo Vecchio, where it was installed at the end of the same year. On 18 March 1564 Vasari (Frey, op. cit., ii, No. CDXXXVI) reported to Lionardo Buonarroti that the Grand-Duke had agreed in principle to the use of the Victory for the tomb, but expressed some doubt as to its suitability and suggested that it would be preferable to secure the Pietà (now in the Duomo in Florence) for use on the monument ('che la pieta delle cinque figure chegli roppe, la faceva per la sepoltura sua; et vorrej ritrouare, come suo erede, in che modo laveva il Bandino; Perche se la ricercherete per servjruene per detta sepoltura, oltre che ella e djsegnata per luj, euuj un vechjo che egli ritrasse se') (that he made the Pietà with five figures, the one which he broke up, for his tomb. And you should discover, as his heir, how Bandini came to have possession of it. If you seek it out to use it for the tomb, quite apart from its being designed for that, there is an old man in it which is a self-portrait). It was suggested that in these circumstances Lionardo Buonarroti should hand over to the Grand-Duke the marbles in Via Mozza. The second part of this proposition was agreed to, and thereafter nothing more is heard of the use of works by Michelangelo for the tomb. In the form in which it was executed the monument was planned by Vincenzo Borghini, the Prior of the Innocenti, and designed by Vasari. The design for the monument was drawn up in the course of 1564, and a letter addressed to the Grand-Duke by Vincenzo Borghini on 4 November 1564 (Gaye, iii, pp. 150–1) discusses the choice of artists to carry out the sculpture ('Mi disse anchora (Vasari) che V.E.I. si contenterà che la sepoltura di Mich. Angelo Buonarroti, della quale lui ne haveva fatto un disegno et mostro a V.E.I., ch' gl'era sodisfatto, si tirassi inanzi, et ch' io n'havessi un poco di cura con alogarla a quelli che paressino a proposito, non uscendo della Academia, massime contentandose, come fa, Lionardo Buonarroti suo nipote, il quale più volte me ne ha parlato, et lo desidera. Hora, perch'io non moverei un passo in cosa alcuna senza la participatione di V.E.I., anchor ch'io mi senta mal'atto a questo, pure non fuggirò mai faticha alchuna per honorare la virtù di quelli che hanno honorato questa Città. Io ero di questa fantasia ch' vedendo parte di quelli scultori occupati in servitio di V.E.I., per dar che fare a ogn'uno et dare animo et occasione a certi di quelli giovani, che hanno voglia di fare et virtù di poter condurre affine i loro concetti, di mettergli in campo, et dare questo aiuto alla virtù loro, che havendosi affare tre figure, sene dessi una a Batista di Lorenzo, allievo del Cavaliere Bandinelli, quello che fece nelle esequie di Michelagnolo la statua della Pittura, che fu molto lodata, et a Giovanni, che lavora nel Opera, pure allievo del Cavaliere, che fece la statua del Architettura et il Tevere, un'altra a Batista allievo del Ammanato, che

fece l'Arno, che tutta dua si può ricordare V.E.I. che le lodò assai, un'altra, poichè Vincenzo Perugino et Andrea Chalameh et Valerio Cioli hanno hauuto statue da V.E.I., et a quelli altri che restano non mancherà occasione di poter dare che fare, et la cura del murare et far condurre di quadro, con certi ornamenti ch'vi vanno, perch' vadia con hordine, si dessi a quel Batista del Cavaliere, che è persona destra e sollecita. et perchè questo ha d'essere non solo per lhonore di Michelagnolo, ma di tutta la città, et particular di V.E.I., per più sicurtà della bontà et perfettione del opra, Mess. Giorgio, che ha fatto il disegno della sepoltura, ne terrà particular cura, et vedrà giorno per giorno i designi et modelli') (Vasari has told me that Your Excellency will be glad if the tomb of Michelangelo Buonarotti, for which he has made a design and shown it to Your Excellency, who was satisfied with it, is hurried on, and if I concern myself with the allocation of the work to be done on it to those who seem most suitable, not going outside the Academy. Leonardo Buonarotti, his nephew, is very much in agreement with this, and has spoken to me about it several times, and desires it so. Now (for I would not move a single step in any matter without the participation of Your Excellency), even though I may feel myself hardly qualified in this, yet will I spare no effort in the honouring of the talents of those who have, in their turn, honoured this city. The idea I have is this: having in mind the role of those sculptors who are occupied in the service of Your Excellency, to give something to do to each of them; and to give encouragement and opportunity to some of those young men who have both the desire to execute and the talent to carry right through their conceptions; to put them into the field and give their talent this assistance. There are three figures to do: one would be allotted to Battista di Lorenzo, that pupil of the Cavalier Bandinelli who made the much praised figure symbolising Painting for the funeral of Michelangelo; one to Giovanni, who works at the Opera, is also a pupil of the Cavaliere, and did the figures of Architecture and the Tiber; and one to Battista, Ammanati's pupil, who did the figure of the Arno (Your Excellency will remember both of these, having praised them highly); because Vincenzo of Perugia, Andrea Calamech and Valerio Cioli have had commissions for statues from Your Excellency. For the rest there will be opportunity to give of their work; and the supervision of the masonry and the execution of the frame with certain decoration which is to go on it would be entrusted to Battista, the Cavaliere's pupil and a skilful and conscientious man, in order that it should proceed in an orderly way. And because this undertaking involves not only the honour of Michelangelo but that of the whole city (and especially of Your Excellency), to make the quality and the perfection of it more sure, Master Giorgio himself, who designed the tomb, will supervise with special care and check day by day the drawings and models).
The selection of artists proposed in Borghini's letter was adhered to, save that Ammanati refused to release his pupil Battista for work on the tomb. On 29 December 1564 it was proposed by Borghini (Frey, op. cit., No. CDLXXIX and p. 139) that the third figure should be allocated either to Domenico Poggini or Valerio Cioli, and the latter sculptor, by the decision of the Grand-Duke, was chosen to work on the monument. The

sculptures on the monument as executed (Fig. 67) comprise (i) a marble bust of Michelangelo adapted by Battista Lorenzi from a bronze bust by Daniele da Volterra (for this see E. Steinmann, *Die Porträtdarstellungen Michelangelos*, 1913, pp. 75–77), and (ii) three allegorical figures seated on the sarcophagus representing (*left to right*) Painting (Battista Lorenzi), Sculpture (Valerio Cioli) and Architecture (Giovanni Bandini). An early scheme for the monument is shown in a drawing by Vasari at Christ Church, Oxford, in which the bust is flanked by two female figures. The figures of Painting and Sculpture are confused by A. Venturi (X-ii, Figs. 375, 400). Work on the statue by Battista Lorenzi seems already to have been begun in 1564, and a final quittance for this sculptor's statue, the bust and 'certi trofei' on the tomb is dated 27 January 1575 (for this see E. Steinmann and H. Pogatscher, in *Repertorium für Kunstwissenschaft*, XXIX, 1906, pp. 408–16). Payment was made to Giovanni Bandini for the figure of Architecture in 1568. By this time work on the monument was far enough advanced to justify discussion of the epitaph, and on 13 May 1569 two alternative drafts by 'Mons. Moretta, che sta col Cardle. di Ferrara' and Paolo Manuzio were submitted to Lionardo Buonarroti by Diomede Leoni. These were rejected in favour of the present epitaph which reads:

MICHAELI ANGELO BONAROTIO
E VETVSTA SIMONIORVM FAMILIA
SCVLPTORI, PICTORI, ET ARCHITECTO
FAMA OMNIBVS NOTISSIMO
LEONARDVS PATRVO AMANTISS. ET DE SE OPTIME MERITO
TRANSLATIS ROMA EIVS OSSIBVS ATQVE IN HOC TEMPLO
MAIOR
SVOR SEPVLCRO CONDITIS COHORTANTE SERENISS.
COSMO MED.
MAGNO HETRVRIAE DVCE, P.C.
ANN. SAL. CIƆ. IƆ. LXX
VIXIT ANN LXXXVIII M. XI. D. XV.

A terracotta bozzetto for the figure by Battista Lorenzi is in the Victoria and Albert Museum and a similar bozzetto for that by Giovanni Bandini is in Sir John Soane's Museum, London (for these see Pope-Hennessy, 'Two Models for the Tomb of Michelangelo,' in *Studien zur Toskanischen Kunst: Festschrift für Ludwig Heinrich Heydenreich*, Munich, 1964, pp. 237–43). According to Lapini, the three figures on the sarcophagus were set in place only in 1574. The painter Naldini was paid for the Pietà on the monument in 1578. A passage in Borghini's *Riposo* (1584) explains the imagery of the seated figures:
'Alla prima entrata in Santa Croce (soggiunse il Michelozzo) mi si parano davanti agli occhi le tre statue di marmo sopra la sepoltura del mai appieno lodato Michelagnolo Buonarruoti, sopra cui potrete dire qualche cosa, M. Bernardo, s'egli vi piace. Sopra queste (ripose il Vecchietto) toccherà a dire a M. Ridolfo, quando gli converra favellare dell' attitudini e delle membra; che quanto all'invenzione, mi pare, che la prima statua di Giovanni dell'Opera, per le seste e per la squadra, che ha per insegna, dimostri l'Architettura: e quella di mezzo per Valerio Cioli, per lo martello e per lo scarpello, la Scultura: e la terza di

Batista del Cavaliere, a rimirarla davanti, pare, che dia indizio della Scultura ancor ella, perche tiene in mano un modello abbozzato; ma chi riguarda a pie di detta figura dalla banda dritta, vi vede pennelli, scodellini ed altre cose appartenenti a pittore; laonde chiaramente si conosce esser fatto per la Pittura. Io vi voglio dire la cagione (soggiunse il Sirigatto) di queste insegne, che due cose pare che dimostrino. Egli fu ordinato da principio da Don Vincenzo Borghini, Priore degli 'Innocenti, che si metesse la Pittura nel mezzo, e dove e oggi la statua di Batista del Cavaliere, fosse la Scultura, e cosi furono date a fare le statue: e Batista fu il primo a cominciare a mettere in opera il marmo, e gia aveva assai bene innanzi la sua statua, avendole fatto in mano quel modello, che ora si vede; quando gli eredi di Michelagnolo supplicarono al Gran Duca, che facesse loro grazia, che si dovesse mettere la Scultura nel mezzo . . . e sua Altezza concedette loro quanto domandarono, onde Battista, che avea gia accomodata la sua figura, per darle luogo in su quel canto, dove oggi si vede, non potendo metterla nel mezzo, bisogno, che la sua statua, che per la Scultura avea fatto incino all'ora, tramutasse nella pittura.' ('When I first go into S. Croce,' said Michelozzo, 'what I see is the three statues above the tomb of Michelangelo Buonarroti, a man who can never be praised enough. If you are willing, Master Bernardo, you could tell us something about these.'

'It will be for Master Ridolfo,' replied Vechietto, 'to speak on this subject when he is ready to talk about the attitudes and parts of the figures. As for the invention, I think the first figure, the one by Giovanni dell' Opera, represents Architecture on account of its attributes, the ruler and set-square; the middle one, by Valerio Cioli, Sculpture in virtue of the mallet and chisel. The third one, by Battista the pupil of the Cavalier Bandinelli, if one looks at it from in front seems also to be referring to Sculpture, because it is holding a bozzetto in its hand; but if you look at the foot of the figure on the right hand side you see brushes and bowls and other painters' tools, which clearly shows it was intended as Painting.'

'I will tell you the reason for these attributes,' said Sirigatto, 'and it is proved by two things. The tomb was planned at the beginning by Don Vincenzo Borghini, Prior of the Innocents.

He had arranged for Painting to be in the middle of the group, and Sculpture where the statue by Battista del Cavaliere now is, and it was on this basis that the statues were commissioned. Battista was the first to begin working on the marble, and he already had the figure very well advanced, and had done the model in the hand which is there now. But then the heirs of Michelangelo begged the Grand Duke to do them the favour of having Sculpture put in the middle . . . and His Highness granted what they asked; so that Battista, who had already accommodated his figure to its place on the side where it is now, and could not put it in the middle, had to change it into Painting, even though up to this point he had been making it as Sculpture.')

This story is confirmed by a letter from Vincenzo Borghini to the Grand-Duke of 23 March 1573 reporting that delay in completing the monument was due first to the change in the position of the figures of Painting and Sculpture, and second to the fact that one sculptor had used a larger block while another had reduced his block too drastically so that the result was 'un'opera sproporzionata' ('Lionardo ne resta maliss. mo soddisfatto et gli fanno torto, che spendendo i suoi danari, et toccando a lui principalmente, parrebbe ragionevole che ci havesse la sua sodisfatione in quel che conviene. Et per quello, che io intendo hora, della statua di Giovannino dell'Opera si contenta; di quella di Batista del Cavaliere non si contenta in modo alcuno, l'altra non è anchor fatta ne si fa, escusandosi colui, come occupato ne' servitij di V.A.S.') (Leonardo is most dissatisfied with it, and they do him an injustice; for, when he is spending his own money and is the person most immediately concerned, it seems reasonable that he should be satisfied about its suitability. As I understand the situation at present, the figure by Giovanni dell' Opera is satisfactory, and that by Battista del Cavaliere is not satisfactory at all; and the third is neither done nor in progress, the artist excusing himself as being busy in Your Highness' service). An annotation to this letter, made on the Grand-Duke's instructions, orders Lionardo Buonarroti to complete the work forthwith: 'non voglia sotto questi colori e scuse fuggire quello che doverrebbe cercare per honore della memoria del zio' (A. Lorenzoni, *Carteggio artistico inedito di D. Vincenzo Borghini*, Florence, 1912, pp. 91–3).

BENVENUTO CELLINI
(b. 1500; d. 1571)

Cellini, on whose character and life we are, thanks to his autobiography, better informed than on those of any other sixteenth-century Italian sculptor, was born in Florence on 3 November 1500. Trained as a goldsmith, he moved in 1519 to Rome, which was the main scene of his activity till 1540. His work in Rome was interrupted by visits to Florence (where he was for a time employed as a medallist by Alessandro de' Medici), to Venice, and to France (1537). Cellini's style in these early years can be reconstructed from the Seal of Ercole Gonzaga of 1528 (Curia Vescovile, Mantua), with an Assumption which is generically Raphaelesque, the Seal of Ippolito d'Este of 1539 (Musée de Lyon), the Morse made for Pope Clement VII in 1530–1, known through three drawings by Bartoli in the British Museum, and a number of medals, of which the most notable is that of Clement VII (1534) with alternative reverses of Peace and Moses striking Water from the Rock. One of the two figures on the reverse of a medal of Francis I of France (1537) is imitated from the Night of Michelangelo. From 1540 till 1545 Cellini worked in France, whither he took the celebrated salt-cellar (Kunsthistorisches Museum, Vienna) modelled

for Ippolito d'Este and completed for Francis I. In 1543–4 he executed his first large-scale sculpture, the bronze lunette of the Nymph of Fontainebleau, now in the Louvre, designed for the entrance to the palace at Fontainebleau and later installed at Anet, along with two Victory spandrel reliefs known from reproductions the originals of which have disappeared. In France he was also employed on twelve silver figures of Gods and Goddesses commissioned by the King, one of which, the Jupiter, was completed in 1544, and another of which, the Juno, is recorded in a drawing in the Louvre. In 1545 he left France and returned to Florence, where he received the commission for the Perseus (see Plate 70 below) and executed the bust of Cosimo I (see Plate 69 below). Other works he undertook in Florence were the relief of a Greyhound in the Museo Nazionale (document of 25 August 1545), the marble Apollo and Hyacinth (1546) and Narcissus (1547–8) in the same museum, the restoration of an antique torso as a Ganymede (1545–7), also in the Museo Nazionale, a bust of Bindo Altoviti (ca. 1550), now in the Gardner Museum, Boston (Fig. 122), and a marble Crucifix, now in the Escorial (1556–62, see Plate 72 below). Towards the end of his life (1563), he also prepared designs for the seal of the Academy of Florence (British Museum, London, and Graphische Sammlung, Munich). Cellini died in Florence on 13 February 1571. His celebrated autobiography was written between 1558 and 1562, but remained unpublished till the eighteenth century, and his two treatises on goldsmith's work and sculpture date from 1565.

BIBLIOGRAPHY: The best edition of the text of Cellini's *Vita* is that by Bacci (*Vita di Benvenuto Cellini*, per cura di Orazio Bacci, Florence, 1901). A number of English translations are available, of which the most serviceable is that by Symonds (*The Life of Benvenuto Cellini written by himself*, ed. Pope-Hennessy, London, 1949). Milanesi's edition of the *Trattati* (*I Trattati dell'Oreficeria e della Scultura di Benvenuto Cellini*, per cura di Carlo Milanesi, Florence, 1857), which contains Cellini's letters and poems and the contemporary poems on the Perseus, is preferable to later reprints. An English translation is available (C. R. Ashbee, *The Treatises of Benvenuto Cellini on Goldsmithing and Sculpture*, London, 1898). A monograph by Plon (*Benvenuto Cellini, Orfèvre, Médailleur, Sculpteur*, Paris, 1883), from which most later books on Cellini have been quarried, is superseded by a small book by Camesasca (*Tutta l'opera del Cellini*, Milan, 1955), and by a short analysis of Cellini's style by D. Heikamp (*Benvenuto Cellini*, in I Maestri della Scultura, No. 30, Milan, 1966). For the Vienna Salt-Cellar see Schlosser (*Das Salzfass des Benvenuto Cellini*, Vienna, 1921, reprinted in *Präludien*, 1927, pp. 346–56), and for typological precedents for the Perseus W. Braunfels (*Benvenuto Cellinis Perseus und Medusa*, in Werk-monographien zur bildenden Kunst, Stuttgart, 1961). In the periodical literature of Cellini special importance attaches to articles on the Apollo and Narcissus in the Bargello by Kriegbaum ('Marmi di Benvenuto Cellini ritrovati,' in *L'Arte*, n.s. xi, 194, pp. 3–25) and on the Escorial Crucifix by Calamandrei ('Nascita e vicende del "Mio Bel Cristo",' in *Il Ponte*, vi, 1950, pp. 3–31). Cellini's project (1564) for two pulpits for the Duomo in Florence is described in a memorandum printed by Lorenzoni (*Carteggio artistico inedito di D. Vinc. Borghini*, Florence, 1912, pp. 169–72), and a useful note on his artistic psychology is supplied by A. Grote ('Cellini in gara,' in *Il Ponte*, xix, 1963). For the artist's drawings see P. Calamandrei ('Inediti Celliniani: il Sigillo e i caratteri dell'Accademia,' in *Il Ponte*, xii, 1956) and M. Winnter ('Federskizzen von Benvenuto Cellini', in *Zeitschrift für Kunstgeschichte*, xxxi, 1968, pp. 293–304), discussing drawings in Berlin, the Cabinet des Dessins of the Louvre and a private collection in New York, the latter for one of the lost Satyrs for Fontainebleau.

or a small bronze model for the figure of Juno recorded in the Louvre drawing see J. F. Hayward ('A newly discovered Bronze Modello by Benvenuto Cellini,' in *Auction*, i, 1968, No. 6, pp. 4–7).

Plate 69: COSIMO I DE' MEDICI
Museo Nazionale, Florence

The bust (Fig. 121) is mentioned by Cellini in his *Vita* as made experimentally prior to the casting of the Perseus: 'E la prima opera che io gittai di bronzo fu quella testa grande, ritratto di S. Ecc.ᵗᵃ, che io avevo fatta di terra nell'oreficerie, mentre che io avevo male alle stiene. Questa fu un' opera che piacque, ed io non la feci per altra causa se non per fare sperientia delle terre di gittare il bronzo . . . perchè io non avevo ancora fatto la fornace, mi servì della fornace di maestro Zanobi di Pagno, campanaio' (The first piece I cast in bronze was that great bust, the portrait of His Excellency, which I had modelled in the goldsmiths' shop while suffering from pains in my back. This was a work made for my own pleasure, and my only object in making it was to obtain experience of the clays used for bronze-casting. . . . As I had not yet constructed my own furnace, I made use of that of Maestro Zanobi di Pagno, a bell-founder). Since the Perseus was commissioned in 1545, the bust must have been modelled and cast soon after Cellini's return to Florence. It was completed by 17 February 1547, when Cellini received a payment of 500 gold scudi for it. The bust is mentioned again by Cellini in a letter to Cosimo I of 20 May 1548 ('E feci quella testa, che si vede di bronzo, di Vostra Eccellenza'), in which he explains that the head meant more to him than did the figure of Perseus 'both in the matter of time and in the merit of its workmanship,' and that 'in accordance with the noble fashion of the ancients, there is given to it the bold movement of life; and it is well supplied with various and rich adornments, and is most carefully finished.' It is described in an inventory of the Guardaroba of Cosimo I in October 1553 as 'tocco d'oro' (touched up with gold), and it seems that the eyes were originally silvered or enamelled and that the armour was parcel gilt. On 5 February 1557 Cellini claimed a total sum of 800 gold scudi for the bust, and in November of that year it was moved to Elba and installed over the entrance to the fortress at Portoferraio, where it remained till 1781. The balance of the sum due for the bust was again claimed by Cellini from Cosimo I in a letter of 22 January 1562. A more limited claim for 150 scudi was endorsed by Ammanati in September 1570. The sum claimed by Cellini in letters written in September 1570 to Ammanati and in October

to Carlo de' Medici, was 400 scudi. A reduced marble copy of the bust carved in Cellini's shop probably by Antonio Lorenzi is in the De Young Museum, San Francisco.

Plates 70, 71: PERSEUS
Loggia dei Lanzi, Florence

The commissioning of the Perseus in 1545 is described by Cellini in the *Vita* and, in a more summary fashion, in the *Trattato della Scultura*. According to the first account, Cellini visited Cosimo I at Poggio a Cajano immediately after his return from France, and received a proposal of employment from the Duke. 'Io poverello isventurato, desideroso di mostrare in questa mirabile iscuola, che di poi che io ero fuor d'essa, m'ero affaticato in altra professione di quello che la ditta iscuola non istimava, risposi al mio duca, che volentieri, o di marmo, o di bronzo, io gli farei una statua grande in su quella sua bella piazza. A questo mi rispose, che arebbe voluto da me, per una prima opera, solo un Perseo: questo era quanto lui haveva di già desiderato un pezo; e mi pregò che io gnene facessi un modelletto. Volentieri mi messi a fare il detto modello, e in brevi settimane finito l'ebbi, della altezza d'un braccio in circa: questo era di cera gialla, assai accomodatamente finito; bene era fatto con grandissimo istudio et arte. Venne il Duca a Firenze, e innanzi che io gli potessi mostrare questo ditto modello, passò parecchi di, che proprio pareva che lui non mi avessi mai veduto ne conosciuto, di fatto che io feci un mal giuditio de'fatti mia con sua Eccellentia. Pur da poi, un di dopo desinare, havendolo io condotto nalla sua guardaroba, lo venne a vedere insieme con la duchessa e con pochi altri signiori. Subito vedutolo, gli piacque e lodollo oltra modo' (I poor unhappy mortal, burning with desire to show the noble school of Florence that, after leaving her in youth, I had practised other branches of the art than she imagined, gave answer to the Duke that I would willingly erect for him in marble or in bronze a mighty statue on his fine piazza. He replied that, for a first essay, he should like me to produce a Perseus; he had long set his heart on having such a monument, and he begged me to begin a model for the same. I very gladly set myself to the task, and in a few weeks I finished my model, which was about a cubit high in yellow wax, and very delicately finished in all its details. I had made it with the most thorough study and art. The Duke returned to Florence, but several days passed before I had an opportunity of showing my model. It seemed indeed as though he had never set eyes on me or spoken with me, and this caused me to augur ill of my future dealings with His Excellency. Later on, however, one day after dinner I took it to his wardrobe, where he came to inspect it with the Duchess and a few gentlemen of the court. No sooner had he seen it, than he expressed much pleasure, and extolled it extravagantly). The model referred to in this account is that now in the Museo Nazionale, Florence (Fig. 45). A bronze model in the same Museum (Fig. 46) is of somewhat later date. According to the *Vita*, at a relatively early stage in the preparation of the statue, when the workshop designed for it was still being built, Cellini prepared a full-scale gesso model, from which it was intended that the bronze should be moulded

and cast. 'Uno modello di gesso del Perseo grande' is mentioned in the inventory of Cellini's effects (1571). This method was, however, abandoned, and Cellini thereupon began work on a terracotta model for the Medusa built up on an iron frame, 'modelled like an anatomical subject, and about one finger's thickness thinner than the bronze would be'; this was covered with wax. After the experimental casting of the bust of Cosimo I, the Medusa was cast in bronze. The figure of Perseus was then modelled. According to Cellini, the Duke, when he saw the model, was sceptical whether the head of Medusa could be cast successfully. The *Vita* contains a celebrated account of the casting of the main figure in one piece, successfully save for damage to the right foot. The group was completed in 1554, and on 28 April was disclosed in the Loggia dei Lanzi. The statue was received with popular acclaim. The main figure is inscribed on the strap worn across the shoulder: BENVENVTVS CELLINVS CIVIS FLOR./FACIEBAT MDLIII. (in reference to the date of casting). The base, a wooden model for which appears in the inventory of Cellini's workshop, contains figures of Danae with the child Perseus (inscribed TVTA IOVE AC/TANTO PIGNORE/LAETA FVGOR), Jupiter (Fig. 47) (inscribed TE FILI SIQVIS/LAESERIT VLTOR/ERO), Athena (Fig. 48) (inscribed QVO VINCAS/CLYPEVM DO TIBI/ CASTA SOROR) and Mercury (inscribed FRIS VT ARMA/GERAS NVDVS AD/ASTRA VOLO). Beneath is a relief (Fig. 84) of Perseus rescuing Andromeda (original in the Museo Nazionale, copy beneath the statue), for which a wax model is recorded in Cellini's studio.

Plate 72: CRUCIFIX
Escorial

On the side of the cross is the inscription: BENVEN/VTVS CEL/LINVS.CIV/IS.FLORE/NT. FACIEB/AT. MDLXII. The statue (Fig. 66) was carved between 1556 and 1562, and is referred to in Cellini's *Vita*, in the course of a report of a conversation with Eleanora of Toledo: 'et per questo io me n'andai a trovare la duchessa e gli portai alcune piacevole cosette dell'arte mia, le quale S.E.I. l'ebbe molte care; dipoi la mi domandò quello che io lavoravo, alla quale io dissi: Signora mia, io mi sono preso per piacere di fare una delle piu faticose opere, che mai si sia fatte al mondo: e questo si è un Crocifisso di marmo bianchissimo, in su una croce di marmo nerissimo: ed è grande quanto un grande uomo vivo. Subito la mi dimandò quello che io ne volevo fare. Io le dissi: sappiate, signora mia, che io non lo darei a chi me ne dessi dumila ducati d'oro in oro; perchè una cotale opera nissuno uomo mai non s'è messo a una cotale estrema fatica, nè manco io non mi sarei ubbrigato affarlo per qualsivoglia signore, per paura di non restare in vergogna: Io mi sono comperato i marmi di mia danari, ed ho tenuto un giovane in circa a dua anni, che m'ha aiutato; et infra marmi, e ferramenti in su che gli è fermo, e salarii, e'mi costa più di trecento scudi; a tale che io non lo darei per dumila scudi d'oro: ma se V.E.I. mi vuol fare una lecitissima grazia, io gnele farò volentieri un libero presente: solo priego V.E.I. che quella non mi sfavorisca, nè manco non mi favorisca nelli modelli, che

S.E.I. si ha commesso che si faccino del Nettuno per il gran marmo' (Hearing what the Duke said, I went to the Duchess, and took her some small bits of goldsmith's work, which greatly pleased her Excellency. Then she asked what I was doing, and I replied: 'My lady, I have taken in hand for my pleasure one of the most laborious pieces which have ever been produced. It is a Christ of the whitest marble set upon a cross of the blackest, exactly of the same size as a tall man.' She immediately enquired what I meant to do with it. I answered: 'You must know, my lady, that I would not sell it for two thousand gold ducats; it is of such difficult execution that I think no man ever attempted the like before; nor would I have undertaken it at the commission of any prince whatever, for fear I might prove inadequate to the task. I bought the marbles with my own money, and have kept a young man some two years as my assistant in the work. What with the stone, the iron frame to hold it up, and the wages, it has cost me above three thousand crowns. Consequently, I would not sell it for two thousand. But if your Excellency deigns to grant me a favour which is wholly blameless, I shall be delighted to make you a present of it. All I ask is that your Excellency will not use your influence either against me or for me in connection with the models which the Duke has ordered to be made of the Neptune for that great block of marble').

At a later point in the *Vita* Cellini describes a visit paid by the Duke and Duchess to his studio to inspect the Crucifix. The Crucifix is also mentioned in the *Trattato della Scultura*, where Cellini refers to the difficulty of working the black marble from Carrara of which the cross was made, and states that he had intended it for his own tomb. The terminal date of 1556 for the commencement of work on the Crucifix is confirmed by a supplica of 3 March 1557 addressed by Cellini from the Stinche where he was imprisoned to the Duke asking that his sentence should be reduced 'e cosi io potrei finire il Cristo di marmo, il quale si e procinto di fine'. The black marble for the cross was purchased on 27 November 1557 from the Opera di San Giovanni. Further light is thrown on the sculptor's intentions by a will of 1555, which refers to a wax figure of the crucified Christ to be translated into marble for the sculptor's tomb. The Crucifix was destined for S. Maria Novella, where it was to be set outside the Gondi Chapel as a counterpart to the Brunelleschi Crucifix on the opposite side of the church. It was to be accompanied by a relief of the Virgin and Child, with the Crucifix turned towards them, and with figures of an angel and of St. Peter interceding with the Virgin. The imagery of this relief corresponds with a vision received by Cellini in 1539 when imprisoned in the Castel Sant'Angelo, which is described in detail in the *Vita*, and was recorded by Cellini at the time in a wax model. A codicil of September 1555 substitutes for the relief a fresco of the same scene painted on the wall. In both documents Antonio di Gino Lorenzi is named as the sculptor by whom the marble should be carved. Provision was to be made for showing the wax model in the church in a glass tabernacle. Cellini's will of 1555 was revoked in 1556 and revised in 1558, after the death of his son Jacopo Giovanni da Montepulciano, in favour of his adopted son. On 24 March 1561, after the birth of a further son, Cellini made a new will enjoining that he should be buried in whatever church the Crucifix was housed, and if the Crucifix were not set up in a church, in the Annunziata. The Crucifix is not mentioned in a further will of 1562. Cellini's intention to install it over his own tomb seems to have weakened as early as December 1557, when, in a supplica, he offers to place the sculpture in S. Maria Novella or in whatever other church the Duke should nominate, and in August 1565 the Crucifix was sold to Cosimo I and installed in the Palazzo Pitti. Its price was estimated by the sculptor at 1500 gold ducats, but was reduced, in a valuation made in 1570 by Ammanati and Vincenzo de' Rossi, to less than half this figure. In 1576 the Crucifix was despatched by Francesco I de' Medici as a gift to Philip II of Spain, by whom it was installed in the retro-choir choir of the Escorial and not, as had been planned, on the high altar. The arms were severed during the Spanish war of independence; the figure was originally in one piece.

BARTOLOMEO AMMANATI
(b. 1511; d. 1592)

Born at Settignano in 1511, Ammanati appears to have been trained in the Pisan studio of Stagio Stagi, and is first met with in 1536, when he executed the lunette of an altar in the Duomo at Pisa. Thereafter he carved three statues of Apollo, Minerva and S. Nazaro for the Sannazaro monument in S. Maria del Parto at Naples (1536–8), in which the bulk of the remaining sculptures are by Montorsoli. At the end of 1538 Ammanati received, through the intervention of the painter Genga, the commission for the tomb of Francesco Maria della Rovere, Duke of Urbino. He returned to Florence about 1540 to execute the Nari monument for the Annunziata (see Plate 73 below).

Disappointed at the unsatisfactory outcome of this commission, he moved to Venice, where he worked with Jacopo Sansovino, who had a strong formative influence on his style. There he carved a Neptune in Istrian stone for the Piazza San Marco (lost). His main scene of activity, however, was not Venice, but Padua, where he carved a colossal Hercules and statues of Jupiter and Apollo (much damaged) for the Palazzo Mantova Benavides, and undertook the Benavides monument in the Eremitani (completed 1546). In 1550 he married the poetess Laura Battiferri at Loreto, and on the election of Pope Julius III moved to Rome, where he received the commission

for the Del Monte monuments in S. Pietro in Montorio (see Plate 75 below). In Rome he also executed sculptures for the Villa di Papa Giulio (payments for the so-called Fontana dell' Ammanati 1554–5). On the death of Pope Julius III he established himself (1555) in Florence, where he carried out a fountain designed for the Sala dei Cinquecento of the Palazzo Vecchio, a bronze group of Hercules and Antaeus for Tribolo's fountain at Castello (see Plate 59 above), and the Fountain of Neptune in the Piazza della Signora (see Plate 74 below). A bronze figure of Mars in the Uffizi and a bronze Venus in the Prado date from 1559. In 1572, before the completion of the fountain, he was charged, on the commission of Pope Gregory XIII, with the monument of Giovanni Buoncompagni in the Campo Santo at Pisa (Fig. 72). Throughout these years Ammanati was also active as an architect, constructing the Ponte Santa Trinita (1567–70) and extending the Palazzo Pitti (1558–70). He designed many buildings in Florence and Lucca. At the end of his life he came under the strong influence of the Counter-Reformation, apparently through the agency of Jesuits in whose church in Florence, S. Giovannino dei Scolopi, he constructed his memorial chapel. This is reflected in a letter addressed by him in 1582 to the Accademici del Disegno inveighing against the representation of the nude, and in a further letter of about 1590 addressed to the Grande-Duke Ferdinand I, begging him 'che non lasci più scolpire o pingere cose ignude: et quelle che o da me e da altri sono state fatte si cuoprano, o del tutto si tolgano, in modo che Dio ne resti servito, nè si pensi che Fiorenza sia il nido degli idoli, o di cose provocanti libidine, et a cose che a Dio sommamente dispiacciono' (that he should no longer allow nude figures to be sculptured or painted and that those already executed, whether by myself or others, should be covered up or removed, so that Florence shall cease to be regarded as a nest of idols, or of lustful provocative things, which are highly displeasing to God). Ammanati died on 22 April 1592.

BIBLIOGRAPHY: The best general account of Ammanati's work is contained in an excellent chapter of Venturi (X-ii, pp. 346–432). On the early work of Ammanati see especially A. M. Gabrielli ('Su Bartolommeo Ammanati', in *Critica d'Arte*, ii, 1937, pp. 89–95) and M. G. Ciardi Dupré ('Prima attività dell'Ammanati scultore', in *Paragone*, 1961, No. 135, pp. 3–28). Ammanati's work in Venice is discussed by S. Bettini ('Note sui soggiorni veneti di B. Ammanati', in *Le Arti*, iii, 1940–1, pp. 20–7), and his work in Rome by L. Biagi ('Di Bartolommeo Ammanati e di alcune sue opere', in *L'Arte*, xxvi, 1923, pp. 49–66). The style of the bronze Mars and Venus and the sculptor's relationship to the antique are well discussed by H. Keutner ('Die Bronze Venus des Bartolommeo Ammanati: ein Beitrag zum Problem des Torso im Cinquecento,' in *Münchner Jahrbuch für Bildende Kunste*, xiv, 1963, pp. 79–92), who relates the Venus to an antique marble in the corridor of the Uffizi and to a stucco variant in the Casa Vasari at Arezzo. The fountain planned for the Palazzo Vecchio is reconstructed in a remarkable article by Kriegbaum ('Ein verschollenes Brunnenwerk des Bartolommeo Ammanati', in *Mitteilungen des Kunsthistorischen Institutes in Florenz*, iii, 1919–32, pp. 71–103).

Plate 73: VICTORY
Museo Nazionale, Florence

The principal source for the Nari monument of Ammanati, for which the Victory was carved, is the life of the sculptor by Baldinucci: 'Fu poi chiamato a Urbino . . . ma essendo in quel tempo seguita la morte del Duca, convennegli tornare a Firenze, dove col suo scarpello fece il Sepolcro di marmo, che doveva esser posto nella Chiesa della Santissima Nunziata per Mario Nari Romano, che combattè con Francesco Musi. Aveva egli figurata la Vittoria, che sotto di se teneva un prigione, e ancora aveva scolpito due fanciulli, e la statua di esso Mario sopra la cassa; ma fra'l non sapersi di certo da qual parte fosse stata la vittoria, e'l poco servizio, che il povero Ammanato ricevè dal Bandinello, quell'opera non si scoperse mai, onde essendone poi state levate le statue, fu quella della Vittoria collocata in una delle testate nel secondo cortile di quel Convento, dalla parte della Chiesa, presso alla Cappella degli Accademici del Disegno. I fanciulli furono posti un di qua, e un di là avanti all'Altar maggiore, facendo loro fare ufizio d'Angioli, che sostengono candellieri, e non son molti mesi che a cagione di non so qual disegnato nuovo acconcime, sono stati tolti di detto luogo. La statua di Mario fu portata altrove; quest' accidente di non essersi potuta quell'opera scoprire, apportò a Bartolommeo tanto disgusto, che immantinente lasciò la patria, ed a Venezia di nuovo se n'andò' (Then he was summoned to Urbino . . . but since the death of the Duke occurred at that time, he was obliged to return to Florence, where he carved the marble tomb of Mario Nari of Rome, who fought a duel with Francesco Musi. It was intended that this should be installed in the church of the Annunziata. Ammanati carved the figure of Victory with a prisoner beneath, and two boys, and the effigy of Mario on the tomb chest, but partly because of uncertainty as to what victory was represented, and partly because of the intrigues which Bandinelli directed against poor Ammanati, the work was not unveiled. After the statues had been removed from it, the Victory was placed in the second cloister of the convent, on the side towards the church, near the chapel of the Accademici del Disegno. The boys were placed one on each side in front of the high altar, doing service as candle-bearing angels, but after a few months, because of some newly designed restoration, they were moved from this position. The effigy of Mario was transported elsewhere. The fact that he was not able to show this work, caused Bartolommeo such disgust, that he forthwith left his native town, and went once more to Venice). Bandinelli's part in frustrating the monument is attested by Borghini. The Victory (which was installed in a niche in the south-east corner of the cloister and was subsequently in the Giardino dei Semplici) and the effigy of Nari are now in the Museo Nazionale; the two figures of boys have disappeared. The commission for the Nari monument probably dates from 1540, and Ammanati's departure for Venice may have resulted from a visit paid to Florence by Jacopo Sansovino in this year (Ciardi Dupré).

Plate 74: THE FOUNTAIN OF NEPTUNE
Piazza della Signoria, Florence

The project for a fountain in the Piazza della Signoria is first mentioned in a letter of Bandinelli to Jacopo Guidi of 15 March 1550 (Bottari-Ticozzi, *Raccolta di lettere*, i, pp. 90–2, No. XXXVII): 'E si degni notare i disegni che io gli ho mandati delle fonti, perchè sua eccellenza più volte mi ha detto che vuole che superino tutte le altre, e per ubbidirlo, vostra signoria gli dica, come io ho diligentemente investigato e ricerco de' maestri che hanno lavorato sopra le fonti di Messina, e truovo che sono magnifiche . . . io prometto a sua eccellenza, se le mie fatiche gli piaceranno, fargli una fontana, che non solo supererà tutte quelle che oggi si veggono sopra della terra, ma io voglio che i Greci e i Romani non abbiano mai avuto una simile fontana; e se gli altri signori hanno speso dieci, darò tali ordini brievi, che sua eccellenza non ispenderà cinque' (Please take note of the designs for fountains which I have sent, as His Excellency has told me more than once that he wants them to surpass all others; and let Your Lordship tell him how, in obeying him, I have diligently searched out and made enquiries from masters who have worked on the fountains of Messina, and I find they are magnificent. . . . I promise His Excellency, if my labours please him, to make him a fountain which will not only surpass all those to be seen at the present day on the surface of the earth. I intend that the Greeks and Romans should never have had such a fountain; and if the other gentlemen have spent ten, I shall give such tight instructions that His Excellency will not spend five). The scheme for the fountain is alluded to again in a letter of 11 February 1551 (op. cit., pp. 92–4) in conjunction with a plan for a fountain outside the Palazzo Pitti: 'ed avendomi a disporre a trovare invenzione di fontane, farò ancora qualche disegno della fontana di Piazza, come mi comandò l'ill. duca' (and as I am to prepare to work out fountain schemes, I will make some more designs for the fountain in the Piazza, as the Illustrious Duke commands me). The building of the fountain was contingent on the provision of water, which was eventually brought from a spring at Ginevra outside the Porta San Niccolò, by way of the Ponte a Rubiconte and the Borgo de' Greci to the Piazza. This is commemorated on a medal of Cosimo I (Supino, *Il Medagliere Mediceo nel R. Museo Nazionale di Firenze*, Florence, 1899, No. 384, p. 134), showing on the reverse a basin with a figure of Neptune drawn by sea-horses raising his trident, and an aqueduct. The principal source for the later history of the fountain is Vasari, who records that a block of marble ten and a half braccia in height and five braccia in width was excavated at Carrara, and was immediately inspected by Bandinelli (probably in 1558), who paid a deposit of fifty scudi for the block. Through Eleanora of Toledo he obtained authority to make models for a projected fountain for the Piazza making use of the new block ('nel quale luogo si facesse una gran fonte che gittasse acqua, nel mezzo della quale fusse Nettunno sopra il suo carro tirato da cavagli marini; e dovesse cavarsi questa figura di questo marmo. Di questa figura fece Bandinelli più d'uno modello' (in this place a large fountain, spouting water, was to be made, in the middle of which was to be Neptune on his car, drawn by sea-horses; and this figure

was to be carved from marble. Bandinelli made more than one model for it). In 1559 the owner of the marble asked for the balance of the sum due, and the block was then purchased by Vasari for Cosimo I. At this point both Cellini and Ammanati, resenting the opportunity offered to Bandinelli, asked permission to make models in competition with Bandinelli's. The Duke agreed to this, not because he proposed to open the fountain to competition, but because he felt that the stimulus might be beneficial to Bandinelli. The latter 'vedutasi addosso questa concorrenza, ne ebbe grandissimo travaglio, dubitando più della disgrazia del duca, che d'altra cosa; e di nuovo si messe a fare modelli' (was much upset at the announcement of this competition, suspecting the displeasure of the Duke, rather than anything else; and he set himself to making models again). Bandinelli then proceeded to Carrara, where he defaced the block in such a way as to render it less useful to his opponents. This phase in the history of the fountain closes with the death of Bandinelli (1560). Thereafter Cellini and Ammanati pressed the Duke for the commission, the latter enlisting the support of Michelangelo, who, with the concurrence of Vasari, was instrumental in securing the commission for Ammanati. After further protests from Cellini, this sculptor was also allowed to make a full-scale model of the figure, both artists working in segregated areas in the Loggia dei Lanzi. This situation was further complicated by the claims of Giovanni Bologna (who was allowed to prepare a model in S. Croce) and of Vincenzo Danti (who prepared a model in the house of Alessandro d'Ottaviano de' Medici), Francesco Moschino (who prepared a model at Pisa), and Vincenzo de' Rossi, who also claimed the right to make a model but seems not to have carried this out (see Gaye, iii, p. 24: 'Per sapere io che la eccellenza vostra vole far fare uno Gigante di marmo, e desideroso di esere anche io nel numero di quelli che la servano, la prego che la si voglia degnare, poiché di mio nonè opere in firenze, e qua a Roma ciè di Bartolomeo et del Moschino; e mià intendere la verità che tale leriuscierà in modello, che poi in marmo sarà adrieto un gran pezo . . . ora la Eccellenza vostra faccia vedere il mio teseo quando rapì elena, magior del naturale e di marmo, chè una tanta opera, quale è codesto gigante') (Knowing that Your Excellency is having a colossal figure made in marble, and desiring that I too should be one of those that serve you, I beg you will allow it; for there is no work of mine in Florence, while there are works by Bartolommeo and Moschino in Rome. I think that what goes well for them in the model, will turn out to be a great deal inferior in the actual marble . . . let Your Excellency inspect my Theseus carrying off Helen, which is over life-size and of marble, and just such a work as the colossal figure is to be). Cellini later presented his two models for the statue to Francesco de' Medici. An objective account of the competition is provided in a letter of 14 October 1560 from Leone Leoni to Michelangelo (Plon, *Cellini*, p. 236 n.): 'L'Amanato ha hauto e tirato il marmo nela sua stanza; Benvenuto balena et sputa veleno et getta fuoco per gli hocchi e brava il duca con la lingua. Hano fatto questi modelli quatro persone; l'Amanato, Benvenuto, un Perugino (Vincenzo Danti), et un Fiamengo detto Gian bologna. L'Amanato si dice ha fatto meglio, ma io non l'ho veduto per eser fasciato per lo tirare del marmo in quel

luogho dove è. Benvenuto mi ha mostrato il suo, ond'io gli ho pietà che in sua vecchiezza sia cosi male stato ubidito da la terra e da la borra. Il Perugino ha fatto assai per giovine; ma non ha voce in capitolo. Il Fiammengho è condanato in le spese et ha lavorato la sua terra molto pulitamente: Ecco detto a V.S. la gigantata' ·(Ammanati has had the marble carried into his shop, and Benvenuto is flaring up and spitting out venom, flashing fire from his eyes and flouting the Duke with his tongue. Four people did these models: Ammanati, Benvenuto, a man from Perugia, and a Fleming called Giambologna. Ammanati says he has done best; but I have not seen his model, since it is bound up for the transport of the marble to the place where it is. Benvenuto has shown me his; over which I am sorry that in his old age he should be so ill served by the clay and rags. The man from Perugia has done very well for one so young, but has no influence. The Fleming was turned down on account of his expense, but worked his clay very cleanly. So much for this giant contest). The competition is also described in the *Vita* of Cellini. The sequence of construction of the fountain is established by Wiles (*Fountains of the Florentine Sculptors*, Cambridge, 1933, p. 119) on the basis of information in the manuscript *Diario Fiorentino* of Settimani, which shows that the marble for the fountain was brought to Florence on 22 June 1560. On 17 October 1560 it was taken to the Loggia dei Lanzi. Donatello's Marzocco, then on the ringhiera at the left of the Palazzo Vecchio, was moved on 5 March 1564 to enable work to begin on the new fountain, and on 4 May 1565 the foundations were laid. On 3 October 1565 the Gigante was set up among temporary figures as part of the decorations for the marriage of Francesco de' Medici and Giovanna d'Austria. Work on the marble and bronze subsidiary figures began in March 1571, and the fountain (Fig. 96) was unveiled in June 1575. The appearance of the fountain in its temporary installation in 1565 is described by Vasari. The *Riposo* of Borghini (1584) contains an analysis of the pose of the Neptune, a discussion of the appropriateness of the signs of the zodiac on the chariot, and a description of the completed work: 'Ma perchè il marmo gli riuscì stretto nelle spalle, non potè egli, siccome desiderava, far mostrare alla sua figura attitudine con le braccia alzate; ma fu costretto à farla con gran difficultà, come hoggi si vede. Il qual Nettuno, come sapete è alto braccia dieci, e ha fra le gambe tre Tritoni di marmo, posando sopra una gran conca marina, che gli serve per carro, à cui sono in atto di tirarla quattro cavalli due di marmo bianco, e due di mistio: il gran vaso in cui l'acqua christallina (che per molti zampilli salendo in aria ricade) è fatto à otto facce di marmo mistio, di cui le quattro minori di bambini di bronzo con molte cose marine, d'alcuni Cornucopi, e d'uno Epitaffio in mezzo sono fatte adorne: e sopra il piano d' esse (che più d'ogn'altro all'intorno s'innalza) posano quattro statue di metallo più grandi del naturale, due femine figurate per Teti e per Dori, e due maschi rappresentanti due Dei marini, e à piè di queste facce otto Satiri di bronzo seggono in varie attitudini: le facce poi maggiori son fatte basse, acciò che l'acque chiare, che nella gran conca vanno ondeggiando si possan vedere. Ma troppo lungo sarei, se i gradi di marmo, se le pile basse, e se gl'infiniti ornamenti di questa fontana, che per settanta bocche manda fuore l'acque sue,

volessi raccontare' (As the block of marble was narrow around the shoulders, he could not, as he wished, give his figure a pose with the arms raised, but had to work it under great difficulties, as you can see even now. The Neptune is, as you know, ten braccia high, and has three marble tritons between its legs; it stands on a great sea-shell which serves as a chariot, and four horses are pulling this, two of them of white marble and two variegated. The great basin, holding the crystal-clear water which rises into the air through many spouts and then falls back again, is made with eight sides of variegated marble, and the four smaller ones are decorated with bronze putti and many objects from the sea, some cornucopias and an epitaph in the middle. On the top of these, and higher than anything else around, stand four metal statues, larger than life-size; two of them are female figures, representing Thetis and Doris, and two are male, representing sea-gods. At the foot of the sides there are eight satyrs sitting in different attitudes. The longer sides are low, so that one can see the clear water rippling in the great basin. But it would take too long to describe the marble steps, the shallow basins and innumerable ornaments of this fountain, which pours out water from seventy outlets).

In addition to Ammanati the names of the following sculptors are mentioned in documents relating to the fountain (see A. Lensi, *Il Palazzo Vecchio*, Milan, 1929, pp. 200–2): Andrea Calamech (1514–78), Michele Fiammingo, Girolamo dei Noferi da Sassoferrato, Battista di Benedetto Fiammeri (1530–1606), Donato Berti, and Raffaello Fortini. Of these sculptors Calamech alone is known as an independent artist. Fiammeri was later active as a painter at the Gesù, and Raffaello Fortini in 1600 prepared models for a relief and four figures of Apostles for the doors of the Duomo at Pisa, which were 'biasimati da ogniuno' and were not executed. There is considerable divergence of view as to Ammanati's responsibility for the subsidiary figures on the fountain, the criteria of judgment varying between those of Venturi ('Vari furono gli esecutori dei bronzi della fonte di piazza, ma l'Ammanati dovette sorvegliarne dappresso il lavoro, tanto è l'unità d'effetti raggiunta tra figura a figura') and Kriegbaum ('Augenscheinlich ist nur der bärtige Flussgott von der Hand des Meisters selbst, alle andern Figuren stammen von nicht nur selbstständig ausführenden, sondern auch selbstständig entwerfenden und modellierenden Gehilfen und verschleiern das Bild der Persönlichkeit eher als dass sie es klärten'). The attributions for individual figures advanced by Venturi are based on suggestions by Kriegbaum, and are as follows:

North-west face.

Bearded Marine God (Nereus?) (Ammanati).
Cartouche beneath (assistant of Ammanati).
Satyr (*left*) (Vincenzo de'Rossi).
Faun (*right*) (Guglielmo Fiammingo).

South-west face.

Doris with Shell (Calamech after model by Ammanati).
Cartouche beneath (assistant of Ammanati).
Faun (*left*) (Ammanati).
Satyr (*right*) (Vincenzo de' Rossi).

South-east face.

Thetis with Shield of Achilles (Ammanati).
Cartouche beneath (Ammanati).
Satyr (*left*) (unattributed).
Satyr (*right*) (described as missing by Baldinucci; the present
figure executed by Francesco Pozzi in 1831).

North-east face.

Youth with Cornucopia (Vincenzo Danti).
Cartouche beneath (assistant of Ammanati).
Faun (*left*) (Guglielmo Fiammingo).
Faun (*right*) (Guglielmo Fiammingo).

There is no documentary evidence of Vincenzo Danti's par-
ticipation in the fountain. The attributions to Vincenzo de' Rossi
are also conjectural.

Plate 75: THE DEL MONTE MONUMENTS
S. Pietro in Montorio, Rome

On the death of Cardinal Antonio del Monte (20 September
1533) his two nephews, Cardinal Giovanmaria and Balduino
del Monte, were required, under the terms of the Cardinal's
will, to erect a marble tomb in S. Pietro in Montorio. After the
election of Giovanmaria del Monte (8 February 1550) as Pope
Julius III, plans were laid for the construction of a memorial
chapel in the Cappella di San Paolo of S. Pietro in Montorio,
containing monuments to Cardinal Antonio del Monte and to
Fabiano del Monte (d. 2 July 1498), who was buried in the
Chiesa della Misericordia at Monte San Savino. The construc-
tion was entrusted to Vasari and the sculpture to Ammanati.
The complex history of the tombs can be reconstructed from
passages in Vasari's *Vite*, from the contract for the chapel, and
from letters of Borghini and Michelangelo. The first passage
occurs in the life of the sculptor Simone Mosca and reads as
follows: 'Avendo dunque Giorgio Vasari, che portò sempre
amore al Mosca, trovatolo in Roma, dove anch'egli era stato
chiamato al servizio del papa, pensò ad ogni modo d'avergli a
dare da lavorare; perciocchè avendo il cardinal vecchio di
Monte, quando morì, lasciato agli eredi che se gli dovesse fare
in San Piero in Montorio una sepoltura di marmo, ed avendo il
detto Papa Giulio suo erede e nipote ordinato che si facesse, e
datone cura al Vasari, egli voleva che in detta sepoltura facesse il
Mosca qualche cosa d'intaglio straordinaria. Ma avendo
Giorgio fatto alcuni modelli per detta sepoltura, il Papa conferì
il tutto con Michelagnolo Buonarruoti prima che volesse
risolversi. Onde avendo detto Michelagnolo a Sua Santità che
non s'impacciasse con intagli, perchè, se bene arricchiscono
l'opere, confondono le figure; là dove il lavoro di quadro,
quando è fatto bene, è molto più bello che l'intaglio, e meglio
accompagna la statua, perciocchè le figure non amano altri
intagli attorno; così ordinò Sua Santità che si facesse. Perchè il
Vasari non potendo dare che fare al Mosca in quell'opera, fu
licenziato; e si finì senza intagli la sepoltura, che tornò molto
meglio che con essi non arebbe fatto' (Giorgio Vasari, who
always liked Mosca, met him in Rome, where he too had been

summoned to the Pope's service, and thought he would
certainly have some work to give him. For the old Cardinal
del Monte, when he died, had left instructions to his heirs that
a marble tomb should be built for him in S. Pietro a Montorio;
and Pope Julius, his heir and nephew, had ordered that it should
be done and had put Vasari in charge, who wished that Mosca
should do some exceptional piece of carving on the tomb. But,
after Giorgio had made some models for the tomb, the Pope
discussed the whole question with Michelangelo Buonarroti
before he would make up his mind. At this Michelangelo told
His Holiness not to involve himself in carving, because, although
it enriches the work, it makes for confusion with the figures;
while simple framing, on the other hand, when it is well done, is
much more beautiful than carving, and goes better with figures,
since it does not suit figures to have other carving round them.
And His Holiness ordered that it should be done in this way. So
Vasari could not give Mosca anything to do in that work, and
he was dismissed; and the tomb was finished without any carv-
ing and was much better than it would have been with it).
The second passage occurs in the life of Michelangelo: 'avendo
il Vasari fatto disegni e modelli, papa Giulio, che stimò sempre
la virtù di Michelagnolo, ed amava il Vasari, volse che Michel-
agnolo ne facessi il prezzo fra loro; ed il Vasari suplicò il papa a
far che Michelagnolo ne pigliassi la protezione: e perchè il
Vasari aveva proposto per gl'intagli di quella opera Simon
Mosca, e per le statue Raffael Montelupo, consigliò Michel-
agnolo che non vi si facessi intagli di fogliami, nè manco ne'
membri dell'opera di quadro, dicendo che dove vanno
figure di marmo, non ci vuole essere altra cosa. . . . Non
volse Michelagnolo che il Montelupo facesse le statue, avendo
visto quanto s'era portato male nelle sue della sepoltura di
Giulio secondo, e si contentò più presto ch'elle fussino date a
Bartolommeo Ammanati' (Since Vasari had made drawings and
models, Pope Julius, who always respected the genius of
Michelangelo, and loved Vasari, wanted Michelangelo to fix
the price between them; and Vasari begged the Pope to get
Michelangelo to take it under his supervision. Vasari had
suggested Simone Mosca for the carved decoration of the work,
and Raffaello da Montelupo for the figures, but Michelangelo
advised that there should not be any foliate carving on it, not
even on the structural part, and that there should be nothing
else. . . . Michelangelo did not want Montelupo to do the
figures, because he had seen how badly he had performed in
those of his own tomb of Julius II, and he preferred that
they should be given to Bartolommeo Ammanati). Accord-
ing to his own account, Vasari came to Rome immediately
upon the election of Pope Julius III, whom he had known at
Bologna, and the promise of the contract for the chapel must
have been proffered soon after this time. The choice of Am-
manati as the sculptor of the tombs in place of Raffaello da
Montelupo was presumably decided on before 28 May 1550,
when Borghini learned at Padua (Frey, *Vasaris Literarischer
Nachlass*, No. CXL) that 'la sepoltura del papa, quanto appartiene
alla scoltura, l'haveva l'Ammanato. Non intesi gia se per
ordine vostro (of Vasari) o del papa. E questo intesi da Mantoua
gentil'huomo Padovano, el quale l'Ammanato ha fatto molti
lavori et belli' (Ammanati had the commission for that part

of the work on the Pope's tomb which involves sculpture. Whether this is on your instructions or the Pope's is not yet known. I learned this from Mantova, a Paduan gentleman from whom Ammanati has done many beautiful works). On 3 June 1550 a contract was signed, whereby Vasari bound himself to construct the chapel and tombs within thirty months on the basis of a wooden scale model submitted to the Pope. The contract (Frey, op. cit., ii, pp. 869–70) names Ammanati as the sculptor of one effigy and one allegorical figure ('et quelle per ordine di Michelagniolo Buonarruoti et mia fussino date a Bartolommeo Ammanati, scultore Fiorentino') and reserves the choice of the sculptor of the second effigy and allegorical figure to Vasari and Michelangelo. Immediately after the signing of the contract (6 June 1550) Vasari and Ammanati left for Carrara to select the marble for the tombs. It is made clear in letters of Michelangelo (Frey, op. cit., No. CXLI and i, pp. 289–94) that at this point difficulties arose, in so far as the Pope, on 1 August 1550, proposed transferring the project for the chapel from S. Pietro in Montorio to S. Giovanni dei Fiorentini. On 13 October 1550, however, this proposal was cancelled, and S. Pietro in Montorio was confirmed as the site of the monuments. A letter of Michelangelo of 22 August 1550 suggests that Ammanati had already begun work on the sculptures: 'Circa all'opera vostra, io sono stato a veder Bartolommeo, e parmi che la vadi tanto bene, quant'è possibile. Lui lavora con fede e con amore e è valente giovane, come sapete, e tanto da bene, che e'si può chiamare l'angelo Bartolommeo' (About your work: I have been to see Bartolommeo, and I think he is getting on as well as possible. He is working faithfully and enthusiastically, and is a worthy young man, as you know; and there is so much good in him that you could call him Bartolommeo the angel). Vasari returned to Rome at the end of December 1550. A receipt signed by him on 3 October 1552 relates to the marble parapet, and in a letter of Borghini to Vasari of 22 October 1552 work in the chapel is described as complete. Ammanati's sculptures, however, were not ready till the summer of 1553, and payments for them were made on 25 June 1553, 11 September 1553 and July 1554. There is some doubt as to the extent of Vasari's responsibility for the design of the Chapel in the form in which it was carried out. A preliminary drawing by Vasari in the Louvre differs from the chapel as executed (i) in the greater elaboration of its decoration, (ii) in the totally different form of the sarcophagi, and (iii) in the mannerist posing of the figure sculpture. The architecture of the chapel is credited by Venturi (XI–ii, pp. 220–2) to Ammanati; it is likely that its impressive scheme is due not only to the collaboration of this artist but to the intervention of Michelangelo. Certainly the chapel as executed represents not merely a simplification of the scheme of the Louvre drawing, but a radical departure from it at many points. The figure sculpture of the tombs (Fig. 67) comprises (left) the effigy of Antonio del Monte, with, above, a figure of Religion, (right) the effigy of Fabiano del Monte, with, above, a figure of Justice, and (front) a marble balustrade with four pairs of putti and two portrait reliefs.

VINCENZO DANTI
(b. 1530; d. 1576)

Born at Perugia, and trained as a goldsmith at Perugia and in Rome, Vincenzo Danti was inscribed as a member of the guild of goldsmiths in his native town on 28 January 1548. His first important work, the seated bronze statue of Pope Julius III outside the Duomo in Perugia, was commissioned jointly from him and from his father on 10 May 1553, but is signed by Vincenzo Danti alone (VINCENTIUS DANTIUS PERUSINUS ADHUC PUBER FACIEBAT); it was finished by the summer of 1556, and the concluding payment for it dates from 7 April 1559. In April 1554 Danti was at work at Perugia on a silver-gilt vessel, but by 5 August 1557 he had joined the artists assembled at the court of Cosimo I in Florence. Between this date and 1573 he worked principally in Florence, returning intermittently to Perugia, where he spent the last years of his life and died on 26 May 1576. In Florence, he undertook the monument of Carlo de' Medici in the Duomo at Prato (erected 1566), executed the marble group of Honour triumphant over Falsehood (see Plate 77 below), and three figures over the entrance of the Uffizi (1563), and cast the group of the Decollation of the Baptist over the south door of the Baptistry (see Plate 76 below), and the large relief of Moses and the Brazen Serpent (Fig. 85) and a safe-door for Cosimo I (both in the Museo Nazionale, Florence). He was also responsible (1570) for an impressive stucco statue of St. Luke executed for the Cappella di S. Luca in SS. Annunziata on the commission of the Accademia del Disegno (1565) in conjunction with statues by Poggini (St. Peter), Camilliani (Melchisedek), Stoldo Lorenzi (Abraham) and other artists. One of his last works in Florence is the Venus Anadyomene in the Studiolo of the Palazzo Vecchio (see Plate 78 below). To the same late date belong a marble Venus in the Palazzo Pitti, Florence, and a marble Leda and the Swan in the Victoria & Albert Museum, London. A statue of Cosimo I in the Museo Nazionale, Florence, was carved after 1568. In 1567 Danti published his celebrated Primo libro del trattato delle perfette proportioni, dedicated to Cosimo I de' Medici.

BIBLIOGRAPHY: For the career of Danti see W. Bombe, in Thieme Künstlerlexikon (viii, 1913, pp. 384–5), and Venturi (X–ii, pp. 507–29). An article by Kriegbaum ('Zum "Cupido des Michelangelo" in London', in Jahrbuch der Kunsthistorischen Sammlungen, n.f. iii, Vienna, 1929, pp. 247–57), though based on a misattribution, contains an interesting analysis of Danti's

style, which is investigated with greater sureness and perspicacity by Keutner ('The Palazzo Pitti "Venus" and other Works by Vincenzo Danti', in *Burlington Magazine*, c, 1958, pp. 427–31). For the Cappella di S. Luca statues see D. Summers ('The Sculptural Program of the Cappella di San Luca in the Santissima Annunziata,' in *Mitteilungen des Kunsthistorischen Institutes in Florenz*, xiv, 1969, pp. 67–90). The standard edition of the *Trattato* is by Barocchi (*Trattati d'arte del Cinquecento fra Manierismo e Controriforma*, i. Bari, 1960, pp. 209–69).

Plate 76: THE DECOLLATION OF ST. JOHN THE BAPTIST
Baptistry, Florence

The three-figure group of the Decollation of St. John the Baptist (Fig. 40) over the south door of the Baptistry is described by Borghini in the following terms: 'Gittò con gran felicitàle tre figure del bronzo, che si veggono sopra la porta di San Giovanni di verso la Misericordia, e vennero tanto bene, tanto sottili, e tanto pulite, che non bisognò rinettarle: nel mezzo si vede l'humiltà, e la patienza di S. Giovanni, che ginocchioni con le man giunte attende il dispietato colpo, che gli dee venir sopra: dalla parte sinistra la fierezza dell'ardito ministro co' capelli rabbuffati, e colla spada alta in atto di tagliarli la testa: e dalla parte destra la crudeltà mescolata con orrore d'Erodiana, che con un bacino sotto il braccio aspetta di portare il dimandato dono all'iniqua madre' (He cast most successfully the three bronze figures which stand above the door of S. Giovanni opposite the Misericordia; and they came out so well, so delicately and so cleanly that there was no need to polish them. In the centre are the humility and long-suffering of St. John, who is kneeling with hands together, waiting for the pitiless blow to come from above. On the left is the ferocity of the savage executioner, with his hair disordered and his sword held high in the act of cutting off St. John's head. And on the right cruelty is mixed with horror in the person of the daughter of Herodias, waiting with a charger under her arm to bring the commanded gift to her evil mother). On the socles of the three figures are (*centre*) three cardinal virtues, (*left*) allegory of lust, (*right*) allegory of intemperance. The group was set in place on 22 June 1571 (Lapini, *Diario Fiorentino*: 'A' dí 22 giugno 1571, in venerdí, che fu l'antivigilia di San Giovanni Battista, a ore 23 in circa, si scoperse quella decollazione di S. Giovanni Battista, di bronzo, che è sopra la porta di detto S. Giovanni, che guarda verso Mercato Vecchio, condotta e fatta per mano di Vincenzo perugino. Ritornossi su a' dí 15 e 16 di detto mese, ma si scoperse poi a' dí 22 com' è detto') (On Friday 22 June 1571, the day before the eve of the festival of St. John the Baptist, at about 11 p.m., the bronze group over the door of S. Giovanni facing the Mercato Vecchio, was unveiled; it was the work of Vincenzo of Perugia. It had been put up on the 15th and 16th of June, but was unveiled later on the 22nd, as I have said). Two documentary references to the making of the figures are published by Frey (Vasari, *Vite*, i, ed. Frey, 1911, p. 349):

1570. Statue tre di bronzo, che si facevano da Perugino per
 mettere sopra la porta di S. Giovanni, che guarda verso la

Misericordia, si gettono, dove lavora l'Ammannato e Giovan Bologna 1570. Fa dal 1564 al 1573.

1571. Statue tre di bronzo sudetto, fatte per Vincenzo Danti
 Perugino scultore, si pagano fior. 400 l'una, la fattura sola-
 mente, 1571. Fa dal 1564 al 1573.

The relevance of the date 1564 in these two documents is not clear, and the figures were probably modelled in 1569–70. Paatz (ii, pp. 197, 245) infers that the tabernacle in which the figures are set was designed at the same time as the bronze group.

Plate 77:
HONOUR TRIUMPHANT OVER FALSEHOOD
Museo Nazionale, Florence

Vasari, after describing the failure of Danti's attempt to produce a bronze group of Hercules and Antaeus for the Castello fountain, refers to the Honour triumphant over Falsehood in the following terms: 'Voltossi dunque, per non sottoporre le fatiche al volere della fortuna, a lavorare di marmo: condusse in poco tempo di un pezzo solo di marmo due figure, cioè l'Onore che ha sotto l'Inganno, con tanta diligenza, che parve non avesse mai fatto altro che maneggiare i scarpelli ed il mazzuolo; onde alla testa di quell'Onore, che è bella, fece i capelli ricci, tanto ben traforati, che paiono naturali e propri, mostrando oltre ciò di benissimo intendere gl'ignudi: la quale statua è oggi nel cortile della casa del signore Sforza Almeni nella Via de' Servi' (He then turned to marble sculpture, so that his labours would not be dependent on the will of Fortune. Within a short time he worked two figures in a single piece of marble, namely Honour standing over Falsehood, and did them with such diligence as to seem never to have handled anything but chisels and mallet. He made the hair on the head of the figure of Honour very elaborate, and hollowed it out so well that it seems natural and real; and he showed too an excellent understanding of the nude. This statue is now in the courtyard of Signor Sforza Almeni's house in the Via de' Servi). The group is also described by Borghini and Pascoli, who states that as a result of its success Danti was invited by Sforza Almeni to undertake garden sculptures at Fiesole. All early sources are in agreement that the group was the first marble sculpture executed by Danti in Florence, and it is generally assumed to date from immediately after the completion of the safe door for the Palazzo Vecchio in 1561 (cf. U. Middeldorf and F. Kriegbaum, 'Forgotten Sculpture by Domenico Poggini', in *Burlington Magazine*, liii, 1928, p. 10 n., and Venturi, X-ii, p. 509). The group was purchased by the Grand-Duke Pietro Leopoldo in 1775, and placed at the end of the Stradone in the Boboli Gardens, whence it was transferred to the Bargello. A terracotta sketch-model (H. 46.5 cm.) in the Museo Nazionale, Florence, is identified by Brinckmann (*Barock Bozzetti*, i, 22, pp. 64–5) as a preliminary study for the present group. The open pose used in this group seems, however, to belong to a rather later point in Danti's development, and it is rightly regarded by Venturi (op. cit., pp. 514–5) as a later variant made in preparation for a bronze statuette in the Museo degli Argenti.

Plate 78: VENUS ANADYOMENE

Palazzo Vecchio, Florence

In 1570 the apartments of Francesco de' Medici in the Palazzo Vecchio were decorated under the direction of Vasari. Among them was a newly constructed Studiolo, which fulfilled the function of a 'guardaroba di cose rare e pretiose, et per valuta, et per arte, come sarebbe a dire Gioie, Medaglie, Pietre intagliate, Cristalli lavorati et vasi, ingegni, et simil cose non di troppa grandezza: riposte ne proprii armadii ciascuna nel suo genere' (cabinet of objects that are rare and precious, both for their value and their art, such as jewels, medals, engraved gems and crystal, vases, instruments, and similar things of moderate size, kept in cupboards each according to its kind). The wall surfaces of the room were designed to accommodate a sequence of paintings, with eight niches for statuettes. The matter of the programme for the statuettes and paintings was referred by Vasari to Borghini, who replied on 29 August 1570 (Frey, *Vasaris Literischer Nachlass*, ii, No. DCCXLVIII): 'Io vi mando una lunga diceria sopra lo stanzino del principe, et chi vuol piu o meglio faccia da se; che questo e tutto quello che io so. Voi vedrete, et perche sintenda piu facilmente vi mandro in su uno spartimento segnato cosa per cosa' (I send you a long screed about the Prince's little room, and if anyone wants either more or better let him do it himself; this is all I know. You will see I am sending as well a plan marked item by item, so that it will be understood more easily). Borghini's invention (for which see A. Del Vita, 'Lo Zibaldone di Giorgio Vasari', in *Il Vasari*, i, 1927–8, pp. 150–63) begins by describing the purpose of the room (see above) and continues: 'Però havea pensato, che tutta questa inventione fosse dedicata alla natura e all'arte, mettendoci statue che rapresentino quelli che furno o inventori, o cagioni, o (come credette l'antica poesia) tutori et preposti à tesori della natura. . . . Et perchè la natura ha per subietto, nelle sue operazioni, et effetti principalmente i quattro elementi, de' quali due sono come il corpo et le matiere di queste cose, che è la terra et l'acqua; gli altri due servono per efficienti et per operatori, che è l'aria et molto più il fuoco, essendo le facce quattro io ne accomoderei uno per ciascuna in quel miglior modo che si potessi. . . . Però farei così cominciandomi dalla Terra. In una faccia nelle due nicchie metterei la statua di Pluto, non quel fratello di Giove, ma un altro creduto da Poeti Dio della Ricchezza . . . Nell'altra la Terra o Ope che la si habbia a chiamare. . . . Per l'acqua metterei nelle nicchie due statue di donne perchè l'acqua è molto generativa. . . . Per la prima piglierei Venere in su la sua conca marina, con perle in mano. Nell'altra Amphitrite o altra ninfa marina, la qual vorrei da mezzo in giù pesce come sono le sirene con ambre et coralli in mano, che sono le gioie del mare. . . . Per l'aria pensavo di pigliare per la femina Giunone tenuta dagl' antichi signora dell'aria. . . . Per il mastio metterei il vento Borea, che sarebbe un giovane, con l'ale . . . et a lui dare in mano il cristallo, che si congela per il gran freddo. . . . Nell'ultimo per il foco metterei Apollo signor della luce, et del calore, un bellissimo giovane. . . . Nell'altra nicchia metterei Vulcano, per le miniere forti, come acciai, ferri, dove ha il principal luogo in operare, il fuoco . . . '

(So I conceive that the whole invention should be dedicated to Nature and Science, and should include statues representing those who were discoverers or causes, or (as the ancient poets believed) teachers and guides to the treasures of Nature. . . . And the matter used by Nature in its operations and actions consists above all of the four elements. Two of these are, so to speak, their substance and material, namely Earth and Water; the other two act as factors and agents, namely Air and more particularly Fire. And since there are four walls, I would allot one element to each in the best way possible. . . . Therefore, beginning with Earth, I should do it in the following way. On one side I should put in the two niches the statue of Pluto, not the brother of Jupiter, but another one of the same name, believed by the poets to be the god of Wealth. . . . In the second niche Earth, or Ope as she is called. . . . To stand for Water I should put two figures of women in the niches, because Water is very fruitful. . . . For the first I should take Venus on a sea-shell with pearls in her hand; in the second, Amphitrite or another sea-nymph, whom I should wish to be in the form of a fish from her waist down, as the Sirens are, and to have in her hand amber and coral, the jewels of the sea. . . . For Air I decided to take as the female representative Juno, who was considered by the ancients mistress of the Air. . . . As the male figure I should put the wind Boreas, who would be a youth with wings, and place crystal in his hand, since it solidifies with great cold. . . . On the last, representing Fire, I should put Apollo, master of light and warmth, a beautiful youth. . . . In the second niche I should put Vulcan, to stand for the hard metals such as steel and iron, in the working of which Fire is the main agent). In a further letter of 3 October 1570 Borghini expresses satisfaction that 'l'altezza del principe sia contento della inventione', and immediately after he appears to have received drawings of the intended statuettes. On these he commented on 5 October 1570 (Frey, op. cit. ii, No. DCCLVII, pp. 534–5) that the representation of Pluto was incorrect and that 'dove e quella statua di Zephiro, ha a esser' Borea . . . avertiteci presto rispetto a chi ha a far', che la persona di Borea è d'altra qualità che quella di Zephiro' (There should be a Boreas where the figure of Zephyr now is . . . let whoever is doing it know at once that the character of Boreas is different from that of Zephyr). With the exception of the Galatea, who is not represented as a mermaid, Borghini's instructions seem in general to have been complied with. It is clear from a later passage in Borghini's letter of 3 October 1570 that the disposition of the paintings in the Studiolo was determined by the placing of the statuettes. The ceiling of the Studiolo, painted by Poppi, shows in the centre Nature offering a piece of quartz to Prometheus, the first worker of precious stones. Above the four walls are paintings of the elements, Earth, Fire, Air and Water, with representations of the affinities and of the complexions of man (for this see L. Berti, *Il Principe dello Studiolo, Francesco I dei Medici e la fine del Rinascimento fiorentino*, Florence, 1967, pp. 61–83).

The eight statuettes (for the attributions of which see H. Keutner, 'The Palazzo Pitti Venus and other Works by Vincenzo Danti', in *Burlington Magazine*, c, 1958, p. 428 n.) are now set in their intended order, and are as follows:

East wall.

 Left niche. Pluto (Fig. 132) (Domenico Poggini) (signed DOMEN. POGGINI. F., executed between February 1572 and July 1573).

 Right niche. Ops (Fig. 131) (Ammanati) (executed between February 1572 and June 1573).

South wall.

 Left niche. Galatea (Fig. 133) (Stoldo Lorenzi) (completed August 1573).

 Right niche. Venus (Vincenzo Danti) (undocumented).

West wall.

 Left niche. Juno (Fig. 134) (Giovanni Bandini) (executed between February 1572 and August 1573).

 Right niche. Aeolus (signed 1573 L. FO. ELIAO. CANDDO FIAM. DI BRUGIA, for Elia Candido).

North wall.

 Left niche. Apollo (Plate 79) (Giovanni Bologna) (executed between December 1573 and April 1575).

 Right niche. Vulcan (Vincenzo de' Rossi) (executed by September 1572).

The statuettes (for the movements of which see D. Heikamp, 'Zur Geschichte der Uffizien-Tribuna,' in *Zeitschrift für Kunstwissenschaft*, xxvi, 1963, pp. 193–268, and 'La Tribuna degli Uffizi come era nel Cinquecento,' in *Antichità Viva*, iii, 1964, No. 3, pp. 11–30, superseding G. Poggi, 'Lo studiolo di Francesco I in Palazzo Vecchio,' in *Marzocco*, 11 December 1910) were set in place after their completion. In 1584 six of them were transferred to the Tribuna of the Uffizi, where, after 1587, they were shown on wooden bases designed by Buontalenti. The figures were restored to the Studiolo in 1910. The reddish patination of the bronze, typical of the studio of Susini, was added in the seventeenth century, and is not original. Incorrect attempts have been made to ascribe the Venus of Vincenzo Danti to Ammanati, and the Ops of Ammanati to Calamech, who left Florence in 1564. The Venus of Vincenzo Danti is mentioned by Pascoli ('una Venere in atto di rilegarsi le trecce').

GIOVANNI BOLOGNA
(b. 1529; d. 1608)

Giovanni Bologna or Jean Boulogne was born in Douai in 1529. An earlier birth-date (1524) recorded by Baldinucci is incorrect. According to Vasari and Borghini (both of whom must have depended upon information supplied by the sculptor himself) he was trained in the studio of Jacques Dubroeucq, and travelled to Italy for purposes of study probably about 1554. After two, years in Rome, on his return journey to Flanders he arrived in Florence (1556?), where he attracted the notice of Bernardo Vecchietti. His first Medicean commission for the stemma of Cosimo I on the Palazzo di Parte Guelfa, dates from 1558–9, and in 1560 he emerged from obscurity with the competition for the Fountain of Neptune in Florence (see Plate 74 above). Giovanni Bologna's work before this time is difficult to reconstruct. He has been credited with figures of David and Moses in Ste. Wautrude at Mons, and an alabaster figure of a kneeling Venus, formerly in the Lydig collection (untraced), must have been executed soon after he arrived in Florence. Baldinucci and other sources describe a figure of Venus carved for Vecchietti, which served to introduce the sculptor to Francesco de' Medici; this is possibly identical with the so-called Venus of the Grotticella (now set on a fountain in the Boboli Gardens), which is usually dated ca. 1572–3 but may have been produced at a far earlier time. To the period 1559–62 belong the Cortesi Bacchus (see Plate 80 below) and two fishing boys in the Museo Nazionale made for a fountain in the Casino Mediceo. A bronze figure of Florence on the Fountain of the Labyrinth at Petraia (Fig. 93), based on a model by Tribolo, dates from the same time, as does a bronze bust of Cosimo I in the Uffizi. Giovanni Bologna's first major work, the Fountain of Neptune at Bologna (see Plate 81 below), was begun in 1563 and completed in 1566. Concurrently he produced the earliest of his statuettes of Mercury (Museo Civico, Bologna, ca. 1563), which was later developed into a figure despatched in 1564–5 to the Emperor Maximilian II, and in 1580 into the so-called Medici Mercury in the Museo Nazionale, Florence. Small bronzes of the composition at Vienna and Naples date from 1575–9. Work on the Bologna fountain was interrupted by the gesso group of Florence triumphant over Pisa (1565), which was translated into marble in 1570 (Figs. 49–51), and was followed by the commissions from Francesco de' Medici for the Samson and a Philistine (see Plate 82 below) and from Cosimo I for the Fountain of Oceanus (see Plate 83 below). From the late sixties date the bronze birds (now in the Museo Nazionale, Florence) modelled for the grotto of the Villa Reale at Castello. In 1573–5 Giovanni Bologna executed the bronze Apollo for the Studiolo of Francesco de' Medici (see Plates 78, 79), which also exists in a bronze reduction and provides a firm point of reference for the dating of the sculptor's bronze statuettes. A figure of the Dwarf Morgante mounted on a Dragon, in the Museo Nazionale, cast for the garden on the roof of the Loggia dei Lanzi, dates from 1583–4. Giovanni Bologna's first major religious work, the Altar of Liberty in Lucca Cathedral (see Plate 84 below; 1577–9) was followed by commissions for the sculptures of the Grimaldi Chapel at Genoa (see Plate 87 below; 1579–85) and for the Salviati Chapel in S. Marco (see Plate 89 below; 1579–88). While engaged upon these works, he was also occupied with a secular subject, the Rape of the Sabines (see Plate 85 below). In the last decade of the century Giovanni

Bologna's efforts were directed to the equestrian statue of Cosimo I (see Plate 90 below), the Hercules and the Centaur in the Loggia dei Lanzi (see Plate 91 below), and to a number of religious works, the bronze statue of St. Luke on Or San Michele (1597–1602), the related marble statue of St. Matthew in the Museo dell'Opera del Duomo at Orvieto (carved by Francavilla from Giovanni Bologna's model in 1597–1600), two bronze angels carrying candlesticks in the Duomo at Pisa (1601), and his own funerary chapel in the Annunziata (1594–9), which includes versions of the Genoa Passion reliefs. The completion of the equestrian statue of Cosimo I gave rise to a number of similar commissions for mounted statues of Ferdinand I (1601–8) (Fig. 137), Henry IV of France (1604–11) (see Plate 95 below), and Philip III of Spain (1606–16), in which Giovanni Bologna's intentions were realised by Francavilla, Tacca and other sculptors. Giovanni Bologna died in Florence on 13 August 1608. An artist of great intellectual power, he was, after Michelangelo, the outstanding sculptor of his century, and though his sculptures, with few exceptions, were carved or cast in and for Florence, his style became a universal language through the small bronzes that were turned out in his studio. Giovanni Bologna is the only sixteenth-century Italian sculptor many of whose preliminary models survive; the most important nucleus of these, in the Victoria & Albert Museum, London, throws much light on the sculptor's creative processes.

BIBLIOGRAPHY: Study of Giovanni Bologna was dominated by a book by Desjardins (La vie et l'oeuvre de Jean Bologne, Paris, 1883) until 1936, when a thesis by Gramberg (Giovanni Bologna: eine Untersuchung über die Werke seiner Wanderjahre, bis 1567) opened a new phase of critical analysis. A more recent monograph by Dhanens (Jean Boulogne: Giovanni Bologna Fiammingo, Brussels, 1956) gives a thorough factual survey of the sculptor's works, and includes as appendices the texts of letters written to, by and about Giovanni Bologna, and the lives of the sculptor by Borghini and Baldinucci. Over and above the works cited below, reference may be made to the following books and articles. For Dubroeucq and Giovanni Bologna's Flemish sources and contemporaries see R. Hedicke (Jacques Dubroeucq von Mons, Strassburg, 1904), P. Champagne (Jacques du Broeucq, Charleroi, 1926), Devigne ('Le sculpteur W. D. van Tetrode, dit Guglielmo Fiammingo,' in Oud Holland, lvi, 1939, pp. 89–96), D. Roggen–J. Withof ('Cornelis Floris,' in Gentsche Bijdragen tot de Kunstgeschiedenis, viii, 1942, p. 79 f., ix, 1943, p. 133 f.) and E. Dhanens ('De Romeinse ervaring van Giovanni Bologna,' in Bulletin de l'Institut Historique Belge de Rome, xxxv, 1963, pp. 149–90). The best analyses of Giovanni Bologna's style are those of Kreigbaum ('Der Meister des "Centauro" am Ponte Vecchio,' in Jahrbuch der Preuszischen Kunstammlungen, xlix, 128, pp. 135–40, and 'Der Bildhauer Giovanni Bologna,' in Zur Florentine Plastik des Cinquecento, Munich, n.d.), Keutner ('Die Tabernakelstatuetten der Certosa zu Florenz,' in Mitteilungen des Kunsthistorischen Instituts in Florenz, vii, 1955, pp. 139–44; 'Der giardino pensile der Loggia dei Lanzi und seine Fontäne,' in Kunstgeschichtliche Studien für Hans Kauffmann, 1956, pp. 240–51) and J. Holderbaum ('A bronze by Giovanni Bologna and a painting by Bronzino,' in Burlington Magazine, xcvii, 1956, p. 439), and Giambologna, in I Maestri della Scultura, No. 13, Milan, 1966). For the fountains see Wiles (The Fountains of the Florentine Sculptors, Cambridge, 1933), and for the small bronzes Bode ('Gian Bologna und seine Tätigkeit als Bildner von Kleinbronzen,' in Kunst und Künstler, ix, 1911, pp. 632–40).

Plate 79: APOLLO
Palazzo Vecchio, Florence

See Plate 78 (above).

Plate 80: BACCHUS
Borgo San Jacopo, Florence

The Bacchus, which has been exhibited in its present position over a fountain at the corner of the Borgo San Jacopo and Via Guicciardini only since 1838, is identified (Kriegbaum) with a statue mentioned by Vasari ('E di bronzo ha fatto la statua d'un Baccho, maggior del uiuo, a tutta tonda'), which is stated by Borghini (1584) to have been made for Lattanzio Cortesi ('Fece per Lattantio Cortesi vn Bacco di bronzo di braccia quattro'). The figure was in Medici possession in 1597. It has been conjecturally dated ca. 1559 (Kriegbaum), ca. 1560 (Holderbaum), before 1562 (Dhanens), and ca. 1562–3 (Gramberg). The earliest of these datings is likely to be correct.

Plate 81: THE FOUNTAIN OF NEPTUNE
Piazza del Nettuno, Bologna

Giovanni Bologna's first major commission, the Fountain of Neptune (Fig. 94) is described in laudatory terms by Vasari: 'Il quale ha condotto con bellissimi ornamenti di metallo la fonte, che nuouamente si è fatta in sulla piazza di san Petronio di Bologna, dinanzi al palazzo de' Signori, nella quale sono, oltre gl'altri ornamenti, quattro Serene su canti bellissime, con varij putti attorno, e maschere bizarre, & straordinarie. Ma quello, che più importa, ha condotto, sopra e nel mezzo di detta fonte, un Nettuno di braccia sei, che è un bellissimo getto, e figura studiata, e condotta perfettamente' (He has executed with most beautiful bronze ornaments the fountain which has recently been set up in the Piazza di San Petronio at Bologna, in which there are four most beautiful Sirens at the corners, with various children round them, and bizarre and extraordinary masks. But what is more important, he has completed for a position above them in the centre of the fountain a Neptune six braccia in height, which is a most beautiful cast, and is perfectly studied and executed).

The fountain is also described by Borghini. The commission to Giovanni Bologna resulted from the competition for the Neptune fountain in Florence (see Plate 74 above), and he appears to have visited Bologna in connection with the fountain early in 1562. A contract for the structure of the fountain was signed on 2 August 1563 by Pietro Donato Cesi, Bishop of Narni and Vice-Legate in Bologna, with the Sicilian architect Tommaso Laureti, and immediately afterwards Laureti visited Florence to secure the services of Giovanni Bologna and the

bronze caster Zanobio Portigiani ('per andare a Firenze e tornare e per condurre seco a Bologna: Maestro Gio Bologna quale a gettare l'opera di Metallo che va alla fonte'). A contract between the Vice-Legate on the one hand and Giovanni Bologna and Zanobio Portigiani on the other was signed at Bologna on 20 August 1563. This provides for the making of 'una figura di bronzo di grandezza de piedi novi, quattro puttini coi loro vasi dalle quali deve uscire l'acqua d'altezza de piedi 3 perciascuno, e quattro Arpie d'altezza di tre piedi l'una o piu secondo la correspondenza della principal figura, quattro Armi, cioe quella di Sua S'ta, dell'Ill.mo Borromeo legato, del R.mo vicelegato predetto, et l'altra della Communita di Bologna.' The materials required for the figures were to be provided by the Vice-Legate, and Giovanni Bologna and Zanobio Portigiani were to receive jointly the sum of one thousand scudi. A 'modello piccolo de Nettuno' was completed by 31 December 1563, when a payment was made for the base, and in May 1564 this was submitted to Pope Pius IV. By mid-January 1565 the four harpies, the four dolphins, the coats-of-arms, swags and inscriptions, and certain other bronze components of the fountain had been cast and installed on the fountain, which was lacking the central figure of Neptune and the four putti. At this point Giovanni Bologna returned to Florence, and work on the fountain was discontinued until the spring of 1566, when on 11 May a new contract was signed, whereby Giovanni Bologna, with the consent of Francesco de' Medici, agreed to assume undivided responsibility for the casting of the remainder of the sculptures. The figure of Neptune was cast in August 1566, and was installed on the fountain on 16 December. Work was completed by 30 January 1567, when a letter was sent to Francesco de' Medici by the authorities in Bologna thanking him for Giovanni Bologna's services. The stages in the evolution of the central figure are recorded in a clay model in London, which has a Bolognese provenance, and in a bronze model in the Museo Civico at Bologna (H. 77 cm.).

Plate 82: SAMSON SLAYING A PHILISTINE
Victoria & Albert Museum, London

The earliest reference to the group occurs in Vasari's notes on Giovanni Bologna (1568): 'Il medesimo . . . ha . . . quasi condotto a fine al Signor Prencipe un Sansone, grande quanto il vivo, il quale combatte a piedi con due Filistei' (He has almost finished for the Prince a Samson, the size of life, who is fighting with two Philistines at his feet). It is described by Borghini (1584) and in greater detail by Baldinucci: 'Ebbe Gio. Bologna per lo Casino del Granduca Francesco a scolpire il gruppo del Sansone, che ha sotto il Filisteo; al quale fu dato luogo sopra la Fontana del Cortile de' Semplici, ove fece ancora bellissime bizzarrie di mostri marini, che reggevano la tazza. . . . Quella fonte poi fu dal Granduca Ferdinando mandata in dono al Duca di Lelma in Ispagna, insieme con un'altra, ov'era Sansone, che sbarra la bocca al Leone, fatta da Cristoforo Stati da Bracciano' (Giovanni Bologna was commissioned to carve for the Casino of the Grand-Duke Francesco the group of Samson with a

Philistine beneath him, which was accommodated on the fountain in the Cortile de' Semplici, where he made extremely beautiful fantasies of marine monsters supporting the basin. . . . The fountain was later sent by the Grand-Duke Ferdinando as a gift to the Duke of Lerma in Spain, along with another, showing Samson and the lion, made by Cristoforo Stati of Bracciano). The fountain by Giovanni Bologna was despatched to Spain in 1601. In 1623 the group of Samson slaying a Philistine (for which see Pope-Hennessy, *Catalogue of Italian Sculpture in the Victoria and Albert Museum*, ii, London, 1964, pp. 460–5) was presented by Philip IV of Spain to Charles, Prince of Wales, who in turn gave it to the Duke of Buckingham. When Buckingham House was acquired by George III as a palace in 1762, the group was presented by the King to Thomas Worsley, and before 1778 was installed at Hovingham. The basin and base of the fountain are now at Aranjuez. Two drawings after Giovanni Bologna in the Uffizi, Florence, show the group standing in the centre of the fountain. If the group was almost finished in 1568, it can hardly have been commissioned later than 1565, and was thus begun before the completion of the Fountain of Neptune at Bologna, and immediately after the gesso model of Florence triumphant over Pisa in the Accademia in Florence. There is some doubt whether the group was, from the first, intended as a fountain figure. Two letters written by Tommaso Inghirami to Francesco de' Medici in May and August 1569 seem to refer to the base, and the group must have been installed on the fountain in or after 1570. The companion fountain by Stati was carved in 1604–7, and was despatched direct to Spain.

Plate 83: THE FOUNTAIN OF OCEANUS
Boboli Gardens, Florence

The origin of the Fountain of Oceanus (Fig. 95) is described by Baldinucci: 'Aveva il Granduca in questo tempo fatto cavare nell'Elba uno smisurato sasso di granito per farne una gran tazza ad una fonte nel Giardino di Boboli, ed avuto a se Gio. Bologna, così gli parlò: Io ho fatto cavar questo sasso come tu vedi, per fare una bella fonte per lo Giardino; sia dunque tuo pensiero il fare essa fonte in modo, che la tazza faccia onore a te, e l'opere tue alla tazza; ond'egli messa mano all'opera, e condotta la tazza, invento un bellissimo piede, e sopra la medesima accomodò un' Essagono, con tre figure di marmo rappresentanti tre fiumi, che versano acqua nella tazza figurata per lo mare Oceano, e questi sono il Nilo, il Gange, e l'Eufrate, tutti in atto di sedere, che se fossero ritti, alzerebbersi sino a quattro braccia; e'l basamento adornò con bassi rilievi bellissimi di storie marittime. Nella più alta parte fece il Nettuno, che posando sopra angustissimo spazio si fa vedere per termine della fonte con maraviglia d'ogn'uno' (The Grand-Duke at this time had had excavated on Elba an exceptionally large block of granite destined to form the basin of a fountain in the Boboli Gardens. Sending for Giovanni Bologna he addressed him as follows: "I have had this block quarried as you see, in order to make a beautiful fountain for the garden; see to it that you design the fountain in such a way that the basin does honour to you and

your sculptures do honour to the basin." After carving the basin, Giovanni Bologna invented a very beautiful support, and on top of the basin he set a hexagon with three figures representing the three rivers which pour water into the basin representing the ocean. The rivers are the Nile, Ganges and Euphrates, all seated; if they were erect they would measure four braccia in height. He adorned the base with beautiful low reliefs of marine scenes. For the top he carved a Neptune, which is set on an extremely narrow base and so appears the terminal point of the fountain, to the wonder of everyone.) The quarrying of the granite block (which was from the first intended for a fountain 'per lo prato grande de' Pitti') by Tribolo in 1550 is described by Vasari. The granite for the basin reached Florence in 1567. Giovanni Bologna's design for the fountain appears to date from this year. A model was made in 1571, and from 1572 till 1575 there are payments for the marble for the figures and support. In May 1576 the fountain was fully installed outside the palace, where it is shown in a lunette by Justus Utens in the Museo Topografico (1599). In 1618 it was moved to its present position on the Isolotto of the Boboli Gardens. A drawing in the Ashmolean Museum, Oxford, inscribed in the sculptor's hand, shows the fountain with its original balustrade. The central figure is now replaced by a copy on the fountain, and is in the Museo Nazionale, Florence.

Plate 84: THE ALTAR OF LIBERTY
Duomo, Lucca

The so-called Altar of Liberty (Fig. 73) to the left of the high altar of Lucca Cathedral was dedicated in 1369 to celebrate the freedom regained by the city in that year. In 1577 it was decided that it should be replaced by an altar by Giovanni Bologna. The surviving documents (for which see E. Ridolfi, *L'arte in Lucca studiata nella sua cattedrale*, Lucca, 1882, pp. 53–4, and Dhanens, pp. 218–21) show that the decision to entrust the altar to Giovanni Bologna was taken on 23 January 1577 ('Fu deliberato che l'Operaro dovesse portarsi dalli magnifici signori, per pregarli a darli licenza di scrivere all'ambasciatore di Firenze per ottenere da S.A. di far venir qua per 8 giorni Mo. Giovan Bologna fiammingo, scultore, per conto dell'altare da farsi della Libertà in S. Martino') (It was decided the Operaro should go before the noble magistrates to beg leave to write to the Florentine ambassador with a view to persuading His Highness to send here the sculptor Giovanni Bologna, the Fleming, for eight days, on account of the Altar of Liberty which is to be made in S. Martino). On 19 March 1577 a model for the altar was submitted by Giovanni Bologna to the Opera del Duomo, and was approved, with the provision that its price should not exceed the sum of 2000 scudi. Work on the altar was completed by 19 February 1579, when it was inspected by the Consiglio dell'Opera, and full payment to the sculptor was authorised ('e al detto Operaro di sodisfare per lo intero di quello che resta havere il detto Mo. Giovanni secondo il contratto'). The statues on the altar appear to have been completed by this time, since simultaneous payment was made to a carpenter 'della sua mercede per il tempo di circa un mese che è

stato qui per conto dell' altar della libertà a mettere su le statue...' (as his salary for the period of about one month during which he has been here over the matter of the Altar of Liberty, erecting the statues). The figure sculpture on the altar comprises a central figure of Christ, lateral figures of SS. Peter (*left*) and Paulinus (*right*), two angels (*above*), and (*below*) a predella with a panorama of the city of Lucca. The iconography of the central figure of Christ as the Redeemer (which is related by Holderbaum to a painting by Bronzino in SS. Annunziata, Florence) is explained by an inscription above which reads: CHRISTO LIBERATORI AC DIVIS TVTELAIBVS. On the console beneath the central figure is the artist's name and date of completion:

IOANNIS BOLONII.

FLANDREN OPVS

A.D. MDLXXIX.

The Christ is an autograph work of high quality; the lateral figures, on the other hand, seem to have been executed in the main by Francavilla. As noted by Dhanens, both of the lateral figures look forward to similar figures in the Salviati Chapel in San Marco (see Plate 89 below). Baldinucci mistakenly implies that Giovanni Bologna undertook more than one figurated altar for the Cathedral ('Chiamato a Lucca, fecevi due Cappelle con alcune statue').

Plates 85, 86:
THE RAPE OF THE SABINES
Loggia dei Lanzi, Florence

The earliest reference to the composition known as the Rape of the Sabines occurs in a letter from Giovanni Bologna to Ottavio Farnese, Duke of Parma, of 13 June 1579: 'Havevo apunto compito et rinettato il groppo delle due Figure di bronzo che io promessi a V. Ecc. Ill.ma di volerli fare quin li mandaj il Mercurio e la Femina, et cosi fornitolo d'una basa di ebano, adorna d'alcune pietre, in due casse l'havevo gia consegnato al condottore, che per la strada ordinaria a Parma gliene conducesse.... Le due predette Figure che possono inferire il rapto d'Elena et forse di Proserpina o, d'una delle Sabine: eletto per dar campo alla sagezza et studio dell'arte sono alte ciascuna br(accio) 1½ inc.' (I have just completed and chased the bronze group of two figures which I promised your Excellency to prepare when I sent you the Mercury and the female figure. It has been supplied with an ebony base inlaid with stones, and has been handed over in two cases to the courier who is to take it to Parma by the normal route.... The aforesaid figures can be interpreted as the rape of Helen, or even as that of Proserpine, or as the rape of one of the Sabine women. The subject was chosen to give scope to the knowledge and study of art. The two figures are about one and a half braccia high). This bronze is now in Naples (Fig. 53). A second version is in the Kunsthistorisches Museum, Vienna. The intervening stages between the two-figure bronze group and the three-figure marble version are marked by two small wax models in London (Figs. 54, 55) and by a full-scale gesso model in the Accademia,

Florence. The group is mentioned in a letter of Simone Fortuna of 27 October 1581 as not yet complete ('presto uscira fuori un gruppo di tre statue a fronte della Iuditta di Donatello su la loggia de' Pisani'). According to the diary of Settimani the Judith of Donatello was removed from the Loggia dei Lanzi on 30 July 1582 to make way for the new statue, which was installed on 28 August ('Fu posto nel luogo dov'era la Giuditta in Piazza il miracoloso gruppo di tre statue di marmo fatto come si e detto da Gio Bologna ad imitazione di uno di quei giovani Romani, quando rubarono le vergini Sabine; ma furono fasciate e coperte per non essere ancora perfettamente ripulite: poi vi fu fatto dinanzi un muro, mattone sopra mattone, per poterle finire a suo piacere senza essere veduto da nessuno') (In the place where the Judith used to be there was set up the miraculous group of three figures made by Giovanni Bologna to represent one of those young Romans who stole the Sabine virgins. The figures were covered with straw as they were not yet fully polished, and later a wall was built round them, brick by brick, so that the sculptor could complete them at his convenience without being seen by anyone). The group was unveiled on 14 January 1583. It bears the signature OPVS IOANNIS BOLONII FLANDRI MDLXXXII. Further light is thrown on the genesis of the group by a celebrated passage in the *Riposo* of Borghini (1584). In the course of this Vecchietti explains that Giovanni Bologna 'avendo . . . nel fare molte figure di bronzo grandi, e piccole, ed infiniti modelli, dimostrato quanto egli fosse eccellente nell'arte sua, non potendo alcuni invidiosi Artefici negare, che in tali cose egli non fosse rarissimo; confessavano, che in fare figurine graziose, e modelli in varie attitudini con una certa vaghezza, egli molto valeva; ma che nel mettere in opera le figure grandi di marmo, in che consiste la vera scultura, egli non sarebbe riuscito. Perlaqualcosa Giambologna, punto dallo sprone della virtù, si dispose di mostrare al Mondo, che egli non solo sapea far le statue di marmo ordinarie, ma eziandio molte insieme, e le più difficili, che far si potessero . . . e cosi finse, solo per mostrar l'eccellenza dell'arte, e senza proporsi alcun' istoria, un giovane fiero, che bellissima fanciulla a debil vecchio rapisse, ed avendo condotta quasi a fine quest'opera maravigliosa, fu veduto dal Serenissimo Francesco Medici Granduca nostro, ed ammirata la sua bellezza, diliberò, che in questo luogo, dove or si vede, si collocasse. Laonde, perche le figure non uscisser fuori senz'alcun nome, procacciò Giambologna d'aver qualche invenzione all'opera sua dicevole, e gli fu detto, non so da cui, che sarebbe stato ben fatto, per seguitar l'istoria del Perseo di Benvenuto, ch'egli avesse finto per la fanciulla rapita, Andromeda moglie di Perseo, per lo rapitore Fineo zio di lei, e per lo vecchio Cefeo Padre d'Andromeda. Ma essendo un giorno capitato in bottega di Giambologna Raffaello Borghini, ed avendo veduto con suo gran diletto questo bel gruppo di figure, ed intesa l'istoria, che dovea significare, mostrò segno di maraviglia; del che accortosi Giambologna, il pregò molto, che sopra ciò gli dicesse il parer suo, il quale gli concluse, che à niun modo desse tal nome alle sue statue; ma che meglio si accomoderebbe la rapina delle Sabine; la quale istoria, essendo stata giudicata a proposito, ha dato nome all'opera' (By numerous large and small bronze figures and an infinite quantity of models Giovanni

Bologna had given proof of his excellence in his own art, so that even jealous artists were unable to deny that in such works his talent was exceptional. In making charming figures and models in different poses with great elegance, he was, they admitted, outstanding, but they claimed that he would not be successful in executing large marble figures, which were the essence of sculpture. For this reason Giovanni Bologna prepared to show the world that not only did he know how to make ordinary marble statues, but was able to carve a number together and the most difficult ones possible. . . . So solely to prove his excellence in his art, and without selecting any subject, he represented a proud youth seizing a most beautiful girl from a weak old man. When this marvellous work was almost finished, it was seen by our Grand-Duke Francesco de' Medici, who admired its beauty, and decided that it should be placed in the position it now occupies. Wherefore, since the figures could not be shown without a name, he urged Giovanni Bologna to find some invention for his work. The sculptor was told, I do not know by whom, that it would be a good thing to associate the story with the Perseus of Benvenuto, and that he might have intended the raped girl for Andromeda, the wife of Perseus, the youth seizing her for Phineus, and the old man for Cepheus the father of Andromeda. But one day when Raffaello Borghini chanced to go to the studio of Giovanni Bologna, and to his great delight saw this beautiful group and was told the story it was supposed to depict, he expressed surprise. Giovanni Bologna begged him insistently to express his own view, and he declared that in no circumstances should such a name be given to the statues, but that the subject of the Rape of the Sabines would suit them very well. This subject was deemed to be appropriate, and the name was accordingly given to the group). The bronze relief beneath appears to have been made in 1582-3.

Plates 87, 88: SCULPTURES FROM THE GRIMALDI CHAPEL
University, Genoa

The bronze sculptures by Giovanni Bologna and his studio now preserved in the Aula Magna and Chapel of the University of Genoa comprise:

(i) six figures of Faith, Hope, Charity, Fortitude, Prudence and Justice (H. ca. 175 cm.).

(ii) six recumbent figures of Angels (H. 40-50 cm.).

(iii) six Passion scenes (Christ before Pilate, the Flagellation, the Mocking of Christ, Ecce Homo, Pilate washing his Hands, and Christ carrying the Cross) (47×71 cm.) and a somewhat larger relief of the Entombment.

These works, with three bronze epitaphs and a bronze Crucifix (lost), formed the sculptural decoration of the Grimaldi Chapel in S. Francesco di Castelletto, Genoa. At the time of the French Revolution the church and convent of S. Francesco were secularised, the church proper being sold in 1802 and demolished in 1806. Giovanni Bologna's chapel was destroyed at this time, and at some time between this date and 1820, the sculptures

were moved to the University of Genoa. The sequence of work on the Grimaldi Chapel is attested by a number of documents. On 20 April 1579 Luca Grimaldi in a letter to Francesco I de' Medici (see Dhanens, p. 342) sought permission for Giovanni Bologna to visit Genoa ('Si bisogneria in questa citta dell'industria et della presenza di Gio. Bologna scultore et architetto di Vostra Altezza per qualche pochi giorni . . . et però la preghiamo a farci gratia di dar licenza al detto Gio. che possi venire qua per quindici giorni') (The skill and presence of Your Highness' sculptor and architect, Giovanni da Bologna, are needed in this city for a few days . . . and so we beg you to be pleased to give Giovanni leave to come here for a fortnight). The Grand-Duke sanctioned the visit in a letter to Grimaldi of 26 May 1579, provided that Giovanni Bologna first completed certain works he had in hand for the Grand-Duke ('ha fra mano alcune cose mie le quali però doverà haver finite fra pochi giorni et all'ora . . . gli concederò il venir da loro') (he has some things of mine in hand, but should have finished them in a few days, and then . . . I will let him come to you). On 10 June 1579 Grimaldi was notified by the Grand-Duke of the impending departure of Giovanni Bologna, and on 13 June 1579 Giovanni Bologna, in a letter to Ottavio Farnese, Duke of Parma, himself mentions his imminent visit to Genoa. A contract was signed by Grimaldi and Giovanni Bologna in Genoa on 24 July 1579 (for this see Dhanens, pp. 243–5). The principal points in this read as follows: 'In nomine Domini Amen: D. Ioannes Bologna scultor sereniss. Magni Ducis Etrurie: sponte etc. et omni modo etc. Promissit et promittit Magnif. D. Luce de Grimaldis filio quondam D. Francisci presenti et acceptanti etc. facere construere et fabricare in civitate Florentie infrascripta laboreria pro dicto Magnif. Luca et ejus nomine videlicet sex statuas aeneas scilicet Fidei, Spei, Caritatis, Iusticie, Fortitudinis et Prudentie, que statue esse debeant altitudinis palmorum septem pro qualibet statua. . . . Item sex tabulas aeneas super quibus sit impressa Passio D. N. Jesu Christi figuris quas appelant di basso rilievo repartita hoc modo videlicet in una quando ductus fuit ad Pilatum, in alia quando fuit flagellatus ad columnam, in alia quando imposuerunt ei coronam spineam, in alia quando presentaverunt eum populo dicendo Ecce homo, in alio quando Pilatus lavit manus coram populo et in alio quando D. N. portabat Crucem que sex tabule sint et esse debeant altitudinis palmorum duorum cum dimidio et latitudinis palmorum trium. . . . Item sex statuas aeneas Angelorum nudorum cum eorum alis pro illis apponendis super frontispicio trium tabullarum picture que esse debeant altitudinis palmorum quatuor in circa. . . . Item tres Epitaphios aeneos cum eorum ornamentis prout melius dicto D. Ioanni videbitur pro illis apponendis sub Icona et sub duobus quadris picture ab utroque latere altaris. . . . Et ipsa omnia laboreria statuarum tabularum angelorum et aliorum predictorum facere de illa pulchriori qualitate aeris coloris aurei et illiusmet qualitatis cujus est statua aenea raptus mulieris Sabine quam dictus D. Joannis trasmissit Sereniss. Duci Parme et Placentie et omnia quidem expolita et diligenter quam fieri possunt et in ipsis adhibere omnem ejus scientiam artem curam studium et diligentiam et ea facere finire et perficere intra annos quinque proxime venturos salvo tamen 'usto et legitimo impedimento quatenus a prefato Sereniss. Magno Duce Etrurie sibi non mandaretur in contrarium' (In the Name of Our Lord, Amen: Giovanni da Bologna, sculptor of His Highness the Grand-Duke of Tuscany, of his own free will etc. and in every way etc. has undertaken and undertakes to the noble Luca di Francesco Grimaldi in person and in full agreement etc. to make, construct and build in the city of Florence, on behalf of the said noble Luca and in his name, the following works: namely, six bronze statues, to wit, Faith, Hope, Charity, Justice, Fortitude and Prudence, the height of each of these statues to be 7 palmi. . . . Item, six bronze panels on which the Passion of Our Lord is to be engraved, with figures in what is known as bas-relief. They will be disposed in the following way: in one, His being led to Pilate; in another, His flagellation at the column; in another, the imposition of the crown of thorns; in another, His presentation to the people with the words 'Ecce homo'; in another, Pilate washing his hands in the presence of the people; in another, Our Lord carrying the cross. That is, six panels, and they are to be 2½ palmi high and 3 palmi broad. . . . Item, six statues of nude angels with wings, to put above the mouldings round three pictures, each to be about 4 palmi high. . . . Item, three bronze epitaphs, with ornaments as the said Giovanni may think best, to put under the altarpiece and the two pictures on each side of the altar. . . . And he undertakes to make the whole series of statues, panels, angels and the other things here stated out of that more beautiful quality of bronze of a gold colour, and of the same quality as the bronze statue of a Rape of a Sabine Woman which the said Giovanni sent to His Highness the Duke of Parma and Piacenza; to polish the whole as carefully as he can; to use on them all his experience, art, care, zeal and diligence; and to make, finish and complete them within the next five years, unless there is just and legitimate impediment, and as long as he is not instructed otherwise by His Highness the Grand-Duke of Tuscany).

The total fee to be paid to Giovanni Bologna for the sculptures of the chapel amounted to 4,200 scudi. On 27 July 1579 Luca Grimaldi wrote to the Grand-Duke to express his satisfaction at the result of his consultations with Giovanni Bologna: 'Gio. Bologna scultore di cui li giorni passati V. A. ci fece gratia venne et ha sodisfatta benissimo a quello che si desiderava ma sopravenendo il bisogno dell'industria et giudicio suo sopra certe capelle che si fabricano, si è trattenuto un poco più di quello che si credeva; ancora che l'opera ricercaria per qualche tempo di più la sua presenza per certi adornamenti o figure de dronzo che vi bisognano, hora egli se ne ritorna; et però ringratiando V.Al. del favore, la preghiamo ad havere per iscusato il suddetto Gio. del tempo trascorso, et insieme concedergli che possi comandare o dare ordine a quelle figure o adornamenti di bronzo che si hanno da fare per compimento delle capelle e con questo fine ci raccomandiamo all'Al. V. et le preghiamo felicità' (The sculptor Giovanni da Bologna, with whose presence Your Highness recently favoured us, came and has satisfied us fully in what was desired. But a need arose for his skill and judgement in the matter of some chapels which are being built, and he stayed a little longer than was anticipated. Though the work needs his presence rather longer on account of some ornaments or figures of bronze required in these, he is now returning. Thanking Your

Highness for your favour, we beg you to excuse Giovanni the extra time and also to let him supervise the figures or ornaments of bronze which are to be made to complete the chapels. With this we recommend ourselves to Your Highness and wish you good fortune). The Genoa commission is mentioned in a letter from Simone Fortuna to the Duke of Urbino of 27 October 1581 ('Egli ha tre o 4 giovani, uno fra gli altri che di già è in grado di molta eccellenza, et chi può havere delle cose di costui, fatte però col disegno di Gio. Bologna, si tien contento et aventurato, et di tal mano sono la maggiore parte delle statue c'hanno i particolari della città. Questo tale le farebbe, ma perchè anco esso è occupato molto et è di corto per andare a portare una sua opera a Genova, vorrebbe del tempo assai') (He has three or four young assistants, and one of them has already reached a very high standard of excellence. Whoever is able to obtain works by this one, though done to Giovanni da Bologna's designs, thinks himself fortunate and satisfied. Most of the statues owned by private citizens here are by him. He would do them, but because he too is very busy and is shortly going to take one of his works to Genoa, he would need a long time), and by Borghini (1584): 'Hoggi ha fra mano vna Cappella per Genoua, in cui vanno sei statue di bronzo, e sei historie di basso rilieuo' (At present he has in hand a chapel for Genoa, including six bronze figures and six scenes in low relief). There is no firm date for the completion of work in the Grimaldi Chapel, but this may have been finished in 1585. It is suggested by Holderbaum that a seventh relief, the Lamentation, was added in 1586. The completed chapel is described by Soprani (*Le vite de' pittori, scultori et architetti Genevosi e de' Forestieri che in Genova operarono*, Genoa, 1674, pp. 291–2). Baldinucci states that Giovanni Bologna's work at Genoa was carried out with the assistance of Francavilla; it is suggested by Dhanens that this results from confusion between the Grimaldi Chapel in S. Francesco di Castelletto and the Senarega Chapel in the Duomo at Genoa.

Wax sketch-models for three of the six Passion scenes (Christ before Caiaphas, Ecce Homo, and Christ led from Judgement) are in the Victoria and Albert Museum (for these see Pope-Hennessy, *Catalogue of Italian Sculpture in the Victoria and Albert Museum*, ii, London, 1964, pp. 469–72). A wax sketch-model for the Flagellation is in the Queensland Art Gallery, Brisbane (for this see Pope-Hennessy, in *Bulletin of the Victoria and Albert Museum*, ii, 1966, pp. 75–7).

Plates 89, 92: THE SALVIATI CHAPEL
S. Marco, Florence

The first reference to a chapel in the church of S. Marco in honour of St. Antoninus (canonised 1523) occurs in a letter of 11 March 1526 in which Cardinal Pucci notifies Fra Roberto da Gagliano of S. Marco of the determination of Pope Clement VII to embellish the tomb of his fellow-citizen and predecessor as Archbishop of Florence (Gori, *Descrizione della Cappella di S. Antonino*, 1728). Owing to lack of funds this project was not proceeded with. At a considerably later date it was resumed by Filippo Salviati (Richa), whose family were connected with St. Antoninus first through Bernardo Salviati (appointed by the

Saint one of the twelve Buonomini of the Nobile Compagnia di S. Martino) and second through Fra Francesco Salviati (a member of the community of S. Marco and founder of the convent of S. Vincenzo at Prato). After the death of Filippo Salviati, the project for a chapel in honour of the Saint was realised by his sons Averardo and Antonio. The circumstances of the commission for the construction and decoration of the Chapel are described by Baldinucci: 'Avendo i Frati Predicatori del Convento di S. Marco determinato di cavare dall' antico, ed umil luogo, dove per lo spazio di presso a centotrenta anni erasi conservato incorrotto il sacro Corpo di S. Antonino Arcivescovo di Fitenze, stato Religioso di quel Convento, il qual luogo era non molto lungi dal Coro, per collocarlo in altro più decorosamente, con ispesa però confacevole alle forze loro; quello spirito, che aveva eccitato in quei Padri tale sentimento, mosse altresì la volontà di due ricchissimi Gentiluomini, che furono Averardo, ed Antonio di Filippo Salviati, ad offerirsi di condurre a fine lor disegno, e così elessero Gio. Bologna a fare con suo disegno, e di suo scarpello, e getto la gran Cappella in essa Chiesa di S. Marco, celebre ormai per ornamento, e ricchezza in ogni luogo, affine di renderla più degna di conservare in se stessa tanta Reliquia, la quale finalmente agli 9. di Maggio del 1589, con solenne pompa, ed apparato, vi fu traslatata; cosa che rese più piena, e più gioconda la comune allegrezza, che fecesi in quel tempo nella Città di Firenze per le felicissime Nozze del Granduca Ferdinando Primo colla Sereniss. Madama Cristina di Lorena. In questa fece Gio. Bologna il bel getto della figura del Santo Arcivescovo giacente sopra la cassa, quattro Angeli maggiori di naturale, più bassi rilievi, e le belle statue di marmo, che vi si veggono coll'aiuto di Pietro Francavilla, come diremo nelle notizie di lui. Ma perchè di questa Cappella non pure il Padre Fra Tommaso Buoninsegni Frate di detto Ordine, con altri hanno ragionato, ma anche noi medesimi nelle notizie del Francavilla, e del Passignano, altro non è d'vopo il dirne qui' (The Preaching Brothers of the Convent of S. Marco decided to disinter the holy body of St. Antoninus, Archbishop of Florence and former brother of the Convent, from the old and humble place near the choir where it had survived incorrupt for nearly 130 years, in order to install it elsewhere in a more worthy manner and with an outlay consistent with their means. The same piety which had aroused this feeling among the Brothers impelled also two very wealthy gentlemen, Averardo and Antonio, the sons of Filippo Salviati to offer to carry through their plan. They chose Giovanni Bologna to design, carve and cast the large chapel in the Church of S. Marco, now famous for its decoration and richness throughout, to make it more worthy of the preservation of such relics. These were finally moved there with solemn pomp and spectacle on 9 May 1589; and this completed and enhanced the public rejoicing of that time in the city of Florence over the propitious wedding of Grand-Duke Ferdinand I and Cristina of Lorraine. For it Giovanni Bologna, with the help of Pietro Francavilla, as I shall describe in my account of the latter, made the fine cast of the figure of the Sainted Archbishop lying on the coffer, four angels over life-size, several low-reliefs, and the fine marble figures there. But as this chapel has been discussed not only by Fra Tommaso Buoninsegni, Brother of the Order, and

by others, but also by myself in my accounts of Francavilla and Passignano, there is no need for me to say more about it here). Giovanni Bologna's plans for the as yet uncompleted chapel are described in a letter of 27 October 1581 from Simone Fortuna to the Duke of Urbino: 'ha le mani in mille cose, non solo per il gran Duca et la G. Duchessa (che gli hanno accresciuto la provisione a 50 scudi il mese) ma di consenso di lor Altezze fa la capella de' Salviati in S. Marco, dove va 'l corpo di S. Antonino, la cui spesa passerà 40000 Scudi, et è molto inanzi: et egli vi ha l'humore terribilmente per la gloria' (He has a thousand things in hand, not only for the Grand Duke and Grand Duchess, who have put up his salary to 50 scudi a month, but also the making, with Their Highness' consent, of the Salviati Chapel in S. Marco, where the body of St. Antoninus is going; it will cost more than 40000 scudi and is well advanced. He is extremely anxious to win glory in this work). They are mentioned again in 1584 in the *Riposo* of Borghini. The construction and decoration of the Chapel was undertaken between 8 January 1579, when space for the chapel was conceded to the Salviati (who agreed also to build a second chapel opposite dedicated to St. Dominic in substitution for a chapel of the Martini family scheduled for destruction) and 9 May 1589, when, under the direction of Cardinal Alessandro de' Medici, the future Pope Leo XI, the Saint's body was moved to its new resting place. Supervision of the construction of the Chapel was entrusted to Benedetto Gondi. The figure sculpture in the Salviati Chapel (Fig. 75) comprises: (i) six marble statues in niches representing (*left wall*) SS. Dominic and Edward, (*altar wall*) SS. John the Baptist and Philip, and (*right wall*) SS. Anthony the Abbot and Thomas Aquinas; (ii) six bronze narrative reliefs set in the walls above the niches, and representing (*left wall*) the Clothing of St. Antoninus by the Blessed Giovanni Dominici and St. Antoninus giving Alms, (*altar wall*) St. Antoninus preaching to the People of Florence and the Entry of St. Antoninus as Archbishop, and (*right wall*) St. Antoninus reconciling the Signoria and St. Antoninus raising a Child of the Filicaia Family (Fig. 88); (iii) (*above the altar*) a bronze Angel and two bronze Putti; (iv) (*on the altar*) a gilt bronze Crucifix; (v) (*originally beneath the altar, since 1710 in the Sacristy*) the bronze effigy and marble sarcophagus of St. Antoninus, and (vi) (*over the entrance of the chapel*) a marble statue of St. Antoninus. So far as concerns the authorship of individual sculptures, it may be noted that Baldinucci, in his life of Francavilla, states that all six marble figures were carved by Francavilla from models by Giovanni Bologna. The two statues on the altar wall (SS. John the Baptist and Philip) are superior in conception to the other four (Kriegbaum), and for both of these models by Giovanni Bologna seem to have been employed. An autograph bronze reduction by Giovanni Bologna of the St. John the Baptist (H. 66 cm.) exists in S. Maria degli Angiolini. The six bronze reliefs appear to have been executed with the assistance of Antonio Susini, but have also been assigned to Francavilla (two reliefs, Venturi; six reliefs, Brinckmann). On the strength of a payment made to Antonio Susini on 22 July 1581 'per avere formato una storia de bassorilievo da farsi di bronso a Salviati' recorded in the account book of Fra Domenico Portigiani (see Dhanens, p. 256) two of the

reliefs (the Clothing of St. Antoninus and St. Antoninus giving Alms) have been ascribed by Kriegbaum to Antonio Susini. There is some doubt as to the applicability of this payment to the Salviati Chapel reliefs, and all six narrative scenes appear to depend from models by Giovanni Bologna. The intervention of Adriaen de Vries has been postulated in the three bronzes above the altar (Dhanens), as has that of Hans Reichel (Brinckmann). The Crucifix, the effigy of St. Antoninus and the Angel over the altar are autograph works by Giovanni Bologna.

Plate 90:

EQUESTRIAN MONUMENT OF COSIMO I
Piazza della Signoria, Florence

On 27 October 1581 Simone Fortuna, in a letter to the Duke of Urbino (Dhanens, pp. 345–6) mentions among the works on which Giovanni Bologna is engaged a horse for the Piazza della Signoria: 'In molte altre opere ha le mani, tutte d'importanza et presto uscirà fuori . . . un cavallo Traiano, che getta di bronzo, due volte grande quanto quello di Campidoglio, a fronte del gigante di Mich. Agnolo' (He has many other works in hand, all of them important; and there will soon leave his workshop . . . a 'Trajan' horse which he is casting in bronze, twice as large as the one in the Campidoglio, to stand opposite the colossal figure by Michelangelo). It is possible that this reference is to an early project for an equestrian monument to Cosimo I. The recorded history of the monument, however, goes back only to 1587 when, according to Baldinucci (who states that in this year Ferdinando I ordered 'il fare gli studj per lo Cavallo di bronzo lungo sette braccia, sopra cui doveva essere la statua di Cosimo Primo lor padre, per collocarlo in piazza') (studies made for the bronze horse, 7 braccia long, upon which is to be the statue of Cosimo I, their father, to be put in the Piazza) and Galluzzi (*Istoria del Granducato di Toscana sotto il governo della casa Medici*, 1781, iii, p. 287), who writes: 'Questo eccellente Scultore . . . fino dai sedici Dicembre 1587 fu impiegato da Ferdinando per erigere al Gran Cosimo con la direzione di Bernardo Vecchietti una statua equestre di bronzo, monumento eterno della virtù di quel principe, della gratitudine del figlio, e della sublimità dell'artefice') (This excellent sculptor was commissioned by Ferdinand from 16 December 1587 to erect, under the direction of Bernardo Vecchietti, a bronze equestrian statue to the great Cosimo – a permanent monument to the virtue of that Prince, to the gratitude of his son, and to the sublime talent of the artist). Baldinucci states that 'a questa nobilissima faccenda s'applicò a tutto suo potere l'Artefice; e perch'egli è proprio di quei che sanno, il non fidarsi di loro stessi, ma dar volentieri orecchio all'altrui parere, egli comunicato suo pensiero col gran Pittore Lodovico Cigoli, e con Goro Pagani, fecene loro far disegni, de' quali più d'uno n'è in varj tempi pervenuto sotto l'occhio nostro' (The artist applied himself to this noble undertaking with all his powers; and because he is the sort of person who has no self-confidence, but willingly takes advice from others, he consulted the great painter Lodovico Cigoli and Goro Pagani, and had them do designs for it. At various times I have seen several of these).

Baldinucci indicates elsewhere that Giovanni Bologna made extensive use of the services of Antonio Susini in the preparation of this work: 'Venutagli poi l'occasione di fare il Cavallo colla Statua di Cosimo Primo, che poi fu messo in Piazza del Gran Duca, si servì del Susini per condurre i Modelli, le Forme, e il Getto, ed anche a rinettare, poi al metterlo in opera, che tutto sì bene esercitò sua parte, che non venne poi occasione qualunque ella si fusse, che Gio. Bologna non lo facesse del continuo operare, posando sopra di lui la maggior parte del pensiero' (When the opportunity came to him of making the horse and the statue of Cosimo I, later put in the Piazza of the Grand Duke, he made use of Susini in carrying out the models, moulds and casting, and in polishing it and working it up. He performed his part so well in every way that on every subsequent occasion, whatever it was, Giovanni Bologna had him work on it continuously, putting the greater part of the responsibility on him). From documents published by H. Semper ('Dokumente über die Reiterstatue Cosimo's I von Giovanni Bologna', in *Jahrbücher für Kunstwissenschaft*, ii, 1869, pp. 83–7) and J. Del Badia (*La Statua Equestre di Cosimo I: documenti inediti*, Florence, 1868), it is known that on 27 September 1591 casting preparations were in progress under the direction of Giovanni Alberghetti. At this time 39,239 libri of casting material had been assembled, and eighteen workmen were employed. On 28 September 1591 all of the metal had been 'condotto in bagno', and the casting of the horse in a single piece was presumably completed forthwith. When weighed on 6 May 1594, the horse weighed 15,438 libri and the rider 7,716 libri. According to the *Diario* of Lapini, excavation of the ground on the intended site of the statue began on 6 November 1591. On 5 December 1591 the foundations of the base were laid ('et io scrittore essendo presente, nel detto fondamento, gittai tre sassi'). On 11 June 1594 'si pose il cavallo di bronzo in su la basa di Piazza', and on 5 June 1595 'si scoperse la bella e maravigliosa statua del serenissimo gran duca Cosimo a cavallo'. Work on the three reliefs for the base seems to have been undertaken after this time. A letter of 26 May 1596 from Seriacopo to the Opera del Duomo at Orvieto (Dhanens, p. 361) mentions that 'havendo M. Gio. Bologna condotto il centauro molto innanzi se n'andò alla villa circa un mese fa per essere libero in finire una storia che restava per la basa del cavallo. . . . E certo che questa istoria et centauro l'avevanno troppo ingombrato l'animo e la mente' (Master Giovanni Bologna, having progressed far with the Centaur, left for the villa about a month ago, so that he would be free to finish a scene which remained to be done for the base of the horse. . . . There is no doubt that this scene and the Centaur have been weighing too heavily on his mind and spirit). Giovanni Bologna, in a letter to Seriacopo of 4 April 1598, mentions preparations for the casting of the narrative reliefs, and on 16 May 1598 payment for work on the reliefs was made to Francesco di Girolamo della Bella, Pietro Tacca, Guasparre di Girolamo della Bella and other sculptors. A payment of 24 April 1599 related to two bronze shields of arms for the base of the statue. The three reliefs represent (*north side*) the Coronation of Cosimo I as Grand-Duke (inscribed OB ZELVM REL. PRAECIPVVMQ, JVSTITIAE STVDIVM), (*south side*) Cosimo I triumphant over Siena (inscribed PROFLIGATIS HOSTIB. IN

DEDITIONEM ACCEPTIS SENENSIBVS), and (*east end*) Cosimo I accepted by the Senate as Duke of Tuscany (inscribed PLENIS LIBERIS SEN. FL. SVFFRAGIIS DVX PATRIAE RENVNTIATVR). The third of these reliefs (Fig. 89) is an autograph work by Giovanni Bologna. On the west end is the inscription:

COSMO MEDICI MA
GNO ETRVRIAE DVCI
PRIMO. PIO. FELICI. IN
VICTO. IVSTO. CLEMEN
TI. SACRAE MILITIAE
PACISQ. IN ETRVRIA
AVTHORI. PATRI ET
PRINCIPI OPTIMO
FERDINANDVS F. MAG.
DVX III. EREXIT AN.
MDLXXXXIIII.

(To Cosimo Medici, first Grand-Duke of Tuscany, god-fearing, fortunate, unconquered, just and merciful, promoter of holy war and of peace in Tuscany: Ferdinand, his son and third Grand-Duke, erected this to his excellent Prince and father. 1594).

At least since the time of Bode ('Gian Bologna und seine Tätigkeit als Bildner von Kleinbronzen', in *Kunst und Künstler*, ix, 1911, pp. 632–40) a bronze equestrian statuette of Cosimo I in the Museo Nazionale, Florence, has been accepted as a model by Giovanni Bologna for the large statue. This statuette is tentatively connected by Dhanens with the project of 1581. The connection with the present statue and with Giovanni Bologna is very slight, and the bronze seems to have been produced by an artist in the circle of Baccio Bandinelli. A wax model for Giovanni Bologna's horse is stated by Venturi (X-iii, p. 766) to exist in a Florentine private collection. A bronze anatomical horse formerly in the Loeser collection and now in the Palazzo Vecchio is identified by Dhanens (pp. 278–9) as a study made in connection with the large statue.

Plate 91: HERCULES AND THE CENTAUR
Loggia dei Lanzi, Florence

Giovanni Bologna's group of Hercules and the Centaur was begun in 1594 as the result of a visit paid by the Grand-Duke Ferdinand I to the sculptor's studio, which is described by Baldinucci: 'Trovasi nell'altra volta notato libro di memorie, e ricordi del 1594, del Provveditore delle Fortezze il Cap. Gio. Batista Cresci, come essendo un giorno il Granduca andato a suo diporto alle stanze di Gio. Bologna a Pinti, ed anche per vedere un bel Crocifisso di bronzo fatto da lui medesimo, che poi quell' Altezza donò al Duca di Baviera, risolve, che si facesse un'Ercole in atto d'ammazzare il Centauro; e nel tempo stesso comandò, che fosse spedito a Mess. Jacopo Piccardi a Carrara per negoziare il prezzo d'un marmo d'altezza di sopra cinque braccia, che dovesse servire al nostro Artefice per formarvi essa statua. Il tutto fu dal Piccardi eseguito con ispesa di dugento ducati nel marmo condotto a marina, cinquanta per

farlo bozzare al modo degli scarpellini, e di centodieci per condurlo in Firenze. Aplicatosi Gio. Bologna di gran proposito al lavoro della bellissima statua, con l'aiuto del Francavilla, come diremo a suo luogo, diedela finita, e fuori di stanza agli 19. di November del 1599. . . . Questa per certo fu una delle più maestrevoli opere, che formasse mai lo scarpello di Gio. Bologna' (In the volume of ricordi of 1594 of the Provveditore of the fortresses, Giovanni Battista Cresci, already referred to, it is described how the Duke, on a visit to the studio of Giovanni Bologna in the Borgo Pinti to inspect a beautiful crucifix which His Highness later gave to the Duke of Bavaria, decided that Giovanni Bologna should carve a Hercules in the act of killing the centaur. Forthwith he gave instructions that messer Jacopo Piccardi at Carrara should negotiate the price of a marble block over five braccia in height, from which the group was to be carved. Piccardi carried out his instructions, spending two hundred ducats on the transport of the marble to the sea, fifty on having it roughly blocked out, and a hundred and ten to bring it to Florence. Giovanni Bologna, aided by Francavilla, applied himself with great concentration to work on this beautiful statue, and it left his studio in a finished state on 19 November 1599. . . . Certainly this was one of the most masterly works that the chisel of Giovanni Bologna ever carved.) According to Settimani, the group was exhibited on its plinth at the Canto dei Carnescchi on 24 December 1599. On the centaur is the artist's name and the date 1600 (IOANES BOLOGNA BELGIA EA MDC.). The close attention given by Giovanni Bologna to this work is attested by a number of letters. Thus on 5 April 1596 Seriacopo reported to the authorities at Pisa that Giovanni Bologna was not prepared to undertake reliefs for the new doors of the Cathedral 'massime non havendo altro ne l'animo che il centauro'. On 26 May 1596 the same source reported that 'havendo M. Gio. Bologna condotto il centauro molto innanzi se n'andò alla villa circa un mese fa per essere libero in finire una storia che restava per la basa del cavallo' (the statue of Cosimo I). Finally, on 3 March 1597 Giovanni Bologna himself states that 'il Centaura va inanzi alegramente'. Though the group was not begun till 1594, the theme had occupied the sculptor at least since 1576, when he received silver for a small group of this subject. Intervening stages in the development of the scheme are marked by a wax model in the Victoria & Albert Museum, London, the reverse of a medal of Ferdinand I of 1587-8, and a small bronze of which examples exist at Genoa and elsewhere.

GIOVANNI CACCINI
(b. 1556; d. 1612-3)

Born on 24 October 1556, Giovanni Caccini was trained as an architect under Dosio. His earliest sculpture is the statue of San Giovanni Gualberto in the Badia at Passignano (1578). About 1584 he carved the statues of SS. Zenobius and Bartholomew in the Carnesecchi Chapel in S. Maria Maggiore, Florence. At this time and later he was also active as a restorer of antiques. His best known statues are in the Strozzi Chapel of S. Trinita (after 1606) and on the Ponte S. Trinita in Florence (Summer and Autumn). Four statues of Saints commissioned in 1593 for the Certosa di S. Martino at Naples were begun in 1609 and were left incomplete at the sculptor's death. Caccini's most substantial commissions are those for the reliefs on the central door of Pisa Cathedral (see Plate 93 below), the choir balustrade, high altar and ciborium of Santo Spirito (after 1590), and the loggia in front of the Annunziata (1601-4). One of the most popular portrait sculptors of his time, he executed statues of members of the Medici family for the Sala del Consiglio of the Palazzo Vecchio (1592-5) and many portrait busts, of which a bust of Baccio Valori in the Museo Nazionale, Florence, is representative.

BIBLIOGRAPHY: A good account of Caccini's career is given by Sobotka in Thieme Künstlerlexikon (v, 1911, pp. 336-8). The only available corpus of reproductions of works by Caccini is in the Storia of Venturi (X-iii, pp. 792-816).

Plate 93: THE ANNUNCIATION
Duomo, Pisa

The doors cast by Bonanno for the Porta Regia of Pisa Cathedral were destroyed by fire in 1595. Such parts of them as survived appear to have been melted down, and the bronze, to a total weight of 12760 libbre, was made available for the making of new doors. The doors (for which see I. B. Supino, 'Le porte del Duomo di Pisa', in *L'Arte*, ii, 1899, pp. 373-91, and Tanfani-Centofanti, *Notizie di artisti tratte dai documenti pisani*, Pisa, 1897, pp. 155-76) were commissioned by the Deputati of the Cathedral from Raffaello Pagni, the architect of the Grand-Duke, and the casting, on the suggestion of Girolamo Seriacopo, provveditore delle fortezze di Firenze, was entrusted to the Dominican Fra Domenico Portigiani. Three drawings by Pagni for the doors survive in the Uffizi (Nos. 114, 115 and 116). One of these provides for a door with four oblong scenes in each wing, and was adopted, with some modifications, for the central door of the Cathedral. A second shows three upright scenes in each wing, and was adopted for the two lateral doorways. The third, which is not related to the doors as executed, shows two irregular scenes in each wing. On 26 March 1597 a payment was made to Andrea di Michelangelo Ferrucci for

making two wax models of the doors for submission to Fra
Domenico Portigiani. Prior to this time difficulties appear to
have arisen with Portigiani over the price of the three doors, the
Deputati offering 1900 scudi and Portigiani, with the support
of Giovanni Bologna, insisting upon 2,300. A sum of 2,200
scudi was eventually agreed. It appears originally to have been
intended by Portigiani that the six reliefs modelled by Giovanni
Bologna for the Holy Sepulchre at Jerusalem should be used
again for the Pisa doors, but owing to the large size of the doors
this proved unpractical. On 23 March 1595 Seriacopo reported
to the Deputati that he was attempting to secure narrative scenes
from Giovanni Bandini, but nothing came of this proposal. At
this time it was also hoped that reliefs would be contributed by
Giovanni Bologna, and that Giovanni Bologna would super-
vise work on the doors. On 2 March 1596 Seriacopo writes to
the Deputati: 'Spero che fra tutte le storie ce ne sara sei di mano
di Giovanni Bologna, e l'altre saranno riviste e ridotte mediante
il suo consiglio' (I hope that six of the scenes will be from the
hand of Giovanni Bologna, and the others will be revised and
retouched with his advice). Portigiani, on the other hand, at the
same date held out the hope that Giovanni Bologna would
execute two reliefs. A month later these hopes began to recede,
and Seriacopo reported that 'non apparisce che messer Giovanni
Bologna faccia di sua mano le storie, ma sipotrà credere che la
maggior parte, o forse tutte sieno come fatte da lui' (It seems that
Master Giovanni Bologna will not be doing the scenes with his
own hand, but one can suppose that most, or perhaps all, may
be as if they were done by him). On 5 April 1596, however,
Giovanni Bologna 'persiste nel suo proposito di non voler
mettere mano nelle cose di altri, massime non havendo altro ne
l'animo che il centauro, di sorte che l'altre cose vi hanno poco
luogo' (persists in his intention not to touch others' things,
particularly because he has nothing but the Centaur in his mind,
so that other things have little place there). The narrative
scenes were then allocated to other sculptors (see below), and
on 22 April 1596 a contract was signed with Portigiani whereby
the three doors were to be completed in two years. On
5 October 1596 Portigiani reported that two narrative scenes
had been cast and returned to Caccini for cleaning and chasing,
and that another would be moulded on Monday and cast the
following day. Work was also in progress on the foliated
frieze. Rapid as was this advance, the Deputati were dissatisfied.
At the death of Portigiani (5 December 1602) a report was
prepared showing that approximately half of the work on the
doors was complete. In this Christ's Entry into Jerusalem, the
Flagellation, the Mocking of Christ, the Coronation of the
Virgin and the Arrest of Christ are entered as 'storie finite e
ricotte da gettare', the Nativity and Purification appear as
'storie interate e armate di ferro da una banda', the Adoration
of the Magi and the Temptation were 'interate senza armare',
and the Annunciation, Christ carrying the Cross and the Agony
in the Garden were those 'che non e cavato la cera'. An inspec-
tion of the pieces was made by Pietro Tacca and Antonio
Susini, on behalf of the Deputati, and control of the work was
then handed over to Angiolo Serani, a pupil of Giovanni
Bologna, by whom it was brought to completion.
The scenes on the three doors are disposed as follows:

CENTRAL DOOR. (Fig. 90).
Left wing (*bottom to top*).
 The Birth of the Virgin (Giovanni Caccini; payment of
 12 May 1599 for wax relief).
 The Marriage of the Virgin (Giovanni Caccini; payment
 of 5 May 1600).
 The Visitation (Pietro Francavilla; letter of Francavilla,
 quoted by Supino).
 The Assumption (Giovanni Caccini; payment of 5 May
 1600. Perhaps remade by Angiolo Serani).

Right wing (*bottom to top*).
 The Purification of the Virgin (Giovanni Caccini; payment
 of 8 June 1599 for wax relief).
 The Annunciation (Giovanni Caccini; payment of 17 July
 1599).
 The Presentation in the Temple (Gaspare Mola; consigned
 to Portigiani 5 November 1599).
 The Coronation of the Virgin (Orazio Mochi; consigned to
 Portigiani 9 February 1600. Perhaps remade by Angiolo
 Serani).

LEFT DOOR. (Fig. 91).
Left wing (*bottom to top*).
 The Nativity ('Ansi Tedesco,' probably Hans Reichel; pay-
 ment **not** transcribed. Previously allocated to Giovanni
 Catesi).
 The Temptation of Christ (Giovanni Catesi; payment not
 transcribed).
 The Raising of Lazarus (Francesco della Bella; payment of
 13 March 1601 for unspecified narrative scene identified by
 elimination as present relief).

Right wing (*bottom to top*).
 The Adoration of the Magi (Pietro Tacca; payment of
 1601 not transcribed. Previously allocated to Giovanni
 Catesi).
 The Baptism of Christ (Pietro Francavilla; payment of
 17 July 1601. Previously allocated to Raffaello Fortini;
 payment of 30 September 1600).
 Christ's Entry into Jerusalem (Giovanni Catesi; payment not
 transcribed).

RIGHT DOOR.
Left wing (*bottom to top*).
 The Agony in the Garden (Gregorio Pagani; Baldinucci.
 Consigned to Portigiani 25 November 1600. Payment of
 10 May 1601).
 The Mocking of Christ (Gregorio Pagani; Baldinucci.
 Consigned to Portigiani 10 May 1601. Payment of 10 May
 1601).
 Christ carrying the Cross (Pietro Francavilla. Payment of
 21 July 1601).

Right wing (*bottom to top*).
 The Arrest of Christ (Pietro Francavilla. Payment of 10 Nov-
 ember 1601).
 The Flagellation (Gregorio Pagani; Baldinucci. Consigned
 to Portigiani 12 December 1600. Payment of 10 May 1601).
 The Crucifixion (Gaspare Mola. Payment not transcribed).

Responsibility for the execution of the decorative parts of the doors cannot be apportioned with any confidence. It may be noted, however, that payments were made to Caccini for eighteen unspecified figures, twelve in niches and six on 'cartelle', which correspond with the figures of prophets on the central door; to Orazio Mochi for four figures of Apostles for the left door (SS. Thomas, James, Philip and Bartholomew), parts of the foliated frieze, eight vases, four with roses and four with cedar, four 'imprese, due d'un cane ed un lupo e due di testuggini', and four niches, to Angelo Scalani for parts of the foliated frieze, four 'imprese, due d'una civetta et una grua, et dua di due oriuoli per la porta maggiore', four vases of pomegranates for the central door, sixteen niches for the lateral doors, and eight animals for the top and bottom of the lateral doors 'uno rinoceronte, uno cervio, un'aquila, un cigno, un ariete, un vitello et una vitella', to Angiolo Serani for parts of the foliated frieze for the lateral doors, to Pietro Rutinesi for parts of the foliated frieze, to Antonio Susini for eight figures on the right door (four Apostles, two Evangelists, and SS. Thomas and Bonaventure), and to Raffaelle Fortini for four figures of Apostles at the top of the left door (SS. Peter, Andrew, James and John; models apparently rejected).

The symbolism of the imprese represented above and below the narrative reliefs is discussed by H. W. von Erffa ('Das Programm der Westportale der Pisaner Doms,' in *Mitteilungen des Kunsthistorischen Institutes in Florenz*, xii, 1965–6, pp. 55–106). Above the Annunciation is the emblem of an open mussel with a pearl (for this see *Dell'Imprese di Scipion Bargagli gentil'huomo Sanese*, Venice, 1594) and the words RORE COELESTI FOECUNDOR.

When the first door was completed, an attempt was made to divert it to the Duomo in Florence, on the ground that at Pisa 'non sara visto da nessuno', but on 10 January 1603 it was drawn by twelve yoke of oxen to Ponte a Signa and shipped to Pisa. By December 1603 one of the lateral doors was finished, and of the last door thirteen pieces of frieze, four small figures and one narrative scene alone remained to be cast. In March 1604 the third door was also finished. At this point the Deputati offered a sum of 200 scudi to Serani. On 10 March 1604, however, a committee was appointed by the Grand-Duke to report on the doors, and this raised the remuneration to 500 scudi. A minimum figure of 460 scudi was eventually agreed by the Grand-Duke.

PIETRO FRANCAVILLA
(b. 1546?; d. 1615)

Born at Cambrai between 1546 (Baldinucci 1548) and 1553 (date on an engraved portrait by Pieter de Jode), Franqueville or Francheville, after a brief period in Paris, moved to Innsbruck (1566), where he worked for five or six years. Here he attracted the notice of the Archduke Ferdinand of Tirol, by whom he was sent to Italy (1571?) to study with Giovanni Bologna. He rapidly became Giovanni Bologna's principal assistant, travelling with him to Genoa in 1579, and assisting him in the carving of the Rape of the Sabines (see Plate 85 above), the marble statues of the Salviati Chapel (see Plate 89 above), and other works. A letter of 1582 from Simone Fortuna states that Francavilla 'non ha mai fatto nulla di suo cervello, lavorando sempre i modelli di Giovanni Bologna' (has never produced anything from his own brain, but has always executed Giovanni Bologna's models). It is debatable how far this is a correct statement of fact. As early as 1574 Giovanni Bologna transferred to Francavilla the commission for garden statues for the villa of Abate Antonio Bracci at Rovezzano (now at Kew Gardens, Windsor Castle, and the Wadsworth Atheneum, Hartford); one of these, the Apollo, is adapted from the Apollo of Giovanni Bologna in the Studiolo of the Palazzo Vecchio, but there is no reason to postulate the existence of models by Giovanni Bologna for the remaining statues. It has been wrongly suggested that the models for Francavilla's statues in the Niccolini Chapel (see Plate 94 below) are by Giovanni Bologna. In Genoa Francavilla executed

two colossal figures of Jupiter and Janus for the Palazzo Grimaldi (signed and dated 1585), and six statues for the Senarega Chapel in the Duomo. Two cartapesta figures made for the decoration of the Duomo façade on the occasion of the marriage of Ferdinand I and Cristina of Lorraine in 1589 are preserved, with other figures from the same commission, in the Duomo. One of the finest of his independent statues is the Jason with the Golden Fleece, formerly in the Palazzo Zanchini and now in the Palazzo Ricasoli, Florence, and one of the poorest is the Orpheus in the Louvre, carved for Girolamo Gondi in 1598. To this phase belong the figure of Spring on the Ponte Santa Trinita, the two statues of Ferdinand I in the Piazza dei Cavalieri and Piazza San Nicola at Pisa (ca. 1594, after a model by Giovanni Bologna), the statue of Ferdinand I outside the Duomo at Arezzo (1595), and reliefs for the doors of Pisa Cathedral (see Plate 93 above). The last evidence of Francavilla's presence in Florence occurs on 21 November 1604, when he signed a will, before leaving for France whither he was invited by Henry IV and where he had apartments in the Louvre. His principal task there was the erection and completion of the equestrian monument of the King on the Pont Neuf (see Plate 95 below). A marble David in the Louvre dates from 1608, and shows a marked decline in quality from Francavilla's earlier works. He died in Paris on 25 August 1615.

BIBLIOGRAPHY: The primary source for Francavilla's career is a life by Baldinucci. Good surveys are supplied by H. Vollmer, in Thieme *Künstlerlexikon*, xii, 1916, pp. 384–6, and Venturi (X-iii pp. 817–50). A volume by R. de Francqueville (*Pierre de Francqueville, sculpteur des Medicis et du Roi Henri IV*, Paris, 1968) contains an appendix of unpublished documents transcribed by Dr. Gino Corti, but is otherwise of little value. For Francavilla's part in the Giovanni Bologna workshop see Dhanens (*Jean Boulogne*, 1956, passim), for the two figures made for the Duomo façade J. K. Schmidt ('Le Statue per la facciata di S. Maria del Fiore in occasione delle nozze di Ferdinando I,' in *Antichità Viva*, vii, 1968, pp. 43–53), and for the Bracci figures A. H. Scott-Elliot ('The Statues by Francavilla in the Royal Collection', in *Burlington Magazine*, xcviii, 1956, pp. 77–84). H. Keutner ('Pietro Francavilla in den Jahren 1572 und 1576,' in *Festschrift Ulrich Middeldorf*, Berlin, 1968, pp. 301–7) establishes, from a portrait of 1572, Francavilla's responsibility for the marble version of Giovanni Bologna's Florence triumphant over Pisa, and, from a portrait of 1576, his authorship of an écorché bronze of which examples exist in the Biblioteka Jagiellonska, Cracow, and elsewhere (for these see Z. Ameisenowa, *The Problem of the Ecorché and the three Anatomical Models in the Jagiellonian Library*, Breslau/Warsaw/Cracow, 1963).

Plate 94: MOSES
Cappella Niccolini, Santa Croce, Florence

Dosio's Cappella Niccolini (Fig. 76) off the left transept of S. Croce is planned (Paatz) as a variant of the same architect's Gaddi Chapel in S. Maria Novella. Preparations for the building of the chapel appear to have begun in 1571, but work was initiated only after 1579, when the Niccolini acquired the Cappella dei Laudesi in S. Croce which occupied part of the site of the present chapel. Work on the chapel was still in progress in 1584, when it is mentioned by Borghini, and it is described as incomplete in wills drafted by Giovanni Niccolini on 15 July 1608 and 30 June 1611 (Richa). The cupola was completed before 1653, and the entire chapel was finished by 1664. The sculptures consist of marble figures of (*right wall*) Aaron (*centre, over sarcophagus*) and (*left*) Humility, and (*left wall*) Moses (*centre, over sarcophagus*), Virginity (*left*), and Prudence (*right*). The five figures are described by Richa in the following terms: 'Sopra de' Depositi laterali a man ritta vedesi una Statua di marmo bianco in una nicchia quadra, ornata di due colonnette di verde antico, rappresentasi in essa Aronne con abiti, ed ornamenti sacerdotali, ed all'incontro a man manca si vede un Mosè, che in atto simile, ma molto vivace, tiene le tavole della Legge. Restano dalle pareti tre altre nicchie, che terminano in tondo, nelle quali vi sono statue di femmine maggiori del naturale, scolpite l'une, e l'altre con raro artifizio da Pietro Francavilla Fiammingo' (Above the side tombs there is on the right a statue of white marble in a rectangular niche, decorated with two small green marble columns; the statue represents Aaron wearing the vestments and ornaments of a priest. Opposite this, on the left, is a Moses holding with a

similar but very lively gesture the Tables of the Law. There are also three other niches in the walls, round-topped and containing figures of women, larger than life; they were all carved with unusual skill by Pietro Francavilla the Fleming). All five figures are signed by Francavilla, and are generally assumed to have been carved in or after 1585, when the chapel was dedicated. The Humility is inferior to the figures on the left wall, and is by a studio hand. Two terracotta sketch-models for the figures of Aaron and Moses are in the Museo Nazionale. These are dismissed by Brinckmann (*Barock-Bozzetti*, i, p. 18) as copies of the marble statues. Their status as sketch-models is vindicated by Kriegbaum (in *Jahrbuch der Preuszischen Kunstsammlungen*, xxxxviii, 1927, p. 50, n. 2). Kriegbaum regards the bozzetti as models by Giovanni Bologna on which the Francavilla figures are based, and is followed in this view by Paatz (i, pp. 576–7) and Dhanens (pp. 261–2). The case in favour of the view that the models are by Giovanni Bologna rests in the main on a statement of Simone Fortuna, in a letter of 10 February 1582 to the Duke of Urbino, that Francavilla 'non ha mai fatto nulla di suo cervello, lavorando sempre i modelli di Gio. Bologna.' The evidential value of this passage is questionable, and the two bozzetti differ appreciably from autograph sketch-models by Giovanni Bologna. Both are accepted as works of Francavilla by Venturi (X-iii, pp. 831–2). The folds of the cloak of Moses in the marble version are greatly elaborated.

Plate 95: PRISONERS
Louvre, Paris

The four bronze Prisoners of Francavilla in the Louvre were cast for the corners of the base of the statue of Henry IV formerly on the Pont Neuf (for which see F. Boucher, *Le Pont Neuf*, ii, 1926, pp. 66–94). The proposal for the statue originated in 1604–5 with Marie de Médicis, who left Florence for France in 1600, and was therefore familiar with Giovanni Bologna's equestrian statue of Cosimo I in the Piazza della Signoria (see Plate 90 above). From a letter written by Marie de Médicis to Ferdinand I on 29 April 1605, it appears that the decision to commission an equestrian statue of Henry IV from Giovanni Bologna had already been communicated to the Grand-Duke. Giovanni Bologna at the time was engaged in completing the equestrian statue of Ferdinand I for the Piazza dell'Annunziata, and it was suggested by Marie de Médicis that in view of the sculptor's age, his work should be limited to the seated figure of the King, and that the Grand-Duke should send to Paris the horse from his own monument, which could then be replaced 'tout à loisir par le mesme ouvrier'. In reply the Grand-Duke refused to sacrifice the horse from his own monument, but agreed that the new horse should be moulded from the old. A bust of Henry IV was sent to Florence in 1606 to serve as a model for the portrait statue. In 1606 and 1607 emissaries of Marie de Médicis were sent to Florence to accelerate work on the statue and agree its price. In 1608 a M. d'Ocquerre was instructed by the Queen to ascertain from the Grand-Duke how far the statue was advanced. After the death of Giovanni Bologna in this year, work on the

monument was entrusted to Tacca, and it was cast, probably in the Portigiani workshop, and despatched to France (30 April 1613) by way of Leghorn and Le Havre, arriving in Paris on 4 July 1614. The first stone of the base had been laid on the Pont Neuf by Louis XIII on 2 June 1614. In the course of the summer the Commissaires et Directeurs des bâtiments et édifices du Pont Neuf proposed that Francavilla should be assisted by a second sculptor in carrying out the 'fontes de bronze du pied de l'estail', that is the four Prisoners, but on 25 July 1614 Marie de Médicis gave instructions that no other sculptor than Francavilla 'ne mette la main à cet ouvrage' since he had 'déjà fait les desseings et modelles'. Early in September she acknowledged the arrival of the statue: 'les figures du feu Roy Monseigneur et le cheval de bronze sont enfin arrivez à bon port à Paris. J'ay été bien aisé de ces bonnes nouvelles la tant pour l'importance de la chose que pour nostre particulier contentement; je ne vois rien qui doive faire differer pour mettre ces figures hors des quaisses et de leurs enchaissements de bois et qu'au plus tost l'on ne travaille et donne ordre a les faires monter et poser . . . conformement aux advis du sculpteur Franqueville et autres qui y doivent prendre garde.' The inauguration of the statue took place on 23 August 1614, when a procès verbal was inserted in a lead case in the belly of the horse stating that the monument had been begun by Giovanni Bologna, elaborated by Tacca, and sent by the Grand-Duke Cosimo II 'en très digne present à la reine de France'. After the death of Francavilla, the four captives for the base were finished (1618) by his pupil Francesco Bordoni. They are inscribed: A PETRO FRANCA-VILLA CAMARCENSI INVETVM ET INCEPTVM FRANC. AVTEM BORDONI FLORENTEVS GENER PERFECIT LUTETIAE AN DN MDCXVIII. Of the five reliefs projected for the base, three, showing the entry of Henry IV into Paris and the Battles of Arques and Ivry, were modelled by Francavilla and completed by Bordoni, and two, the Siege of Amiens and the Siege of Montmelian, were executed by Barthelemy du Tremblay and Thomas Boudin (installed 1628). The statue was destroyed under the terms of a revolutionary decree of 10 August 1792; fragments of it are now in the Louvre, along with the four Slaves which survived intact. It was later replaced by a statue of Henry IV by Lemot, which was inaugurated by Louis XVIII in 1818 and is still in position on the Pont Neuf.

PIETRO TACCA
(b. 1577; d. 1640)

Born at Carrara in 1577 and trained locally, Tacca, armed with an introduction from Alderano Cibo, moved to Florence in 1592, entering the workshop of Giovanni Bologna, where he was employed on the equestrian statue of Cosimo I (see Plate 90 above), and modelled a relief for the doors of Pisa Cathedral (see Plate 93 above). After the departure of Francavilla for France (1604), he became Giovanni Bologna's principal assistant, and is mentioned in a will drawn up by Giovanni Bologna on 1 September 1605 as the heir to his studio in the Borgo Pinti and to its contents. Tacca was responsible for the completion of the equestrian statues of Ferdinand I, Henry IV of France and Philip III of Spain, and in 1609 was appointed Giovanni Bologna's successor as sculptor to the Grand-Duke. Between 1615 and 1624 he carried out his most celebrated work, the four Slaves at the base of the monument of Ferdinand I at Leghorn (see Plate 96 below). In 1627 he cast for Leghorn two bronze fountains, which were not put in position and were later (1643) installed in the Piazza Annunziata in Florence, and at a date not ascertained he cast the bronze Boar in the Mercato Nuovo, after a Roman marble copy of a Hellenistic original. The most notable of the many bronze Crucifixes cast by Tacca was despatched to Spain with the equestrian statue of Philip III, and is now in the Escorial. The major commission carried out by Tacca in Florence is that for the tombs in the Cappella dei Principi (see Plate 97 below). In 1619 he modelled an equestrian statuette of Charles Emmanuel of Savoy (cast and completed 1621, now in the Löwenburg at Cassel). Between 1634 and his death on 26 October 1640 he was occupied with the great equestrian statue of Philip IV of Spain (Fig. 138).

BIBLIOGRAPHY: The primary source for the career of Tacca is a life by Baldinucci. A modern monograph by E. Lewy (*Pietro Tacca*, 1929) gives a brief survey of Tacca's work, but makes no serious attempt to analyse his style, and reproduces a number of small bronzes by Bertos and other artists as Tacca's work. Its documentation is supplemented by S. Lo Vullo Bianchi ('Note e documenti su Pietro e Ferdinando Tacca', in *Rivista d'Arte*, xiii, 1931, pp. 133–213).

Plate 96: SLAVES
Piazza della Darsena, Leghorn

The history of the statue of the Grand-Duke Ferdinand I of Tuscany at Leghorn (Fig. 60) (for which see H. Keutner, 'Ueber die Entstehung und die Form des Standbildes im Cinquecento', in *Münchner Jahrbuch der Bildenden Kunst*, vii, 1956, pp. 158–60) begins in 1595 when the marble statue was commissioned from Giovanni Bandini. The statue was completed in 1599. In 1602 a base supported by Slaves is mentioned for the first time, and in 1607 Tacca was sent to Leghorn to prepare wax models of

these figures. After the death of the Grand-Duke (1609) the statue was installed on its pedestal (1617), but in 1621 it was suggested by Tacca that the marble statue should be replaced by a statue of the 'Religione di S. Stefano' in bronze. This proposal was not accepted, and in 1622 bronze trophies (removed at the time of the French Revolution) were placed at the feet of the standing statue. The two Slaves on the front of the monument were installed in 1623 (when that on the right was reproduced in a drawing by Petel), and the two remaining Slaves were put in position in June 1624. According to Baldinucci, work on the Slaves was begun only in 1615: 'Aveva il nostro Pietro fino del 1615 ricevuta commissione dal Gran Duca di por mano all'adempimento dell'altro concetto di quell'Altezza, che fu d'ornare il Molo di Livorno col gran Colosso di Marmo fatto da Giovanni dell' Opera per rappresentare la G. Memoria del Gran Duca Ferdinando Primo e di altri quattro Schiavi Turchi incatenati al tronco della bellissima Base; onde egli applicatosi a tale insigne lavoro ne aveva incominciati grandi studj; ma il maggiore fu il portarsi a Livorno insieme con Cosimo Cappelli suo Discepolo, che da giovanetto formava eccellentemente: quivi ebbe facoltà di valersi di quanti Schiavi vi avesse riconosciuti, de' muscoli più leggiadri, e più accomodati all'imitazione per formarne un perfettissimo corpo, e molti e molti ne formò nelle più belle parti. Uno di costoro fu uno Schiavo Mor o Turco, che chiamavasi per soprannome Morgiano, che per grandezza di persona, e per fattezze d'ogni sua parte era bellissimo, e fu di grande ajuto al Tacca per condurne la bella figura, colla sua naturale effigie, che oggi vediamo; ed io che tali cose scrivo, in tempo di puerizia in età di dieci anni il vide, e conobbi, e parlai con esso non senza gusto, benchè in sì poc'età, nel ravvisar, che io facevo a confronto del Ritratto il bello originale.' (At the end of 1615 our Pietro received the commission from the Grand-Duke to set his hand to the completion of another project of his Highness, which was to decorate the Mole of Leghorn with the great marble colossus made by Giovanni dell' Opera to commemorate the Grand-Duke Ferdinand I and with four Turkish slaves chained to the beautiful base; having applied himself to this noble task, he had embarked on many studies, of which the chief was to visit Leghorn in the company of his pupil Cosimo Cappelli, who from boyhood modelled in a most excellent way. Here he was able to study many Slaves and to select those most suited for imitation to form an absolutely perfect body, and he modelled very many of them in their most beautiful parts. One was a Turkish Slave, named Morgiano, who for his size and lineaments was especially beautiful, and he was of great assistance to Tacca in modelling the beautiful figure which we see to-day. I who record these things saw him in boyhood at the age of ten, and young as I was, I enjoyed talking to him, as I compared the beautiful original with Tacca's likeness.) Baldinucci records the presence in the official house of the Grand-Ducal sculptor in the Borgo Pinti (then inhabited by Giovanni Battista Foggini) of models for gesso casts after the four Slaves, which were frequently reproduced as small bronzes in the late seventeenth and early eighteenth centuries. Two fountains by Tacca now in the Piazza Annunziata, Florence, were originally destined to form part of the same complex as the Leghorn statue.

Plate 97: FERDINAND I, GRAND-DUKE OF TUSCANY
Cappella de' Principi, San Lorenzo, Florence

The plan for a funerary chapel for the members of the Grand-Ducal family was first conceived by Cosimo I, who, according to Vasari, planned to construct at S. Lorenzo 'una terza sagrestia . . . tutta di vari marmi mischi a musaico, per dentro chiudervi in Sepolcri ornatissimi, e degni della sua potenza, e grandezza l'ossa de' suoi morti figliuoli, del padre, madre, della magnanima Duchessa Eleanora sua Consorte, e di sè. Di ciò ho già fatto modello a suo gusto' (a third sacristy . . . covered with a mosaic of mixed and variegated marble; inside it, in highly decorated tombs worthy of his power and greatness, he intends to install the bones of his dead children, of his father and mother, of the noble Duchess Eleanora his consort, and of himself. I have already made a model for it which he likes). Cosimo I died before this plan could be put in operation. A funeral oration for his son, Francesco I, preached by Monsignor Lorenzo Giacomini, Bishop of Achaea, on 21 December 1587, shows that he had intended to realise his father's plan ('avea deliberato erigere gloriosi Sepolcri, ornandoli di preziose pietre, calcedonii, prasme, sardonii, agate, e diaspri di variati colori, tutte da se con propria diligenza ne' suoi propri paesi ritrovate') (he had planned to raise noble tombs and decorate them with precious stones, chalcedony, green and other agates, sardonyx and jasper of various colours, all of which he had himself through his own efforts found on his territory). The construction of the chapel was finally undertaken by Ferdinand I, who is described by Moreni (*Descrizione della gran cappella delle Pietre Dure e della sagrestia vecchia . . . nell'imp. Basilica di S. Lorenzo di Firenze*, Florence, 1813, p. 6) as 'Principe assuefatto alle grandezze del Vaticano'. Plans for the chapel were prepared by Buontalenti, Don Giovanni de' Medici, brother of the Grand-Duke, and Giorgio Vasari il Giovane, the model by Buontalenti being rejected in favour of that of Don Giovanni de' Medici. Some of the considerations which influence this unfortunate decision are given in a letter from Giorgio Vasari il Giovane to the Grand-Duke (printed by Franceschini, 'San Lorenzo — xv,' in *Il Nuovo Osservatore Fiorentino*, 1886, p. 368): 'dico, che il modello dell' illustrissimo ed eccellentissimo signor Don Giovanni mi piace piu, poiche egli lo divisa e scompartisce di maniera che si vede in una occhiata sola ogni cosa, cosi per le mura, dove egli finge le nicchie colle statue, come anche nelle tribunette che sono da' lati dove vanno que' sepolcri piu piccoli. Il che non succede in quello di M. Bernardo, perche, facendovi sette cappelle, o vero nicchie, difficilmente si puo in un'ochiata sola vedere ogni cosa senza entrare o condursi nel mezzo. . . . Delle statue, e de' sepolcri che in questo tempio sono cosa di considerazione, mi pare che oltre alla bella invenzione loro, il Signore collochi le statue come conviene in bellissime nicchie ed osserva il decoro dell'architettura. M. Bernardo fa posare le sue sopra certe mensole poste e finte in un paese di maniera tale che pare che elle passeggino per un giardino, o vero che siano attacate a una tela di Fiandra' (I declare that I prefer the model designed by the illustrious and excellent Don Giovanni;

for he has laid it out and divided it up in such a way that one can see everything at a glance, both as regards the walls, where he makes niches with statues, and in the small tribunes at the sides, where the smaller tombs stand. This is not the case with Master Bernardo's model: as he has seven chapels or niches in it, it is difficult to see everything at a glance without entering or walking to the centre. . . . As for the statues and the tombs, which have a particular importance in this church, I think that, quite apart from their fine invention, his Lordship properly puts the statues in fine niches and conforms to the decorum of the architecture. Master Bernardo, on the other hand, has his on top of some consoles, represented as being in a landscape, so that they seem to be strolling through a garden, or stuck on some Flemish tapestry). The foundation stone of the Chapel, which was to be 'superiore di pregio alla Casa aurea di Nerone, et a quella del Re Ciro,' was laid on 10 January 1604, and construction proceeded under the direction of Nigetti, who departed at a number of points from the original design (Paatz, ii, pp. 487–90), producing 'eine frühbarocke Variation über das Thema des Florentiner Baptisteriums.' The installation of the pietra dura was begun in 1613, but the introduction of the figure sculptures was deferred till a considerably later date. The contract for two of these, representing Cosimo II and Ferdinand I, was awarded to Pietro Tacca on 19 August 1626 (S. Lo Vullo Bianchi, 'Note e documenti su Pietro e Ferdinando Tacca,' in *Rivista d'Arte*, xiii, 1931, p. 204): 'Magnifica Serenissima ha comandato di dire a V. S. Ill. ma che Ella ricordi a S.A. di dar opra per fare due delle figure grandi per la regia Cappella cioe quella per il Granduca Ferdinando e S.A. Cosimo di Gloriosa Memoria pelle quale S.A. vuole che se ne faccia il modello grande, che saranno da 8 braccia luno per farvi lega la forma di gesso e gettarli quanto prima di esso gesso, e metterli e posarli nelle nicchie di detta Cappella quali forme é modello grande serviranno poi per farle di bronzo. Per tutte queste spese prima di un modello piccolo e per l'ossatura fattane e varie spese per il grande, e formarli e spese di gesso ci andra da sc. 250 per l'un incerca – e più a gettarli di gesso per suddetta per ora sara di spesa da 40 scudi incirca et sara per auto a V.S. Ill. ma alla quale faccio reverenza' (His Highness has given instructions for Your Lordship to be informed that he urges Your Lordship to set to work on making two of the large figures for the Cappella Regia, namely that of the Grand-Duke Ferdinand (I) and that of His Highness Cosimo (II) of glorious memory. Each is to be 8 braccia high, and His Highness wishes that you should make large models for them, and fill the moulds with a mixture of plaster and so cast them first in plaster, and that you should put these in place in the niches of the said Capella Regia; and these moulds and large models would then be used for making (the figures) out of bronze. The total expenditure on these, first for small models and the armatures made for them, and then various expenditure for the large ones and for moulding them, and the expenditure on plaster, will come to about 250 scudi each; and further, for casting them temporarily in plaster for this, about 40 scudi. And this will be received by Your Lordship: to whom I make reverence).

According to Baldinucci, there was some initial doubt as to whether the figures should be carved in marble or cast in bronze: 'Era l'Anno 1630 terribile alla nostra Città per la crudele pestilenza, quando trovandosi il Tacca a cagione della medesima senza impiego di gran momento, forte temendo, che i molti Scultori, ch'ei teneva in suo servigio, non abandonassero esso, e la Città per portarsi in diverse parti, e quel ch'era più, a' servigi d'altri Principi, onde si facesser comuni all'Europa tutte le belle invenzioni, e'l bel segreto da lui inventato per le fusioni de' Metalli, per la facilità de' Getti, e finalmente per la leggiadra, e stabile comettitura de' pezzi, e avendo osservato, che nella Regia Cappella di S. Lorenzo erano i grandi Colossi di Gesso, fatti pure da lui sopra i Sepolcri, de' quali dovevano esser poi le figure di Marmo di Francesco Primo, di Ferdinando Primo, e di Cosimo Secondo Gran Duchi, ottenne che le Statue non si facessero altrimenti di Marmo, ma di Metallo, e ciò non senza gran contrasto, e contro la volonta di Michelagnolo Buonarruoti il giovane, e di Jacopo Giraldi l'uno l'altro deputati sopra tale affare, e che già s'erano impegnati d'appoggiare ad altri tale nobile lavoro, offerendosi il Tacca di comporre le grandi figure con tale artifizio, che dovendo essere di molti pezzi inchiavardati per commetersi, e scommetersi bene, potesse poi riuscire il dorargli a oro macinato, giacchè non poteansi comodamente macchine sì smisurate dorare a fuoco, e questo oltre al cimento d'una eccedentissima spesa. Era fra questi il gran Modello di gesso del Ferdinando, del quale sotto il corto calzone scopriva la metà della coscia calzata insieme con la gamba al modo di vestire di quei tempi, restando l'altra coperta dal ricco abbigliamento di panno, ma i malevoli a lor solito non potendo attaccare l'Artefice in altra cosa, per detrarre alle sue onorevolezze, dissero, che quella Statua con quella coscia scoperta rappresentava inanzi la figura d'un S. Rocco che quello che doveva rappresentare, e andò la cosa a segno che convenne al Tacca il rifarne un nuovo Modello, che veramente riuscì bellissimo' (The year 1630 was a terrible one for our city on account of the cruel plague. Tacca, at this time and for this reason, found himself without any important commission on hand, and very much feared that the many sculptors he had in his service would leave both him and the city and go off to different places, in the service, moreover, of other princes; and he feared that in this way all his fine inventions and the secret process he had discovered for founding metals, making casting easier and also assembling the parts neatly and firmly, would be spread all over Europe. So, as he noticed that there were in the Cappella Regia of S. Lorenzo the colossal plaster figures, made by himself above the tombs, which were intended ultimately to be marble figures of the Grand Dukes Francesco I, Ferdinando I and Cosimo II, he contrived that the figures should not be made of marble but rather of metal. It was against much opposition that he effected this, and against the wishes of Michelangelo Buonarroti the Younger and Jacopo Giraldo, who were the two deputies in charge of this undertaking and had already committed themselves to allotting this noble commission to other artists. Tacca undertook to construct the figures in such a way that, since they were to consist of a number of pieces bolted together for proper assembly and disassembly, it would be possible to gild them successfully with ground gold; for such huge objects could not conveniently be fire gilded, which, quite apart from the risk, would be extremely expensive.

One of the figures was the large plaster model of Ferdinand; in this, half of the stockinged thigh and the leg was shown uncovered under the short breeches, as was the fashion at that time, while the other was covered by the rich arrangement of the drapery. Ill-wishers, as is their habit, since they could not attack him on any other grounds, detracted from his honour by saying that this statue with the uncovered thigh was more like the figure of St. Roch than him who it was meant to be. And the matter came to such a point, that Tacca was obliged to make a new model for it, which indeed turned out most beautiful). Tacca worked on the two figures of Cosimo II and Ferdinand I between 1626 and 1634, when he was instructed by the Grand-Duke to work exclusively on the equestrian monument for Madrid. According to an unconfirmed statement of Campori, he received a payment of 3,000 scudi for the completion of the statue of Cosimo II on 28 September 1631. Tacca died on 26 October 1640, when work was still in progress on the equestrian statue. The unfinished statue of Ferdinand I is mentioned in a memorandum submitted by his sons and heirs to Pierfrancesco de' Ricci, *provveditore generale delle fortezze* (D. M. Manni, *Addizioni necessarie alle vite de' due celebri statuari Michelagnolo Buonarroti e Pietro Tacca*, Florence, 1774: 'Una

Statua di circa braccia otto di bronzo per la Regia Cappella, la quale perchè fu di sua nuova invenzione, e non più provata, portò seco e spesa, e tempo il doppio più del premeditato') (A bronze figure of about 8 braccia for the Cappella Regia which, since it was made by his new and untried method, took twice as much time and money as was expected). After the completion of the statue in Madrid (29 October 1642), Ferdinando Tacca returned to Florence, and finished the outstanding statue (Baldinucci). There is some confusion about the early history of the project for statues in the Cappella de' Principi, which appears at one time to have provided for marble statues of Francesco I, Ferdinand I and Cosimo II by Giovanni Bologna five braccia in height. It is also possible that Ferdinand I at one time contemplated a tomb with two large marble supporting figures (Patrizi, *Il Giambologna*, 1905, p. 214: 'Anzi, sta il fatto che nel 1599 il Principe mandò a Carrara due intagliatori per scegliere tre grossi blocchi di marmo destinati al Giambologna perchè da essi ritraesse due grandi figure simboliche da porre ai lati della propria statua') (In 1599 the Duke sent two sculptors to Carrara to select three great blocks of marble, for Giambologna to make two large symbolic figures to put at the sides of his own statue).

GUGLIELMO DELLA PORTA

(d. 1577)

The birth-date of Guglielmo della Porta is not recorded. Nothing is known of his father Cristoforo della Porta; his uncle, the sculptor Gian Giacomo della Porta, is generally assumed (Gramberg) to have been born about 1485 and died in 1555. If, however, as is supposed by some students (Gibellino-Krascenninikowa), Gian Giacomo della Porta is identical with an artist of this name active at Pavia in 1494-5, and Guglielmo with an artist of this name active in Milan till 1534, the former would have been born about 1470 and the latter about 1490. The first satisfactory record of Guglielmo della Porta's activity occurs in Genoa, where he was working in partnership with his uncle Gian Giacomo and Niccolò da Corte in 1534. He appears to have been active in the chapel of St. John the Baptist in the Cathedral (1530-3) and in the Cibo chapel (see Plate 98 below). The evidence regarding the duration of Guglielmo's residence in Genoa is contradictory. He is first mentioned in Rome on 3 May 1546 when he received a payment for marble doors of the Sala del Re in the Vatican. It has been inferred from this (Gibellino-Krascenninikowa) that Guglielmo remained in Genoa until shortly before this time. According to Vasari (whose pages on the sculptor are conspicuously well informed), Guglielmo della Porta moved from Genoa to Rome in 1537. Both in Genoa and Rome he appears to have been associated (Gramberg) with the painter Perino del Vaga, and he was perhaps responsible (ca. 1537-8) for executing stuccoes in the Cappella Massimi of S. Trinità dei Monti (destroyed). At

this time, according to Vasari, Guglielmo came in contact with Michelangelo. Despite a subsequent rupture between Guglielmo and Michelangelo, the former showed no reluctance to acknowledge his indebtedness to the older artist ('et anch'io credendo di esser in nel numero delli suoi scolari'). In 1547, on the death of Sebastiano del Piombo, Guglielmo della Porta succeeded to the office of Bollatore Apostolico, and thereafter is known as Fra Guglielmo della Porta. Guglielmo's career in Rome is relatively fully documented. Cn 14 August 1546 he received payment for a head of Antoninus Pius for the Castel Sant'Angelo, and for a bust. Later in the year (23 December 1546) payments relate to the repair of a marble Cupid and to a bust of the Pope. On 9 December 1547 payment was made for a bronze bust of the Pope. Three marble busts of Pope Paul III (two in the Pinacoteca Nazionale di Capodimonte and one in the Museo di San Martino at Naples) appear to have been carved at this time. Before the death of the Pope (1549) Guglielmo was also engaged in preparing a seated statue for the Pope's tomb (see Plate 100 below). Work on this commission occupied him for many years, and the monument was not finally erected till 1575. At this time he was employed by the Fabbrica of the Palazzo Farnese. In March 1551 he repaired an antique female figure of a Faun (Bacchessa), and in August of this year was engaged on a relief of Vulcan. Documents of 1556 refer to a marble St. John the Baptist carved for the portal of the Castel Sant'Angelo, the completion of two bronze candle-

sticks ordered by Pope Paul III, and prophets and angels destined for the Cappella Paolina. A will drawn up by Guglielmo della Porta on 4 July 1558 refers to the presence in his studio of Passion scenes and bronze crucifixes. Some of the former seem to have been cast in bronze in 1564–5. In 1569 Guglielmo was involved as arbitrator in a dispute over the gilding of the ceiling of St. John Lateran. In 1574 he obtained a bull authorising him to dispose freely of his own property despite his religious status. He died in 1577. Guglielmo della Porta's principal works, apart from those noted above and below, comprise:

(i) Monuments of Paolo (d. 1537) and Federigo (d. 1565) Cesi in S. Maria Maggiore, Rome (Fig. 146).

(ii) Monument of Bernardino Elvino in S. Maria del Popolo (ca. 1548).

(iii) A cycle of sixteen reliefs of scenes from Ovid, cast initially by Cobaert and much plagiarised in the late sixteenth, seventeenth and eighteenth centuries. A version of one of these, with the Fall of the Giants, in the Metropolitan Museum of Art, New York, is signed by Guglielmo's natural son Fidia.

In addition there are records of a number of lost major works, which include:

(i) Four statues of Prophets in the Cappella Paolina mentioned by Guglielmo in a letter to Cardinal Farnese, made in the first year of the pontificate of Paul IV (1555). Instructions given by the Pope to the Cardinal of Carpi that these should be cast in bronze for the niches of the cupola piers of St. Peter's appear to have been cancelled on the death of the Pope (1559).

(ii) Fourteen scenes from the life of Christ described by the artist as 'il più ricco e onorato lavoro che sia mai fatto in scultura da' moderni'. These were at one time to have been placed in a circular structure housing an equestrian monument of the Emperor Charles V projected in the first year of the Pontificate of Julius III (1549–50), were later, under Pius IV, to have been assembled in a door, and were subsequently proposed to Cosimo I de' Medici as a door incorporating subsidiary figures and a portrait of the Duke. These projects can be in part reconstructed from the sketchbooks by Guglielmo della Porta at Düsseldorf (Gronau). One of the reliefs is identified by Gramberg ('Die Hamburger Bronzebüste Paul III. Farnese von Guglielmo della Porta,' in Festschrift für Erich Meyer, 1961, pp. 160–72) with a Flagellation formerly in Berlin.

(iii) A project for altars for St. Peter's (prepared before 1567) with large reliefs showing the Deposition, the Presentation of the Keys and Pentecost, and (?) Christ's entry into Jerusalem. These have also been in part reconstructed from the Dusseldorf sketchbooks (Gronau and Gramberg).

BIBLIOGRAPHY: Modern knowledge of Guglielmo della Porta is due to an exemplary edition by W. Gramberg of the sculptor's sketch-books at Düsseldorf (Die Düsseldorfer Skizzenbücher des Guglielmo della Porta, 3 vols., Berlin, 1964). A monograph by M. Gibellino-Krascenninikowa (Guglielmo della Porta, scultore del Papa Paolo III Farnese, Rome, 1944) is inadequate. The transcription of documents throughout this book is unreliable, and for these reference should be made to Bertolotti (Artisti Lombardi a Roma, Milan, 1881, 2 vols.), and other primary sources. An excellent analysis of the Paul III monument by E. Steinmann (Das Grabmal Pauls III in St. Peter in Rom, Rome, 1912) is restricted only by the fact that quotations from the letters of Anninbale Caro relating to the tomb are quoted throughout in German translation not in the original. For these reference should be made to Delle lettere del Commendatore Annibale Caro, 3 vols, Padua, 1763–5, and Delle lettere familiari del commendatore Annibal Caro, Venice, 1574. For the Düsseldorf sketch-books and cognate works see, in addition to Gramberg's volumes, G. Gronau ('Über zwei Skizzenbücher des Guglielmo della Porta in der Düsseldorfer Akademie', in Jahrbuch der Preuszischen Kunstsammlungen, xxxix, 1918, pp. 171–200). From the scattered literature of the Ovid plaquettes mention must be made of R. Berliner ('Ein Plakettenfolge von Jacob Cobaert', in Archiv für Medaillen und Plakettenkunde, 1921–2, pp. 134–5), L. Planiscig (Die Estensische Kunstsammlung in Wien, 1919, pp. 188–92), J. Goldsmith Phillips ('Guglielmo della Porta: his Ovid Plaquettes', in Bulletin of the Metropolitan Museum of Art, xxxiv, 1939, pp. 148–51), and, most notably, W. Gramberg ('Guglielmo della Porta, Coppe Fiammingo und Antonio Gentili da Faenza,' in Jahrbuch der Hamburger Kunstsammlungen, v, 1960, pp. 31–52).

Plate 98: THE CHAPEL OF THE APOSTLES
Duomo, Genoa

The history of the Chapel of SS. Peter and Paul in the Duomo at Genoa is confused, and the sculptures carved for it present a number of attributional difficulties. In 1529 the architect Domenico de' Marchesi da Caranca was requested to undertake the construction of a sacristy for the Chapel of St. John the Baptist and two chapels beneath the organ. There is some doubt as to whether the chapels beneath the organ were proceeded with since in the following year (1530) Giuliano Cibo, Bishop of Girgenti, applied for a space beneath the organ in which to construct a funerary chapel. The contract for the chapel and its sculptures, which appears to have been entered into not long after with Gian Giacomo della Porta, Guglielmo della Porta and Niccolò da Corte, does not survive. On 10 February 1533, however, an agreement (for which see S. Varni, 'Delle opere di Gian Giacomo e Guglielmo della Porta e Niccolò da Corte in Genova', in Atti della Società Ligure di Storia Patria, iv, 1866, pp. 35–78) was drawn up between Gian Giacomo della Porta and Niccolò da Corte on the one hand and Bernardo di Giovanni Sisto and Bernardo Pellicia of Carrara on the other, by which the latter were to supply a quantity of pieces of marble itemised separately in the document. It was specified that 'omnes figurae et sic figura mortui debent esse pulcrae albae sine vene et marmore de lo polvazo', and provi-

sion was made in the contract for marble for six statues and an effigy. Work on the chapel was certainly in progress before 23 December 1534, when the three sculptors, who had formed a collective profit-sharing body, stipulated that the agreement entered into for the distribution of earnings should apply to the still unfinished Cibo Chapel ('et sic intelligatur comprehensum opus quod restat ad perficiendum Reverendi Domini Episcopi Agrigenti quod reponi debet in Ecclesia Sancti Laurentii; Januae'). On 9 August 1535 Gian Giacomo della Porta (on his own behalf and that of Guglielmo and Niccolò da Corte) acknowledged the receipt of a total sum of 790 scudi (for this document see Alizeri, *Notizie dei Professori di Disegno*, v, Genoa, 1877, p. 177). Giuliano Cibo died on or before 12 January 1536, and in a will drawn up before his death provided for the completion of the Chapel ('Item, jussit et legavit compleri dictam Capellam, jam construi inceptam in dicta Ecclesia major; Ianuensi sub vocabulo S. Petri et Pauli in omnibus prout extat instrumento inter ipsum Rev. Testatorem, et magistros fabricantes ipsam Capellam') (Item, he ordered and appointed that the said Chapel, the construction of which had already been begun in the said Cathedral of Genoa, should be completed in the name of SS. Peter and Paul, in every way according to the deed drawn up between the Rev. testator and the Masters who are building the chapel). The Chapel was completed in 1537, when objection was raised to the fact that the tomb protruded too far into the church; this appears to have been rectified (for these documents see Alizeri, op. cit., v, pp. 179–81). The recumbent effigy has been removed from the chapel. In its present form (Fig. 143) the altar consists of a central niche, containing a seated figure of the Redeemer accompanied by (left) St. Peter and (right) St. Paul, lateral niches with figures of (left) St. Jerome and (right) St. John the Baptist, and at the two ends, standing on a front plane, statues of (left) Abraham and (right) Moses. Beneath are two large reliefs, each with two Virtues, and above are small reliefs with scenes from the legends of the Saints and Prophets represented on the altar. There is some reason for supposing (Varni) that the original disposition of the statues has been changed, since the scenes of the Conversion of St. Paul and the Freeing of St. Peter appear respectively over the statues of SS. Peter and Paul. The statues of SS. Jerome and John the Baptist are not sunk into the base of their niches. There is no direct evidence for the authorship of individual statues or reliefs, and this must be deduced (i) from works executed by Guglielmo della Porta in Rome and (ii) from works executed by Gian Giacomo della Porta and Niccolò da Corte after Guglielmo della Porta had left Genoa. Vasari states that Guglielmo della Porta 'al vescovo di Servega fece due ritratti di marmo ed un Moisè maggiore del vivo il quale fù posto nella chiesa di San Lorenzo' (made two marble portraits for the Bishop of Servega, and a Moses larger than life, which was put in the church of S. Lorenzo). It is assumed by Alizeri that Vasari's reference is to the Abraham not the Moses. Venturi (X-iii, pp. 534–6) ascribes the Redeemer to Guglielmo della Porta, along with the relief of Justice and Fortitude below, and Gibellino-Krascenninikowa (in *Illustrazione Vaticana*, Anno III, 1932, vol. I, p. 302 ff., 344 ff., 407 ff.) credits him with the four Saints and two Prophets, and (*Guglielmo della Porta*,

pp. 34–5) the frieze above and the statues of the Redeemer and of SS. John the Baptist and Jerome. Gramberg (in Thieme, *Künstlerlexikon*, xxvii, 1933, pp. 282–3) accepts the Abraham as a work of Guglielmo della Porta, but questions the attribution to him of the SS. Peter and Paul. The only statues on the altar for which the name of Guglielmo della Porta can be seriously entertained are the Abraham and the St. Paul (which is executed by a different hand from the St. Peter, and is a work of exceptional force). The Moses conforms closely to the later statues carved by Gian Giacomo della Porta for the choir of the Cathedral. All of the six small narrative reliefs are by a single artist, but the two reliefs of Virtues are by separate hands, one of which may (as suggested by Venturi) be that of Guglielmo della Porta. The difficulty of identifying the individual sculptors responsible for the altar results from the cooperative procedure practised in the Della Porta studio.

Plates 99, 100: THE TOMB OF POPE PAUL III
St. Peter's, Rome

Guglielmo della Porta's monument of Pope Paul III (Fig. 145) (for the documentation of which see K. Escher, 'Guglielmo della Porta', in *Repertorium für Kunstwissenschaft*, xxxii, 1909, pp. 302–20; L. Cadier, 'Le tombeau du pape Paul III Farnese', in *Mélanges d'archeologie et d'histoire*, ix, 1889, pp. 49–92; E. Steinmann, *Das Grabmal Pauls III in St. Peter in Rom*, Rome, 1912 and H. Siebenhühner, 'Umrisse zur Geschichte der Ausstattung von St. Peter in Rom von Paul III bis Paul V,' in *Festschrift für Hans Sedlmayr*, Munich, 1962, pp. 229–320) was commissioned on 17 November 1549 after the death of the Pope, when a sum of 10,000 ducats was allotted to the monument. Certain features of the monument were already predetermined, since the Pope before his death had selected an antique sarcophagus in which he wished his body to be placed, and had purchased from Guglielmo della Porta for use in the tomb a marble base decorated with bronze scrolls and reliefs originally intended for the tomb of Francesco de Salis (Solis), Bishop of Bagnorea (1528–49) (mistakenly identified by Steinmann as Bishop of Salamanca). The tomb was eventually erected in 1575 at the expense of the Pope's great-nephew, Cardinal Alessandro Farnese: a medal struck on the Cardinal's instructions in this year describes the monument as 'aere publico inchoatum, adjecta de suo pecunia perfecit an. Jub. M.D.LXXV' (begun with public funds, he completed it with money added from his own resources, in the Jubilee year of 1575). Supervision of the execution of the monument was entrusted by Cardinal Farnese to Annibale Caro and Antonio da Capodistria, Bishop of Pola. From letters written by Annibale Caro to the Cardinal of Santa Croce and the Bishop of Pola in 1550 and on 5 August 1551 it is known that a wooden model had been prepared. At this time it was intended that the tomb should be free-standing; the sarcophagus selected by the Pope was to rest in the chapel-like interior, and the structure was to be supported by eight terms. Provision was made for eight recumbent allegorical statues, with, at the top, the bronze figure of the Pope. On 25 November 1553 it was reported by Annibale Caro that the statue of

the Pope had been cast in the autumn of 1552 and was then complete. A document of May 1553 refers to the chasing of the statue. The Allegories (the models for which had been approved in July 1552) were already under way. From a further letter of Annibale Caro of 6 April 1554 we learn that the first marble statue was finished by this time and that the second had been begun, and that the marble blocks for the third and fourth figures had been moved to Guglielmo della Porta's workshop. The completed statue was the Justice. The drapery by which this figure is now covered was added by Teodoro della Porta in 1593–4; before this addition it is described by Vasari as 'una figura nuda sopra un panno a giacere'. By 1555 the sum of 8042 ducats had been expended on the bronze figure of the Pope, the four marble allegories and other materials. The total cost of the monument was 26,500 ducats.

In the form in which it was approved by Caro (who in 1551 vetoed a proposal of the sculptor that statues of the four Seasons should be incorporated in the tomb), it comprised the central statue of the Pope raised on a bronze base decorated with four putti at the corners and reliefs of (*left*) Hope and Faith, and (*right*) Temperance and Fortitude. Four marble allegories were set on consoles two at the front and two behind. The tomb seems also to have included a relief of River Gods which is mentioned by Vasari but is not recorded in documents. Exception to the size and scheme of the monument was taken by Michelangelo. The nature of his objections are given in detail by Vasari: 'il quale (Guglielmo della Porta) avendo ordinato di metterla in San Piero sotto il primo arco della nuova chiesa sotto la tribuna, che impediva il piano di quella chiesa, e non era in verità il luogo suo; e perchè Michelagnolo consigliò giudiziosamente che la non poteva nè doveva stare, il frate gli prese odio, credendo che lo facessi per invidia; ma ben s'è poi accorto che gli diceva il vero, e che il mancamento è stato da lui, che a havuto la comodità, e non l'ha finita, come si dirà altrove; ed io ne fo fede, avvengachè l'anno 1550 io fussi, per ordine di papa Giulio terzo, andato a Roma a servirlo, e volentieri per godermi Michelagnolo, fui per tal consiglio adoperato: dove Michelagnolo desiderava che tal sepoltura si mettessi in una delle nicchie dove è oggi la colonna dei spiritati, che era il luogo suo; ed io mi ero adoperato, che Giulio terzo si risolveva, per corrispondenza di quella opera, far la sua nell' altra nicchia col medesimo ordine che quella di papa Paulo; dove il frate che la prese in contrario, fu cagione che la sua non s'è mai poi finita, e che quella di quello altro pontefice non si facessi; che tutto fu pronosticato da Michelagnolo' (Guglielmo arranged to put it in St. Peter's, under the first arch of the new church, beneath the tribune; this obstructed the floor of the church, and was certainly not the best place. Because Michelangelo quite rightly advised that it could not stand there, Guglielmo fell out with him, thinking that he was doing this out of envy; but he later realised that Michelangelo had been right, and that it was he himself who had been in the wrong, since he had had the opportunity and yet had not finished it, as I shall tell presently. And I myself bear witness to this, because in 1550 I had gone by order of Pope Julius III to Rome to work for him, which I did willingly out of affection for Michelangelo, and so took part in this discussion. Michelangelo wanted the tomb put in one of the niches, where the Column of the Possessed now is, and that was the best place; and I had contrived that Julius III should decide, so as to balance the other work, to have his own tomb made in the other niche after the same design. But in this Guglielmo, who set himself against it, was responsible for his own work being unfinished, and also for the other Pope's tomb not being made; and Michelangelo had predicted all this). The subsequent history of the monument is not altogether clear. On 16 August 1553 a contract was entered into with Giovanangelo Gellato for the construction of the tomb. Prior to this time it had been agreed between Michelangelo and the Cardinal of Santa Croce that it should stand 'ne la cappella del Re de l'entrare a man manca, con disegno che dirimpetto ve n'abbia da stare un altro per un altro Pontefice.' A document of 6 April 1554 states that the foundations were to be laid in a few months, but that objections might be raised by Michelangelo. Before 25 November 1553 the statue of the Pope had been placed in the first arcade of the new tribune of St. Peter's. After the deaths of Michelangelo (1564) and Annibale Caro (1566) Pope Gregory XIII authorised the erection of the tomb as a free-standing monument in the right aisle of the new basilica. A drawing by Grimaldi (Cod. Vat. Barb. 2733) shows the tomb as it was set up at this time, with two allegories in front and two behind. The tomb was subsequently transferred to the pier beneath the cupola which now houses the St. Andrew of Duquesnoy; at this time (1587) the pairs of allegories were shown above each other on the front of the monument. In 1628 the tomb was finally transferred to the apse of the church as a pendant to the Urban VIII monument of Bernini. At this time two of the allegories (Peace and Abundance) were removed from the tomb; these statues are now in the Palazzo Farnese. At the same time the base of the monument was reduced; the reliefs of Faith and Fortitude (which are recorded in drawings by Grimaldi) and two of the four putti have disappeared. There is some additional visual evidence for the stages through which the design of the monument passed, in the form (i) of a drawing by Guglielmo della Porta at Düsseldorf (see G. Gronau, 'Über zwei Skizzenbücher des Guglielmo della Porta in der Düsseldorfer Akademie', in *Jahrbuch der Preuszischen Kunstsammlungen*, xxxix, 1918, pp. 171–200) showing the effigy of Paul III incorporated in a wall monument beneath a baldacchino, and (ii) of a Michelangelesque drawing in the Ambrosiana at Milan identified by Steinmann as a version of a scheme by Michelangelo for a fresco above the niche in the cupola pier now containing the Longinus, in which he wished the Paul III statue to be displayed.

Plate 101: POPE PAUL III
Museo Nazionale di Capodimonte, Naples

Made of white marble and giallo antico, the bust appears to have been carved in 1546–7, and is probably identical with 'un ritratto del papa' for which a payment was made on 23 December 1546 (for this see Bertolotti, 'Speserie segrete e pubbliche di Paolo III', in *Atti e memorie per le provincie dell'Emilia Sez. Modena*, iii, 1878, p. 207, and Gramberg, 'Die Hamburger Bronzebüste Paul III Farnese von Guglielmo della Porta', in

Festschrift für Erich Meyer zum 60. Geburtstage, Hamburg, 1959, pp. 160–72), and with a bust recorded in 1568 in the possession of Cardinal Farnese (for this see *Documenti inediti per servire alla storia dei musei d'Italia*, i, 1878, p. 73). An inferior workshop bust in which the head is a replica of the present bust but which lacks the decoration on the cope, is also in the Museo di Capodimonte (H. 73 cm.). A small bronze bust, which is possibly prior to the two marbles, and which is also known in a number of inferior variants, is in the Museum für Kunst und Gewerbe, Hamburg, and a third unfinished marble bust, which was also in Farnese possession, is in the Museo di San Martino, Naples, On the front of the cope are figures of Abundance, Peace, Victory and Justice, and on the shoulders are reliefs of (*right*) Moses and the Tables of the Law, and (*left*) Moses and the dead Egyptians. The political significance of the two last scenes is discussed by Gramberg.

ANNIBALE FONTANA
(b. 1540?; d. 1587)

Of Milanese origin, Annibale Fontana was active initially as a gem engraver. He appears to have been trained as a sculptor in Rome, and was active in 1570 in Palermo in association with the Sicilian sculptor Vincenzo Gaggini. Returning to Milan, he was employed after 1574 on the sculptures of S. Maria presso San Celso (see Plate 102 below). In Milan he enjoyed a considerable practice as a bronze caster, producing four great candlesticks for the Certosa at Pavia (1580) and works for S. Fedele in Milan and for Bergamo.

BIBLIOGRAPHY: Venturi (X-iii, pp. 466–82), and the article by Kris noted below.

Plate 102: THE ASSUMPTION OF THE VIRGIN
S. Maria presso S. Celso, Milan

The façade designed by Alessi for S. Maria presso San Celso in Milan (Fig. 144) was completed in 1572, and a year later Stoldo Lorenzi was engaged to supply the sculptural decoration (for this see E. Kris, 'Materialien zur Biographie des Annibale Fontana und zur Kunsttopographie der Kirche S. Maria presso S. Celso in Mailand', in *Mitteilungen des Kunsthistorischen Instituts in Florenz*, iii, 1919–32, pp. 201–53). By 1575 two statues by Stoldo Lorenzi, an Adam (now in the Museo Civico, Milan, based on the Adam of Bandinelli) and an Eve, both destined for the niches at the base of the façade, were complete. Between 1575 and 1578 the sculptor seems to have been mainly engaged on four figures destined for niches in the interior of the church beneath the cupola, but in the latter year he resumed work on the façade, carving the Annunciation over the entrance (1578). By 31 December 1581 he had completed a further figure of Ezechiel for the façade, as well as reliefs of the Adoration of the Magi and the Flight into Egypt. Early in the following year he left Milan for Tuscany. Concurrently Annibale Fontana (who entered the service of the Fabbrica in 1574, a year after Stoldo Lorenzi) was also employed on sculptures for the façade and interior of the church. The sequence of Fontana's work on the façade is represented by statues of Isaiah and Jeremiah (1575–6), two reclining figures of Sibyls beneath Stoldo Lorenzi's Annunciation over the central doorway (1577), a large relief of the Adoration of the Shepherds above the entrance (1580), a statue of Zacharias and a relief of the Presentation in the Temple (1582), and the figure of the Virgin at the apex of the façade (1584) and two angels nearby (1587). In the interior of the church two statues of (*left*) St. John the Baptist and (*right*) Elias were completed for niches beneath the cupola by Stoldo Lorenzi, who was also responsible for carving four scenes from the life of the Virgin above the niches. A third statue (*right*) of St. John the Evangelist was carved by Annibale Fontana. The fourth niche (*left*) is blocked by the Altar of the Virgin, which is set at right angles to the presbytery. For this Fontana undertook a Virgin of the Assumption with two Angels (completed 1586), to which two angels holding a crown above the Virgin's head were later added by Giulio Cesare Procaccini.

LEONE LEONI
(b. 1509; d. 1590)

Born of Aretine stock about 1509, Leoni was an established artist in 1537, when he was engaged at Padua on a medal of Bembo. At this time he was in touch with both Aretino and Titian, of whom he prepared medals in this same year. At the end of 1537 he moved to Rome, where from 1538 till 1540 he was engraver at the papal mint. Condemned to the galleys in 1540 for his part in a conspiracy against the papal jeweller, Pellegrino di Leuti, he was freed in the spring of 1541 through the agency of Andrea Doria, of whom and of his nephew Giannetino Doria he prepared two medals and an allegorical

plaquette. From 1542 till 1545 and from 1550 till 1589 he was master of the imperial mint in Milan. In 1546 Leoni proposed that he should execute a monument to Alfonso d'Avalos, Marchese del Vasto. At the end of 1548 he left Milan for Brussels, returning late in the following year. This was followed by further visits to the imperial court at Augsburg (1551) and Brussels (1556), which yielded a number of Leoni's best-known sculptures, the Charles V restraining Fury in Madrid (Fig. 141) (commissioned 1549, figure of Emperor cast 1551, figure of Fury cast 1553, completed by Pompeo Leoni in Spain 1564), a marble statue of Charles V also in Madrid (finished by Pompeo Leoni in Spain before 1582), and bronze statues of Philip II (cast 1553), Isabella of Portugal (cast 1555) and Mary of Hungary (cast 1553) also in Madrid (see Plate 106 below). For the high altar of the Escorial Leoni, in collaboration with his son Pompeo, made a total of twenty-seven statues (despatched to Spain 1582). In addition Leoni executed a number of reliefs and busts of members of the Habsburg family, now in Madrid and Vienna. In North Italy his principal achievements are the commemorative statue of Vincenzo Gonzaga for Sabbioneta (now on the tomb of Vincenzo Gonzaga in the Incoronata), the statue of Ferrante Gonzaga at Guastalla (Fig. 142) (commissioned 1557, cast 1564, exhibited 1594), the Medici monument in Milan Cathedral (see Plate 103 below), and the decoration of the Casa degli Omenoni in Milan (see Plate 104 below). Leoni died on 22 July 1590.

BIBLIOGRAPHY: The standard monograph on Leone Leoni is that by Plon (*Leone Leoni et Pompeo Leoni*, Paris, 1887). The only available analysis of Leoni's sculptural style is provided by Venturi (X-iii, pp. 399–465). A useful account of the Casa degli Omenoni is provided by U. Nebbia (*La Casa degli Omenoni in Milano*, Milan, 1963). F. Sricchia Santoro (*I Leoni*, in I Maestri della Scultura, No. 55, Milan, 1966) provides some excellent colour plates of works by Leone and Pompeo Leoni. For the small bronzes ascribed to Leoni see a generally unconvincing article by Planiscig ('Bronzi minori di Leone Leoni', in *Dedalo*, vii, 1926–7, pp. 544–67).

Plate 103: MONUMENT OF GIAN GIACOMO DE' MEDICI, MARQUESS OF MARIGNANO
Duomo, Milan

Gian Giacomo de' Medici, Marquess of Marignano, died on 5 October 1555. In 1559 his brother, Gian Angelo de' Medici, Bishop of Ragusa, was elected Pope as Pope Pius IV, and on 12 September 1560 a contract was signed between Cardinal Morone and Gabriele Serbellone, as the Pope's representatives, and Leone Leoni, under which the latter undertook to erect the monument of Gian Giacomo de' Medici (Fig. 69) in the Medici Chapel in the right transept of Milan Cathedral. This contract (original text in Casati, *Ricerche intorno a Leone Leoni di Arezzo*, Milan, 1884, pp. 56–62, French paraphrase in Plon, pp. 304–6) bound Leoni to complete the monument in a period of two and a half years for the sum of 7,800 scudi. Two deputies, Gian Giacomo Rainoldo and Alessandro Olocato, were appointed to

ensure that the tomb as executed followed the model approved by the Pope. The contract provided for sixteen pieces of bronze sculpture, of which all but four remain on the monument; these comprise the standing figure of Gian Giacomo de' Medici in the centre, seated figures of Military Virtue (*left*) and Peace (*right*) at the sides, two swags above them and two reliefs of Dawn and Evening above the swags, two standing figures of Fame (*left*) and Prudence (*right*) in the upper section at the sides, two bronze candlesticks, and a central relief of the Adoration of the Magi. The missing elements are four consoles ('zampe') designed to support the marble sarcophagus in the now vacant area above the standing figure (see below). The contract refers to the four columns of black marble veined with white on the front of the monument, which were despatched by the Pope from Rome for use in the tomb, and to two red marble columns at the sides which were supplied from the Pope's palace in Milan. The sarcophagus, which was to be made of the same marble as the lateral columns, was either not completed or was removed soon after the completion of the monument as a result of the decision of the Council of Trent (1565) that burial should be effected beneath the pavement of churches and not in sarcophagi forming part of a sepulchral monument. According to Giussano (*Vita di San Carlo Borromeo*, Rome, 1610, p. 91), St. Charles Borromeo was responsible for removing the sarcophagus from the Medici monument: 'Per lo che fece prima in esecuzione al Concilio di Trento, levar tutti quei depositi e vani trofei: e se bene sono permessi i sepolcri di pietra, overo di metallo, volle nondimeno che fosse levata l'arca o sia deposito di bronzo del Marchese di Melegnano, suo zio, fratello di Pio IV, e ciò per dar buon esempio in questa parte' (For this reason, in execution of the edict of the Council of Trent, he first ordered that all those tombs and vain trophies should be removed. And although stone and metal tombs are permitted, he was anxious none the less that the bronze sarcophagus of the Marquess of Melegnano, his uncle, the brother of Pius IV, should be removed, in order to give a good example in this respect). An interim payment was made to Leoni in January 1563, and the tomb was finished later in this year, the concluding payment of 3,200 scudi (for which see Beltrami, 'Il monumento funerario di G. Giacomo Medici nel Duomo di Milano', in *Rassegna d'Arte*, iv, 1904, pp. 1–4) being made on 10 March 1564.

Vasari, in his life of Michelangelo states that Michelangelo was responsible for the design of the Medici monument: 'Particolarmente se ne servì nel fare un disegno per la sepultura del marchese Marignano suo fratello, la quale fu allogata da Sua Santità per porsi nel duomo di Milano al cavalier Lione Lioni, aretino, scultore eccellentissimo, molto amico di Michelagnolo, che a suo luogo si dirà della forma di questa sepoltura' (In particular he made use of him to prepare a design for the tomb of the Marquess of Marignano his brother. This was destined by His Holiness for the Duomo in Milan, and its execution was allotted to Leone Leoni of Arezzo, a most excellent sculptor and a great friend of Michelangelo. The form of this tomb will be described in the proper place). In the life of Leoni Vasari also credits the design of the monument to Michelangelo. Malespini (Novella lxxxv, in *Dugento Novelle*, Venice, 1609) prints a

variant of this story, according to which the commission for the monument was offered to, and refused by, Michelangelo, and was then, on Michelangelo's suggestion, transferred to Leone Leoni. A letter from Leoni to Michelangelo of 26 August 1562 (Frey, *Sammlung ausgewählter Briefe an Michelagniolo Buonarroti*, Berlin, 1899, p. 389) contains a reference to the monument couched in terms suggesting that Michelangelo was directly interested in its progress: 'Non uoglio neanche con questa occasione mancar di dirli, come io ho posta l'opera mia (con tutte le aduersita) piu di meza in opera nel duomo et al dispetto dei manti Esperi et mar' fortunosi et con gran sodisfatione di Sua Santita per la relatione dei deputati qui; et di piu ho tanto menato le mani questa state per questi buontempi, che ho tutte le figure che mi restano di fondere apresso ale fornaci, facendo conto il primo di settempre, a Dio piacendo, far il restante. Io credo di farmi honore, percio che non ho guardato ad auaritia, ma ho anpliato ogni cosa' (I do not want this occasion to pass without telling you, that, against all adversity, my work in the Opera del Duomo is more than half complete, in despite of the snow and floods and to the great satisfaction of His Holiness as I am told by the deputies here. Better still, this summer, in this favourable weather, I have put my hands to such good use that I have at the foundry all the figures which remain to be cast, and God willing I count on doing the rest by the first of September. I believe the work will do me honour, because I have not economised in any way, and everything has been amplified). The majority of writers on Michelangelo deny his responsibility for the Medici monument or (Tolnay) regard the monument as a reflection of his style. The case in favour of the view that the architecture of the monument goes back to a design by Michelangelo is well argued by Thode (*Michelangelo, Kritische Untersuchungen*, ii, Berlin, 1908, pp. 239–41), and is restated by A. Schiavo (*Michelangelo architetto*, Rome, 1949, n. to Pl. 22; *La vita e le opere architettoniche di Michelangelo*, Rome, 1953, pp. 97–101).

Plates 104, 105: CASA DEGLI OMENONI
Via Omenoni, Milan

In or prior to 1565 Leoni was granted a house in Via Moroni for his lifetime by the Senate of Milan. In a letter to the Senate of 24 July 1565 he complains of the hazardous condition of the house, and begs that it should be repaired before the cost becomes prohibitive. After this time it was rebuilt in the form it has today, with an entrance flanked by half-length male supporting figures, a façade punctuated at each side by three bearded supporting figures in three-quarter length, and, above the central window, a relief of a satyr devoured by two lions. In the frieze are reliefs of lions and eagles. In the inner courtyard the columns are surmounted on the left side by a frieze containing ten reliefs with the attributes of sculpture, goldsmith's work, architecture, music, and, among other subjects, a lion revolving the wheel of Fortune. The two reliefs on the extreme right of the frieze appear to have been renewed. Two bronze lion masks from the original decoration also survive; one of these is built into a modern pool in the centre of the courtyard. The identity of the three-quarter length prisoners on the façade

is indicated by inscriptions reading (*left to right*) SVEVVS, QVADVS, ADIABENVS, PARTHVS, SARMATVS, MARCOMANVS. The lion was adopted by Leoni as a personal emblem, and the satyr attacked by lions appears, as on the Guastalla monument, to represent the defeat of Envy or Vice. The barbarian prisoners on the façade seem to have been related to the presence, in the courtyard, of a cast of the Marcus Aurelius on the Campidoglio. The house is described by Vasari in the following terms: 'Il quale Lione, per mostrare la grandezza del suo animo, il bello ingegno che ha avuto dalla natura, ed il favore della fortuna, ha con molta spesa condotto di bellissima architettura un casotto nella contrada de' Moroni, pieno in modo di capricciose invenzioni, che non n'è forse un altro simile in tutto Milano. Nel partimento della facciata sono sopra a pilastri sei prigioni di braccia sei l'uno, tutti di pietra viva; e fra essi, in alcune nicchie fatte a imitazione degli antichi, con terminetti, finestre, e cornici tutte varie da quel che s'usa, e molto graziose; a tutte le parti di sotto corrispondono con bell' ordine a quelle di sopra; le fregiature sono tutte di vari strumenti dell'arte del disegno. Dalla porta principale, mediante un andito, si entra in un cortile, dove nel mezzo sopra quattro colonne è il cavallo con la statua di Marco Aurelio, formato di gesso da quel proprio che è in Campidoglio. Dalla quale statua ha voluto che quella sua casa sia dedicata a Marco Aurelio; e, quanto ai prigioni, quel suo capriccio da diversi è diversamente interpretato. Oltre al qual cavallo, come in altro luogo s'è detto, ha in quella sua bella e comodissima abitazione formate di gesso quant' opere lodate di scultura o di getto ha potuto avere, o moderne o antiche' (To prove the greatness of his spirit, the beauty of his natural talent, and the favours which fortune had poured on him, Leoni has, at great expense and with most beautiful architectural invention, built for himself a house in the contrada de' Moroni. This is full of capricious fancies, and there is perhaps no other similar house in the whole of Milan. On the façade above pilasters are six prisoners each six braccia in height made of stone, and between them are niches made in imitation of the antique, with terms, windows and cornices all different from those commonly found and very pleasing. These lower parts are admirably adjusted to those above, and the friezes are decorated with the various implements of the art of design. Through a passage leading from the main doorway one enters a courtyard, where in the centre, on four columns, is the equestrian statue of Marcus Aurelius, moulded in gesso from the original on the Campidoglio. By this statue Leoni has signified that his house is dedicated to Marcus Aurelius. As for the prisoners, this fancy had been interpreted by different people in different ways. Beside the horse, as has been said elsewhere, he has in this beautiful and commodious dwelling gesso casts of as many carvings and bronze castings, both ancient and modern, as he has been able to procure).

Plate 106: MARY OF HUNGARY
Prado, Madrid

Leoni's statue of Mary of Hungary (1505–58) is inscribed on the socle: LEO. P. POMPE. F. ARET. F. 1564. Round the base run the words: MARIA. AVSTRIA. REGINA. LVDOVICI. VNGARIAE.

REGIS. The statue is mentioned in a letter from Ferrante Gonzaga to the Emperor Charles V on 28 December 1553: 'Ho più uolte uoluto scriuere a la M. V. de l'opere di scoltura fatte da Leone Aretino, ma per le sue occupationi de la guerra più graui mi son ritenuto infin ad hora; et non è stato se non bene il retardare questo officio insin a qui, percioche egli ha fatto in questo più di tempo più opere. . . . Se mal non mi ricorda sono quattro anni che egli cominciò a lauorare. In questo tempo ha fatte et fondute quattro statue di metallo, et le tre di esse di altezza naturale, l'una è di V. M. la quale et per le attitudini, et per lo artificio grande che ui è, è tenuta per cosa singolare. A piedi di questa giace l'altra statua fatta per lo Furore. . . . La terza statua è del Principe mio Sre già rinettata; sopra essa sono molti uaghi abbigliamenti; et con molto giudicio accomodati; et è cosa rara. La quarta è de la Serma Reina Maria fatta insieme con la precedente a sua richiesta et questa non mi pare punto inferiore a le altre' (I have often wanted to write to Your Majesty about the works of sculpture done by Leone of Arezzo, but I have delayed doing so till now because of your more serious occupations in war; and postponing this duty until now has been for the good, because in this greater length of time he has done a greater number of works. . . . If I do not mistake, it is now four years since he began working. In this time he has made and cast four statues of metal, three of them life-size; and one of them is of Your Majesty and is held a marvellous piece, both for its demeanour and its skill. At its feet lies the second statue, representing Fury. . . . The third statue is of My Lord the Prince, and it has already been polished; there are many charming decorations above it, set out with great judgement, and it is a thing of rare quality. The fourth is of the Most Serene Queen Mary, done together with the preceding one at her request, and it seems to me in no way less good than the others) (for full text see Plon, pp. 368–9). A letter of Leoni to Ferrante Gonzaga of 10 November 1553 seems to imply that the statue was not yet cast at that time. On 14 August 1555 Leoni outlined to Granvella a project for shipping to Flanders 'sei pezzi, senza le due statue de la Sᵐᵃ Reina che intenderei parimente di portare'. The despatch of the statues seems to have been deferred as the result of a letter of 12 October 1555, but on 27 December 1555 Leoni was instructed by Granvella to proceed to Flanders with his statues as rapidly as possible. Leoni left Milan on or after 11 February 1556, and the statue of Mary of Hungary seems to have been transported to Brussels at this time. It was completed by Pompeo Leoni in Madrid. With the statue of Philip II referred to above, it subsequently decorated the façade of a house in the garden of San Pablo de Buen Retiro, both figures flanking the group of Charles V triumphant over Discord now in the Prado, Madrid.

POMPEO LEONI
(b. ca. 1533; d. 1608)

Born ca. 1533 and trained by his father Leone Leoni, Pompeo Leoni was employed at Innsbruck in 1551 by Granvelle. He visited Brussels with his father in 1556, later accompanying Leoni's sculptures to Spain. Arriving shortly after the abdication of the Emperor Charles V, he was taken into the service of the regent, Juana of Austria, and was employed on the completion of his father's sculptures, some of which are inscribed jointly as the work of the two artists. From the documents it transpires that the bronze sculptures lacked much of their detail – a Spanish silversmith, Miguel Mendez, was, for example, employed on the dress of the statue of Isabella of Portugal – and that the marble sculptures were blocked out and in part carved at Genoa. A marble statue of Isabella of Portugal in the Prado, Madrid, is signed by Pompeo Leoni alone and dated 1572. After a short period of imprisonment at the hands of the Inquisition, Pompeo Leoni settled in Madrid, where he played an important part in the decorations for the marriage of Philip II and Anne of Austria (1570), and carved the kneeling figure of Juana of Austria for her monument in the Descalzas Reales, Madrid (1574), the Valdes monument at Salas (commissioned 1576), and the tomb of Cardinal Diego de Espinosa at Martin Munoz de las Posadas (commissioned 1577). In 1579 he received a contract for the high altar of the Escorial, returning to Milan in 1582 to execute the sculptures for it jointly with his father. In 1589 he returned to Spain to complete the Escorial altar (1591), and thereafter was engaged on the monumental groups of Charles V and Philip II and their families in the Escorial (see Plate 107 below). Pompeo Leoni died on 13 October 1608.

BIBLIOGRAPHY: As for Leone Leoni. A booklet by B. G. Proske (*Pompeo Leoni: work in marble and alabaster in relation to Spanish sculpture*, New York, 1956) gives a useful analysis of Pompeo Leoni's career in Spain, and distinguishes between his style and that of his father.

Plate 107: MONUMENTS OF THE EMPEROR CHARLES V AND KING PHILIP II OF SPAIN
Escorial

After the completion of the sculptures for the high altar of the Escorial (1591), Pompeo Leoni was entrusted by Philip II with the bronze figures destined for the monuments of Charles V and Philip II to left and right of the Capilla Mayor of the church. The commission is first mentioned in the future tense in a letter of Pompeo Leoni to Ferrante II Gonzaga, Duke of Guastalla, of 2 February 1591, where it is also stated that the King wished the

work to be undertaken in Madrid so that he and his son might watch its progress. The two projected groups comprised (*left*) Charles V kneeling at a prie-dieu with his wife, the Empress Isabella, and, behind, his sisters, Eleanora of France and Mary of Hungary, and his daughter, Mary, wife of the Emperor Maximilian, and (*right*) Philip II kneeling at a prie-dieu with his fourth wife, Anne of Austria, and, behind, Isabella of Valois and Mary of Portugal, respectively third and first wives of King Philip II, and his son, Don Carlos. The progress of the work can be established from a contract (for the Spanish text of which see Plon, pp. 419–20) of 23 April 1597, which describes the five figures for the tomb of Charles V as already cast and in course of retouching, and obliges the sculptor to deliver the prie-dieu and the five figures for the tomb of Philip II by the end of June of the following year. The cloak for the figure of Philip II was to be delivered by May 1597, so that the necessary gems could be added to it. When the figures were complete, they were to be set in position by Pompeo Leoni. If the work were accelerated, the artist would receive an additional sum of two hundred ducats for each month saved. The figures were completed and set in place in May 1598, shortly before the death of Philip II.

All sources observe that the imperial mantle of Charles V and the royal mantle of Philip II (like the armour of Leone Leoni's statue of Charles V triumphant over Discord in the Prado) could be removed. Among the artists employed in a specialised capacity on the two tombs may be noted the Spaniard Martin Pardo, who was responsible for gilding the bronze figures and shields, Jacopo da Trezzo the Younger, who, with Giovan Paolo Cambiagio, undertook the incrustation of the mantle of Philip II and the shield above this tomb, Giulio Miseroni, who prepared the imperial shield, Milano Vimercado and Baldassare Mariano, who worked on the prie-dieu and figures for the tomb of Philip II, and Leoni's son, Miguel. The two tombs represent a synthesis of the kneeling figures which occur in many earlier Spanish tombs (e.g. the statues of Don Alonso de Castille at Miraflores and of Don Juan de Padilla at Frex del Val) and the style of bronze portraiture evolved in Milan by Leone Leoni. They are related by Panofsky (*Tomb Sculpture: four lectures on its changing Aspects from Ancient Egypt to Bernini*, New York, 1964, p. 80) to the tradition establishment by the tomb of Francis I by Philibert de l'Orme and Pierre Bontemps at Saint-Denis.

JACOPO SANSOVINO
(b. 1486; d. 1570)

See p. 350.

Plates 108, 109: LOGGETTA
Piazza San Marco, Venice

In 1489 the Loggetta at the base of the Campanile facing the entrance to the Ducal Palace (which was used as a ridotto by the patricians of Venice) was damaged by a thunderbolt. Temporary repairs were effected, but in 1511 it was again damaged, on this occasion by an earthquake. Finally, in August 1537 it was once more damaged by a thunderbolt, and later in the same year the construction of a new Loggia was entrusted by the Signoria to Sansovino. The Loggia (for which see G. Lorenzetti, 'La Loggetta al Campanile di S. Marco: notizie storico-artistiche,' in *L'Arte*, xiii, 1910, pp. 108–33) is mentioned on 20 November 1537 in a letter from Aretino to Sansovino: 'che bel vedere farà l'edificio di marmo e di pietre miste ricco di gran colonne che dee murarsi appresso la detta (Libreria)! e gli havrà la forma composta di tutte le bellezze dell'architettura servendo per loggia, nella quale spasseggeranno i personaggi di cotanta nobiltade' (What a fine sight the building to be constructed opposite the Libreria will be, with its marble and variegated stone, enriched with great columns! Its form will be a blend of all the beauties of architecture, and it will serve as a loggia for people of proper nobility to stroll in). Work on the construction of the Loggia was begun at the end of 1537, and by January 1539 the structure was far enough advanced for the introduction of the figurated reliefs. At the end of 1540 the Loggia (Fig. 101)

was complete. Its principal sculptural decoration, the four bronze figures in the niches of the façade, are mentioned for the first time in February 1540, and were completed by 10 February 1545. A terracotta group of the Virgin and Child with the young St. John, now in the Palazzo Ducale but previously in a niche in the interior of the Loggia for which it was destined by Sansovino, was put in position before 20 March 1565.

The original form of the Loggetta is represented in an engraving by Giacomo Franco (Fig. 102), showing the façade with three open arches, that in the centre approached by a flight of five steps, and those at the sides closed by marble balustrades. Between 1653 and 1663 an extensive restoration of the Loggetta was carried out, perhaps under the supervision of Longhena, the most important feature of which was the addition of a terrace in front closed by a balustrade of red marble columns; the balustrades barring access to the lateral archways were removed at this time. This phase in the history of the Loggetta is illustrated in an engraving by Carlevaris. In the eighteenth century further restorations became necessary, and in 1732 it was decided to close the entrance to the terrace ('chiudere l'ingresso della Lozetta con una balaustrata'). The contract for this was awarded on 16 March 1733 to Antonio Gai, who completed the present bronze gate by 28 August 1735. A report on the condition of the fabric was prepared in 1749 by Giorgio Massari, which recommended, among other points, that the upper part of the Loggetta, which had hitherto terminated at the outer edge of the lateral arches beneath, should be extended to cover the whole length of the lower part of Sansovino's structure. On 14 Sept-

ember 1749 Massari's proposals were agreed to, and the additional reliefs by Gai to left and right of the façade and on the ends of the Loggetta were completed in the following year. The original sculptural decoration of the Loggetta comprises: (i) four bronze statuettes in the niches of the façade representing (*left to right*) Pallas, Apollo, Mercury and Peace: (ii) four small reliefs above the niches; (iii) four small reliefs below the niches representing (*left to right*) two scenes from the legend of Venus alluding respectively to the Dardanelles and Cyprus (Selvatico), the Fall of Helle and Thetis succouring Leander; (iv) a number of reliefs of marine deities on the bases of the columns; (v) six Victory figures in the spandrels of the arches; and (vi) three large oblong reliefs above representing (*left to right*) Jupiter on the Island of Candia, Venus with two River Gods, and Venus on the Island of Cyprus, separated by two reliefs with putti and trophies. Vasari mentions three pupils of Jacopo Sansovino as working on the sculptures of the Loggetta; these are Girolamo Lombardo, Tiziano Minio and Danese Cattaneo. Of the sculptures enumerated above (**ii**) are given by Lorenzetti to Girolamo Lombardo, (**iii**) to Tiziano Minio, (**iv**) distributed between these two artists, and (**vi**) ascribed to Tiziano Minio (left and centre relief) and Danese Cattaneo (right relief). These attributions are correct, save that the central upper relief is a substantially autograph work by Sansovino.

An account of the imagery of the Loggetta is given by Francesco Sansovino: 'A pie del campanile dirimpetto alla porta di Palazzo è situata la Loggetta antica per instituto, & rouinata del 1489. per la furia d'vna saetta, la quale percotendo la cima del campanile mandò tanta materia a terra, che distrusse quasi ogni cosa. Rifatta adunque con l'architettura del Sansouino bene ordinata & intesa di lauoro Corinthio, ha nella faccia sua ornamenti di molto artificio con significati esquisiti. Percioche nelle nicchie che sono a punto quattro, vi sono quattro statue di bronzo di mano del detto Sansouino. L'vna figurata per Pallade, l'altra per Apollo, la terza per Mercurio, & la quarta per la Pace. Diceua l'auttore di esse statue, quando rendeua ragione della fattura & del ritrouato loro, che la Città di Venetia, ha di gran lunga auanzato tutte l'altre Rep. con la diuturnità del tempo, col mezzo del suo marauiglioso gouerno, & essendo nel suo primo stato. Questo mantenimento (diceua egli) non può dirsi che sia proceduto da altro effetto, che da vna somma sapienza de suoi Senatori, conciosia che hauendole dato buon fondamento con la religione & con la giustitia, è durata e durerà lungamente. Hauendo dunque gli antichi figurata Pallade per la sapientia, ho voluto (diceua egli) che questa figura sia Pallade armata, & in atto pronto, & viuente, perche la sapientia di questi Padri, nelle cose di Stato è singolare & senza pari alcuno. Et fauellando poi della statua del Mercurio soggiugneua. Et perche tutte le cose prudentemente pensate & disposte, hanno bisogno d'essere espresse con eloquenza, percioche le cose dette con facondia, hanno molto più forza ne gli animi di coloro che ascoltano, che quelle che si espongono senza eloquenza, & in questa Rep. la eloquenza ha sempre hauuto gran luogo, & gli huomini eloquenti vi sono stati in numero grande & in sommo grado di riputatione: ho voluto figurar Mercurio, come significatio delle lettere & della eloquenza. Quest'altro ch'è Apollo, esprime, che si come Apollo

significa il Sole, & il Sole è veramente vn solo & non piu, & però si chiama Sole, cosi questa Rep. per constitutioni di leggi, per vnione, & per incorrotta libertà è vna sola nel mondo senza piu, regolata con giustitia & con sapienza. Oltre a ciò si sa per ognuno, che questa natione si diletta per ordinario della musica, & però Apollo è figurato per la musica. Ma perche dall' vnione de i Magistrati che sono congiunti insieme con temperamento indicibile, esce inusitata harmonia, la qual perpetua questo ammirando gouerno, però fu fabricato l'Apollo. L'vltima statua è la Pace. quella pace tanto amata da questa Rep. per la quale è cresciuta à tanta grandezza, & la quale la constituisce Metropoli di tutta Italia, per i negotij da terra & da mare. quella pace dico, che il Signor diede al Protettor di Venetia, San Marco, dicendoli, "Pax tibi Marce Euangelista meus." La quale, dalla religione, della giustitia, & dall'osseruanza delle leggi, prouiene in quella maniera che esce il concento da vna ben concorde harmonia, così diceua egli. Ne i tre quadri di basso rilieuo posti di sopra alle predette quattro figure si contiene il dominio & la Signoria di terra ferma & di mare. Conciosia che nel quadro di mezzo siede vna Venetia in forma di Giustitia, sotto alla quale sono distesi i fiumi che versano acqua, & questi rappresentano le città di terra. Nell'altro quadro dalla parte di mare è scolpita Venere significatiua del Regno di Cipro, come quella che la Dea & Regina di quel Regno. Dall'altro lato è vn Gioue che fu Rè di Candia, la cui sepoltura, come afferma Lattantio Firmiano, stette lungamente in quell' Isola, & appresso vi è il Laberinto, doue habitaua il Minotauro. & accioche si conosca che la figura sia Gioue, vi è vna Aquila in aria che gli porge la Verga reale, & tutte queste cose sono espressiue dell' Isola di Candia. In faccia della porta maestra cioè nella Loggia, è collocata vna nicchia sopra il seggio dei Procuratori, nella quale è vna Imagine di Nostra Donna con San Giouanni Battista bambino di tutto tondo, tenuta in molto pregio da gli intendenti, & fu di mano d'esso Sansouino. Seruiua la predetta Loggia ne gli anni andati per ridotto de nobili, i quali ne tempi cosi di verno, come di state, vi passauano il tempo in ragionamenti. Ma cessato quell'vso, stà serrata per la maggior parte, fuori che ne giorni che si fa gran Consiglio. Percioche allora i Procuratori (toccando la volta a vicenda ad ogni Procuratia) vi stanno alla guardia, sino che i nobili escono di Consiglio' (The Loggetta stands at the foot of the campanile, opposite the gate of the Ducal Palace, and is of ancient origin; it was destroyed in 1489 by the violence of a thunderbolt, which struck through the top of the campanile and brought down so much masonry, that it ruined almost everything. It was rebuilt on Sansovino's well-arranged and clever design in the Corinthian order, and it has on its façade decorations of great skill and recondite meaning. For there are four bronze statues from Sansovino's hand in the four niches: the first represents Pallas, the second Apollo, the third Mercury, and the fourth Peace. The author of these statues, explaining their making and invention, said that the city of Venice has by far surpassed all other republics in length of time, by means of its admirable government, and by being still in its first condition. 'This continuity,' he said, 'can only be said to have come from one cause, namely its Senators' unsurpassed wisdom; because they have given it a good foundation in religion and justice, it

has lasted and will last a long time. Since the ancients represented Pallas as Wisdom, I decided that this figure should be Pallas, armed and in an alert and lively attitude, because the wisdom of these elders of ours in public affairs is unique and without rival.' Speaking next of the statue of Mercury, he went on: 'Since everything thought and worked out needs to be expressed eloquently, because things said with eloquence have far more effect on the minds of the hearers than those expounded without it; and since eloquence has always had an important place in this Republic, eloquent men being many here and of very great repute, I decided to portray Mercury to stand for letters and eloquence. This next figure, Apollo, signifies that, just as Apollo stands for the Sun, and the Sun (Sole) is truly single (solo), for this reason being called Sole, so this Republic is unique in the world, through its constitution, unity and complete liberty, governed with justice and wisdom. And the Apollo was made because a rare harmony, making this admirable government secure, issues from the unity of the magistrates, joined together as they are in inexpressible concord. The last statue is Peace, that Peace so loved by this Republic and through which it has grown so great and become the business Metropolis by land and sea for the whole of Italy. And it is, I say, that Peace which Our Lord gave to St. Mark, the patron of Venice, when he said to him: "Peace to you, Mark, my Evangelist." And it so springs from religion and the observance of the laws, that a general unanimity issues from the concordant harmony.' In the three panels in low-relief above these four figures are the dominion and seigniory over the terra ferma and the sea. For a figure of Venice in the shape of Justice sits in the central panel, and beneath her recline river-gods pouring water, representing the cities of the terra ferma. In the second panel, representing the sea, Venus has been carved to stand for the Kingdom of Cyprus, for she was Goddess and Queen of that Kingdom. On the other side is a Jupiter, King of Crete, whose tomb, according to Lactantius Firmianus, was long on that island, and the labyrinth in which the Minotaur lived is nearby; and so that one may recognise the figure as Jupiter, there is an eagle in the air, holding a sceptre out to him, and all these things represent the island of Crete. There is a niche inside the Loggetta, on the wall of the main door above the seat of the Procuratori, and in it is a figure of Our Lady with St. John the Baptist as a child, done in the round; it is held in high esteem by the knowledgeable and it too is by Sansovino. The loggia served for many years as a ridotto for the nobles, who both in winter and summer spent the time in conversation there. But since this practice ceased, it has been for the most part shut up, except on days when there is a Gran Consiglio, when the Procuratori stand on guard there, each Procuratoria in turn, till the nobles leave the Consiglio).

Plate 110: SACRISTY DOOR
St. Mark's, Venice

The bronze door designed by Sansovino for the entrance to the sacristy of St. Mark's is concave, and is planned in two registers. In the upper register is a relief of the Resurrection, flanked by two Evangelists (*left* St. John the Evangelist, *right* St. Matthew) in niches, with their symbols beneath and two playing putti above. In the lower register is a relief of the Entombment with (*left*) St. Mark and (*right*) St. Luke. Across the top and bottom of the door and between the two narrative reliefs run three horizontal strips containing in the centre a reclining Prophet flanked by pairs of playing children, and at the sides protruding male heads.

The account of the door by Francesco Sansovino reads as follows: 'Dalla sinistra s'entra nella Sagrestia, la cui porta di bronzo scolpita di basso rilieuo dal predetto Sansouino, contiene la morte, & la resurrettione di Christo, con i Vangelisti & i Profeti su cantonali, opera di venti anni quanto a fattura, & di valore infinito quanto a prezzo, & degnissima d'ogni lode quanto a Scoltura. nella quale per la sua molta bellezza, Federigo Contarini Procurator della Chiesa, ui fece, come in cosa nobiliss. & per douere essere eterna, intagliare queste parole.

Deo D. Marco Federicus Cont. D. Marci Proc. Sancto eius Aerario Praefectus, erigi curauit.

& piu sotto vi si legge.

Opus Iacobi Sansouini.

Nella quale opera si dee notare, oltra allo artificio delle figure che vi sono, le prospettiue dei paesi di basso rilieuo, fatte à sembianza di pittura. & che nelle teste infuori, vi sono i ritratti d'esso Iacomo, di Titiano Pittore, & di Pietro Aretino, che furono strettissimi amici insieme nel tempo loro' (On the left one enters the sacristy, whose bronze door in low relief by the aforesaid Sansovino contains the death and resurrection of Christ, with the Evangelists and Prophets at the corners. This work took twenty years to make, and is of infinite value as to price, and worthy of every praise as sculpture. On account of its great beauty Federigo Contarini, the procurator of the church, ordered that as a most noble thing which would endure for ever it should be inscribed with the words:

Deo D. Marco Federicus Cont. D. Marci Proc. Sancto eius Aerario Praefectus, erigi curavit.

Beneath is the inscription:

Opus Iacobi Sansouini.

In this work should be noticed, beside the skill of the figures, the perspectives of the landscapes in low relief, depicted as though in painting, and the fact that the heads contain portraits of Jacopo himself, Titian the painter and Pietro Aretino, who were all very close friends in their time). The door was commissioned in 1546 by the Procurators of St. Mark's, on the basis of a wax model prepared before this time, probably in the preceding year. A number of payments of 9 February 1546 refer to the making of a wooden door for the Sacristy, to the completion of the wax model by Sansovino's pupil, Tommaso Lombardo, to the purchase of gesso in connection with the moulding of the door, and to the preparation of gesso casts of the narrative scenes, single figures, putti and heads. A payment of May 1546 'a Alessandro (Vittoria) et a Antonio scultori per havermi aiutato a nettare le ditte historie et figure di cera' seems to represent the final stage of work on the model. The model was cast at some time between this date and 9 August 1553 when a payment was made to Agostino Zotto of Padua for work on the bronze cast ('Io Aug. scultor da Padua ha ricevuto adi sop. da

M. Jao. Sansovino duc. vinti a ben conto de buttare l'historie e figure della porta della sagrestia di S. Marco'). Further payments to Agostino Zotto in connection with the door occurred on 22 January 1555, 22 May 1555, and 26 May 1556, with a concluding payment on 4 February 1563. In November 1569 the door was fully assembled, and on 4 November 1572 it was set in place.

Plate 111: TRIBUNE RELIEFS
St. Mark's, Venice

The two tribunes or singing galleries to right and left of the choir of St. Mark's were designed by Sansovino, and incorporate eight bronze reliefs, three narrative reliefs on the face of each gallery and, on the ends of the galleries facing the body of the church, two upright reliefs with seated figures of St. Mark. The narrative reliefs on the two tribunes represent: (*right*) St. Mark baptising Amianus and his companions in Alexandria, St. Mark dragged through the streets as stones shower upon the unbelievers, St. Mark curing a woman possessed of a devil; (*left*) St. Mark saving from death a servant of the Lord of Provence, the servant and people praising the Saint, and the conversion of the Lord of Provence. There is some doubt as to the subject matter of the reliefs on the left tribune (for this see G. Lorenzetti, 'Jacopo Sansovino scultore: note e appunti', in *Nuovo Archivio Veneto*, xx, 1910, pp. 332–3). The first of the two tribunes, that on the right, was already under construction on 15 February 1537 when a payment was made 'a Thomaso scultore per haver lavorato su la nostra donna de marmo et in sul pergolo della chiesa' (for this and other documents see Weihrauch, *Studien zum bildnerischen Werke des Jacopo Sansovino*, Strassburg, 1935, pp. 90–1). Sansovino's reliefs are mentioned for the first time in a letter to the sculptor from Pietro Aretino on 20 November 1537 (*Lettere sull'arte di Pietro Aretino*, i, Milan, 1957, p. 83): 'Dove è quella mirabile Madre di Cristo, che porge la corona al protettore di questa unica patria? L'istoria del quale fate vedere di bronzo con mirabile contesto di figure, nel pergolo de la sua abitazione; onde meritate i premi e gli onori dativi da le magnificenze del serenissimo animo dei suoi riguardanti divoti' (Where is that wondrous Mother of Christ, who proffers the crown to the protector of this unique city? That protector whose history you have shown us in bronze, with a wondrous quality of figures, in the tribune of his abode. For these scenes you merit the prizes and honours that have been accorded you by the magnificences for the most serene mind of your devoted onlookers). The reliefs must have been virtually completed by this time, since the final payment for them was made on 12 December 1537 ('a mistro Jacomo Sansovino nostro protto per tanti spese nelle scolture de bronzo del pergolo fatto novamente in essa giesia in Choro cioe a mistro Zuane Campanaro et titiano per bronzo et loro fatiche ducati 78, e Thomas scultor ducati 56 a lucha scultor ducati 45 a aluise et mistro francesco et Dominego ducati 36 come per poliza del ditto protto adi 10 ditto apar'). The reliefs of the left hand tribune were executed between 1541 and 1544. The course of work on these reliefs can be established in greater detail than

with the earlier series. On 1 March 1541 a sum of fifty lire was provided by the Procuratori for the purchase of wax 'per far le historie del percolo rincontro a quello di coro fatto di bronzo nella chiesa di S. Marco', and on 15 September 1541 and 18 September 1541 payments were made respectively to Tommaso Lombardo and Sansovino for work on the wax reliefs. On 15 November 1542 a sum was allocated 'per libre 450 di metallo per buttar le ditte historie', and on 7 December 1542 a payment was made 'a maestro Gianni Campanaro per aver buttato 2 historie et una ributtata et un San Marco'. Sansovino was paid on 14 July 1543 'per haver lavorato a rinettar le ditte historie di bronzo'. Payments to unidentified craftsmen 'per haver lavorato a rinettar le ditte Istorie' were made on 5 November 1543 and 15 July 1544, and on 14 February 1544 a small sum was paid to Campanaro 'per haver buttato il San Marco'. These documents show conclusively that all the reliefs for the first tribune were modelled in or before 1537, and that all the reliefs for the second tribune were complete by November 1542. The reliefs are signed across the base JACOBVS SANSOVINVS FLORENTINVS FACIEBAT or JACOBVS SANSOVINVS FLORENTINVS F.

Plate 112:
THE MIRACLE OF THE MAIDEN CARILLA
Sant' Antonio, Padua

The first sculptural task allotted to Sansovino after his arrival in Venice was the completion of an unfinished relief by Antonio Minelli destined for the Chapel of St. Anthony in the Santo at Padua. This relief (which conformed in size and style to the reliefs already installed in the Chapel, and represented the Miracle of the child Parrasio) had been begun by Antonio Minelli in 1512 and was still unfinished in 1528, when it was entrusted to Sansovino ('1528. Mo. Jacopo Sansovin die havere per fornire el quadro haveva comenzato el q. ser. zuan de Minelo'). In these years Minelli received two thirds of the total sum due to him for the relief, and in 1528 the relief must therefore have been roughly two thirds complete. Two payments of 25 and 100 ducats were made to Sansovino on 4 May 1532 and in 1533, and the concluding payment dates from 28 August 1534. Analysis of the payments shows that Sansovino received not only the balance of the third part of the sum agreed for the relief, but a substantial bonus, and it is likely, from these payments alone, that in addition to completing the unfinished parts of the relief he reworked a number of Minelli's figures. This hypothesis is confirmed when the relief is compared with the Reception of St. Anthony into the Franciscan Order, for which Antonio Minelli was solely responsible, and which was completed in 1512. Thus the figures on the left side of the relief are substantially Minelli's, but the head of the Saint seems to have been recut and modified by Sansovino. Also in large part by Sansovino is the man holding a net in the centre of the scene, the kneeling figure of the mother in the centre and the standing woman and child to her right. In 1536 Sansovino was awarded the contract for a second relief of the Miracle of the Maiden Carilla (Fig. 114), which had originally been assigned to

Tullio Lombardo, for a total sum of L. 1860 ('1536. Ms. Jacomo Sansovin scultore excellentissimo sta in Venetia die avere per fare un quadro de marmoro qual doveva fare el q. Tulio Lombardo con el miracholo de la donna anegata con el santo Antonio in aria, dandoghe nui (massari) i marmori et e obligato a meter el suo nome scholpito sotto ditto quadro; et questo per pretio di ducati tresento a L.6 s.4 per ducato; et tanto piu quanto parera al magnifico mess. Jacomo Cornaro et magnº mess. Federigo de Priuli ec., come appare per scritto fatto per mano de ser zuan de' Zaghi canceliero del magnº. mess. Jacº. Cornaro capitanio de Padoa fatto adi 3 Zugno 1536, val a moneda L.1860'). No record of payments for the relief occurs before 1557, when it is known that the sculptor had received a total of L.1184 s.4. A final payment of L.1023 was made in 1562, making in all a total of L.2207 in place of the stipulated sum (for the concluding payment see R. Gallo, 'Contributi su Jacopo Sansovino,' in *Saggi e memorie di storia dell'arte*, i, 1957, p. 91). The sequence of work on the relief does not emerge clearly from the documents, but it can be inferred that there was considerable delay in starting it (perhaps as a result of the more pressing commission for the Loggetta), that it was rather more than half finished by 1557, and that certain parts of it (including the male figure on the left) represent the sculptor's late style, and were carved between 1557 and 1562. The relief is inscribed along the base: IACOBVS SANSOVINVS SCVLP. ET ARCHITEC. FLORENT. F.

Plate 113: NEPTUNE
Palazzo Ducale, Venice

The colossal figures of Mars (Fig. 107) and Neptune carved by Sansovino for the staircase leading to the Ducal Palace are mentioned by Vasari at a time when they were still incomplete: 'All'entrare delle scale del palazzo di San Marco fa tuttavia di marmo in forma di due giganti bellissimi, di braccia sette l'uno, un Nettuno ed un Marte, mostrando le forze, che ha in terra ed in mare quella serenissima republica' (At the beginning of the stairway of the palace of St. Mark's, he has made two most beautiful marble statues in the form of giants, each seven braccia high, a Neptune and a Mars, symbolising the power of the republic by land and sea). Documents relating to the two figures assembled by P. L. Rambaldi ('La scala dei Giganti', in *Ateneo Veneto*, 1910, i–ii), show that they were commissioned on 31 July 1554 ('Ritrovandosi in questa Citta dui pezi di marmoro di longhezza de piedi X incirca luno, fatti qui condur per quelli che hebbero il carico di far la stantia de palazzo che habita li serenissimi Principi, con animo di far fare in quelli due figure de ziganti da esser posti per adornamento di esso palazzo, dove meglio cascheranno, et ritrovandosi in questa citta al presente D. Jacomo Sansovino'). It was agreed by the Provedditori of the Palazzo Ducale to commission the two figures from Sansovino for a sum of 250 ducats each 'le qual figure sia obligato a far che le siano belle et ben finite in termine de uno anno proximo alla piu longa' (Since there exist in this city two pieces of marble each about ten feet long, brought here for the use of those charged with the decoration of the ducal palace,

with the intention of having made from them two figures of giants to be installed for the adornment of the palace, wherever they shall appear best, and since Jacopo Sansovino is at present resident in the city . . . he shall be obliged to carve these figures so that they may be beautiful and well finished, within the term of one year at the latest.) The statues were carved in a workshop in the Arsenale, and were completed by 12 January 1567 when there are records of payments for putting them in place ('spexe fate per il meter suxo le do figure in cima la scala di marmoro'), and to a 'mistro Bernardo' for preparing the bases on which they were to stand, and a 'mistro Beneto' for making a metal lance for the Mars and a trident for Neptune ('una zagaja e un tridente fati per mistro Beneto'), both of which have disappeared. The Protomagister of the Palazzo Ducale, Antonio da Ponte, was charged with the installation of the figures, which were set up temporarily in the position they have since occupied on the Scala dei Giganti. The two bases were left in the rough, and the decoration with which they are now carved was added in 1727–8. The uniform signatures on the two statues (OPVS. JACOBI. SANSOVINI. F.) were added at this time. A supplica presented to the Signoria by Francesco Sansovino in 1572, after his father's death, names six assistants who were employed on the statues; these are Domenico da Salò, Domenico de' Bernardin, Battista del quondam Bernardin di Venezia, Antonio Gallino di Padova, Francesco detto il Toccio settignanese, and Jacomo de' Medici venziano. The account outstanding between the Signoria and Francesco Sansovino was settled in 1582 by a payment of 400 ducats.

Plate 114: SAINT JOHN THE BAPTIST
S. Maria dei Frari, Venice

The marble figure of the Baptist executed by Sansovino for a holy water basin in the Frari is mentioned by Vasari: 'Sopra la pila dell'acqua santa ne' frati della Ca grande è di sua mano una statua fatta di marmo per un San Giovanni Battista, molto bella e lodatissima' (On the holy water basin in the church of the friars by the Grand Canal there is a marble statue of St. John the Baptist from his hand, a very beautiful work and greatly praised). The statue is now in the Corner Chapel, but was originally carved for the Florentine chapel (since transferred to the right transept), for which the wooden Baptist of Donatello was also carved. It is mentioned in a will drawn up by Sansovino on 10 September 1568 in which he expresses the wish to be buried in this chapel 'dove e el santo Giovanni di mia propria mano sulla pila di Giustinian' (where is the St. John by my own hand on the Giustinian basin). The work is not dated but a *terminus ante quem* is provided by Dolce's *Aretino* (1557) which contains a reference to it, and its execution has consequently been assigned to the years 1554, 1555 and 1556. Weihrauch (p. 72) brings the figure into relation with a marble statuette of the Baptist by Vittoria in S. Zaccaria (payment of 26 April 1550), and infers that the figure in the Frari must have been produced before 1550. The relationship between the figures is a matter of spirit and function rather than of motif, and it cannot be assumed that the Frari figure necessarily precedes that in S. Zaccaria.

Plate 115: ALLEGORY OF REDEMPTION
St. Mark's, Venice

Designed for the Altar of the Sacrament in St. Mark's, the relief is mentioned by Francesco Sansovino ('portella di bronzo, con figure di mezzo rilievo, scolpita dal Sansovino con artificio notando'), and was completed before 1565, when a claim for payment for this and other works was submitted by the sculptor to the procurators of the church. The relief exists in a second ungilded version with a lunette in the Museo Nazionale, Florence, and in a much inferior gilt version in Berlin. One or other of the reliefs in Venice and Florence must have been in existence in 1542, since on 2 September of that year the painter Lotto records a small payment 'per zetar la storia del bassorilievo de la gloria del Cristo del San Sovino et de la fede et eresia tute tonde L. 1 s. 16'. That this refers to Sansovino's composition is confirmed by the fact that in 1543 Lotto painted 'un trionpho del Salvator Yesu in atto del sacramento sparger il sangue in aria con molti anzoleti,' which is identical with a painting in Vienna corresponding with Sansovino's reliefs. It has been argued (i) (Lorenzetti) that the tabernacle door was executed before the relief in Florence, (ii) (Planiscig) that the figure of Christ on the tabernacle door is closer to Sansovino's Florentine statues than the more mannered figure in the Bargello relief, but that the priority of one relief over the other cannot be established, (iii) (Weihrauch) that the reliefs depend from a design by Lotto, that in Florence being made prior to the relief in Venice, in which the composition is slightly curtailed. The tabernacle door is not mentioned in a document of 1546 relating to payment for the tribune reliefs, and must have been cast (Lorenzetti, Weihrauch) after this time. Berenson (*Lorenzo Lotto*, London, 1956, p. 117) assumes that the composition of the relief depends from that of Lotto's painting, and that Lotto attended to the casting of the relief. The composition at the bottom of Lotto's painting suggests, however, that it was extended from a smaller design, and is therefore likely to have been based on one of the reliefs.

Plate 116:
MONUMENT OF TOMMASO RANGONE
S. Giuliano, Venice

The monument of Tommaso Rangone (1492–1577) is set on the façade of the church of San Giuliano (Fig. 116), which was reconstructed by Sansovino at Rangone's charge after 1553. The façade of San Giuliano is described by Francesco Sansovino in the following terms: 'Poco discosto è situato San Giuliano, luogo antico & eretto dalla famiglia Balbi in 3. naui, ma poi rifato del tutto a persuasione & spesa in parte, di Thomaso da Rauenna Medico, sul modello del Sansouino quanto alla faccia, su la quale apparisce la memoria del detto Thomaso, con la sua statua di bronzo & con questa inscrittione.

Thomas Phylologus Rauennas Physicus, aere honestis laboribus parto, aedes primum Paduae virtuti, post has Senatus permissu, pietati erigi fecit. Illas animi, has etiam corporis monumentum.

Ann. Mundi VI. MDCCLIIII Non. Octob.
Jesu Christi MDLIIII. Urbis MCXXXIIII.

(Nearby is San Giuliano, an ancient place erected by the Balbi with three naves, and then completely remodelled at the instance and in part at the expense of the doctor Tommaso da Ravenna. The façade is from a model by Sansovino, and on it appears the memorial of the aforesaid Tommaso, with his statue in bronze and the following inscription). Temanza records that 'la facciata della Chiesa di San Giuliano, eretta co' danari di Tommaso Rangone da Ravenna, fu idea del Sansovino, ma ci ebbe anche mano il Vittoria. Lo stesso Tommaso nel suo testamento, parlando della facciata predetta, ce ne fa testimonianza dicendo: laboribusque magnis, plurimoque sudore amicorum, ac principum quorumdam sufragiis, Architectis illustribus Sansovino & Alexandro Victoria . . . aedificaverim. E di fatto nelle finestre del secondo ordine, e nel frontespizio, ci vedo qualche cosa, che non è del Sansovino. Nel tempo che si gettavano le fondamenta di questa facciata cadde, una notte, tutto il tetto della Chiesa. Chi avrà combinato questo accidente con quello della pubblica Libreria avrà probabilmente avuto soggetto da farne ciancie: ma tali accidenti possono addivenire anche senza colpa degli Architetti. Questa caduta fece pensare di proposito alla rifabbrica della Chiesa, della quale si fece pure dal Sansovino il modello. Il predetto Tommaso Rangone da Ravenna ordinò nel suo testamento che fosse portato a processione dietro il suo cataletto Archetypus, vulgo modello, Ecclesiae Sancti Juliani, a fornice Sansovini, ligneus magnus. Io però son d'avviso, che nell'interior della fabbrica abbiaci avuto mano, e non poco il Vittoria' (The façade of the church of S. Giuliano, which was built at the charge of Tommaso Rangone of Ravenna, was conceived by Sansovino, but Vittoria also had a hand in it. In his will Tommaso, speaking of the aforesaid façade, provides evidence of this when he declared: laboribusque magnis, plurimoque sudore amicorum, ac principum quorundam sufragiis, Architectis illustribus Sansovino & Alexandro Victoria . . . aedificaverim. And indeed in the windows of the second register and in the architrave I see something that is not Sansovino's. One night, at the time when the foundations of this façade were being laid, the whole roof of the church collapsed. Anyone who chooses to associate this accident with that which befell the Library will have a topic for malicious gossip, but it must be remembered that such accidents can occur through no fault of the architects. The collapse of the roof gave rise to a proposal for the rebuilding of the church, for which the model was also made by Sansovino. The aforesaid Tommaso Rangone of Ravenna left instructions in his will that in his funeral procession a large wooden model of the church of S. Giuliano should be carried behind his coffin. My own impression is that Vittoria had a hand in the interior of the church, and that by no means a small one).

From material assembled by R. Gallo ('Contributi su Jacopo Sansovino,' in *Saggi e memorie di storia dell'arte*, i, 1957, pp. 96–105), it transpires that Rangone's first wish was to instal his monument on the façade of S. Geminiano in the Piazza San Marco, but that this was forbidden, on the ground that private individuals could not be exalted in so prominent a place. In 1553 a supplica was submitted to the Doge and Signoria explaining

that Rangone had offered to reconstruct the ruined church of S. Giuliano and to supply it with a new façade provided that he was allowed 'mettere et eternamente stare una sua figura dal vivo, et imagine di bronzo in piedi over sedendo, come par a V. Serenita, fatta a spese sue.' The agreement for the construction of the new façade was signed on 20 September 1553. A document summarised by Lorenzetti (Vasari: *Vita di Jacopo Tatti detto il Sansovino*, Florence, 1913, pp. 121–2) shows that the wax model for the figure of Rangone on the façade was consigned by Sansovino to the bronze caster Giulio Alberghetti on 27 August 1554. Subsequent correspondence (for which see Gallo) proves that the work had not been cast by the summer of 1555, when a letter from Rangone to Alberghetti refers to damage to the wax model which had necessitated its being reworked by Sansovino. On 2 March 1556 responsibility for casting the figure was transferred from Alberghetti to two other casters, Tommaso delle Sagome and Giacomo di Conti 'iuxta la forma di tal figura fatta per ms. Alexandro da Trento'. The statue was delivered by 1 February 1557. Comparison of the statue with Vittoria's bust of Rangone (see Plate 124 below) leaves no doubt that the head is wholly due to Sansovino. The scheme of the monument is also due to Sansovino, and is unique in its combination of firmly defined architectural forms, which find a focus in the heavy keystone of the arch above the seated figure of Rangone and in the sarcophagus beneath, and illusionism in the treatment of the interior space whereby the bronze figure of Rangone is shown seated at a table between a globe and an astrolabe. The document published by Gallo is misconstrued by Cessi (*Alessandro Vittoria Scultore* I, Trent, 1961, p. 27), who ascribes the figure to Vittoria.

Plate 118: JUPITER
Kunsthistorisches Museum, Vienna

The most characteristic and important of the surviving bronze statuettes of Sansovino, the Jupiter has been associated (Planiscig) with the bronze statues on the Loggetta, but is more closely related to the St. John the Baptist in the Frari (Plate 114), and like this work appears to date from about 1550–5. A bronze of Christ carrying the Cross at Modena, in which the forms closely recall those of the Christ in the Medici tabernacle in the Museo Nazionale, Florence (Plate 115), is earlier in date.

DANESE CATTANEO
(b. ca. 1509; d. 1573)

Born at Carrara, Cattaneo became a pupil of Jacopo Sansovino in Rome before 1527, and after the Sack followed him to Venice, where he worked on the sculptural decoration of Sansovino's Libreria di San Marco, and on the Loggetta (see Plate 108 above). He executed a fountain for the cortile of the Zecca (see Plate 119 below), was engaged with Tiziano Minio on stucco decorations in the Chapel of St. Anthony in the Santo at Padua, and for the same church executed the portrait bust of Bembo for Sanmicheli's Bembo monument (1547) and that of Alessandro Contarini (1555). The finest of his bronze portraits is the bust of Lazzaro Bonamico (d. 1552) in the Museo Civico at Bassano, formerly in S. Giovanni di Verdara at Padua. At Verona he undertook a statue of Girolamo Fracastoro for the Piazza dell'Erbe, and the Fregoso monument in S. Anastasia (see Plate 121 below), returning to Venice to execute the Loredano monument in SS. Giovanni e Paolo (see Plate 120 below). At the end of December 1572 he signed the contract for a relief of the Healing of the Youth at Lisbon for the Chapel of St. Anthony at Padua, and on his death in 1573 this was carried out by his pupil Campagna. Cattaneo was a poet as well as sculptor, and his *Dell'Amor di Marfisa* was printed in 1562.

BIBLIOGRAPHY: A good short account of Cattaneo's career is given by Paoletti (in Thieme *Künstlerlexikon*, vi, 1912, pp. 189–191). See also Planiscig (*Venezianische Bildhauer der Renaissance*, 1921, pp. 411–32) and Venturi (X-iii, pp. 1–35).

Plates 117, 120: THE LOREDANO MONUMENT
SS. Giovanni e Paolo, Venice

The monument of Doge Leonardo Loredano (d. 1521) on the right wall of the choir of SS. Giovanni e Paolo (Fig. 112) was commissioned from the architect Girolamo Grappiglia. The sculptures for the tomb were executed by Danese Cattaneo, with the assistance of Girolamo Campagna, who was responsible for the central figure of the Doge. An account of the imagery of the monument and of the circumstances in which it was produced is given by Temanza: 'Di Verona avea Danese seco condotto un giovane chiamato Girolamo Campagna, che sotto di lui si rese molto valente. Danese era assai vecchio; onde con l'aiuto di costui tirava innanzi le sue opere, e per ciò lo teneva seco, e lo amava come figliuolo. . . . Le ultime opere, che Danese Cataneo fece in Venezia, per ciò ch'io ne credo, furono le statue pel deposito del Doge Leonardo Loredano nella Cappella maggiore de' SS. Gio: e Paolo. Questi fu quell'Eroe, che sedendo sul Trono ducale allorchè, per la lega stabilita in Cambrai fra le principali Potenze di Europa, si faceva guerra ai Veneziani, col suo consiglio, col sagrifizio dei propri figliuoli, e delle proprie sostanze, ispirò vigore, e costanza nei Senatori, onde resistere alla mole di tanti nemici, e restituire alla Patria la dignità, e l'impero. Quest'opera fu commessa da Leonardo Loredano pronipote del Doge predetto all'Architetto Girolamo Grapiglia, e volle, che fosse magnifica come alla dignità di sì

ragguardevole principe si conveniva. La Cappella de' SS. Giovanni e Paolo è così vasta, che non c'è forse la più grande in questa Città. Era questa una circostanza, che impegnava l'Architetto a far cosa grandiosa e mobile. Rappresentò egli per tanto uno prospetto di tre intercolonnj d'ordine composito, con piedistallo sotto, sopraornato, ed attico sopra. Le colonne sono di tutto tondo spiccate in fuori con loro pilastri di retro. Termina l'attico con frontispicio rispondente all'intecolonnio di mezzo. In questo intercolonnio sopra tre scaglioni, che rilievano sul piedistallo, siede la statua del Doge in manto reale, col Corno o sia Corona in capo. Sulla destra del trono v'è una statua figurata pel potere delle armi della Repubblica, sulla sinistra altra che rappresenta la Lega di Cambrai. Questa è una Donna armata; quella un Uomo vestito da guerriero alla foggia dei Romani. Nei due nicchj fra i due intercollonni laterali vi sono due altre statue; cioè l'Abbondanza alla destra, e la Pace alla sinistra, co'simboli loro. Sotto e sopra ciascheduna delle quali sonvi bassorilievi di bronzo allusivi al soggetto delle statue medesime. Queste statue maggiori del naturale sono di marmo di Carrara. Di marmo pure di Carrara, e di paragon nero è il rimanente di questa mole, la quale a dir vero è cosa grandiosa' (Danese had brought with him from Verona a youth called Girolamo Campagna, who proved himself while working under him. Danese was extremely old, and for this reason he advanced his works with the assistance of Campagna, whom he retained in his service and loved like a son. . . . The last works that Danese Cattaneo made in Venice, to the best of my belief, were the statues for the tomb of Doge Leonardo Loredano in the choir of SS. Giovanni e Paolo. This was the hero who occupied the ducal throne at the time when, through the league entered into at Cambrai between the principal European powers, war was waged on the Venetians. The Doge, with his prudent counsel, and the sacrifice of his resources and of his own sons, inspired the Senators with vigour and constancy, which enabled them to resist the weight of so many enemies, and to restore to their fatherland its dignity and dominion. This work was commissioned by Leonardo Loredano, pronipote of the aforesaid Doge, from the architect Girolamo Grapiglia. His wish was that it should be as magnificent as the dignity of so notable a prince deserved. The choir of SS. Giovanni e Paolo is so vast, that there is not perhaps a larger in this city. This fact imposed upon the architect the obligation of making something grandiose and noble. He devised a scheme with four columns of composite order, with a plinth beneath and an attic above. The columns are fully in the round and stand forward from the pilasters behind. The attic is closed by a pediment corresponding to the area between the central columns. In this central area, on three steps rising from a plinth, is the seated statue of the Doge in his ducal robes with his cap or crown upon his head. On the right of the throne is a statue representing the power of the arms of the Republic, and on the left is another representing the League of Cambrai. The former is a woman armed, the latter a man clad in warlike dress in the manner of the Romans. In the two niches between the lateral columns are two more statues, Abundance on the right and Peace on the left, with their symbols. Above and below each of these figures are bronze basreliefs alluding to the

subjects of the two statues. These statues are over life-size and are in Carrara marble. Also of Carrara marble and black paragone is the remainder of the monument, which is truly grandiose. The iconography of the monument is related to that of the Allegory of the League of Cambrai by Palma Giovane in the Palazzo Ducale. The history of the tomb (for which see A. del Mosto, *I Dogi di Venezia con particolare riguardo alle loro tombe*, Venice, 1939, pp. 146–51) goes back to 1517, when a concession was obtained during the Doge's lifetime by his son Lorenzo for a tomb in SS. Giovanni e Paolo. A will made by Lorenzo Loredano in 1532 provides a sum of 1300 ducats for the erection of the tomb. The project was interrupted in 1533 by Lorenzo Loredano's death, but three years later the Loredano family made available a sum of 1500 ducats for a new high altar which would incorporate the tomb, and would be surmounted by three statues. Action on this was again deferred, and the present tomb, replanned as a wall monument, was completed in 1572. The central figure of the Doge is signed on the base IERONIMVS CANPAG. F., and the two lateral figures in the central area are inscribed: D.K.F. The Peace is unsigned, and the Abundance is signed in full: DANESIVS KATANEVS. The marble relief in the centre of the upper section appears to have been executed by Girolamo Campagna, but the four small bronze reliefs above and below the allegorical figures at the sides are autograph works by Danese Cattaneo, and are much superior in quality to the marble sculpture on the monument.

Plate 119: FORTUNA
Museo Nazionale, Florence

The figure belongs to a small group of bronzes by Danese Cattaneo, which include a second figure of Fortuna in the Kunsthistorisches Museum, Vienna, the Negro Venus (wrongly ascribed to Vittoria) of which examples are found in the Metropolitan Museum, New York, and elsewhere, and a statuette of Luna, also in Vienna, which appears to have been cast from a model for a statue of the Moon as Goddess of Silver projected for a fountain in the courtyard of the Zecca. The facture of all four bronzes is uniform, and the type of the present figure (which has been wrongly identified as a Venus Marina) is closely connected with the figure of Venus Cyprica in the marble relief carved by Cattaneo for Sansovino's Loggetta. For the imagery compare the Fortuna on a broken wheel on the reverse of the medal (1520) of Niccolò di Marco Giustinian (Hill, No. 532).

Plate 121: THE FREGOSO ALTAR
S. Anastasia, Verona

The Fregoso altar, which is situated on the right side of the nave of S. Anastasia at Verona, is described in some detail by Vasari: 'Ma la maggior opera e più segnalata che abbia fatta il anese è stata in Verona, a Sant'Anastasia, una cappella di marmi

ricca e con figure grandi, al signor Ercole Fregoso, in memoria del signor Jano, già signor di Genova, e poi capitano generale de' Viniziani, al servizio de' quali morì. Questa opera è d'ordine corinto in guisa d'arco trionfale, e divisata da quattro gran colonne tonde striate con i capitelli a foglie d'oliva, che posano sopra un basamento di conveniente altezza, facendo il vano del mezzo largo una volta più che uno di quelli dalle bande; con un arco fra le colonne, sopra il quale posa in su' capitelli l'architrave e la cornice; e nel mezzo, dentro all'arco, un ornamento molto bello di pilastri con cornice e frontespizio, col campo d'una tavola di paragone nero bellissimo, dov'è la statua d'un Cristo ignudo maggior del vivo, tutta tonda e molto buona figura, la quale statua sta in atto di mostrare le sue piaghe, con un pezzo di panno rilegato ne i fianchi fra le gambe e fino in terra. Sopra gli angoli dell' arco sono segni della sua passione; e tra le due colonne, che sono dal lato destro, sta sopra un basamento una statua tutta tonda, fatta per il signor Jano Fregoso, tutta armata all' antica, salvo che mostra le braccia e le gambe nude, e tiene la man manca sopra il pomo della spada che ha cinta, e con la destra il bastone di generale; avedon dietro, per investitura che va dreto alle colonne, una Minerva di mezzo rilievo, che stando in aria tiene con una mano una bacchetta ducale come quella de' Dogi di Vinezia, e con l'altra una bandiera drentovi l'insegna di San Marco; e tra l'altre due colonne, nell'altra investitura, è la Virtù militare armata col cimiero in capo, con il sempreivo sopra e con l'impresa nella corazza d'uno ermellino, che sta sopra uno scoglio circondato dal fango, con lettere che dicono *Potius mori quam foedari*, e con l'insegna Fregosa; e sopra è una Vittoria, con una ghirlanda di lauro e una palma nelle mani. Sopra la colonna, architrave, fregio e cornice, è un'altro ordine di pilastri, sopra le cimase de' quali stanno due figure di marmo tonde e due trofei pur tondi e della grandezza delle altre figure. Di queste due statue una è la Fama in atto di levarsi a volo, accennando con la man dritta al cielo e con una tromba che suona: e questa ha sottili e bellissimi panni attorno, e tutto il resto ignuda; a l'altra è fatta per l'Eternità, la quale è vestita con abito più grave e sta in maestà, tenedo nella man manca un cerchio, dove ella guarda, e con la destra piglia un lembo di panno dentrovi palle che denotano vari secoli, con la sfera celeste cinta dalla serpe che con la bocca piglia la coda. Nello spazio del mezzo sopra il cornicione, che fa fare e mette in mezzo queste due parti, sono tre scaglioni, dove seggono due putti grandi e ignudi, i quali tengono un grande scudo con l'elmo sopra, drentovi l'insegna Fregosa; e sotto i detti scalini è di paragone un epitaffio di lettere grandi dorate: la quale tutta opera è veramente degna d'esser lodata, avendola il Danese condotta con molta diligenza, e dato bella proporzione e grazia a quel componimento, e fatto con gran studio ciascuna figura' (But the greatest and most notable work Danese made is at Verona, in S. Anastasia, a chapel richly decorated with marbles and with large figures, commissioned by Signor Ercole Fregoso, in memory of Signor Jano, once governor of Genoa and later captain general of the Venetians, in whose service he died. This work is of the Corinthian order in the form of a triumphal arch, and is divided by four large free-standing fluted columns with olive leaves on their capitals. These are set on a base of suitable height leaving a central aperture the width of which is half as large again as the joint width of these at the sides. Between the columns is an arch on which, above the capitals, the architrave and cornice rest. Within the arch in the centre is a most beautiful ornament with pilasters, cornice and pediment, backed with a handsome slab of black pietra di paragone, in which is an over life-size statue of the naked Christ, a most beautiful figure completely in the round, in the act of showing His wounds, with a piece of drapery tied round his hips falling between his legs to the ground. Above the angles of the arch are the symbols of the Passion, and between the two columns on the right side, on a plinth, stands a statue fully in the round, representing signor Jano Fregoso, armed in the antique style, save that the arms and legs are bare, with his left hand on the pommel of his girded sword, and in his right a general's baton. Behind him is a Minerva in half-relief, in the air, holding in one hand a ducal wand, like that of the Doges of Venice, and in the other a banner with the device of St. Mark. Between the other two columns on the opposite side is Military Virtue, armed and wearing a helmet, with evergreen above and the device of an ermine on the breastplate, standing on a rock surrounded by mud, with an inscription which reads *Potius mori quam foedari*, and the Fregoso device. Above this figure is a representation of Victory, with a garland of laurel and a palm in her hands. Above the column, architrave, frieze and cornice is another order of pilasters, and above the moulding are two male figures and two trophies, both in the round, of the size of the other figures. One of these two statues is Fame, in the act of taking off in flight, pointing with her right hand to heaven and with a trumpet which she sounds. This figure has delicate and subtle drapery, and all the rest is naked. The other figure represents Eternity, and is clad in a sober habit and stands majestically, holding in the left hand a circle into which she looks, and with the right hand lifting a piece of drapery, on which are balls representing various centuries with the celestial sphere surrounded by a snake swallowing its tail. In the central space above the cornice dividing these two parts are three steps, on which are seated two large naked putti holding a large shield surmounted by a helmet, bearing the Fregoso device. Under the steps is an epitaph of pietra di paragone with large gold letters. The whole work is truly praiseworthy since Danese executed it with much care, gave beautiful and graceful proportions to all its parts, and devoted much study to each figure). Vasari's description is of some importance for the iconographical programme of the altar, which shows (*centre*) the suffering Christ, with in the spandrels above two angels holding the lance and nails and the crown of thorns and flail, (*left*) Jano Fregoso with, above, Minerva, (*right*) Military Virtue with, above, Victory, (*upper left*) Fame about to take off in flight, (*upper right*) Eternity. The figure sculpture is throughout of notably high quality. The colouristic effect of the altar depends in part upon the use of black pietra di paragone in the areas noted by Vasari, and in part on the contrast between the white marble used for the columns and the figure sculpture and the light yellowish-pink Verona marble with which it is relieved. Venturi (X-iii, p. 24) rightly observes that the architectural forms employed by Cattaneo in the Fregoso altar

derive from Sanmicheli, and Planiscig suggests that Sanmicheli may have participated in the planning on the altar. The year in which the altar was commissioned cannot be established; the date of its completion is recorded in an inscription across the base of the central section: ABSOLVTVM OPVS AN. DO. M.D. L.X.V. DANESIO/CATANEO CARRARIENSI SCVLPTORE ET ARCHITECTO. According to Temanza, Marchese Almerigo Malaspina, whom Cattaneo encountered at Carrara in 1559, was instrumental first in encouraging the sculptor to publish his poem *Dell'Amor di Marfisa*, which appeared in Venice in 1562,

and then in obtaining for him the commission for the Fregoso altar. Vasari's statement that the altar was erected at the instance of Ercole Fregoso is confirmed by the inscription on the central tablet at the top:

DEO. OPT. MAX.
IANVS FREGOSIVS LIGVRVM PRINCEPS
AC VENET. REIP. TERRESTRIVM COPIARVM OM
NIVM PRAEF. VBI FORTISS. DVCIS OFFICIA
DOMI FORISQVE PRAESTISSET SAC. H.T.F.I.
HERCVLES F. PATERNAE PIETATIS MEMOR. P.

GIROLAMO CAMPAGNA
(b. 1549-50; d. 1625?)

Born at Verona, Campagna was trained by Danese Cattaneo, whom he assisted after 1565 in work on the Fregoso monument in S. Anastasia (see Plate 121 above) and with whom he moved to Venice. In 1572 he executed, from Cattaneo's model, the seated statue of the Doge on the Loredano monument in SS. Giovanni e Paolo (see Plate 117 above), and in 1573 undertook responsibility for the relief of the Raising of the Youth in Lisbon in the Santo at Padua (Fig. 115), which had been commissioned from Cattaneo. He was again active in the Santo in 1578-9, when he replanned the high altar. In 1578 he carved the statue of S. Giustina over the entrance to the Arsenale. An exceptionally prolific artist, Campagna was active in Venice through the fifteen-eighties and nineties, working among much else on the altar of the Cappella del Rosario in SS. Giovanni e Paolo, the Altar of the Sacrament in S. Giuliano (before 1581), the stucco statues in the upper choir of S. Sebastiano (1582), decorative sculptures for the Palazzo Ducale, statues for the Scuola Grande di San Rocco (1587), a bronze Crucifix and bronze figures of SS. Mark and Francis for the high altar of the Redentore (ca. 1590), one of the two Giganti at the entrance to the Zecca (1591; the companion figure by Tiziano Aspetti), and a bust of Francesco Bassano now in the Museo Civico at Bassano (1592). Perhaps his most original and distinguished works in Venice are the high altar of S. Giorgio Maggiore (see Plate 123 below) and the Altar of the Sacrament in S. Giuliano (Fig. 111). Works produced by Campagna in the first quarter of the seventeenth century include the sculptures of Scamozzi's monument of Doge Marino Grimani (d. 1605) and his wife in S. Giuseppe di Castello and of the Dolfin monument in S. Salvatore, and statues of SS. Roch and John Baptist for the Scuola di S. Rocco (commissioned 1606, executed 1607-13). In 1604-6 he carved the posthumous statue of Federigo da Montefeltro in the Palazzo Ducale at Urbino and the busts of Federigo and Guidobaldo da Montefeltro for their tombs in S. Bernardino. The bronze Annunciation at Verona (see Plate 122 below) dates from about this time. The last reference to Campagna in Venice occurs in 1623, and he seems to have died in or before 1625. Fundamental for know-

ledge of Campagna as a maker of bronze statuettes are a figure of Humility on a holy-water basin in S. Maria dei Frari (signed and dated 1593) and a group of figures made for the high-altar of S. Lorenzo, now in the Museo Correr (probably 1615-18).

BIBLIOGRAPHY: Connected accounts of Campagna's career are provided in an excellent article by Paoletti (in Thieme Künstlerlexikon, v, 1911, p. 455), and by Planiscig (*Venezianische Bildhauer der Renaissance*, 1921, pp. 527-49, reproducing a number of wrongly attributed minor works) and Venturi (X-iii, pp. 207-64). A volume by P. Rossi (*Girolamo Campagna*, Verona, 1968), contains a useful review of the documentary and other material. For the figures by Campagna on the parapet of the Biblioteca Marciana see N. Ivanoff ('Il coronamento statuario della Marciana,' in *Ateneo Veneto*, 1964, p. 11) and for the altar in the Scuola di S. Rocco W. Timofiewitsch ('Ein Entwurf für den Altar der Scuola di San Rocco,' in *Festschrift Ulrich Middeldorf*, Berlin, 1968, pp. 342-49). An exhaustive account of the Grimani monument is supplied by W. Timofiewitsch ('Quellen und Forschungen zum Prunkgrab des Dogen Marino Grimani in San Giuseppe di Castello zu Venedig,' in *Mitteilungen des Kunsthistorischen Institutes zu Florenz*, xi, 1963, pp. 33-54). The bronze statuettes from S. Lorenzo are discussed by G. Mariacher ('Bronzetti del Rinascimento al Museo Correr,' in *Bollettino dei Musei Civici Veneziani*, 1966, i, p. 17).

Plate 122: THE ANNUNCIATION
Castelvecchio, Verona

The group of the Annunciatory Angel and Virgin Annunciate, formerly on the façade of the Palazzo del Consiglio and now in the Castelvecchio at Verona (for which see G. Gerola, 'L'Annunciazione di Gerolamo Campagna', in *Atti dell' Accademia d'agricoltura, scienze e lettere di Verona*, ser. V, iii,

1926, pp. 1–10), owes its origin to a decision of the Consiglio Communale of 25 January 1606 to institute a nightly ceremony in honour of the Virgin before a statue on the 'Domus nova' adjacent to the Palazzo del Consiglio, and to commission a new statue to serve as a focus for this cult. The reliefs, which appear to have been executed in 1609–10, were originally housed in tabernacles on the façade of the Palazzo del Consiglio, and the installation on either side of the doorway of the palace shown in Fig. 118 dates from the middle of the nineteenth century. The figures are described in 1610 in a poem by Giovanni Battistella (*De Annunciatione Deiparae Virginis aeneis figuris expressa et Curiae Senatus veronensis affixa*, for which see G. da Re, 'Palazzo del Consiglio' in G. Sartori, *Protomoteca veronese*, Verona, 1881–7).

Plate 123: HIGH ALTAR
San Giorgio Maggiore, Venice

The sculptures executed by Campagna for the high altar of S. Giorgio Maggiore comprise a central group of the four Evangelists (*front*, SS. John and Mark; *back*, SS. Luke and Matthew) supporting a globe on which stands a figure of God the Father in benediction. On the front of the globe is the dove, and beneath this is the crucified Christ. At the sides are two bronze angels by Pietro Boselli (1644). The high altar is described by Temanza, in his life of Campagna, in the following terms: 'Col favore di Antonio Aliense rinomato pittore, il Campagna ebbe la commissione di fare le Statue di bronzo, che sono sopra il principal altare della Chiesa di S. Giorgio Maggiore. Quattro di esse rappresentano gli Evangelisti, che reggono una gran pala figurata pel Mondo; nel mezzo della quale si spicca una Colomba, simbolo dello Spirito Santo. Sulla sommità dell'asse verticale di lei vi sta una statua del Redentore in atto di benedire. Nobile non meno, che misteriosa è l'invenzione, e sì l'Aliense, che il Campagna si sono meritate le lodi degli intelligenti. Concorreva a quest'opera anche il Vittoria. Ma prevalse il favore del suddetto Aliense, il quale era disgustato di lui, come si è detto nella vita di esso Vittoria' (Through the support of the well-known painter Antonio Aliense, Campagna obtained the commission to make the bronze statues which stand over the high altar of S. Giorgio Maggiore. Four of them represent the Evangelists, who support a great ball symbolising the world, from which there protrudes a dove, the symbol of the Holy Ghost. On the top of the vertical axis of the ball stands a statue of the Redeemer in the act of benediction. The invention is noble as well as strange, and both Aliense and Campagna have earned the praises of connoisseurs. Vittoria also competed for this work. But the choice that prevailed was that of Aliense, who was disgusted with Vittoria, as has been said in the life of that sculptor). The circumstances in which the commission for the high altar was withheld from Vittoria are described in Temanza's life of this sculptor: 'Quindi avendo destinato le Monache di S. Giustina di Venezia di far dipingere il soffittà del coro della loro Chiesa, l'Aliense celebre pittore aspirava a quell'opera. Ma il Vittoria, con i suoi uffici, e con le sue insinuazioni operò in modo, che l'ebbe il Palma. . . . Punse bensì

non poco il Vittoria l'onta fattagli dall'Aliense predetto (atteso la smodata protezione, ch'ei donava al Palma, per la quale esso Aliense in più incontri n'era restato addietro, con suo grave danno). E fu che avendosi a fare, per la nuova Chiesa di S. Giorgio maggiore, il principale altare, procurava il Vittoria di avere quell'opera, che molto onore gli avrebbe arrecato. Ma prevalendo presso quei Monaci il consiglio dell'Aliense, il quale ne avea fatto il disegno, fu allogata a Girolamo Campagna assai buono scultore, non però da preferirsi al Vittoria. Questo colpo gli penetrò assai l'animo, perch'ei si teneva franco di averla; nè potè nascondere la sua passione, sicchè i suoi amici non se ne avvedessero' (When the nuns of the convent of S. Giustina in Venice decided to have the roof of the choir of their church painted, the well-known painter Aliense wished for the commission. But Vittoria used his offices and insinuations to ensure that Palma received it. . . . Vittoria suffered not a little from the shame inflicted on him by the aforesaid Aliense, arising from the excessive support he gave to Palma, through which Aliense on several occasions was passed over to his grave loss. When the high altar of the new church of S. Giorgio Maggiore was to be made, Vittoria endeavoured to secure the commission, which would have brought him great honour. But the advice tendered to the monks by Aliense, who had designed the altar, prevailed, and the commission was awarded to Girolamo Campagna, an extremely good sculptor, but not to be preferred to Vittoria. This blow struck deep into his mind, because he was holding himself free for this commission, but he was able to hide his fury, so that his friends did not perceive it). The account of the commission given by Ridolfi leaves no doubt that when Campagna was selected to undertake the work the main features of the design had already been decided on: 'Haueuano i Padri di S. Giorgio Maggiore rinouata la Chiesa loro co'modelli di Andrea Palladio, & eretti molti nobili Altari con pitture del Tintoretto e d'altri valorosi Pittori; onde mancaua solo per dar compimento a si bella struttura stabilire l'Altare, oue posar doueua il Sacramento, pensando l'Abbate di fare il più bello e riguardeuole, che giamai si vedesse, onde per tal effetto gli furono recati molti disegni e modelli per il tabernacolo, che concerneuano molta spesa e fatica; ma quegli confuso tra la moltitudine, non sapeua a quale appigliarsi, & introdotto Antonio (Vassillacchi) a dire il suo parere, come quello, ch'era modesto e gentile gli li lodò più e meno secondo l'esser loro, e ricercato se si poteua far cosa migliore prese egli l'assunto di formar l'inuentione, che hor si vede, e di quella fatto vn disegno e spiegatolo alla presenza de' Padri cosi prese a discorrere. Questo globo, ch'elle vedono è figurato per il Mondo sostenuto da queste quattro figure, che rappresentano gli Euangelisti: Nella cima stà Iddio Padre, Rettore dell' Vniuerso. Qui nel mezzo è lo Spirito Santo in forma di Colomba, & a piedi si ponerà in vna particolare custodia l'Eucaristia; onde haueremo raccolte in vno le tre Diuine Persone, il Mondo e gli Euangelisti, promulgatori della Cattolica Fede. Parue a Padri, & all'Abbate in particolare mirabile l'inuention, onde posto da parte ogn'altro disegno, che solo conteneua colonne e ordinarij ornamenti, deliberò di valersi del pensiero di Antonio: e discorrendo sopra la materia di che far doueuasi, quegli soggiunse, che per far opera degna conueniua il farla di bronzo.

Ma la difficoltà consisteua nella grandezza del globo, che di tal materia (diceuano i Padri) poteua riuscire molto pesante. Ma Antonio disse, che far si hauerebbe di rame dorato, incrociato da ferri, onde restò finalmente leuata ogni difficoltà. Approuato il parere di quello dall'Abbate, gli rimise ancora l'elettione dello Scultore, e fù da lui scelto Girolamo Campagna, non senza mortificatione del Vittoria, che per tale cagione gli fù poi all'auuenire sempre poco amico. A cui fece Antonio a chiaro scuro quelle figure vedute da molte parti, nelle quali tuttauia si comprende la sua maniera; e questa opera si bella e pellegrina viene dal continuo ammirata e commendata da ogni intendente, che visita quella Chiesa, tutto che que' Padri si arrogassero il concetto, che da loro meno fù giamai pensato' (The fathers of S. Giorgio Maggiore had rebuilt their church from models by Andrea Palladio, and erected many noble altars with paintings by Tintoretto and other valiant painters. All that remained to be done to complete this beautiful building was to set up the altar where the sacrament was to be placed. The Abbot determined to make it the most beautiful and noteworthy that had ever been seen, and with this in view many designs and models for the tabernacle were brought to him, involving much expense and trouble. Confused by the number of designs, he did not know to whom to turn. When Antonio Vassellacchi who was a gentle and modest man was introduced to give his view, he praised them more or less according to their schemes. Asked whether something better could not be made, he worked out the invention that is to be seen today, made a drawing of it, and explained it in the presence of the fathers in this way. This globe that you see symbolises the world sustained by these four figures who represent the Evangelists. At the top is God the Father the controller of the universe. Here in the middle is the Holy Ghost in the form of a dove, and at the feet there will be a special tabernacle for the Eucharist. In this way we shall have united the three divine Persons, the world and the evangelists, the propagators of the Catholic faith. The fathers and especially the Abbot thought this invention wonderful, and rejecting all the other drawings, which only contained columns and ordinary ornaments, they decided to avail themselves of Antonio's plan. Discussing the material which was to be used, he insisted that if the work were to be worthy of its place it must be made of bronze. The difficulty in the way of this was the size of the globe, which, the fathers objected, would be extremely heavy if it were in bronze. Antonio replied that it could be made of gilded copper crossed by iron supports, and at this every difficulty was disposed of. After Antonio's scheme was approved by the Abbot, he was entrusted with the choice of the sculptor, and Girolamo Campagna was nominated by him, to the mortification of Vittoria, who thenceforth was always unfriendly towards him. For Campagna Antonio drew the figures in a number of positions in chiaroscuro, and in these his style can be seen. This work, at once so beautiful and strange, was continuously admired and commended by every connoisseur who visits the church, so much so that the fathers claimed credit for the conception of a work for which they were not in any way responsible). The pyramidal design of the group, which is so well adjusted to the columns of the choir, and the struggling figures at the base supporting the illusory weight of the globe, are thus due to Vassillachi, not to Campagna. The sculptures were commissioned from Girolamo Campagna, his brother Giuseppe, and the coppersmith Francesco Mozzoleni (who was presumably responsible for the globe) on 20 January 1591, for a comprehensive figure of 1650 ducats, and were completed before Easter 1593 (for this see G. Damerini, *L'Isola e il Cenobio di San Giorgio Maggiore*, Venice, 1956, pp. 75–6). The altar is signed on the book held by St. Matthew:

OPVS

HIERONIMI

CAMPANEAE

VERONENSIS

Four coarse bronze reductions from the kneeling figures on the altar have been claimed (Rossi) as models for the statues of Evangelists.

ALESSANDRO VITTORIA
(b. 1525; d. 1608)

Born at Trent in 1525, Vittoria moved in 1543 to Venice, where he entered the workshop of Jacopo Sansovino. In Trent he appears to have been trained in the studio of Vincenzo and Giovanni Gerolamo Grandi, and their style, as it is seen in the Cantoria of S. Maria Maggiore at Trent (in course of execution 1534), had some influence on his early work. In 1547, apparently as the result of a rupture with Sansovino, Vittoria left Venice for Vicenza, where he worked on the stucco decoration of a room in the Palazzo della Sindacaria di San Paolo. In 1550 he was paid by Sansovino for four River Gods on the Libreria di San Marco, and about this time he carved a small marble figure of St. John the Baptist for S. Zaccaria. In 1553 the breach with Sansovino was at least temporarily healed, and in 1557 Vittoria notes in his *Memorie* that 'fui notato nella nostra schola per patrone'. In 1553 he was already active as a medallist, and according to a letter to Marco Mantova Benavides was engaged in this year on two colossal caryatids at the entrance to the Libreria (completed 1555). In 1555 he was employed in Padua on Sanmicheli's monument of Alessandro Contarini (till 1558). In 1557–8 he was also responsible for carving the lunette of Sansovino's Venier monument in S. Salvatore, Venice, and soon afterwards undertook the stucco decoration of the stairway of the Libreria and of the Scala d'Oro of the Palazzo Ducale. Between 1561 and 1563

he executed an altar in S. Francesco della Vigna (see Plate 126 below), the St. Sebastian from which was cast as a small bronze (1566), and probably in the late sixties this was followed by the Zane altar in the Frari (see Plate 128 below). A wall slab commemorating the visit of Henry III of France to Venice (Palazzo Ducale) dates from 1574, when Vittoria was also engaged on stucco figures for S. Giorgio Maggiore. Leaving Venice with his family in 1576 because of the plague, Vittoria worked at Brescia (remains of monument in Museo Civico) and Vicenza, and on his return to Venice (1577), after the fire in the Ducal Palace, carved statues of Justitia and Venetia for the façade (completed 1579). A bronze relief of the Annunciation made for Johann Fugger (1580) is now in the Art Institute of Chicago. Vittoria's altar in S. Giuliano dates from 1583–4, as does conjecturally the St. Jerome in Santi Giovanni e Paolo (see Plate 129 below). Figures over the doorway between the Anticollegio and Collegio of the Palazzo Ducale are closely related to those on the altar in S. Giuliano. Two bronze figures of SS. Francis and John the Baptist (see Plate 130 below) in S. Francesco della Vigna probably date from the early eighties, and not, as assumed by Cessi, from a considerably earlier time. Vittoria's late style is represented by the Altare dei Luganegheri in S. Salvatore (see Plate 125 below), and by the sculptor's own monument in S. Zaccaria. Vittoria died on 27 May 1608. The chronology of Vittoria's portrait busts, like that of the remainder of his work, presents many problems. A framework of date can, however, be established from the bust of Priamo da Lezze (d. 1557) in the Gesuiti, the Manzino bust in the Ca d'Oro (before 1566) and the stylistically uniform bust of Marcantonio Grimani in S. Sebastiano, through the bronze bust of Tommaso Rangone in the Ateneo Veneto (1571), for which a terracotta model is in the Museo Correr, and the related bust of Ottaviano Grimani (d. 1576) in Berlin, to the terracotta bust of Niccolò da Ponte in the Seminario and the bust of Domenico Duodo in the Ca d'Oro (1596). Two Contarini busts in S. Maria dell'Orto, reproduced by Planiscig and Venturi, are not by Vittoria, and the terracotta busts ascribed to him include a large number of studio works.

BIBLIOGRAPHY: Vittoria is a great but difficult artist, who has never received the treatment that the quality of his works and the wealth of documentation regarding them seem to deserve. Predelli's transcript of the sculptor's *Memorie* (in *Archivio Trentino*, xxiii, 1908) is fundamental for the study of his work. A monograph by Serra (*Alessandro Vittoria*, Rome, 1923) is inferior to the chapter on the artist in Planiscig's *Venezianische Bildhauer der Renaissance* (1921, pp. 435–524), and this in turn is less well conceived than the later chapter in Venturi's *Storia* (X-iii, pp. 64–179). Four small volumes by F. Cessi (*Alessandro Vittoria medaglista*, Trent, 1960; *Alessandro Vittoria bronzista*, Trent, 1961; *Alessandro Vittoria architetto e stuccatore*, Trent, 1961; *Alessandro Vittoria Scultore*, 1, Trent, 1961, 2, Trent, 1962) contain some new information but are unreliable. For the documented reliefs executed for the Libreria Marciana in 1550 see N. Ivanoff, 'Ignote primizie veneziane di Alessandro Vittoria,' in *Emporium*, cxxxiv, 1961.

Plate 124: BUST OF TOMMASO RANGONE
Ateneo Veneto, Venice

The bronze bust of Tommaso Rangone (d. 1577) appears to have been made in or about 1571, when Rangone received permission to install his portrait with a dedicatory inscription in a corridor adjacent to the sacristy of S. Geminiano in Venice. According to Cicogna (*Delle iscrizioni veneziane*, iv, 1834, p. 101), the inscription read: RELIGIONI. VIRTVTI/THOMAS. PHILOLOG. RANG. RAVEN./PHYS. EQ. COM. M B PAL. ECCL./ ET FAB. PROCVRATOR. The bust was later transferred to its present site, in the Sala Superiore of the Ateneo Veneto. A terracotta model is in the Museo Correr. For Sansovino's portrait of Rangone (who was also portrayed by Tintoretto in 1562 in three canvases for the Scuola Grande di San Marco), see Plate 116.

Plates 125, 127: ALTAR
S. Salvatore, Venice

The altar of the Scuola dei Luganegheri on the left side of the nave of S. Salvatore was designed by Vittoria. The unusually high central aperture contains an altarpiece by Palma Giovane, which is flanked by pilasters and by double columns. The external columns are recessed, and against these are set the only sculptural decoration of the altar, statues of (*left*) St. Roch and (*right*) St. Sebastian. The altar, statues and altarpiece are described by Temanza (*Vita di Alessandro Vittoria*, Venice, 1827, pp. 44–5): 'Nella chiesa di s. Giuliano fu eretto, con suo disegno l'altare de' Merciai, e in quella di s. Salvatore l'altare de' Pizzicagnoli, ciascheduno adorno di quattro colonne di bei marmi, ma con sopraornati e frontespici triti e di nuove e strane forme. Sopra quello de' Merciai vi sono nobilissime statue di marmo, s. Daniele e santa Catterina, e due di stucco sopra il frontespicio; e su quello de' Pizzicagnoli due altre statue di marmo, s. Rocco e s. Sebastiano: tutte opere che gli fanno molto onore. . . . E molto osservabile che le tavole degli altari de' Merciai in s. Giuliano, e de' Pizzicagnoli in s. Salvatore sono di Iacopo Palma. Tant' era l'amicizia e tanto l'impegno del Vittoria per questo artefice, che, ovunque egli operava, non altre pitture vi dovean essere che di mano di questo. E perche li Pizzicagnoli avenno allogato la pala del loro altare ad Andrea Vicentino, il Vittoria non voleva, a verun putto, mettere le due statue de' santi Rocco e Sebastiano sopra il loro altare, dicendo che non conveniva alla dignita delle opere sue, che le pitture vicine ad esse fossero d'altra mano, che del Palma. E fu tale il suo impegno che dovettero cedere, e in cambio della tavola dell'altare allogarono al Vicentino la mezza luna che vi sta sopra' (In the church of S. Giuliano the altar of the Merciai was built from his design, and in S. Salvatore the altar of the Pizzicagnoli. Each of them is adorned with four marble columns, but the architraves and cornices are commonplace and make use of new and strange forms. On the altar of the Merciai are two noble marble statues of St. Daniel and St. Catherine, with two stucco figures on the architrave. On that of the Pizzicagnoli are two further marble statues of St. Roch and St. Sebastian. These are all

works which do him much credit. . . . It is deserving of notice that the altarpieces of the Merciai altar in S. Giuliano and the Pizzicagnoli altar in S. Salvatore are by Jacopo Palma. So great was the friendship of Vittoria for this artist, and so strong was the support he lent him, that wherever he worked there could not be paintings by any other hand than that of this painter. The Pizzicagnoli had commissioned the altarpiece for their altar from Andrea Vicentino. For this reason Vittoria would not agree to place the two statues of St. Roch and St. Sebastian on their altar, and declared that it was an affront to the dignity of his works that the paintings near them should be by another hand than Palma's. So strongly did he insist, that they were obliged to yield, allocating to Vicentino in place of the altarpiece the semi-circular lunette above). This account is based on a passage in Ridolfi. The altar is one of Vittoria's last major works. Serra follows Giovanelli in assigning it tentatively to the year 1600. Planiscig places it immediately before the sculptor's own monument in S. Zaccaria (begun 1602), and Cessi relates it to the Chapel of S. Saba in S. Antonino (1591–4).

Plate 126: ALTAR
S. Francesco della Vigna, Venice

The earliest of Vittoria's major works in Venice, the second altar on the left of S. Francesco della Vigna, was commissioned on 21 November 1561 by the Procuratori di Citra (summary of document in Serra). By the terms of the contract the work was to be completed by September 1562. According to Planiscig, the commission for the altar was awarded to Vittoria by Messer Niccolò da Montefeltre. The altar is planned as a triptych divided by columns, with three niches of which that in the centre is half as high again as the two niches at the sides. The disparity of size in the three niches is reflected in the statues with which they are filled, the figure of St. Anthony the Abbot in the centre being somewhat larger in scale than the figures of SS. Roch (left) and Sebastian (right) at the sides. All three figures are signed on their bases, the St. Anthony the Abbot in the form A.V., the St. Roch in the form ALEX. VIC. F and (above) ALEXANDER, and the St. Sebastian in the form ALEXANDER. VICTOR. T.F. The progress of the altar can be traced through two passages in Vittoria's accounts (Predelli, 'Le memorie e le carte di Alessandro Vittoria' in Archivio Trentino, xxiii, 1908, p. 131). The first of these is dated 24 July 1563 and reads as follows: 'adi. 24. luio. 1563. Ricordo io Alessandro Vittoria chome questo di ss.to comperai un pezo di pietra da ruinio per far il S.to Sebastiano a San Francesco dila Vigna, et io lebi dala moglie e figlioli che fu di m. Pietro da Salo Scultore, e m.ro Saluatore tagliapietra fece il mercato e fu presente ala sborssatione di sei ducati per resto e saldo.' The second entry occurs on 3 December 1563, and reads as follows: 'Adi. 3. Decembrio. 1563. Ricordo io Alessandro Vitoria chome questo di ss.to mi saldai con M. Zuaniachomo proto da san Chassano de li due pezi di pietra che io ebi da lui per far il S.to Antonio e il S.to Rocho che fu posti a S.to Francesco de la uigna.' The three figures thus date from 1563–4. Vittoria appears to have attached

special importance to the figure of St. Sebastian, of which a bronze reduction was cast in 1566 by Andrea di Alessandro da Brescia (Predelli, op. cit., p. 132: 'Adi. 14. Decembrio 1566. Ricordo io Alessandro Vittoria chome questo di ss.to sborssai a M. Andrea che zeta di bronzo, emmio Char.mo Compare, scudi sete da L. 7 luno per resto e saldo dil auermi zetato il S.to Sebastiano di bronzo col suo metalo, et io gli deti la cera rinetata bene.') A second version of the St. Sebastian was cast in 1575 and preserved in the sculptor's studio. This bronze is mentioned in the will drawn up by Vittoria shortly before his death in 1608 (Predelli, op. cit., p. 225: 'Lasso che il mio S.to Sebastiano de bronzo, se venira buona occasione di qualche Principe o d'altra persona che ne facci conto, sii venduto et il tratto sia diuiso tra la detta M.o Doralice et M. Vigilio.') One of these two bronzes is now in the Metropolitan Museum of Art, New York.

Plate 128: SAINT JEROME
S. Maria dei Frari, Venice

The earlier of Vittoria's two statues of St. Jerome stands on the third altar on the right of the church of the Frari. This, the altar of the Zane family, is described in its original form by Vasari, and must thus have been completed before the issue of the second edition of Vasari's lives in 1568. Vasari's account is as follows: 'e ne' Frati minori una cappella, e nella tavola di marmo, che è bellissima e grandissima, l'Assunzione della Nostra Donna di mezzo rilievo, con cinque figurone a basso, che hanno del grande e son fatte con bella maniera, grave e bello andare di panni, e condotte con diligenzia; le quali figure di marmo sono San Ieronimo, San Giovanbatista, San Pietro, Santo Andrea e San Lionardo, alte sei piedi l'una, e le migliori di quante opere ha fatto infin'a ora. Nel finimento di questa cappella sul frontespizio sono due figure pure di marmo, molto graziose, e alte otto piedi l'una' (He did a chapel for the friars minor and in the marble altarpiece, which is most beautiful and very large, he depicted the Assumption of Our Lady in half relief, with five large figures below, which are made in admirable style and carefully finished, with weighty and beautiful treatment of the drapery. These marble figures, which show St. Jerome, St. John the Baptist, St. Peter, St. Andrew and St. Leonard, are each six feet high, and are the best works he has produced till now. The chapel is completed by two figures on the cornice, also in marble; these are very graceful and each of them is eight feet high). The St. Jerome is the only marble sculpture from this complex that survives. An account of the destruction of the relief of the Assumption, which was made of stucco not marble, is given by Temanza, who also describes the St. Jerome: 'Nella Chiesa dei Frari frati minori conventuali, fece di stucco una gran tavola dell'altare del Procurator Girolamo Zane, con la Vergine assunta circondata di angeli, e sei figurone de' Santi, alcune di mezzo, ed altre quasi di tutto rilievo, che non potevasi vedere cosa, la quale paragonare se le potesse, in disegno, diligenza, e perfezione. Sopra il frontespicio vi fece due maestose Sibille, con le pieghe dei panni grandiose, e

facili, con bellissime arie di teste, ed un putto nel mezzo pur esso perfettamente condotto. Sopra piedistallo nel mezzo dell'altare vi collocò una statua, maggiore del naturale, di S. Girolamo da lui scolpita in marmo, risentita alquanto nei muscoli, sulla maniera del Buonaroti, con bellissimo leone appiedi. L'aria della testa non può essere più nobile, perchè spira senno, santità, e divozione. Sono così ben spiccate le gambe, e le braccia, che sembra come impossibile, che si possa traforare il marmo in cotal guisa, e con tanta franchezza. In somma questa statua è condotta con tanta intelligenza, che ella sola basterebbe a caratterizzarlo per eccellentissimo artefice. Ma che! La maestosa tavola di stucco, pochi anni sono, fu barbaramente manomessa da que' Padri, affine di porvi una tavola dipinta del loro S. Giuseppe da Copertino. Non fu piccolo avanzo in tanta strage che abbiano preservato, oltre il S. Girolamo, di marmo, due di quelle figurone quasi di tutto rilievo, e che le abbiano collocate in due nicchi accanto all'altare predetto, ma in modo che niente spiccano agli occhi dei Professori. . . . Se la nobilissima famiglia Zane, testè spenta, sussistesse ancora, quei malaccorti Padri non avrebbero tolto alle bell'Arti cotanta opera, nè spogliata avrebbero questa Metropoli di così raro ornamento' (In the church of the conventual friars minor, he made in stucco a great altarpiece for the altar of the Procurator Girolamo Zane, with the Virgin of the Assumption surrounded by angels, as well as six large figures of Saints, some in half relief and others almost in the round. For design, care and perfection no work could be found that would compare with these. Above the cornice he made two majestic Sibyls, with grandiose and simple folds of drapery, and with beautiful expressions in the heads. In the middle is a putto which is also perfectly executed. On a plinth in the middle of the altar he placed an over life size statue of St. Jerome carved in marble, in which the muscles are emphasised, in the style of Buonarroti, with a most beautiful lion at the feet. The expression of the head could not be more noble; it breathes wisdom, devoutness and sanctity. The legs and arms are so well defined that it seems almost impossible that the marble should be carved in such a fashion and with such freedom. In brief, this statue is executed with such intelligence, that it alone would suffice to characterise Vittoria as a most excellent artist. But alas, a few years ago the majestic stucco altarpiece was barbarously destroyed by the Franciscan friars, in order to make room for a painted altarpiece of S. Giuseppe da Copertino. It is no small mercy that they have preserved, in addition to the marble St. Jerome, two of the large figures almost in the round, and that they have placed these in two niches beside the altar. . . . If the noble family of Zane, now extinct, were still preserved, those maladroit friars would never have deprived the fine arts of such a work, nor would they have despoiled this city of so rare an ornament). Temanza's account implies that the figures mentioned by Vasari as carved in marble were in fact modelled in stucco, and that the St. Jerome was the single marble figure in the chapel. The statue is signed on the front of the base: ALEXANDER VICTORIA FACIEBAT. Two stucco figures of Apostles in deep relief in niches beside the altar, and two stucco sibyls on the cornice, survive. The altar is assumed by Cessi, following Giovanelli, to have been completed in 1565.

Plate 129: SAINT JEROME
SS. Giovanni e Paolo, Venice

The statue of St. Jerome, which is now on the first altar on the left of SS. Giovanni e Paolo, was carved for the Scuola di San Fantin, now the Ateneo Veneto. The Scuola di San Fantin or Scuola dei Giustiziati (which was suppressed in 1806) was the seat of the joint confraternities of St. Jerome and of S. Maria della Giustizia. The statue is signed on the front of the base: ALEXANDER VICTORIA F. Universally regarded as a late work, it has been brought into relation (Serra, Planiscig, Venturi) with bronze statues of the Virgin and St. John the Evangelist from the Scuola and with the sculptures on the façade. Vittoria's account books (Predelli, op. cit., pp. 192–3) record payments to three pupils, Jacopo da Bassano, Andrea dell'Aquila and Agostino Rubini, for work on the façade sculptures between 21 May 1583 and 9 May 1584. Cessi follows Gerola (in *Atti dell' Istituto Veneto di Scienze, Lettere e Arti*, 1925, p. 339) in identifying the statue with a St. Jerome on which Vittoria was working in 1576. The compressed pose and the relatively weak side views suggest that it was destined for a niche.

Plate 130: SAINT JOHN THE BAPTIST
S. Francesco della Vigna, Venice

The bronze statuettes of SS. John the Baptist and Francis, which surmount the two holy-water basins at the west end of S. Francesco della Vigna, are signed on their circular bases: ALEXANDER. VICTORIA. F. They are mentioned inaccurately by Temanza ('Fece il Vittoria, con molto applauso le tre statue di marmo, S. Antonio Ab., S. Rocco, e S. Sebastiano nella seconda cappella alla dritta della Chiesa di S. Francesco della Vigna, e due altre in bronzo, S. Francesco e S. Bernardino di Siena sulle pile dell'acqua Santa nella Chiesa medesima'), but do not figure in Vittoria's account books, and are therefore not precisely datable. Apart from Serra and Cessi, who follows Giovanelli in relating them to the S. Francesco della Vigna altar of 1561–4 (see Plate 126 above), there is general agreement that they are late works, and they are referred by Venturi (X-iii, p. 126) to the bronze figures of the Virgin and St. John the Evangelist from the Scuola di S. Fantin, now in the Cappella del Rosario in SS. Giovanni e Paolo, which were presumably executed at the same time as the statues from Vittoria's models on the façade of the church (1583). They are conjecturally dated about 1583–4 by Planiscig and are regarded as late works by Lorenzetti (*Venezia e il suo estuario*, Venice, 1926, p. 364).

Plate 131: NEPTUNE
Victoria & Albert Museum, London

The finest of Vittoria's surviving bronzes, the Neptune is related in handling and pose to the bronze Baptist in S. Francesco della Vigna (Plate 130), which is dated by Cessi ca. 1564, but is rightly assigned by Planiscig to a considerably later date. Both bronzes were perhaps made ca. 1580–5.

TIZIANO ASPETTI
(b. 1565; d. 1607)

Probably trained by Girolamo Campagna but influenced by Vittoria, Aspetti, who is consistently referred to in documents as 'patavinus' or 'paduanus' and must therefore have been born at Padua, is first heard of in Venice in 1580. The authority for his birth-date is a memorial slab in the cloister of the Carmine at Pisa, and it has been argued that his birth took place some six years earlier. In the fifteen-eighties Aspetti seems to have been active solely as a carver, not as a bronze sculptor. His commissions at this time include reliefs of SS. Mark and Theodore for the Ponte di Rialto (possibly 1586), one of the two colossal figures at the entrance to the Zecca (1590), the pair to which is by Campagna, a chimney-piece in the Sala dell'Anticollegio of the Palazzo Ducale, with male supporting figures and a relief of the Forge of Vulcan (begun before 1589), and figures of Hercules and the Hydra and Atlas at the entrance to the Scala d'Oro. In or after 1590 he received commissions for his first recorded bronze sculptures, figures of Justice and Temperance for the Grimani Altar in S. Francesco della Vigna, which were followed (1592) by the contract for figures of Moses and St. Paul on the façade of the church. Thereafter he divided his time between Venice and Padua, where he executed an important group of bronze sculptures for the Santo (1593–5, see Plate 132 below), and two reliefs of scenes from the Martyrdom of St. Daniel for the Duomo (1592–3). In 1604 he accompanied Antonio Grimani, Bishop of Torcello and Apostolic Nuncio in Tuscany, to Pisa, where he worked until his death in 1607. At this time he was patronised by Camillo Berzighelli, for whose kinsman, Lorenzo Usimbardi, he made his last and finest relief, the Martyrdom of St. Lawrence in the Usimbardi Chapel in S. Trinita, Florence.

BIBLIOGRAPHY: A well documented survey of Tiziano Aspetti's career is supplied by M. Benacchio Flores d'Arcais (*Vite e Opera di Tiziano Aspetti*, Padua, 1940). A review of Aspetti's work by L. Planiscig (*Venezianische Bildhauer der Renaissance*, Vienna, 1921, pp. 359–94) is vitiated by some debatable attributions. The relevant chapter of A. Venturi's *Storia* (X-iii, pp. 279–311) is useful mainly for its illustrations.

Plate 132: FAITH
S. Antonio, Padua

After the completion (1577) of the last of the marble narrative reliefs of scenes from the life of St. Anthony, that of Girolamo Campagna, the attention of the Congregazione dell' Arca was directed to the altar in the Chapel of St. Anthony containing the body of the Saint. Plans for a new altar were made in 1587 by Vincenzo Scamozzi and in 1588 by Marc Antonio de' Sordi, but these were not implemented, and in 1592 two further designs were solicited from Tiziano Aspetti and Marc Antonio Palladio. On 25 October 1593 Aspetti's design was approved by ballot ('Dopo lungo et vario discorso intorno all accomodamento dell'altare del glorioso Santo Antonio, a chi piace che sia fatto il modello apresentato di Titiano Aspetti con le colonelle schiette et a bene placito della veneranda congregatione senza la palla della quale si parlera un'altra volta, metta nel rosso e a chi piace, metta nel verde'). A contract of 6 November 1593 enumerates the bronze sculptures which were to decorate the altar; these comprised three statues of SS. Anthony of Padua, Bonaventure and Louis of Toulouse, four angels holding candlesticks, and four bronze figures of Virtues. The latter were removed in 1651 to the balustrade of the choir, where they still stand. The four figures represent Faith, Charity, Temperance and Fortitude, and are signed on the front of rectangular bases cast in one with the main figure TNI.ATI. PNI.OVS. These four figures, with the seven figures remaining on the altar, two documented reliefs made for the altar of St. Daniel in the crypt of the Duomo at Padua (1592) and a relief of the Martyrdom of St. Lawrence in S. Trinita, Florence, form the basis for study of Aspetti's bronze statuettes.

NICCOLO ROCCATAGLIATA
(active 1593–1636)

Genoese by birth, Roccatagliata is first heard of in 1593, when he executed two figures of SS. George and Stephen (see Plate 133 below) for S. Giorgio Maggiore, Venice. A number of documented sconces (1594) and candlesticks (1598) by Roccatagliata exist in the same church. Along with an altar frontal with an Allegory of Redemption in San Moisè (1633), signed by the sculptor with his son Sebastiano and cast by Jean Chenet and Marin Feron, these form the sole basis for the reconstruction of Roccatagliata's work. If the tradition recorded by Soprani, that Roccatagliata prepared models for Tintoretto (d. 1594), is correct, the sculptor must already have been active in Venice in the 1580s. He is last heard of in 1636, when he received, with Pietro Boselli, a contract for two bronze angels for the high altar of S. Giorgio Maggiore. It has been suggested (Venturi)

that between 1596 and 1633 Roccatagliata returned to Genoa; there is no confirmation of this. Roccatagliata was a prolific maker of small bronzes.

BIBLIOGRAPHY: A survey of Roccatagliata's work by L. Planiscig (*Venezianische Bildhauer der Renaissance*, Vienna, 1921, pp. 597–628) is less perceptive than the relevant chapter of the *Storia* of Venturi (X-iii, pp. 378–97).

Plate 133: SAINT STEPHEN
S. Giorgio Maggiore, Venice

The first reference to the presence of Roccatagliata in Venice occurs in a commission of 31 January 1593 for two bronze figures of SS. Stephen and George for the church of S. Giorgio Maggiore ('Accordo con M. Nicolo Roccatagliata scultore per le due figure in bronzo, cioe un S. Giorgio ed un S. Stefano li quali si avranno a porre nel choro nuovo sopra li scabelli delle prime sedie per ducati 60'). This document is wrongly referred by Venturi (X-iii, p. 379) to the year 1595, and is given in its correct form by Mothes (*Geschichte der Baukunst und Bildhauerei Venedigs*, 1860, ii, p. 266) and Planiscig. The two figures, for which Roccatagliata received the sum of fifty ducats, are on the left and right sides of the balustrade across the choir of the church. Other works commissioned for the church from Roccatagliata (for which see G. Damerini, *L'Isola e il Cenobio di San Giorgio Maggiore*, Venice, 1956, pp. 73–4, 77) include 'ventidue puttini di bronzo che si convertono in scartozzi con campanello attaccato a una mano a candelabro sopra la teste' (assessed at a figure of 140 ducats) and a number of paired candelabra made jointly with Cesare Grappo and Giovanni Francesco Alberghetti.

TADDEO LANDINI
(b. 1550? d. 1596)

Born in Florence about 1550, Landini worked in Rome under Popes Gregory XIII, Sixtus V and Clement VIII, dying there in 1596. His major works include a relief of Christ washing the Feet of the Disciples, made for the Cappella Gregoriana in St. Peter's, now in the Quirinal, a gilt bronze statue of Sixtus V for the Palazzo dei Conservatori (see below), and the Fontana delle Tartarughe. This last work was commissioned by the *Diputati sopra le fontane* on 28 June 1581 for completion in April of the following year. Though designed by Giacomo della Porta, it is strongly influenced by Florentine fountains of the type of the Fountain of Neptune in the Piazza della Signoria. The tortoises from which the fountain derives its name are additions made in 1658 under Pope Alezander VII; the original form of the fountain is shown in an engraving of 1618. It is implied by Baglione that Landini was responsible solely for the models for the figures: 'Fabbricò il modello delle quattro figure rappresentanti giovani, che furono gettati di metallo, e posti in opera' (he made the model for the four figures of youths, which were cast in bronze and installed on the work).

BIBLIOGRAPHY: The prime source for Landini's activity is a brief life by Baglione. For the Fontana delle Tartarughe see C. d'Onofrio (*Le Fontane di Roma*, Rome, 1957, pp. 52–6) and B. di Gaddi (*Le Fontane di Roma*, Genoa, 1964, pp. 57–63) and for the lost statue of Sixtus V in the Palazzo dei Conservatori E. Steinmann ('Die Statuen der Päpste auf dem Kapitol,' in *Miscellanea Francesco Ehrle*, ii, Rome, 1924, pp. 480–503).

Plate 134: POPE SIXTUS V
Staatliche Museen, Berlin

The bust (for which see Sobotka, 'Bastiano Torrigiani und die Berliner Papstbüsten,' in *Jahrbuch der Preuszischen Kunstsammlungen*, xxxiii, 1912, pp. 252–74) was formerly in the Royal Palace in Berlin. As noted by Sobotka, the figure of Justice on the right shoulder of the cope corresponds with that on a bust of Gregory XIII in the former Kaiser Friedrich Museum, Berlin, now Staatliche Museen, Berlin-Dahlem, also ascribed by him to Torrigiani. The basis of the attribution is a statement of Baglione that this sculptor 'nella bella vigna degli Eccellentissimi Peretti, dentro il casino verso termini, fece di bronzo il busto del Pontefice Sisto V.' The bust from the Vigna Peretti is now in the Duomo at Treja (Macerata), and exists in a second version in the Victoria and Albert Museum, London. The pose adopted in these busts does not correspond with that of the Berlin bust, and it is a moot point whether the busts depend from models by a single sculptor or from models by two different sculptors cast in a single studio. Landini is known to have made a portrait of Pope Gregory XIII, and was also responsible for the gilt bronze statue of Sixtus V for the Palazzo dei Conservatori (payment of 1300 ducats on 26 June 1587), which was overthrown by the mob on 1 September 1590 after the Pope's death. It is suggested by Holderbaum (lecture in New York, 1965) that Torrigiano was responsible only for the casting of the busts, and that the models are due to Taddeo

Landini. This case is accepted by U. Schlegel (*Bildwerke des Christlichen Epochen von der Spätantike bis zum Klassizismus aus den Beständen der Skulpturabteilung der Staatlichen Museen, Berlin-Dahlem*, Munich, 1966, No. 589). The present bust was presumably produced in the lifetime of the Pope, and is therefore datable 1585–90.

GIOVANNI ANTONIO PARACCA DA VALSOLDO
(d. after 1628)

Born in Lombardy (date unrecorded), Valsoldo came to Rome as a youth (Baglione) and was active as a restorer of antiques under Pope Gregory XIII. He is described (Baglione) as an artist of indolent habits and dissolute character. His earliest surviving works are the sculptures for the Cappella Sistina in S. Maria Maggiore (see Plate 135 below). After the completion of these, in 1591 he received the commission for two statues of SS. Peter and Paul for the Cesi Chapel in S. Maria di Vallicella, and later (1612) worked for the Cappella Paolina. The last reference to his activity occurs in 1628, when he restored a figure for the Villa Borghese. According to Baglione, he was responsible for the tomb of Cardinal Giovanni Girolamo Albani in S. Maria del Popolo, and for restoring the colossal Horse-Tamers on the Quirinal.

BIBLIOGRAPHY: The primary source for Valsoldo's activity is a life by Baglione (pp. 79–80). The only assessment of his work is contained in some pages by Venturi (X-iii, pp. 592–601).

Plate 135: CAPPELLA SISTINA
S. Maria Maggiore, Rome

The circumstances of the construction of the Cappella Sistina are described by Bellori in his life of the architect Domenico Fontana, who was responsible for the overall design of the chapel and for its tombs:

'Divenuto Architetto del Cardinal Montalto fece la pianta, e cominciò la gran Cappella del Presepio in Santa Maria Maggiore, e'l palazzetto del giardino verso la medesima Basilica. Haveva Montalto con l'animo suo grande dato principio à quest'opere, e mostrato le forze superiori alla fortuna di povero Cardinale; e perciò il Papa, ch'era Gregorio XIII gli tolse il piatto (così chiamano in Roma il sussidio solito darsi a Cardinali poveri). Per la qual cagione intermettendosi le spese delle fabbriche, Domenico mosso dal desiderio dell'arte, e dal amore insieme che portava al Cardinale suo benefattore, si lasciò tirare da un pensiero generoso, ch'à lui riuscì fortunatissimo. Havendo egli de' denari guadagnati in Roma mandati alla patria mille scudi, determinò spenderli, per non abbandonare affatto l'edificio della Cappella, con isperanza che di giorno in giorno sarebbono succedute occasioni di rivalersene, e di avantaggiarsi nella generosità di Montalto. Siche fattasi rimettere quella quantità di denari, seguitava il meglio che poteva la fabbrica, non senza piacere del Cardinale, che osservando molto bene la buona volontà, & amorevolezza di Domenico, in quel tanto succeduta la morte del Papa, & egli assunto al Pontificato col nome di Sisto V. lo dichiarò suo Architetto, e senza alterar punto la pianta della Cappella, gli ordinò che la terminasse, variando solo gli ornamenti arricchiti di marmi, statue, e stucchi d'oro. . . . Di quà, e di là ne' muri laterali per tutto il vano vi sono li sepolcri, l'uno di Sisto V l'altro di Pio V che l'haveva creato Cardinale, con le loro statue, e storie di marmo sollevate in due ordini, frà colonne di verde antico essendo, tutti i pilastri, e le mura incrostate di marmi varij fino al cornicione, e'l resto adorno di pitture e scompartimenti di stucco d'orato. Onde tutta la Cappella per gli ornamenti, e buona simmetria riesce magnifica, essendovi accommode due cappellette entro le grossezze de' primi pilastri con li cori di sopra, e di fuori li muri adornati di ordini d'architettura, e membri di travertino. Siche la pianta di questo edificio per la sua bellezza è stata seguitata nell'altra cappella di rincontro di Paolo V. la quale se bene è superiore per la ricchezza, nondimeno cede nell'ordine, e nel disegno' (Becoming Cardinal Montalto's architect, he made the plan for the large Cappella del Presepio in S. Maria Maggiore and began work on it, as well as on the Villa in the garden near the same basilica. Seeing that Montalto, with his great ambition, had begun these works and that their scale exceeded that suitable to the fortune of a poor Cardinal, the Pope, Gregory XIII, withdrew his piatto (the name given in Rome to the subsidy customarily awarded to poor Cardinals). For this reason Domenico, moved by his artistic aspirations and by the love he bore the Cardinal, his benefactor, succumbed to a generous instinct which turned out well for him. Of the money he had earned in Rome he had transmitted to his native town a thousand scudi, and in order to avoid the total cessation of work on the structure of the chapel, he determined to spend them, in the hope that from day to day opportunities might occur to reimburse himself, and to gain advantage from the generosity of Montalto. Having ensured the return of this sum of money to Rome, he continued with the chapel as best he could, to the great pleasure of the Cardinal, who observed his good will and affection. At this moment the Pope died, and Montalto, raised to the pontificate with the title of Sixtus V, named Fontana as his architect, and without modifying the scheme of the chapel in any way, ordered that it should be completed, enjoining only that the decoration should be enriched with marbles, statues and gilt stuccos. . . . On either side the lateral walls are fully occupied by the tombs of Sixtus V and of Pius V, by whom he had been created Cardinal, with statues, two tiers of narrative marble reliefs, between columns

of verde antico, and pilasters and walls encrusted with fine marbles up to the cornice, and the rest decorated with paintings and gilded stuccos. So the whole chapel, through its decoration and good symmetry, succeeded magnificently. Two small chapels were set in the depth of the first pilasters, and outside the walls were adorned with architectural orders and members of travertine. On account of its beauty the scheme of this chapel was imitated in the chapel of Paul V opposite, which, though superior in richness, is none the less inferior in order and design). The sculptured decoration of the chapel comprises: (A) *facing wall*, statues of SS. Peter and Paul by Leonardo da Sarzana after models by Prospero Bresciano, (B) *left wall*, tomb of Pope Pius V (Fig. 150) (statue of the Pope by Leonardo da Sarzana; left relief lower register, Pope Pius V confers the papal banner on Marcantonio Colonna by Egidio della Riviera; right relief lower register, Pope Pius V invests the Count of Santa Fiora with the command against the Huguenots by Egidio della Riviera; central relief upper register, Coronation of Pope Pius V by Egidio della Riviera; left relief upper register, the Battle of Lepanto by Niccolò Pippi; right relief upper register, the Victory of the Count of Santa Fiora by Niccolò Pippi), statues of St. Dominic by Giovanni Battista della Porta and St. Peter Martyr by Valsoldo. (C) *right wall*, tomb of Pope Sixtus V (Fig. 149) (statue of the Pope by Valsoldo; left relief lower register, Charity and Munificence with an allegory of the achievements of Pope Sixtus V by Valsoldo; right relief lower register, Justice and Peace with an allegory of the Pope's campaign against the brigands by Niccolò Pippi; central relief upper register, the Coronation of Pope Sixtus V by Egidio della Riviera; left relief upper register, the Canonisation of S. Diego by Egidio della Riviera; right relief upper register, the Peace between the Emperor of Austria and the King of Poland by Egidio della Riviera), statues of St. Francis by Flaminio Vacca and St. Anthony of Padua by Olivieri.

The project for the chapel was sponsored by Sixtus V before his election to the papacy in April 1585. As Pope he visited the Chapel in September and October 1585, and celebrated Mass there at Christmas 1586. Relics of St. Lucy and St. Paul for the altars beside the entrance were installed in the chapel on 1 November 1586. The tomb of Pope Pius V was commissioned by the Pope in July 1586 at an estimated cost of 25,000 scudi, and the statue of Pius V was inspected by the Pope in September of this year in the sculptor's studio, and was installed in June 1587. The body of Pope Pius V was transferred to the tomb on 8 February 1588. The statue for the monument opposite was installed in an unfinished state in the presence of the Pope on 30 July 1589; payments for it are recorded on 28 March 1588 and 10 March 1590. The monument was still incomplete at the time of the Pope's death in August 1590, and his body was committed to it by his nephew, Cardinal Montalto, on 26 August 1591.

NICOLA CORDIERI
(b. ca. 1567; d. 1612)

Born in Lorraine, probably in 1567 if, as stated by Baglione, he died at the age of forty-five, Cordier, known in Italy as Cordieri or il Franciosino, came as a youth to Rome. In 1601 he received a payment for nine angels for the nave of St. John Lateran, and in 1602 completed a statue of St. Gregory the Great, carved from a block used by Michelangelo, for S. Gregorio al Celio. Probably in the latter year he received the commission from the same patron, Cardinal Baronio, for the statue of S. Silvia in the Oratorio di S. Silvia at S. Gregorio. For the Aldobrandini Chapel in S. Maria sopra Minerva (commissioned 1600 from Giacomo della Porta, completed by Carlo Maderno), he carved the sculptures for the tombs of the parents of Pope Clement VIII, Silvestro and Luisa Deti Aldobrandini (Fig. 147) (figure of Religion on latter monument by Camillo Mariani, who was also responsible for the statues beside the altar in the chapel: effigies inspected by the Pope in 1604, tomb of Luisa Deti Aldobrandini still unfinished at the Pope's death in 1605). Cordieri also executed (1608) the bronze statue of King Henry IV of France in the portico of St. John Lateran and a bronze statue of Pope Paul V at Rimini. His finest works are four statues for the Cappella Paolina in S. Maria Maggiore (see Plate 136 below), which were carved after 1609 and for which he received a sum of 3400 scudi. The date given for Cordieri's death by Baglione (25 November 1612) is confirmed by a contemporary avviso (Orbaan), but is rejected by Venturi, who assumes that he was active until 1634.

BIBLIOGRAPHY: A brief account of Cordieri's career is given by Baglione (pp. 114–6), and a useful corpus of illustrations is supplied by Venturi (X-iii, pp. 642–69). For the documentation of the Cappella Aldobrandini see Pastor (xi, pp. 657–9), and for Cordieri as a restorer of antiques see Faldi (*Galleria Borghese; le sculture dal secolo XVI al XIX*, Rome, 1954, pp. 48–9). Cordieri's activity as a maker of small bronzes has not been investigated; a bronze reduction of the Charity on the tomb of Luisa Deti Aldobrandini is in the Victoria & Albert Museum, London.

Plate 136: CAPPELLA PAOLINA
S. Maria Maggiore, Rome

The first reference to the project for the construction of the Cappella Paolina occurs soon after the election of Pope Paul V in an avviso of 25 June 1605 (Orbaan, p. 49): 'Nostro Signore rissolvè far la cappella in Santa Maria Maggiore ricontro a

quella di Sisto, ove vuol essere sepellito, ma per l'Iddio gratia ci havrà tempo.' The chapel was designed to house the painting of the Virgin traditionally ascribed to St. Luke and the tombs of the Pope and of his predecessor Clement VIII. It occupied the site of a sacristy, which was forthwith demolished, and on 6 August 1605 the foundation stone was laid by the Pope (Orbaan, p. 58: 'di sua mano buttò la prima pietra nella capella che fa Sua Beatitudine fare'). It was rumoured at the time that the Pope was prepared to spend 150,000 scudi on the chapel (Orbaan, p. 58). This sum was greatly exceeded, and by October 1618 the total expenditure on the chapel was 306,987 scudi (Pastor, xii, p. 666). During the whole period of construction the Pope paid repeated visits to the church. Among those recorded in the avvisi are visits on 5 August 1606, when he rode to the church 'et diede gli ordini che gli parsero più a proposito per la continuatione della fabrica della sacrestia et capella' (Orbaan, p. 75), and 8 September 1610, when he 'volse veder minutamente la fabrica della sua cappella' (Orbaan, p. 176). In 1611 the structure of the chapel was complete, and on 8 January 1611 the Pope announced his intention of transferring the body of Clement VIII to its new tomb on the feast of the Assumption in the same year (Orbaan, p. 183). Immediately afterwards he nominated the painters Arpino, Baglione, Cigoli and Giovanni dei Vecchi to decorate the chapel. The statues of the Pope and of Clement VIII were installed in their places on 14 December 1611 (Orbaan, pp. 195–6). On 27 January 1613 the miraculous Virgin and Child was installed over the altar, and on 8 September 1613 the Pope said Mass in the chapel (Orbaan, pp. 12–3). The architect of the chapel and of the tombs was Flaminio Ponzio. The principal sculptured decoration of the chapel comprises: (A) *altar wall*, statues of (*right*) St. John the Evangelist by Camillo Mariani and (*left*) St. Joseph by Ambrogio Bonvicino, relief of the Foundation of the Church of S. Maria Maggiore over the altar by Stefano Maderno, (B) *right wall*, tomb of Pope Clement VIII (Fig. 151) (statue of

the Pope by Silla di Viggiù; left relief lower register, Surrender of Ferrara by Buonvicino; right relief lower register, Gian Francesco Aldobrandini leading the papal troops against the Turks by Mariani; central relief upper register, Coronation of Pope Clement VIII by Pietro Bernini; left relief upper register, Conclusion of peace between France and Spain by Ippolito Buzio; right relief upper register, Canonisation of SS. Raymond and Hyacinth by Valsoldo; caryatids in upper register by Pietro Bernini), statues of (*left*) Aaron and (*right*) St. Bernard by Cordieri, (C) *left wall*, tomb of Pope Paul V (Fig. 152) (statue of the Pope by Silla di Viggiù; left relief lower register, Papal army in Hungary fighting against the Turks by Maderno; right relief lower register, the Fortification of Ferrara by Buonvicino; central relief upper register, Coronation of Pope Paul V by Buzio; left relief upper register, Canonisation of St. Charles Borromeo and S. Francesca Romana by Valsoldo; right relief upper register, Persian ambassadors received by the Pope by Cristoforo Stati; caryatids in upper register by Buzio), statues of (*left*) St. Athanasius and (*right*) David by Cordieri. Payments to Cordieri for the four statues run from 1609 till 1612 when the figures were placed in their niches, a final payment being made on 19 June of the latter year (for this see M. C. Donati, 'Gli scultori della Cappella Paolina in Santa Maria Maggiore,' in *Commentari*, xviii, 1967, pp. 231–60). The discrepancy between the poses of the papal statues is explained by an avviso of 26 July 1608 (Orbaan, p. 120), which records that the Pope took over a statue of Clement VIII destined for the Campidoglio, where it was to have been a counterpart to Olivieri's statue of Gregory XIII. The caryatids and relief carved by Pietro Bernini for the Clement VIII tomb were executed between 1611 and 1614, a final payment being made for the relief on 19 January 1614. The present relief appears to have been carved in substitution for an earlier rejected relief by the same sculptor of the same scene (for documents see Sobotka, 'Pietro Bernini,' in *L'Arte*, xii, 1909, pp. 401–22).

PIETRO BERNINI
(b. 1562; d. 1629)

Born at Sesto near Florence on 5 May 1562 and trained in Florence by Ridolfo Sirigatti (Baglione), Pietro Bernini migrated as a youth to Rome, and in 1584 'invitato dalla speranza di maggiori avantaggi' (Baldinucci) moved to Naples. Nothing is known of his activity in his first Roman period, though it is stated (Baglione, Baldinucci) that at this time he worked at Caprarola, and suggested (Sobotka) that he was employed on decorations in the Vatican. The earliest surviving works carried out by Bernini in Naples are two statues of the Madonna of the Snow and St. Catherine of Alexandria at Terranova Sappo Minulio, a marble statue of St. John the Baptist in the Museo Nazionale at Palermo, and a terra-

cotta figure of the same Saint in S. Giovanni a Carbonara, Naples. In 1591 he accepted the commission for a marble altar or tabernacle for S. Maria di Colorito at Morano Calabro, of which statues of SS. Catherine and Lucy survive in this church, and two figures of angels are in the Chiesa della Maddalena. In 1594 he returned with his wife to Florence, where he was still resident in 1595. He collaborated with Caccini on a terracotta model for the relief of the Trinity over the entrance to S. Trinita (document of 28 June 1594) and on the carving of the relief. A year later he returned to Naples, according to Domenico Bernini in connection with a commission from the Viceroy for sculptures for the Certosa di S. Martino, for which

statues had been commissioned from Caccini in 1593. Domenico Bernini's statement is confirmed by a payment of 26 August 1598 for sculptures for this church (for this see Addosio, *Documenti inediti di artisti napoletani dei secoli XVI e XVII*, Naples, 1920, p. 146). Works executed by Pietro Bernini for S. Martino at this time comprise a statue of the Virgin and Child with the young Baptist, recarved about 1626–31 by Fanzago, and a relief of St. Martin and the Beggar (Martinelli), now in the Museo di San Martino, and a figure of Purity in the choir of the church. To this or to a slightly later date belong statues of SS. Peter and Paul in the Duomo in Naples, a figure of St. Matthew in the Gesù Nuovo, two statues of Charity (Fig. 154) and Security on the façade of the Monte di Pietà (1600–1), statues of SS. Lawrence and Stephen in the crypt of the Duomo at Amalfi (1602), a Prophet in S. Giovanni dei Fiorentini, and the important cycle of six statues on the Ruffo altar in the Gerolomini. After 1600 Pietro Bernini was associated in Naples with the sculptor Naccherino, with whom he worked on the Fontana Medina now in Piazza Bovio (extent of Bernini's responsibility for existing figures doubtful).

In 1605 or 1606 Pietro Bernini moved with his family to Rome, where he undertook the Assumption in S. Maria Maggiore (see Plate 138 below) and was employed on the tomb of Pope Clement VIII in the Cappella Paolina (see Plate 136 above) (four caryatids 1611–2; relief of the Coronation of the Pope, first version 1611, second version 1613). After this time he carved the statue of St. John the Baptist for the Barberini Chapel in S. Andrea della Valle (see Plate 137 below), and an angel for the doorway of the chapel in the Quirinal (1616–7), and was employed on decorative sculptures for the Villa Borghese (1617–20). In the latter year he seems to have been active at Caprarola with Girolamo Rainaldi, with whom he was associated in work on the Bellarmine monument in the Gesù (1621–3, statues of Religion and Wisdom in conjunction with Giuliano Finelli), the Sfondrato monument in S. Cecilia in Trastevere, and the Dolfin monument in S. Michele in Isola, Venice (1622–3, statues of Faith and Hope). Pietro Bernini died on 29 August 1629. The problems arising from his work relate (i) to the identification of his early Neapolitan sculptures, (ii) to the delimitation of his sculptures from the early sculptures of his son, Gian Lorenzo Bernini (q.v.), and (iii) to the definition of his style, which, though not properly baroque (as claimed by Muñoz), is not adequately covered by the alternative definitions of Wittkower ('a gifted but facile late Mannerist sculptor') or Martinelli('manierisimo espressionistico').

BIBLIOGRAPHY: The career of Pietro Bernini is the subject of parenthetical references in Baldinucci's life of Gian Lorenzo Bernini and Domenico Bernini's life of his father, and is described in a brief biography by Baglione (pp. 304–6). The best general account of his style and development is contained in an article by V. Martinelli ('Contributi alla scultura del Seicento: iv, Pietro Bernini e figli,' in *Commentari*, iv, 1953, pp. 133–54), which supersedes earlier articles by A. Muñoz ('Pietro Bernini,' in *Vita d'Arte*, iv, 1909, pp. 425–70) and G. Sobotka ('Pietro Bernini,' in *L'Arte*, xii, 1909, pp. 401–22) and the well illustrated chapter on Pietro Bernini in the *Storia* of Venturi (X-iii, pp. 886–922). Venturi's chapter is based in part on an unpublished thesis by P. Rotondi (*Pietro Bernini Scultore*, Rome, 1932), whose articles ('Le opere giovanili di Pietro Bernini,' in *Capitolium*, xi, 1933, pp. 10–1; 'L'educazione artistica di Pietro Bernini,' in *Capitolium*, xi, 1933, pp. 392–9; 'Studi intorno a Pietro Bernini,' in *Rivista del R. Istituto d'Archeologia e Storia dell'Arte*, v, 1935–6, pp. 189–202, 345–61) deal primarily with the reconstruction of the artist's early works. For Pietro Bernini's connection with Rainaldi see Hoogewerff ('G. Vasanzio fra gli architetti romani,' in *Palladio*, vi, 1942, pp. 53–4).

Plate 137: SAINT JOHN THE BAPTIST
S. Andrea della Valle, Rome

The Barberini Chapel in S. Andrea della Valle was purchased by Cardinal Maffeo Barberini on 29 November 1604, and was consecrated on 8 December 1616. It contains statues of (*right*) St. Martha by Francesco Mochi and St. John the Evangelist by Ambrogio Bonvicino, and (*left*) St. Mary Magdalen by Cristoforo Stati and St. John the Baptist by Pietro Bernini. The four statues are not documented, and the only one of them that has been studied in detail is that by Mochi (for which see Hess, *Die Künstlerbiographien von Giovanni Battista Passeri*, 1934, pp. 132–3). The St. Martha seems to have been begun after Mochi's return from Orvieto in 1610, was left incomplete on his departure for Piacenza in 1612, and was probably not completed till 1629. It is likely (Hess) that a companion figure of St. John the Baptist was commissioned from Mochi at the same time, and that owing to Mochi's absence in Piacenza the commission was later transferred to Pietro Bernini. Mochi's Baptist was none the less completed, and is now in the Hofkirche at Dresden. Pietro Bernini's statue is conjecturally assigned to the year 1616. If Passeri's account is to be believed, an attempt to replace it with Mochi's statue of the same Saint was defeated by Gian Lorenzo Bernini.

Plate 138:
THE ASSUMPTION OF THE VIRGIN
S. Maria Maggiore, Rome

The commissioning of Pietro Bernini's Assumption is described by Baglione: 'Negli anni di Paolo V. fu Pietro Bernini dal Caualier Giuseppe Cesari proposto al Pontefice, per fare vna storia grande di marmo, e metterla nella facciata della cappella Paolo a s. Maria Maggiore; venne egli da Napoli, e fece l'Assunta con gli Appostoli, scultura grande di marmo, di basso rilieuo; la quale poi fu posta sopra l'altare del Choro della nuoua Sagrestia di quella Basilica fatta da Paolo v' (During the reign of Paul V Pietro Bernini was proposed to the Pope by Cavaliere Giuseppe Cesari to undertake a large marble relief intended for the façade of the Cappella Paolina in Santa Maria

Maggiore. He came from Naples, and carved the Assumption of the Virgin with the Apostles, a large marble sculpture in low relief, which was then placed over the altar in the choir of the new sacristy of the basilica constructed by Paul V). The relief was commissioned on 30 December 1606; the last recorded

payment for it occurs in December 1610. The composition is referred by Venturi to Correggio, but finds its closest point of reference in two altarpieces by Lodovico Carracci in the Pinacoteca at Bologna and the North Carolina Museum of Art, apparently painted about 1585.

GIAN LORENZO BERNINI
(b. 1598; d. 1680)

Born at Naples on 7 December 1598, Gian Lorenzo Bernini in or about 1605 was brought by his father Pietro Bernini to Rome, and was trained in Rome in his father's workshop. Study of the antique, however, from the beginning played a major part in his development, and his earliest surviving work, the Goat Amalthea nursing the Infant Jupiter (Wittkower ca. 1615. Lavin 1609, perhaps ca. 1612), in the Galleria Borghese, is indebted in style and technique to classical sculpture. Related groups of a Boy with a Dragon in a private collection in New York and a Putto with a Dolphin in Berlin seem to date from ca. 1614. At a very early date he also experimented with portraiture and with religious sculpture. In the first category his juvenilia comprise the bust of Antonio Coppola for the Archconfraternity of the Pieta in S. Giovanni dei Fiorentini (payments of 1612, installed 1614), the bust of Monsignor Giovanni Battista Santoni (d. 1592) on a wall monument in S. Prassede (Wittkower ca. 1616, Lavin, following Baldinucci, ca. 1610; certainly prior to the Coppola bust) and the bust of Giovanni Vigevano (d. 1630) in S. Maria sopra Minerva (Wittkower ca. 1617–8, perhaps somewhat earlier). The Santoni bust is a conventional commemorative portrait, and the Coppola bust was made after death from a wax mask, while the Vigevano bust is a life portrait. In the second category he carved statues of St. Lawrence for Leone Strozzi (Contini-Bonacossi collection, Florence) and St. Sebastian, the latter perhaps intended (Wittkower) for the Barberini Chapel in S. Andrea della Valle (Thyssen-Bornemisza collection, Lugano), both dated by Wittkower ca. 1617; the St. Lawrence appears to have been carved (Lavin, following Baldinucci and Domenico Bernini) in 1614, and the St. Sebastian perhaps dates from the following year. In his twenties Bernini produced the masterly mythological groups which are now, with one exception, assembled in the Galleria Borghese; these comprise the Aeneas and Anchises (see Plate 139 below), the Pluto and Proserpine (see Plate 140 below), the Apollo and Daphne (see Plate 142 below), the David (see Plate 144 below), and the Neptune and Triton in London, which was carved ca. 1621 for the Villa Montalto. Concurrently Bernini was engaged in the restoration of antiques, notably the Borghese Hermaphrodite in the Louvre (to which a mattress was added in or before 1620), the Barberini Faun at Munich, and the right foot and other parts of the Ludovisi Ares in the Museo delle Terme (ca. 1621). He first gives the measure of his capacity as a

portraitist in a small bust of Paul V in the Galleria Borghese (ca. 1617), and as a religious sculptor in the Anima Beata and Anima Dannata in the Palazzo di Spagna (ca. 1621). His first major religious sculpture is, however, the S. Bibiana (see Plate 143 below). After the election of his patron Cardinal Maffeo Barberini as Pope Urban VIII (6 August 1623), Bernini was extensively employed in St. Peter's, initially on the Baldacchino (first payment 12 July 1624, completed 29 June 1633) and subsequently on the Longinus (Bernini's design for the systematisation of the piers approved 15 May 1628, model completed 5 April 1632, carving begun 1634–5 and completed in the first half of 1638), the balconies above the colossal statues, the tomb of Pope Urban VIII (see Plate 146 below), the tomb of the Countess Matilda (commissioned 1633, unveiled 20 March 1637), and the relief of Christ's Charge to Peter over the central door (commissioned and designed 1633, not completed before 1646). In addition to these works he undertook a number of Barberini commissions, for the busts of the Pope (see Plate 145 below), of the Pope's uncle Francesco Barberini (see Plate 144 below), for a memorial and statue to the Pope's brother, Carlo Barberini (d. 1630, former carved in 1630 for S. Maria in Aracoeli, latter carved in the same year in association with Algardi, now in the Palazzo dei Conservatori) and for a memorial statue of Urban VIII in the Palazzo dei Conservatori (after 1635). Bernini reaches full maturity as a portraitist with the two busts of his early patron Cardinal Scipione Borghese in the Galleria Borghese (see Plate 148 below) and the head of Costanza Buonarelli (Museo Nazionale, Florence, ca. 1636). A bust of King Charles I (lost) was carved in 1636–7, and was followed by a second bust of an Englishman, Thomas Baker (Victoria and Albert Museum, London), and a portrait of Richelieu (Louvre, 1640–1). Bernini's most important sculptures of the 1640s are the Ecstasy of St. Teresa in the Cornaro Chapel in S. Maria della Vittoria (see Plates 150, 151 below) and the Truth Unveiled in the Galleria Borghese (see Plate 152 below). From this time on he tended increasingly to act as designer rather than executant; he designed but did not execute the high altar of S. Francesca Romana (in large part destroyed, 1644–9), the Raimondi Chapel in S. Pietro in Montorio (completed 1648), the colossal project for the decoration of the pilasters of St. Peter's (initiated 1645, completed end of 1648), the Noli Me Tangere in SS. Domenico e Sisto (after 1649), the Fountain of the Four Rivers (see Plate 153 below), and the tomb

of Cardinal Pimentel in S. Maria sopra Minerva (after 1653). The autograph works of this period, the bust of Francesco I d'Este at Modena (see Plate 149 below) and the Daniel and Habakkuk in the Chigi Chapel in S. Maria del Popolo, are none the less of notably high quality. After the election of Pope Innocent X (1644) Bernini suffered a temporary estrangement from the papal court, and the work of Algardi was preferred, but the breach appears to have been healed by the Fountain of the Four Rivers. Innocent X's successor, Alexander VII, proved one of the sculptor's most liberal and imaginative patrons, and was responsible, among much else, for the commissions for the Cathedra Petri (see Plate 155 below), the church of S. Andrea al Quirinale and the churches at Castel Gandolfo and Ariccia, the Chigi Chapel in the Duomo at Siena (see Plate 156 below), the statues over the colonnades of St. Peter's (after 1659), and the Scala Regia of the Vatican (1663–6). In 1665, Bernini visited France, carving the bust of Louis XIV (completed 5 October 1665) and thereafter returning to Rome, where he supervised the completion of the Cathedra and undertook his only equestrian figures, the Constantine on the Scala Regia of the Vatican (unveiled 1 November 1670) and the Louis XIV for Versailles (unfinished till 1677, subsequently modified by Girardon). To this late phase belong three great collaborative projects, for the Angels on the Ponte Sant'Angelo (see Plate 157 below), the tomb of Pope Alexander VII (see Plate 147 below), and the Altar of the Sacrament in St. Peter's (1673–4), as well as Bernini's only late portrait sculpture, the magnificent figure of Gabriele Fonseca in S. Lorenzo in Lucina (ca. 1668), and one of his finest autograph works, the Death of the Beata Lodovica Albertoni in S. Francesco a Ripa (see Plate 158 below). At the time of his death (28 November 1680) Bernini was engaged on a half-length figure of the Salvator Mundi.

BIBLIOGRAPHY: A volume by Fraschetti (Il Bernini, Milan, 1900), for long the standard monograph on Bernini, has been in large part superseded, but contains a wealth of background information and some reproductions that are not available elsewhere. The modern phase in Bernini's studies (in the course of which Bernini's work has been more strictly analysed than that of any Italian sculptor save Donatello and Michelangelo) opens with a classical volume by Brauer and Wittkower on the artist's drawings (Die Zeichnungen des Gianlorenzo Bernini, Berlin, 1931) and culminates in an exemplary monograph by Wittkower (Gian Lorenzo Bernini, London, 1955; second revised edition 1966). A short volume by H. Hibbard (Bernini, London, 1965) is remarkable for its expository clarity, and contains some original material. No such claim can be made for M. and M. Fagiolo dell'Arco (Bernini: una introduzione al gran teatro del barocco, Rome, 1967). The best account of Bernini's activity as a decorator and architect is that of Wittkower (in Art and Architecture in Italy 1600–1750, London, 1958). The principal early sources for Bernini's career are the lives of Baldinucci (1682, reprinted as Vita di Gian Lorenzo Bernini scritta da Filippo Baldinucci, ed. Samek Ludovici, Milan, 1948) and Domenico Bernini (Vita del Cavalier Gio. Lorenzo Bernino, Rome, 1713, no modern reprint), and Chantelou's Journal du Voyage du Cav.

Bernini en France (Paris, 1885, modern edition incomplete). Of the single books and articles published before 1958 special reference should be made to Faldi's analysis of the documentary background of the early works (in Bollettino d'Arte, xxxviii, 1953, pp. 140–6, 310–6, and Galleria Borghese: le sculture dal secolo XVI al XIX, Rome, 1954), Battaglia's remarkable study of the Cathedra (La Cattedra berniniana di San Pietro, Rome, 1943), a lecture by Wittkower on the Louis XIV bust (Bernini's Bust of Louis XIV, London, 1951), an early article by Voss on the fountains ('Berninis Fontänen', in Jahrbuch der Preuszischen Kunstsammlungen, xxxi, 1910, pp. 99–129, in part superseded by later literature), Heckscher's iconographical examination of the Elephant and Obelisk outside Santa Maria sopra Minerva ('Bernini's Elephant and Obelisk,' in Art Bulletin, xxix, 1947, pp. 155–82), and Panofsky on the Scala Regia of the Vatican ('Die Scala Regia im Vatikan und die Kunstanschauungen Berninis', in Jahrbuch der Preuszischen Kunstsammlungen, xl, 1919, pp. 241–78), and on the iconography of the papal tombs ('Mors Vitae Testimonium,' in Studien zur Toskanischen Kunst: Festschrift für L. H. Heydenreich, Munich, 1964, pp. 221–36).

The most important contribution to the study of Bernini since the appearance of Wittkower's book (1955) is an article by I. Lavin ('Five new youthful sculptures by Gianlorenzo Bernini and a revised Chronology of his early Works,' in Art Bulletin L, 1968, pp. 223–48) publishing a number of unrecognised early works by the sculptor and proposing a much advanced chronology, according to which Bernini would have been active as a sculptor from about 1609. With some qualifications, this chronology appears to be substantially correct, and is embodied in the biography above. In addition there must be mentioned articles by U. Schlegel ('Zum Oeuvre des jungen Gian Lorenzo Bernini,' in Jahrbuch der Berliner Museen, ix, 1967, pp. 274–94, publishing a Putto with a Dolphin carved by Gian Lorenzo in the workshop of Pietro Bernini), H. Kauffmann ('Die Aeneas- und Anchises-Gruppe von Gianlorenzo Bernini in der Villa Borghese,' in Studien zur Geschichte der Europäischen Plastik: Festschrift für Theodor Müller, Munich, 1965, pp. 281–91, dealing with the Raphaelesque sources of this group) S. Rinehart ('A Bernini Bust at Castle Howard,' in Burlington Magazine, cix, 1967, pp. 437–42, publishing a bust of Cardinal Antonio del Pozzo, Archbishop of Pisa, listed by Baldinucci), and R. Wittkower ('The Role of Classical Models in Bernini's and Poussin's Preparatory Work,' in Studies in Western Art: Acts of the 20th International Congress of the History of Art, iii, Princeton, 1963, pp. 41–50). On the Fountain of the Four Rivers see H. Kauffmann ('Romgedanken in der Kunst Berninis,' in Jahresberichte der Max-Planck-Gesellschaft, Göttingen, 1953–4, pp. 55–80), and, in opposition to this thesis, N. Huse (Gian Lorenzo Berninis Vierströmebrunnen, Inaugural Dissertation, Ludwig-Maximilians-Universität, Munich, 1967). Drawings for the Longinus and the Pasce Oves Meas in Düsseldorf and Berlin are published in a useful article by A. Sutherland Harris ('New Drawings by Bernini for "St. Longinus" and other contemporary Works,' in Master Drawings, vi, 1968, pp. 383–91). A documented small bronze of the Duke of Bracciano, for which see Wittkower (1966), is in the Linsky collection, New York. Small bronzes based on Bernini's

models for the St. Agnes on the colonnade of St. Peter's and for the central figure on the tomb of the Countess Matilda are published by J. Montagu ('Two Small Bronzes from the Studio of Bernini,' in *Burlington Magazine*, cix, 1967, pp. 437–42). Articles of less general interest are noted below.

Plate 139: AENEAS, ANCHISES AND ASCANIUS LEAVING TROY
Galleria Borghese, Rome

Baldinucci states that the Aeneas and Anchises was made for Cardinal Scipione Borghese, 'e fu questa la prima opera grande, ch'egli facesse, nella quale quantunque alquanto della maniera di Pietro suo padre si riconosca, non lascia però di vedersi, per le belle avvertenze, ch'egli ebbe in condurla, un certo avvicinarsi al tenero e vero, al quale fino in quell' età portavalo l'ottimo gusto suo, ciò che nella testa del vecchio più chiaramente campeggia. Onde maraviglia non è che lo stesso porporato di subito gli ordinasse una statua d'un David, di non minor grandezza della prima' (and this was the first large work he did. Though one notices something of the manner of his father Pietro in it, yet in the fine accuracy with which he carried it out one clearly distinguishes a certain approach to sensitivity and truth, and it is to these qualities that from this time on his excellent taste led him, as is particularly clear in the head of the old man. So it is not surprising that the same Cardinal at once commissioned from him a statue of David, no less large than this first group). The group is described by Domenico Bernini as a work executed by Gian Lorenzo Bernini at the age of nineteen, that is in 1617. Already in the seventeenth century, however, there was some doubt as to the authorship of the group, and it is mentioned by Sandrart in his life of Pietro Bernini (*Academie*, 1675, p. 285), apparently on the basis of information culled in Rome in 1629–30, as a work by this sculptor: 'Romae cum duobus filiis et marmore multa sculpsit, internaque praecipue in palatio Vineae Borghesiae oecus magnus in quo multae statuae marmoreae viventium magnitudine majores: & inter alias Aeneas Anchisen patrem e flammis exportans, ex uno marmore arte insigni' (at Rome he carved many things in marble with his two sons, particularly in the palace of the Vigna Borghese, a great house in which there are many marble statues over life-size, including an Aeneas carrying his father Anchises out of the flames, done with excellent art from a single block of marble). The view that the work was designed and executed by Pietro Bernini has been restated in modern times by Longhi ('Precisioni nelle Gallerie italiane,' in *Vita Artistica*, i, 1926, pp. 65–6). For the contrary case, that the group was carved by Gian Lorenzo Bernini without the intervention of his father, see Martinelli ('Contributi alla scultura del Seicento: iv, Pietro Bernini e figli,' in *Commentari*, iv, 1953, p. 146 ff.). Wittkower ('Bernini Studies – 1: The Group of Neptune and Triton,' in *Burlington Magazine*, xciv, 1952, pp. 68–76) sees the group as a work of collaboration between father and son, in which Gian Lorenzo Bernini had a preponderant share. The date of completion of the group is established by a document (published by Faldi, 'Note sulle

sculture borghesiane del Bernini,' in *Bollettino d'Arte*, xxxviii, 1953, pp. 140–6) showing that on 14 October 1619 a mason, Giuseppe di Giacomo, was paid for the carving of the 'piedistallo della statua di Enea'. A payment of 350 scudi on the same date to Bernini 'per una statua da lui fatta de novo' must therefore also refer to the same group. It is inferred by Faldi (*Galleria Borghese: le sculture dal secolo XVI al XIX*, Rome, 1954, pp. 26–9) that the group was carved by Gian Lorenzo Bernini alone, and belongs not to the initial period of close association between father and son, but to a moment about 1620 when Gian Lorenzo's style once more for a short time approximated to that of Pietro Bernini. The validity of this argument is questionable, (i) because the documents offer no indication of the date at which the group was commissioned or begun, and (ii) because the form argues the intervention of Pietro Bernini both in its ideation (Riccoboni) and in its execution (Wittkower and others). The use of the term 'de nouo' in the payment to Bernini has not been satisfactorily explained; it does not recur in the payments for Bernini's other early statues, but is used in the record of payment for the pedestal ('per hauer refatto di nouo cioe refondato le tre teste di boue'), where it refers to the recarving of an existing work. It has been repeatedly observed that the figure of Aeneas depends from the Minerva Christ of Michelangelo, and that the scheme of the whole group is related to the group on the left of Raphael's fresco of the Burning of the Borgo. The group originally stood on a cylindrical Roman base, the form of which confirms what is also attested by other sources, that initially and till the middle of the nineteenth century it was shown against a wall. For this reason it is planned with a front view and two side views.

Plate 140: THE RAPE OF PROSERPINE
Galleria Borghese, Rome

The date of execution of the group, which was commissioned by Cardinal Scipione Borghese, is established by three documents published by Faldi ('Note sulle sculture borghesiane del Bernini,' in *Bollettino d'Arte*, xxxviii, 1953, pp. 140–6), recording payments to Bernini in June 1621 of 300 scudi 'a bon conto d'una statua di Plutone che rapisce Proserpina,' and in September of the same year of 100 scudi for the same work. A total of 60 scudi were paid in the summer of 1622 to the mason responsible for the base, and the group was presumably completed by that time. According to Baldinucci, the statue on completion was presented by Cardinal Scipione Borghese to Cardinal Lodovico Ludovisi; this is confirmed by payments of September 1622 (also published by Faldi, 'Nuove note sul Bernini,' in *Bollettino d'Arte*, xxxviii, 1953, p. 315) 'per la portatura della statua di Plutone et Proserpina da Santa Maria Maggiore a Porta Pinciana,' and of July 1623 for the transfer of a statue from the Villa Borghese 'quale fu donata a Ludovisi'. The statue remained in the Villa Ludovisi till 1908, when it was purchased by the state and installed in the Galleria Borghese. Martinelli (*Roma ricercata nel suo sito*, Venice, 1664, p.137) records that the base (now lost) was inscribed with an epigram by Maffeo Barberini, the future Pope Urban VIII, which read: 'Quisquis humi pronus flores legis, inspice, me saevi ditis ad

domum rapi.' Wittkower ('Bernini Studies – 1: The Group of
Neptune and Triton,' in *Burlington Magazine*, xciv, 1952, p. 72,
relates the movement of Pluto to a torso in the Capitoline
Museum, discovered about 1620, which was restored by
Algardi into a Hercules killing the Hydra, and connects the face
of Proserpine with the Niobids. A drawing at Leipzig is
identified by Brauer and Wittkower (pp. 18–9) as a preliminary
study for the group.

Plate 141: DAVID
Galleria Borghese, Rome

The David of Bernini (Fig. 157), like the Aeneas and Anchises,
was commissioned by Cardinal Scipione Borghese, and is
described by Baldinucci as follows: 'In quest' opera egli
superò di gran lunga se stesso e condussela in ispazio di sette
mesi e non più, mercecche egli, fin da quella tenera età, come
egli era poi solito dire, divorava il marmo, e non dava mai colpo
a voto; qualità ordinaria non de' pratici nell'arte, ma di chi
all'arte stessa s'è fatto superiore. La bellissima faccia di questa
figura che egli ritrasse dal proprio volto suo, con una gagliarda
increspatura di ciglia all'ingiù, una terribile fissazione d'occhi,
e col mordersi colla mandibula superiore tutto il labro di sotto,
fa vedere maravigliosamente espressò il giusto sdegno del
giovane israelita, nell'atto di voler con la frombola pigliar la
mira alla fronte del gigante filisteo; nè dissimile risoluzione,
spirito e forza si scorge in tutte l' altre parti di quel corpo, al
quale, per andar di pari col vero, altro non mancava che il moto;
ed è cosa notabile, che mentre egli la stava lavorando, a somig-
lianza di se medesimo, lo stesso Cardinal Maffeo Barberino
volle più volte trovarsi nella sua stanza e di sua propria mano
tenergli lo specchio' (In this work he surpassed himself al-
together, and he completed it in the space of seven months; this
was possible only because even from so early an age he devoured,
as he used to say later, the marble, and never gave an un-
necessary stroke. This is not a quality common to all practi-
tioners of the craft, but rather peculiar to one who has mastered
the art itself. The fine face of this figure, done from his own,
with strong downward turn of the eyebrows, fearsome set of
the eyes, and biting of the lower lip with the teeth, expresses
remarkably the just anger of the young Israelite, who is stand-
ing in the act of aiming his sling at the forehead of the giant
Philistine. The same determination, spirit and vigour appear
in every other part of his body which, but for the absence of
movement, equals reality. And it is worth recording that, while
he was working on it and using his own likeness, Cardinal
Maffeo Barberini himself was pleased to visit his room several
times and hold the mirror for him in his own hand). The date
of the group is established by documents published by Faldi
('Note sulle sculture borghesiane del Bernini,' in *Bollettino
d'Arte*, xxxviii, 1953, p. 146), which record (i) the payment to
Bernini on 18 July 1623 of sums of 200 scudi 'per conto della
scultura d'una statua di Dauid' and of 60 scudi for the marble,
and (ii) payments for the base of the figure on 31 January and
2 May 1624. The original base of the figure has disappeared, but
it can be established (Faldi, *Galleria Borghese: le sculture dal secolo

XVI al XIX, Rome, 1954, pp. 31–3) that it was originally shown
against a wall. Wittkower (p. 183) points out that the platform
on which the figure stands has been made up in plaster, and was
originally irregular, and (in *Burlington Magazine*, xciv, 1952,
p. 72) relates the pose to that of the Borghese Fencer in the
Louvre, which until 1798 stood in the Villa Borghese.

Plate 142: APOLLO AND DAPHNE
Galleria Borghese, Rome

As established by Faldi, a terminus post quem for the carving of
the Apollo and Daphne is supplied by a payment to Bernini
authorised by Cardinal Scipione Borghese on 8 August 1622
('cioue s. 100 per il prezzo di un marmo nuouo da scolpirui una
statua di Apollo et s. 8 per il porto a casa sua'). A further pay-
ment of 100 scudi was made on 16 February 1623, when the
group was in course of execution. A third payment of 150 scudi
was made on 17 April 1624, and a final payment of 450 scudi is
recorded in November 1625 ('per saldo . . . del prezzo della
statua di Dafne che a scolpito in marmo bianco e fatto condurre
in Villa fuori di Porta Pinciana'). The base was also paid for in
this year. The group therefore dates from 1622–5 and not, as
was previously supposed, from 1621–2. According to Passeri
(p. 247), Bernini was assisted by Giuliano Finelli in the execu-
tion of the group (for this see also Muñoz, 'Il gruppo di Apollo
e Dafne e la collaborazione di Giuliano Finelli col Bernini,' in
Vita d'Arte, xi, 1913, pp. 33–44). Finelli arrived in Rome in 1622.
Work on the group was interrupted by the execution of the
David (see Plate 141 above). The group is described by Baldi-
nucci in the following terms: 'Ma il cardinale Borghese, a cui
pareva per avventura, siccome era veramente, d'avere in questo
grande artefice ritrovato un tesoro, non permesse mai, ch'egli
senz'alcuna bell'opera da farsi in proprio suo servizio rimanesse;
e così ebbe egli a fare il gruppo della Dafne con il giovane
Apollo, e quella in atto d'esser trasformata in alloro. Il volere io
qui descrivere le maraviglie, che in ogni sua parte scuopre agli
occhi d'ognuno questa grande opera, sarebbe un faticare assai
per poi nulla concludere; perchè l'occhio solamente e non
l'orecchio ne può formar concetto bastante. Conciossiacosachè
e per lo disegno e per la proporzione e per l'arie delle teste e
squisitezza d'ogni parte e per la finezza del lavoro, elle è tale
che supera ogni immaginazione e sempre fu e sempre sarà agli
occhi de' periti e degl'indotti nell'arte un miracolo dell'arte:
tanto che ella dicesi per eccellenza la Dafne del Bernino
senz'altro più: e bastimi solamente il dire, che non solo subito
che'ella fu fatta veder finita, se ne sparse un tal grido, che tutta
Roma concorse a vederla per un miracolo, ed il giovinetto
artefice stesso, che ancora 18 anni non avea compiti, nel
camminar ch'e'faceva per la città, tirava dopo di sè gli occhi
di tutte le persone, le quali li guardavano e ad altri additavano
per un prodigio . . . Ma perchè la figura della Dafne quanto
più vera, e più viva, l'occhio casto di alcuno meno offender
potesse, allorchè da qualche morale avvertimento ella venisse
accompagnata; l'altre volte nominato cardinal Maffeo Bar-
berino operò, che vi fusse scolpito il seguente distico, parto
nobile della sua eruditissima mente:

Quisquis amans sequitur fugitivae gaudia formae
Fronde manus implet, baccas seu carpit amaras'

(But Cardinal Borghese, who believed correctly that in this great sculptor he had found a treasure, never allowed him to remain without some beautiful work to carve, and so he was commissioned to make the group of Daphne and the young Apollo, and to depict her in the act of being transformed into laurel. To describe the marvels that this great work discloses in all its parts to the eyes of everyone would be a useless task, since the eye alone can form an impression of it and not the ear. For its design and proportion, the sentiment of the heads, the exquisiteness of all its parts and the fineness of its handling, it surpasses all imagining, and to the eyes of experienced connoisseurs has always been and always will be a miracle of art. Suffice it so to say as a standard of excellence, the Daphne of Bernini. I shall only say that when it was shown in its finished state, there arose such a cry that all Rome hurried to see it as though it were a miracle, and the young sculptor, who had not completed his nineteenth year, when he walked about the city, attracted the gaze of all the people, who looked at him and pointed him out to others as a prodigy. . . . Since the figure of Daphne, no matter how truthful and lifelike it was, would be less offensive to the eye of a chaste spectator if it were accompanied by a moral warning, Cardinal Maffeo Barberini arranged that the following distich should be carved on it, the noble fruit of his most erudite mind:

Quisquis amans sequitur fugitivae gaudia formae
Fronde manus implet, baccas seu carpit amaras).

The inscription on the opposite side of the base was carved by Lorenzo Cardelli in 1785, when the group was moved from its position against a wall into the centre of the room. The original inscription was composed by Maffeo Barberini as Cardinal. Finelli's share in the group has not been determined, and it is likely that this involved general assistance rather than responsibility for the plinth, the foliage or any other specific part of the work. A good summary of the material relating to the group and of the aesthetic problems to which it gives rise, is supplied by P. A. Riedl (*Apollo und Daphne*, Stuttgart, 1960). For the iconography see Stechow (*Apollo und Daphne*, Leipzig/Berlin, 1932, pp. 45–9).

Plate 143: SANTA BIBIANA
S. Bibiana, Rome

The statue (for the documents concerning which see O. Pollak, *Die Kunsttätigkeit unter Urban VIII*, Vienna, 1928, i, pp. 22–30) is first mentioned on 10 August 1624, when a preliminary payment was made to Bernini for the purchase of the necessary marble. The body of the Saint 'in due gran Vasi di vetrogrosso, uniti da una lama di piombo' (in two large vases of thick glass, held together by a lead band) had been discovered by the Chapter of S. Maria Maggiore on 2 March 1624, and was inspected by Pope Urban VIII at the end of July in the same year. In August 1624 an alabaster vase was disinterred containing

the bodies of the Saint's mother and sister. On 17 August 1624 instructions were given by the Pope 'che si ristauri in qualche parte la chiesa di Santa Bibiana et che anco si facci una statua di marmo di essa Santa' (for the partial restoration of the Church of S. Bibiana, and the making of a marble statue of this Saint). The reconstruction of the church was completed by 14 November 1626, when the relics were installed, and Mass was celebrated in the new church by the Pope on 28 November 1626. Bernini's statue appears to have been finished by 20 July 1626, when it was inspected by Domenico Passignani and the balance (350 scudi) of the total sum due to the sculptor (600 scudi) was paid. The tabernacle in which the statue is set was also designed by Bernini, along with 'tre casse in bronzo' to which the relics were transferred. No preliminary studies for the statue are known. According to Passeri, Bernini was assisted in the S. Bibiana, as in the Apollo and Daphne, by Giuliano Finelli. The facture of both statues is uniform, and in neither case can the extent of Finelli's participation be defined.

Plate 144:
MONSIGNOR FRANCESCO BARBERINI
National Gallery of Art, Washington, Kress Collection

A bust 'di Monsignor Francesco Barberino Zio di Urbano VIII' is listed by Baldinucci in his life of Bernini as in 'casa Barberina'. This bust appears in a Barberini inventory of 1627 (for this see Fraschetti, *Il Bernini*, Milan, 1900, p. 140), and must therefore have been carved before this year. It is mentioned again in a document of 1635 (for this see O. Pollak, *Die Kunsttätigkeit unter Urban VIII*, Vienna, 1928, i, p. 334: 'Robbe andate alla Cancelleria per ordine del Emᵐᵒ Sign. Card. Padrone. . . . Una testa di marmo bianco, ciouè testa e busto del Ritratto di Monsign. Francesco Barberini fatta dal Cavalier Bernini') (things gone to the Chancellery by order of His Eminence the Cardinal Padrone. . . . A white marble head, that is, portrait head and bust of Monsignor Francesco Barberini, done by the Cavaliere Bernini). The bust is published by Martinelli ('Capolavori noti e ignoti del Bernini; i ritratti dei Barberini, di Innocenzo X e di Alessandro VII,' in *Studi Romani*, iii, 1955, pp. 40–1) from a photograph made while it was still in the Palazzo Barberini, and by Wittkower (pp. 189–90) as in the National Gallery of Art, Washington. The handling of the bust and of the cartouche on the base is closely similar to that of the Apollo and Daphne and the S. Bibiana, and would be consistent with a dating about 1624–5. According to Wittkower (1966, p. 192), 'Pope-Hennessy dates the bust too early: 1624–5. My old date ca. 1626 has to be maintained.' It is correctly observed by Lavin that the bust 'must have been conceived within a very short time after the bust of Montoya' (latter bust documented 1622). Monsignor Francesco Barberini (d. 1600) had been responsible for the Pope's upbringing, and was his first sponsor in Rome. The bust appears to have formed part of a series of posthumous portraits by Bernini, which included those of the mother and father of the Pope. Unlike these busts, a bust of Antonio Barberini (d. 1559) which is still in Barberini ownership, is

ignored by Baldinucci. Its attribution to Bernini, which is accepted by Martinelli and Wittkower, is doubtful, and it is possible that we have here to do with an early work by Finelli carved soon after he joined Bernini's studio in 1622.

Plate 145: POPE URBAN VIII
Heirs of Prince Enrico Barberini, Rome

This bust, which is the finest of Bernini's many portraits of the Pope, is ignored in the earlier Bernini literature, and was published simultaneously by Martinelli ('Capolavori noti e ignoti del Bernini: i ritratti dei Barberini, di Innocenzo X e di Alessandro VII,' in *Studi Romani*, iii, 1955, p. 46–7, reprinted in *I Ritratti di Pontefici di G. L. Bernini*, Rome, 1946) and Wittkower (p. 184). It is tentatively connected by both students with a bust of the Pope described by Teti (*Aedes Barberinae ad Quirinalem*, Rome, 1642, p. 170: 'effigies marmorea a Bernino exculpta'), and by Martinelli with a bust mentioned in the inventory of Cardinal Antonio Barberini in April 1644. The bust is certainly later in date than the life-size bust of the Pope in the collection of Prince Urbano Barberini, which is assigned by Muñoz ('Alcune opere sconosciute del Bernini,' in *L'Arte*, xx, 1917, p. 187), followed by Martinelli and Wittkower, to the years 1623–4. First dated by Wittkower (1955) ca. 1630 and subsequently (1966) ca. 1637–8, the bust seems to date from the early sixteen-thirties, and is in any event earlier than the dating ca. 1640–2 proposed by Martinelli. A second version of the bust, in a private collection, is presumed by Wittkower ('A New Bust of Pope Urban VIII by Bernini,' in *Burlington Magazine*, cxi, 1969, pp. 60–3) to be an earlier version of the present portrait, which would have been rejected on account of damage to the base. The Barberini bust is identified by C. D'Onofrio (*Roma vista da Roma*, Rome, 1967, p. 381) with a bust of the Pope mentioned in a letter of Monsignor Lelio Guidiccione of 4 June 1633; in this event it would date from 1632–3.

Plate 146: THE TOMB OF POPE URBAN VIII
St. Peter's, Rome

The tomb of Pope Urban VIII, which is set in the right-hand niche of the tribune of St. Peter's, consists of a bronze statue of the Pope in benediction raised on a high plinth, a marble and bronze sarcophagus surmounted by a cartellino held in place by a bronze figure of Death, and at the sides, leaning against the ends of the sarcophagus, white marble figures of (*left*) Charity, and (*right*) Justice. As erected, it forms a counterpart to Guglielmo della Porta's tomb of Pope Paul III in the corresponding niche on the left (see Plate 99 above). Comparing the iconography of the tomb with that of Pope Paul III, Panofsky (*Tomb Sculpture: four lectures on its changing aspects from Ancient Egypt to Bernini*, New York, 1964, p. 94) observes that 'one of the moral Virtues (Prudence) (is) replaced by one of the theological ones (Charity), so that the Pope is characterised as the Vicar of Christ, whose attributes are justice and mercy,

rather than as a ruler of men, whose attributes are justice and prudence.' The history of the tomb, which is reconstructed in detail by Brauer and Wittkower (i, pp. 22–5) and more summarily by Wittkower (pp. 193–4), shows that it was destined initially for the niche now occupied by the tomb of Pope Alexander VIII, and that the tomb of Pope Paul III, which as a result of the replanning of the piers beneath the cupola was removed from the niche destined for the Longinus, was intended initially for the niche now occupied by Bernini's monument. The symmetrical treatment of the tombs was decided on late in 1627 or early in 1628. The earliest documents referring to the Urban VIII monument (for which see O. Pollak, *Die Kunsttätigkeit unter Urban VIII*, Vienna, 1931, ii, p. 590–610) date from January and February 1628, when instructions were given by Monsignor Angelo Giori (who was deputed by the Pope to supervise the commission) for the ordering of marble for the tomb. A document of 26 June 1628 refers to Bernini's design for the niche, and payments for the construction of the niche continue till September 1630. The first of the figure sculptures to be completed was the bronze statue of the Pope, for which a model was made in December 1628 or early in the following year. An account prepared by Bernini on 25 March 1630 estimates the cost of the Papal statue (which had not yet been cast) at 3000 scudi, of the figure of Death and the cartellino on the sarcophagus at 1000 scudi, the feet of the sarcophagus at 800 scudi, the gilding at 1000 scudi, and work on the marble tomb-chest at 400 scudi. No estimate is made of the cost of the supporting marble statues, or of the two or three putti by which each of these was to be accompanied. The bronze appears to have been cast at the end of April 1631. A document of 23 April 1631 refers to 'le due statue di bronzo di Nro. Sign.'; the second of these figures was presumably the bronze memorial statue for the Piazza at Velletri (decreed 1627; installed 1633; destroyed 1798). The statue for the tomb was gilded during the summer of 1644. A wooden model of the sarcophagus was prepared early in 1630, and was carried out in marble between August 1630 and December 1642. The epitaph and other bronze components of the sarcophagus were made between 1639 and 1644, when they too were gilded. Payments for the figure of Death occur in 1643 and 1644, and casting seems to have taken place in the course of the latter year. Three drawings for this figure are published by Brauer and Wittkower.

The Pope's body was committed to the still unfinished tomb in July 1644 ('Di Roma li 1 Agosto 1644. La sera di Lunedì... si diede sepoltura nel nuovo deposito fatto nella Basilica Vaticana in contro quello di Paolo al Cadavero del Defonto Urbano 8'). The state of the tomb at this time is revealed in a report drawn up on 20 May 1644. According to this, Bernini had prepared the small models for the bronze parts of the tomb and had supervised and retouched the full-scale models, and had made two full-scale models of the statue of the Pope, had made the small model for the Death and retouched the large wax model for this figure, had carved the Charity and would shortly undertake the Justice, and would complete the whole tomb in three years. Wittkower (p. 194) infers that the Charity, though blocked out in 1634, was not carved till 1639, and that the

Justice was begun after 1644. The lateral figures were finished off in 1646, and the tomb was unveiled on 9 February 1647. The seated figure of the Pope, the statue of Charity and that of Justice therefore belong to three separate phases of Bernini's development. The breast of the Charity is covered in stucco probably dating (Wittkower) from the late seventeenth century.

Plate 147:
THE TOMB OF POPE ALEXANDER VII
St. Peter's, Rome

According to Baldinucci, Bernini, towards the end of the reign of Pope Alexander VII, prepared a design for the Pope's tomb, and an autograph model which was approved by the Pope and by his nephew Cardinal Flavio Chigi. This account is confirmed by Domenico Bernini, who reports that his father 'per gratitudine alla memoria di quel principe prese risoluzione di produrlo ancora con l'opera, non ostante la gravezza dell'eta, e lo scemo delle forze, che lo rendevano giornalmente men'habile a somiglianti lavori' (out of gratitude to the memory of that prince, decided to undertake this work, in spite of the advanced age and diminished strength which were making him every day less capable of such tasks). Initially the tomb was destined for St. Peter's. Under Pope Clement IX, however, the project for the tomb was transferred from St. Peter's to S. Maria Maggiore, where it was to be set in a reconstructed choir opposite the tomb of the reigning Pope. Three drawings for the tomb planned for S. Maria Maggiore survive (for an analysis of these see Brauer and Wittkower, pp. 168–71). On the accession of Clement X, his predecessor's plans for the reconstruction of S. Maria Maggiore were abandoned, and the original plan for a tomb in St. Peter's was revived. The position selected was a niche adjacent to the left transept, which was blocked at the sides by columns and had in the centre a door, later modified by Bernini and used in the monument for illusionistic purposes. In the form in which it was executed the tomb comprises a figure of the Pope kneeling on a cushion on a high plinth, in front full-length figures of Charity (left) and Truth (right), and at the back half-length figures of Justice (left) and Prudence (right). In the centre foreground is a bronze figure of Death holding an hour-glass portrayed as though emerging from the door. A terracotta sketch-model for the figure of Charity in the Pinacoteca at Siena (for which see Vigliardi in *Rassagna d'Arte Senese*, xiii, 1920, p. 36 ff.) was possibly part of the original model submitted to Pope Alexander VII by Bernini. A terracotta model for the figure of the Pope in the Victoria & Albert Museum, London, is more closely related to the drawing for the tomb in S. Maria Maggiore than to the monument as executed. The documents relating to the history of the tomb are printed and analysed by Golzio (*Documenti artistici sul seicento nell' archivio Chigi*, Rome, 1939, pp. 107–47). On 16 December 1671 a carpenter was paid for the wooden skeleton of a full-size model of the tomb, and in the following January the sculptor Giovanni Rainaldi was engaged in making full-scale models of the figures of Charity, Truth, Justice, Prudence and Death, from Bernini's small models. Bernini, though he did not intervene directly in the execution appears to have maintained close supervision over the progress of work on the monument. In April a contract was drawn up between the Cardinal and a stonemason by which the latter was bound to provide two blocks of marble of the same exceptional quality as that from which Bernini was at the time carving the equestrian statue of Louis XIV.

The only recorded payment for the monument made to Bernini is a sum of 1000 scudi for the design and model paid on 7 October 1672. The figure of Truth was carved from a block delivered in July 1673, initially by Lazzaro Morelli and subsequently by Giulio Cartari, and appears to have been finished in the summer of 1675. Cartari was also responsible (1677) for executing the figure of Justice, and completed the Prudence (1676) which had been begun by Giuseppe Baratta. At the instance of the Cardinal the figure of Charity was entrusted to the Sienese sculptor Giuseppe Mazzuoli, and was carved in 1673–5. The kneeling figure of the Pope was carved by Michele Maglia (1675–6), assisted by Cartari and another sculptor and was completed in May 1677. In December 1675 provision was made for Lazzaro Morelli's wax model of Death to be cast by the bronze founder Girolamo Lucenti. A payment of 17 March 1673 relates to 'dieci pezzi di diaspro fatto cavare in Trapani' destined for the shroud. The entire tomb was completed by March 1678, when the body of the Pope was transferred from its provisional grave to the new monument. After the monument was completed, exception was taken by the Pope (Innocent XI) to the nakedness of the figure of Truth. Baldinucci records that: 'Questa era interamente ignuda, benchè venisse alquanto adombrata quella nudità dallo scherzare, che le faceva attorno la coltre e dal sole, che le copriva un tal poco il petto; ma perchè femmina nuda, benchè di sasso, ma però di mano del Bernino, non bene si confaceva colla candidezza de' pensieri dell'oggi regnante pontefice, egli stesso si lasciò benignamente intendere, che sarebbe stato di suo gusto che il Bernino nel modo che migliore a lui fusse paruto, l'avesse alquanto più ricoperta' (This figure was completely naked, though this nakedness was to a certain extent shielded by the folds of the shroud round it, and also by the sun which covered some of the breast. But as a naked woman, even though made of stone and by the hand of Bernini, did not agree with the purity of mind of the present Pope, he let it be known, in a kindly way, that it would have been more to his taste if Bernin had covered it up a little more, in whatever way seemed to him best). A wax model for the drapery of this figure was made by Carcani (10 October 1678), was cast in bronze by Lucenti and was painted white to simulate marble.

Plate 148: CARDINAL SCIPIONE BORGHESE
Galleria Borghese, Rome

The story of Bernini's two busts of Cardinal Scipione Borghese (d. 1633) is told by Baldinucci: 'Anche la santità di papa Paolo V volle di mano di lui il proprio ritratto, dopo il quale ebbe a scolpire quello del cardinal Scipione Borghese di lui nipote; e già s'era condotto al fine del bel lavoro, quando portò la disgrazia che e' si scoprisse un pelo nel marmo, che

occupava appunto tutto il più bello della fronte; egli, che animosissimo era e già aveva fatto una maravigliosa pratica nel maneggiare il marmo, a fine di togliere a se stesso e molto più al cardinale la confusione che era per apportargli una sì fatta novità, fattosi condurre in camera un pezzo di marmo di sufficiente grandezza e di conosciuta bontà, senza darne notizia a persona, nel corso di quindici notti, che solamente impiegò in quel lungo lavoro, ne condusse un altro simile, di non punto minor bellezza del primo; poi fattolo portar nel suo studio ben coperto, acciocchè da niuno de' suoi familiari potesse esser veduto, attendeva la venuta del cardinale a vedere il ritratto finito. Comparso finalmente quel signore, e veduto il primo ritratto, del quale, col darsi il lustro, s'era fatto il difetto assai più palese e più sconcio, a prima vista si turbò in se stesso; ma per non contristare il Bernino dissimulava. Fingeva in tanto il ben avveduto artefice di non accorgersi del disgusto del cardinale e perchè più grato gli giugnesse il sollievo, ove più grave era stata la passione, il tratteneva in discorsi; quando finalmente gli scoperse l'altro bellissimo ritratto. L'allegrezza, che mostrò quel prelato nel vedere il secondo ritratto senz' alcun difetto, fece ben conoscere quanto era stato il dolore ch'egli avea concepito nel rimirare il primo' (His Holiness Pope Paul V also wanted his portrait done by Bernini, and after this he had to carve one of Cardinal Scipione Borghese, the Pope's nephew. This fine work had already been almost completed when a disaster occurred: a crack appeared in the marble, crossing in fact the finest part of the forehead. Bernini, who was quite undaunted and had already carried through a remarkable piece of work in the handling of the marble, so as to avoid for himself and, far more, for the Cardinal the annoyance of bringing him such a piece of news, had brought to his room a piece of marble sufficiently large and of known quality. And without letting anyone know, within fifteen nights, which was all the time he took over the lengthy undertaking, he executed a second one, like the first and in no way less beautiful. Then he had it brought to his studio, carefully covered up so that it could not be seen by any of his household, and waited for the Cardinal to come and see the finished portrait. When this gentleman at last appeared and saw the first portrait, the fault in which had become after the polishing more obvious and damaging, he was at first sight disturbed; but he concealed it so as not to distress Bernini. In the meantime this resourceful craftsman was pretending not to notice the Cardinal's disappointment and making conversation with him, so that the relief might come to him all the more sweetly for the heaviness of his distress before, when he finally uncovered for him the second fine portrait. The joy the prelate showed at seeing the portrait without any fault made clear how great his sorrow had been when he was looking at the first). The busts remained in Borghese possession until they were acquired in 1892 for the Italian state. The first and earlier of the two busts has a fracture running through the head above the level of the eyebrows and other flaws (for a detailed account of its condition see I. Faldi, *Galleria Borghese: le Sculture dal Secolo XVI al XIX*, Rome, 1954, pp. 37–9). Baldinucci's account, if read literally, would suggest that the busts were executed during the lifetime or soon after the death of Pope Paul V (d. 1621). A dating

ca. 1632 is, however, advanced by Fraschetti (*Bernini*, 1900, p. 106 ff.) and has been generally accepted (Faldi, Wittkower and others), on the strength of a report of 8 January 1633 from a correspondent of the Este court in Rome that 'il Cau. re Bernini di commissione del Papa, ha fatto in marmo la testa del Card. Borghese, che li ha donato in ricompensa 500 zecchini et un diamante di 150 scudi' (the Cavaliere Bernini with the Pope's commission has made a marble head of Cardinal Borghese, who has paid him 500 sequins and a diamond worth 150 scudi). A payment from Cardinal Borghese to Bernini of 500 scudi on 23 December 1632 seems to refer to the portrait busts (for this see H. Hibbard, 'Un nuovo documento sul busto del Cardinale Scipione Borghese del Bernini,' in *Bollettino d'Arte*, xlvi, 1961, pp. 101–5). Unconvincing arguments in favour of a dating ca. 1625 are advanced by Modigliani ('I busti del Cardinale Scipione e una scultura Berninesca alla Galleria Borghese', in *Bollettino d'Arte*, ii, 1908, pp. 66–73). The aggregate effect of the numberless small differences between the two versions of the bust is that in the first the treatment of the features is rather more lively, while in the second (Fig. 178) the handling of the lower part is simpler and more unified. The two busts are closely related to a bust of the same sitter by Algardi, which also appeared in the Borghese sale of 1892 and is now in the Metropolitan Museum of Art, New York. It is suggested by O. Raggio ('A rediscovered portrait: Alessandro Algardi's bust of Cardinal Scipione Borghese,' in *The Connoisseur*, cxxxviii, 1956, pp 203–8) that the latter is a posthumous portrait executed some years after Bernini's busts. Domenico Bernini (pp. 133–4) records that Bernini, when engaged upon a portrait, 'non voleva che il figurato stasse fermo, ma ch'ei colla sua solita naturalezza si movesse, e parlasse, perchè in tal modo, diceva, ch'ei vedeva tutto il suo bello, e'l contrafaceva com 'egli era, asserendo, che nello starsi al naturale immobilmente fermo, egli non è mai tanto simile a se stesso, quanto è nel moto, in cui consistono tutte quelle qualità, che sono sue, e non di altri, e che danno la somiglianza al Ritratto' (did not wish his sitter to stay still but rather to move and talk naturally and in his usual way, since by this means, he said, his beauty could be seen as a whole; and he represented the sitter as he was, affirming that when in life he stays immovably still he is never as like himself as when he is in movement, in which lie all those qualities that are his and no other man's and give the portrait its verisimilitude). Bernini's habit of making life drawings in preparation for his portraits is also mentioned by Pascoli. A drawing of Cardinal Scipione Borghese in right profile in the Morgan Library, New York, apparently made in connection with the two portrait busts, is discussed by Brauer and Wittkower (i, pp. 29–30).

Plate 149: FRANCESCO I D'ESTE
Pinacoteca Estense, Modena

The first reference to Bernini's bust of Francesco I d'Este occurs on 8 July 1650, when the Duke wrote to his brother, Cardina Rinaldo d'Este, asking for an answer to an earlier letter 'intorno al mio Ritratto in profilo, e del Cuneo e della Statua da farsi dal Bernino' (about my profile portrait, and the quoin and the

statue that Bernini is to make) (for this and other documents see Fraschetti, *Il Bernino*, Milan, 1900, pp. 221–6). On 16 July 1650 the Cardinal wrote from Rome stressing the difficulty of securing a portrait from Bernini, but adding 'questo col bastantemente remunerarlo si può adempire' (it can be managed if he is paid enough). A week later, on 22 July 1650, the Duke wrote again from Sassuolo proposing that two busts should be commissioned, one of the Cardinal and one of himself, from Bernini and Algardi 'dichiarandomi di havere il gusto indifferente che il Bernino faccia la mia statua, o quella di V. Em.ᶻᵃ' (declaring that it is all the same to me whether it is my statue or that of Your Eminence that is done by Bernini). If 'il regalo di cento doble' were insufficient for Bernini, Algardi could be charged to execute both busts. Bernini, however, agreed to undertake the commission, and asked for three portraits of the Duke. Two of these were available in the form of portraits by Sustermans, who had been sent to Modena by the Grand-Duke Ferdinand II of Tuscany in 1649. By 20 August 1650 the missing full-face portrait for which Bernini asked had been painted by Boulanger, and was ready to be sent to Rome. By this time the bust had already been begun, and according to the Cardinal 'rieschi isquisitamente et certo similissimo alla pittura' (is succeeding exquisitely and is certainly most like the picture). On 31 August 1650 he reported again that 'il Bernino tira avanti il ritratto di V.A. con gran franchezza ma non si può creder la difficoltà di cavare da pitture non egualmente disegnate un rilievo' (Bernini is boldly proceeding with the portrait of Your Highness, but it is incredibly difficult to carve a relief from pictures drawn in different ways). By 21 September 1650 the bust was already far advanced: 'S'affatica il Caval.ʳᵉ Bernini a ridurre a fine l'opera sua . . . et in ciò che ne riesce obligato alle proportioni, come del volto, et in ciò che si concede libero a capricij d'arte, come delle veste e del capello' (The Cavaliere Bernini is labouring to bring his work to an end . . . both those parts, such as the face, which depend on real proportions, and those, such as costume and hair, which are open to the caprices of art). In November there arose the question of payment for the bust, and the Cardinal advised the Duke to present Bernini (with 'una di quelle piccole credenze d'Alemagna che possono importare da circa 7 in 800 scudi' (one of those small German vessels worth about seven or eight hundred scudi). Early in January the Cardinal again reported that the bust was almost finished, but that it could not be despatched until Bernini had received the Duke's gift. The Duke replied that he had sent to Germany for the 'credenza di argenti', but had not procured it since the prices were so high; he now proposed instead to send the money to the Cardinal. By the summer of 1651 the bust was still unfinished, and the Duke returned to the project of two busts, both by Bernini, at a price of 1000 ducatoni. On 16 September 1651, however, the Cardinal reported that the bust was finished: 'A me pare cosa bellissima, ma in quanto alla naturalezza non ne so dar conto, essendo sette anni che non ho veduto Sua Altezza' (I think it is a most beautiful thing, but I cannot judge as to its truth to nature, for I have not seen Your Highness for seven years). Bernini, in showing him the bust, had declared 'che mai più vuole far Ritratti di Scultura cavati dalla Pittura, essendo cosa laboriosa e difficile da incontrare; che vi ha con-

sumato nell'opera mesi quattordici' (that he never again wants to do sculptured portraits carved after paintings, as it is a laborious business and difficult to achieve; and that he has spent fourteen months on the work). On completion the bust was exhibited in Bernini's studio. The Duke thereupon enquired how large a sum the Pope had paid to Bernini for the large fountain in the Piazza Navona, and in November after the bust arrived in Modena sent him an equivalent amount (3,000 scudi). This was acknowledged by Bernini on 13 January 1652.

Plates 150, 151: THE ECSTASY OF ST. TERESA
S. Maria della Vittoria, Rome

Bernini's most celebrated work, the Ecstasy of St. Teresa (Fig 163) is described by Baldinucci as follows: 'In quel tempo stesso fece vedere a Roma le più bell'opere che facesse mai. Tali furono primieramente il disegno della cappella del cardinal Federigo Cornaro nella chiesa di S. Maria della Vittoria de' padri Carmelitani Scalzi, non lungi da Porta Pia, e quel ch'è più, il mirabil gruppo della S. Teresa coll'angelo, il quale mentre ella è rapita in un dolcissimo estasi, collo strale dell'amor divino gli ferisce il cuore, opera, che per gran tenerezza e per ogni altra sua qualità fu sempre oggetto d'ammirazione, nè io voglio estendermi in lodarla, bastandomi per ogni maggior lode il raccontare, che il Bernino medesimo era solito dire, questa essere stata la più bell'opera che uscisse dalla sua mano. L'acutissimo ingegno del nominato monsignor Pier Filippo Bernino, figliuolo del cavaliere, ammirando anch'egli questa degnissima fattura, in lode di quella diede fuori i seguenti versi:

> Un sì dolce languire
> Esser dovea immortale;
> Ma perchè duol non sale
> Al cospetto divino,
> In questo sasso lo eternò il Bernino.'

(At the same time he exhibited at Rome the most beautiful works he ever made. These were first the design of the chapel of Cardinal Federigo Cornaro in the church of S. Maria della Vittoria of the Discalced Carmelites, not far from the Porta Pia, and what is more, the wonderful group of St. Teresa with the angel, who pierces her heart with the arrow of divine love while she is caught up in a most sweet ecstasy. For its tenderness and for its many other qualities this work has always been an object of admiration, and I do not wish to praise it at length. It suffices to record that Bernini himself was accustomed to say that this was the most beautiful work that ever left his hand). Federigo Cornaro, who had been created Cardinal in 1626 moved from Venice to Rome in 1644, and the commission for the Cornaro Chapel in the left transept of S. Maria della Vittoria, of which the St. Teresa is the central feature, is generally assumed (Fraschetti, Brauer-Wittkower, Wittkower) to date from this time. The architecture of the chapel seems to have been completed by 1647 (Wittkower), when a commemorative medal was struck by Travani, but the complex was not finished till 1652 (see *Roma*, xvi, 1938, p. 528). Four drawings at Leipzig (for which see Brauer-Wittkower, pls. 23b, 24a, 24b, 25a) are early studies for the figure of St. Teresa, and have been con-

jecturally dated in 1645. The figures are set on an elliptical stage framed by polychrome marble columns, against a polychrome ground, and are lit from above through a window of yellow glass. Over the lateral doorways are illusionistic reliefs, each with four half-length figures of members of the Cornaro family; a sketch for the left hand relief is in the Fogg Art Museum. Baldinucci, in his catalogue of Bernini's works includes 'l'ultimo Cardinal Cornaro alla Madonna della Vittoria'. This is identified by Wittkower with the head of the Doge Giovanni Cornaro on the extreme right of the left relief. Baldinucci's reference, however, can only be to the figure of Cardinal Federigo Cornaro to the left of this head, which is by the same studio hand as the remainder of the reliefs. The relevance of these figures is not to the group behind the altar but to the altar itself. The programme of the chapel is completed by a ceiling fresco by Abbatini, showing a vision of the Holy Ghost, and by two inlaid skeletons on the floor. The genesis of the group is also discussed by H. Kauffmann ('Der Werdegang der Theresa-gruppe von Giovanni Lorenzo Bernini,' in *Essays in the History of Art presented to Rudolf Wittkower*, London, 1967, pp. 222–9).

Plate 152: TRUTH UNVEILED
Galleria Borghese, Rome

The Truth Unveiled was planned by Bernini as part of a two-figure group of Truth revealed by Time, conceived as a result of the reversal of his fortunes in 1646 after the death of Pope Urban VIII and the accession of Pope Innocent X. The genesis of the group is connected by Domenico Bernini (p. 80) with the destruction of Bernini's Campanile at St. Peter's and with the campaign of calumny of which this was the climax. Baldinucci appears to have been unaware of the origin of the group, which he dates in the vicinity of the Modena bust (1650–1). The terminal date of the Truth is established by a letter of 30 November 1652 to Francesco I d'Este, which reads: 'Al presente (il Bernini) non opera ne s'affatica in altro che in un lavoriere suo proprio che dice che vuol che resti per memoria nella sua casa. L'opera sarà grande assai, cioè le figure molto più del naturale, et il pensiero è bellissimo. Rappresenta la Verità, che è una donna ignuda coricata sopra di uno scoglio in atto ridente, che tiene nella mano destra uno scudo col sole scolpito di dentro. Sopra di essa in aria si vederà il Tempo che sosterra un panno, col quale stara coperta la Verità, mostrando di haverla scoperta. Per compire detto Lavoro egli dice che per lo meno vi correrà lo spatio di otto anni, e poco altro ha pensiero che faccia il suo scalpello' (At present Bernini is working and labouring solely on a work of his own, which he says he wishes to stay in his own house as a memorial. The work will be very large, the figures in fact much more than life-size, and the conception is most beautiful. It represents Truth, a nude woman, reclining on a bank, smiling and holding in her right hand a shield with the sun carved on it. In the air over her is Time, holding a veil which will be Truth's covering, showing that he has uncovered her. He says he will take at least eight years to complete this work, and is thinking of nothing else but using his chisel). The figure of Time was not begun, and the block for this was in Bernini's

studio at his death. In Bernini's will the Truth unveiled was bequeathed in trust to his family to be preserved in perpetuity in his house (for this see Fraschetti, p. 176: 'E perchè delle mie opere non senza raggione hò ritenuta appresso di me la Statua delle uerità scoperta dal Tempo, perciò cadendo questa Statua sotto la presente Dispositione Testamentaria uoglio che stia in Casa, dove habiterà il Primogenito per hauer sempre, et in perpetuo una memoria nella mia descendenza della mia Persona come ancora perche guardando quella tutti li miei discendenti potrano ricordarsi che la più bella uirtù del mondo consiste nella uerità, e che è necessario operare con La uerità perche alla fine questa viene discoperta dal tempo') (Since out of the number of my works I have deliberately kept by me the statue of Truth uncovered by Time, and as this statue comes under this present testament, I desire that it should remain in the house where the firstborn of my family resides, so that my descendants shall have always and in perpetuity a memorial of me; and also so that all my descendants may remember that the finest virtue on earth is Truth, and that one must always act with Truth, since in the end it is uncovered by Time). The statue was deposited at the Galleria Borghese in 1924, and was purchased by the state in 1957. It appears that Bernini's determination to complete the group did not lapse when he regained papal favour, and as late as 1665 he mentioned to Chantelou his intention of carving the missing figure of Time. Evidence of his intentions is provided (i) in a chalk drawing at Leipzig (for which see Brauer and Wittkower, i, pp. 45–6, ii, pl. 20), (ii) two further sheets at Leipzig for the figure of Truth (Brauer and Wittkower, ii, pl. 21a, b), (iii) a shop drawing in black chalk and wash at Düsseldorf, (iv) an account by the artist reported by Chantelou ('M. de Créqui a parle ensuite de sa statue de la Vérité, qui est chez lui, a Rome, comme d'un ouvrage parfaitement beau. Le Cavaliere dit qu'il l'a fait pour le laisser à sa maison, que la figure du Temps, qui porte et montre cette Vérité, n'est pas achevée; que son dessein est de la representer la portant par l'air, et de montrer par même-moyen des effets du temps, qui ruine et consume enfin toutes choses: que dans son modèle il a fait des colonnes, des obelisques, des mausolées, et que ces choses, qui paraissent renversées et détruites par le Temps, sont celles qui le soutiennent en l'air, et sans lesquelles il n'y pourrait etre, "quoiqu'il ait des ailes", a-t-il dit en riant. Il a ajouté qu'à la cour de Rome c'est presentement un commun proverbe de dire: "La Vérité n'est que chez le Cavalier Bernin"' (M. de Créqui then spoke of his statue of Truth, in his house at Rome, as an entirely beautiful work. The Cavaliere said that he had done it to leave to his family, and that the figure of Time carrying and revealing this Truth has not been carried out. He said that his intention is to show it carrying Truth through the air, and to show in the same way some effects of Time, which in the end destroys and consumes everything. He also said that in his model he has made columns, obelisks and tombs, and that it is these objects, giving the appearance of being overturned and destroyed by Time, which support it in the air, and that without them it could not be there, 'even with its wings', he said with a laugh. He added that at present a current bon mot at the court of Rome is to say: 'Truth is only to be found at Cavaliere Bernini's').

The typological tradition from which Bernini's group depends is discussed, with a wealth of illustrative material, by M. Winner ('Bernini's "Verità",' in *Munuscula Discipulorum: Festschrift Kauffmann*, Berlin, 1968, pp. 393–413).

Plate 153: FOUNTAIN OF THE FOUR RIVERS
Piazza Navona, Rome

A detailed account of the story of the Fontana dei Quattro Fiumi (Fig. 174), of the structure of the fountain and of its iconography is given by Baldinucci: 'Tanto poteron le sinistre impressioni state fatte dagli emuli del Cavaliere nella mente di quel Pontefice (Innocent X), che avendo egli deliberato di alzare in Piazza Navona la grande Aguglia condotta già a Roma dall'Imperadore Antonio Caracalla, stata gran tempo sepolta a Capo di Bove, per finimento d'una nobilissima fontana, fecene fare a' primi Architettori di Roma diversi disegni, senza, che al Bernino fusse dato ordine alcuno. Ma come è grande oratrice la vera virtù a benefizio di chi la possiede, e quanto bene parla per sè! Il principe Niccolò Lodovisio che era congiunto in matrimonio con una nipote del Papa, e col Bernino avea non pure domestichezza, ma anche autorità, il contrinse a farne anch'esso un modello, e fu quello in cui egli rappresentò i quattro Fiumi principali del Mondo: il Nilo per l'Affrica, il Danubio per l'Europa, il Gange per l'Asia ed il Rio della Plata per l'America, con un masso, o scoglio forato, che sostener dovesse la grandissima Aguglia. Fecelo dunque il Bernino, ed il principe operò, ch'e' fusse portato in Casa Panfilia in Piazza Navona, e quivi situato segretissimamente in una Camera, per la quale il Papa, che un tal giorno era per andarvi a desinare, nel partirsi da mensa, dovea far passaggio. In quel giorno stesso, che fu il giorno della Annunziazione di M.(aria) V.(ergine) dopo la Cavalcata comparve il Papa, e già finito il desinare, passò insieme col Cardinale, e la cognata Donna Olimpia per quella camera ed in vedere una così nobile invenzione ed un disegno per una mole così vasta, rimase quasi estatico; e consciossiacosachè egli Principe fusse di chiarissimo intelletto e di altissime idee, dopo essersi trattenuto attorno al modello sempre ammirandolo, e lodandolo per lo spazio di mezz' ora e più; alla presenza di tutta la camera segreta proruppe in così fatta sentenza: 'Questo è un tiro del Principe Lodovisio; bisognerà pure servirsi del Bernino a dispetto di chi non vuole, perchè a chi non vuol porre in opera le cose sue, bisogna non vederle'; e subito mandollo a chiamare, e con mille dimostrazioni di stima, e d'amore, e con tratto maestoso, quasi scusandosi con esso, addussegli le cagioni, ed i varj rispetti, per i quali egli infino a quel tempo non s'era servito di lui, e la commessione gli diede di far la fonte secondo il proprio modello ... (La fonte) ... si annovera fra le più maravigliose invenzioni del Bernino, per cui alla Città di Roma sì bello ornamento risultò. Nel bel mezzo dunque della lunghezza e larghezza della gran Piazza Navona giace in sul suolo uno scaglione, o grado, che vogliamo chiamarlo, il quale forma un gran tondo di diametro in pianta di circa a 106 palmi romani. Questo in distanza dalle sue estremità circa a 10 palmi contiene in se una gran vasca figurata, cred'io, per lo Mare, nel mezzo del quale s'innalza per circa 30 palmi un masso, o vogliamo dire uno scoglio composto di travertino, che dai lati è traforato, onde da quattro bande lascia libero per entro quell'apertura il luogo, per cui la Piazza veder si possa. Mediante tali aperture viene lo scoglio ad aprirsi in quattro parti, che nella sommità di esso restano fra di loro unite e congiunte e son fatte per rappresentare le quattro parti del Mondo. Queste nel dilatarsi che fanno, e nello sporger la pianta in fuori con certi scoscesi massi, danno luogo a potervi sopra sedere quattro grandissimi Giganti fatti di bianco marmo figurati per li quattro nominati Fiumi. Il Nilo per l'Affrica, e questo si cuopre con un certo panno la testa dal mezzo in su, per denotare l'oscurità, nella quale è stato per gran tempo il luogo appunto, ove egli vien partorito dalla terra e appresso vi ha una bellissima palma. Il Danubio per l'Europa in atto di ammirare il maraviglioso Obelisco, e quelli ha presso un Leone. Il Gange per l'Asia con un gran ramo in mano per denotare l'immensità dell' acque sue, e poco sotto ha un Cavallo. Finalmente il Rio della Plata per l'America figurato in un Moro, appresso al quale vedonsi alcuni danari per significare la ricchezza de'metalli, di che abbonda quel Paese, e sotto di sè ha uno spaventoso mostro, che il Tatù dell'Indie volgarmente è nominato; e da presso a tutti i Fiumi scaturiscono acque in gran copia tolta della fontana di Trevi. Al piano dell'acqua della vasca vedonsi alcuni gran pesci quasi in atto di sguizzar per lo Mare, tutti bellissimi; uno di questi, che è quegli appunto ch'è verso la Piazza degli Orsini, mentre dimostra di abboccar l'acqua per sostentar sua vita, viene a riceverne in se tutto il soverchio, e a darle sfogo; concetto per vero dir è ingegnosissimo. Lo scoglio è composto in modo, ch'e' par tutto d'un sol pezzo, e da non potersi mai per veruno accidente spezzare, conciossiacosachè tutte le congiunzioni de' pezzi siano tagliate a coda di rondine, ed in tal modo incassate, che l'una all'altra fa legatura, a tutte le legature concertano per tenere insieme il tutto. In su'l bel mezzo della parte superiore dello scoglio posa maravigliosamente in altezza di circa 23 palmi il piedistallo, sopra il quale è ferma la grand'Aguglia di circa palmi 80; sopra questa vedesi in altezza di circa 10 palmi un bel finimento di metallo, sopra il quale una Croce dorata risplende, e sopra essa graziosamente campeggia la colomba coll'ulivo in bocca, che è l'arme di casa Panfilia, e non cagiona poca maraviglia il vedere come una così smisurata mole sia retta sopra lo scoglio così forato e diviso, e come (per parlar co' termini dell'arte) ella si regga tutta in falso. . . . In questo gran lavoro sono di tutta mano del Bernino lo scoglio tutto e la palma, il leone, e mezzo il cavallo. Fu il Nilo opera della mano di Jacopo Antonio Fancelli, il Gange di Monsù Adamo, il Danubio di Andrea detto il Lombardo, ed il Rio della Plata di Francesco Baratta. E'però vero, che in questo Gigante e nel Nilo diede molti colpi di sua mano lo stesso Bernino' (The Cavaliere's rivals had been able to influence the mind of the Pope so much against him, that when he considered, as the crowning touch for a magnificent fountain, the raising in the Piazza Navona of the great obelisk which the Emperor Caracalla had brought to Rome, and which had for a long time lain buried in Campo di Bove, the Pope, while he had the other leading architects of Rome prepare different designs, gave no order to Bernini to do so. But how well true talent speaks on the side of its possessor, and how well too for itself! Prince Niccolò Ludovisi, who was married to a niece of

the Pope's, and was not only an intimate friend of Bernini but also had influence over him, persuaded him to make a model as well. It was that in which he represented the four principal rivers of the world: the Nile for Africa, the Danube for Europe, the Canges for Asia, and the Rio della Plata for America, with a mound or tunnelled rock to support the great obelisk.

Bernini made the model and the prince had it taken to the Casa Panfilia in the Piazza Navona, and secretly placed there in a room through which the Pope, who sometimes came to dine there, would have to pass when leaving the table. On that very day, the Feast of the Annunciation of the Virgin, after the cavalcade, the Pope arrived and, having dined, passed in the company of the Cardinal and his kinswoman Donna Olimpia through that room. And when he saw so magnificent an invention and a design for such a vast construction, he went almost into ecstasy. And since that Prince was of great intelligence and high ideals, after spending half an hour or more around the model, continually gazing at it and praising it, he burst out in the presence of the whole Camera with the following remark: 'This is a plot of Prince Ludovisi's; but we shall have to make use of Bernini, in spite of those who do not wish it, because if one does not want his things put into execution, one must just not see them.' He had Bernini summoned at once and, with many signs of respect and affection, with great condescension almost apologising, he explained the various reasons for his not having made use of him before; and he commissioned him to construct the fountain according to his own model. . . .

The fountain . . . is one of Bernini's most admirable inventions and . . . is a beautiful ornament of the City of Rome. Exactly in the centre of the Piazza Navona lies a step or raised level, so to speak, which forms a great circle about 106 Roman palmi in diameter. About 10 palmi from its outside edge it contains a great basin representing, in my opinion, the sea. In the middle of this a mass, or, let us say, a cliff, made of Travertine rises about 36 palmi high; this is tunnelled through from all four sides in such a way that one can from any one side see through these openings to the other side of the Piazza. On account of these holes the cliff falls into four sections, joined and united at the top, and these represent the four continents of the World. Broadening and jutting out with abruptly falling blocks of stone, they give room for four very large giant figures of white marble to be set above, representing the four rivers I have mentioned.

The Nile stands for Africa, and covers the upper part of its head with a cloth, denoting the obscurity which long reigned over the exact point where it springs from the earth; next to it is a fine palm tree. The Danube, representing Europe, is gazing at the stupendous obelisk and has a lion near it. The Ganges, for Asia, has a large oar in its hand, denoting the extent of its waters, and, a little below it, a horse. Lastly, the Rio della Plata, for America, is represented by a Moor; next to it are some coins to show the wealth of minerals abounding in that country, and it has beneath it a terrible monster, commonly known as the Indian Tatu or armadillo. Round all these figures water spouts, led here from the Trevi Fountain. And at the level of the water in the basin there are some large fish, apparently gliding through the sea, and all of them most beautiful. One of them, on the side

towards the Piazza Orsini, seems to be swallowing the water necessary for its life, and then blowing out the excess, a truly brilliant conceit.

The cliff is so constructed that it seems to be all of one piece, and cannot break into pieces through some accident, because all the joins of the blocks are dovetailed and so connected that one acts as bond for another, and all join in holding the whole together. Exactly in the middle of the upper part of the cliff stands, in a remarkable way, the pedestal, about 23 palmi high; and on this rests the great obelisk, about 80 palmi high. It has a fine metal tip of about 10 palmi, and above this a gilt cross shines; and above this again rests the dove with an olive-branch in its beak, the emblem of the Pamfili family. It is astonishing to see how so huge a construction has been erected on so tunnelled and divided a rock, and how (to speak in artistic terms) the whole thing is a counterfeit. . . .

In this great work, the whole cliff, the palm tree, the lion and half of the horse are altogether from the hand of Bernini. The Nile is by the hand of Jacopo Antonio Fancelli, the Ganges by Monsù Adamo, the Danube by Andrea Lombardo, and the Rio della Plata by Francesco Baratta. Yet it is true that, in the case of this last great figure and that of the Nile, Bernini himself gave many of the strokes with his own hand).

The project for ornamenting the Piazza Navona with fountains goes back to Pope Gregory XIII, who constructed at the south end the fountain now known as the Fontana del Moro with four figures of tritons by Leonardo da Sarzana, Flaminio Vacca, Silla da Viggiù and Taddeo Landini, and in a corresponding position at the north end a basin of similar shape without sculptured decoration, known as the Fontana dei Calderari. In the centre of the square between them was placed a rectangular basin designed for watering horses. The siting of these fountains is shown, e.g., in an engraving by Tempesta of 1593. The position of the central trough determined the position of Bernini's Fountain of the Four Rivers, which is set in the centre of the square and is not related to the façade of S. Agnese in Agone. In 1645 (Wittkower), and certainly before 1647, Pope Innocent X conceived a plan for diverting water from the Acqua Vergine to the Piazza Navona; in the relevant rescript Borromini is named as the architect of this work. From this time on the plan for the fountain was associated with Pope's intention to erect in Piazza Navona a recently discovered obelisk, which he visited on 27 April 1647 ('Giovedì doppo desinare il Papa fu a S. Sebastiano per vedere nella Naumachia di Claudio destrutta, sta rovinato per terra un obelisco grandissimo per farlo risarcire et erigerlo in mezzo Piazza Navona imitando in ciò li vestigij di Sisto V') (After dinner on Thursday the Pope was at S. Sebastiano to see in the ruined Naumachia of Claudius a large obelisk lying in pieces on the ground, with a view to its repair and erection, following Sixtus V, in the middle of the Piazza Navona) (Deone, *Diario*, quoted by Fraschetti, p. 180.) The model by Bernini described by Baldinucci must have been made after this time. This is probably identical with a model in wood and gesso (H. 175 cm.) formerly in the Giocondi collection, Rome, published by Brinckmann (*Barock-Bozzetti*, ii, pl. 16, 17), in which the figures are set vertically and are represented supporting stemme. Two

bozzetti for the statues of the Nile and River Plate in the Ca d'Oro, Venice, are in general correspondence with the figures as executed. The genesis of the design can be traced through a number of preliminary drawings reproduced by Brauer and Wittkower, of which the most important are (i) a wash drawing at Ariccia (pl. 25b) showing the obelisk rising from the rock with a River God holding a cartouche with the arms of Innocent X in a grotto beneath; (ii) a drawing at Windsor (pl. 27) of two figures with a cartouche with the papal tiara and keys above a shell-shaped basin with a low surround; (iii) a drawing at Leipzig (pl. 28) for the base of the fountain with the obelisk and figures roughly indicated; (iv) a drawing in the Vatican (pl. 29a) for the point of juncture of the obelisk and the rock; and (v) three drawings in Florence, two supposedly for the figure of Nile (pls. 29b, 30) and one for the River Plate (pl. 31), the pose in each case differing in certain fundamental respects from the figures as executed. An undated letter written from Rome by Francesco Mantovani (printed by Fraschetti, p. 180) refers to a silver model prepared by the sculptor for Donna Olimpia Pamphili. A second letter by the same correspondent, dated 25 July 1648 states that work on the foundations of the fountain had been begun, and that the obelisk was broken in six pieces and would require to be repaired before it could be set up. A tax was levied by the Pope to cover the cost of the fountain. According to the *Diario* of Gigli, the pieces of the obelisk arrived in Piazza Navona in August 1648, and it was erected in August 1649. The course of work on the sculptures is recorded in documents printed by Fraschetti (pp. 181–2, supplemented by Wittkower). 'Due forme di gesso dello scoglio' were paid for in September 1648, and the Travertine base was in course of execution by Giovanni Maria Franchi in March 1650. According to a MS. source quoted by Fraschetti, 'detti Lavori tanto d'Animali come di alberi fiori, o piante cauati e scolpiti tutti dal med.mo. Masso dello Scoglio che regge la Guglia, hanno apportato difficultà e fatiche grandissime, quali credo non si possono molto ben considerare, se non da chi l'ha viste operare in atto prattico' (These operations, which involve the carving of both animals and trees or plants in leaf from the very mass of the cliff supporting the obelisk, have caused very great difficulty and labour; one can hardly appreciate this unless one has seen the work actually in progress). Payments are recorded in the course of 1650–1 for the Nile to Giacomo Antonio Fancelli, the Danube to Antonio Raggi, the Ganges to 'monsù Claudio' (Claude Poussin), and the Rio della Plata to Baratta. Other artists involved in the work were Nicola Sale and Ambrogio Appiani (the former responsible for coats of arms, dove and lily), Giovanni Battista Palombo (palm and snake), and Abbiatini (colouring of rock, palm and plants). There is no reason to question the statement of Baldinucci that certain parts of the base were executed or recarved by Bernini. Gigli records a visit paid by the Pope after the completion of the fountain in June 1651, when the water was turned on for the first time. The fountain was fully disclosed on 12 June of this year. There is some uncertainty as to the sum paid to Bernini for the fountain, which certainly exceeded the nominal payment of 3000 scudi. According to a report by Giovanni Battista Ruggeri of 18 October 1651, Bernini, when asked 'chi è stato piu generoso

o Urbano per la Tribuna di S. Pietro, o Innocentio per la Fontana, egli rispose prontamente che Innocentio haveva superato poi che havendole donato 3m. scudi e un Cavalierato a suo fratello, che vale Mille, stando la qualità de tempi, e le strettezze del Papa, egli diceva a tutti che il donativo era stato di 4m. scudi' (who was the more generous, Pope Urban over the Tribune of S. Pietro, or Pope Innocent over the fountain, he readily replied that Innocent was the more so; for, since he had given him 3000 scudi and a knighthood for his brother, which was worth another thousand, in view of the general state of affairs at that time and the Pope's straits, he always said that the reward had been 4000 scudi). The sculptors of the four large figures received 720 scudi each.

The programme of the sculptures can be established (Huse) from the inscriptions on the four sides of the fountain recorded by M. Lualdi (*Istoria Ecclesiastica*, ii: *La Propagatione del Vangelo nell'Occidente*, Rome, 1651). That beneath the River Nile reads:

OBELISCUM
Ab Imperatore Caracalla Romam advectum
Cum inter Circi Castrensis rudera
Confractus diu iacuisset,
INNOCENTIUS X. Pontifex. Maximus,
Ad fontis, forique ornatum
Transtulit, instauravit, erexit.
Anno. Sal. 1651. Pont. Septimo.

Under the Rio della Plata the inscription is as follows:

Noxia Aegyptiorum monstra
INNOCENS premit Columba:
Quae pacis oleam gestans
Et virtutum lilijs redimita.
Obeliscum pro trophaeo sibi statuens
Roma triumphat.

Beneath the Danube are the words:

Innocentius X. Pont. Max.
Niloticis Aenigmatibus exaratum lapidem
Amnibus subterlabentibus imponit
Ut salubrem spatiantibus amoenitatem
Sitientibus potum,
Meditantibus escam,
Magnifice largiretur.

The fourth inscription, beneath the Ganges, reads:

Innocentius X. Pont. Max.
Natali domo Phamphilia
Opere, cultuque amplificata,
Liberataque importunis aedificis
Agonali area
Forum urbis celeberrimum
Multiplicati Maiestatis incremento
Nobilitavit.

Huse concludes that Lualdi is likely to have advised Bernini on the programme.

Plates 154, 155: THE CATHEDRA PETRI
St. Peter's, Rome

The Cathedra Petri (Fig. 166), Bernini's most important single contribution to St. Peter's, stands in the apse of the church where

it is flanked by the tombs (*left*) of Pope Paul III and (*right*) of Pope Urban VIII. It is planned in four registers, which comprise (i) the base with the arms of Pope Alexander VII, (ii) the four colossal bronze figures of (*left front*) St. Ambrose, (*left back*) St. Athanasius, (*right front*) St. Augustine, (*right back*) St. John Chrysostom, (iii) the throne containing the Chair of St. Peter, flanked by two angels and with a relief of the Pasce Oves Meas on the back, (iv) a glory of angels surrounding an oval glass window showing the Holy Ghost. Under Pope Urban VIII the relic of the Sedia was installed in an altar of the basilica carved from models by Flori and Balsinelli (payment of 27 August 1639); a drawing showing the installation of the Sedia at this time, over an altar against a painted background with the Holy Ghost, is preserved in Cod. Barb. Lat. 4409 (Battaglia, pl. VII 1). The Cathedra of Bernini owes its origin to a decision of Pope Alexander VII in April 1656 that the relic should be transferred to the apse of St. Peter's, 'ibique decentius quo poterit ornari remotis Columnis nunc ibi existentibus, et earum loco positis aliis duabus e marmore Cottonelli coloris magis rubri.' In the following year it was decided that the ornamentation of the Cathedra should be of 'aeneum magnificentissimum', and application for the necessary bronze was made to Amsterdam and Venice. On 3 March 1657 Bernini prepared a 'delineamentum' of the Cathedra, and was engaged in assembling a wooden model ('modelletto di legnio della nicchia do(ve) va la cattedra'). Bozzetti for the Doctors of the Church were entrusted to Ercole Ferrata, Antonio Raggi and Lazzaro Morelli. In April the model was approved, and a fee of 6000 scudi was proposed. In August of the same year this was raised to 8000 scudi, at the rate of 200 scudi per month for forty months. The decision to install the relic between the Urban VIII and Paul III tombs was formally announced in March 1657, and provision was made for rare marbles for the base. Work continued through the second half of 1657, and in 1658 a specialist in bronze casting, Peter Verpoorten, was named as assistant to Bernini. Verpoorten, however, died in September 1658, and was replaced by Lazzaro Morelli. Verpoorten appears to have made models for the 'angeli sopra la cattedra', and large models for the Doctors of the Church were prepared by Raggi and Ercole Ferrata in and after June 1658. After this year Raggi's name does not again appear in the documents relating to the Cathedra until 1664. In 1659 or 1660 Bernini appears to have begun work on the site, and in 1660 practical preparations for the casting of the bronzes were started by Artusi. In June of this year, however, it was reported that the available bronze was insufficient, and a search for bronze was instituted in Trieste and Hungary. A wooden model was executed by Carcani in 1659–60, but was criticised by Sacchi as being insufficiently large and imposing. Thereafter the figures were enlarged. Mariani (in *Bollettino d'Arte*, xxv, 1931, pp. 161–72) publishes two sets of models for the angels beside the throne in the Museo Petriano, one (H. 1.55 m.) for the angels in their early reduced form and the other (H. 2.24 and 2.31 m.) for the angels as executed. A reference at the beginning of 1661 to wax models for the Doctors of the Church is probably (Battaglia) to models for the smaller scheme, but by the autumn of this year the full-scale model of the St. Augustine five metres high was

in course of preparation. The first casting of this figure was unsuccessful; in November 1661 the figure was cast up to the neck, and the head was cast separately in the following year. Work then proceeded with the St. Ambrose. The last of the statues to be cast was the St. Athanasius (1663). Bernini's principal assistant in these figures was Lazzaro Morelli. By 1665 the Doctors of the Church had been gilded and erected in the church. Morelli, assisted after 1664 by Raggi, was also largely responsible for the Glory above the Cathedra. The Chair proper was cast in 1663; in 1664 Carlo Mattei was engaged on its 'rinettatura', and in 1665 Giovanni Paolo Schor was working on the ornamented section at the base. On 29 April 1665 Bernini left for France, and on his return to Rome found everything in place save the angels on the Chair, the second of which was delivered in December. The Cathedra was disclosed on 16 January 1666, and the relic of the Sedia was transferred to it. On 30 January 1666 Bernini wrote to Chantelou: 'Io per gratia di Dio ho finito l'opera della catedra.'

Plate 156: SAINT JEROME
Duomo, Siena

In 1658 it was decided to modify the right flank of the Duomo in Siena. The most important feature of this work was the construction of a new Cappella del Voto for the Chigi family designed by Bernini, who is described in a document of 11 June 1662 as 'Architetto di d.a opera' (for the relevant plans and documents see Golzio, *Documenti artistici sul seicento nell'archivio Chigi*, Rome, 1939, pp. 79–106). Work on the chapel appears to have begun in 1659, with the arrival in Siena of the painter Giovanni Paolo Schor, who was entrusted with the supervision of the work. The whole of the interior decoration of the Chapel, including the frame of the Madonna del Voto over the altar (cast by Artusi and gilded in June 1662), the angels and putti (modelled by Ercole Ferrata and cast by Artusi), the paliotto (gilded 1663), arca, bronze gate (installed at the end of 1663), and lapis lazuli inlay on the altar wall, was carried out under the general direction of Bernini. The principal sculptural features of the Chapel are four marble statues, two (SS. Jerome and Mary Magdalen in niches beside the entrance) by Bernini, and two (SS. Bernardino and Catherine of Siena by Raggi and Ercole Ferrata respectively in niches beside the altar). The correct identification of the statues of Raggi and Ercole Ferrata is due to Pascoli. Payments to Ercole Ferrata and Raggi were made in February and April 1662. Final payments for the four figures date from June 1663, and they were installed in the Cappella del Voto before the feast of the Assumption in the same year. According to Domenico Bernini, Pope Alexander VII visited Bernini's studio to examine the figures before they were despatched to Siena ('L'honore della prima Visita fu confermato di nuovo dalla seconda che fece: poichè havendo il Cavaliere scolpito ad istanza del Pontefice la Statua di S. Girolamo, e di S. Maria Maddalena più grandi del naturale, e fatto il Modello della Statua intiera del medesimo Papa, che poi scolpì in marmo Antonio Raggi detto il Lombardo, tornò di nuovo con ugual pompa in Casa di lui; avanti che fussero

portate queste Statue a Siena, over erano destinate') (The honour done by the first visit was reconfirmed by the second he made. For the Cavaliere had, on the Pope's instructions, carved the statue of St. Jerome and that of St. Mary Magdalen over life-size; and when the model of the full-length figure of the same Pope, later carved in marble by Antonio Raggi, called il Lombardo, was finished, the Pope came again with the same pomp to Bernini's house. This was before these statues were carried to Siena, for which town they were intended). The execution of the St. Mary Magdalen is weaker than that of the St. Jerome. Raggi and Ercole Ferrata received 300 scudi each in payment for their work, while Bernini was presented with two silver cups and two crimson damask purses embroidered with gold thread containing 2128 scudi. Three drawings at Leipzig for the St. Jerome are published by Brauer and Wittkower (pl. 50a–c), and a terracotta sketch-model for the head of this figure is in the Fogg Art Museum, Cambridge. A terracotta model for the whole figure is in the Museo Civico at Termini Imerese (for this see M. V. Brugnoli, in *Arte Antica e Moderna*, 1961, pp. 291–3). Small terracotta reproductions of this figure (but not of the St. Mary Magdalen) were produced in Siena in some numbers in the late seventeenth and early eighteenth centuries.

Plate 157:
THE ANGEL WITH THE SUPERSCRIPTION
S. Andrea delle Fratte, Rome

Soon after his election, Pope Clement IX determined to replace the fourteen stucco statues by Raffaello da Montelupo on the Ponte Sant'Angelo with ten marble statues of Angels. In order to accelerate the work, the commissions were distributed between Lazzaro Morelli, Antonio Raggi, Paolo Naldini, Cosimo Fancelli, Girolamo Lucenti, Ercole Ferrata, Antonio Giorgetti and Domenico Guidi. It was originally intended that two Angels should be carved by Bernini, and one by each of the remaining sculptors, working under Bernini's general direction and in at least one case from his designs. In the event Bernini's two Angels were not put into position on the bridge, one of them, the Angel with the Superscription, being copied by Giulio Cartari with extensive intervention by Bernini, and the other, the Angel with the Crown of Thorns, by Naldini, who there-fore carved two statues. The circumstances which led to this result are described by Baldinucci: 'Aveva egli condotto di sua mano due de' medesimi angioli per dar loro luogo fra gli altri sopra di esso ponte; ma non parve bene a Clemente che opere sì belle rimanessero in quel luogo all'ingiurie del tempo; che però fecevene fare due copie e gli originali destinò ed esser posti altrove a disposizione del cardinal nipote. Ciononostante il Bernino ne scolpì un altro segretamente, che è quello che sostiene il titolo della croce, non volendo per verun modo che un'opera d'un pontefice, a cui egli si conosceva tanto obbligato, rimanesse senza una qualche fattura della sua mano. Ciò risaputo il papa, ebbene contento, e disse: "Insomma cavaliere, voi mi volete necessitare a far fare un'altra copia." E qui consideri il mio lettore che il nostro artefice constituito in età

decrepita in ispazio di due anni e non più condusse le tre statue di marmo intere assai maggiori del naturale, cosa che ai più intendenti dell'arte sembra avere dell'impossibile' (He had him-self carved two of the aforesaid angels with his own hand in order to place them with the others on the bridge. But it did not seem right to Clement that works so beautiful should remain there exposed to the injuries of weather, and he therefore had two copies made and gave instructions that the originals should be placed elsewhere and held at the disposition of the Cardinal nephew. Despite this Bernini carved another secretly, namely the Angel with the Superscription, since he was anxious that the commission of a Pope to whom he knew he owed so much, should not lack something by his hand. When he learned this, the Pope, happy as he was, declared: 'You compel me to have yet another copy made.' And here let my readers consider that our artist, though in a decrepit state, in the space of two years carved three marble statues larger than life, something that even those who understand most about the art of sculpture believed to be impossible).

Work on the commission (for which see Evers, *Die Engels-brücke in Rom von Gio. Lorenzo Bernini*, Berlin, 1948, and Wittkower, 1966, pp. 248–51) was begun after 22 September 1667, when eight blocks of marble were purchased for the statues. The carving of the statues was initiated in the summer of 1668, and five of the Angels were inspected by Pope Clement IX on 21 September 1669. Payment was made for blocks of marble for the two copies of Bernini's Angels on 15 December 1669, and payments for these to Cartari and Naldini date from July 1670 and November 1671. Payments of 700 scudi each to Bernini and Paolo Bernini were made on 17 August 1670. Wittkower (whose analysis of 1966 super-sedes that of 1955 and is based on a re-examination of the documents) argues that it is impossible to discover any dif-ference in quality between the two Angels, and that the inter-vention of Paolo Bernini must therefore have been restricted to preparing the marble for his father. The treatment of drapery is, however, markedly different in the two statues, as it is in the St. Jerome and St. Mary Magdalen at Siena, and it is likely that the Angel with the Crown of Thorns was carved in part by the same sculptor as the Magdalen, probably by Pietro Bernini. A drawing for the Angel with the Superscription in the Galleria Nazionale, Rome, is, as noted by Wittkower ('Role of Classical Models') based on the antique. The material relating to the terracotta bozzetti for the Angels is collected by H. W. Kruft and L. O. Larsson, ('Entwürfe Berninis fur die Engelsbrücke in Rom,' in *Münchner Jahrbuch für Bildende Kunst*, 3f., xvii, 1966, pp. 145–60).

Plate 158: THE DEATH OF THE BEATA
LODOVICA ALBERTONI
S. Francesco a Ripa, Rome

According to Baldinucci, the statue of the Beata Lodovica Albertoni was commissioned by Cardinal Paluzzo degli Albertoni, nephew of Pope Clement X, soon after the election of the Pope (20 April 1670). The cult of the Beata Lodovica

Albertoni was sanctioned in a papal brief of 28 January 1671. It is established by Wittkower (pp. 236–8) that the work was begun in 1671 and was completed by mid-October, 1674. The altarpiece by Gaulli above and behind it seems to have been painted after the completion of the statue. Bernini's drawings for the frame survive.

STEFANO MADERNO
(b. 1576; d. 1636)

According to Baglione, Maderno died in 1636 in his sixtieth year, and he was therefore born ca. 1576–7. Initially he practised as a restorer of antiques, making reductions from classical statues many of which were cast in bronze. A number of signed terracotta statuettes by Maderno derived from the antique are known (examples in the Ca d'Oro, Venice, the Hermitage, Leningrad, and elsewhere), and his bronze statuette of Hercules and Antaeus (terracotta model in Ca d'Oro, Venice) achieved considerable popularity. His earliest large work in marble is the St. Cecilia (see Plate 159 below). Subsequently he executed two putti for the Aldobrandini Chapel in S. Maria sopra Minerva, two statues on the exterior of the Cappella Paolina (1608) (with Francesco Caporale), two statues of Peace and Justice over the high altar of S. Maria della Pace (1614?), and a St. Peter over the entrance of Montecavallo (companion figure by Berthelot). He was also employed on work for the Duomo at Orvieto, and in the interior of the Cappella Paolina (see Plate 136 above), and worked for the Duomo at Orvieto. The most representative large statue by Maderno is the arid Jacob wrestling with the Angel in the Palazzo Doria, Rome.

BIBLIOGRAPHY: For Maderno see Baglione (pp. 345–6), A. Muñoz ('Stefano Maderno', in *Atti e Memorie della R. Accademia di S. Luca*, Annuario 1913–4, iii, Rome, 1915, pp. 1–23) and Venturi (X-iii, pp. 611–8).

Plate 159: SAINT CECILIA
S. Cecilia in Trastevere, Rome

On 20 October 1599, in the course of work on the high altar of S. Cecilia in Trastevere undertaken by Cardinal Sfondrato, there were discovered two white marble sarcophagi, one of which, on the basis of an inscription of Pope Paschal I, was identified as that of St. Cecilia. Inside the sarcophagus was a cypress coffin, containing the body of the Saint, which is described by Bosio (*Historia passionis S. Caeciliae*, Rome, 1600) as lying on its right side with the face turned towards the ground as though in sleep and clad in a gold embroidered dress. The body was visited on 10 November 1599 by Pope Clement VIII, who gave a sum of 4,000 scudi for a silver casing for the coffin. On 22 November 1599 the relic was reinterred under the high altar by the Pope. The confessio in front of the high altar was enriched by Cardinal Sfondrato with coloured marbles, onyx, lapis and bronze. The reconstruction of the altar was entrusted to Maderno, who was also responsible for the figure of the Saint, which is placed in a black marble recess as though in an open sarcophagus. Three architects, Pompeo Targone, Giacomo della Porta and Gaspare Guerra are also mentioned in connection with work in the church. The statue is assumed to have been completed by 1600, since it is mentioned by Bosio, and this is confirmed by a payment to Maderno of 16 December 1600 printed by A. Nava Cellini ('Stefano Maderno, Francesco Vanni e Guido Reni a Santa Cecilia in Trastevere,' in *Paragone*, 1969, No. 227, pp. 18–41) from the Registro dei Mandati of that year: 'Vi piacera di pagare a ms. Stefano scultore scudi sessantacinque di moneta, quali sono per intiero saldo, et final pagamento di quanto egli deve havere o piu pretendere havere da No per qualsivoglia cosa, sino et per tutto questo di 16 di dicembre 1600' (be pleased to pay to the sculptor maestro Stefano sixty-five scudi, which are for the total salary and final payment of what he should have or rather may claim to have from us for everything that he has done, up to and including 16 December 1600). But the assumption that it was based on direct study of the Saint's body when this was disinterred is almost certainly incorrect (for this see L. de Lacger, in *Bulletin de littérature ecclésiastique publié par l'Institut Catholique de Toulouse*, xxiv, 1923, p. 218 ff., and Cabrol, *Dictionnaire d'Archéologie*, ii-2, 2736). The dimensions of the statue none the less correspond with the recorded dimensions of the body, and Baglione and other early sources describe the pose as 'nell'atto appunto che fu trouata'. It has been suggested (N. von Holst, 'Die Cäcilienstatue des Maderna', in *Zeitschrift für Kunstgeschichte*, iv, 1935, pp. 35–46) that the pose was taken over from an engraving in the British Museum ascribed to the school of Marcantonio. This case (which rests on the assumption that the engraving was produced ca. 1540–80) is unconvincing, and it is likely that the engraving depends from Maderno's statue. A painting by Francesco Vanni destined for the crypt of S. Cecilia in Trastevere is closely related in pose to, though more naturalistic than, the present statue. It is shown by Nava Cellini, on the basis of a payment of 1605, that this work and a preliminary drawing in the Uffizi (No. 10794F.) also postdate the statue. The discovery of the body is assigned by Salerno (*Altari Barocchi in Roma*, Rome, 1959, pp. 49–52) to the year 1600. For the correct dates see Pastor (xi, pp. 684–9).

FRANÇOIS DUQUESNOY
(b. 1597; d. 1643)

François Duquesnoy, known in Italy as Il Fiammingo, was born in Brussels in 1597. Trained by his father, the sculptor Jérome Duquesnoy the elder, he is said by Bellori to have executed two angels for the façade of the Jesuit church in Brussels, and figures of Justice and Truth for the Hôtel de Ville at Hal, none of which survive. As the result of an application made to the Archduke Albert early in 1618, he received the sum of 600 livres payable in four instalments for study in Italy, whither he went in August of this year. After the death of the Archduke (1621), he practised in Rome as a woodcarver. The foundations of his success were laid by a Flemish merchant, Pieter Visscher, for whom he carved a life-size figure of Venus suckling Cupid (lost). Through Visscher he came to the notice of Filippo Colonna, by whom he was employed on the restoration of antiques, and for whom he carved an ivory Crucifix presented by Colonna to Pope Urban VIII. Urban VIII was in turn attracted by Duquesnoy's ivory carvings, and in 1626 purchased from him a Crucifix and a statuette of St. Sebastian. An amber carving of a Bacchanal, bearing Duquesnoy's initials and the date 1625, is in the Bayerisches Nationalmuseum, Munich. At this time Duquesnoy became intimately associated with Poussin, who had arrived in Rome in 1624, and like Poussin enjoyed the patronage of Cassiano del Pozzo. Through Sandrart, who arrived in Rome in 1629, he came in contact with Vincenzo Giustiniani, for whom he made three bronze figures of Mercury, Hercules and Apollo, two of which are probably identical with bronzes now in the Liechtenstein collection at Vaduz. Duquesnoy's first major work, the popular figure of St. Susanna in S. Maria di Loreto, was commissioned in 1626 and designed in the following year, though it was executed after 1629. In 1627–8 he embarked on the St. Andrew for St. Peter's (see Plate 160 below). On 2 October 1628 payment was made to 'Francesco Chente' for two busts for the monuments designed by Pietro da Cortona in S. Lorenzo fuori le Mura, which had been erected in the preceding year. One of these, a bust of Bernardo Guglielmi (d. 1623), survives. Of the same date is a bust of John Barclay (d. 1621) in the Museo Tassiano at S. Onofrio. Other works of this time are the Vryburgh (1628–9) and Van den Eynde (1640) memorial slabs in S. Maria dell'Anima, and Duquesnoy's most celebrated relief, the Concert of Angels for the Filomarino altar in SS. Apostoli, Naples (installed 1642). A marble bust of Cardinal Maurizio di Savoia in the Galleria Sabauda, Turin (terracotta model in Museo di Roma) seems to date from 1635. In January 1639 Louis XIII of France offered Poussin the post of Peintre Ordinaire, and in October of the same year the post of Sculpteur du Roi was offered to Duquesnoy. In 1640 Chantelou visited Rome to secure Poussin's and Duquesnoy's services. Duquesnoy, however, deferred accepting the proffered post till 1642, and was still in Rome when Louis XIII died (14 May

1643). In June 1643 he left for France, but was taken ill at Leghorn, where he died on 19 July 1643. Before leaving Rome, he appears to have been offered a commission for the tomb of Mgr. Antoon Triest (1576–1657) in Saint-Bavon at Ghent, subsequently executed by his brother Jérome Duquesnoy; two terracotta models of putti made by Francois Duquesnoy for this tomb are preserved at Ghent. In the eyes of his contemporaries Duquesnoy's appeal resided first in the strict classicism of his style, most clearly manifest in the St. Susanna, which, according to Bellori, was based on a statue of Urania on the Capital, and second on his reliefs of putti and mythological scenes.

BIBLIOGRAPHY: The standard monograph on Duquesnoy is that of M. Fransolet (*François du Quesnoy, Sculpteur d'Urbain VIII*, Brussels, 1941), in which the facts are carefully assembled, but which contains a superficial analysis of the sculptor's style. The interpretative deficiencies of this book are in part redressed by articles by I. Faldi ('Le "virtuose operationi" di Francesco Duquesnoy scultore incomparabile,' in *Arte Antica e Moderna*, v, 1959, pp. 52–62), V. Martinelli ('Un modello di "creta" di Francesco Fiammingo,' in *Commentari*, xiii, 1962, pp. 113–20), and K. Noehles ('Francesco Duquesnoy: un busto ignoto e la cronologia delle sue opere,' in *Arte Antica e Moderna*, x, 1964, pp. 88–96), and by Wittkower (*Art and Architecture in Italy, 1600–1750*, London, 1958, pp. 177–80). For the amber carving at Munich see A. Kosegarten ('Eine Kleinplastik aus Bernstein von François Duquesnoy,' in *Pantheon*, xxi, 1963, pp. 101–8), and for Duquesnoy's share in the Triest monument E. Dhanens ('De Bozzetti van Frans du Quesnoy: het Problem van de Ontwerpen voor de Graftombe van Mgr. Triest,' in *Gentse Bijdragen tot de Kunstgeschiedenis en de Oudheidkunde*, xix, 1961–6 pp. 103–22).

Plate 160: SAINT ANDREW
St. Peter's, Rome

On 18 November 1626 the basilica of St. Peter's was consecrated by Pope Urban VIII, and six months later (7 June 1627) reference is made for the first time to a project for erecting four altars beneath the niches of the piers supporting the dome (for the documents see O. Pollak, *Die Kunsttätigkeit unter Urban VIII*, Vienna, 1931, ii, pp. 426–9), for the celebration of Masses 'massime in quella dove sta sopra il Volto Santo, et il ferro della lancia, et nell'altra, dove si conserva la Testa di Sant'Andrea, con altre sante reliquie' (particularly in the one over the Volto Santo and the iron from the spear, and in the other one where the head

of St. Andrew and other sacred relics are preserved). On 15 May 1628 it was agreed that the niches should be systematised according to a design prepared by Bernini. The scheme made provision for four colossal statues of Veronica, Longinus, St. Helena and St. Andrew, and these figures were allotted respectively to Mochi (see Plate 161 below), Bernini, Bolgi and Duquesnoy. The history of the St. Andrew can be reconstructed from documents published by Pollak (loc. cit.) and Fransolet ('Le S. André de François Duquesnoy à la Basilique de S. Pierre au Vatican, 1629–40,' in Bulletin de l'Institut historique belge de Rome, xiii, 1933, pp. 272–5), and by I. Lavin (Bernini and the Crossing of St. Peter's, New York, 1969). An initial sketch for the figure in clay or wax was prepared between 7 June 1627 and March 1628, and on 15 May 1628 this was approved by the Congregazione della Fabbrica. It is assumed by Pollak and Fransolet that this sketch was by Duquesnoy, but it is argued, with considerable force, by Lavin that it was in fact due to Bernini. The evidence for this view is in part documentary (in the official report of the meeting of the Congregation it is specifically affirmed that the members 'approbarunt ex eis unum ab Equite Bernini delineatum') and in part stylistic (in that the figure seems to have been planned jointly with the Longinus of Bernini). A stucco model twenty-two palmi high was begun by Duquesnoy in May 1629 and was placed in the niche in December of the same year. The full-scale models for the three remaining statues were installed in March 1632. Work on Duquesnoy's marble statue began in May 1633, and in July 1639 the statue was taken to St. Peter's, where it was unveiled before the Pope on 2 March 1640. Owing to a decision of the Congregation of Rites as to the relative status of the four relics involved, Bolgi's St. Helena was given precedence over Duquesnoy's St. Andrew, and the niche in which the marble stands is not that in which the stucco model was shown. It is recorded by Bellori and other sources that Duquesnoy regarded the consequent change of light as prejudicial to the statue. The statue, for which Duquesnoy received a total sum of 3300 scudi, is inscribed on the rock under the raised right foot FRAN. DV QVESNOY BRVXELL. FAC. Bellori's appreciation of the statue reads as follows: 'Stà il Santo Apostolo con la testa eleuata in atto di rimirare il cielo: dietro le spalle si attrauersa la Croce decussata in due tronchi, & abbracciandone vno con la mano destra, distende aperta la sinistra in espressione di affetto, e di amore diuino nella gloria del suo martirio. Nella quale attione il Santo espone il petto ignudo col braccio destro, che si attiene al tronco: e'l manto passando dietro la destra spalla, ricade dalla sinistra sopra il braccio, e si rilega al fianco, diffondendosi sotto à mezza gamba, & all'altro piede. Ma più si accresce la bellezza, e l'arte; poichè nell'abbigliarsi il manto sotto il petto, viene à cadere in se stesso il panno sopra il panno, mentre staccandosi vn gran lembo dal fianco destro, pende dal sinistro, & insieme dalla mano dilatato in più falde. E tale è l'industria che imitando vn panno lano non graue, anzi arrendeuole, e leggiero, esplica sotto le membra; e le pieghe sono à tempo, e con grata corrispondenza ordinate sopra l'ignudo, seguitando la dispositione del corpo in modo elegante. Onde si riconosce questa massima ne' panni di allegerire i rilieui delle membra, e supplire i luoghi vuoti, e che all'intrecciamento delle pieghe

succedano le falde ampie, e spatiose. Quanto l'ignudo, e l'altre parti di questa statua, il Santo nel rimirare il cielo, volge la testa del lato destro, e piega soauemente il petto à sinistra con attione quieta, e riposata. Sichè nell'arretrare alquanto la spalla frà l'vno, e l'altro tronco della croce, espone il petto formato di parti, robuste in qualità di pescatore affaticato, e forte, ma però estenuato dagli anni, espressa nella carne l'ossatura, & i muscoli con risentimenti moderati. L'istessa dispositione serba ancora il volto alquanto dimagrato, ampia, e calua la fronte, la barba inculta, & aperte le labbra nell'affetto diuino. Et operando sola questa figura in luogo si grande, l'attitudine sua è tutta aperta, e magnifica, mentre il braccio destro si solleua al tronco della croce, e si stende il sinistro. Così da questo lato posa il piede in terra, e l'altro si discosta, e si solleva à mezza pianta: onde con raro effetto, sporge in fuori il ginocchio, e si offerisce la coscia pura sotto il semplice panno; tantoche alle ordinate contrapositioni, e bellezza de' panni, e dell'ignudo l'occhio s'empie d'harmoniche proportioni, e si desta alla marauiglia' (The Apostle stands with his head raised to gaze at heaven; behind his shoulders goes the cross, its two shafts intersecting, and, holding one of them with his right hand, he stretches out his left, open in the expression of emotion and divine love at the glory of his martyrdom. With this movement the Saint exposes his naked breast and his right arm, stretching out to the shaft of the cross; his mantle passes behind his right shoulder and, falling from above the arm on his left, is fastened at the hip, spreading half down one leg and to the other foot. But the beauty and art go further: for the mantle, arranging itself beneath his breast, falls on itself in fold upon fold of drapery; and one long hem stands out from the right hip and hangs from the left, and is at the same time spread out by the hand in numerous folds. The sculptor's care is such that, imitating a woollen material by no means heavy, even supple and light, he clearly defines the limbs underneath it; the folds are fully arranged with a pleasing conformity over the nude body, elegantly following its attitude. Thus, above all, the drapery mitigates the relief of the limbs, filling in the empty spaces, and there is an alternation of full, wide folds and intertwining ones. As for the nude parts and the rest of the statue, the Saint, gazing toward heaven, turns his head from the right, and his breast gently to the left, with a restrained and easy movement. In this way, in the slight recoil of the shoulders between the two shafts of the cross, he exposes his breast, its different elements distinctly modelled and robust in the character of a strong and hardened fisherman, attenuated however by age, the bone-structure and muscles being modelled in the flesh with moderate relief. The face has the same character, a little thin, the brow broad and without hair, the beard untended, and the lips open in divine emotion. And since there is just this one figure in so large a space, his attitude is open and spirited, the right arm rising up to the shaft of the cross, the left stretching outwards. In the same way, on one side the foot rests on the ground, while on the other it is coming away from it, half of the sole raised up; so that the knee pushes outwards with unusual effect and the thigh shows under the simple drapery. Thus is one's eye filled with harmonious proportion in the well-arranged contrapposto and in the beauty of the drapery and nude body, and one is excited by wonder).

FRANCESCO MOCHI
(b. 1580; d. 1654)

Son of the Florentine sculptor Orazio Mochi, Francesco Mochi was born at Montevarchi on 29 July 1580 and was trained in Florence by the painter Santi di Tito and in Rome by the sculptor Camillo Mariani, whom he may have assisted before 1603 on the colossal stucco figures in S. Bernardo alle Terme. At this time he attracted the notice of Mario Farnese, who secured him the commission (1603) for an Annunciation group for the Duomo at Orvieto, now in the Museo dell'Opera del Duomo. The Annunciatory Angel from this group is dated 1605, and the Virgin Annunciate was carved between 1605 and 1608. He later (1609–10) carved a statue of St. Philip for Orvieto. Between 1610 and 1612 he was engaged in the Cappella Paolina of S. Maria Maggiore (see Plate 136 above), completing a relief by his master Mariani and carving a statue of St. Matthew. The next seventeen years were devoted to his most celebrated works, the two equestrian monuments at Piacenza (see Plates 162, 163 below). On his return to Rome he received the commission for the statue of St. Veronica in St. Peter's (see Plate 161 below) and carved a statue of St. John the Baptist for the Barberini Chapel in S. Andrea della Valle which was not put in place and is now in the Hofkirche at Dresden. The same fate overtook a group of the Baptism of Christ carved by Mochi for S. Giovanni dei Fiorentini (model exhibited 1634), which was not installed, was subsequently placed on the Ponte Molle, and is now in the Museo di Palazzo Braschi. A second statue for Orvieto (St. Thaddeus, 1631–44) was used for the purpose for which it was designed, but two figures of SS. Peter and Paul intended for S. Paolo fuori le Mura (1638–52) are now on the Porta del Popolo, and the commission for a bronze statue of Pope Innocent X was withdrawn from Mochi and awarded to Algardi (see Plate 165 below). A model for an equestrsan statue of Carlo Barberini is in the Barberini collection. Mochi died in Rome on 6 February 1654.

BIBLIOGRAPHY: A detailed account of Mochi's career is given by Wittkower (in Thieme Künstlerlexikon, xxiv, 1930, pp. 601–2), who has also provided an excellent critical estimate of his Roman sculpture (Art and Architecture in Italy, 1600–1750, 1958, p. 85). See also V. Martinelli ('Contributi alla scultura del Seicento – 1. Francesco Mochi a Roma', in Commentari, ii, 1951, pp. 224–35, and 'Contributi alla scultura del Seicento – 2. Francesco Mochi a Piacenza', in Commentari, iii, 1952, pp. 35–43), and E. Borea (Francesco Mochi, in I Maestri della Scultura, No. 43, Milan, 1966), with a number of good photographs.

Plate 161: ST. VERONICA
St. Peter's, Rome

The statue of Veronica for the first of the niches in the piers beneath the dome of St. Peter's (for which see Plate 160 above)

was commissioned from Mochi in December 1629 when a payment of 50 scudi is recorded for the first model (for this and other documents see O. Pollak, Die Kunsttätigkeit unter Urban VIII, Vienna, 1931, ii, pp. 442–52). In accordance with a decision of the Congregation of Rites of 5 May 1631, a full-scale model of the figure was prepared, and was exhibited in 1632 along with full-scale models for the three companion figures. In the case of Mochi's model alone an additional payment of 100 scudi was made 'di ordine di Nro. Signore per soplimento'. In 1632 it was agreed that the figures should be made sectionally from a number of blocks of marble, and work on the marble statue appears to have begun after April 1634, when the marble for the figure was approved. On 7 June 1640 the statue was inspected in St. Peter's by the Pope ('Hier mattina la Santità di Nro Sign. su le 10 hore calata nella Basilica Vaticana si compiacue . . . di dar una occhiata alla statua marmorea fatta con gran artif(iti)o dall'Ecc^{mo}. scultore Sign. Andrea Mochi da Cortona della Statua di S^{ta} Veronica sotto il primo Nicchione dove si conserva il volto santo') (Yesterday morning at 10 o'clock His Holiness went down to the Basilica of the Vatican and was pleased . . . to look at the marble statue of St. Veronica, most skilfully made by the excellent sculptor Andrea Mochi of Cortona under that first niche where the Volto Santo is preserved), and on 4 November 1640 it was unveiled. A uniform sum of 3300 scudi was paid for each of the four statues. A year after the exhibition of Mochi's figure there appeared a volume of poems La Veronica Vaticana del Signor Francesco Mochi, with contributions by Francesco Bracciolini, Salvator Rosa and other writers. The most remarkable of the contemporary descriptions of the statue is that of Passeri (pp. 133–4): 'La rapresentò in atto di moto, e d'un moto violente non solo di caminare; ma di correre con velocità, e qui mancò (e sia detto con sua pace) dalla sua propria essenza, perche, se la parola nominativa di Statua deriva dal verbo latino sto stas, che significa esser fermo, stabile, et in piedi, quella Figura non è più Statua permanente, et imobile come esser deve, per formare un Simulacro da esser goduto, et amirato dai riguardanti; ma un personaggio, che passa, e non rimane. . . . Il gesto della Figura è singolare con tutte quelle osservazioni, che si richiedono ad un atto di moto con le sue parti contraposte regolatamente. Lo scherso del panneggiare è mirabile, perche fa che la veste riceva un vento, che la rende agitata, e percossa in modo, che, conservando tutto il nudo distintamente del corpo, rimane arteficiosamente vestita scherzando nel lembo con uno svolazzo, che rende adornamento, e vaghezza. Mostra alquanto le braccia nude, le quali, esponendo quel lino ove sta impresso il volto sudante di Christo ai riguardanti, fanno un gesto leggiadrissimo delle mani di graziosa, e vaga proporzione. Nel sembiante è tutta spirito perche, nel moto degl'occhi, e della bocca, fa conoscere, che esclama ad alta voce il mirabile portento della impressione di quel Santissimo Sudario, et ha lavorato

quel marmo con sommo arteficio e fatica, con fondi gagliar-
dissimi di scuri, e piegature di panni oltra modo sollevate, e
benche di più pezzi congiunti, non lascia penetrare il luoco ove
insieme siano collegati quanto ha saputo schermire l'arte con
l'arte' (He represented her in movement, and in violent move-
ment, not just walking but quickly rushing; and in this, if I may
say so without offence, the statue lacked something of its proper
character. For, if the noun, *statue*, derives from the Latin verb,
sto, *stas*, meaning to be still, steady and on the feet, this figure
is not, as it should be, an unchanging and motionless statue,
constituting an image to be enjoyed and wondered at by the
spectator, but rather a person passing by and not staying. . . .
The gesture of the figure is unusual, and entirely consistent with
such movement, every part being justly balanced. The play of
drapery is remarkable, for the sculptor represents the dress as
struck by a wind, so shaking and convulsing it that, while the
nude part of the body is kept distinct, it is nevertheless cun-
ningly clad by the fluttering edges of the cloth, which endow
it with embellishment and grace. To a certain extent it reveals
the bare arms, holding out to the spectator the cloth on which
the perspiring face of Christ had left its likeness, and she makes a
light movement of the hands, gracefully and elegantly disposed.
In appearance the figure is all soul; for she shows in the move-
ment of her eyes and mouth that she is crying out with loud
voice the miracle of the likeness on the Holy Sudary. The
sculptor has worked the marble with the utmost skill and care,
with boldly incised shadows and the folds of the drapery raised
very high; and though it consists of several pieces of marble
joined, he has concealed art with art so well that one cannot
tell at what point they are joined together). The motif of the
Veronica is related by Hess to a figure in a fresco of the Madness
of Nebuchadnesor by Santi di Tito in the Museo Etrusco of the
Vatican and by Fransolet to a statue from the Niobe group.

Plates 162, 163: EQUESTRIAN MONUMENTS
OF ALESSANDRO (1545–1592) AND
RANUCCIO (1569–1622) FARNESE
Piazza Cavalli, Piacenza

The two equestrian monuments (Figs. 139, 140) (for which see
Pettorelli, *Francesco Mochi e i gruppi equestri farnesiani*, Piacenza,
1926) owe their origin to a decision of Ranuccio Farnese, Duke
of Parma, in 1612 that his son should be baptised in Piacenza,
and that his wife, Margherita Aldobrandini, should make her
formal entry into the city at the same time. The necessary
decorations were entrusted to Malosso, and it was agreed by the
Consiglio Generale of Piacenza 'di erigere a perpetua gloria di
sua altezza serenissima et della serenissima (di) lei casa due statue
sulla piazza grande di questa citta sopra due grandi colonne.'
This proposal was agreed to by Ranuccio Farnese on 4 April
1612. The three deputatati appointed by the Council to super-
vise the making of the statues obtained drawings for the bases
from Malosso. Between April and June the project for statues
was transformed into a project for equestrian monuments, and
on 10 June 1612 there arrived in Piacenza 'l'Illmo. Franco.

Mochio fiorentino co' doi suoi compagni scultori, quali
ahervano da fare li Cavalli et Statue.' Simultaneously an
approach was made to the Milanese sculptor Giulio Cesare
Procaccini (1546–1626), who prepared a model for the statue of
Alessandro Farnese, while Mochi undertook that for the statue
of Ranuccio. The models were completed by 18 September 1612,
and on 28 November 1612 the contract for both statues was
awarded to Mochi. In this the Roman bronze founder Marcello
Manachi is named as the caster of the groups, and final authority
over the statues is vested in Mario Farnese, Duke of Latera. The
contract makes provision for full-scale wax models of the
statues, and stipulates that the two riders should be 'armate
all'anticha', and that the horses should be differently posed,
though in general correspondence with each other. Work
began immediately, but late in 1614 difficulties arose between
Manachi and Mochi, and the latter assumed responsibility for
the casting of the statues. In June 1615 Mario Farnese reported
favourably on the progress of the work; a reply of Ranuccio
Farnese of 17 June 1615 alludes to a proposal for narrative scenes
on the bases of the statues. Early in 1616 the horse for the statue
of Ranuccio Farnese was reported to be almost complete, and
on 24 March 1616 Mochi sought permission to study the Gatta-
melata and Colleoni statues before finishing it ('Havendo avuto
sempre pensiero vedere il Cavalo di Padova avanti ch'io lasci
per fornito il mio . . .'). By 21 April 1616 he had returned to
Piacenza, and reported that 'con grandissimo gusto e soddis-
fatione dell'animo mio ho veduto non solo la statua et caval di
Padova, ma ancora quelli di Venetia, si li antichi come il
moderno, et sono ritornato a casa con quiete d'animo con
openion come sempre ebbi de affaticarmi per poter colpire
il segno, et non potendo almeno darvi vicino. Piaccia a Dio che
cio sia'. The casting of the horse 17 February 1618 was de-
fective but remediable, and thereafter Mochi began work on the
statue of the Duke, for which life study in Parma was required.
A letter from Mochi on 22 January 1619 complains of the
difficulty of obtaining sittings from the Duke. The statue was
cast in the course of 1620, and the complete monument was
unveiled on 9 November of that year. Thereafter work began
on the monument of Alessandro Farnese, and shortly after the
death of Ranuccio Farnese (5 March 1622) the second horse was
cast. On 9 July 1622 the Regent of Parma, Cardinal Odoardo
Farnese, expressed his satisfaction that the casting had been
successful. The successful casting of the statue of Alessandro
Farnese was reported on 25 December 1623, and the second
monument was formally unveiled on 6 February 1625. The
bronzes for the plinths were made by Mochi between this date
and 6 April 1629, when the balance of the sum due to him was
paid. The bronze tablet on the front of the plinth of the monu-
ment of Ranuccio Farnese carries the inscription:

RAINUTIO FARNESIO
PLACENTIAE PARMAE ETC. DUCI IIII
S.R.E.
CONFALONERIO PERPETUO
CUSTODI IUSTITIAE
CULTORI AEQUITATIS
FUNDATORI QUIETIS
OB

OPIFICES ALLECTOS
POPULUM AUCTUM
PATRIAM ILLUSTRATAM
PLACENTIA CIVITAS
PRINCIPI OPTIMO
EQUESTREM STATUAM
D.D.

On the sides of the base are reliefs with allegories of Peace and of Good Government. The statue of Alessandro Farnese (for which a model exists in the Museo Nazionale, Florence) is inscribed:

ALEXANDRO FARNESIO
PLACENTIAE PARMAE ETC. DUCI III.
S.R.E.
CONFALONERIO PERPETUO
BELGIS DEVICTIS BELGICO

GALLIS OBSIDIONE LEVATIS GALLICO
PLACENTIA CIVITAS
OB AMPLISSIMA ACCEPTA BENEFICIA
OB PLACENTINUM NOMEN
SUI NOMINIS GLORIA
AD ULTIMAS USQUE GENTES
PROPAGATUM
INVICTO DOMINO SUO
EQUESTRI HAC STATUA
SEMPITERNUM VOLUIT EXTARE
MONUMENTUM.

The two reliefs on the base show the investment of Antwerp by means of a bridge thrown across the Scheldt (1584) and Alessandro Farnese receiving the ambassadors of Queen Elizabeth (1587). The balance of evidence is that the design of the plinths in their present form is due to Mochi not Malosso.

ALESSANDRO ALGARDI
(b. 1595; d. 1654)

Born at Bologna on 27 November 1595, Algardi was trained in his native town in the academy of Lodovico Carracci and by the sculptor Giulio Cesare Conventi (Bellori). After a period in Mantua, where he was employed by Vincenzo II Gonzaga (d. 1627), he moved to Rome, probably in 1625, with an introduction from the Duke of Mantua to Cardinal Ludovisi. In Rome he worked with his compatriot Domenichino on the Bandini Chapel in S. Silvestro al Quirinale, for which he modelled stucco statues of SS. Mary Magdalen and John the Evangelist (1629?). According to Passeri, Algardi's progress in Rome at first was slow, and he was largely occupied in the restoration of antiques and the carving of small sculptures, of which a sleeping putto in the Galleria Borghese (probably 1625–30) seems to have been representative. His first major commissions for works in marble were for the tomb of Pope Leo XI in St. Peter's (see Plate 166 below), and the statue of St. Philip Neri in the sacristy of S. Maria in Vallicella (commissioned by Pietro Buoncompagni and completed by 26 May 1640). The second of these works was followed by the commission for the Martyrdom of St. Paul for S. Paolo at Bologna (see Plate 168 below). Contemporary with the commission for the Leo XI monument is a gilt-bronze figure of the Magdalen for the Eglise de la Madeleine at Saint-Maximin (1634). A volume of *Poesie dedicate alle glorie del Sig. Alessandro Algardi ottimo degli scultori* (Perugia, 1643) mentions a number of lost works. With the accession of Pope Innocent X, Algardi came into his own both as sculptor and architect. In the latter capacity he was responsible for the Villa Pamphili and the high altar of S. Nicola dei Tolentini, and in the former for the Attila relief in St. Peter's (see Plate 167 below), the bronze statue of the Pope in the Palazzo dei Conservatori (see Plate 165 below), the fountain in the Cortile di San Damaso in the Vatican (1645–50),

and the stucco reliefs over the tabernacles designed by Borromini in the nave of St. John Lateran (1648?–50). Passeri records that in 1648 an attempt was made by Mazarin to induce Algardi to move to France.

Algardi's portrait busts present a number of chronological problems, which are summarised by Wittkower. The evidence for the dating of the earlier busts is specially inadequate. It is generally assumed that the bust of Cardinal Millini (d. 1629) in S. Maria del Popolo was carved about 1630, and that that of Cardinal Laudivio Zacchia (see Plate 164 below) and the Santarelli portrait in S. Maria Maggiore date from this same time, and were followed by the Frangipani busts in S. Marcello al Corso and a bust of Cardinal Scipione Borghese in the Metropolitan Museum, New York. A coherent picture of Algardi's late portrait style can be formed from the busts of Pope Innocent X and Donna Olimpia Pamphili-Maidalchini in the Palazzo Doria, Rome.

BIBLIOGRAPHY: The primary sources for Algardi's career are lives by Bellori and Passeri, the latter edited with a wealth of documentation by J. Hess (*Die Künstlerbiographien von Giovanni Battista Passeri, Römische Forschungen der Biblioteca Hertziana*, xi, 1934). Broad pictures of the development of Algardi's style are given by Wittkower (*Art and Architecture in Italy, 1600–1750*, 1958, pp. 173–7), and, in a more succinct and stimulating form, by W. Vitzthum (*Alessandro Algardi*, in I Maestri della Scultura, No. 85, Milan, 1966), who reproduces a number of works of which photographs are not otherwise available. A general article on Algardi's work by Posse (in *Jahrbuch der Preuszischen Kunstsammlungen*, xxv, 1905, pp. 169–201) is less superficial than a later article by Muñoz (in *Atti e memorie della Reale Accademia di San Luca*, ii, 1912, pp. 37–58),

On Algardi as a portraitist see Muñoz (in *Dedalo*, i, 1920, pp. 289–304) O. Raggio (in *Connoisseur*, cxxxviii, 1956, pp. 203–8) and A. Nava Cellini ('Per l'integrazione e lo svolgimento della ritrattistica di Alessandro Algardi,' in *Paragone*, 1964, No. 177, pp. 15–36), who provides an acceptable chronology for the portrait busts. For Algardi's restorations of antique sculpture see particularly M. Neusser ('Alessandro Algardi als Antiken-restaurator.' in *Belvedere*, 1928, pp. 3–9), Y. Bruand ('La restauration des sculptures antiques du Cardinal Ludovisi,' in *Mélanges d'archéologie et d'histoire de l'Ecole Française de Rome*, 1956, pp. 414 ff.) and A. Nava Cellini ('L'Algardi restauratore a Villa Pamphili,' in *Paragone*, 1963, No. 161, pp. 25–37). For individual works reference may be made to M. Labò ('La cappella dell'Algardi nei Santi Vittore e Carlo a Genova', in *Dedalo*, xi, 1931, pp. 1392–1405, for the Franzoni Chapel in SS. Vittore e Carlo at Genoa), G. Gallo Colonni ('Note su Alessandro Algardi in Genova,' in *Arte Lombarda*, x, 1965, pp. 161–8) Wittkower ('Algardi's relief of Pope Liberius baptising Neophytes,' in *Bulletin of the Minneapolis Institute of Arts*, xlix, 1960, pp. 29–42, for the fountain in the Cortile di San Damaso), Hess ('Ein Spätwerk des Bildhauers Alessandro Algardi,' in *Münchner Jahrbuch der bildenden Kunst*, n.f. viii, 1931, pp. 292–203, for the firedogs cast by Guidi from Algardi's models for Spain), Wittkower (in *Rassegna Marchigiana*, vii, 1928, pp. 41–4, for a small bronze by Algardi), and A. Nava Cellini ('Note per l'Algardi, il Bernini e il Reni,' in *Paragone*, 1960, No. 207, pp. 35–52, for a number of Crucifixes by or after Algardi). A good account of Algardi's contribution to the cult images of St. Philip Neri is given by R. Engass ('Algardi's Portrait Bust of St. Philip Neri,' in *Arte Antica e Moderna*, 1960, pp. 296–9) in connection with a bronze and marble bust in the Galleria Nazionale, Rome.

Plate 164: CARDINAL LAUDIVIO ZACCHIA
Staatliche Museen, Berlin

Prior to its purchase in Rome in 1903, the bust stood on a plinth with the inscription: LAVDIVIVS CARD. ZACCHIA. ANNO MDCXXVI. No bust of Cardinal Laudivio Zacchia is recorded in seventeenth-century sources, though a bust of his elder brother Cardinal Paolo Emilio Zacchia (1554–1605) is mentioned by Baldinucci and described by Bellori ('il Cardinale Zacchia Rondenini, questo in atto di volgere il foglio di vn libro che tiene nelle mani'). This second bust is identified by Muñoz ('Alessandro Algardi ritrattista,' in *Dedalo*, i, 1920–1, pp. 289–304) with a bust in the Ojetti collection, Florence. A bust of a Cardinal Zacchia is mentioned in an inventory attached to the will drawn up by Algardi in 1654 ('ed un ritratto di marmo del detto sig. Cardinale Zacchia, non finito'). This bust, which is generally identified with that in the Ojetti collection, appears to have been based on two paintings of Cardinal Zacchia also listed in Algardi's inventory ('un quadretto di ritratto del signor cardinale Zacchia; un quadro d'un ritratto del sig. cardinale Zacchia') as the property of Marchesa Rondanini, the daughter of Cardinal Laudivio Zacchia, to whom the commission appears to have been due. If this identification is correct, the bust of Cardinal Paolo Emilio Zacchia must have been

carved in the last years of Algardi's life. Whereas the Ojetti bust has the generalised character of Algardi's posthumous portraits, the bust in Berlin (for which see Posse), shows the particularised treatment of a life portrait. Laudivio Zacchia, after serving as Nuncio in Venice in 1621, received preferment from Pope Urban VIII, by whom he was appointed (29 January 1626) Cardinal-priest of San Sisto. The inscription on the original base of the bust refers to this event, and the bust was therefore carved between 1626 and Zacchia's death on 7 August 1637. It is assumed by Nava Cellini ('Per l'integrazione e lo svolgimento della ritrattistica di Alessandro Algardi', in *Paragone*, 1964, No. 177, pp. 15–36) that the bust dates from the year inscribed on the plinth (1626). The height of Ojetti bust (126 cm.) is considerably greater than that of the bust in Berlin (70 cm.), and there is no reason to suppose that the commissions were interdependent.

Plate 165: POPE INNOCENT X
Palazzo dei Conservatori, Rome

On 15 March 1645, a year after the election of Pope Innocent X, the Roman Senate decreed that a memorial statue of the Pope should be erected in the Capitol, as a counterpart to the statue of Pope Urban VIII by Bernini, which had been installed five years earlier in the Palazzo dei Conservatori. The statue (for which see E. Steinmann, 'Die Statuen der Päpste', in *Miscellanea Francesco Ehrle*, Rome, 1924, ii, p. 492 ff. and W. Hager, *Die Ehrenstatuen der Päpste*, Leipzig, 1929, No. 54, pp. 62–4) was initially to have been commissioned from Mochi, who, through intrigue, was then rejected in favour of Algardi. Passeri (pp. 201–2) records that Algardi 'diede principio al Lavoro, e, per farlo con comodità migliore, gli fù assegnata la fonderia Vaticana, la quale tenne sempre per l'inanzi il Cavalier Bernini. Dopo gli studi antecedenti necessarii ad ogni operazione per renderla perfetta, pose mano al modello grande in quella proporzione, che deveva esser l'Opera, per formarlo, e gettarlo di cera, per alotarlo doppo, e fare la forma dalla quale si cava la figura di metallo. Quando si venne alla operazione del gettito, o fosse inavertenza, trascuraggine, o poca pratica, andò il tutto in conquasso, e la fusione del metallo andò dispersa, col distruggimento della forma, e con una perdita cosi considerabile. Si publicò questo accidente essere accaduto per divina permissione per l'atto d'ingiustizia da lui comesso in togliere ad altri, e dalle proprie mani, et in particolare d'un'Amico, le occasioni che gia erano in suo potere, e il Mochi ne faceva risate con grandissima sua sodisfazione. Quanto a questo non so chi possa assicurarsi del giusto giudizio di Dio, che possa di fatto chiamare sua permissione una cosa, che può nascere cosi facile, da un puro accidente, et io non voglio entrare a decidere se l'Algardi facesse male, o bene a procurare per se quell'Opera; aducendo per sua discolpa, che, essendo egli in quel tempo al servizio attuale dei Padroni presenti, e trovandosi sempre impiegato dai comandi di quelli del quale impiego riceveva scarsissima ricognizione (e credo, che ciò fussi la verità) gli pareva di ricevere un affronto capitando un occasione de Padroni medesimi, vedersene escluso, dichiarato cosi come insufficiente ad opera di tale considerazione. . . . Per verità

Alessandro si sentì assai tormentato dalla passione di questa disgrazia, e per molto tempo ne sentì qualche afflizione; ma rincorato, e confortato da suoi buoni amici, con offerte amorevoli d'aiuti, di denari, ed altre assistenze, fattosi animo, incominciò di nuovo ad applicarsi all'operazione, et in poco tempo se ne cavò fuori con ogni sodisfazione, e lode, essendogli riuscito il gettito del metallo perfettamente, e ripulita, e terminata la Statua, fu posta al Campidoglio con applauso universale' (began the work; and so that he might do it with better facilities, he was allotted the Vatican foundry, which the Cavaliere Bernini had always had before. After the preliminary studies necessary for the perfection of any undertaking, he started on the model, which was as large as the work was to be, shaping it, casting it in wax, arranging it afterwards in sections, and making the mould from which the metal figure would be taken. When it came to the stage of casting, whether by inadvertence, negligence or lack of experience, the whole thing was ruined and the molten metal scattered, destroying the mould and so causing considerable loss. It was put abroad that this accident had happened by Divine Will, on account of Algardi's injustice in taking from others, even out of their hands, and particularly from one of his friends, the opportunities that had been given them; and Mochi laughed about it with much satisfaction. As for this, I do not know who can be sure enough about God's just judgement to attribute to His Will a thing which can happen so easily, simply by accident; and I do not want to enter the question of whether Algardi did well or ill in getting this commission for himself. But I will mention in his defence that he was at this time in the active service of these patrons and was always occupied with their orders, with but little recognition for it, and so, rightly I think, felt himself slighted when an opportunity for a commission from the same patrons arose and he saw himself excluded from it, thus labelled as not good enough for so important a work. . . . Alessandro was really very distressed at suffering this disgrace, and was afflicted by it for a long time; but after he had been consoled and comforted by good friends of his, with kind offers of help, money and other assistance, he took courage and set to work on the undertaking again. And soon he completed it in an entirely satisfactory way and with much praise, the casting of the metal succeeding perfectly; and when the statue was polished and finished it was put in the Campidoglio with general approval). The statue was installed on 9 March 1650. Hager reproduces a terracotta bozzetto allegedly for the statue of the Pope in a Viennese private collection; a second bozzetto is in the Ashmolean Museum, Oxford (both attributions doubtful).

Plate 166: THE TOMB OF POPE LEO XI
St. Peter's, Rome

The tomb of Pope Leo XI, who was elected Pope in 1605 and reigned only for twenty-seven days, was commissioned from Algardi on 21 July 1634 by the Pope's great nephew, Cardinal Roberto Ubaldini (1581–1635). The contract for the monument (for which see O. Pollak, *Die Kunsttätigkeit unter Urban*

VIII, Vienna, 1931, ii, pp. 281–6) enumerates the sculptures intended for the tomb as follows:

'Primieramente: Il sopradetto Alessandro Algardi spontaneamente et in ogni miglior modo si obliga di fare di sua propria mano tutte le figure, che si dovrano collocare nel sud°. deposito, che sono li seguenti:

La Statua del soprad°. Papa lustrata, et finita compitamente con ogni studio, et diligenza d'altezza di Palmi tredici e mezzo vestita Pontificalmente con ogni studio rapresenterà in forma che benedice, et sedente sopra una sedia, che sta posta sopra l'Urna dove sarà collocato Il suo corpo.

Due figure intiere in piedi compitamente finite d'Altezza di Palmi 12½ per ciascheduna, che vanno nelli lati della medema Vrna, cioè una à man destra, che rapresenta La Magnanimità, e l'altra alla sinistra, che rapresenta la Liberalità con duoi bassi rilevi nelli zoccholi, ò piedistalli delle medeme figure, con l'impresa del Papa, che è un mazzo di rose con le parole sotto sic florui.

Due historie di basso rilievo finite con ogni studio, d'altezza di P^mi 5, et di longhezza p^mi 9 fra tutti duoi Intagliate nel'medemo marmo dell'urna nella parte della prospettiva in faccia.

Duoi Puttini . . . di grand^a P^mi 7 l'uno in circa, che vanno collocati nelle due lunette, overo angolli, che si fanno sopra l'arco della Cornice della nicchia nella quale va collocata tutta l'opera, che regono un'Arma di marmo nella sumità della Sopradetta Cornice.'

(Firstly: the said Alessandro Algardi undertakes of his free will and as best he may to make with his own hand all the figures which are to be installed on the said tomb, to wit:

The statue of the said Pope, polished and finished in an elegant manner and with full care and diligence, 13½ palmi high and in accurate pontifical dress; he will represent him in the act of benediction, sitting on a throne placed over the urn in which his body will lie.

Two full-length standing figures elegantly finished, each of them 12½ palmi high, which will go at the sides of this same urn; that is, one on the right representing Magnanimity, the other on the left representing Liberality, together with two bas-reliefs on the plinths or pedestals of these figures, with the emblem of the Pope, which is a bunch of roses with the words *sic florui* beneath.

A bas-relief with two histories carefully finished, 5 palmi high and 9 palmi across, carved from the same marble as the urn on the part facing the front.

Two small putti, each about 7 palmi high, which will go in the two lunettes or corners above the arch of the cornice of the niche in which the whole work will be put; they will bear a marble escutcheon at the top of the said cornice.)

The contract further stipulates that a wooden model with plaster figures should be prepared, that Algardi should undertake responsibility for the adaptation of the niche in which the tomb was to be set, and that the marble used throughout should be 'marmi del Polvaccio della più bella pasta, et candidezza, che si trovi', and should be selected by the sculptor at Massa Carrara. The total remuneration for the tomb was 2,550 scudi, including two sums of 700 scudi for the statue of the Pope and for the two lateral figures. After the death of Cardinal Ubaldini responsibility for the tomb was assumed by the Congregazione di

Propaganda Fide. The first payment for the tomb occurs on 2 November 1634, and the last payment on 4 July 1652 (for the payments between 1634 and 1644 see Pollak, op. cit., pp. 286–92). The relief on the front of the sarcophagus shows the conversion of King Henry IV of France (1593), at which the Pope had been present as Cardinal-Legate. As noted by Hess (in Passeri, pp. 202–3) the two lateral figures appear to have been virtually complete by 1644. According to Passeri, the figure of Liberality was carved by Giuseppe Peroni (1626–59?), and that of Magnanimity (here described as 'Maestà del Regno') by Ercole Ferrata (1610–86). Wittkower, however, points out that these two artists did not join Algardi's studio till shortly before the completion of the tomb. The Magnanimity depends from a statue of Athena in the Museo delle Terme, which was restored by Algardi. The monument occupies a niche in the third pier on the left side of the left aisle of the basilica. A terracotta model for the relief is in the Accademia di San Luca.

Plate 167: THE MEETING OF POPE LEO THE GREAT AND ATTILA
St. Peter's, Rome

Between 1626 and 1628 a painted altarpiece of the meeting of Pope Leo the Great and Attila was commissioned from Arpino for the altar of St. Leo in the left transept of St. Peter's. This painting was still unfinished at Arpino's death when Lanfranco (14 July 1640) attempted to secure the reversion of the commission. Five years later, after the election of Pope Innocent X, a colossal marble relief (Fig. 165) was commissioned for the altar from Algardi. On 2 July 1646 Algardi received a payment of 100 scudi for a full-scale stucco model of the relief (presented by Pope Alexander VII to the Chiesa Nuova in 1661 and now on the stairway to the Biblioteca Vallicelliana). Payments for the marble run from 28 September 1647 to 30 August 1653, when the total sum of 10,000 scudi payable to Algardi was completed by a payment of 2,800 scudi. A small version of the composition in wax at Dresden, published by Brinckman (Barock-Bozzetti, i, 1923, p. 112) as a model by Algardi, is apparently a derivative from the relief. Passeri's description of the relief reads as follows (pp. 203–4): 'Fu dato intanto all' Algardi l'impiego di quel mirabile basso rilievo (se pare può chiamarsi cosi un lavoro di marmo cosi ben condotto di tutto rilievo) della Istoria d'Attila *flagellum Dei*, che è al presente nello Tempio di San Pietro in Vaticano, et havendo l'assegnamento di cento scudi il Mese ben pagati, si diede a questa operazione con grande assiduità. Si valse, in questo lavoro, dell'aiuto del Guidi, il quale più d'ogn'altro gli fù di gran sollievo, particolarmente in certo tempo che gli convenne fermarsi in letto inchiodato dalla podagra, e durò qualche mese, che, essendone guarito, e tornato al lavoro, il vide portato cosi avanti dalla diligenza di quello, che si stupì, parendogli, che una simile spedizione richiedesse qualche anno d'assistenza, e più s'accalorò nell'affezione del Guidi. Si condusse finalmente alla sua perfezione lavoro cosi considerabile nello spazio di pochi anni, e riuscì, in vero, un Opera, che nella grandezza della Mole non

ha il simigliante, ne tragl'antichi, e tra i moderni Scultori. Rapresenta il Tiranno Attila, quando, essendo incontrato, nelle rive del Pò, dal Pontefice Leone primo, resta atterrito dalla visione Celeste di due personaggi, che lo minacciano dall'alto con le spade nude in mano, siche desistesse dall'impresa di condursi, con l'Esercito in Roma a danni di quella Citta, che furono li due principali Apostoli San Pietro, e San Paolo. Viene accompagnato il Tiranno da quantità di soldati, el Pontefice Leone in abito Pontificale, assisuito dal Clero, lo stà esortando a non proseguire l'intrapreso camino; mentre egli di già spaventato, per la visione, rimane imobile, e confuso. Questa opera riuscì a quel gran huomo, d'una squisita maniera, e condotta ad una estrema perfezione a segno, che non è mai (a parere dei piu saggi) per temere il paragone d'ogn'altro, benche celebre, e renomato Scultore. Io m'assicuro, che questa lode, che con tanta scarsezza, impiego in Opera cosi mirabile, non sia mai per esser derisa, ne dall'Invidia, ne dalla Ignoranza, inimici li più potenti della Virtù, l'una implacabile nel suo livore, e l'altra incapace nella sua stolidezza; perche da se medesima è bastante a farsi una libera apertura all'applauso universale' (Algardi was given the commission for the remarkable bas-relief (if that is the right term to use of a work in marble so well done in full relief) of the story of Attila, the Scourge of God, which is now in the Church of S. Pietro in Vaticano; and, being duly paid a salary of 100 scudi a month, he set to work on this undertaking with great diligence. He had in this work the assistance of Guidi, who more than anyone else was his great support, especially during one period when he had to stay confined to his bed with gout. It was some months before he was better and returned to work, and then he saw things had been carried so far forward by Guidi's diligence that he was astonished, thinking such progress required some years assistance, and he warmed in his affection for him. This great work was finally brought to completion within a few years, and it became a creation which, in the greatness of its size, has no peer, either among the ancient or the modern sculptors. It represents the tyrant Attila met by Pope Leo I on the banks of the River Po, and so struck with terror by the heavenly vision of two figures, the two principal apostles St. Peter and St. Paul, threatening him from above with drawn swords in their hands, that he gave up his intention of marching on Rome to destroy that city. The tyrant is accompanied by a number of soldiers, and Pope Leo, in pontifical dress and assisted by the clergy, is exhorting him not to continue the march he has undertaken; while Attila, terrified by the vision, stands still and uncertain. This work, done in an excellent manner and brought to extreme perfection, came to be a token for that great man of his having, in the opinion of the best judges, nothing to fear in comparison with any other sculptor, however celebrated and famous. I am sure that this praise, which I use of this remarkable work so sparingly, will never be belittled, not even by the two most powerful of Talent's enemies, Envy and Ignorance, the one implacable in its rancour, the other unprofitable in its stupidity; because it is in itself sufficient to bring general approbation). A small terracotta sketch-model for the relief is in the Museo Nazionale, Florence; a second terracotta sketch-model, with disfiguring plaster additions, appeared in 1969 in the Demidoff sale at Pratolino.

Plate 168: THE MARTYRDOM OF ST. PAUL
S. Paolo, Bologna

Algardi's group, which is set behind the high altar in an open tabernacle by Facchetti, is described by Passeri (p. 198): 'Stando cosi applicato gli furono proposte alcune occasioni di lavoro di marmo, una fù San Pauolo in atto d'esser decollato, e la figura del Manigoldo, che gli tronca la testa figure che andarono a Bologna nella Chiesa di detto Santo.' The work (for a comprehensive note on which see A. Mezzetti, in *L'Ideale Classico del Seicento in Italia e la Pittura di Paesaggio*, Bologna, 1962, pp. 356–8, No. 147) was commissioned by Padre Virgilio Spada, probably on behalf of Cardinal Bernardino Spada (1593–1661), and was carved in Rome. Probably begun in 1641, it is mentioned in a letter of Algardi of 3 January 1643 (for this see A. Arfelli, 'Tre note intorno ad Alessandro Algardi,' in *Arte Antica e Moderna*, 1959, pp. 461–5) in the words: poco (resta) che fare nelle figure destinate per S. Paolo di Bologna, dove penso di venire a porle in opera' (little remains to be done to the figures destined for S. Paolo in Bologna, whither I am thinking of coming to install them). According to Masini (*Bologna perlustrata*, 1650, p. 133), the group and its marble decoration were completed by 26 October 1647, when the altar was dedicated. Hess, followed by Wittkower, relates the scheme to an altarpiece of the Martyrdom of St. Longinus by Sacchi at Castelgandolfo (1633–4). The tabernacle is inscribed: DOMINICI FACCHETTI OPVS ANNO JUBILAEI 1650. For the altar, which was designed by Borromini, Algardi prepared a circular gilt bronze relief of the Martyrdom of St. Paul, of which an old gesso cast is in the Museo Estense at Modena and two bronze replicas are in the Victoria and Albert Museum, London.

INDEX OF PLACES

INDEX OF SCULPTORS